A New HISTORY OF ANIMATION

MAUREEN FURNISS

A *New*
HISTORY
OF
ANIMATION

460 ILLUSTRATIONS

Illustrations

p. 2: José Antonio Sistiaga, *Ere erera baleibu izik subua aruaren*, 1970. Courtesy José Antonio Sistiaga and Light Cone

p. 8 Anima Mundi festival poster, Rio de Janeiro, Brazil, 1999. © Anima Mundi Festival Archives

First published in 2016 in paperback in the United States of America by
Thames & Hudson Inc., 500 Fifth Avenue, New York, New York 10110

thamesandhudsonusa.com

Library of Congress Catalog Card Number 2016932436

ISBN 978-0-500-29209 9

Printed and bound in China by C&C Offset Printing Co. Ltd

Contents

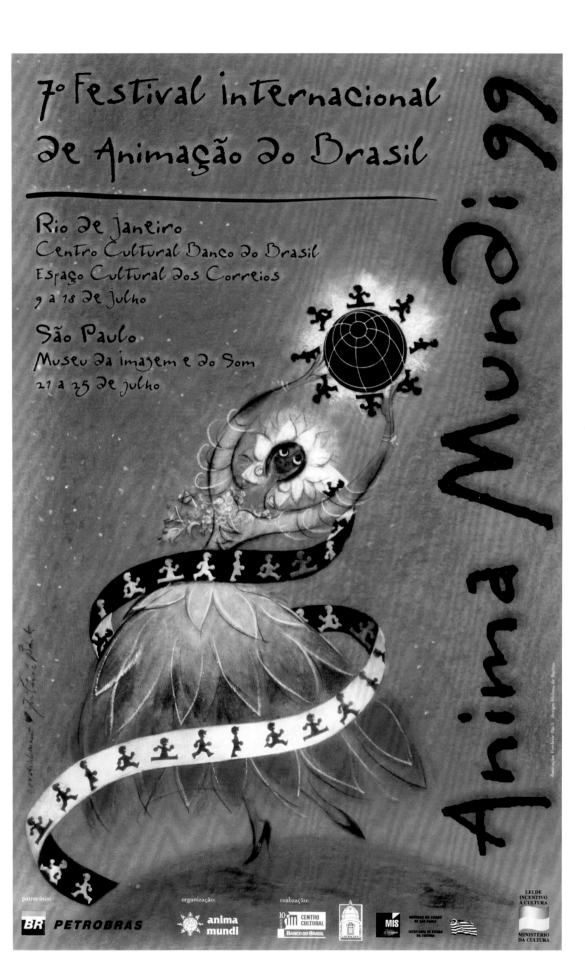

Preface

In twenty years of teaching animation history, I have never found one book that covered all of the aspects of history I wished to present. Consequently, I developed my own extensive database of historical notes to use for my lectures and eventually I assigned students varied readings I found online. When I was contacted by Thames & Hudson and asked if I would develop a book on the history of animation, I thought it would be a great opportunity to unify the wide range of resources I had been using. I looked to my lecture notes as the basis of the chapters that eventually formed the book you are reading today.

Animation Studies as a field has been growing since the late 1980s, following a surge in animation production that had begun earlier in that decade and has continued to this day. Indeed, animation is now ubiquitous worldwide. Developments in the history, theory, and criticism of animated works have flourished through the support of the Society for Animation Studies (an international organization of animation researchers founded in the late 1980s) as well as through the increasing numbers of university programs that have embraced this growing area of scholarship.

This book provides a foundation for the study of animation in its many forms, introducing readers to industrial productions and arts-based practices related to drawn and painted animation, stop-motion, and computer-generated imagery; major studios within the United States and Japan; and animation produced throughout Eastern and Western Europe, the UK, Australia, Latin America, South Africa, and elsewhere. The analysis of these works is placed within historical contexts that help readers understand the "big picture" that has influenced the development of animation throughout the years.

To help with the presentation of material and to assist the reader's understanding, this book's content is presented in a four-part structure. Each part begins with a timeline that places in historical context the major turning-points in animation. Global Storylines provide an overview of the content in each chapter, and a glossary in the back of the book defines animation-specific terminology.

I would like to thank my publisher, Thames & Hudson, for its support in this very large project and for striving to produce the best book possible. I especially would like to thank Nicole Albas, Jasmine Burville, Lucy Smith, Jo Walton, and Ellie Sorell for their help with editing and images, and for their vision in shaping the form and content of the book, which represents the culmination of my writing career.

I am grateful for the many talented CalArts students who have populated my history courses throughout the years and made teaching a pleasure, and for my colleagues at the Institute who have played a part in the best job I have ever had and can ever imagine. Thanks also to the many other friends and colleagues who have supported my work. Among them, I would like to recognize Sheila Sofian, an educator and artist who has been guided in her life and work by strong values and compassion. She has been a true friend and I admire her greatly. Finally, I would like to thank my lifelong friend, Susan Fox, who is also a teacher with a vision for making the world a better place. I am dedicating this book to her in appreciation for the many years of friendship we have shared.

I hope my book provides you with a greater understanding of the art and industry of animation and that you enjoy reading about its many forms.

Maureen Furniss
Santa Clarita, California

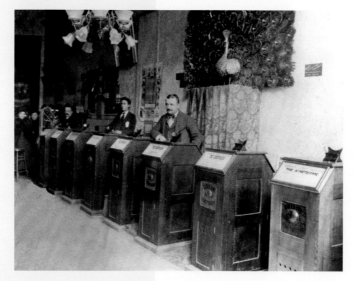

World War I
1914–18

1659

Christiaan Huygens develops the first functioning magic lantern

1712

Invention of the steam engine begins the Industrial Revolution, which continues through the nineteenth century

1733

Jacques de Vaucanson begins building automata

1797

Étienne Gaspard Robertson performs *Fantasmagorie* shows in his Paris theater

1824

Thaumatrope

1832–34

Phenakistoscope and zoetrope

1868

Flipbook

1878

Eadweard Muybridge documents the movements of a running horse

1892

Émile Reynaud's *Pantomimes Lumineuses* are the first animated projections

1895

Film projectors come into use. Public screenings in France (Lumière brothers) and Germany (Skladanowksy brothers)

The Execution of Mary, Queen of Scots (Alfred Clarke) is made at the Edison studio; it includes visual effects

1896

Thomas Edison holds the first American film screening, in New York City

1899

Matches Appeal (Arthur Melbourne-Cooper) is the first stop-motion film

1902

Un Voyage dans la Lune (Georges Méliès)

1906

Humorous Phases of Funny Faces (John Stuart Blackton)

1908

Thomas Edison forms the Motion Picture Patents Company (MPPC)

1908

El Hotel Electrico (Segundo de Chomón)

1908

Fantasmagorie (Émile Cohl)

1910s

Films screened in nickelodeon theaters

1911

Little Nemo (Winsor McCay)

1914

Gertie the Dinosaur (Winsor McCay) is the first example of personality animation

Establishment of formal animation studios by Bray and Barré, both in New York City

1915

Earl Hurd is granted a patent for cel animation

International Film Service (IFS) founded by William Randolph Hearst

American Supreme Court refuses to grant cinema freedom of speech, declaring it to be "a business, pure and simple"

1917

Max Fleischer is granted a patent for the rotoscope process

1918

El Apóstol (Quirino Cristiani) is the first feature-length animated film

Origins of Animation

■ Technological development ■ Development of the animated medium ■ Development of the film industry as a whole ■ Landmark animated film, television series, or game ■ Historical event

Development of radio broadcasting, Jazz Age, and Harlem Renaissance

1919–early 1930s

1919

Feline Follies (Pat Sullivan) introduces a prototype of Felix the Cat

The Tantalizing Fly (Max Fleischer) introduces Koko the clown

1920s

American studios begin practice of block-booking theaters; some countries retaliate with quotas

The film industry begins to adopt sound-on-film processes widely

1920

Edwin Lutz publishes *Animated Cartoons*, the first book about animation production

1921

Margaret J. Winkler begins distributing animation in the US

1922

Felix the Cat is heavily merchandized as the first cartoon celebrity

1923

Disney releases *Alice's Wonderland*, the first of his live-action/animation series

1925

The Lost World (visual effects by Willis O'Brien)

1926

Both Warner Bros. and Fox employ sound-on-film processes. The film industry as a whole adopts sound over the next few years

1926

The Adventures of Prince Achmed (Lotte Reiniger)

1928

Dinner Time (Paul Terry) introduces synchronized sound-on-film animation

1928

Steamboat Willie (Walt Disney, Ub Iwerks) introduces Mickey Mouse in Disney's first sound film

1929

Universal establishes its animation studio, headed by Walter Lantz

Setting the Scene for Animation

Chapter Outline

Global Storylines

The development of mass-market production during the Industrial Revolution establishes the necessary technologies for animation production

Magic-lantern shows and optical toys appear in Europe and delight the public with their illusions of movement

The popularity of newspaper comic strips in the United States provides a basis for animated series

Eadweard Muybridge and Étienne-Jules Marey in turn carry out pioneering research in motion studies

Introduction

"Animation" is a term used to describe a broad range of practices in which the illusion of motion is created through the incremental movement of forms, displayed sequentially as a "motion picture." Commonly, it is further divided into three subcategories: 2D animation, typically employing a series of drawn or painted images; stop-motion, involving a puppet or other object that is modified in form or position over time; or 3D animation, which has come to represent digitally produced images simulating deep space. Animation is such a diverse field, however, with its origins dating far back into history, that it is difficult to define its parameters precisely. Today, many types of animation are being produced, from forms of entertainment to education, promotion, therapy, and fine art.

The earliest examples of images that suggest animated movement are found in prehistoric paintings, such as the ones in the Lascaux caves in France, dating from c. 15,000 BCE (1.1). These ancient images, which include horses and other animals in sequences of slightly altered positions, may indicate that even the earliest humans wanted to set their images in motion. Since then, many industrial, technological, scientific, cultural, aesthetic, and personal factors have influenced the development of animation. This chapter focuses mainly on the nineteenth century, before the widespread availability of flexible filmstrips and related technology allowed the projection of motion pictures, beginning internationally around 1895. In those early years, principles related to animation were developed thanks to new discoveries in the fields of science, mechanics, and entertainment, including magic-lantern shows, optical toys, moving figures known as "automata," motion studies of human and animal movement, and comic

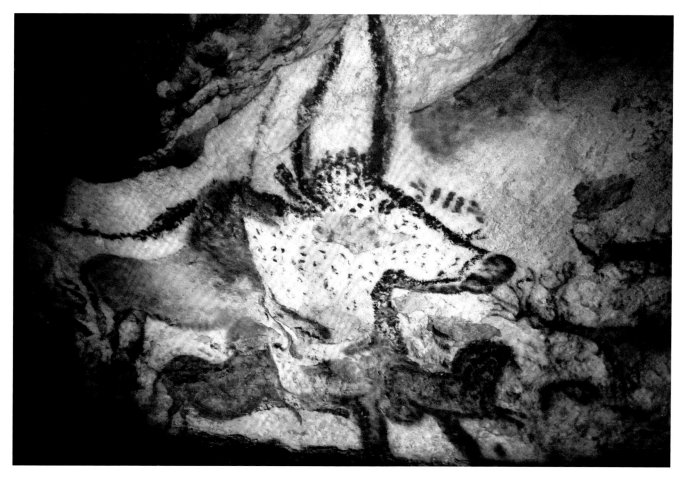

1.1 Prehistoric paintings, Lascaux caves, southwest France, c. 15,000 BCE

strips. Some say the first publicly projected animation is found in the work of French inventor Émile Reynaud, dating from 1892, in shows he called *Pantomimes Lumineuses* (see pp. 23–24).

To appreciate fully the development of animation into an art form and an industry, one must consider the wider historical context from which it evolved: the social, political, industrial, and creative forces surrounding it. The technology that made animation possible appeared at the end of the nineteenth century as part of a larger shift toward modernization; as a result of the Industrial Revolution, machines of every kind proliferated and mass production became the norm. It was also a time of great social change in much of the world, as the British nurse Florence Nightingale and the German political theorist Karl Marx focused attention on social inequity, the American Harriet Tubman fought for women's rights and the end of slavery, the British scientist Charles Darwin defended his theory of evolution over religious views of creation, and the Austrian Sigmund Freud expounded his theories of psychology,

which would revolutionize views on human behavior. As a result of these new ideas and technological advances, people began to see the world differently and through new forms of representation, animation being one of them. This cultural climate influenced the form, content, creation, and reception of animation, both at the time and far into the future.

Early Innovations in Simulating Movement

Magic-Lantern Shows

Magic lanterns are a forerunner of slide projectors, and were once a popular way to purvey information and entertainment (1.2, see p. 14). From their origins in the seventeenth century onward, magic lanterns have been utilized by presenters in many different ways, as they sought to appeal to a variety of different audiences, from

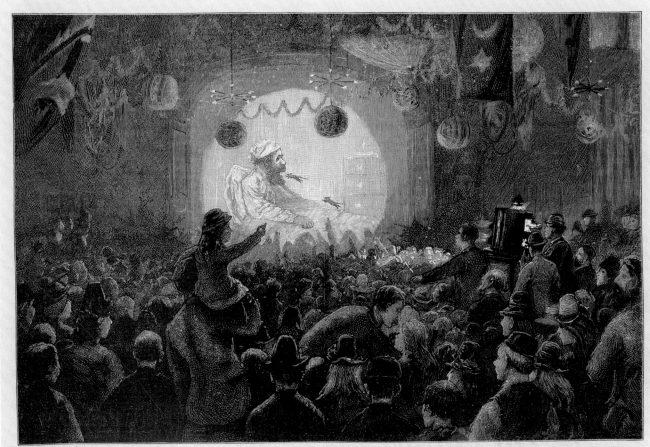

MAGIC LANTERN ENTERTAINMENT GIVEN TO 1,450 POOR AND DESTITUTE CHILDREN BY THE MEMBERS OF THE FULHAM
LIBERAL CLUB AND INSTITUTE

1.2 Engraving showing a magic-lantern show, 1889

the general public to the scientific community. Some of
these presentations were staged in permanent locations,
with content that was fairly consistent from show to
show, but many were conducted by itinerant lanternists,
who moved from location to location and adapted their
shows for each new audience. As a result, it is difficult
to document much of magic-lantern history with
precision. Nonetheless, we can see magic-lantern slide
shows—with their bawdy jokes, scintillating scandals,
merry sing-alongs, edifying travel documentaries,
spiritual enlightenment, scientific demonstrations, and
other forms of content—as precursors to motion-picture
film **projections**, which would emerge at the turn of the
twentieth century.[1] To illustrate their stories and lectures,
magic-lanternists generally relied on a series of hand-
painted or, eventually, photographic glass slides, which
they would purchase in sets or create themselves (**1.3**).

Often, these slides were placed one by one into
a simple wooden **frame**, before being pushed into a

1.3 Nineteenth-century magic-lantern slide

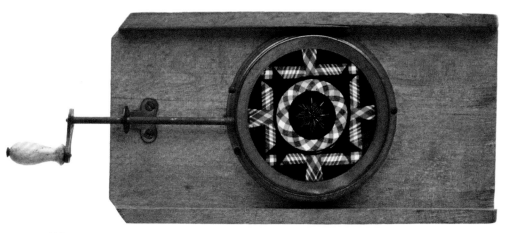

1.4 Chromatrope, c. 1850

beam of light for projection and out of it again to be changed. By the mid-nineteenth century, slides and related equipment had become more varied, with some of them incorporating animated movement for visual effects or storytelling. For instance, the **chromatrope** consisted of two colorful, overlapping circular glass plates; when they were lit with the projection lamp and spun in opposite directions with a crank handle, viewers were treated to a dazzling light show **(1.4)**. Another device, the **choreutoscope**, held six images that, when projected in rapid succession, simulated simple animated movement **(1.5)**.

The projection of shadows onto a wall, using hands and objects, has occurred worldwide since the earliest years of humanity. We find the first reference to a projecting technology that resembles a magic lantern in the fifteenth century, in a description by the Italian engineer and physician Giovanni Fontana published around 1420. It depicts a man holding a lamp behind a small **cutout** image of the devil, casting a larger form of it onto a wall. By the mid-seventeenth century, the technology behind magic lanterns was being developed by inventors across Europe. One of the best-known is the German Jesuit priest Athanasius Kircher, who discussed such devices in his book *Ars Magna Lucis et Umbrae* (*The Great Art of Light and Shadow*, 1646), which was revised in 1671 to depict a relatively complex projector. By 1659, the Dutch mathematician and scientist Christiaan Huygens (1629–1695) had created what many consider to be the first practical, usable model of a magic lantern. In the eighteenth century, many other inventors joined in developing magic lanterns and their accessories, eventually creating portable equipment for widespread professional practice as well as small-scale projectors for use in the home, including models for children.[2]

Ghost stories, known as **phantasmagoria**, became the basis for a popular form of magic-lantern performance at the end of the eighteenth century **(1.6,** see p. 16**)**. In such shows, portable lanterns were hidden behind

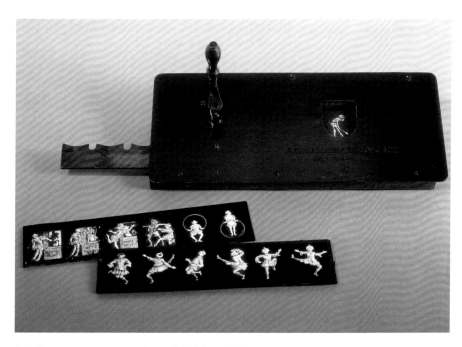

1.5 Choreutoscope, replica of an original from 1866

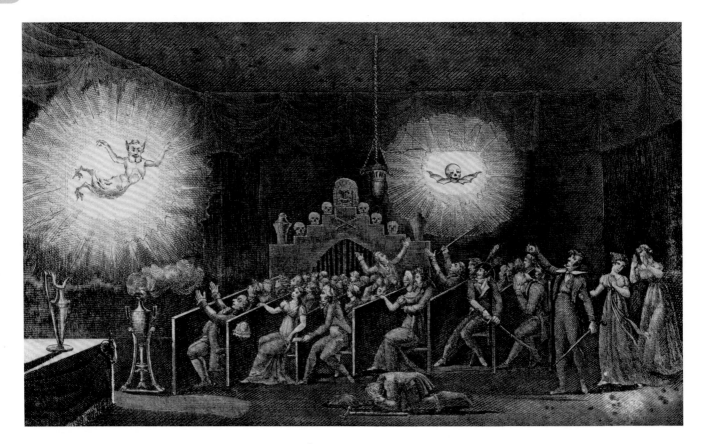

1.6 *Fantasmagorie*, probably 1797, depicted in an engraving in Étienne Gaspard Robertson's *Mémoires Récréatifs Scientifiques et Anecdotiques*, 1831

a translucent screen and used to project frightening images onto its surface. The Belgian scientist and artist Étienne Gaspard Robertson (1763–1837) is probably the best-known presenter of phantasmagoria, which he called *Fantasmagorie* to distinguish his work from similar shows. Although he toured Europe, in 1797 he settled into his own Paris theater, where he was able to design relatively complex productions. His shows involved:

> a thin percale screen across one end of the cloister, hiding his "fantascope," a large magic lantern that could slide back and forth on a double track between fifteen and eighteen feet long. When the lantern was moved along its track, the images projected on the screen from behind would grow or diminish in size, depending on the distance from the machine to the screen.[3]

The subjects of the projections included witches, the head of Medusa, a bloody nun, a grotesque devil, tombs, and ghostly references to contemporary figures. Suspense could be heightened by the use of smoke, eerie music, loud bursts of thunder, and streaks of lightning.

When Robertson was not presenting his *Fantasmagorie*, he would give scientific demonstrations in another section of his theater, including displays related to hydraulics and physics, which incorporated a variety of animation-related techniques. Although the mixture of science and fantasy in Robertson's theater might seem contradictory by today's standards, at the time the general public did not necessarily understand science to be completely "real," as opposed to completely "magic" or supernatural—they perceived the world and its phenomena as both scientific and magical. Animation fit neatly into both realms.

By the mid-nineteenth century, magic-lantern technology was becoming increasingly sophisticated. Eventually, it entered inexpensive mass production, making innovations in technology and science accessible to the broader public. People were becoming increasingly familiar with the experience of image screenings, and this familiarity would prepare audiences for the advent of cinema. The magic lantern was not the only form of entertainment to emerge as a by-product of scientific developments, however; an array of other motion devices had similar origins.

Motion Devices

The nineteenth century saw many medical advancements, as doctors studied the human mind and body and disseminated their findings to their peers. To illustrate discoveries and theories about the eye and how humans process visual information, some researchers developed motion devices that demonstrated perceptual processes, sometimes giving them lofty, Greek-sounding names to add to their credibility. A number of such inventions would later filter down to the general public as forms of entertainment, or optical toys. One of them, the **thaumatrope**, is a disk containing pictures on both sides that is spun to create an effect of two images merging into one (such as a bird on one side and a cage on the other becoming a bird in a cage) **(1.7)**. The name roughly translates as "wonder turner," suggesting that its spinning created a surprising effect. The device's invention has been credited variously, but its popularity dates from the early nineteenth century, after the British doctor John Ayrton Paris used one in 1824 to demonstrate principles of vision to his colleagues at the Royal College of Physicians in London.

A thaumatrope contains two images that are combined into a single static one. Other motion devices utilize a series of images to create the **illusion** of animated movement. The **phenakistoscope**, meaning "spindle viewer," which was invented by the Belgian scientist Joseph Plateau (1801–1883) in 1832, uses only one side of a large, slotted disk **(1.8)**. Images are lined up around its edge, separated by the slits. The viewer stands in front of a mirror, with the back of the disk facing toward him- or herself. By spinning the phenakistoscope and looking through the slits, the viewer sees animated movement that occurs in a continuous loop, or **cycle**.

A **zoetrope**, meaning "wheel of life," is another motion device that uses a series of images, in this case printed on a strip of paper that is placed inside a spinning drum **(1.9)**. When the viewer looks through slits in the edge of the drum, he or she sees a continuous loop of motion. Although precursors existed, the zoetrope is generally attributed to the British mathematician William Horner (1736–1837), who built his model in 1834 as a variation on the phenakistoscope; he originally called his invention a "daedalus," popularly translated as "wheel of the devil."

Nowadays, the thaumatrope, phenakistoscope, and zoetrope are nostalgic collector's items. In contrast,

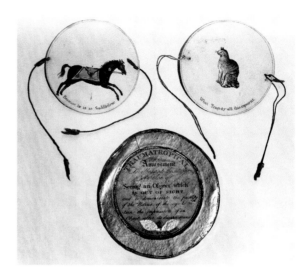

1.7 Thaumatropes with their original box, 1826

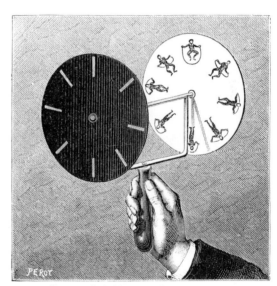

Fig. 99. — Phénakisticope de Plateau. (Page 125.)

1.8 Phenakistoscope, c. 1832

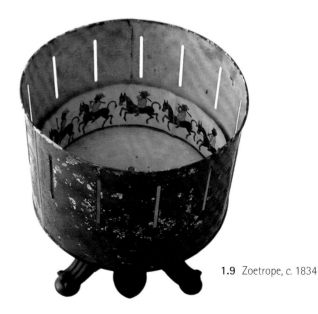

1.9 Zoetrope, c. 1834

another early invention, the **flipbook**, remains quite popular today: a series of images on paper are assembled in book form, so that, when "flipped," the pages are viewed in succession, creating the illusion of motion. The invention of flipbooks is generally attributed to the British printer John Linnett, who produced one—using the name "kineograph" (meaning "moving picture")— in 1868. This type of device differs from the others discussed in this section because it creates an effect that is **linear**, rather than static or cyclical. The process of flipping a flipbook has links with a common technique in **drawn animation** in which artists create a series of movements in pencil outline on separate sheets of drawing paper and then flip through them to ensure that the action moves as desired.

Automata

The late eighteenth century saw a transition from the manual production of goods to machine manufacturing on a larger scale and at a faster rate. Certainly, machines were employed in industrial settings to speed up production, but they were also used for entertainment and even as art, in creations known as "automata."

Foreshadowing the development of stop-motion animation, these figures—primarily human and animal in form—created the impression of real life by carrying out an automated sequence of actions. Advances in technology enabled the development of advanced automata, run by cams, gears, and other internal parts, but sophisticated figures have existed since at least the sixteenth century, with some of the most remarkable examples including clockwork mechanisms of various scales, ranging from public clock towers to fine ladies' jewelry. Early automata were also developed to demonstrate hydraulics, illustrating scientific principles related to properties of air, water, and heat, for example.

The intertwined histories of automata and industrial change are illustrated in the work of the French inventor Jacques de Vaucanson (1709–1782), who created automation processes for weaving looms that were to lead to significant improvements in the textile industry in the early years of the Industrial Revolution.[4] He also built remarkable automata, including an intricately crafted flute player dating from 1738 and a duck from the same period that simulated an actual bird by paddling in water, shaking its head and neck, eating food, and excreting pellets.[5]

The Printing Press and Comic Strips

For many years before the cinema and the animated film appeared, newspapers purveyed information and entertainment to the public. The printing press was invented in Germany in 1440 by Johannes Gutenberg and came to the US in 1638, when it was used in the production of religious materials.[6] Printing spread as literacy increased, largely thanks to groups promoting the word of the Bible, and by the early nineteenth century, the so-called "penny press" in America made inexpensive newspapers available to the middle class. By the late 1890s, newspapers were widely read and competed with each other for dominance.[7] In the US, Joseph Pulitzer's *New York World* (founded in 1860) achieved top circulation, in direct competition with *New York Morning Journal* (founded in 1882), which was purchased by William Randolph Hearst in 1895.[8]

In an effort to gain readers, both publications engaged in lurid, sensationalist "yellow journalism." The term was derived from

1.11 Richard Outcault, "The Yellow Kid Loses Some of His Yellow," *New York World*, 1897

As a sign of both their wealth and their up-to-date interest in modern technology, wealthy patrons purchased intricate automaton figures that were surprisingly lifelike. For example, in 1784, King Louis XVI of France acquired a female piano player (said to have been made in the likeness of the Queen, Marie-Antoinette) to entertain guests at the Palace of Versailles. Capable of playing eight tunes, it had been made by two German clockmakers, Peter Kintzing and David Roentgen. By the nineteenth century, automata had diversified into all levels of production, ranging from individually designed and painted works of art to inexpensive tin toys that could be operated with a crank. They had also spread internationally: at that time in Japan, manufacturers were making automata referred to as *karakuri*, which were able to serve tea to guests. By the early twentieth century, automata often appeared in the windows of stores, with the aim of attracting the attention of passersby. For example, some tobacco shops featured automata of monkeys inhaling smoke into their mechanical lungs (1.10).

1.10 Smoking monkey automaton, early twentieth century

a comic-strip series that began in 1895, but eventually was run by both papers: Richard Outcault's "The Yellow Kid," which features a young character in a yellow nightshirt (1.11). During the 1890s, the *New York World*'s staff of cartoonists attracted readers with their **caricatures** of well-known personalities; its artists included Kate Carew (born Mary Williams), one of the rare female cartoonists of the time (1.12), and future animation pioneer John Stuart Blackton. The subsequent growth of newspaper comics was vital to the development of animation because the first animators would come from that field, and because beginning in the 1910s, animated series based on popular comic strips began to be created. Cartoonists were ideally suited to become animators because they had the ability to draw well for the long periods required to create animation. As a result, the form and content of early animated images were greatly influenced by print comics.

1.12 Kate Carew, cartoon from the *New York World*, 1903

The Impact of Photography on Studies of Locomotion

From a technical perspective, the introduction of cinema in 1895 and the eventual appearance of animated films grew out of the invention of photography, another of the major developments of the Industrial Revolution. Although experiments in image capture had begun in the late eighteenth century, the creation of true photographs is generally dated later. In the 1830s, the French inventor Nicéphore Niépce (1765–1833) collaborated with the Frenchman Louis-Jacques-Mandé Daguerre (1787–1851) on the invention of the daguerreotype, a system that employed photographic plates to capture images. Various other relatively complex methods involving glass plates were practiced until the 1880s, when the American entrepreneur George Eastman (1854–1932) was the first to introduce both paper photographic materials and then **flexible film bases**, made for still photography but later becoming a critical component of motion-picture technology.

Photography created a dramatic shift in modern culture, causing a great upheaval in the realms of art and science, as well as in everyday life. The advent of photography gave ordinary people, who did not have the money to commission paintings, the ability to preserve images of family members, as a way to hold onto the past and solidify memories. It also had an educational purpose, as it was incorporated into a range of enlightening talks, including travel lectures illustrated by photographic magic-lantern slides (see p. 13). These lectures also appealed to members of the growing middle class, who considered a knowledge of other cultures, the arts, and scientific advances to be a sign of sophistication.

The Study of Human and Animal Locomotion

The art of animation relies on an ability to render movement, and animators frequently film figures in motion and study the footage frame by frame in order to perfect their skills. Before the invention of photography, however, people had little understanding of the mechanics of human and animal movement. Photographic images proved invaluable to scientists and medical professionals, as well as to artists, since they made it possible to study how motion is carried out in various contexts.

Beginning in the mid-1800s, different types of photographic motion study were undertaken in an effort to understand the way that humans, animals, birds, and other figures move on land and in the air. Series photography recorded images of a figure onto separate photographic plates as it moved through time and space; each plate showed a more advanced point in the total movement. **Single-plate chronophotography** captured the figure's entire sequence of movements on a single photographic plate, creating superimposed images that revealed patterns of movement not so easily discerned when using separate frames (1.13).

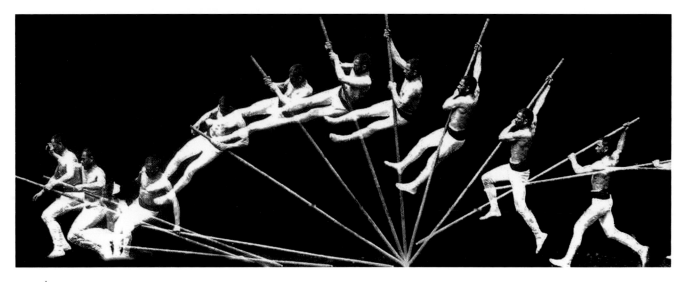

1.13 Étienne-Jules Marey, chronophotograph depicting a pole vault, 1887

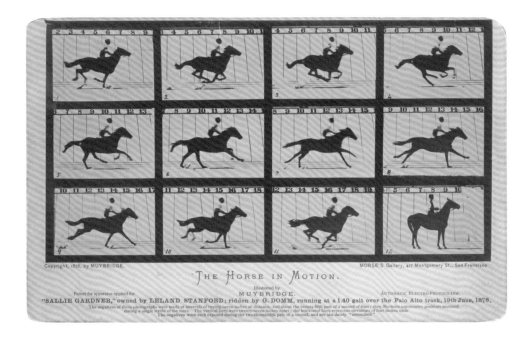

1.14 Eadweard Muybridge, motion study of a horse running, 1878

The English photographer Eadweard Muybridge (1830–1904), who carried out much of his work in the US, is well known for recording a running racehorse in Sacramento, California, to show how all of its legs lifted off the ground at one point in its movement; he did so using a series of cameras set to capture snapshots as the horse ran past, with a failed first attempt in 1872 followed by success in 1878 **(1.14)**.[9] Among Muybridge's other achievements is the invention in 1879 of the **zoopraxiscope**, a combination of magic lantern and phenakistoscope, which enabled the projection of images that had been painted on a circular disk (the images were traced from his photographic studies). Muybridge used this equipment to give talks as a traveling performer.

Motion studies also affected the work of artists, such as the American painter Thomas Eakins, a professor at Pennsylvania Academy of Fine Arts. Inspired by Muybridge's documentation of a running horse, Eakins incorporated the observation into his painting practice, notably in *A May Morning in the Park* (also known as *The Fairman Rogers Four-in-Hand*) from 1879–80, which is one of the first paintings to portray the movement of a horse with accuracy **(1.15)**. The painting was commissioned by its subject, Fairman Rogers, a retired professor from the

University of Pennsylvania. Later, Rogers helped arrange for Muybridge to continue his motion studies at the university, between 1884 and 1886. In 1887, with his book *Animal Locomotion: An Electro-Photographic Investigation of Connective Phases of Animal Movements*, Muybridge began publishing thousands of his images. His publications became important references for anyone seeking models of figures in motion, including animators.

Meanwhile, in France, the scientist and physiologist Étienne-Jules Marey (1830–1904) had begun his study of human and animal **locomotion** in 1867, using many

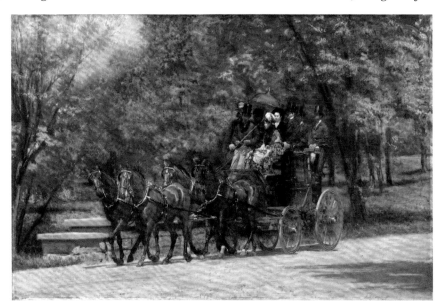

1.15 Thomas Eakins, *A May Morning in the Park* (*The Fairman Rogers Four-in-Hand*), 1879–80

innovative technologies of his own design. For example, he developed a pair of shoes containing materials in the toe that functioned as an **odograph**, or a device for measuring distance—in this case the number, length, and frequency of steps. The shoes also measured variations in pressure as the foot stepped down. Marey later created a similar device for a horse, which utilized a ball placed within its shoe, allowing to him record such data as "average paces" for the first time. Using a bar graph drawing as a means of notation, he described the resulting information as a record of a "sort of music" that was "written by the horse himself."[10] The graphic approach to documentation had its limitations, however, and Marey was inspired to try new methods after he saw Muybridge's published racehorse images in 1878 and began corresponding with him.

The movements of some of the subjects studied by Marey, such as insects and birds, were very difficult to record. Marey fashioned a small forceps-like tool to hold the body of an insect while its wings brushed against blackened paper, leaving an impression. He found this method to be unsatisfactory because the wings were slowed when they rubbed on the surface, but this line of investigation was nonetheless important. Creating a foundation for the future of human flight, Marey pushed on in his attempts to record the methods by which creatures fly **(1.16)**. Since he opposed vivisection (the dissection of live animals to see how their bodies function), during the 1870s Marey built mechanical models of birds in order to understand the **dynamics** of their movement better. In 1882, he constructed a "photographic gun," known as the *fusil photographique*, that allowed him to take a series of images of a bird in flight by pulling a trigger to record photographs at a rate faster than 1/500th of a second **(1.17)**.

The same year, the Station Physiologique, a research facility in the Bois de Boulogne, Paris, was funded to support Marey, who was aided by an assistant, the French inventor Georges Demeny. The two men carried out many studies there, using methods that anticipated the modern technique of **motion capture**, in which the actions of live performers are digitally captured and used as the basis for computer-animated characters. Marey designed a tight-fitting black outfit

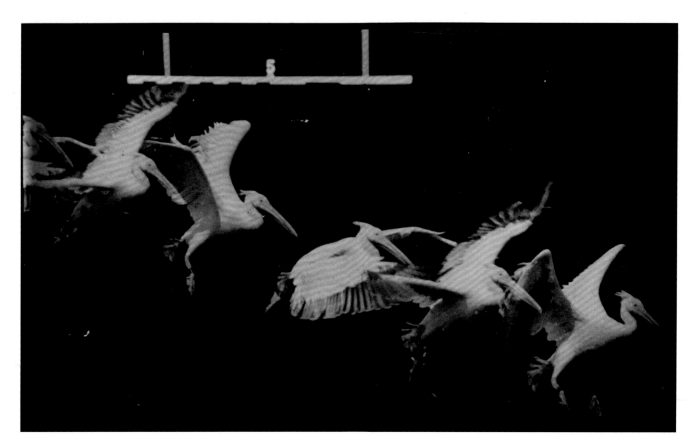

1.16 Étienne-Jules Marey, chronophotograph depicting a flying pelican, 1882

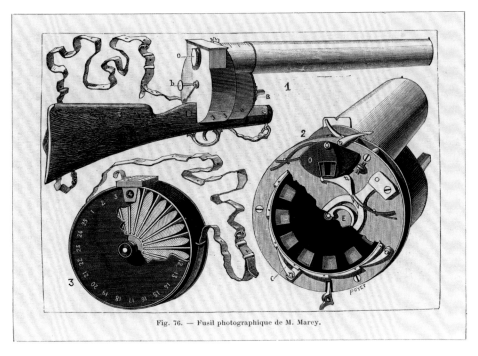

Fig. 76. — Fusil photographique de M. Marey.

1.17 Étienne-Jules Marey's "photographic gun," 1882

with a white line along the side of the body, including the arm and leg, with joints indicated by shiny buttons; when it was worn by the subject as he or she was filmed against a black background, the path of movement of the subject's limbs stood out clearly in a kind of wave-like form.

In this way, Marey could "transform the subject into a graphic notation. Because the surface of the subject was greatly diminished—only the dots and lines made an impression on the plate—the number of photographs could be greatly augmented. 'Instead of ten pictures each second, one hundred can be taken,'"[11] thereby increasing the precision of documentation. By the mid-1880s, Marey was experimenting with **stereoscopic** images in order to see his subjects in three dimensions. In 1887, he created plaster models of birds in flight that were set into a zoetrope (see p. 17), bringing his subjects to life in a manner that prefigured stop-motion animation (see p. 29).

Marey helped bring about great advances in medicine, physiology, and other aspects of life. He studied how labor is carried out in a modern workplace by photographing the flow of movements being used to complete different tasks; thus, there was a link between his discoveries and the developments of the Industrial Revolution and social movements related to the design of working environments. He was among the first people to understand the hydraulics of blood flow within the body, his study of birds in flight informed the development of aviation technology in France, and his images of figures moving through time appear to have served as models for modern artists concerned with similar depictions (including Marcel Duchamp's *Nude Descending a Staircase, No. 2* in 1912, see p. 72).[12] He even influenced the birth of cinema, since Thomas Edison, a pioneer of early American filmmaking, visited him to seek help with some technology design problems.[13] Marey was a true visionary whose contributions to the fields of locomotion were instrumental in many aspects of modern life, including the development of animation.

The Transition to Animated Cinema

The eventual birth of cinema, and in its wake the advent of animated film, came about in an atmosphere of entrepreneurship, experimentation, and changing perspectives. Inventors made many contributions to the development of motion pictures, some of which endured into the twentieth century, while others were relatively short-lived. Viewed within the larger scope of history, the significance of early endeavors becomes easier to acknowledge, and we can see that breakthroughs occurred, even if they were considered to be failures at the time.

The Inventions of Émile Reynaud

The Frenchman Émile Reynaud (1844–1919), an eclectic inventor with a scientific and artistic background, was involved in the field of engineering as well as those of sculpture, photography, and magic-lantern exhibition. Like many entrepreneurs at the time, Reynaud was interested in **optics** and the development of moving-

image media, and in 1877 he made his own contribution to the field: the **praxinoscope**, which was similar to a zoetrope except that, rather than looking through slits, viewers saw images reflected by a set of mirrors built around a central drum.[14] Reynaud continued developing his technology with the aim of using it in public lectures and performances, inventing the Projection Praxinoscope, which projected up to twelve cycled images onto a screen.

Screen projection was a vital new development, but Reynaud's device was limited by the small number of visuals that could be shown. By the end of the 1880s, he had resolved this problem with a new invention capable of projecting a long series of frames: a large-scale praxinoscope he called the Théâtre Optique, which he **patented** in 1888. Images were painted on gelatin squares suspended within leather bands (up to 700 images on a strip 65 millimeters wide and up to 500 meters long), which were routed through the

projector and aligned with a mirrored surface using a series of spools. Reynaud's concepts were related to the eventual realization of the flexible bases (e.g. celluloid **film stock**) and other equipment for recording images and projecting them. His performances, called *Pantomimes Lumineuses*, were shown in Paris between 1892 and 1900, in almost 13,000 15-minute screenings **(1.18)**.[15] Despite this remarkable success, Reynaud was soon bypassed by a growing number of inventors and businesspeople seeking to cash in on the new **medium** of motion pictures. By the late 1910s, when cinema was increasingly becoming a factory-line product, created by a team of workers using increasingly complex processes and **narratives**, Reynaud must have seemed terribly out of date, and his work meaningless. Sadly, Reynaud could not foresee the significance of his role in the history of cinema and, in 1918, the inventor himself destroyed his technology and most of his bands, so that today only two examples exist.

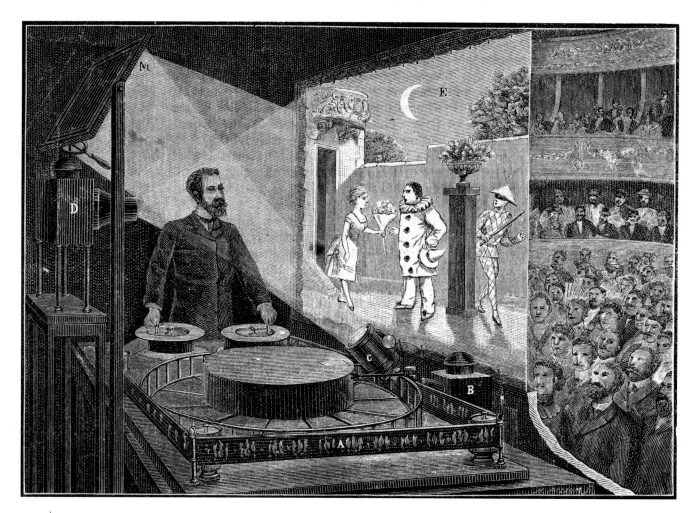

1.18 Émile Reynaud and his Théâtre Optique, projecting his film *Pauvre Pierrot*. Engraving by Louis Poyet from *La Nature*, July 23, 1892

Conclusion

In this chapter, a variety of the inventions and
entertainments that preceded and contributed to the
development of the animated film have been considered.
We have also taken into account the impact of the
Industrial Revolution and the modernization that came
in its wake, as this also helped to lay the foundations for
the growth of motion pictures in the twentieth century.

Many years before, by the eighteenth century,
magic-lantern shows had introduced audiences to
the projection of moving images in an atmosphere
of spectacle, while motion devices developed in the
nineteenth century, such as thaumatropes and zoetropes,
demonstrated scientific principles and also provided
entertainment. Science, technology, and art merged in
the development of automata, objects mechanized to
appear animate, while photography made it possible
to isolate and study the motion of living beings. The
inventions of Émile Reynaud came at a crucial moment,
when decades of experimentation had cleared the way
for the creation of the defining art form of modern
society: cinema, and with it the animated film.

Notes

1 Deac Rossell, *Living Pictures: The Origins of the Movies*
(Albany, NY: State University of New York Press, 1998), 153.

2 The Magic Lantern Society, "An Introduction to Lantern
History," *The Magic Lantern*. Online at http://www.
magiclantern.org.uk/history/history01.php

3 Frances Terpak, "Magic Lantern," in Barbara Maria Stafford
and Frances Terpak, *Devices of Wonder: From the World in
a Box to Images on a Screen* (Los Angeles, CA: Getty Research
Institute, 2001), 301. This book accompanied an exhibition
held at the J. Paul Getty Museum from 13 November 2001
through 3 February 2002: "Devices of Wonder: From the
World in a Box to Images on a Screen."

4 Terpak, "Automata," in Stafford and Terpak, *Devices of
Wonder*, 266–74; 268.

5 The duck was apparently completed by 1734, but not
displayed until 1738. Barbara Maria Stafford, "Cog-in-a-Box,"
in Stafford and Terpak, *Devices of Wonder*, 35–46; 43–44.

6 Perry Frank and Suzanne Ellery Greene, "Popular Literature
and Best Sellers," in *The Greenwood Guide to American
Popular Culture*, Vol. 3, ed. M. Thomas Inge and Dennis Hall
(Westport, CT: Greenwood, 2002), 1239–76; 1241.

7 Agnes Hooper Gottlieb, Amy Kiste Nyberg, and Richard
Schwarzlose, "Newspapers," in *The Greenwood Guide to
American Popular Culture*, 1163–98; 1167.

8 Gottlieb, Nyberg, and Schwarzlose, "Newspapers," 1170.

9 Brian Coe, *Muybridge & the Chronophotographers* (London:
Museum of the Moving Image, 1992), 13. Marta Braun,
*Picturing Time: The Work of Etienne-Jules Marey (1830–
1904)* (Chicago, IL: University of Chicago Press, 1992), 45.

10 Marey, quoted in Braun, *Picturing Time*, 27.

11 Ibid., 81.

12 Ibid., 264–318 (see "Marey, Modern Art, and Modernism").

13 Ibid., 189–91.

14 Stephen Herbert and Luke McKernan, ed., *Who's Who of
Victorian Cinema* (London: British Film Institute, 1996), 121.

15 Rossell, *Living Pictures*, 21.

Key Terms

animation	motion capture
automata	motion studies
chromatrope	narrative
cutout	phantasmagoria
film stock	phenakistoscope
flexible film base	praxinoscope
flipbook	single-plate
frame	chronophotography
linear	stereoscopy
magic lantern	thaumatrope
medium	zoetrope

The Magic of Early Cinema

Chapter Outline

Global Storylines

In England, Arthur Melbourne-Cooper creates some of the first stop-motion animation in the world with his "Matches" films

The British art teacher William Harbutt develops plasticine, an essential material for clay animation, in the 1890s

In France, former illusionist Georges Méliès becomes famous for creating elaborate trick films; he goes on to make more than five hundred of them

The Spanish director Segundo de Chomón employs stop-motion, hand-coloring, camera perspective tricks, and miniatures to create the special effects for his films

Introduction

The introduction of motion-picture technology occurred roughly within the period of 1893 to 1895. First came the development of flexible film bases in strips, and cameras that were compatible with them, and then came the invention of equipment that would display these films, individually, in viewing machines, and then for groups, as projections. Early cinema was dependent on the increasingly specialized skills of opticians, who ground lenses for eyeglasses as well as for magic lanterns and, eventually, motion-picture equipment. It also relied on the spread of electricity, which was widely introduced after the turn of the twentieth century, but varied from country to country; in many places it was not available until the 1920s or even later. As a result, early cameras and projectors would have been cranked by hand and the first filming took place using natural light rather than electrical lamps. These and other

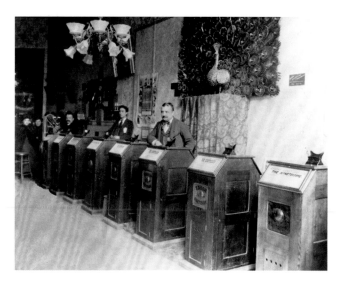

2.1 A kinetoscope arcade in San Francisco, CA, c. 1899

2. THE MAGIC OF EARLY CINEMA

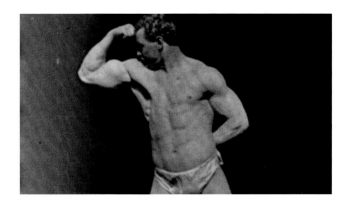

2.2 W. K. L. Dickson, *Sandow* (*Eugen Sandow, the Modern Hercules*), 1894

Black-and-white film dominated, although experiments with color were made from the start, and every year film technologies developed further. The **silent era** is said to have lasted from 1895 until the late 1920s, when **synchronized sound** processes were widely employed, but in spite of its name, films of this era were not really silent, as they almost always included live sonic elements of various kinds. Theaters hired musicians to play along to films, and sound effects were created using musical instruments or noise-making objects. As stories became more complex, cards printed with words, known as **intertitles**, were included in films to impart narrative details. In some cases, live performers voiced various parts during a film screening:

influences meant that film production emerged in different forms across the world.

By 1894, people could visit a viewing parlor full of many individual machines **(2.1)** and watch a film of a blacksmith shoeing a horse, or maybe a strongman entertainer flexing his muscles **(2.2)**. As in these examples, the first films depicted **live-action** scenarios and were quite short, running about a minute in length. They might feature individuals from popular theater, simple narratives, re-enacted moments from sporting events, or documentary shots of local or famous locations. Animated images were to arrive a few years later, after films began to be projected. Film projectors, which came into use in 1895, made it possible to display multiple films for a group audience using a single machine, which was much more economical as a business. From this point on, it was easy to integrate film into other forms of popular culture as a novelty, either as an act in vaudeville or music-hall shows **(2.3)**, as the magic lantern had been (see p. 13), or in a more informal way by means of itinerant camera operators and performers who came to town, filmed local scenes, and projected them for curious audiences **(2.4)**. By 1905, short films were being projected in storefronts seating some two hundred patrons; such makeshift theaters became known as "**nickelodeons**" in the United States, because of their usual admission fee of five cents (a nickel).[1]

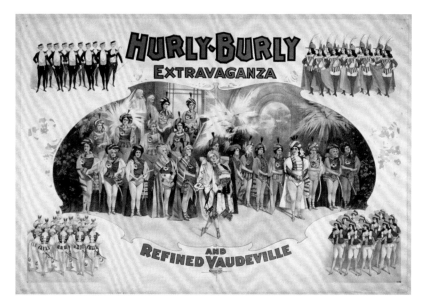

2.3 Poster for the "Hurly-Burly Extravaganza and Refined Vaudeville" show, c. 1899

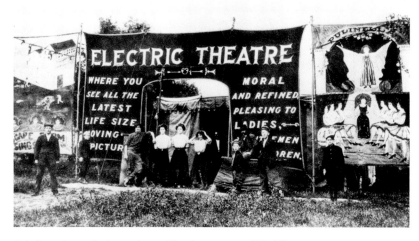

2.4 An early movie theater housed in a large tent, c. 1905, US

perhaps the best-known examples are the *benshi* in Japan, actors who accompanied films from the beginnings of Japanese cinema projection in the late 1890s until the 1930s.

For a fifteen-year period, between 1895 and 1910, cinema was in a formative stage, developing aesthetic norms, new technologies, and conventions for production. For the most part, these pertained to live-action filmmaking, but during this time animation also made appearances on screen. This chapter explores these earliest years in the history of animated film, when the primary use of animation was to provide **special effects**. These were created using stop-motion objects, by **scratching and painting** individual frames, or by employing the related technique of **stopped-camera substitution**. It also identifies links between the new medium of film and the world of magic, including similarities in presentation, an emphasis on

visual spectacle, and the sense of wonder that both forms of entertainment provoked in audiences.

Visual **illusions** created by such artists as Georges Méliès and W. R. Booth laid the foundations for special effects in the years to come and enhanced the apparent magic of the new film medium. This sense of novelty was central to the appeal of early cinema, which relied on the audience's curiosity about how such illusions were achieved: it is not surprising that early specialists in animated effects had often come from careers in magic. Sometimes animated effects appeared in the context of **lightning sketches**, a format carried over from music hall and variety theater, in which an artist stands at a drawing board and transforms images with a few deft strokes—that is, at lightning speed. "Haunted" location films, featuring stop-motion effects of furniture or other items moving of their own accord, were another popular **genre** at the time.

Entrepreneurs of Early Cinema

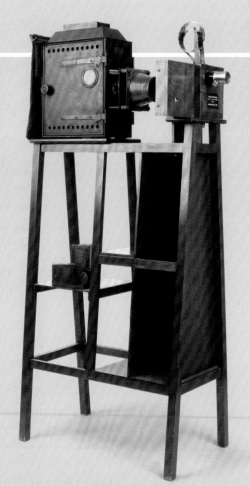

The development of cinema was a truly international enterprise. Early entrepreneurs included the Frenchman Louis Le Prince, who carried out seminal work in England in 1888, and the British inventor William Friese-Green, who was working on cinema technology by 1890. Both men patented motion-picture cameras, shot sequential images on filmstrips, and screened their works; like Émile Reynaud (see p. 23), however, they failed in their attempts to develop their inventions on a large scale.

History books generally cite 1895 as the time of cinema's birth, owing to a number of public screenings that took place that year. In July of 1895, the Germans Max (1863–1939) and Emil Skladanowsky (1866–1945) debuted the Bioscop projector they had invented. When Julius Baron and Franz Dorn, directors of the Wintergarten Theater in Berlin, saw it, they scheduled a public exhibition of the brothers' films at their theatre, beginning on November 1, 1895.[2] The following month, the French brothers Auguste (1862–1954) and Louis Lumière (1864–1948) held a screening at the Grand Café in Paris. The Lumières' family business focused on photographic technology, and they had devised a practical machine called a *cinématographe* **(2.5)**. It combined three key components needed to make and project film: it was a camera, developing unit, and projector, all in one.

The American Thomas Edison (1847–1931), an entrepreneur who held more than 1,000 patents, including the **phonograph** (1877) and a range of electrical light bulbs (c. 1880), was also

2.5 Cinématographe, c. 1895

First Approaches to Animation

The Allure of Trick Films

Like cinemagoers today, early cinema audiences were captivated by the spectacle of special effects, which were achieved through the use of **miniatures**, explosives, smoke, wires, **double exposures**, and **hand-coloring** or the tinting and toning of frames to add color to black-and-white footage. Sometimes **under-cranking** (recording images at a slowed frame-per-second rate) was used while filming to add extra speed to the action when it was played back at a normal frame rate. Another popular technique, **stopped-camera substitution**, made items seem to appear or disappear from the **set**. This technique was used in *The Execution of Mary, Queen of Scots*, a fifteen-second film made at the Edison studio in 1895. The director, Alfred Clarke,

filmed a re-enactment of the beheading, stopping the camera as the executioner raises his axe; at this point, the actor (a man dressed as a woman) is replaced by a mannequin, and its head tumbles to the ground at the fateful moment. For the first ten or so years of cinema history, production could be relatively spontaneous, involving a very limited crew (perhaps just a director and a camera operator); there was no lack of creativity, however, especially as far as animation was concerned.

Arthur Melbourne-Cooper and Early Stop-Motion Film

Stop-motion was the dominant style of animation created for early cinema; often, an animator worked on it single-handedly. Initially, stop-motion was used mostly to create visual effects for live-action productions, but it was also applied in entirely animated narratives.

working on the development of film technologies. Aided by his employee, the Scottish inventor William Kennedy Laurie Dickson, Edison's film-related machines included an individual viewer for motion pictures called the Kinetoscope and a camera called the Kinetograph. Edison's first screening, held in 1896 in New York City, featured individuals he had filmed in his specially constructed New Jersey studio, the "Black Maria" **(2.6)**. In 1901, he built another studio, this one on a rooftop in New York City, which had glass walls to enable him to use natural lighting.

At first, the film business was relatively disorganized and competitive. There was no system for the standardization of equipment or film stocks, no adequate legal protection for products (copying was rampant), and not a great deal of concern for aesthetics. In the United States, Edison helped centralize the industry by forming the Motion Picture Patents Company (MPPC) in 1908, in alliance with other leading US and French film firms. This organization, which existed for about seven years, standardized technology and pooled patents, effectively shutting out the competition. As a result, the American film industry became a much stronger contender internationally as it moved into the 1910s.

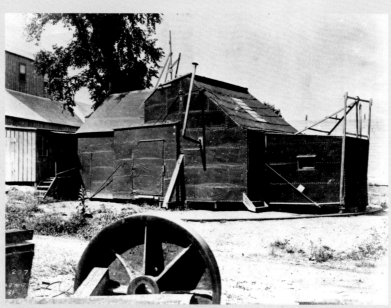

2.6 Thomas Edison's studio, the "Black Maria," in use 1892–1901

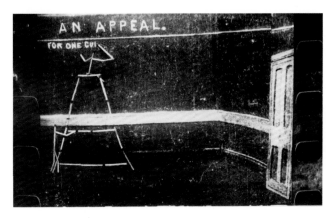

2.7 Arthur Melbourne-Cooper, *Matches Appeal, c.* 1899–1915

In England, Arthur Melbourne-Cooper (1874–1961) was probably creating stop-motion films before the turn of the century, which would make him the first animator in history. An experienced photographer and cameraman, in 1901 Melbourne-Cooper opened his own studio, the Alpha Cinematograph Company, located in St. Albans. By that time, he is thought already to have made three stop-motion films as promotions for Bryant & May matches. They are thought to have been released in 1899, although this date has been contested, with some placing the films at around 1915. All three still exist: they are known as *Animated Matches Playing Volleyball*, which runs 50 seconds; *Animated Matches Playing Cricket*, which runs 1 minute, 15 seconds; and *Matches Appeal*, at the same length (though the opening of the film was removed and is missing from the prints) **(2.7)**. The content of the first two films is self-explanatory. The third film shows a match figure writing on a wall, asking viewers to donate money for matches to be sent to the military.[3]

Melbourne-Cooper made more than thirty films, but only six of them survive. Aside from the three "Matches" films, we are able to view *A Dream of Toyland* (1907), *Noah's Ark* (1909), and *Road Hogs in Toyland* (1911). Of these, *A Dream of Toyland* is the most complex **(2.8)**. This delightful fantasy runs about seven minutes and comprises six **shots**. These include

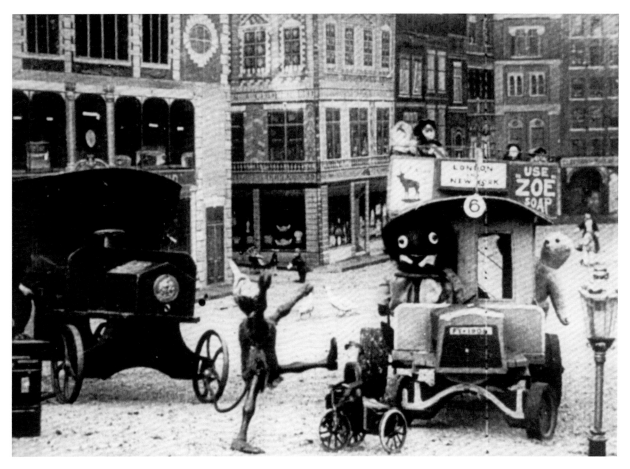

2.8 Arthur Melbourne-Cooper, *A Dream of Toyland*, 1907

a live-action **framing story** and a stop-motion animation sequence that lasts for around one-third of the film and shows a number of figures moving simultaneously on an open-air set, filmed in natural light.

The story revolves around a young boy who is taken to a toyshop, where his mother buys him many wonderful things. After falling asleep, he dreams that his new toys have come to life in a city scene (a single set used for the duration of this animation sequence). The main toy in the film, the double-decker bus, was constructed as a prop, but the other toys were supplied by a London toyshop. Melbourne-Cooper was assisted in the animation by several people, including studio staff, friends, and neighbors, but it seems clear that there was no clear plan behind the animated movements. The figures are not jointed to move as animated puppets and so tend to have stiff legs and arms, jerking about as though they are mechanical beings or possibly inebriated. They move in aimless or odd ways at a relatively slow speed, tumbling over or spinning around in a kind of anarchic dance, with the effect that the images in the film take on a surreal quality, appropriate for the "it's just a dream" scenario. The animation of the toys also features a lot of unprovoked fighting and other forms of physical contact, which play for humor. For example, a white bear pulls a creature to the top of the bus, but then falls over the side. Regaining its composure, the bear starts a fight with another creature until they roll off screen. Meanwhile, a flock of geese randomly attack characters as they make their way across the Toyland set. Although the animation in *A Dream of Toyland* is quaint, it is nonetheless very ambitious. Much of Arthur Melbourne-Cooper's work has been lost, but this film and others reveal that he played a significant role in the early years of animation.

The Origins of Clay Animation

Clay animation developed largely thanks to the work of the British art instructor William Harbutt, who in the 1890s perfected a soft modeling medium, **plasticine**, which remained pliable for longer than other materials, making it highly suitable for use in the long production process of filmmaking with clay. One of the earliest uses of clay in film was released in 1902: *Fun in a Bakery Shop*, by Edison's top director, Edwin S. Porter **(2.9)**. The comedy, which runs for less than two minutes, depicts a baker who sees a

rat on the wall, throws clay "dough" at it, sculpts the clay, and then gets in a tussle with his fellow employees. It is a variation on a lightning-sketch act.

During the sculpting process, the man's body hides the clay that he is working on, so that the camera can be stopped while the sculpture is adjusted, creating the illusion that he has worked very quickly. What we see is not really animation, but rather a stopped-camera substitution technique.

True clay animation first appeared in America in two films from 1908, Porter's *A Sculptor's Welsh Rarebit Dream*, made at the Edison studio, and *The Sculptor's Nightmare*, directed by Wallace McCutcheon at another leading studio, American Mutoscope and Biograph. Both films relate the dreams of artists who fall asleep while their work "sculpts itself" through animation, with the clay object apparently being built up by magic. The cast of the Biograph film includes some future Hollywood

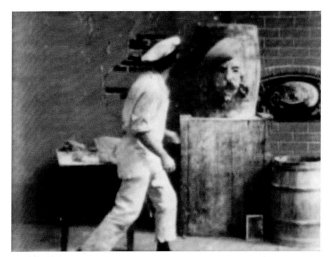

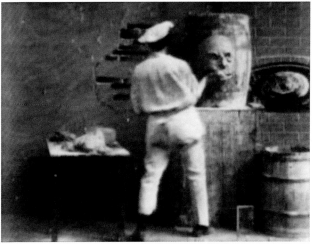

2.9 Edwin S. Porter, *Fun in a Bakery Shop*, 1902

legends, including Mack Sennett, whose studio produced the Keystone Kops (see p. 44), and D. W. Griffith, who became one of America's best-known directors and also a co-founder of the United Artists studio. The film was shot by Billy Bitzer, Griffith's future cameraman and one of the most accomplished cinematographers in silent-film history. Bitzer had begun working for Biograph in the 1890s, in its previous incarnation as a manufacturer of "magical toys and optical novelties"–another indication of early cinema's roots in magic and illusion.

Other early examples of clay animation include John Stuart Blackton's *Chew Chew Land: The Adventures of Dolly and Jim*, from 1910, which is set within a live-action story about a boy who is a mischievous gum-chewer. After being reprimanded by his teacher, he goes to sleep that night and dreams about a man's head that emerges from a mound of clay in another surreal scenario. In contrast, W. R. Booth's *Animated Patty*, from 1911, is pure fantasy of the "it's alive!" type, featuring a lump of clay that escapes from a glazier and transforms into various shapes.

John Stuart Blackton and Lightning-Sketch Animation

Stopped-camera substitution, stop-motion, and drawn animation were all used to create films based on the lightning-sketch format, which had its roots in popular theater but was embraced by cinema in its earliest years. By 1896, the celebrated English caricaturist Tom Merry (born William Mecham) had been filmed at the Birt Acres studio in England creating live-action (that is, filmed in real time) lightning sketches of British and German political figures, although these films do not survive. Lightning-sketch films were often topical and, like other forms of cinema, grew more complex with every passing year.

John Stuart Blackton (1875–1941) created a number of lightning-sketch films that fortunately do still exist. In these works, he employed not only stopped-camera substitution, but also stop-motion titles and animated line drawings. Before entering the field of cinema, Blackton, a well-known newspaper cartoonist, performed a variation on lightning sketches in popular theater, presenting, with two partners, "magic, magic lanterns, drawings, ventriloquism and recitation."[4] He was filmed doing a lightning-sketch routine in Edison's Black Maria studio (see p. 29), probably in 1896 or

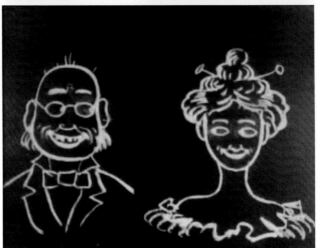

2.10 John Stuart Blackton, *Humorous Phases of Funny Faces*, 1906

1897, and later this footage was released as a film, *The Enchanted Drawing*, copyrighted in 1900. In the film, Blackton faces a large pad of paper and quickly draws a man's head in real time, turning toward the camera twice, as if to acknowledge the audience. Then a series of tricks occur, as he draws several objects—a wine bottle and glass, a hat, and a cigar—and removes these things as real objects from the pad, a feat achieved by stopping the camera and substituting items into the picture. Meanwhile, the drawn character changes his expression within the span of two frames, another instance of substitution achieved by a stopped camera.[5]

A few years later, Blackton's *Humorous Phases of Funny Faces* (1906) was filmed at Vitagraph, the studio he co-founded in 1897. This lightning-sketch film opens with stop-motion cutout titles that pop into the frame. Then, when the action begins, we see only Blackton's hand, which outlines a man's head in

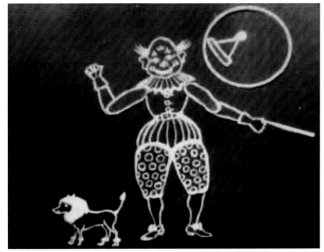

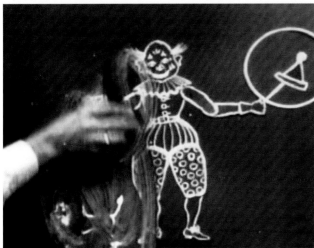

2.11 John Stuart Blackton, *Humorous Phases of Funny Faces*, 1906

employs stop-motion. A clown is made to look entirely drawn on the board, but in fact its legs and arms are cutouts. As a result, they can move about freely as the clown interacts with a cutout hoop and a cutout dog that jumps through it. Later, the clown's leg and arm are instead depicted as chalk drawings. Like a magician, Blackton then erases them to "prove" it is chalk on a board; meanwhile, the remaining cutout limbs move about freely (**2.11**). At the end, the clown is almost completely erased, after chalk drawings are substituted for its remaining cutout appendages.

Wonderful Tricks: Special Effects in Early Film

The Visual Innovation of Georges Méliès

The effects used in early film were seen as somewhat comparable to magic tricks, part of the range of unexplainable phenomena and feats of conjuring that had fascinated society throughout the nineteenth century. Professional magic had reached a peak in the shows of Jean Eugène Robert-Houdin in Paris during the mid-nineteenth century, and in those of his protégé, Harry Houdini. Houdini was a strong advocate for professionalism in his field, exposing charlatans who professed to have "real" magical powers. He specifically targeted hoaxes associated with Spiritualism, a belief system that spread through Western culture during the nineteenth century. Its practitioners claimed to have the ability to connect to the spirit world during séances. This was at a time when such new technologies as microscopes, photography, and x-rays were revealing phenomena that had previously been invisible, making the existence of other hidden forces seem plausible.

The Frenchman Georges Méliès's (1861–1938) reputation as a performer was established after he purchased the famous magic house Théâtre Robert-Houdin in 1888 and developed many stage illusions. After he attended the Lumières' first screening in 1895 (see Box: Entrepreneurs of Early Cinema, p. 28), he envisaged cinema as an attraction for his theater. He created a company called Star Film and in 1896 built a studio made of steel and glass in his garden at Montreuil-sous-Bois, France, where he was able to film his subjects in natural light. By the end of that year, he

chalk on a board (**2.10**). After Blackton finishes the outline, his hand disappears, but gradually a female companion is rendered by an autonomous animated line that appears on the drawing surface. This sequence is generally cited as the first example of drawn animation created using multiple drawings (as opposed to the stopped-camera substitution movement of Blackton's earlier film) to be screened in America. The appearance of the artist's hand in the film is also significant, as this visual became a motif of silent cinema, generally known as the "**hand of the artist**" (**2.10** and **2.11**). It functioned as a reminder for the audience that an animator had magically brought the images to life.

Humorous Phases of Funny Faces includes a range of tricks. **Reversed footage** is shown in a sequence that begins with an **abstraction**, moves to a blur, reveals a man and woman, and ends with the figures being "undrawn." The final part of the film

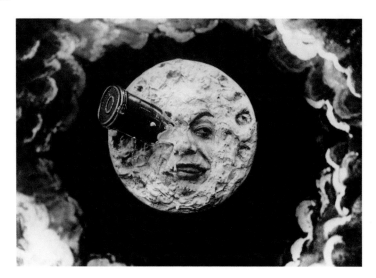

2.12 Georges Méliès, *A Trip to the Moon*, 1902

had shot about eighty short films, and he went on to make many more, including reconstructions of historical events and comedies as well as spectacular fantasies.[6] Méliès has been described as "the cinema's first true artist and the most prolific technical innovator of the early years," and is credited with "creating the basic vocabulary of special effects."[7]

Méliès began his film work in 1896 doing lightning sketches, billing himself as the "*dessinateur express*" (speedy draughtsman),[8] but he soon became famous for the elaborate **trick films** that he created around the turn of the century. Méliès's best-known film, *Le Voyage dans la Lune* (*A Trip to the Moon*, 1902) **(2.12)**, is about a group of travelers from Earth who are pursued by moon people called "Selenites," in an adaptation of the Jules Verne novel *De la Terre à la Lune* (*From the Earth to the Moon*, 1865). It includes stopped-camera effects, double exposures, and a variety of miniature models. At more than ten minutes, it was long for the time.

It was also unusual because the action was staged on multiple sets, resulting in scenes that were edited together after shooting (something few films then did). Méliès himself acted in the film, along with a cast of local performers that included acrobats and dancers. A written narrative that could be read aloud during screenings was circulated with the film, a unique component that emphasized the production's prestige.

In the course of his career, Méliès made more than 500 films, contributing greatly to the worldwide domination of French production before World War I. By the mid-1910s, however, he had gone into a downward spiral. Trick films enjoyed a relatively short period of popularity, due to the novelty of their "magic" wearing away. As cinema moved toward longer running times and more diverse production, animation also adopted complex stories and techniques. It seems there was little room for the artistic approach espoused by Méliès, who in the early 1910s lamented,

I am only an artist, so be it. That is something. . . I say the cinema is an art, for it is the product of all the arts. Now either the cinema will progress and perfect itself to become more and more an art, or if it remains stationary and without possible progress, if the price of the sale is fixed, it will go down in ruin at short notice. . .[9]

Facing a number of personal problems and distribution hurdles, and subsequently falling into great debt, he burned his Star Film negatives, sold off his remaining prints and spent the end of his life working in a toy-and-candy kiosk.

2.13 W. R. Booth, *Artistic Creation*, 1901

The Visual Effects of Walter Booth

The dual nature of visual effects in the nascent film industry is demonstrated by the backgrounds of two important British pioneers, the director W. R. Booth (1869–1938), who had worked as a magician, and the producer Robert W. Paul (1869–1943), who was a developer of scientific and industrial technologies, including some of the first cinema equipment in Britain. Paul is also noted for building the first professional film studio in England, located in London, in 1898, where he employed a number of top directors of the time, including Booth. Between 1899 and 1906, they collaborated to create innovative films that applied creative tricks and reflected the true potential of cinema at the time.

Like many others, Booth had made lightning-sketch films early in his career. In one of them, *Artistic Creation* (1901), Booth makes individual drawings of a woman's head, upper body, and arms **(2.13)**. Each body part transforms into a model as he lifts it off the drawing board and assembles it on a side table, before further transforming into the top half of a living woman, all through stopped-camera substitutions. The half-lady is unhappy, however, and insists she be made whole so that she can move about. Booth draws her lower body, which he joins to the rest of her in the same way. She moves about happily until Booth begins to draw a baby, causing her to flee the scene before it, too, is brought to life through stopped-camera substitution. The artist, after looking around for the woman, holds the infant out to the audience, as if to ask who will take it. This scenario is likely a commentary on the "modern woman" of the day, who was thought to have lost her natural maternal instincts.

Among Booth's other interesting films of this period is *The ? Motorist* (1906) **(2.14)**. In this humorous fantasy scenario, a car hits and runs over a policeman, who is replaced by a human-sized dummy before falling under its wheels. The policeman manages to survive and gets up to chase the car, but the vehicle goes up the side of a building and continues into outer space, driving around the rings of Saturn before it plummets back to earth. Booth used double exposure to show the car running through a courtroom and a stopped camera to transform it into a horse-and-buggy and back again before it flees the scene once more.

In 1906, Booth began to work at the studio of Charles Urban, an American who had moved to London after working for Edison. From 1903 until the mid-1920s, Urban ran his own studio and became known for his production of documentary and educational subjects. At the studio, Booth directed *Airship Destroyer* (1909), a relatively complex film in terms of narrative and effects. The emotional **melodrama** begins with a love story about a couple who are forbidden to marry. Then comes an attack of enemy dirigibles on their small town, allowing the young man to prove himself by launching a "destroyer" missile at them. Animation is used to show cutouts of the enemy ships moving across the land, and miniatures depict the town burning after being bombed. Although the aircraft seen in Booth's film are quaint by today's standards, the film was ambitious in its depiction of aviation development, an issue that would have been on the minds of contemporary audiences.

The Spectacle of Modern Technology

Electricity and the modern technologies that appeared at the turn of the century must have seemed somewhat

2.14 W. R. Booth, *The ? Motorist*, 1906

otherworldly, especially considering that many people were not well educated (until at least the end of the nineteenth century, illiteracy was high in most of the world). By the time motion pictures were invented, people were ready to embrace "movie magic," and, indeed, some early animators capitalized on the associations between magic, the spirit world, and that strange modern phenomenon, electricity. This is evident in the genre of haunted location films that were popular early in cinema history. An example is John Stuart Blackton's live-action film *The Haunted Hotel*, released by his Vitagraph studio in 1907, which includes an animated sequence of a meal that serves itself to a traveler, partly through the aid of a puppet.

In *El Hotel Electrico* (*The Electric Hotel*, 1908), by the Spanish director Segundo de Chomón (1871–1929), an entire hotel room comes to life, powered by electricity. De Chomón made this film for the leading French studio Pathé Frères, where his wife, Julienne Mathieu, was employed as an actor. In the film, a couple (played by de Chomón and Mathieu) sit back and relax while their travel bag is unpacked, their shoes are shined, their coats are removed, and their hair is coiffed, all by various objects in the room (**2.15**). At the start of this narrative, the actors' movements are highly gestural because they are setting up the story without the use of intertitles. During the animation sequences, however, the performers become very stiff, and do not smile or move their eyes, probably because they are trying to accommodate a long period of stop-motion animation, which takes place partly on their bodies. As a result, the actors themselves seem to become part of the "machine." Ironically, none of the animated props in the film (for example, the hairbrush, the suitcase, or the chest of drawers) would actually be run by electricity, so the implication is that the new technology operates magically, making ordinary objects come alive. As with all magic, however, it has the capacity to go wrong, and when an inebriated employee interferes with the electrical circuits, the room's objects go crazy. Adopting **iconography** from print cartoons, de Chomón uses hand-drawn wavy lines to show the energy escaping.

De Chomón was a master of special effects, drawing on a wide range of techniques. In *Les Kiriki— Acrobates Japonais* (1907), he applies tricks of camera **perspective** to create the illusion of complex balancing acts, featuring a troupe of performers costumed to look Japanese. Since they are shot from above, the

2.15 Segundo de Chomón, *The Electric Hotel*, 1908. Top: the man's shoes are shined; middle: the woman's hair is styled; bottom: a cloth wipes the man's face as he receives a close shave

acrobats can, in fact, lie on the floor, making outrageous stunts possible, including one where a child balances several adults on a plank he holds. Although de Chomón's film was originally colored by hand, only black-and-white copies exist today. In recent years, however, replicas of the original colored images have been made by painting prints frame by frame using a short segment of the surviving film for reference.

De Chomón was a prolific filmmaker, known for his technical innovations. In his *En Avant la Musique!* (*Strike Up the Band!*), from 1907, a hand-colored film, Mathieu directs a group of musicians, magically miniaturizing them so they can be transported into a large sheet of music. In *L'Aspirateur* (*The Vacuum Cleaner*), made the following year, de Chomón develops a plot around this modern device and two criminals, who steal one to swallow up the contents of a home they burgle, as well as several people that they encounter. The effect uses stopped-camera substitution to make everything seem to disappear within the machine. De Chomón's career flourished in the 1910s and 1920s, as he moved into **feature**-film production, creating visual effects for leading directors in France and Italy.

Notes

1 Charles Musser, *The Emergence of Cinema: The American Screen to 1907* (Berkeley, CA: University of California Press, 1990), 417.

2 Deac Rossell, "Max Skladanowsky," *Who's Who in Victorian Cinema.* Online at http://victorian-cinema.net/skladanowsky

3 Information on the director and his work is taken from Tjitte de Vries and Ati Mul, *"They Thought it was a Marvel": Arthur Melbourne-Cooper (1874–1961) Pioneer of Puppet Animation* (Rotterdam: Amsterdam University, 2009).

4 Stephen Herbert and Luke McKernan, *Who's Who of Victorian Cinema* (London: British Film Institute, 1996), 134.

5 Scott Simmon, "Notes on the Origins of American Animation, 1900–1921," Origins of American Animation Collection, Library of Congress. Online at http://memory.loc.gov/ammem/oahtml/oapres.html

6 Paolo Cherchi Usai, "A Trip to the Movies: Georges Méliès, Filmmaker and Magician (1861–1938), *Image* 34:3/4 (Fall/Winter 1991), 4. Online at http://image.eastmanhouse.org/files/GEH_1991_34_03–04.pdf; Herbert and McKernan, *Victorian Cinema*, 94.

7 Herbert and McKernan, *Victorian Cinema*, 94; Usai, "A Trip to the Movies", 3–16; 4.

8 Donald Crafton, *Before Mickey: The Animated Film 1898–1928* (1982. Chicago, IL: University of Chicago Press, 1993), 50.

9 Georges Méliès, quoted in John Frazer, *Artificially Arranged Scenes, The Films of Georges Melies* (Boston, MA: G. K. Hall, 1979), 51; Usai, "A Trip to the Movies," 11.

Conclusion

The turn of the century produced some of the first instances of drawn and stop-motion animation. The roots of animation in vaudeville and magic shows were evident from the nature of the films, which relied on the novelty provided by various tricks. These were achieved by employing such innovative special effects as stopped-camera substitution, miniatures, double exposures and hand-coloring. One of the earliest genres of animation to employ these techniques, the lightning-sketch act, was borrowed from the stage.

By 1910, pure visual trickery became outmoded as the narrative complexity and length of films increased. The 1910s marked a period of greater standardization through the adoption of shared technologies, the development of studio systems, longer formats, larger budgets, and more formalized systems of distribution and exhibition, mainly favoring live-action productions. The decade also saw the appearance, internationally, of dedicated animators and the formation of studios creating 2D animation and stop-motion productions.

Key Terms

framing story	nickelodeon
genre	reversed footage
hand of the artist	scratch and paint
hand-coloring	set
intertitles	shot
lightning sketch	silent era
live action	special effects
melodrama	stop-motion
miniature	trick film

CHAPTER 3

Foundations of the Animation Industry

Chapter Outline

Global Storylines

The Canadian Winsor McCay creates the first instances of personality animation with his films *How a Mosquito Operates* (1912) and *Gertie the Dinosaur* (1914)

In New York City, J. R. Bray and Earl Hurd hold the patent to the cel-animation technique, which they retain until 1932

Also in New York City, the Barré studio develops the "slash-and-tear" technique and the peg-bar registration system

Introduction

The late 1910s were a period of great change worldwide. World War I, which spanned 1914 to 1918, pitted members of the Triple Alliance (Germany, Austria-Hungary, and Italy, formed in 1881) against the Triple Entente (Britain, Russia, and France, formed in the early 1900s). The war created significant shifts within the European powers and gave rise to political and economic instability that would last for the next two decades. For Germany, the after-effects were particularly devastating: the country was found to be responsible for the losses of the war and fined a huge sum in reparations, which was only finally paid off in 2010.

Meanwhile, America, which had joined the conflict relatively late, in 1917, enjoyed a postwar period of prosperity. This was significantly linked to the rapid growth of its film industry; by war's end, American live-action features had become very popular internationally and US studios were ready to respond by stepping up production. As a result, the American film industry replaced France's as the world leader in film production.[1] Before the conflict, England had been the hub of international film **distribution** between the US and Europe, but when the war disabled its system, American studios moved toward a model of self-distribution and began to establish themselves internationally. Live-action short films of various kinds, standardized at the lengths of one reel of film (about eleven minutes) and two reels (about twenty-two minutes), also remained vital to production, as several of them would be shown as part of the "film bill" at theaters.

At that time, and as is the case today, advertising commissions were a mainstay of many animation studios, in the US and across the world, and were screened alongside other types of film in theaters.

One of the first "studio system"-type animation studios in Europe, Publi-Ciné, focused on the production of advertising; it had been founded in Paris by the Frenchman Lortac (Robert Collard) in 1919, after he established himself in the worlds of fine and graphic arts, including caricatures. Lortac opened his studio after he visited the US and was influenced by the work of Winsor McCay, among other animators.[2] In America, many other studios created sponsored films as well; for example, Walt Disney's studio got its start in the late 1910s with commissions for advertising and promotional works.

The growth of the American animation industry was fueled by the adoption of assembly-line practices, which overtook small-scale, **artisanal** methods. During the 1910s, both live-action and animation film studios began to apply the principles of scientific management developed by such theorists as Frederick Winslow Taylor, which described how to structure a workforce efficiently using a few top managers and a large base of skilled workers. Within this kind of system, employees at animation studios could and often did move horizontally from company to company, occupying equivalent positions because job duties were quite similar at each studio. This structure allowed the animation industry to become a fluid institution, with employees, concepts, and characters moving from place to place and social networks dictating its development to a great extent. Partnerships were formed to keep up with the rapidly growing needs of the industry, but these allegiances were also divided by competition, as animators were lured from one studio to the next by the promise of better pay or greater creative freedom. The system was welcoming to some, but pervasive discrimination limited the employment of women and people of color, with long-lasting implications.

During the 1910s, the American film industry attracted ambitious filmmakers from other countries, among them the Frenchman Émile Cohl and the Canadian Winsor McCay, who entered the field after establishing themselves as artists in other realms. In 1914, another Canadian, the cartoonist (Vital Achille) Raoul Barré, was one of the first to set up a formal animation studio: co-founded with the animator Bill Nolan, it was located in New York City, which remained the center of American animation production until the 1930s, even after live-action filmmaking began to shift to California in the late 1910s. At his studio, Barré developed techniques that lent themselves to a production line and standardization, leading to a more efficient system. The American John Randolph Bray, who got his start as a reporter and cartoonist, improved industry methods further. His studio, also founded in 1914, was the most important of the earliest years, serving as a training ground for artists who later became studio owners themselves.

These pioneers of animation established themselves when the art form was unknown territory and invented their own methods for creating 2D animated films, including developing the appropriate drawing techniques and the technology involved in production. Once these entrepreneurs broke ground, it was not long before investors saw the field as lucrative. As a result, newcomers entered production, creating competition with the existing studios. A good example is the newspaper mogul William Randolph Hearst, who saw the opportunity and founded International Film Service (IFS) in 1915.

Cohl, McCay, Bray, and Barré all had backgrounds in drawn art, including print cartoons of some sort. Even Hearst did, insofar as he published comics in his newspapers and therefore owned the rights to several valuable print properties. This chapter focuses on the key individuals mentioned above, the artists and studio owners who were significant in defining early animation in America. Although it mainly looks at 2D production, which was ideal for the emerging industrial studio system, it also notes the continued role of stop-motion in various contexts.

The Beginnings of Drawn Animation

Émile Cohl: Emerging from the Art World

The French artist Émile Cohl (born Émile Eugène Jean Louis Courtet, 1857–1938) was in his fifties when he came to cinema and began animating, after moving in Parisian modern-art circles for a number of years. As a young man in the late 1870s, he had found a position assisting the well-known French caricaturist André Gill. Through Gill, Cohl met many other artists, and during the 1880s, he associated himself with a group called the Incohérents that valued absurdist concepts and dream imagery.[3] As an artist, Cohl was

3.1 Émile Cohl, *Fantasmagorie*, 1908

diverse; not only did he excel at caricature, but he also produced poetry, painting, illustration, and writing for the stage, in addition to editing literary publications.

Cohl completed his first film, *Fantasmagorie*, in 1908, for the Gaumont studio in France **(3.1)**. Although this film seems to be drawn as chalk lines on a blackboard, in the style of Blackton's lightning sketches, in this case Cohl actually drew black lines on white paper; after filming, the white-on-black effect was achieved by reversing the print (turning black into white and white into black). *Fantasmagorie* begins and ends with the hand of the artist bringing to life a line-drawn clown, which drifts in and out of the action, metamorphosing into other forms as it moves. The structure follows a stream-of-consciousness style, like that of a dream. It does also relate to "real life," however, for example when it depicts one of the problems of cinema exhibition at the time: ladies with big hats blocking the view. The film's dreamlike quality means it creates a spectacle rather than a narrative, which recalls the trick-film tradition.

When Cohl began his work at Gaumont, animated filmmaking was so new that he was required to figure out the process himself, without guidance from publications or the use of any pre-existing animation equipment. Eventually, he would branch out, creating not only drawn films, but also stop-motion, including animated effects inserted into live-action films, puppet animation, and hinged cutouts. Cohl worked within Gaumont's efficient industrial structure[4] and thus learned to navigate the emerging studio system; he went on to work for Pathé and then another French studio, Éclair.

While he was still working for the Éclair studio, Cohl and his family emigrated to the United States in 1912. In 1913 and 1914, his production duties for the studio involved the direction of "The Newlyweds," a series based on a comic strip by the cartoonist George McManus in the *New York World*. It relates the adventures of a young couple and their temperamental baby, Snookums. Cohl followed the style of the cartoonist's work, and McManus was primarily credited, as would have been expected at the time; production personnel of all types operated largely in anonymity, and McManus's name was the "draw" for the public. We cannot fully appreciate Cohl's contribution to animation history because a studio fire at Éclair destroyed most of the work he completed there. Nonetheless, he is recognized as an important figure in the history of popular graphic humor, as well as in the emergence of animated film.

Winsor McCay's Thinking Characters

(Zenas) Winsor McCay (*c.* 1867–1934), who also signed the name Silas, was an animator far ahead of his time. In the 1910s, he created the first examples of **personality animation**, an approach not fully embraced by others until the 1930s. Unfortunately, his highly artisanal production process, with the majority of all drawings rendered by the artist himself, did not have a future within an increasingly industrialized system.

McCay began his career creating portraits in a dime museum and later moved on to posters for

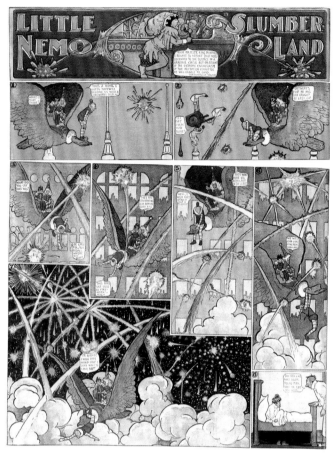

3.2 Winsor McCay, "Little Nemo in Slumberland," *New York Herald*, May 6, 1906

circuses and other types of popular theater. In the early 1900s, while working on editorial cartoons and illustrations, he launched several popular comic strips, including "Little Sammy Sneeze" (1904–6) and "Dream of the Rarebit Fiend" (1904–11). These

successes led to a strip in the *New York Herald* newspaper, "Little Nemo in Slumberland," which he began in 1905, before being wooed away to the Hearst newspapers, where he continued to publish it (**3.2**). McCay's comics are today considered great works of art for their detailed visual design and accomplished storytelling, and at the time of their publication they made him a celebrity. He created a number of popular series before moving on to become an important figure in the area of animated film. McCay's success foreshadowed a general migration of print comic artists toward animated cinema, though few of these early animators achieved the level of stardom that he did.

McCay's first film, *Little Nemo*, released in 1911, was inspired by his popular comic strip (**3.3**). The film is composed of two parts: a brief animated section and a live-action narrative **frame** that lengthens the piece to fit the standard one-reel **running time** of the day. The live-action component, directed by John Stuart Blackton (see p. 32) at Vitagraph, establishes the premise: McCay bets his friends he can make his characters move by creating thousands of drawings in the span of a month. He does indeed manage to animate his characters, providing an example of the self-figurative tendency of early animation, in which animators were often depicted bringing their characters to life. At the end of the film, viewers are treated to a relatively brief scene where Nemo and his friends stretch and move about in surprisingly sophisticated ways, given the early date of this work.

Viewers are instructed to "WATCH ME MOVE" as one of the figures goes through its animated actions.

3.3 Winsor McCay, *Little Nemo*, 1911

3.4 Winsor McCay, *How a Mosquito Operates*, 1912

In this early film, McCay's characters do not tell the story; their ability to move is in itself the point. Thus, the animation is of the trick-film variety insofar as it relies completely on novelty. The viewer may recognize McCay's famous cartoon characters from their print incarnations, but their personalities are not in any way revealed during the film. Still, it must have been exciting for audiences of the time to see the popular figures come to life. At times Nemo and his friends move in repeated cycles, in an exaggerated **squash-and-stretch** style, while at others they are relatively realistic in their movements. Today, audiences still marvel at the level of mastery demonstrated in the film, especially the intricacy of the character designs, the precise way that McCay rotates figures in space, and, above all, the fact that he, as one of the first animators in the American cinema, was self-taught.

In his next two films, McCay added another achievement to these accomplishments: the development of personality in his characters. Personality animation is an important concept in animation, referring to a set of visual (and later aural) techniques used to give a character a distinct persona. It is said that McCay's films *How a Mosquito Operates* (1912) and *Gertie the Dinosaur* (1914) are the first to demonstrate personality animation, even if it is not as fully developed as in American films of the 1930s, when this style became conventionalized. McCay's characters appear to think and have objectives that they act upon in specific ways. In the first example, a mosquito (whom McCay called "Steve") tracks down its victim, a sleeping man, and draws blood from him in calculated, ghoulish ways **(3.4)**. Eventually, his greed gets the best of him and he has to pay the price.

In *Gertie the Dinosaur*, a seemingly domesticated creature performs for the camera as McCay instructs her to do various things, revealing that she is disobedient, as well as playful and unpredictable **(3.5)**. When she interacts with a mammoth, she not only expresses fear, but also mischievously exacts revenge. Gertie's charming personality appears well developed partly because we can see that the animation of her form is based on the study of real animals: for example, at one point she takes a very cat-like roll on the ground, curling her tail, which enables us to associate this drawn prehistoric creature with a familiar household pet. At another point, in a great display of effects animation, she repels a stream of water with such force that we get a sense of the mass and physicality of her form. In these ways, McCay builds the Gertie character into something "real," thinking, and dimensional.

The animated portion of this film was used as part of a stage act, in which McCay as a performer appears to interact with Gertie and give her instructions, before finally stepping behind the projection screen seemingly to enter the frame as an animated version of himself and ride off on Gertie's head. A live-action framing story was added when McCay's employer, William Randolph Hearst, interceded and ordered him to bring these performances to a halt, invoking an exclusivity clause in his contract. Although McCay restricted his shows to New York City, his vaudeville career was essentially over from that point. The live-action section that was added to the animation of Gertie allowed the film to be played in any location as a one-reel film; its premise is similar to that of *Little Nemo*, involving a bet that McCay can bring a dinosaur to life.

McCay's approach to his work reflects the time in which it was made. He drew these films himself, frame by frame, with only a small number of assistants, who were generally limited to tracing backgrounds. Though his characters—Nemo, Steve, and Gertie—became increasingly modern in aesthetic terms, his production process was very artisanal in nature. The same methods were used in his film *The Sinking of the Lusitania* (1918), which documented one of the most heinous acts of World War I—the torpedoing of the British passenger

3.5 Winsor McCay, *Gertie the Dinosaur*, 1914

ship RMS *Lusitania* by German U-boats in 1915. The sinking and the consequent deaths of many civilians played a significant role in uniting the American public, compelling the nation to abandon its official policy of neutrality and initiate the draft of servicemen to join the war in 1917. McCay's artistic abilities are showcased in his renderings of the ship sailing under dramatic skies; the silhouetted vessel contrasting with the high, crashing waves; the underwater attack of the torpedoes; the descent of the ship into the ocean; and the fate of the many passengers who were cast into the sea, left to perish in the freezing water. Diagonal movements emerging from deep in the frame create perspective shots that are impressive by any standard of animation, but particularly those of contemporary practice.

In this film, McCay shifted away from his method of drawing on paper, using a new invention—clear celluloid drawing sheets—to aid the creation of waves in the sea. **Cels** entered the animation world in the mid-1910s, and would become increasingly vital to the production system in America (see p. 46). Unfortunately, the same cannot be said for McCay. Like so many other pioneering filmmakers, he found himself outmoded by the quickly evolving industry, which favored rapid production over artistry. McCay famously told his fellow animators, who gathered in 1927 at an event to celebrate his accomplishments, "Animation should be art. That is how I conceived it. But as I see, what you fellows have done with it, is making it into a trade. Not an art, but a trade. Bad luck!"[5] His perspective, sad to say, was quite similar to that of Georges Méliès (see p. 33), whose methods also became outmoded during the 1910s. Indeed, Cohl, McCay, and Méliès all fell into relative obscurity as cinema moved into the late silent era. Fortunately, their reputations have now been restored, thanks to the research of historians dedicated to documenting their accomplishments.

Bray, Barré, and the Emergence of the Animation Studio System

In 1914, John Randolph Bray (1879–1978) and Raoul Barré (1874–1932) founded separate studios in the New York City area, initiating processes that enabled the development of efficient production. By increasing the speed of output, animation studios were able to offer commercially viable products within the live-action-dominated film industry.

J. R. Bray and the Hub of Early American Animation

John Randolph Bray operated the most tenacious of the early studios. He began his career working for newspapers, including a job as cartoonist, beginning in 1903, at the *Brooklyn Daily Eagle*, where he met one of his future employees, Max Fleischer. In 1906, Bray's comics began to be published in the weekly satirical magazine *Judge*; his series "Little Johnny and the Teddy Bears" reflected a national craze for "Teddy Bear" toys started after the American president Theodore "Teddy" Roosevelt went on a hunting trip in 1902 and refused to shoot a helpless bear.

Bray continued to create print comics for other publications while he began to think about animation. In 1913, he completed his first film, alternately known as *The Artist's Dream* and *The Dachshund and the Sausage*, which is built around the live-action story of an artist who draws a dog and a set of drawers containing some sausage. Whenever the artist leaves the room, the drawn dog becomes animated and retrieves the sausage. After eating too much sausage, the animal gets extremely fat, resulting in a fate similar to that of Winsor McCay's bloated insect in *How a Mosquito Operates*. At the end, the artist (played by Bray) is awakened by his

The Development of the Hollywood Studio System and the Modern Cinema Experience

Until World War I, France was the world leader in film production. America was just one of many other players, including England, Russia, Germany, Denmark, and Italy. The war changed everything, however, by limiting production and distribution in European countries engaged in the conflict. Meanwhile, the American industry had become organized, standardized, and prolific. Its development began in about 1908, when Edison gathered the top studios into the Motion Picture Patents Company (MPPC), which pooled important **patents** and therefore limited competition among outsiders. Edison's organization was eventually found to be monopolistic, however, and was forced to disband in 1915.

Meanwhile, some production houses located in California had become powerful, and they formed the basis for what would become the American studio system in the 1920s. Originally, the American live-action and animation film industries had been concentrated in the east, in New York and New Jersey. In the early 1910s, however, what came to be Universal Pictures—founded by Carl Laemmle and Pat Powers and originally called the Universal Film Manufacturing Company[6]—and other new studios began to settle in the Los Angeles area, partly to put physical distance between themselves and Edison's monopolistic trust. In this way, the Hollywood industry was born.

By 1916, more than half of US live-action film production took place in the Los Angeles area. Keystone Pictures Studio, founded by Mack Sennett in 1912, was one of the new studios established there. It was well known for its "Keystone Kops" series, which featured physical comedy, or **slapstick** humor—a string of humorous pranks related to the body, including pratfalls and other violence played for comedy, or "hurt gags." Charlie Chaplin, a great source of inspiration for animators throughout the years, is among the comedians who emerged from that studio **(3.6)**.

During the 1910s, feature-length films were introduced, but live-action and animated shorts of various kinds continued to be produced to fill out a program that would screen each day and generally change several times a week. Animated shorts might include character-based comedies, advertising films (sometimes as **industrials** to promote an organization or explain a process), and **topicals**, referencing events of the day.[7] Though films were still integrated into vaudeville performances through the 1920s—as an attraction alongside **minstrel shows**, slapstick routines, or dance numbers, for example—they were increasingly shown in the context of a complete film program.

Makeshift storefront nickelodeon theaters of the mid- to late 1910s were often of ill repute, because the audiences were mixed, meaning that there was nothing to separate men of unknown reputation from women and children. The content of early films was very daring at times, as provocative sexual themes and nudity made their way into cinema (by the 1920s, pornographic "stag films" were already thriving, though not shown in general theaters). A series of theater fires, caused by the flammable nitrate film stock in use until the mid-twentieth century, created another safety concern.

The government cracked down on the film industry by subjecting it to censorship under American law. In 1915, the Supreme Court declared cinema to be "a business, pure and simple" rather than a means of expression that would be guaranteed freedom of speech. The industry tried to clean up its image by creating "movie palaces" that could seat many people in luxurious, air-conditioned surroundings and sometimes housed full orchestras. In the US, the first movie palace was the 3,000-seat Strand Theater in New York City, which opened in 1914 **(3.7)**. For the white middle class, going to a movie theater would become an "event." Not everyone was entitled to the same experience, however; for many years, movie theaters in the US were segregated, with separate seating, screening times, and locations for viewers of color.

Until the late 1910s, few film stars existed in the way that they do today, although well-known personalities, such as government officials, athletes, and stage performers, were recorded on film. There was also little acknowledgment of production personnel, with the exception of a few prominent directors; in general, films were promoted under their studio names and the names of studio heads. During the late 1910s and into the 1920s, the star system

3.6 Charlie Chaplin in *His New Profession*, 1914

3.7 Strand Theater, New York City, 1914

grew and actors came to be seen as valuable assets with the ability to attract audiences to movies. Within the world of animation, many starring characters had migrated from comics, so they were already familiar to audiences, but newcomers also appeared. By far the most significant animated character of the late 1910s and early 1920s was Felix the Cat, the creation of the producer Pat Sullivan (see p. 53), who became famous internationally **(3.8)**.

3.8 Felix the Cat, drawing by Pat Sullivan's studio, 1919

wife (who is played by his actual wife, Margaret), and he realizes it has all been a dream. Bray took the film to Pathé, where he signed a contract for an animated series about a little man who appears in situations that are hard to believe, beginning with *Colonel Heeza Liar in Africa*, in 1914, and opening his studio that year. The following year, in 1915, Bray changed **distributors**, signing a contract to release "Colonel Heeza Liar" within the "Paramount Pictograph" series **(3.9)**.

3.9 John Randolph Bray, *Colonel Heeza Liar at the Bat*, 1915

During the late 1910s, one of Bray's companies held the patent on a process that became the industry standard: drawing moving parts on clear celluloid sheets that are stacked over a background. This important labor-saving process aided the development of the American animation industry. The use of clear celluloid overlays, known as "cels," meant that only the moving parts of an image had to be re-drawn. They allowed backgrounds made on paper to show through. As useful as they were, it took some time for cels to become widely used. For one thing, until the 1950s, they were made of cellulose nitrate, just as 35mm film stock was, so they were highly flammable. At first they were also relatively thick and yellowish, and as a result could not be stacked too thickly (perhaps three at most).[8]

The cel-animation process was developed by the animator Earl Hurd, who joined Bray in the mid-1910s, bringing with him a series called "Bobby Bumps," which he had been distributing through Universal (3.10). The two then formed the Bray-Hurd Process Company, securing various patents in an attempt to dominate American production; as was the case with Edison's patent pooling, a great deal of time was spent litigating against those who used their processes but neglected to purchase the appropriate licenses. Bray and Hurd's copyright on the cel technique lasted from about 1914 until 1932, when it entered the public domain and could be used freely, without a license.[9]

Bray set the standard for production processes and provided a kind of ground zero for much of the development of the American animation studio system in the 1920s. During the 1910s, many of the founding figures of animation passed through his doors, including David Hand and Clyde "Gerry" Geronimi, best known for their later work at Disney (see p. 128). Jamison "Jam" Handy was hired by Bray to supervise a Detroit wing of the studio and fulfill contracts for the automotive industry, which he did for a few years; later, under the name Jam Handy Organization, the studio became one of America's most significant producers of industrial films. Max Fleischer was hired in 1916 and brought with him the patent for the **rotoscope process** (filed in 1915 and granted in 1917), in which footage of a live performer is projected frame by frame onto paper and then traced to form the basis for drawings of animated characters (3.11a, 3.11b). Fleischer used the process in his "Out of the Inkwell" entertainment films featuring Koko the Clown (3.12). He also worked on a number of war-related films with fellow employee Jack Leventhal, who went on to be a pioneer in the field of stereoscopic films.

Bray created what is considered to be the first American animated film made on color film **stock**, *The Debut of Thomas Cat*, in 1920, using the Brewster Color Process, one of a number of experimental methods

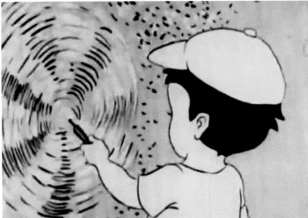

3.10 Earl Hurd, *Bobby Bumps' Fourth*, 1917

3.11a (above) and **3.11b** (below) Diagrams from Fleischer's patent for the rotoscope process, filed in 1915 and granted in 1917

3.12 Koko the Clown, from Max Fleischer's "Out of the Inkwell" series, 1910s

in development during the 1920s. For the most part, however, Bray's productions lacked creativity or experimentation. He was extremely frugal in production, allowing relatively few drawings for each film and closely monitoring the use of supplies, to the point of providing just one pencil per animator. This economy affected the aesthetic appearance of the work he produced, and ultimately its popularity. The studio began to flounder, and by 1922 Bray had lost his distributor. He later moved further into industrial pictures, including filmstrips for schools.

Innovations at the Barré Studio

Raoul Barré had studied at the Academy of Fine Arts in Paris before returning home to Quebec and becoming a founding figure in the city's cartoon culture, signing his work "VARB" (the initials of his full name). After moving to New York in 1902, he pursued illustration and painting, participating in shows with other Canadian painters. In 1912, Barré was visiting the Edison studio when he met Bill Nolan, who was employed there. The two worked together on advertising films and then in

1914 co-founded one of the first animation studios, creating animated segments for the "Animated Grouch Chaser" series, which was distributed by Edison. Nolan was one of the key animators of the silent era, known for being fast and inventive, especially in his development of the **"rubber-hose" style** of animation, which features loose, rubbery body movements, reflecting a kind of physical comedy or gag-based sensibility.[10] Rubber-hose animation was the dominant style of American studios of the 1920s, though it continued to be used even later. Barré, for his part, developed the **"peg and perf"** system of registering images through a peg bar and paper that was punched with holes fitting onto it. The alternative was to use wooden frames that aligned sheets of drawing paper at the bottom corner, but this method was not very precise and led to shaky images on screen.

At Barré's studio, an innovation known as the "slash system," or **slash and tear,"** offered an alternative to cels; it used layers of paper that were cut away to reveal the moving image or the background, depending on how the artwork was stacked. This system could be used to avoid paying licensing fees to the Bray-Hurd Process Company for the right to use cels.

Most of Barré's staff were lured away when William Randolph Hearst established the International Film Service (IFS) studio in 1915 and offered better pay. Barré himself worked for Hearst for a short time in 1916, directing a series of seven "Phables" films based on a comic strip by T. E. Powers. He then partnered with Charles Bowers, who was working on an animated adaptation of "Mutt and Jeff," which in 1907 had become the first daily comic strip published in America, with the artist of the series, Bud Fisher.[11] Barré left the animation world in 1919 and took some time off before returning to work for a year, from 1926 to 1927, at the studio of one of his former employees, Pat Sullivan, on the "Felix the Cat" series (see p. 53).

IFS Raises the Stakes

Hearst's International Film Service (IFS) represented another cornerstone in the establishment of American animation during the 1910s. As it was affiliated with his newspapers, IFS promoted comic strips published in them—such titles as George Herriman's "Krazy Kat" (3.13), Frederick Burr Opper's "Happy Hooligans," Walter Hoban's "Jerry on the Job," George McManus's "Bringing up Father," and Rudolph Dirks's "The Katzenjammer Kids." Unlike Barré and Bray's enterprises, which had been developed from the ground up, or "vertically," implementing new processes to create their own versions of an efficient production system, Hearst's organization was created by taking advantage of established processes (by purchasing a license to use the Bray-Hurd cel process, for example) and luring away relatively experienced talent from his competitors with the promise of higher salaries. For example, Bill Nolan and Gregory La Cava, both from Barré's studio, were enticed into joining Hearst, making the kind of "horizontal" move that increasingly characterized the maturing animation industry.[12] IFS closed in 1918, but some of its animators—including Nolan, La Cava, (Myron) Grim

3.13 George Herriman, *Krazy Kat and Ignatz Mouse at the Circus,* 1916

Natwick (who had met La Cava in art school), and Walter Lantz—continued to work together in a New York City studio owned by John Terry (brother of future Terrytoons owner Paul Terry) and backed financially by Hearst.[13]

Stop-Motion Developments of the 1910s

Cutouts

Although drawn animation began to dominate in US production in the 1910s, stop-motion remained vital worldwide. For example, hinged cutouts were used in several popular British series, including "Bully Boys" (1914), by Lancelot Speed, G. E. Studdy's wartime series "Studdy's War Studies" (1914–15), and "John Bull's Animated Sketchbook" (1915–16), by Anson Dyer and Dudley Buxton. In *John Bull's Animated Sketchbook*,

No. 15 (1916), which runs just under seven minutes in length, the hand-of-the-artist concept is used to begin the program, which also includes a mocking reference to contemporary censorship efforts in its introduction by stating that the film was passed by the Board of Sanitary Engineers, or trash collectors. Throughout the short, the artist's hand reappears briefly to paint backgrounds or other 2D elements. Cutouts are used for figures, which are moved in repeated cycles to speed up the process of animation. Intertitles, sometimes written out by the artist, create a kind of conversation with the viewers, as he confides, for example, "I receive renumeration for doing this . . . sometimes."

Cutouts were also used by the Australian animator Harry Julius to create one of his country's first animated films, a "Cartoons of the Moment" topical called *The War Zoo* (1915), in which the countries that were engaged in World War I were represented by different animal characters. In Argentina, cutouts were used for the seventy-minute *El Apóstol* (*The Apostle*), directed by the Italian cartoonist Quirino Cristiani (1896–1984); released in 1917, it seems to have been the first animated feature ever produced **(3.14)**. Unfortunately, it has been lost. We know the film was topical in its focus, however, using models and visual effects to satirize the Argentine president Hipólito Yrigoyen, who is shown ascending into the heavens to purge Buenos Aires of its problems. Cristiani also made other feature-length animations, as well as advertisements, topical works (including sporting events), and medical films.

Clay

The great American stop-motion animator Willis "Obi" O'Brien (1886–1962) got his start at an Edison studio, Conquest Pictures. His earliest work includes *The Dinosaur and the Missing Link* (1915), about a group of caveman characters who vie for the attention of the lovely cavewoman Araminta Rockface **(3.15, see p. 50)**. Significantly, it features an ape named Wild Willie, who is considered to be a forerunner of the character O'Brien animated in *King Kong* (dir. Merian C. Cooper and Ernest B. Schoedsack, 1933). Other prehistoric-themed films followed in the course of O'Brien's early career, including *R. F. D. 10,000 B.C.* (1917). The title refers to a turn-of-the-century American innovation, Rural Free Delivery, which provided postal services in remote country locations. The film depicts a postal

3.14 Quirino Cristiani, *The Apostle*, 1917

delivery man's attempts to thwart the romance between a young woman who spurns him and her preferred suitor.

At about the same time, the American Willie Hopkins was producing clay animation for a series of fifty-three "Miracles in Mud" segments (about two minutes each). They appeared in the "Universal Screen Magazine," a late 1910s program from Universal Pictures designed to be the equivalent of a newspaper supplement, including short films on a variety of popular subjects and topical issues. Most of Hopkins's work has been lost. One of the surviving segments, *Swat the Fly*, from 1916, shows the sculpting of three clay caricatures that turn back into a lump of clay at the end of the film, using the hand-of-the-artist convention.

3.15 Willis "Obi" O'Brien, *The Dinosaur and the Missing Link*, 1915

Helena Smith Dayton was one of the first female animators in the history of American animation. During the late 1910s, she worked in clay, but none of her films has survived. She is primarily remembered as a writer and painter with connections to the women's suffrage movement, which culminated with the passage of the Nineteenth Amendment to the Constitution, granting women the right to vote.[14]

In Great Britain, F. Percy Smith used stop-motion in such documentaries as *To Demonstrate How Spiders Fly* (1909), a one-minute film showing a spider model spinning a web. The Russian-born Władysław Starewicz began his filmmaking career creating live-action nature documentaries after he became director of the Museum of Natural History in Kovno, Lithuania. In 1910, he used animation in one of them, *Lucanus Cervus*, to re-enact the activities of stag beetles. Starewicz continued his career as a stop-motion animator making theatrical films, first working in Moscow and then in France, after moving there in 1920.

Conclusion

The devastating impact of World War I resulted in a realignment of the international film industry, shifting its center from France to the United States. At the same time, the American animation business was changing from an artisanal process into an industry, at first centered in New York City. To increase efficiency, a more factory-like production process was embraced, employing methods that favored drawn animation, which came to dominate greatly over stop-motion production in the US. In other parts of the world, stop-motion techniques continued to be widely employed in both short novelties and ambitious works.

This chapter surveyed the innovations of four prominent figures in American animation of the 1910s—Émile Cohl, Winsor McCay, John Randolph Bray, and Raoul Barré—as well as the IFS studio established by William Randolph Hearst. These pioneers had an association with print comics, including caricatures, political cartoons, and newspaper strips, which laid a foundation for the growth of animation. But the 1920s would bring great changes, as the entire American film industry grew more powerful and the technology of sound resulted in new ways of working. During this transitional period, emerging leaders in the field of animation established new studios and produced animated works that reflected the variations in their creative practices.

Notes

1 Richard Koszarski, *An Evening's Entertainment: The Age of the Silent Feature Picture, 1915–1928* (1990. Berkeley, CA: University of California Press, 1994), 66; William Uricchio, "The First World War and the Crisis in Europe," in Geoffrey Nowell-Smith, ed., *The Oxford History of World Cinema: The Definitive History of Cinema Worldwide* (1996. Oxford: Oxford University Press, 1997), 62–70, 65.

2 Richard Neupert, *French Animation History* (Sussex, UK: Wiley-Blackwell, 2011), 46.

3 Donald Crafton, *Emile Cohl, Caricature, and Film* (Princeton, NJ: Princeton University Press, 1990).

4 Crafton, *Emile Cohl*, 114.

5 John Canemaker, *Winsor McCay: His Life and Art* (New York: Harry N. Abrams, 2005), 199.

6 It became Universal Pictures in the 1920s, but is more generally known as Universal Studios.

7 Tino Balio, *The American Film Industry* (1976. Madison, WI: University of Wisconsin Press, 1985), 112.

8 Donald Crafton, *Before Mickey: The Animated Film 1898–1928* (1982. Chicago, IL: University of Chicago Press, 1993), 153.

9 Mark Langer, "John Randolph Bray: Animation Pioneer," in Gregg Bachman and Thomas J. Slater, ed., *American Silent Film: Discovering Marginalized Voices* (Carbondale, IL: Southern Illinois University Press, 2002), 94–114; "John Randolph Bray," in Gale Encyclopedia of Biography. Online at http://www.answers.com/topic/john-randolph-bray

10 Michael Barrier, *Hollywood Cartoons: American Animation in its Golden Age* (New York: Oxford University Press, 1999), 175.

11 Fisher had also been employed by Hearst but, like Winsor McCay, he was chastised for dividing his time between vaudeville acts and his work for the paper—so he left for another distributor.

12 Crafton, *Before Mickey*, 178.

13 Leonard Maltin, *Of Mice and Magic: A History of American Animated Cartoons* (1980. New York: New American Library, 1987), 17.

14 Michael Frierson, *Clay Animation: American Highlights 1908 to the Present* (New York: Twayne, 1994), 74–81.

Key Terms

caricature
cel
cutout
cycle
distribution
patent
peg-and-perf system

personality animation
rotoscope process
rubber-hose style
slash-and-tear system
squash and stretch
stop-motion

The Late Silent Era and the Coming of Sound

Global Storylines

Sound-on-film technology is developed and gradually introduced throughout the 1920s and early 1930s

Meanwhile, animation becomes increasingly established, not only as an art form but also as a career path, with the first educational publications released to meet the demand from budding animators

Walt Disney releases his first well-known works: the "Alice Comedies" and "Oswald the Lucky Rabbit" series

Felix the Cat becomes the first animated "celebrity" and a range of merchandise is launched in his name

Introduction

By the early twentieth century, America had become a powerful influence on the rest of the world. This was to some extent due to the popularity of its cinema: in the 1920s, American production accounted for well over half the films being screened worldwide. During this period, animation came to represent a viable career path: it was fully entrenched within the larger studio system and developed norms of production as well as training opportunities. This chapter focuses on the American studios that paved the way for the national animation industry, their assimilation of sound technology, and the development of conventions in the form and content of their output. It includes the work of several industry leaders who would emerge during the late silent era, including the studio owners Pat Sullivan, Paul Terry, Max and Dave Fleischer, Walt Disney, and Walter Lantz, as well an influential distributor, Margaret J. Winkler. Working within a system controlled by a handful of powerful live-action studios, these individuals contributed to the development of animation style as they sought new ways to balance creativity and economy. By this time, two-dimensional work prevailed in the American animation world, although Willis O'Brien and his contemporaries developed stop-motion productions on a smaller scale.

The adoption of **sound-on-film technology**, beginning in the mid-1920s, represented an opportunity for growth and creativity for some individuals, while for others it was a burden taken on unwillingly. In any case, advances in film sound represented just one aspect of much bigger changes in audio technology, which had effects far beyond the movies. The development of radio broadcasting caused profound cultural shifts, creating connections across countries and eventually the world,

providing access to news, as well as to entertainment. Radio created the first instances of simultaneous social experience among large groups, as people gathered around their receivers to listen to broadcasts. In America, the advent of radio ushered in the decadent "Jazz Age"; new dance moves flourished, leading to social changes that would have been hard to predict. Beginning in 1919 and lasting until the early 1930s, the Harlem Renaissance took place in New York, home of an expanding African American middle class. Music, literature, performance, and other expressions from black artists began to cross over in appeal to white audiences, especially young people, thanks to the cultural phenomenon of radio. For many, such radical changes were unwelcome. As a form of resistance, the American prohibition against alcohol started in 1920 and lasted until 1933; the ban was partly a reaction to the decreased inhibition of young adults, especially women, who were wearing shorter skirts and boyish hairstyles—and had been given the vote.

Iconic Figures of the Late Silent Era

Pat Sullivan and Felix the Cat

Felix the Cat is perhaps the most iconic figure of the Jazz Age (4.1). Pat Sullivan (c. 1885–1933) created the character and produced the series, which became popular worldwide in the early 1920s. Sullivan was an Australian who had had various occupations before settling into animation. From 1911 to 1914, he worked for the New York cartoonist William Marriner, and he then joined Barré's studio for about nine months. When he left, he opened his own studio and in 1916 and 1917 produced films for Pat Powers, who released them through Universal. Among this work was a ten-episode series from 1916 called "Sammie Johnsin," which featured a black boy character;[1] it was adapted from Marriner's print comic "Sambo and his Funny Noises," the origins of which were in Helen Bannerman's children's book *The Story of Little Black Sambo* (1899), about an Indian boy and his encounter with some hungry tigers.[2]

In 1918 and 1919, Sullivan produced a series known alternately as "Charlie" and "Charley," based on the persona of Charlie Chaplin; these films were distributed through the Nestor Film Company, affiliated

with Universal. Sullivan shifted to Paramount in 1919, contributing animation to the "Paramount Screen Magazine" series. During this time, he met and hired Otto Messmer, who would be the creative force behind "Felix the Cat." Messmer had grown up watching vaudeville and other popular theater, and was influenced by Winsor McCay's films and Émile Cohl's series "The Newlyweds." Meanwhile, Sullivan continued in his role as studio head and, as was the practice of the day, "Felix the Cat" was promoted under the producer's name, as "A Pat Sullivan Cartoon," rather than acknowledging the role of Otto Messmer as animator.

Felix, Jazz Age Icon

Felix made his debut somewhat anonymously in 1919, as a character called Master Tom in *Feline Follies* (4.2, see p. 55), as part of "Paramount Screen Magazine"; in the film, he has a liaison with a lady cat that results in a large litter of kittens—helping set the tone for his

4.1 Felix the Cat wooden jointed doll made by Schoenhut, c. 1922–24

naughty persona in films to come. Felix became popular partly because his personality was relatively well developed. Like McCay's mosquito and dinosaur (see p. 42), he is a thinking character;[3] he also has an adult sensibility, as a heavy drinker and a womanizer prone to infidelity. The character clearly reflects the persona

Distribution Options

During the 1920s, there were many small live-action studios in the US that made films aimed at specialized audiences. Despite this, most American films came from just a few big, live-action studios, such as Paramount and United Artists, businesses that were largely run by an inner circle of original founders. When these studios wanted to distribute animation, they generally contracted with one or more producers, who in turn might distribute through different studios. Animation producers who were not lucky enough to get a contract with one of the big Hollywood studios had the option to distribute on a **state's rights** basis, selling a print to an agent who would bring it across the US, from territory to territory—but there was less money to be made that way.

During the 1920s, it was sometimes difficult for studios from outside the US to exhibit work, even within their own countries. Many were constrained by a business practice American studios adopted to limit competition: **block-booking**, or distributing a studio's entire year's output as a single unit. American studios implemented this practice internationally, requiring theater owners to purchase all their works in order to show the few pictures audiences really wanted to see. Consequently, American films often filled theater programs abroad, leaving little room for exhibitors to show films from their own countries. By the end of the 1920s, a number of European countries, including France and Germany, had established quotas to curb the flow of American films, despite their popularity with audiences (although boycotts of American films did occur from time to time in reaction to offensive **stereotyping** of various nationalities).

To deal with growing public-relations problems that affected distribution, in 1922 the American film industry established an internal organization, the Motion Picture Producers and Distributors Association (MPPDA), and two years later, the Studio Relations Board (SRB), to handle concerns from outside the country as well as domestic censorship and local Hollywood problems. The Hollywood film industry had suffered a public relations crisis in the early 1920s when a series of star scandals broke out, unveiling illicit affairs, drug use, and deaths.[4] Industry advisors developed a document referred to as the "Don't and Be Carefuls," which addressed nudity, profanity, drugs, and sex, among other topics,

but did not make a strong impact. Censorship intensified at the end of the 1920s, however, and would be a defining factor in the **aesthetics** of Hollywood cinema during the 1930s. Film censorship in America was largely aimed at live-action features, but animation was expected to adhere to moral standards as well. Nonetheless, scandalous behavior was frequent. For example, in the "Felix the Cat" short *Woos Whoopee* (1928), the character goes out to the Whoopee Club, gets drunk, and dances with loose females **(4.4)**.

4.4 Otto Messmer, *Woos Whoopee*, 1928

of the internationally famous comedian Charlie Chaplin, known for swinging a cane and wobbling about, while its design has links to Sullivan's Sammie Johnsin character. Part of Felix's appeal lies in his ability to metamorphose into any shape, which creates a dreamlike effect in a wide range of scenarios. The content of the "Felix the Cat" series often reflects contemporary social issues: for example, he stirs up the evolution debate in *Felix Doubles for Darwin* (1924), angering a bunch of monkeys by suggesting that they are related to humans.

In 1921, after "Paramount Screen Magazine" closed down, Sullivan obtained the rights to the "Felix the Cat" series and started to offer it to a range of distributors. At Warner Bros., he failed to interest a studio executive, but he did catch the attention of a secretary, Margaret J. Winkler (see page 59). With the support of her boss, Winkler took on the distribution of the series in December 1921,[5] announcing the formation of her new company in early 1922. A combination of Winkler's creative energy and continued development of the Felix character led to a great surge in the series' popularity. Increasing production demands at about that time led to new hires at the studio, including Bill Nolan, whom Sullivan had worked with at Barré's studio—and Barré himself.

From 1922, Felix was widely merchandized (4.3), initially with a line of plush toys made by Gund. In 1923, in a twist of the standard procedure of the time, the character was adapted to print, becoming a comic strip after being successful in animation. As Felix's popularity grew, it was no surprise that Sullivan expected more money from his distributor, but negotiations did not go well. Sullivan ended his contract with Winkler in 1925 and took his series to another distributor, Educational Films.[6] Felix remained popular for a few more years, but interest in him declined in the 1930s. Pat Sullivan at first resisted the transition to sound and then—unlike his forward-looking competitors—viewed sound as an afterthought, not as an integral part of the storytelling. Sullivan died in 1933, as a result of alcoholism.

Paul Terry's Widespread Influence

Paul Terry (1887–1971) was a great influence on the developing animation industry because he demonstrated that films could be both popular and economically made. Terry first ran his own studio between 1914 and

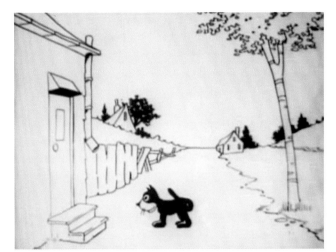

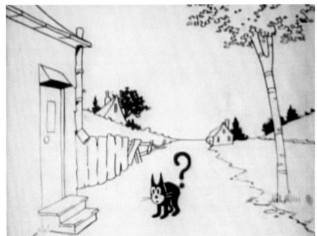

4.2 Otto Messmer, *Feline Follies*, 1919

4.3 Felix the Cat plush toy, made in England, c. 1925

1917, except for a short stint with Bray in 1916, when he developed his long-running Farmer Al Falfa character. In 1920, he partnered with Amadee Van Beuren to create Fables Studios, which began producing the popular "Aesop's Film Fables" the following year (4.5a). Some episodes were based on actual fables, but in other cases the name functioned only as a general title. Episodes ended with a humorous "moral."

Terry had learned valuable lessons from his time at the Bray studio, but he emerged with his own sensibility. John Randolph Bray (see p. 43) used labor-saving techniques indiscriminately, with an emphasis on **holds** that tended to make the studio's characters seem lifeless. In contrast, Terry saved on labor by using cycled actions that kept characters moving; he grabbed the viewer's attention not so much with the story as with the kind of gag elements found in live-action slapstick comedies, including lots of action and violence playing for humor. Another very functional aspect of Terry's work is found in simple character designs that were relatively easy to draw.[7]

One of the "Aesop's Film Fables," *Dinner Time* (4.5b), directed by Terry and released in October 1928, is said to be the first animated narrative film to incorporate sound-on-film technology, employing RCA Photophone Synchronization. The film focuses on a group of animals who are all trying to round up something to eat: for example, a cat pursues a bird and a band of dogs takes over a butcher's shop, which is guarded by Al Falfa. Along the way, many tussles occur. The film's soundtrack provides synchronized effects, but these were very general and played in the background, without the tight sound–object correlation found in Disney's first synchronized sound film, *Steamboat Willie* (dir. Ub Iwerks, 1928), which would be released the following month (see p. 94).

4.5a "Aesop's Film Fables" poster, 1930s

4.5b Paul Terry, *Dinner Time*, 1928

The Introduction of Sound Technology

The introduction of sound was taking place worldwide throughout the 1920s and into the 1930s, but it is important to remember that films were never completely silent; most screenings had some kind of musical accompaniment, and there were even some sound effects. Integrated sound and image had been an objective from the start, and research into various processes reached back to the early days of cinema. For example, experimentation occurred in Edison's labs; an image from the *Dickson Experimental Sound Film* (dated c. 1894) shows W. K. L. Dickson testing the Edison Kinetophone, which combined a Kinetoscope viewer with a phonograph **(4.6)**.

The American inventor Lee DeForest played a pivotal role in advancing film sound: he developed essential technologies and by 1920 had patented a sound-on-film process, DeForest Phonofilm. The animation studio owner Max Fleischer partnered with DeForest and others in creating a distribution company, Red Seal Pictures, and employing sound-on-film processes in sing-along films as early as 1924. Later in the decade, the American studio owner Pat Powers closely duplicated DeForest's system with his Powers Cinephone. Yet another system was RCA Photophone Synchronization. Studios sometimes used different technologies: for example, Disney first used Powers Cinephone and later employed RCA Photophone. There was no clear path for the adoption of sound and court cases resulted as individuals argued about patent ownership and rights.

In the United States, the sound-on-film race was led by the Warner Bros. and Fox Studios, which invested deeply in different processes. In 1926, Warner Bros. adopted a sound-on-disk system called Vitaphone, which allowed exhibitors to use a phonograph system rather than projectors geared for sound. The same year, Fox came out with its Movietone sound-on-film process, which made the picture area of a filmstrip smaller in order to accommodate a sound strip running down the side. By 1928, the industry had collectively embraced sound-on-film technologies, and the transition to "talkies" occurred worldwide over the next several years.

There were practical reasons why sound on film was not universally adopted as soon as it was available. Theaters were not equipped for sound projection and the cost of conversion was quite high. Actors in live-action productions faced challenges because suddenly they had to speak: some had strong accents or voices that did not match their personas. Sound also complicated international distribution, since it was much easier to insert different title cards or forgo dialogue altogether than to record dialogue in various languages. In Japan, the tradition of using actors known as benshi in theaters to voice various parts in a film delayed the implementation of recorded dialogue, because they were so popular.

It is important to remember that the transition to sound films occurred during an extremely difficult time in world history, with the start of the Great Depression. Stock prices had been dwindling in value for about two months before "Black Tuesday" on October 29, 1929, when the market crashed. The resulting economic crisis, the Great Depression, spread throughout most of the world, reaching a kind of apex in 1933. Nonetheless, the transition to sound-on-film processes moved onward through this period, occurring faster or slower in various contexts.

4.6 Thomas Edison, *Dickson Experimental Sound Film*, c. 1894

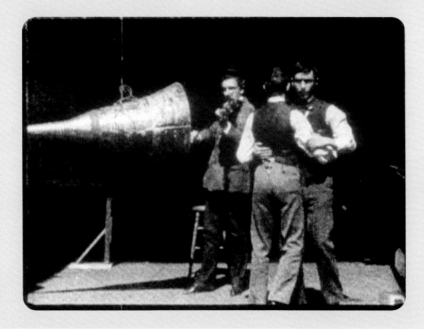

Fleischer's Scientific Roots

Max (1883–1972) and Dave Fleischer (1894–1979) were among the first to experiment with recorded sound in animated films during the 1920s. This is not surprising, since they were very technologically engaged and took every opportunity to make their films stand out by using the latest inventions. They came from a family of inventors (émigrés from a Polish region of Europe) and Max had been an editor for *Popular Science* magazine by 1915. In 1916, he began working in the technical division of Bray's studio, and later he was sent to Fort Sill, Oklahoma, with Jack Leventhal to supervise production of training films for the armed forces. The Bray studio was a leader in this sort of production, holding contracts with the US military for many years.

In 1915, Max Fleischer filed a patent for the process of rotoscoping, using films of live-action figures as the basis of animation, and two years later it was granted (see p. 46); by speeding up the process of animating and at the same time creating relatively realistic characters and movements, the technique proved to be valuable for making military films at the Bray studio. A rotoscope was also used to create the Koko the Clown character in the Fleischers' "Out of the Inkwell" films, which were originally distributed in Bray's "Pictograph" series at Paramount. The first in the series, *The Tantalizing Fly* (4.7), from 1919, opens with Max playing the role of artist at his drawing pad. The shot cuts to the hand of the artist inking the image of Koko as a fly lands on the paper and gets in the way. After Koko is fully rendered, the character begins to move, dodging the fly by gyrating on the paper. The clown's movements are based on filmed footage of Dave Fleischer, and the live-action basis of the animation is evident—Koko moves with the fluidity that is the hallmark of rotoscoping. The film contains no shots actually combining live-action and animation, however. In wide shots the viewer sees both the live Max and the drawn Koko, but at that time the clown is still (it is also clearly larger than the image seen in close shots). Films in this series always end in the same manner: the mischievous clown is "poured" back into the ink bottle, which is capped until the next episode.

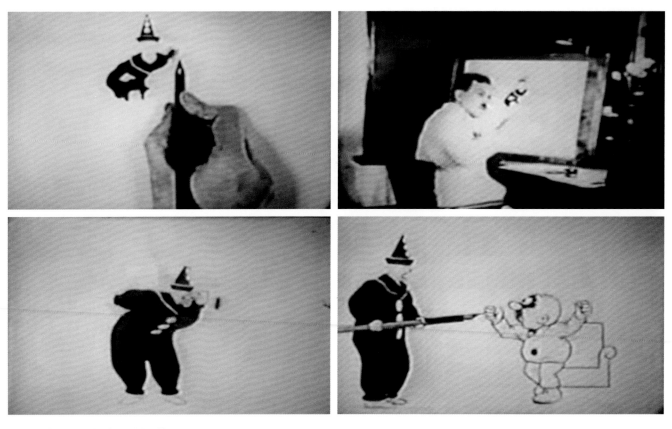

4.7 Max Fleischer, *The Tantalizing Fly*, 1919

M. J. Winkler Represents Animation

When Bray left Paramount in 1921, the Fleischers opened their own studio, Out of the Inkwell Films, Inc., and continued production of the "Out of the Inkwell" films. The following year, they signed with M. J. Winkler (1895–1990), a distributor who eventually represented three of the dominant American animation studios during the 1920s: those run by Pat Sullivan, Max and Dave Fleischer, and Walt Disney. Hungarian by birth, Winkler had emigrated to the US with her family when she was nine years old, and as a young woman took a job as secretary at the Warner Bros. studio. She began distributing in 1921, and went by the initials M. J. to disguise the fact she was a woman (named Margaret) in a field dominated by men. She later married and became a mother and, as a result, in 1926 she handed the business over to her husband, Charles Mintz (1889–1940), who was aided by her brother, George Winkler. At first, they distributed films on a state's rights basis (see Box: Distribution Options, p. 54), but later they were also able to secure distribution through Hollywood studios.

Walt Disney's First Steps into the Limelight

Eventually, the Disney studio would become known for its distinctive style of personality animation, which it developed during the 1930s. When Walt Disney (1901–1966) opened his first studio in the early 1920s, however, it, too, employed the economical methods of animation production found at contemporary studios: for instance, cycled movements, reused imagery, and holds on still art, as well as the aesthetics of rubber-hose animation. Disney and his employees learned these animation techniques primarily from two sources: a book by Edwin G. Lutz, *Animated Cartoons: How They Are Made, Their Origin and Development*, which first appeared in 1920 (see p. 63), and the work of other studios, particularly that of Paul Terry, including his "Aesop's Film Fables" (see p. 56)[8].

In 1911, at the age of nine, Disney moved to Kansas City, Missouri, with his family, and was exposed to movies and vaudeville. After a few years, they relocated to Chicago, where he took evening courses in cartooning at the Chicago Art Institute while still attending high school. Disney's career as an artist began in 1919, when he was hired by the Pesman-Rubin Commercial Art

Studio in Kansas City. There he struck up a friendship with Ub Iwerks (born Ubbe Ert Iwwerks, 1901–1971), who was already a highly skilled artist at the young age of nineteen. In 1920, the two banded together as Iwerks-Disney Commercial Artists, though it was a short-lived enterprise. The following year, Disney began to work as a cartoonist for the Kansas City Slide Company (later renamed Kansas City Film Ad Company) and soon Iwerks joined him there.[9] Disney continued with plans to start his own company, however, collaborating with another co-worker, Fred Harman, working after hours in a venture they called Kay-Cee Studio.

In 1920 Disney had produced for a local theater a series of variety reels called "Newman Laugh-O-grams" that included advertisements as well as subjects of local interest. In the first of them (a sample reel),[10] Disney himself plays a role: in a variation on the lightning-sketch artist, he appears as an editorial cartoonist at his desk, facing the camera. The perspective then changes to the work he is doing, which includes an advertisement and an editorial cartoon. The images are mostly still, though there is some animation at the end. Walt Disney drew all the images in this initial Newman Laugh-O-gram himself, but eventually he hired other artists, including Iwerks, Rudolph (later "Rudolf" or "Rudy") Ising (1903–1992) and Hugh Harman (1903–1982), who was the younger brother of Disney's former partner Fred.

Disney quit Kansas City Film Ad to run a studio by himself: Laugh-O-gram Films, which he incorporated in 1922. At that studio, he produced a ten-minute film, *Tommy Tucker's Tooth* (1922), commissioned by a local dentist, which is mostly live-action. In 1923, Disney embarked on a live-action sing-along series called "Song-O-Reels," though he made only one, *Martha* (1923), and it now exists only in the form of some **stills** and a title card. It was created for the local Isis Theater, where Disney met one of his other significant collaborators: Carl Stalling (1891–1972), the theater's organist, who later **scored** a number of Disney's early sound films.[11]

The most substantial material available from this early period in Disney's history is a series of "Laugh-O-gram" films based on fairy tales, starting with *Little Red Riding Hood*, most often dated to 1922. It took some time, but Disney finally secured a distributor for these films, a Tennessee-based company called Pictorial Clubs. Unfortunately, it went out of business before paying the eleven thousand dollars it owed

him. As a result, Laugh-O-gram faced bankruptcy; Disney's staff disbanded and eventually his equipment was taken in exchange for unpaid loans. Disney and his cameraman, Red Lyon, then took on a variety of jobs, including filming newsreel coverage for Pathé and Universal and also making "home movie" films about local children, commissioned by their parents.

In 1923, before he pulled up stakes and moved to California, Disney made another film: *Alice's Wonderland*, which features a live-action girl in an animated environment. In the live-action frame story, the four-year-old actress Virginia Davis (1918–2009), whom Disney met at Kansas City Film Ad, gets a tour of an animation studio, resulting in an animated dream when she goes to sleep that night **(4.8)**. Live-action and animation combinations were used relatively often by then, and the "it's just a dream" narrative was certainly familiar. Even the animal figures seen in the film were similar to those of contemporary series. The innovative aspect of *Alice's Wonderland* lay in placing a live person in an animated environment, rather than the usual formula of animation in a live-action world, and in using a female protagonist, rather than a boy.

Alice's Wonderland was the film that attracted the attention of M. J. Winkler, whose company was to distribute Disney's subsequent "Alice Comedies" series on a state's rights basis from 1924 to 1927. When Winkler signed Disney in 1923, she was going through contract difficulties with Pat Sullivan and his "Felix the Cat" series (see p. 53). The "Alice" films seem to have functioned partly as a backup plan, especially after

Disney agreed to expand the role of a cat character in his series, Julius—a kind of stand-in for Felix, though he never reached that character's level of fame.

During the period of 1924 to 1927, Disney was producing crowd-pleasing work and building a foundation for the future, though it would have been hard to predict the extent of his eventual success. He relied on a stable of gags to populate his films, and even reused elements.[12] M. J. Winkler pushed action and gag structure in Disney's early films, going so far as to edit them to emphasize the comedy; popular movie stars—such as the silent-film comics Charlie Chaplin and Buster Keaton and the swashbuckler Douglas Fairbanks—were referenced as desirable character types.[13] But Disney favored plot development, and his films were becoming more **cinematic** with respect to editing, camera movements, simulated iris effects, and **point-of-view shots**.[14] Nonetheless, the animation itself had not evolved much. Disney continued to rely heavily on cycles[15] and there was not yet evidence of an understanding of the movement of human and animal forms—of the kind seen in Winsor McCay's animation of Gertie in 1914 (see p. 42)—that would come to characterize the personality animation of Disney's later work, in the 1930s.

To produce the "Alice" series contracted to Winkler, Disney had hired some new employees and also called out some of his acquaintances from Kansas City, including Rudy Ising and Hugh Harman, as well as the star, Virginia Davis, whose family moved to California. Walt's brother Roy O. Disney (1893–1971),

4.8 Walt Disney, *Alice's Wonderland*, 1923

the business manager, was the first cameraman. Live-action images for the first films were shot on an open-air stage, placing the actress in front of a white canvas backdrop, with the animation later synced to her. Unfortunately there were soon struggles in producing the work, partly due to the difficulty of incorporating the live-action girl; it was so much easier to animate without her in the shot and so her role, played by a number of young actresses, dwindled.

In 1927, when Disney ended the "Alice Comedies" series and started a new one, "Oswald the Lucky Rabbit," Charles Mintz continued to represent his work. This time, Mintz was able to attract the interest of Universal Pictures, which bought the rights to the series—a big achievement for a young studio owner from the Midwest who had been in business for only a few years. Disney began the wholly animated series with *Trolley Troubles* (1927) **(4.9)**. In it, the rabbit Oswald and a group of other fairly generic animals take a trolley ride, encountering such obstacles as an ornery cow and steep hills that are hard to navigate. Filled with gags, the film also includes some innovative action aimed at drawing in the audience: for example, some **z-axis** movement where the trolley heads directly toward the viewer, and an exciting ride over a series of hills near the end. Some graphic elements, such as sweat beads, impact stars, and thought bubbles are lingering elements of a drawn comics tradition and add to the charm of the gags. Nonetheless, the film remains relatively generic in its aesthetic. Disney continued to produce the series for about a year; of twenty-six films, fewer than ten survive, so it is not possible to get a complete picture of the quality of the work, but the films were popular.

Despite this success, there was trouble on the horizon. By the time Disney was in production on "Oswald the Lucky Rabbit," in 1927, tensions had developed with his distributor. The studio's difficulties escalated in 1928, when Charles Mintz taught Disney a valuable lesson.

While Mintz had seemingly negotiated a step up in Disney's distribution by signing the rights to the "Oswald" series to Universal, the betrayal that resulted from this deal is now legendary. When it was time for Disney to renew his contract in early 1928, Mintz hired most of Disney's animators away from the studio in a kind of coup, transferring production to a facility run by his brother-in-law (Margaret's brother), George Winkler. Disney refused to accept Mintz's terms and so

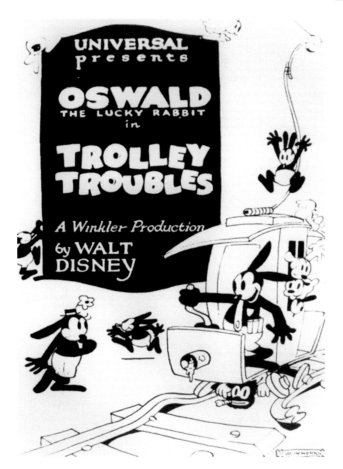

4.9 Walt Disney, *Trolley Troubles*, 1927

lost the right to produce his "Oswald the Lucky Rabbit" series. He must have felt some justice was served, however, when, the following year, Mintz himself lost the contract. In 1929, "Oswald the Lucky Rabbit" continued to be produced by Universal, but under the direction of Walter Lantz (1899–1994). Meanwhile, Disney had come up with a new character, Mickey Mouse, which would bring his studio into the sound era, beginning with *Steamboat Willie* in 1928 (see p. 94), and lay the foundations for the studio's domination of the animation world in the twentieth century.

Walter Lantz's Tour of the Studio System

During the 1910s and 1920s, as Walter Lantz rose through the ranks of the animation world, he met many of the era's most influential figures and built his career through relationships with them. As a boy, he had taken a cartooning correspondence course and studied at the New York Art Students League, which led to a job as an office boy for one of William Randolph Hearst's publications, *New York American*.

4.10 Publicity image for Walter Lantz, *Peter Pan Handled*, 1925

When Hearst's animation studio, IFS, was being set up, Lantz was recommended for a position there and by the age of eighteen he had been promoted to animator.

After IFS closed in 1918, Lantz worked with both John Terry and Raoul Barré. In 1922, he moved to the Bray studio, where he was promoted to supervising animator and created his live-action and animation combination "Dinky Doodles" series. In it, he interacts with an animated boy, Dinky **(4.10)**.

When Lantz left Bray in 1927, he moved westward, reflecting a shift toward development of animation studios in California. The live-action industry was well established in Hollywood by that time, but animation was still taking root there; Disney was among the first to move, and by this point he had been in the area only for about four years. Lantz worked in a live-action context for a few weeks, creating an animated sequence for a Mack Sennett studio film,[18] before returning to animation to work on the "Oswald the Lucky Rabbit" series at George Winkler's studio. In 1929, when Carl Laemmle created an in-house animation studio at Universal—it was the first of the major live-action studios to have one—he cancelled his contract with Mintz and hired Lantz to be the studio supervisor.

Lantz's work on the "Oswald" series marked the start of a relationship with Universal that was to last for more than forty years.

The Consolidation of the American Animation Industry

Animation as a Career

By the 1920s, animation was a defined practice, no longer a magic act but a series of processes well understood by viewers. The Bray studio's satirical film *How Animated Cartoons Are Made* (1919), directed by and starring the animator Wallace Carlson, contains a humorous but detailed description of production, from drawing to synchronizing sound and even theater exhibition. At one point, for instance, he demonstrates how a series of different mouth movements are created to make his character, Dud, appear to speak. In a later section of the film, Carlson is shown working under the animation camera, which he cranks for each exposure. The dissemination of such information

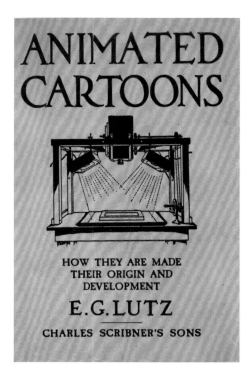

4.11 Edwin G. Lutz, *Animated Cartoons: How They Are Made, Their Origin and Development*, 1920

naturally attracted practitioners interested in animation as a career, and they sought training of some sort. Throughout the 1910s, artists wanting to learn animation had done so primarily on the job, often after becoming print cartoonists and then getting hired at an animation studio. In fact, in America, the Bray studio was an important training ground for animators—and future studio owners. To keep his studio running at top speed, Bray delegated a lot of responsibility to various foremen, whom he hired to oversee series production (Walter Lantz was one of these).[17]

By the 1920s, aspiring animators could also study its methods before entering the industry. A variety of related publications appeared, including a chapter on "The Making of Animated Cartoons" in Homer Croy's *How Motion Pictures Are Made*, dating from 1918, and an illustration of an animation stand in *A Condensed Course in Motion Picture Photography*, by the cinematographer Carl Louis Gregory in 1920.[18] The same year, Edwin G. Lutz published the first book devoted entirely to animation production, *Animated Cartoons: How They Are Made, Their Origin and Development* (**4.11**).[19] Meanwhile, the Federal School of Applied Cartooning, founded in 1914 and located in Minneapolis, Minnesota, offered a twelve-part correspondence course, which included a lesson (in Part 11) by Winsor McCay.

Max Fleischer and Walter Lantz were among the budding animators who received a formal art education, attending the New York Art Students League, founded in 1875. This institution was very progressive, not offering degrees, but instead providing low-cost, flexible educational options and welcoming a diverse student body, including many women. Among its later students were influential cartoonists and pop-culture figures, such as Will Eisner, Al Hirschfeld, Jules Feiffer, and Ramona Fradon.

The Look of 2D animation in 1920s America

The expanded use of cels through the 1920s and beyond encouraged the development of backgrounds in 2D production; when the action was rendered on clear sheets, intricate environments showed through and did not have to be re-drawn for every frame. Cels also created an overall boost in production speed, while introducing new job titles: inkers traced images from paper onto the front of a cel, while painters filled in that area on the back with opaque paints, and **cel washers** rinsed the cels off for reuse several times. **Ink and paint** were two positions largely occupied by women, representing some of the few jobs open to them in the animation industry.

Stylistically, American drawn animation of the 1920s can be easy to distinguish because it typically embraces the rubber-hose style, featuring characters with stretchy and loose bodies and limbs. The animator Bill Nolan is generally credited with developing this approach, and good examples of his work appear in the "Oswald the Lucky Rabbit" series made at the Walter Lantz studio and distributed through Universal Pictures. In *Oil's Well* (1929), the bodies of Oswald and his lady friend are very pliable, with extremities stretching across the screen—for example, when their arms are literally tied in a knot as Oswald proposes marriage.

Also typical of the 1920s is this film's gag structure, similar to live-action physical comedy, which features a string of humorous events rather than the linear cause-and-effect development of a complex storyline: in *Oil's Well*, only a very minimal plot exists, as Oswald courts his girlfriend. The film includes many repeated movements, or cycles, such as Oswald's continual rowing while they are canoeing and the swaying of his girlfriend's hips, and also moments of complete stillness, which one might associate with the look of print comics.[20]

Formulas of Convention and Adaptation

Formulas of convention and adaptation play a
central role in cinema, as they do in every medium.
Conventions are repeated, predictable elements of
experience that manifest themselves in various forms.
Quite often, very conventional character types appear
in animation of the 1920s, generic figures that are
not greatly differentiated from film to film or even
within a single film. For example, there is a similarity
between Krazy Kat and Felix the Cat, not to mention
Julius the Cat (from Disney's "Alice Comedies"),
who looks a bit like one of the cats seen in Disney's
early short *Little Red Riding Hood* and other films.

As animators moved from studio to studio,
they took their drawing styles with them and applied
them in the new contexts, generally staying within
industry norms. To design crowd scenes, it probably
seemed visually confusing or too time-consuming
for the artist to design individualized characters. For
example, in Disney's *Alice's Wonderland*, when the
live-action girl Alice arrives in a land populated by
animated animals, she is greeted by four identical
dogs, all wearing the same hats, eyeing the same
timepieces, and tapping their feet in unison. The many
other animals in the town also follow this pattern,
looking identical to all the others of their species.

Traditional stories have been adapted over time,
retold and written in various versions. The history
of animation is filled with renditions of Little Red
Riding Hood, Cinderella, and other tales of this sort.
When such well-known narratives are used, there is
less need to develop complex characters to explain
their motivations or personalities; so storytelling can
be simplified around a basic, familiar premise. On the
other hand, when stories do differ from the original
source in creative ways, the audience may read the
variations as being humorous or even subversive. Walt
Disney's "Laugh-O-grams" film *Little Red Riding Hood*
(1922) is an example that bears little resemblance
to the original fairy tale, as it has been updated to a
contemporary setting. In it, a little girl departs from
her grandma's house in a cart drawn by her dog and
runs across a suspicious man driving a "flivver," a
slang term used at the time to describe a broken-
down jalopy. This man finds his way to the house and
goes in; grandma is not home, and he accosts the girl
when she returns. Fortunately, her dog alerts a boy

with an airplane, who shakes the two of them out of
the house and deposits the culprit in a lake. The story
ends when the boy and girl kiss, which was already a
well-known narrative convention of live-action films.
So, in a Hollywood ending, the girl is saved by her
true love and grandma is conveniently not involved.

Comics, too, were a seemingly endless resource
for adaptation. Just two of the many examples from
the 1920s are the American "Jerry on the Job" series,
adapted from a long-running Walter Hoban strip and
animated by Walter Lantz for Bray during the 1920s,
and "Bonzo the Dog" (1924–26), a series of twenty-six
animated episodes adapted by George E. Studdy from
his own strip and released by New Era Films in the UK.

Stop-Motion Developments in the Late Silent Era

Despite the domination of 2D production, stop-
motion films were also produced in the American
film industry during the 1920s. Notable are a series
of cutout **silhouette** films (using flat puppets lit from
behind) created in the US by the German Tony Sarg
(1880–1942) and individuals who worked with him, the
American Herbert M. Dawley (1880–1970) and Bryant
Fryer (1897–1963), a Canadian. "Tony Sarg's Almanac"
included more than a dozen episodes created between
1921 and 1923. Many of the films are set in prehistoric
times but also make reference to contemporary topics:
for example, the first film in the series, *The First Circus*
(4.12), co-directed by Dawley, alludes to Darwin's
writing on evolution in the 1870s before it depicts
some monkeys who discover a bottle of alcohol, in
a kind of "survival of the fittest" scenario. From the
following year, *The Original Movie* (1922) shows a
caveman filmmaker whose work—like films of 1922—
is subjected to the censor, being cut up until the final
form barely resembles the original story; the end
titles lament, "The moral is—It's a wise scenario that
knows its own author—after it gets in the movies."

Dawley went on to create a series of "Silliettes"
(1923–25), using the silhouette technique, for Pathé
Exchange. Beginning in 1927, Fryer launched two
short-lived series of his own, "Shadow Laughs" and
later "Shadowettes."[21] In histories of animation,
these and other silhouette films have received less

4.12 Tony Sarg and Herbert M. Dawley, *The First Circus*, 1921

attention than *Die Abenteuer des Prinzen Achmed* (*The Adventures of Prince Achmed*), a silhouette film of 1926 directed by Lotte Reiniger in Germany. This early feature-length animation is notable for being directed by a woman, not to mention its intricate cutting and aesthetic qualities (see p. 75).

Meanwhile, the American Willis O'Brien (1886–1962) continued to create stop-motion animation, including the eighteen-minute *The Ghost of Slumber Mountain* (1918), produced by Dawley, which includes performances by both men. Dawley is presented as

Uncle Jack, "author and amateur artist," who tells a story to his nephews about an old hermit, played by O'Brien. Jack comes across a device used by the hermit to see prehistoric creatures (animated by O'Brien) that fight each other and eventually try to attack him **(4.13)**. All turns out well when the nephews realize it was just a dream. O'Brien's success with this film paved the way for the feature-length *The Lost World* (1925), an adaptation of the Arthur Conan Doyle story of the same name, directed by Harry O. Hoyt. The film depicts British explorers and a servant in blackface who enter a prehistoric world within a South American jungle, created with miniature sets, stop-motion model animation, and even a man in an ape suit. The film's colonial perspective is reminiscent of "ethnographic" films popular in the 1920s, such as Robert Flaherty's *Nanook of the North* (1922) and *Grass* (1925), directed by Merian C. Cooper, Ernest B. Schoedsack, and Marguerite Harrison. O'Brien later worked with two of these individuals, Cooper and Schoedsack, on the film *King Kong* (1933) (see p. 111).

During the mid-1920s, the market for amateur filmmaking and home movies was developing in the United States. In 1927, Kodak began offering a monthly program of Cinegraph titles to purchase or rent. These included stop-motion films by an

4.13 Willis O'Brien, *The Ghost of Slumber Mountain*, 1918

4.14 Kinex, *The Witch's Cat*, from the "Snap the Gingerbread Man" series, c. 1927–30

enigmatic Hollywood studio, Kinex, released mainly between 1927 and 1930. The company made twenty-six films aimed at children, collectively known as "Animated Models Fairyland Series." They were filmed on the high-quality 35mm stock used for theatrical screenings and distributed on 16mm safety stock, which was used for community screenings at schools, churches, and so on, being so named because it was not flammable. These works included three series: "Chip the Wooden Man," "Snap the Gingerbread Man" **(4.14)**, and "Daffy Doings in Doodlebugland." Care was put into the sets, which include interior spaces, open plains, jungles, and rocky mountains dotted with snow. The puppets in this series appear to be mainly made of fabric wrapped around wire. The animation is ambitious, however, often involving multiple characters and moving mouths, and includes such effects as flying through the air, frequent metamorphosing into or out of a ball of clay, canon fire, and the use of replacement heads or component parts showing different expressions. Characters are frequently shown running and jumping through panning backgrounds and at times they turn and acknowledge the viewer.

Conclusion

The 1920s were a significant decade in the history of animation, years that laid the foundation for decades to come. Perhaps most important historically, at that time America—more specifically, Hollywood—became the center of the world film industry, especially in terms of live-action features. The US animation world therefore had to streamline its approach in order to integrate into the dominant structure of the live-action industry, which was an efficient, factory-like system. Animation continued to be an important part of the film bill, along with other short subjects that audiences would see before the screening of a live-action feature. Within this system, the 1920s saw the formation and growth of animation studios that would be cornerstones of the American industry for decades to come.

At this time, a star culture emerged within the live-action world. The phenomenon was mirrored in animation to some extent, especially in the success of the first celebrity cartoon character, Felix the Cat, who became famous internationally. The character's success was in large measure due to the efforts of M. J. Winkler, the first female distributor in the US. Fan culture grew and a new generation of animators learned the basics through books and other resources on animation that began to appear during this period. It was a decade that combined innovation with adaptation and convention, as studio owners and animators tried to stand out from their competitors while also producing animation rapidly and economically. The transition to sound brought challenges to the American film industry in the 1920s, and occurred internationally over a number of years.

In the course of the 1920s, animation developed into a successful entertainment industry. But at the same time, a different application for this art form was developing. Intrigued by the possibilities of film as a time-based medium, a number of visual artists, particularly in Germany, France, England, and the Soviet Union, began to embrace animation as an element of their modern art practice. As a result, during the same decade animated films were also appearing within the **Modernist avant-garde.**

Notes

1 Denis Gifford, *American Animated Films: The Silent Era, 1897–1929* (Jefferson, NC: McFarland, 1990), 47–48.

2 John Canemaker, *Felix: The Twisted Tale of the World's Most Famous Cat* (New York: Pantheon, 1991), 28–29. Marriner's comic featured a black boy and was decidedly racist in comparison with the Bannerman book. The "funny noises" relate to the way the character speaks and acts.

3 Canemaker, *Felix*, 69.

4 Gregory D. Black, *Hollywood Censored: Morality Codes, Catholics, and the Movies* (Cambridge: Cambridge University Press, 1994), 31.

5 J. B. Kaufman, "The Live Wire: Margaret J. Winkler and Animation History," in *Animation: Art and Industry* (New Barnet: John Libbey, 2009), 105–110.

6 The Educational Film Corporation of America also distributed Helena Smith Dayton's film *Romeo and Juliet* (1917).

7 Michael Barrier, *Hollywood Cartoons: American Animation in its Golden Age* (New York: Oxford University Press, 1999), 35.

8 E. G. Lutz, *Animated Cartoons: How They Are Made, Their Origin and Development* (1920. New York: Charles Scribner's Sons, 1923), 58; Russell Merritt and J. B. Kaufman, *Walt in Wonderland: The Silent Films of Walt Disney* (Baltimore, MD: Johns Hopkins University Press, 1993), 39.

9 "Walt Disney Timeline," The Walt Disney Family Museum. Online at http://disney.go.com/disneyatoz/familymuseum/global/pdf/WDFM-Walt-Disney-Timeline.pdf

10 Evidently, other productions used a variety of techniques, including stop-motion and cel animation; Merritt and Kaufman, 47.

11 Russell Merritt and J. B. Kaufman, *Walt in Wonderland: The Silent Films of Walt Disney* (Pordenone, Italy: Edizioni Biblioteca dell'Immagine, 1992), 48. See also Brian Burnes, Dan Viets, and Robert W. Butler, *Walt Disney's Missouri: The Roots of a Creative Genius* (Kansas City, MO: Kansas City Star Books, 2002), 107.

12 Merritt and Kaufman, *Walt in Wonderland*, 15.

13 Ibid., 20.

14 Ibid., 28.

15 Ibid., 30.

16 Tom Klein, correspondence with the author (June 9, 2014).

17 Donald Crafton, *Before Mickey: The Animated Film 1898–1928* (1982. Chicago, IL: University of Chicago Press, 1993), 169.

18 Crafton, *Before Mickey*, 200–201; Carl Louis Gregory, *A Condensed Course in Motion Picture Photography* (New York: New York Institute of Photography, 1920).

19 Lutz, *Animated Cartoons*.

20 These tendencies are similar to animation techniques known as the "hold" (stillness, but when a given character strikes a pose) and the "moving hold" (a form of cycle, or "boil," where the character is still but slightly moving to keep its energy up).

21 "Bryant Fryer family fonds [moving images, sound recording, graphic material]," archival material, Library and Archives Canada. Online at http://collectionscanada.gc.ca/pam_archives/index.php?fuseaction=genitem.displayItem&lang=eng&rec_nbr=192902&rec_nbr_list=193856,193842,193838,193808,193522,193116,192972,192918,192902,192827

Key Terms

block-booking

cel washer

cycle

distributor

drawn animation

feature

hold

ink and paint

personality animation

rotoscope process

rubber-hose animation

score

silhouette

sound-on-film technology

state's rights distribution

still

stop-motion

synchronized sound

In Russia, after leading the October Revolution, Lenin becomes the premier of the Soviet Union, the first Communist dictatorship in the world

1917–22

The Great Depression

1929–39

The Walt Disney Studios grow in size and incorporate specialized departments, in preparation for feature-length animation production

1930–36

1911

The Cameraman's Revenge (Władysław Starewicz)

1911

Wassily Kandinsky publishes his influential text *Concerning the Spiritual in Art*

1919–33

The Staatliches Bauhaus revolutionizes design during the creative Weimar period in Germany

1920s

Sergei Eisenstein and other Soviet filmmakers develop theories related to the importance of montage, or editing, in film

1921–25

Walther Ruttmann experiments with the concept of counterpoint in his abstract "Opus" films

1923

Walt Disney moves from Kansas City, Missouri, to establish the first animation studio in Hollywood

1926

In Germany, Lotte Reiniger completes one of the first feature-length animated productions, her silhouette film *The Adventures of Prince Achmed*

1927

The success of the Warner Bros. film *The Jazz Singer* (Alan Crosland) signals the end of the silent era

1928

Disney begins working with the Acme Tool and Manufacturing Company to develop specialized equipment, including camera stands

1929

The Skeleton Dance (Ub Iwerks) is the first film in Disney's music-driven "Silly Symphony" series

1930

Various color film processes start to be used in animation, along with black and white

1930

In Hollywood, Warner Bros. distributes the "Looney Tunes" and "Merrie Melodies" series, created at Harman-Ising Productions

1930

Betty Boop is introduced, as a dog, in the Fleischer film *Dizzy Dishes*

1932

Disney starts working with the Chouinard Art Institute teacher Don Graham to create an educational program for his animators

1933

Alexandre Alexeieff and Claire Parker use their invention the pinscreen to create *Night on Bald Mountain*

1933

Leon Schlesinger Productions, including directors Tex Avery, Bob Clampett, Chuck Jones, Friz Freleng, and others, produces animation for Warner Bros.

1933

The power of the Nazi party in Germany increases through the 1930s, resulting in many people fleeing the country

Early Animation

■ Technological development ■ Development of the animated medium ■ Development of the film industry as a whole ■ Landmark animated film, television series, or game ■ Historical event

1933
The General Post Office (GPO) Film Unit is established in Britain

A film archive is established at the Museum of Modern Art (MoMA) in New York

1933
E. C. Segar's popular newspaper comics character Popeye appears in the Fleischer "Betty Boop" film *Popeye the Sailor*

1933
Three Little Pigs (Burt Gillett) introduces personality animation at the Disney studio

1934
The Production Code Administration tightens censorship across the American film industry

1934
The Fleischer studio begins to use its stereoptical process (or setback camera) to add dimensionality to its backgrounds

1935
Jews in Germany lose their citizenship as the Nuremberg Laws go into effect

1935
Composition in Blue (Oskar Fischinger) is made as an advertising film, despite German restrictions on "degenerate" abstract art

1935
The Warner Bros. character Porky Pig is introduced at the Leon Schlesinger studio

1935
A Colour Box (Len Lye) promotes the General Post Office in Britain

1936
Disney develops its version of a multiplane camera

1937
Snow White and the Seven Dwarfs (David Hand) is the first cel-animated feature to be produced in the United States

1937
Strike at the Fleischer studio

1937
The Warner Bros. character Daffy Duck is introduced

1938
The Fleischer studio relocates from New York City to Miami, Florida

The Screen Cartoonists Guild, a trade union for animators, is formed

1939
Gulliver's Travels, Fleischer's first animated feature film, is released

1940
The Warner Bros. character Bugs Bunny is introduced

In *Puss Gets the Boot*, William Hanna and Joe Barbera introduce the cat and mouse who go on to star in MGM's "Tom and Jerry" shorts

1940s
Pinocchio (Hamilton Luske and Ben Sharpsteen)

Fantasia (Norman Ferguson) is released as a "concert feature," expanding on the "Silly Symphony" series concept

Dumbo (Ben Sharpsteen)

Bambi (David Hand)

1941
Strike at the Disney Studio

Animation as Modern Art

Chapter Outline

Global Storylines

Modern art movements develop all over Europe, especially in Germany, where artists including Richter, Eggeling, Ruttmann, and Fischinger create animated films using abstract imagery

Also in Germany, Lotte Reiniger makes one of the first animated feature films using silhouette animation

In Russia, such filmmakers as Sergei Eisenstein and Dziga Vertov develop the field of film theory

Modernist animators receive support from the British General Post Office and New York City museums

Introduction

During the 1920s, there was a thriving modern art scene within Europe, concentrated in such major cities as Paris, Berlin, and Moscow. Many modern artists were attracted to popular culture, which in turn influenced fine art in various ways. Cinema—live-action and animated—was particularly attractive as a new realm of art production because it gave artists an added dimension to work with: time. Truly, the medium of film was ideal for capturing the rapid pace of the twentieth century. Dubbed the "seventh art," film eventually joined architecture, sculpture, painting, music, dance, and poetry as a distinct art form.

The avant-garde of the 1920s and early 1930s were responsible for advancing the aesthetics of animation by creating a number of independently produced, experimental productions **(5.1)** that gave voice to new ideas rather than reproducing genre-driven stories and conventional images. Modernist animation typically diverged from the beginning–middle–end linear structure or physical-comedy gags that dominated in mainstream studio animation. Instead, it tended to be built around a theme, exploring concepts, experiences, and aesthetics in depth, and sometimes incorporating elements from painting and other arts. The body of work known as Modernist animation can be described as an aspect of the larger realm of "experimental film," and many of its practitioners considered themselves to be artists, in general, rather than animators, in particular.

Modern art movements of the early twentieth century were varied in nature, and their use of animation was therefore diverse. The first Modernist animators in Europe were interested in abstract imagery, which seemed to them to represent the ideal of a new universal language that moved beyond the limits of culture-

5.1 Original promotional poster for Walther Ruttmann, *Berlin: Symphony of a Great City*, 1927

Another German institution that left a significant legacy is the Staatliches Bauhaus, an art school that operated between 1919 and 1933 and existed in three cities, shifting from Weimar to Dessau to Berlin. Many leading artists and cultural theorists were affiliated with the Bauhaus, including the Russian Wassily (Vasili Vasilievich) Kandinsky, who was a founding member of the **Expressionist** art group **Der Blaue Reiter** (The Blue Rider) in the early 1910s. The Bauhaus embraced a modern approach to the arts, removing the traditional hierarchical distinctions between fine art and craft, and took a cue from Russian **Constructivism** in advocating art for the people. When Hitler and the Nazi party rose to power in 1933, the Bauhaus closed, and its members left Germany and settled in other locations around the world—for example, New York City, where they established the New School for Social Research. The Bauhaus's modern, broad-minded philosophies helped to legitimize animation as modern art.

specific words and into the sensual realm of sounds, colors, design elements, and motion. Some considered abstraction to be truly transcendent, representing a route to spiritual awakening or enlightenment. The term "**absolute film**" was sometimes used to describe abstract animation, because it was considered to be a pure product of the film medium, with no parallel in nature.

Modern art, in general, and Modernist animation, in particular, developed all over Europe, but Germany was a particularly vibrant hub. The country faced many economic, social, and political problems following World War I, resulting in widely ranging cultural shifts that— among other outcomes—made it a leading force in the art world from 1918 to 1933. These years are known as the Weimar Republic period, after the city where Germany's first democratic constitution was signed at the end of World War I. Germany was a center of art cinema during the 1920s, and many German directors, along with other production crew (including writers, cinematographers, and actors), became world famous; they generally worked in the powerful Universum-Film-Aktiengesellschaft (UFA) studio, formed in Berlin in 1917. UFA quickly developed into one of the world's most sophisticated film studios and consequently was a central force in the production of German films, including animation.

This chapter explores the animation produced by mainly European artists of this period, focusing in part on the development of abstract production and a practice known as **visual music**, which was strongly influenced by Kandinsky's writing in the 1910s. Modern art movements were somewhat fluid, and the artists associated with them—including the Modernist animators discussed in this chapter—were often connected through social circles and institutions that provided creative and financial support. This network proved to be vital to these animators, who had to contend with the political turmoil and danger of Europe in the 1930s, and who had relatively few chances to make money from their personal practices, partly because of the domination of American films at theaters. The situation became more difficult after the onset of the Great Depression in 1929 and progress ground to a halt when the Nazis came to power in 1933. Eventually America would become a refuge for many European artists and slowly art culture within the US began to be influenced by them.

Modern Movements in Painting

To appreciate the Modernist work of European animators, it is necessary to understand the context in which they were working and what, at the time, was considered innovative and progressive. During the 1870s and 1880s, the European art world had been turned upside down by **Impressionist** painters in France who were more concerned with capturing patterns of light and visual effects than with including the details that "finished" a painting and helped to define its subject in a concrete way. Édouard Manet's painting *Le Déjeuner sur l'Herbe* (*Luncheon on the Grass*), from 1863, is seen as a pivotal artwork that paved the way for experimental work from younger painters **(5.2)**. In the Germany of the 1910s and 1920s, Expressionist artists went further in emphasizing subjectivity, often distorting their depictions of the subject matter through the use of bold lines and color. This movement grew out of a number of early twentieth-century developments, including the theorizations of Friedrich Nietzsche about the aesthetics of tragedy.[5] It was also influenced by earlier artists, such as Edvard Munch and his painting of 1893, *Skirk* (*The Scream*), and Vincent van Gogh, as well as the boldly colorful and subjective paintings from a turn-of-the-century group known as the Fauves (Wild Beasts), and African art. In Italy, the **Futurists** rejected received notions of art, nature, and society in favor of science, technology,

and bold new assertions about contemporary culture, including the glorification of violence. The movement's founder, the Italian writer Filippo Tommaso Marinetti, published the movement's **manifesto** in 1909. As these examples suggest, modern art defied many expectations and was also quite personal, not always "user friendly" in the way that traditional portraits and landscapes had been.

Cubism, which was at its peak between about 1907 and 1919, investigated subjects from multiple points of view and rejected the concept of a simple truth or single correct way of seeing. It established pictorial rhythm through the abstraction of figures into geometric forms, and rendered three-dimensional space within a flattened surface, as one can see in Marcel Duchamp's *Nu Descendant un Escalier n° 2* (*Nude Descending a Staircase, No. 2*), 1912 **(5.3)**. That work was also influenced by **motion studies**, such as those conducted by Étienne-Jules Marey (see p. 21) in the nineteenth century. Modern art was at times overtly political in nature. In about 1919, in the

5.2 Édouard Manet, *Luncheon on the Grass*, 1863

5.3 Marcel Duchamp, *Nude Descending a Staircase, No. 2*, 1912

wake of the Russian Revolution, Constructivism emerged, calling on art to serve a social purpose and envisioning the artist as a worker for the common good. From this perspective, art was not a series of autonomous works, but rather part of a larger system, with design broken down into a series of simple, abstracted forms that communicated a kind of universal meaning.

Influenced by early twentieth-century developments in psychology, **Surrealism** emerged during the late 1910s, took root in the 1920s, and has had varied manifestations worldwide since that time. André Breton, who published the movement's manifesto in 1924, had served in a psychological ward during World War I and had also studied the work of Sigmund Freud, theorist of the unconscious, dreams, and other aspects of the mind and behavior. Surrealists often relied on free association and "automatic" forms of expression, minimizing conscious thought to tap into creative realms of the psyche and produce work that was not bound to logic. Parallel to the early years of Surrealism and overlapping and following World War I, from 1916 to 1922, **Dada**, too, became a cultural force. Emerging from Zurich, Dada embodied a reaction to the conflict, horrors, and insanity of World War I, with anti-war politics being expressed through an anti-art agenda, which questioned the notion that art takes time to produce, comes from the artist's inspiration, and is unique. The Dada movement found an alternative to this laborious process in "readymades," which were artworks made from everyday objects. Probably the most famous example is the urinal, *Fountain*, which dates from the late 1910s. Attributed to Marcel Duchamp, the piece is signed "R. Mutt 1917," in a reference to the "Mutt and Jeff" comic strip.

Some Modernist animators were members of these and other groups within the realm of modern art. In any case, social circles were relatively small, and experimental works of any kind were appreciated and debated by one's peers in the art world. With this in mind, Modernist animation of the 1920s and early 1930s can be situated within a lively, vital context; and it had many aims that were quite different than those of the animated productions being created by industrial studios in the US and other countries.

One way that Modernist animators made their money was by creating films to be used in advertising, one corner of the market that the Americans did not own—because by their nature advertisements were often produced locally. The German producer Julius Pinschewer ran one of the leading advertising agencies of the time and frequently worked with Modernist animators. He established his business in Berlin in the early 1910s, relocating to Berne, Switzerland in 1933 to escape Nazi persecution, as he was Jewish. There, he continued to produce animated ads, which were screened in theaters, through the 1950s. In Prague, Desider Gross was prominent in advertising during the 1930s, sometimes taking existing films and repackaging them for distribution in other countries, where they would be used to promote different products. The Dutch company Philips (originally a lighting manufacturer) was a big sponsor of animated advertisements, as was the J. L. Tiedemann Tobaksfabrik (Tiedemann Tobacco Company) in Norway.[2] It is not uncommon to find advertising films among the work of Modernist animators of the 1930s, even though a lot of them were made using relatively traditional drawing and stop-motion approaches.

The Development of Modern Art

The term **Modernism** describes perspectives on Western art that developed over a period of about a hundred years, from the mid-nineteenth century to the mid-twentieth century and beyond (c. 1860–1960), which affected all realms of creative expression.[3] Modern artists rejected traditional approaches in favor of more immediate and subjective forms of experience.[4] For example, modern painters rebelled against **Classical** notions of composition and the subject matter approved by European art academies (specifically, the prominent French institution the Académie des Beaux-Arts in Paris). One of the most significant shifts in modern painting was from an objective and technically "accurate" view of the subject being depicted, to an exploration of the artist's process, or subjectivity, in general. As technical documentation of the subject became less central to the artist's work, representations became increasingly abstract—sometimes attempting to depict pure experience, energy, or other intangible concepts—and artists were often interested in revealing

5.4 Pablo Picasso, *The Young Ladies of Avignon* or *The Brothel of Avignon*, 1907

subjectivity within their own production processes. The accomplished German artist Oskar Fischinger was among the Modernist animators who were motivated by a spiritual quest, incorporating celestial imagery and eventually investigating the creative process (see p. 80).

As modern artists sought to distance themselves from norms of academic art, they sometimes adopted methods that were considered to be exotic and novel but were in fact already integral to art production in other cultures. For example, the inclusion of text in painting and the use of the visible brushstroke were essential elements of the ancient calligraphic traditions of Asia long before modern artists saw them as "modern" and groundbreaking. Modern artists also looked to indigenous cultures for inspiration, believing that their "primitive" art embodied a purer way of communicating experience because their artists were not hampered by the complications of modern life. During the early twentieth century, when France was second only to Britain as a colonizing force, part of its territory included areas of Africa. French museums began to collect African art—including masks—for display, and these works had an impact on the development of modern art. One of the best-known examples of this influence appears in the work of Pablo Picasso from about 1907 to 1909, in his "African period," which included the painting *Les Demoiselles d'Avignon* (*The Young Ladies of Avignon*

or *The Brothel of Avignon*, 1907), inspired partly by the artist's interest in African masks **(5.4)**. The painting is considered to be one of the most important examples of modern art for its use of jagged forms to define the figures and the space they inhabit, the influence of masks on the design of their faces, and the indication that the subjects are prostitutes, rather than the wealthy patrons of traditional art.[5] One can observe a similar influence in the work of the New Zealander Len Lye, for example (see p. 86); he was inspired by his experiences with Aboriginal and Samoan cultures to create his films, sculptures, and theories about filmmaking and kinetic art. Much of Lye's work was concerned with energy, which he believed came from deep within humanity and could be drawn out through the creative process.

Lotte Reiniger and the Art and Craft of Silhouette Animation

At the Bauhaus, artists studied industrial design and debated the importance of usefulness, as opposed to beauty, in the value of art. This re-evaluation laid the foundation for functional objects and crafts—such as furniture, weavings, and pottery—to be given a higher cultural status. As a result, a technique such as scissor-cutting, used to create paper figures—widely practiced by German women during the early twentieth century—could be embraced as a form of artistic expression rather than being reduced to a quaint pastime. In fact, scissor-cutting was employed by one of the first female animation directors in history, Lotte Reiniger (1899–1981), in her landmark silhouette film *Die Abenteuer des Prinzen Achmed* (*The Adventures of Prince Achmed*) **(5.5)**. This film is of historical note partly because it is one of the first feature-length animated productions ever made, as it was released in 1926.

By the time Reiniger used the technique to make her film, cutouts in general and silhouettes in particular had been widely used in popular culture. For instance, cutout figures have a long history in the tradition of shadow theaters of various countries, such as Indonesian *wayang kulit* performances dating back more than a thousand years, which use flat cutout figures that are generally made of leather and held aloft by rods, suspended from the side or from below. The puppets are then held behind a screen that is backlit

5.5 Lotte Reiniger, *The Adventures of Prince Achmed*, 1926

so that they cast shadows on its surface. Shadow-theater performances, which were taking place across Europe as early as the seventeenth century, grew into a popular entertainment in Germany, France, and England during the nineteenth century. Silhouette figures had been used as a form of portraiture and a style of book illustration since the mid-eighteenth century, and by the early 1920s had appeared in other animated films, such as "Tony Sarg's Almanac" in the US (see p. 64).

Born in Berlin in 1899, Lotte Reiniger grew up in a family that supported her early artistic leanings, which included a mastery of scissor-cutting. As a child, she was taken by her father to the gatherings of his artist friends and, as a young woman, she studied for a time with the well-known German Expressionist theater director Max Reinhardt. Through him she met Paul Wegener, who by the mid-1910s was a leading actor and film director in Germany. When he asked Reiniger to create cutout imagery for his film *Der Rattenfänger von Hameln* (*The Pied Piper of Hamelin*) in 1918, Reiniger stepped into the film world at the top. From this project, she learned how to take static cutouts and set them into motion, and in the years that followed, she created a series of short films at the Berliner Institut für Kulturforschung (Institute for Cultural Research, Berlin). Wegener introduced Reiniger to a group of people working there, including the filmmaker Carl Koch (1892–1963), whom she later married.[6] As a woman, Reiniger's access to the realm of feature-film production relied to a great extent on the men who opened doors for her. In Germany,

women had made gains in society by the mid-1920s; they had won the right to vote in 1919, the year Reiniger made her first film, *Das Ornament des Verliebten Herzens* (*The Ornament of a Loving Heart*). Nonetheless, women were still largely excluded from creative circles in the fine arts. Reiniger's accomplishments as a director are therefore all the more noteworthy.

In the mid-1920s, Reiniger took on a monumental task that would secure her place in film history: the production of the feature-length animated film *The Adventures of Prince Achmed*. Koch had been commissioned to make a film for a banker, Louis Hagen, who came to the institute one day and watched some of Reiniger's work. Apparently, Hagen had invested in a large amount of film stock, and he proposed the idea of a feature film.[7] Reiniger and Koch agreed and set up a studio at Hagen's home, where they doubled as private tutors for the banker's children.[8] Koch, who was not only Reiniger's husband but also her closest collaborator, was made executive producer and coordinated the technical aspects of production (including the camera). Walther Ruttmann (see p. 79) and Berthold Bartosch (see p. 84), who handled backgrounds and effects, were part of the small crew; these German directors were also important figures in the realm of Modernist animation. Wolfgang Zeller, the accomplished Berlin composer and conductor, created a score that was tightly synchronized to the film's action (however, as it was still the silent era, the score was not recorded onto the film itself, but rather distributed as sheet music for theater musicians to play).

The storyline of Reiniger's film is an adaptation of a tale from *One Thousand and One Nights* (*The Arabian Nights*), a series of Middle Eastern and South Asian tales documented in Arabic that date as far back as the ninth century. In the film, a decrepit sorcerer creates a magic horse to give to the caliph and in exchange wants the hand of the ruler's beautiful daughter, Dinarsade. Dinarsade's brother Achmed steps in and threatens the sorcerer, who tricks the young man. In a story full of adventure and romance, Achmed meets a beautiful woman, Pari Banu, an unfortunate young man, Aladdin (who has a magic lamp), and a witch who helps them. Though the film is

5.6 Lotte Reiniger and Carl Koch at work on a mutiplane rig, creating *The Adventures of Prince Achmed, c.* 1925

based on a traditional narrative, Reiniger and her crew saw the production as an opportunity for technical experimentation. Filming began with the figures being placed on a single glass surface, but evolved into a multiplane setup that used several panes of glass **(5.6)**. The multiplane accommodated various visual effects, such as the use of soap to create haze and clouds. The film's backgrounds employ another innovation as well, abstract designs created using a wax-cutting device invented by the accomplished German animator Oskar Fischinger (see p. 80).

Prince Achmed was not widely released, as mainstream exhibitors doubted that the technique would appeal to large audiences, especially without well-known characters; however, the film did get screened through alternative spaces that were open to independent or experimental filmmakers and attracted like-minded viewers.[9] Indeed, it attracted the attention of many artists, including the French filmmaker Jean Renoir, who saw the film in Paris and initiated a friendship and film collaborations with Koch. The two shared leftist political

views, along with another close friend of the Reiniger–Koch household, the German Marxist poet, playright, and director Bertolt Brecht. Meanwhile, Reiniger continued to produce her own films, both animated and live-action. Eventually, the political situation interrupted her career; Reiniger and Koch attempted to leave Germany in 1933, when the Nazi party began its ascent, but they could not secure visas and were forced to go from country to country seeking asylum. In the late 1940s, the couple finally managed to secure permanent residency in England, where Reiniger was able to produce silhouette films through the General Post Office (GPO, see p. 86).

Abstraction, Transcendence, and Visual Music: Theories of Modernist Animation

Visual Music

Clearly, modern artists—including Modernist animators— had redefined their relationship to art: they no longer saw themselves as conduits that enabled real figures to be immortalized on a canvas, for example, but rather as interpreters of the images they created, acknowledging the way that perception and subjectivity influence our notions of beauty. Some went further, investigating the essence of art and its promise of transcendence, surpassing mundane human experience of the world.

Throughout history, individuals have theorized relationships between forms, sounds, colors, and movements within practices that have become known as visual music—sometimes with spiritual implications, as one aspires to a higher plane of perception. Some of these investigations have been inspired by a physiological condition known as **synesthesia** that leads to unusual perceptual experiences, in which a primary sensory reaction is accompanied by a secondary one that remains constant over time. For example, hearing a certain sound brings on the sensation of a particular smell, or feeling a given texture results in a certain taste being experienced.

Theorizations of visual music date far back into history. The ancient Greek mathematician Pythagoras articulated a theory of the "music of the spheres" in one of the earliest attempts to link material objects

with an intangible, transcendent quality. According to the theory, the movement of the planets creates sounds that cannot actually be heard, but rather suggest an ineffable or spiritual state, with a basis in harmonics and mathematics. In the seventeenth and eighteenth centuries, respectively, the German Jesuit Athanasius Kircher wrote about music and its relationship to color, and the French Jesuit Louis Bertrand Castel wrote theoretical texts about color and a speculative instrument he called the *clavecin oculaire* (ocular harpsichord), in an attempt to illustrate the relationship of sound to light and color **(5.7)**.[10]

The first attempts to create a visual music film date from the early 1910s. In about 1909, the Italian brothers Bruno Corra (born Bruno Ginanni Corradini, 1892–1976) and Arnaldo Ginna (born Arnaldo Ginanni Corradini, 1890–1982) invented a "chromatic piano" that matched keys to the projection of colored lights. They soon began publishing manifestos about the relationship of sound and color in painting, and formed a core group of Futurist artists. By 1911, they had incorporated cinema into their investigations, becoming probably the first artists to draw directly on the surface of filmstrips

5.8 Léopold Survage, preparatory print for *Colored Rhythm*, c. 1912

5.7 Charles-Germain de Saint-Aubin, drawing depicting the ocular harpsichord exhibited by Castel in 1730, 1740–c. 1757

and the first to have created abstract animation.[11] Unfortunately, all of their films, such as *A Chord of Color* (1911) and *Study of the Effects of Four Colors* (1911), seem to be lost. Another attempt at abstract animation occurred in about 1912, when the Paris-based painter Léopold Survage (of Finnish descent and known under variations of this name) created a series of prints he intended to use for a short work, *Colored Rhythm*, which was never completed **(5.8)**.[12] As its name suggests, it also falls under the general category of visual music.

In the late nineteenth century, many intellectuals and artists were influenced by the theories of the Russian occultist Madame (Helena Petrovna) Blavatsky (1831–1891) **(5.9)**. She had a significant impact on

5.9 Helena Petrovna Blavatsky, 1889

modern art, as a co-founder of the Theosophical Society in New York City in 1875. The practice of theosophy is based on the belief that all major religions share essential qualities; it was progressive in that it promoted acceptance across race, color, religion, and social class. Theosophy is generally credited with introducing Eastern religious concepts (for example, karma and reincarnation) to a sizeable portion of the Western public, and it also theorized correspondences between color, sound, and vibration, or the life force of all things.

Wassily Kandinsky (1866–1944), who came to the Bauhaus in 1922, was among the artists whose practice and theory were greatly affected by theosophy. His book *Über das Geistige in der Kunst* (*Concerning the Spiritual in Art*, 1911)[13] created a revolution in the art world with its theories about the relationships between sound, music, movement, and spirituality. Kandinsky himself appears to have had synesthesia, hearing sound when he saw color;[14] his views were also highly influenced by the Viennese composer and painter Arnold Schoenberg, a close friend who shared his interest in visual music.

The Language of Abstract Animation

Abstract imagery offered the possibility of transcendence by facilitating the development of a new, universal form of language that would appeal directly to the senses. Among the first to incorporate film into an investigation of this sort was the Berliner Hans Richter (1888–1976).[15] He began painting in 1905, when he was seventeen, and moved into film production in 1919. Like many painters of his time, he was influenced by modern art movements, including Der Blaue Reiter, **Expressionism**, and early Cubism. In 1916, he became a founding member of the Dada group in Zurich, remaining active until the mid-1920s. Richter believed that it was an artist's duty to oppose war and support the revolution of the people, and in 1919 he founded the Bund Radikaler Künstler (the Association of Radical Artists) in Zurich, calling for far-reaching art reform and the redefinition of art in society. In 1918, Richter met the Swedish painter Helmuth Viking Eggeling (1880–1925) and together they explored the ability of abstract forms to create a universal language based on a model of music and visual perception, composing a manifesto-like pamphlet, *Universelle Sprache* (*Universal Language*).[16]

Richter and Eggeling tested their theories by creating a series of studies in the form of scrolls; on

5.10 Hans Richter, *Rhythm 21*, 1921

long sheets of paper, they articulated abstract forms within space in a sequence of patterns rather like frames on a filmstrip. They soon determined that the paper base restricted expressiveness, and in 1919, Richter began to work with film. Two years later, his animated film *Rhythmus 21* (*Rhythm 21*, 1921) was complete **(5.10)**. Using black-and-white rectangular forms and backgrounds, the film experiments with the development of meaning through the elements of size, movement on the z-axis, speed, rhythm, overlap, and even double exposure, resulting in a kind of musical composition. Richter used the term "*Kontrast-Analogie*" to describe the relationship of dark and light in the film, exploring perceptions of positive and **negative space**. In 1940, Richter moved to the United States, where he taught at the City College of New York. There he continued to make films before returning to Switzerland in the 1960s.

Unfortunately, Richter's collaborator, Helmuth Eggeling, made only two films in his life. His first, *Horizontal-Vertikalorchester* (*Horizontal-Vertical*

Orchestra, c. 1921), has been lost, though still images of it exist. The film, which was ten minutes long, was based on one of the scrolls he had made. His other film, *Symphonie Diagonale*, was screened privately in 1924 and released publicly a year later, a few days before his death in Berlin.[17] In comparison with Richter's *Rhythmus 21*, *Symphonie Diagonale* contains more intricate figures, straight and curved forms that appear to the viewer in complex patterns that reveal themselves and disappear, reverse, and combine in different ways. The film's action occurs all on one plane; thus, it lacks the deep-space component (the use of the z-axis) found in Richter's *Rhythmus 21*. In addition, all the figures in Eggeling's film are consistently white on a black background, unlike the variation of white and black and the shifting figure-and-ground relationships found in *Rhythmus 21*. Both films are concerned with music, but as a parallel art form rather than an accompaniment; images on the screen suggest harmony or different musical elements, while the order in which images are shown can be related to timing and melody.[18] The way visuals are depicted in the films is affected by the original structure of Richter and Eggeling's work, as a multi-framed scroll containing a series of still images.

Walther Ruttmann and the Aesthetic of Counterpoint

The German artist Walther Ruttmann (1887–1941) was inspired by the concept of **counterpoint** in modern music and Soviet film theory, topics he explored in a series of visual-music works he made in the early 1920s. His contemporaries Richter and Eggeling had harnessed the potential of abstraction as a universal language, using music as a structural model for the visuals, but without integrating actual rhythms into their work in a "musical" fashion. In contrast, Ruttmann's films are structured to give the impression of a type of musical performance in their juxtaposition of images. Counterpoint is present in virtually all his work, from abstract animations to live-action documentaries to audio experiments, and even in his commissioned advertising films.

Born in 1887, Ruttmann studied music, architecture, and painting, but like many painters of the time, he gravitated toward the new medium of film, which fascinated him in its ability to capture time. In the early 1920s, he produced a series of abstract films, beginning with *Lichtspiel: Opus I* (*Lightplay: Opus I,*

1921), in which elaborate hand-tinting and -toning methods were used to apply color directly to frames of film **(5.11)**.[19] The film's score was created by the Berlin composer Max Butting, a friend of Ruttmann's who also became known for his use of counterpoint. In yearly succession, Ruttmann added three more films to create a series: *Lichtspiel: Opus II* (1923), *Lichtspiel: Opus III* (1924), and *Lichtspiel: Opus IV* (1925). But around the same time, Ruttmann was also making advertising films for Julius Pinschewer. It is interesting to observe how similar *Der Sieger, ein Film in Farben* (*The Winner, a Film in Color*, 1922), made for the Hanover Rubber Works and its Excelsior tires, is to the "Opus" films in its use of color and forms. Some of the images in the advertising film transform into representative objects—for example, the triangles become grimacing, aggressive characters with arms and faces that try to puncture a circle turned into a tire.

5.11 Walther Ruttmann, *Lightplay: Opus I*, 1921

In the mid-1920s, after contributing to the production of Reiniger's *The Adventures of Prince Achmed*, Ruttmann began to move in other directions. After seeing the work of Dziga Vertov, he was inspired to create the live-action "**city symphony**" film *Berlin: Die Sinfonie der Großstadt* (*Berlin: Symphony of a Great City*, see **5.1** p. 71), which premiered in 1927, two years before Vertov's *Chelovek s Kinoapparatom* (*Man with a Movie Camera*), which was delayed by various production problems. The score for Ruttmann's silent film (written to be played by a theater orchestra) was composed by the Austrian Edmund Meisel, who had written music for the theater director Bertolt Brecht and for Sergei Eisenstein's landmark film *The Battleship Potemkin* (1925).

Although *Berlin: Symphony of a Great City* is primarily live-action, it resembles Ruttmann's "Opus" films to some extent in the appearance of animation at the start of the film, an opening sequence that breaks down scenery into abstract forms, emphasizing their geometry over their representation, and its overall use of counterpoint. The opening scenes of the film shift between live-action images of water to abstract curves and lines, which then transform into a shot of railroad-crossing bars. **Contrapuntal** editing occurs through rapidly cut close-up images of the powerful, speeding train, the track, the landscape, beams of a bridge, and other images, which collide to create a sense of dynamic energy. The film later served as the inspiration for an audio program Ruttmann created for "Weekend," a broadcast by Berlin Radio Hour in 1930. The radio program is also a **collage** using elements of the city, but one made of sound fragments instead of the visuals found in *Berlin: Symphony of a Great City*.

Transcendence in Animation: the Films of Oskar Fischinger

In 1916, the German art critic Bernhard Diebold wrote a series of articles on the topic of painters working in the medium of film. About four years later, Diebold met a German artist, twenty years of age, who had apprenticed as a draftsman, tool designer, and engineer, and was developing expertise in science and technology. Diebold invited this young man, Oskar Fischinger (1900–1967), to a private screening of *Lightplay: Opus I*, and then introduced him to the film's director, Walther Ruttmann. Fischinger described to Ruttmann a series of experiments he had conducted, including the invention of a wax-slicing machine. The device combined a guillotine-type slicer with the shutter of a motion-picture camera, allowing creation of random abstract forms by sheering off thin layers from a block of variegated wax.[20] Ruttmann ordered one and used it to create background effects for Lotte Reiniger's film *The Adventures of Prince Achmed*.[21]

Fischinger's early experiments with color, movement, and form were motivated in part by his belief that abstract art held the promise of transcendence, a belief that was influenced by his interest in theosophy and Buddhism. His films also reflect his scientific background, since they include circular design elements that seem to be inspired by his knowledge of the solar system and the atom, as well as his meditational practice. Although Fischinger is best known for his experimental works, he also made more commercial films. In 1924, he signed a contract with the producer Louis Seel to create six episodes of the character-based cartoon series "*Münchener Bilderbogen*" ("Munich Album"), adapted from a well-known comic strip.[22]

Two years later, in 1926, Fischinger began to collaborate with the Hungarian composer Alexander Laszlo, who was giving shows using a color organ he called the Sonchromatoscope. This instrument controlled several slide projectors and colored lights, all of which accompanied a score he had composed. Laszlo asked Fischinger to prepare animated abstractions that he could incorporate into his performances. The experience inspired Fischinger to perform his own shows, in Munich, which he referred to as "*Raumlichtkunst*" ("*Space-Light Art*"). Later in the 1920s, Fischinger moved to Berlin, where he designed visual effects for live-action films. He also directed a series of black-and-white (charcoal on paper), abstract "*Studie*" films that were quite popular with audiences; his wife Elfriede and his brother Hans worked on some of these. The series begins with *Studie Nr. 1* (1929), which was originally accompanied by a theater musician, and ends with *Studie Nr. 12* (1932), which was sound on film and animated by his brother Hans. Some of the early films in the series were originally screened with sound-on-disc musical accompaniment, using a record. Two other films in the series were incomplete: a No. 13 was partly shot, and 14 was drawn but not shot.[23]

In the early 1930s, Fischinger experimented with sound, exploring the relationship between the way

an object looks and the sound it produces. Some of his investigations involved images created within the optical-sound portion of a filmstrip and then "read" as sound by the projector. Fischinger called his work in this area "Klingende Ornamente" ("Ornament Sound"). Around the same time, the Swiss-born filmmaker Rudolph Pfenninger, who was working in Munich, was engaged in similar investigations, which he called "*Tönende Handschrift*" ("Sounding Handwriting"). Pfenninger and Fischinger first met in the early 1920s; Pfenniger had just begun working for a large German studio, Emelks, where he developed a number of sound-related technologies. Pfenninger used his hand-drawn, audio technique in two films, *Serenade* (1931) and *Barcarole* (1931), by the Diehl brothers (Paul, Ferdinand, and Hermann), who were well-known German stop-motion animators. He then used it in his own animated films: *Largo* (1932), an interpretation of Handel's composition, and *Pitsch und Patsch* (1933), which refers to a well-known German nursery rhyme. Pfenninger's drawn-sound productions from the early 1930s attempt to reproduce conventional melodies, whereas Fischinger's aim was to create sounds that were altogether new.[24] Both filmmakers caught the interest of the Hungarian László Moholy-Nagy in 1932; he had been theorizing the possibility of such "sound scripts" for at least ten years and felt that his theory had been realized in their works. Around the same time, **direct-sound** experimentation was also taking place in the Soviet Union, spearheaded by such artists as Boris Yankovsky, Evgeny Scholpo, Nikolai Voinov, and Arseny Avraamov.

When the Nazis took control of Germany in 1933, they banned what they called "degenerate" art, including jazz music and abstract painting and film, which they considered subversive. During this period, Fischinger made a living producing commissioned films, including maps and graphics for the documentary *Eine Viertelstunde Großstadtstatistik* (*A Quarter-Hour of City Statistics*, 1933).[25] He began to work in color after helping in the development of the Gasparcolor system, which was invented by the Hungarians Bela and Imre Gaspar.[26] Using the process, he created his first color film, *Kreise* (*Circles*), an advertising film containing written text, which he completed in 1934 and revised the same year in an all-abstract version (**5.12**). In the film, circles move in and out of the frame in a variety of ways, loosely complementing the music but also suggesting Fischinger's familiar themes of outer space and meditational experience, in the way that the viewer's eye is drawn in by receding circular

5.12 Oskar Fischinger, *Circles*, 1933–34

5.13 Oskar Fischinger, *Composition in Blue*, 1935

forms. Two mid-nineteenth-century scores accompany these visuals: the Venusberg ballet music from Richard Wagner's opera *Tannhäuser* and "Homage March" from Edvard Grieg's incidental music for the play *Sigurd Jorsalfar*.[27] *Circles* could be screened because it served a clear purpose for the Tolirag advertising agency, with the phrase "*Alle Kreise erfaßt Tolirag*" ("Tolirag reaches all circles of society") added as self-promotion at its end; this message was removed from the edited version.

Fischinger's other advertising from the period includes the stop-motion "marching cigarette" commercial from the mid-1930s, *Muratti Greift Ein* (*Muratti Gets in on the Act*, 1934), in Gasparcolor. It was filmed on a tabletop that was coated with kaolin wax and covered by sawdust dyed to look like tobacco. The "cigarettes" are actually small wooden sticks wrapped with authentic papers and held upright in the wax through the use of small pins protruding from the dowels. His black-and-white advertisement *Muratti Privat* (c. 1935) also features stop-motion cigarettes, but this time moving gracefully in a kind of dance. Supporting himself with the advertising revenue from these and other projects, and despite the risks, Fischinger continued to produce abstract work in secret. His four-minute *Komposition in Blau* (*Composition in Blue*) from 1935 is the last film he made in Germany and is considered to represent a high point in the artist's career **(5.13)**. Shot in Gasparcolor, it is composed of vibrantly colored stop-motion objects and abstract painted

images that glide through space. The musical accompaniment is provided by extracts from the overture to Otto Nicolai's opera *The Merry Wives of Windsor.*

By the end of 1935, Germany's future was becoming clear as the Nuremberg Laws went into effect, declaring that Jews no longer had the right to citizenship, and individuals the government saw as a threat were rounded up and murdered or imprisoned. So it is no surprise that in 1936, when Fischinger was offered a contract by the famous German director Ernst Lubitsch, who had become head of the Paramount film studio in California, he accepted and moved to Los Angeles. Unfortunately, the artist then faced problems of a different kind, as he spoke almost no English and had problems assimilating into the American studio system.

Fischinger moved between various studios, including a stop at Metro-Goldwyn-Mayer (MGM), where he received funding to make *An Optical Poem* (1937). This film was made using paper cutouts held up by sticks and wires, and the images were accompanied by Franz Liszt's Hungarian Rhapsody No. 2, recorded on the lot by studio musicians. The familiar circle motif of Fischinger's work recurs in this film, but this time a connection to meditational experience seems explicit, as these forms pop onto the screen, overlap, and recede into the frame, in the manner of a *mandala* (a circular meditational aid used in some Eastern religions, representing the universe). During the production of *An Optical Poem*, Fischinger was introduced to the avant-garde composer John Cage, then a young man, who was inspired by the older artist's experimental sound works and various inventions. In the late 1930s, Fischinger also began painting in a fine-art sense, exploring themes he had been developing in his personal films, and soon his work was being exhibited in solo gallery shows.

Eventually, Fischinger was hired by Disney to work on *Fantasia* (1940), but it was a tumultuous time in the studio's history and he did not stay long. As a German national, Fischinger was labeled an "enemy alien" and officially could not be employed. He continued to work for film studios on a limited basis, however, and later found financial support from the Museum of Non-Objective Painting in New York, which commissioned a few projects from him. Among them was his last film, the abstract *Motion Painting No. 1* (1947), an exploration of the process of painting and its relationship to music.[28]

The film's visuals, painted in oil on sheets of plexiglass, change in every frame—so, every twenty-fourth of a second—to accompany J. S. Bach's Brandenburg Concerto No. 3.

The Russian Film Theory Revolution

The history of animation in Russia can be traced back to the first decade of the twentieth century and the work of the dancer and animator Alexander Shiryaev. Shiryaev developed a system for documenting the character dances he performed and those he witnessed while on his travels. Working sometime between 1900 and 1906, he drew poses frame by frame on long strips of paper (5.14) and then set them into motion using a "peep show"- type device.[29] As he increased his film production, he made documentaries and live-action narratives, including a variety of trick films. His stop-motion puppet films, probably from around 1907–9, are elaborately animated, employing remarkably fluid body movements to render the dancing characters.

Shortly thereafter, Władysław Starewicz (1882–1965) began to produce stop-motion animation, with early work including *Mest' Kinematograficheskogo Operatora* (*The Cameraman's Revenge*, 1911), made in Moscow at the Khanzhonkov studio (5.15). In this film, Mr. and Mrs. Beetle get into trouble after each has an affair with another

insect. The film is delightful in its use of miniatures and cinematic methods, such as the keyhole shot that frames Mr. Beetle's exploits. The film also reflects the state of contemporary cinema by featuring a theater fire caused by the flammable nitrate film stock used at the time. Starewicz continued working in Russia until 1920, when he moved to France.

In the decade following the production of these films, Russian history took a sharp turn. Public protests against the war and the country's leadership resulted in the forced abdication of the Tsar during the October Revolution of 1917. Vladimir Ilyich Lenin led the Bolshevik party through the overthrow and ensuing civil war, which lasted until 1922. After the war, he became the premier of what became the Soviet Union, forming the first Communist dictatorship in the world.

5.15 Władysław Starewicz, *The Cameraman's Revenge, 1911*

5.14 Alexander Shiryaev, animated dancer, 1900–6

Lenin espoused theories of Karl Marx that predicted the free-enterprise system would collapse under a revolt of the workers, who would then own the means of production; as a result, the concept of social class would become obsolete. Although industrialists and politicians saw Communism and the worker revolution as dangerous, the grand experiment taking place in the Union of Soviet Socialist Republics, or USSR, attracted the attention of intellectuals and political activists worldwide. A number of American filmmakers, including those in the field of animation, believed the Soviet system could bring about much-needed social change.

In 1917, the People's Commissariat of Education was set up to supervise and systematize the screening of films; two years later, the first film school in the world, now known as the Gerasimov Institute of Cinematography, was opened in Moscow. In 1922, Lenin declared that cinema was the most important art form for the Soviet Union, because of its ability to reach the masses.[30] In subsequent years, such filmmakers as Sergei Eisenstein and V. I. Pudovkin theorized aesthetics, advocated social engagement, and directed productions that influenced the development of film art worldwide. Editing, or the ordering of content, was of particular interest to them because it could create meaning in complex ways. Eisenstein described a montage style of editing in which images were placed in juxtaposition—or counterpoint—with each other, resulting in a kind of collision, which would engage the viewer in the production of meaning. Eisenstein became an international celebrity, touring the US and other countries; one of his stops, in the 1930s, was at Disney, where he expressed his love for the studio's animation.

Eisenstein's contemporary in the USSR, Dziga Vertov, was also active in the field of film theory. He was especially interested in the role of the artist as activist, and his idealistic manifestos have inspired politically active filmmakers worldwide ever since.[31] Vertov employed stop-motion and stopped-camera effects in his documentary filmmaking, along with varied camera angles, optical printing, and montage editing to create meaning in contrasting shots. One can see these techniques in his most famous film, *Man with a Movie Camera* (1929); in the "city symphony" tradition, the film documents a day in the life of a city (actually a combination of Odessa and other locations), from dawn until dusk, from when it wakes up to when it goes to sleep.

Collaboration in Unsettled Times: Modernist Animation of the 1930s

Despite the diversity of Modernist animation, the individuals connected with it were part of a relatively small social and artistic network, sometimes being put in touch with like-minded creators or meeting at events involving screenings and visiting artists. After he worked on *The Adventures of Prince Achmed* in the mid-1920s, Berthold Bartosch (1893–1968) moved to Paris and became part of its art world. Through Jean Renoir's wife, the actress Catherine Hesseling, he met Frans Masereel, who by then had become famous for his woodcut prints. Masereel agreed to collaborate with Bartosch to transform one of his works, an eighty-three-print series called *L'Idée* (*The Idea*), into animation. The resulting thirty-minute film (5.16), which was finally completed in 1932, relates its story in a poetic way, without a tightly constructed narrative. It is dedicated to the power of an idea, which lives on beyond any one individual holding it and has the power to lift up those in misery and frighten those in power. The hinged cutout figures were shot on a multiplane rig, while a soapy haze was used to create atmosphere, and imagery was layered through multiple exposures. The film is accompanied by music written by the Swiss composer Arthur Honegger, who was also based in Paris; it was played on the recently invented *ondes Martenot*, one of the world's first electronic instruments.[32]

Present at one of *L'Idée*'s Paris screenings were two filmmakers, Alexandre Alexeieff (1901–1982) and Claire Parker (1910–1981), creative partners who would eventually marry. The two had met when Parker, who was traveling in France, had come to visit Alexeieff; both athletic and academically inclined, this modern young woman had studied art history and aesthetics at the all-female Bryn Mawr College and studio art and aesthetics at Massachusetts Institute of Technology before continuing her education at the Kunstgewerbeschule (School of Arts and Crafts) in Vienna as well as working with painters in Paris.[33] Alexeieff, a book illustrator, was interested in recreating the aesthetic of engravings in animation, and he and Parker were curious about Bartosch's work. Parker and Alexeieff developed a unique apparatus called *L'Écran d'épingles* (pinscreen, or pinboard), which consists of a large frame housing a white board punctured by many pins. These pins can be pushed in and out to

5.16 Berthold Bartosch and Frans Masereel, *The Idea*, 1932

catch any light that is shining upon them at an angle, resulting in a range of shadows along the **grayscale**, from dark to light. Eager to see Masereel's work put into motion, Alexeieff and Parker attended the screening and met Bartosch, and the three became close friends. Soon after, Alexeieff and Parker completed their film *Une Nuit sur le Mont Chauve* (*Night on Bald Mountain*, 1933), using their pinscreen (see p. 186). The two, along with Alexeieff's first wife, Alexandra Grinevsky, also produced more than twenty stop-motion advertisements; one of the earliest was *Parade des Chapeaux* (*Parade of Hats*, 1935) for the Sools hat company. Alexeieff and Parker moved to America in 1940 in advance of the Nazi occupation of Paris that year, but returned to France after the war. Bartosch also fled Paris in 1940, leaving behind the materials for a planned anti-Nazi film, *St. Francis*; they were destroyed by German troops.

In Bartosch's work the political message is overt, but other artists voiced resistance in more subtle ways.

The animated film *La Joie de Vivre* (*The Joy of Life*, 1934), **(5.17)** reflects a refusal to bow to dark political pressures; released during a pivotal year, 1934, when

5.17 Anthony Gross and Hector Hoppin, *The Joy of Life*, 1934

Fascism had spread through Italy, the Nazis were in firm control of Germany, and the far right was gaining strength even in France, the film depicts two women and a man frolicking through an industrial area that functions as an idyllic fantasyland. *The Joy of Life* was made in Paris by the English artist Anthony Gross and the American photographer and producer Hector Hoppin. After moving to Paris, Gross had begun making studies of workers and factories, and he later approached Hoppin with the hope of setting his images in motion. The look of the film is heavily influenced by the **Art Deco** style, which is light and decorative. In 1940, Gross returned to London and became an official war artist.

Support for Modernist Animation

The Film Unit at the British GPO

In 1933, the British government began to support creative filmmaking through the development of a film unit that would promote and explain the function of the General Post Office (GPO). The Scottish documentary filmmaker John Grierson became the GPO Film Unit's first director, and oversaw its production agenda for the remainder of the 1930s. In developing his vision, Grierson looked not to Hollywood, but rather to Soviet Russia and Germany films, whose films were stronger models for social relevance, experimentation, and the documentary form. Under Grierson's leadership, the GPO Film Unit thus embraced experimental visuals and sound, in terms of a poetic documentary practice; it also embraced Modernist animation.[34] The unit lasted until 1940, when it was taken over

by the Ministry of Information after the outbreak of World War II and renamed the Crown Film Unit.

Norman McLaren (1914–1987), from Scotland, and Len Lye (1901–1980), who had emigrated from New Zealand, both began working for the GPO during the 1930s, early in their careers; they were eclectic artists, eventually known for pioneering **direct filmmaking**, where images are created directly on filmstrips without the use of a camera. McLaren's direct film *Love on the Wing*, completed at the GPO in 1937 (**5.18**), reflects the influence of modern art, with title images and backgrounds that suggest the work of the Italian Surrealist painter Giorgio de Chirico.[35] Its animation shows a man and woman, in a romantic relationship, repeatedly **morphing** into objects that fit together, such as a letter and envelope and a lock and key. As the film progresses, the pairings of these stream-of-consciousness-style images become increasingly eroticized, a fact that did not escape the Postmaster General, who put the film on limited distribution.

Len Lye

After moving to England, Lye became one of the most accomplished filmmakers in the GPO Film Unit, as well as one of the most eccentric. As a young man Lye had traveled to Australia and Samoa to pursue his interest in indigenous art. Eventually he took a job on a boat that ended up in England. There he embarked on his first film, *Tusalava* (1929), which depicts a kind of creation myth, influenced by Lye's interest in Maori and Samoan cultures. Lye's rough ways, which earned him the nickname "cowboy from the colonies," and the artwork inspired by his study of indigenous cultures attracted the attention of artists in London. As a result, he was invited to join the Seven and Five Society, which in the 1920s and 1930s was at the

5.18 Norman McLaren, *Love on the Wing*, 1937

a

b

c

d

5.19a–d Len Lye, *Trade Tattoo*, 1937

forefront of Modernist art in England. In December 1929, Sergei Eisenstein gave a series of lectures in London, accompanied by Hans Richter. Lye attended this workshop and he and Richter became close friends.[36]

Lye's first production for the GPO was *A Colour Box* (1935), a delightful direct film created using the Dufaycolor process.[37] Lye made it by painting film stock, using stamps, stencils, and a kind of **batik process**: the result was abstract images that are diverse and highly kinetic, reflecting his fascination with movement. The images in *A Colour Box* are set against a lively score—using a type of Carribean dance known as the *beguine*, played by Don Baretto and His Cuban Orchestra—that allowed Lye to develop visual ideas in counterpoint, reflecting contemporary Modernist aesthetics; images of opposing shapes and moving in different directions are juxtaposed on the screen. The GPO added a message about its "cheaper parcel post" onto the film, displayed in stenciled letters playfully cascading over the screen, in order to justify financing the film as a promotional effort. Distributed to festivals in Europe, *A Colour Box* was seen as something entirely new and was widely screened, both in England and abroad.

Lye went on to receive other commissions from the GPO, such as *Rainbow Dance* (1936) and *Trade Tattoo* (1937) **(5.19a–d)**, and his work there attracted the interest of other organizations, which also commissioned films from him. Lye's art practices varied widely: he worked in direct filmmaking (painting, stenciling, and scratching on film), live-action documentaries

(for example, *Cameramen at War*, 1943, made for the British Ministry of Information), kinetic sculptures, and both creative and theoretical writing. Among his interesting theories is a concept he called the "old brain," a repository in the mind for the entirety of human experience–a kind of parallel to Carl Jung's concept of the **collective unconscious**. Drawing upon this area would allow for "pure" creative experience. Lye's preference for so-called primitive cultures and tapping into the deep recesses of the mind was entirely in keeping with the prevailing currents of modern art in the early to mid-twentieth century. For Lye, working directly on film in a "hands-on" way linked his work to the textiles and other design elements of the indigenous peoples he so admired.

The Rise of Modernist Animation in America

The New York City Armory show of 1913 had introduced Americans to modern art from Europe, but a strong anti-European sentiment lingered after World War I. As a result, modern art practices were slower to develop in the US and in fact did not really take hold until the mid-1940s, after the end of World War II. During the 1930s, however, two women in New York City were instrumental in championing these new methods. One was Iris Barry, an English film critic and theorist who founded the film archive at the Museum of Modern Art (MoMA, in New York City) in 1933 and remained there until 1951 **(5.20)**. Under Barry's guidance, MoMA developed a lending library of "great films," which included both American and European works. Another influential force was the French-born Hilla von Rebay (born Hildegard Anna Augusta Elisabeth Freiin Rebay von Ehrenwiesen, 1890–1967), the artistic director at the Museum of Non-Objective Painting (later the Guggenheim Museum), which opened in 1939. Von Rebay guided the purchase of paintings and supported the production of non-objective (or abstract) painting and animation from mainly European Modernist animators, such as Hans Richter, Oskar Fischinger, and Norman McLaren. At the time, there were relatively few Americans experimenting in the field of animation, though there were some. For example, the work of the non-objective painter Dwinell Grant appeared in a group painting show at the Guggenheim in 1940 and by that time he was already making experimental abstract animations. Within two years, however, he had shifted into military training films, and he later focused on scientific illustration and medical education.[38]

Mary Ellen Bute

In contrast, the American Mary Ellen Bute (1906–1983) dedicated herself to the production of visual music animations for many years, entering the

5.20 Iris Barry at the MoMA film archive, New York City, c. 1935

5.21 Thomas Wilfred with his work *Lumia*, 1960

field in the 1930s as one of the first Modernist animators in America and one of the earliest women in the realm of experimental film production internationally.

Bute had enjoyed a well-rounded art education before the start of her filmmaking career in New York City. She had studied painting at the Philadelphia Academy of Art, stage design at Yale University's school of drama, and fine art at the Sorbonne, in Paris. Influenced by such figures as the abstract filmmaker Oskar Fischinger (see p. 80) and the Russian inventor Léon Theremin, who developed the theremin and other electronic music technology in New York City during the 1930s, she made eleven abstract films between 1934 and 1959. Bute's interest in sound and image correlations led her to consult Theremin, as well as the visual-music pioneer Thomas Wilfred **(5.21)** and the composer Joseph Schillinger, who had created a theoretical system that related the structure of music to a series of mathematical formulae. Schillinger wanted to make a film that would demonstrate an application

of his theory, in collaboration with Lewis Jacobs, who was an important figure in American experimental cinema, and Bute. Although this film, *Synchromy*, was never finished, Schillinger published an article about the project in 1934[39] and Bute later directed her own film, *Synchromy No. 2*, which was completed in 1935.

Bute's first film, *Rhythm in Light*, was created in 1934 with the help of another significant figure in experimental cinema, the director Melville F. Webber. The film includes both drawn images and objects moved under the camera, and is set to "Anitra's Dance" from Edvard Grieg's incidental music for Ibsen's *Peer Gynt*. At this time, she met Ted Nemeth (1911–1986), who became the film's cinematographer, her artistic collaborator, and, in 1940, her husband. Bute continued to make films that explored the relationship between sound and image throughout the mid-1950s, sometimes premiering her work at Radio City Music Hall in New York City. Her titles include *Dada* (1936), which uses stop-motion techniques; *Parabola* (1937), based on a sculpture of the

same name (related to the concept of the parabolic curve) by the artist (John) Rutherford Boyd, who also worked on the film; and *Tarantella* (1940), which explores the musical concept of **dissonance** and has been entered into the National Film Registry of the American Library of Congress. One of Bute's films, *Spook Sport* (1939), features direct animation by Norman McLaren; it was made when he came to New York during the late 1930s, after he had left the GPO in England but before he was offered a position at the National Film Board of Canada (see p. 177).

Conclusion

Modernist animation of the 1920s and 1930s grew alongside the other modern arts, creating a rich, imaginative, and varied range of films that demonstrated the artistic potential of animated imagery. This body of work came from artists experimenting in different contexts, using a range of techniques, and exploring varied aesthetic issues. Unfortunately, this flowering period was to be brief. Political changes—beginning in 1933, when Adolf Hitler was sworn in as chancellor of Germany and the Nazi party assumed power—caused many European filmmakers, including Modernist animators, to flee, moving to the United States and elsewhere.

During the same period, and continuing through the 1930s, American animation also grew as an art form, but in different ways. Despite the onset of the Great Depression in the late 1920s, a complex matrix of production practices and aesthetics emerged, led by the Disney, Fleischer, and Warner Bros. studios in particular. Conventions related to animated movement and humor became solidified within short-form films, and feature-length cel animation began to be produced. Through the honing of their methods, animation studios turned out series rapidly and efficiently, but they too were not immune to labor unrest in the economic aftermath of the Great Depression and the political turmoil gathering in Europe.

Notes

1 Friedrich Nietzsche (trans. Ian Johnston), "The Birth of Tragedy: Out of the Spirit of Music," Vancouver Island University Records (2009). Online at http://records.viu.ca/~johnstoi/nietzsche/tragedy_all.htm

2 Gunnar Strøm, "The German Connection: European Inter-national Relations in Animated Cinema Advertising of the Late 1930s." Online at www.nordicom.gu.se/mr/iceland/papers/five/GStrom.doc

3 For more on the development of Modernism, see Christopher L. C. E. Witcombe, "The Roots of Modernism," online at http://arthistoryresources.net/modernism/roots.html

4 Daniel Albright, *Modernism and Music: An Anthology of Sources* (Chicago, IL: University of Chicago Press, 2004), 6–8.

5 See n. a., "*Les Demoiselles d'Avignon*: Conserving a Modern Masterpiece," the Museum of Modern Art (2003). Online at http://www.moma.org/explore/conservation/demoiselles/index.html

6 In his book *The Silhouette Film*, Pierre Jouvenceau writes about other filmmakers at the Institute who also used this technique at the same time. One of them, Toni Rabolt, assisted Reiniger on *Cinderella* (1922) and then directed and animated *Jorinde & Joringel* (1920), a film based on one of the Brothers Grimm fairy tales. He also writes about Richard Felgenauer, who made the silhouette film *Münchhausen* (1920). Pierre Jouvenceau (trans. Clare Kitson), *The Silhouette Film* (Genova: Le Mani, 2004), 36.

7 Jouvenceau, *The Silhouette Film*, 40.

8 Katja Raganelli (writer and director), *Lotte Reiniger: Homage to the Inventor of the Silhouette Film* (1999). On the Milestone DVD, *The Adventures of Prince Achmed*.

9 K. Vivian Taylor, "National Identity, Gender, and Genre: The Multiple Marginalization of Lotte Reiniger and *The Adventures of Prince Achmed* (1926)," University of South Florida Scholar Commons. Online at http://www.scholarcommons.usf.edu/cgi/viewcontent.cgi?article=4572&context=etd

10 Maarten Franssen, "The Occular Harpsichord of Louis-Bertrand Castel: The Science and Aesthetics of an Eighteenth-Century *Cause Célèbre*," *Tractrix: Yearbook for the History of Science, Medicine, Technology and Mathematics* 3 (1991), 15–77.

11 Giannalberto Bendazzi, "The Italians Who Invented the Drawn-on-Film Technique," *Animation Journal* 4:2 (Spring 1996), 69–77. An excerpt of Corra's writing follows the essay. For more on their work, see also Malcolm Cook, "Visual Music in Film, 1921–1924: Richter, Eggeling, Ruttmann," in Charlotte de Mille, ed., *Music and Modernism, c. 1849–1950* (Newcastle u`pon Tyne: Cambridge Scholars, 2011), 206–21.

12 See the chapter on Lépold Survage in Robert Russett and Cecile Starr, *Experimental Animation: Origins of a New Art* (New York: Da Capo, 1976), 35–39. Survage's abstract images were later put into motion digitally by Bruce Checefsky, in a film he called *Colored Rhythm* (2005).

13 Wassily Kandinsky, *Über das Geistige in der Kunst* (Munich: R. Piper & Co., 1911). Republished in 1914 as *The Art of Spiritual Harmony*. Trans. Michael T. H. Sadler, "The Art of Spiritual Harmony," *Minnesota State University* (June 28, 2004. Online at http://web.mnstate.edu/gracyk/courses/phil%20of%20art/kandinskytext.htm

14 Mo Costandi, "Synaesthesia—Crossovers in the Senses," *The Guardian* (November 19, 2010), http://www.guardian.co.uk/science/2010/nov/19/synaesthesia-cross-overs-senses; Amy Ione and Christopher Tyler, "Neurohistory and the Arts: Was Kandinsky a Synesthete?" in *Journal of the History of the Neurosciences* 12:2 (2003): 223–226, 224. Online at http://www.daysyn.com/IoneTyler2003.pdf

15 For more on Richter, see n. a., "Hans Richter Archive," Museum of Modern Art Archives (2006). Online at http://www.moma.org/learn/resources/archives/EAD/HansRichterf For more on Richter and Eggeling, see also n. a., "Hans Richter," *Dada Companion* (n. d.), http://www.dada-companion.com/richter/

16 Hans Richter, "My Experience with Movement in Painting and in Film," in Gyorgy Kepes, ed., *The Nature and Art of Motion* (New York: George Braziller, 1965), 142–157 (see 144 for discussion of universal language).

17 Louise O'Konor, *Viking Eggeling 1880–1925: Artist and Film-maker, Life and Work* (Stockholm: Royal Swedish Academy of Letters, History and Antiquities, 1971), cited in John Coulthart, "Symphonie Diagonale by Viking Eggeling," *feuilleton* (n. d.). Online at http://www.johncoulthart.com/feuilleton/2008/08/18/symphonie-diagonale-by-viking-eggeling/

18 Malcolm Cook, "Visual Music in Film, 1921–1924: Richter, Eggeling, Ruttmann," in Charlotte de Mille, *Music and Modernism*, 206–21.

19 William Moritz has described Ruttmann's first film as having been shot in 1919 and 1920, though it was not screened until April 1921. William Moritz, "Musique de la Couleur–Cinéma Intégral (Color Music–Integral Cinema)," *Poétique de la Couleur* (Paris: Musée du Louvre, 1995), 9–13. Online at the *Center for Visual Music* (1995): http://www.centerforvisualmusic.org/WMCM_IC.htm

20 William Moritz, *Optical Poetry: The Life and Work of Oskar Fischinger* (Eastleigh: John Libbey, 2004), 3–7.

21 Ruttmann felt the wax was too imprecise because it melted under the heat of camera lights. See Moritz, *Optical Poetry*, 8–9.

22 Ibid., 9.

23 Cindy Keefer and Joop Guldemond, eds., *Oskar Fischinger 1900–1967: Experiments in Abstraction* (EYE Filmmuseum, Amsterdam and Center for Visual Music, LA: 2012), 228; Moritz, *Optical Poetry*, 228

24 Ibid., 44.

25 For this project, he hired a young assistant, Peter Sachs, who had worked with George Pal before Pal left for Holland. Sachs would later go to England and have a significant impact on the development of limited-animation style during the late 1940s. See Moritz, *Optical Poetry*, 47.

26 William Moritz, "Gasparcolor: Perfect Hues for Animation," Fischinger Archive (1995). Online at http://www.oskarfischinger.org/GasparColor.htm

27 Moritz, *Optical Poetry*, 220.

28 James Tobias, "Essay without Words: Motion Painting No. 1, Insight, and the Ornament," in Keefer and Guldenmond, *Oskar Fischinger*, 152–57.

29 David Robinson, "Alexander Shiryaev: Dance to Film," *Film History* 21 (2009), 301–310.

30 Lenin, quoted in a conversation with A. V. Lunacharsky, February 1922, in *Sovietskoye Kino* 1–2 (1933), 10.

31 Dziga Vertov, "Kinoks: A Revolution (From an Appeal at the Beginning of 1922)," in Annette Michelson, ed. (trans. Kevin O'Brien), *Kino-Eye: The Writings of Dziga Vertov* (Berkeley, CA: University of California, 1984), 11–12.

32 The ondes Martenot was invented in 1928 by Maurice Martenot. Russett and Starr, *Experimental Animation*, 84–85.

33 Giannalberto Bendazzi, *Alexeieff: Itinerary of a Master* (Annecy, France: Dreamland, 2001), 213.

34 BFI Archive Interactive, "The GPO Film Unit," British Postal Museum and Archive (n. d.). Online at http://www.btplc.com/bfi/jacobi/jacobi_250.html

35 Michael Brooke, "*Love on the Wing*," *BFI Screen Online* (n. d.). Online at http://www.screenonline.org.uk/film/id/528634/

36 Roger Horrocks, *Len Lye: A Biography* (Auckland: Auckland University Press, 2001), 127–28.

37 Keith Griffiths (director), *Doodlin': Impressions of Len Lye* (1987).

38 Virginia M. Mecklenburg: The Patricia and Phillip Frost Collection: American Abstraction 1930–1945 (Washington, D.C.: Smithsonian Institution Press for the National Museum of American Art, 1989). Online at http://americanart.si.edu/collections/search/artist/?id=1904

39 Russett and Starr, "Mary Ellen Bute," *Experimental Animation*, 102–105; Joseph Schillinger, "Excerpts from A Theory of Synchronization," *Experimental Cinema* No. 5 (1934), 28–31. Online at http://www.angoleiro.com/cine_texts/exper_cine_5.pdf

Key Terms

absolute film	direct film	morphing
abstract	dissonance	multiplane
avant-garde	Expressionism	optical printing
city symphony	grayscale	pinscreen
collage	kinetic art	silhouette film
contrapuntal	Modernism	synesthesia
counterpoint	montage	visual music

CHAPTER 6

Disney's New Aesthetic

Global Storylines

Following the departure of some key employees, Disney restructures his studio, creating new, compartmentalized roles and closely supervising all stages of production

Disney develops a formal education program to provide his animators with training in life drawing, action analysis, and comedy

During the 1930s the Disney studio continues its successful "Mickey Mouse" and "Silly Symphony" series, and makes its debut in feature-film production with *Snow White and the Seven Dwarfs* in 1937

Introduction

During the 1930s, American animation grew in popularity worldwide. Though there were a number of successful animation studios in the US at that time, one of them—the one run by Walt Disney and his brother, Roy—would have an immensely strong impact on the field in years to come. It was during the 1930s that The Walt Disney Studios developed the infrastructure and aesthetics that would make it so powerful. These shifts resulted partly from turnovers in studio staff that occurred in the late 1920s and 1930s, allowing Walt Disney a greater degree of control over studio processes. Disney's decision to come to California in the 1920s, however, was the biggest factor in his success.

Live-action film production houses had begun settling on the West Coast in the 1910s, and by the late 1920s the industry was firmly centered in the Los Angeles area. It revolved around a handful of studios that became known as the "**Big Five**" (Loew's Incorporated/MGM, Paramount Pictures, Warner Bros., Fox Film Corporation, and RKO Radio Pictures) and "**Little Three**" (Universal Pictures, Columbia Pictures, and United Artists). Most of the studios remained under the leadership of the individuals who had founded them, and so continued to bear the stamp of their individual sensibilities. During the 1930s, studio personnel— actors, singers, writers, directors, and so forth—were typically employed on seven-year contracts. The result of this continuity was that studios became known for producing particular genres, such as musicals at MGM or horror films at Universal. Short-film subjects, such as animated films and newsreels, were either created by dedicated units at the parent studio or by separate studios, which worked under contract but functioned relatively autonomously within a distribution deal.

6.1 Walt Disney Pictures, *Snow White and the Seven Dwarfs*, 1937

Until the 1930s, the focus of animation production had remained largely in New York, but eventually it too relocated to California.[1] When Roy O. Disney went to California for health reasons and his brother Walt visited him there, they decided that they wanted their studio to become part of the developing Hollywood film industry. Hollywood was the ideal location for the youthful Walt Disney, who up to that point had dabbled in both live-action and animated production. The Disneys were different than some other animation studio owners of the 1920s, in that they had not learned their skills at the Bray studio in New York City (see p. 43). Their initial workforce was Midwestern, a group of young men from Kansas City, Missouri, who had known each other from the beginning of their working lives. One of them, Ub Iwerks (1901–1971),

was particularly important in developing the studio's early aesthetic. When he and most of the other original employees left in the late 1920s and early 1930s, Walt Disney began hiring new artists who would play a part in the studio's changing style.

Throughout the 1930s, Disney and other animation studios were contending with changing processes, including the adoption of integrated sound, color, other new technologies, and a changing animation style. This chapter discusses these and other shifts in the contexts of Disney's two animated series, the "Mickey Mouse" and "Silly Symphony" films, and how the studio's cumulative experience helped prepare it for an impressive accomplishment at the end of the decade: production of its first feature film, *Snow White and the Seven Dwarfs*, released in 1937 **(6.1)**.

Creating an Identity

The Arrival of Mickey Mouse

In 1928 The Walt Disney Studios' production of "Oswald the Lucky Rabbit" was sabotaged by Charles Mintz (see p. 61), who lured most of its employees away with the promise of more money. Ub Iwerks, at the time a partner in the business, remained, and together with Walt Disney set out to develop a new character, a mouse figure that eventually would become their next—and greatest—star. In July 1928, Mickey Mouse debuted in *Steamboat Willie*; it was the first film in a series that would incorporate both old and new elements, reflecting changes within the evolving studio and the larger industry (6.2). Like the other early films in the series, *Steamboat Willie* was released in black and white; as of 1935, "Mickey Mouse" films would be made in Technicolor. The movements of characters in *Steamboat Willie* are animated in the exaggerated rubber-hose style favored by the film's director and animator, Ub Iwerks. Mickey works on a boat where he and Minnie cause havoc by playing music via the bodies of several animals, and the boat's irritated captain stretches Mickey's stomach into a long tube that then neatly packs back into the mouse's shorts. Even though *Steamboat Willie* was firmly rooted in the old style of animation, it also pointed the way for the future, especially in its use of synchronized sound.

6.2 Disney, *Steamboat Willie*, from the "Mickey Mouse" series, 1928

Sound Options

Sound entered film production during the 1920s, with various experiments and early forms used before its widespread deployment toward the end of the decade. At first there were a number of competing processes vying for domination. RCA Photophone Synchronization, a sound-on-film process, was used in 1928 for one of the first synchronized sound-on-film animated shorts made in the US, Paul Terry's *Dinner Time*. Disney used a different process for *Steamboat Willie*, which came out later that same year. In fact, the first two "Mickey Mouse" shorts—*Plane Crazy* and *The Gallopin' Gaucho*, both directed by Ub Iwerks and not released until 1929—had been developed as silent films. Things changed when the great success of the Warner Bros. film *The Jazz Singer* (dir. Alan Crosland) in 1927 showed that "sound films" were the way of the future. A decision was made to record sound for the "Mickey Mouse" films using the Powers Cinephone system, via the studio's new distributor, Pat Powers. In 1928, *Steamboat Willie* became the first film on general distribution with sound.

Sound caused a shift in the genre of comedy, especially in live-action cinema, as physical comedy gave way to witty dialogue. When sound arrived in the animation world there was at first little attempt to record speech, or studio personnel took on the roles themselves. Walt Disney himself played the parts of Mickey and Minnie in several films, while the animator Vance DeBar "Pinto" Colvig was cast in such roles as the Practical Pig in *Three Little Pigs* (1933) and both Sleepy and Grumpy in *Snow White and the Seven Dwarfs*. At Fleischer, the animator Jack Mercer was the primary voice of Popeye from 1935, and the actress Mae Questel (born Kwestel) played Betty Boop and Olive Oyl during the 1930s. Dialogue soon developed into an art form in its own right and individuals began to specialize as voice talents, broadening the aesthetics of animation. At Warner Bros., from 1937, Mel Blanc became famous for voicing the majority of the studio's characters and is remembered as a true legend in the world of voice acting (6.3).

Various recording methods were used to capture the components of dialogue, sound effects, and music. Dialogue recording might be done before animation, so mouth movements could be animated to fit using "lip sync," or after

6.3 Mel Blanc, c. 1940

animation was completed. Sometimes voice talent was brought together and recorded as an ensemble, allowing actors to play off each other. Other times, voices would be recorded separately and mixed together during sound editing.

Disney initially took his film music from the public domain, as it was not copyrighted and thus available for free of charge, but later the studio saw a moneymaking opportunity and began to produce its own compositions, which it marketed as sheet music and records from 1930. Some animation studios were required to employ music owned by a parent studio, to promote those works within the animation: for example, the Fleischer studio sometimes featured stars from Paramount, which distributed its work.

Experimentation in the "Silly Symphony" Films

The Walt Disney Studios embraced the new technology of sound and within a few months, a second series made an even bigger use of it: the "Silly Symphony" films, beginning with *The Skeleton Dance* in 1929. This film, directed by Ub Iwerks, is similar aesthetically to *Steamboat Willie* in its use of black-and-white imagery and rubber-hose animation. In it, skeletons dance in a graveyard, complete with a howling dog that becomes impossibly thin and dueling cats who pull their long noses across the screen. Over a period of ten years, seventy-five "Silly Symphony" films were produced.

The "Mickey Mouse" and "Silly Symphony" films represent different components of the studio's production. The "Mickey Mouse" shorts involve popular, recurring characters, such as Mickey Mouse and Donald Duck, and are driven by story. The "Silly Symphony" films, on the other hand, are one-offs—without recurring characters—and so provide a safe place to experiment without risking the popularity of a valuable studio property. One example involves developments in color: in the film *Flowers and Trees* (dir. Burt Gillett, 1932), Disney first employed the perfected Technicolor process, which was to become the most significant color system in the American film industry at the time.[2] Disney held an exclusive contract with Technicolor for about a year after the film was released, preventing other animation studios from using the process. For another example, in the film *The Old Mill* (1937) the studio introduced a multiplane camera, built by Disney technical expert William Garity to create dimension in cel-animated productions (6.4); this technology would be used in sophisticated ways in the studio's feature *Snow White and the Seven Dwarfs*, released the same year.

6.4 Disney's multiplane camera

6.5 Sergei Eisenstein visits The Walt Disney Studios, 1930

Selling the Studio: The World's Favorite Mouse

It did not take long for Mickey Mouse to become a popular figure, with a life outside his films. By the early 1930s, Disney had begun serious merchandizing and promotion of the character through a variety of means, including the sale of Mickey Mouse products **(6.6)** and, by 1929, weekly Mickey Mouse Club matinees. By 1933, the studio also had a music department in place to sell its original scores as sheet music. The insertion of promotional material in magazines and newsreels began at around the same time, with displays of artwork in galleries and museums as early as 1932. In 1935, Disney began donating copies of his studio's films to the Museum of Modern Art in New York.[7]

Other companies had begun licensing entertainment characters from comic strips and animation by the early twentieth century, with such properties as the Yellow Kid and Felix the Cat, but Disney merchandizing was an unprecedented phenomenon in the field.[8] By the mid-1930s, the company was selling hundreds of consumer products worldwide bearing Mickey Mouse's image.[9] This phenomenon was managed by Kay Kamen, another native of Kansas City, Missouri, who began promoting the studio's products in 1932,[10] the same year the studio also made a push into fine art institutions. In 1939,

The Soviet filmmaker and theorist Sergei Eisenstein visited The Walt Disney Studios in 1930, reflecting just how popular its series had become by that time **(6.5)**. Eisenstein admired the "Mickey Mouse" and "Silly Symphony" films and proclaimed Walt Disney a master of filmmaking, along with the likes of D. W. Griffith and Charlie Chaplin.[3] The Soviet director found the metamorphic qualities of Disney's characters to be innately appealing, as their shape-shifting linked to human consciousness in what he theorized to be its basic, or "primordial," state.[4] He believed that although humans could not necessarily access the memory of ancient existence, the limitless possibilities of animated form facilitated a connection with that past, and transported the viewer into what he described as a "golden dream," not of action, but of escape to a place of wonder.[5] It is likely that the studio's rubber-hose aesthetics, which still prevailed in 1930, contributed to the fluidity of form that Eisenstein so admired.[6]

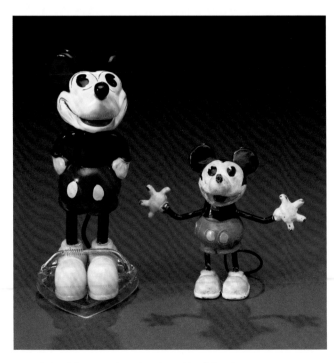

6.6 Mickey Mouse perfume bottle and lead figurine, 1930s

The Walt Disney Studios began its Courvoisier Gallery art-marketing program, creating "**cel setups**" (generally these were painted cels on top of backgrounds) for sale to the public.[11] It was headed by Helen Nerbovig, who had worked in ink and paint at Disney before supervising the cel setup department, where she led a staff of up to twenty women.[12]

The Reorganization of the Studio

In terms of actual production, Ub Iwerks—an adept and very fast animator—had been the cornerstone of The Walt Disney Studios since the mid-1920s. Carl Stalling also joined the studio in the late 1920s, when sound came in, to compose film scores; he had been a theater musician in Kansas City and had met Walt Disney there. The success of the early "Mickey Mouse" and "Silly Symphony" films was due in large measure to the work of these two employees. It is easy to imagine the upheaval felt in 1930, therefore, when both Iwerks and Stalling left The Walt Disney Studios. As a result, within a period of about two years the studio's infrastructure had twice been undermined. So Walt Disney was faced with finding new talent, a situation that ultimately led to a completely new infrastructure at the studio.

By 1930, Disney had been a studio owner for about ten years, during which time he had weathered his share of institutional crises, and he had created animated series that were popular and critically acclaimed. But he had not yet emerged as the singular force at the studio that he later became. He had had a long history with many of his initial employees, and they generally had their own ideas about how things should be done. When they left, Disney was able to start with a clean slate, implementing his personal vision. For his model, he looked at the successful Hollywood studio system and its division of labor, in which individuals carried out specific tasks within a kind of assembly line. For Disney, however, this process was not just about efficiency, as it had been at Bray, but rather it was an opportunity to develop stories further. To that end, he instituted **pre-production** elements that were previously unheard of in the field of animation, such as story meetings, storyboards, and layouts, in an effort to develop the narrative components of his work. He certainly did not

abandon gags, but he felt strongly about story, which could be imparted through dialogue as well as visuals.

Disney re-staffed and significantly enlarged the studio in a push that continued through the mid-1930s; artists remained eager to work there, partly because any job was a good job during the Depression, but also because the studio was increasingly recognized for putting the most artistry into its productions. In 1933, the American government had put in place a series of initiatives, collectively known as the New Deal, to counteract the worsening effects of the Great Depression. Part of the New Deal was the implementation of programs to support artists and the production of art in various forms. The first of these programs, the Public Works of Art Project (PWAP), ran from December 1933 through June 1934 and funded 3,750 artists who produced more than 15,000 works of art. From 1935 through 1943, the Works Progress Administration (WPA) ran programs for more than 5,000 writers, musicians, actors, and artists under the Federal Art Project (FAP). As a result, arts education within the US grew significantly during the 1930s and there were many newly trained artists who were looking for work.

Disney hired some seasoned talent out of New York, but he also took on relatively inexperienced employees, some of whom had "modern" approaches to art making, which were the results of a formal art education. Looking back, the opportunity to renew the workforce constituted a decisive moment in the studio's history, for among the new hires was a core group of animators who would eventually become known as the "Nine Old Men." These individuals brought with them a varied palette of abilities that broadened the aesthetic scope of Disney productions. Their presence enabled a tiered system that allowed rapid production while maintaining the artistic integrity of a piece, as the most experienced animator guided the movement of characters, which was fleshed out by an assistant and then by a third individual known as an **in-betweener**. Iwerks had been reluctant to work in this manner because he preferred to draw "straight ahead," meaning he went from the first frame of action to the end in succession; the tiered method involved pose-to-pose drawings of the defining images, or extremes, of any given action, which could be filled in, or in-betweened, by the lower-ranked artists.

After the upheaval of 1930, the studio personnel who remained included animators Jack King, David

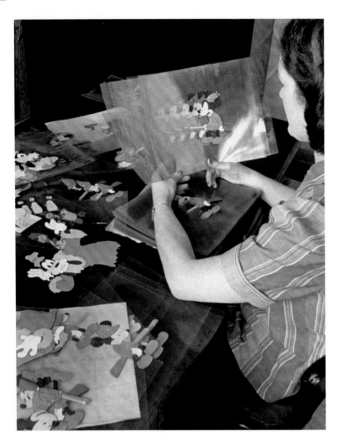

6.7 A Disney animator working on cels of Mickey Mouse, 1938

Hand, John Cannon, Ben Sharpsteen, Les Clark, Tom Palmer, Dick Lundy, and Norman Ferguson; directors Wilfred Jackson and Burt Gillett; composer Bert Lewis; and comic-strip artist Floyd Gottfredson. Additional animators (some had started out in other positions) came on board in subsequent years. In 1931, Ted Sears and his assistant Webb Smith were added, along with Albert Hurter. Art Babbitt joined in 1932, and Fred Moore and Eric Larson came the following year. Disney also hired two more composers, Frank Churchill in 1930 and Leigh Harline in 1932. The stellar team of artists now known as the Nine Old Men was so named as a joking reference to the US president Franklin D. Roosevelt's description of his Supreme Court. Les Clark had joined in 1927, but the others came later: Eric Larson in 1933; Milt Kahl, Ward Kimball, and Frank Thomas in 1934; and Marc Davis, Ollie Johnston, John Lounsbery, and Wolfgang "Woolie" Reitherman in 1935.

Disney's staff (**6.7**) more than tripled between 1930 and 1932,[13] and Disney assumed a new relationship with his employees. Whereas the artists of the 1920s had known Disney as a peer and, in some cases, even as one who was less experienced than themselves, by the 1930s, the staff knew Disney only

as a boss, and as a result were probably less likely to challenge his authority.[14] Iwerks had been a key figure in the studio, not only in respect to production (overseeing the work and influencing its aesthetics), but also because he was a part-owner. When he signed a contract with Pat Powers and left in 1930, his share was bought out. So, both aesthetically and administratively, Disney stepped into a stronger position.

The absence of Iwerks meant that the production process was destabilized for a while, but rather than get involved with the day-to-day technical details of production, Disney decided to hire individuals who specialized in various tasks, and make their work more compartmentalized. This new system would allow Disney to take on the role of objective observer, able to watch the films and comment on what made them work or not work in terms of storytelling, movement, character design, and so forth. Animators began to be cast in character parts, allowing them to work to their strengths and concentrate on longer segments of single films; previously, all the artists had worked on small parts of films somewhat indiscriminately, which could result in an uneven style within productions. Gradually, specialized artistic jobs were introduced and positions were added to meet Walt Disney's new requirements. For example, Albert Hurter became an "inspirational artist"–the first in the industry–whose role was to experiment with design and to encourage the animators to be more inventive in their work. In 1931–32, Disney hired Charles Philippi, Earl Duvall, and Hugh Hennesy to create layouts, arranging backgrounds and positioning characters within them.[15] A formal story department was in operation by the end of 1933, with such figures as Bill Cottrell and Pinto Colvig contributing the overall storyline and the gags within it, as well as the dialogue. Bob Kuwahara joined the studio in 1933, and about a year later he became probably the first dedicated storyboard artist in American studio animation.[16]

An expansion of the facilities resulted in the physical separation of the ink-and-paint departments, where most women worked, from the creative positions of director, animator, and so forth.[17] This change in facilities served to reinforce established gender-based institutional boundaries and reflected the inequities faced by women in the field. At the time, Disney ink-and-paint employees required a lengthy, unpaid training period. After the studio began to gear up for features in the mid-1930s, the need for inkers and painters grew

rapidly, and Disney began to pay trainees a dollar a day. By May 1938, some of the women working full time in ink and paint earned a salary of $16 a week. Though women could move horizontally within the system, from studio to studio, on the whole they were prevented from vertical moves, or advancing to other creative positions. The situation was similar at other studios. Martha Goldman Sigall, who worked in ink and paint on the Warner Bros. lot between 1936 and 1944, recalls that her entry-level pay was about $12.75 for her forty-four-hour work week, and increases were given periodically until her salary capped out at $21 a week; at that point, she became a "journeyman" and no longer qualified for raises.[18] In rare instances, women were hired for creative roles. At the Walter Lantz studio, for example, LaVerne Harding (often credited as "Verne") became one of the first female animators in the American studio system. She had attended the Chouinard Art Institute in Los Angeles before entering the field of animation, and then worked at the Lantz studio between 1934 and 1960, on "Woody Woodpecker" and other series, and later at other studios.

Variations in Composing

As the animation industry matured, the backgrounds of entry-level animators shifted: many of the first animators had started off in the realm of comics and adapted their skills to animation, but more and more the industry saw new artists join the field with a specialization in animation. A comparable shift occurred in the areas of film music and composition. Two of Disney's composers, Bert Lewis and Frank Churchill (1901–1942), came from what might be called similar "old school" backgrounds in silent-cinema organ music, favoring tight sound and image synchronization. Wilfred Jackson and Lewis had arranged the score for the film *Steamboat Willie* (1928), drawing on popular music from 1911, and a nineteenth-century American folk song, "Turkey in the Straw."

Churchill's score for the "Silly Symphony" *Three Little Pigs* (dir. Burt Gillett, 1933) features the kind of tight sound and image correlation developed in early Disney sound films that came to be known as "mickey-mousing." The film tells the well-known story of three pig siblings—one practical and two not so—who are hunted by a wolf. Its music begins during the title card, which proudly announces the film's pedigree: "Mickey Mouse/presents/A Walt Disney/Silly Symphony/Three Little Pigs/United Artists Picture/In Technicolor!" (UA was the distributor) (6.8). The piano figures prominently, anticipating Practical Pig's own piano-playing in the culminating scene of the film (6.9, see p. 100). The music continues over a new title card, containing visuals of the film's title surrounded by musical notes, and then fades out before an **iris shot** of the opening scene of the film. The music in the opening scene is upbeat, matching the joyful dance of Fifer Pig, who is hastily throwing straw onto her makeshift home. She sings that she doesn't "give a hoot" and proceeds to play her flute, which is taken up by the score and reflected in the pace of the pig's little jig. The second character, Fiddler Pig, is similarly depicted, with the score matching the speed of his action as he hammers sticks into a shoddy home, punctuated by a couple of thumps, and then plays his fiddle. The music underlying their introduction continues

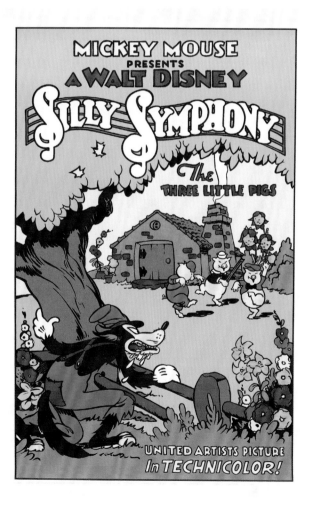

6.8 Title card for *Three Little Pigs*, dir. Burt Gillett, 1933

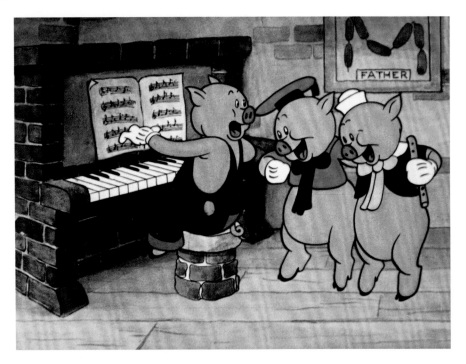

6.9 Burt Gillett, *Three Little Pigs*, 1933

when the Practical Pig comes on the screen, laying down bricks, but the beat is totally incongruous with his very solid actions, reflecting fundamental differences in the pigs' personalities. In parts of the film, sound effects are created through the use of musical instruments: a slide whistle is heard as a pig slips out of the wolf's grasp, and a fife-like sound is used to suggest a squeal. The great popular and critical success of this film and its music, including the song "Who's Afraid of the Big Bad Wolf?," likely made Disney aware of the profit potential of its music, which would come to form another important aspect of its merchandizing efforts in subsequent years.[19]

The Disney composer Leigh Harline (1907–1969) learned music composition in college. Consequently, his composing style represented an approach that was different than that of the theater musicians, with music that was usually more complex, structured in movements that develop throughout the film while at the same time complementing on-screen actions. Harline's score for the "Silly Symphony" *Father Noah's Ark* (dir. Wilfred Jackson), also released in 1933, serves as an example.[20] The film opens with title cards similar to those of *Three Little Pigs*, but over them are lyrics asking, "Who Built the Ark?" This question leads the viewer into the opening scenario, where a group of animals are taking part in its construction. No single animal is synchronized to the score in the way that the pigs were in the other film; even when "significant"

groups of characters appear— such as Noah's generic-looking sons and their wives—there is no obvious relationship between their bobbing movements and the music underlying them, and none of them has a unique musical theme. Sound effects are used to punctuate certain moments—for example, as a rhinoceros splits a log into sheets of lumber or as woodpeckers nail the wood planks together—and the score's pacing becomes more rapid when the storm begins, including ominous drum rolls and then the crash of cymbals to emphasize the lightning bolts on screen. In this film, the visuals and music work together to create an overall mood, but the score is not tightly synchronized to the images, so it represents a departure from the studio's previous approach.

Finding the Right Distributor

The growing popularity of Disney's studio's work resulted in increasingly lucrative contracts with various distributors, and he plowed his profits back into the production process. After leaving Charles Mintz in 1928, he had signed with Pat Powers's Celebrity Pictures, which distributed his films through a subcontract with Columbia Pictures. In 1930, Disney dropped his contract with Powers and negotiated directly with Columbia, which agreed only to a restrictive budget that did not allow for much development. In 1932, Disney shifted to another studio, United Artists, which offered him a better contract, providing an advance of $15,000 per picture, more than double what Columbia had paid. Disney's negotiating power grew as his productions became increasingly popular, resulting in higher profits. The release of *Three Little Pigs* in 1933 solidified the studio's fame internationally and provided much-needed revenue to support further innovation. In 1936, Disney signed with RKO, in preparation for a long-awaited objective: the production of a feature film. But for that goal to be realized, the studio had to undergo many more changes.

A New Aesthetic for a New Era

Story Is King

During the 1930s, after the coming of sound, the popularity of physical comedy waned across the live-action industry, giving way to the humor of the spoken word. At Disney, storytelling methods changed to accommodate this shift, so that gags functioned at the service of more complicated stories and no longer existed as "arbitrary elements."[21] More elaborate stories required much more planning, and as a result a series of new production methods was introduced at the studio. By 1931, story development had evolved from simple sketches on bits of paper into more complex series of drawings laid out in order, and, from about that time, Ted Sears and Webb Smith functioned as the studio's first dedicated writers.[22] Staff meetings became larger and communication more formal; as a result, typed outlines started to be distributed before meetings. The concept of the **pencil test** also developed at this time, as artists began to film and review sketches of their work done only in pencil. Although artists had been filming bits of their images for their own use since the late 1920s, Disney began to encourage that whole scenes be recorded and then projected during meetings, where he could comment on their strengths and weaknesses, and others could watch them too. These meetings initially took place in a tiny room that staff christened the "sweatbox," because it was such a cramped and stressful environment. Such procedures were unique to Disney: no other studio of the time devoted so much attention to pre-production.

The screening of pencil tests had significant repercussions for the creative process, not just in "improving" the work in an objective way, but also fundamentally shifting perceptions about the process of animation. At first, pencil tests were actually projections of "completed" animation (that is, work that had been cleaned up and that would later, once approved, be sent to ink and paint for transfer to production cels). If the pencil test was unsatisfactory, the animation would have to be re-drawn to the same high standard, resulting in a great labor expense. At one point, Disney instructed his animators to film and project only rough drawings, to get an impression more quickly of how the work was going. A revelation occurred when he realized that the essential qualities of the pencil tests could be evaluated in this rough form. The important discovery Disney had made was that the animation was composed of two different elements: form and movement. From that point, he encouraged his animators to focus on the movement, leaving the assistants to add detail to the form and the in-betweeners to fill in the drawings.[23]

Performing Characters

Disney's vision of cinematic animation production would rely on his artists' development of convincing characters, based on an understanding of performance, just as live actors used theories of performance to create their roles on screen. To impart such acting skills to his artists, both the new ones who had not been in the field for long and the seasoned pros in whom old-school methods might be ingrained, he turned to formal education.[24] The idea seems to have originated with the Disney animator Art Babbitt (born Arthur Harold Babitsky, 1907–1992), who organized drawing sessions for his fellow artists.[25] Disney soon realized that a more formal program was necessary and he approached the Chouinard Art Institute for help. This educational institution in downtown Los Angeles was founded in 1921 by Nelbert Murphy Chouinard, with the goal of establishing a significant art school on the West Coast. Her institute was well known by 1932, when Disney was working with one of its teachers, Don Graham (1883–1976), to develop an educational program, first on the Chouinard campus and then at The Walt Disney Studios. Graham's lecture on action analysis provided the Disney artists with an understanding of form and movement as they studied the motion of dancers, entertainers, and other live models, and broke down the action of scenes in films to study them frame by frame.

In a lengthy memo dated December 23, 1935, Disney expressed his desire for Graham to lead a "practical" course dealing with work-related concepts sometime after the start of the new year.[26] He suggested that the young animators he was training at the time needed a total program, whereas the older animators lacked specific skills, and he stressed that the most important foundation for all animators should be life drawing. He explained:

> The following occurs to me as a method of procedure: Take the most recent pictures—minutely analyze all the business, action, and results, using

the better pieces of animation as examples going thru the picture with these questions in mind. 1 What was the idea to be presented? 2 How was the idea presented? 3 What was the result achieved? 4 After seeing this result what could have been done to the picture from this point on, to improve it?

Among the topics Disney covers are the study of motion, caricature, music, and dialogue, and he specifically identifies a number of abilities an animator should have: drawing; visualizing, breaking down, and analyzing action; caricature skills; the capacity to study and feel the force behind a sensation, in order to project it; and an understanding of what creates laughter.[27]

Movement and Personality

The inclusion of sound and dialogue were not necessarily the key to better story development. In fact, Disney returned to body movement to find a superior system of expression. Eventually, Disney-style "Principles of Animation" would be described by two of the Nine Old Men, Frank Thomas and Ollie Johnston, in their book *Disney Animation: The Illusion of Life* (1981):[28]

1. Squash and stretch, or exaggerating a character's body movements while still acknowledging volume and weight
2. Anticipation, or staging a character's movement to suggest what it's going to do next
3. Staging, in order to present an idea so that it is readily understood
4. Straight ahead action and pose to pose, as two approaches to creating movement
5. Follow through and overlapping action, two embellishments on the main action
6. Slow in and slow out, acknowledging the effects of gravity and momentum on a movement
7. Arcs, or the visual path of motion from one extreme pose to another
8. Secondary action, a less prominent action that emphasizes the primary one
9. Timing, or the speed of movements
10. Exaggeration, going beyond the limits of reality for emphasis and/or humor
11. Solid drawing, respecting the weight, volume, and illusion of three-dimensional space
12. Appeal, developing charismatic characters.

These twelve elements are part of a language based on the study of mental states, physical states, and correlations between them; translation of those elements into a kind of coded graphic form; and development of written rules based on those observations. This understanding is at the foundation of personality animation, suggesting how a character feels through development of its actions. The system is effective for viewers because most of our understanding of any given situation comes from non-verbal communication, including the way things look or move and the tone of sounds and voices. Words always fall short when it comes to describing an experience fully; understanding is based on a wide range of cues.

Development of Character

Two films directed by Burt Gillett, *Three Little Pigs* and *Playful Pluto*, from 1933 and 1934 respectively, represent pivotal moments in the studio's development of personality animation: the use of movement, voice, and design to develop substantial, unique, thinking characters.[29] The technique results in characters that the viewer can "get to know" on an individual basis, increasing the emotional identification with the figures on screen. Personality animation also lends itself to an off-screen relationship, and is therefore useful for

The Ideas Behind "Disney Style" Movement

One of the most important changes at Disney during the 1930s occurred with its artists, who undertook a concerted study of human and animal movement and collectively codified a visual language and methodology of animation performance. The studio's characters began to move in more realistic and appealing ways, in a recognizable "Disney style."

The lessons learned at the studio were distilled by Frank Thomas and Ollie Johnston in *Disney Animation: The Illusion of Life*. Such a studied approach was unique for animation studios at the time, and subsequently has had a great impact on the field. The procedures used at the Disney studio can be linked to a broader context, however: other systems of visualization aimed at creating and documenting personality and movement in the contexts of performance. Some of

6.10 Burt Gillett, *Playful Pluto*, 1934

merchandizing, as viewers identify with, and want to be surrounded by, characters they come to know.

The animators responsible for *Three Little Pigs* included Norman Ferguson (mostly wolf scenes), Dick Lundy (mostly pig scenes), and Art Babbitt, with significant contributions by Fred Moore, known for his rounded forms and a relatively cute style.[30] Moore's animation of the pigs in the first three scenes of the film immediately draws the viewer in.[31] Rather than depict them in the rubber-hose style that tends to be used for the wolf, he creates characters that are physically substantial and move realistically, according to our expectation of what a dancing pig character would look like.[32] In addition, even though the three characters are all pigs, they do not look, act, or sound alike: distinctive personalities come through. *Playful Pluto* goes even further in its use of action to create personality, in a famous scene animated by Ferguson: more than a minute of action in which the dog interacts with sticky flypaper (6.10). This funny situation focuses on what Pluto is feeling, rather than the accurate reproduction of his movements.[33] Though personality animation had been practiced as early as the 1910s, in the work of Winsor McCay and his Gertie the Dinosaur character (see p. 42), for example, Walt Disney made it central to his body of work in the 1930s, at a time when most other studios were still employing relatively generic character types.

6.11 Constantin Sergeyvich Stanislavsky, c. 1920s

the best-known were developed in the mid-nineteenth century by the French musician François Delsarte, utilizing a system of gestures and movement connecting the inner emotional experience of an actor with an outer representation of that state. In the late nineteenth century, the Russian actor Constantin Sergeyevich Stanislavsky (6.11) devised a technique in which actors drew upon inner experience and memory to create performances; it is said that Disney made the "Stanislavsky method" required reading for his artists. In the early twentieth century, the Hungarian dancer and theorist Rudolf Laban (born Rezs Lábán de Váraljas) expanded on Delsarte's approach, formulating a system known as Laban Movement Analysis (LMA) to enable the description, visualization, and interpretation of movement. Some animators have found it to be useful in their creative process.

Disney's First Feature Films

Snow White and the Seven Dwarfs

By the mid-1930s, Disney had realized that working in the short-film form limited his ability to make a profit. He therefore set his sights on feature production, a goal that was realized in 1937 with the release of *Snow White and the Seven Dwarfs* (supervising director David Hand). The film was in planning by 1934, and its premiere came three years later, in December 1937, with a general release in 1938. It is an adaptation of the nineteenth-century story *Schneewittchen*, originally recorded by the Brothers Grimm; however, Disney's version was based on two versions for the stage, that of the nineteenth-century writer Karl August Goerner and Winthrop Ames's Broadway production of 1912.[34]

In Disney's version, the prince has no charisma and is given a minimal role, while the dwarfs have well-defined, endearing personalities and the animals are charmingly **anthropomorphic**. Originally, the prince's role was larger, but animators had a difficult time drawing a character as engaging as Snow White. The contrast between the characters is most obvious when he joins her at the wishing well: she moves gracefully and is an appealing, somewhat caricatured character, while he moves stiffly and is based on a more realistic design, with the result that he ends up looking like a somewhat creepy stalker. So, when footage had to be cut, it was natural to reduce his screen time. Disney guided the animation of the Snow White character by providing live-action reference footage of a dancer named Marjorie Belcher (later Marge Champion), who was filmed as she acted out Snow White's parts, under the direction of the animator Hamilton Luske. Animators then used this footage to greater or lesser degrees to assure conformity in their images. Disney felt that the use of reference footage would help ensure that his artists created consistent, well-animated work throughout the production. The dwarfs are much more interesting than the princess, however, because they have such distinctive personalities, which shine through in animation that was not tightly guided by reference footage.

In developing the film's characters, it was important to retain clear differences between Snow White, as a "real girl," and the dwarfs as childlike "little men" (to use the princess's description). She cooks and cleans for them and orders them to wash up for dinner,

6.12 The Cookie Queen in *The Cookie Carnival*, dir. Ben Sharpsteen, 1935

just as a mother would. As a result, we are made to understand that the dwarfs are not suitable love interests for her, as an unmarried woman alone in a house with seven men. Only the prince, who remains off screen, will do. This kind of assurance was important at a time when film censorship required strict morality in storytelling.

The success of *Snow White and the Seven Dwarfs* of course required the development of an appealing female figure, but Disney was not confident that his animators could handle the task. He had encouraged development of human characters in a range of "Silly Symphony" films, but the results had been disappointing. Things began to change when he lured the New York animator Grim Natwick to the studio. Natwick's skill was evident when he was assigned to animate part of the Cookie Queen in the "Silly Symphony" *The Cookie Carnival* (1935, dir. Ben Sharpsteen) **(6.12)**. Although the film is largely characterized by rubber-hose animation, cycles, and fairly generic characters, by the end of the film the Queen has evolved into a relatively well-developed character—the only member of the ensemble to do so. It is easy to see a shift between the first depiction of the character as a "poor cookie," animated by Bill Tytla, and her later visualization by Natwick, when she dresses up for the parade and becomes "queen."[35] The Cookie Queen character has overtones of Betty Boop (see p. 116). That character began her life at the Fleischer studio in 1930 and was principally developed by Natwick, who was working there at the time.

Much of the Snow White character's animation was handled by Natwick; he had originally created a

6.13 Snow White in the forest, *Snow White and the Seven Dwarfs*, 1937

relatively older and more provocative character, but she was eventually toned down to reflect the girlish qualities of the final figure.[36] The dwarfs were designed and animated primarily by Fred Moore and Bill Tytla, whose combined efforts resulted in seven highly charismatic, distinctive personalities, adding dimension to the relatively flat character of the princess and to the prince, who has no personality at all. Moore is credited with developing the appealing, rounded forms of the dwarfs, and is especially acclaimed for the scene when they first meet Snow White in their room. Tytla's work includes the washing sequence, when the characters gather around the tub before dinner (though Moore animated a small portion, in which Dopey swallows a bar of soap).[37]

Snow White and the Seven Dwarfs was a huge success, partly because of its incorporation of the animation techniques developed at the studio during the 1930s, as well as its use of Technicolor and the multiplane camera setup. Unlike sound, color was not universally embraced by the film industry, as it was seen as compatible only with certain genres, such as musicals and animated films (as opposed to detective or horror films, for example). Even within animation, color was used selectively because of the expense. So, the use of color in the film made it stand out from many of the other feature films of the time, live-action or animated.

Early in animation history, camera stands used to shoot the artwork on film were designed by the studios themselves; they were relatively simple, holding both the artwork and the camera in fixed positions. Beginning in 1928, Disney had worked with the Acme Tool and Manufacturing Company,[38] founded by Adolph Furer, to develop specialized camera equipment, including its multiplane rig in 1936; Acme specialized in animation stands, optical printers, **matte** printers, process cameras, and related equipment and accessories. In the 1940s, Acme, Oxberry, and other rostrum camera stands entered the animation market, making the shooting process more flexible: artwork could be shifted from side to side and the camera could be moved toward or away from the artwork.

In *Snow White and the Seven Dwarfs*, the multiplane system is used to create dimensionality and drama in various scenes to impressive effect: for example, when Snow White runs through the forest near the beginning **(6.13)**, her fear (and that of the viewer) is heightened by the dimensionality and resultant

psychological "reality" of the dark space, which cloaks so many frightening entities. In the scene, a sense of terror is developed as the princess confronts "alligator" logs and trees that seem to come alive and stare at her, before she falls through space to land in a darkened, unfamiliar place. The action in the scene, which moves forward and backward in the environment through a series of rapidly cut shots, provides an excellent demonstration of montage editing, as theorized by Sergei Eisenstein; images of various types (in terms of scale or direction of movement, for example) that appear in succession on screen create meaning through their juxtaposition, or "collision" with each other.

The film also shows the influence of German Expressionism, which was developed in cinema during the late 1910s through the mid-1920s, in its dramatic visual design of the background, its lighting, and its psychological elements, such as the wall of eyes in the forest that envelop the disoriented girl.[39] European culture had a great impact on Disney, and its effects can be seen in this film and others from the studio, partly due to a trip that Disney took in the summer of 1935. At that time, many filmmakers were leaving Europe for the US to avoid growing political problems, but Disney went the opposite way. In an effort to recover from stress-related illness, he took an extended holiday with his brother Roy and their wives, visiting England, France, Italy, Switzerland, and other countries. He used the opportunity to pick up fabrics, automata, and other items that were sources of inspiration for this film and others. The Swiss artists Albert Hurter and Gustaf Tenggren and the Hungarian Ferdinand Horvath also made significant contributions to the visual style of *Snow White and the Seven Dwarfs* by developing its look of Old Europe, in the architecture of the castle and cottage, for example.

Disney Features of the Early 1940s

After the release of *Snow White and the Seven Dwarfs*, The Walt Disney Studios quickly moved into production on a number of other feature-length animated films. In order of release, the first of these were *Pinocchio* (1940), *Fantasia* (1940), *Dumbo* (1941), and *Bambi* (1942). Although these features are quite varied in content, they all showcased the development of Disney artists and as a result are considered to be highlights of the studio's history. *Pinocchio* (6.14), which came directly after *Snow White and the Seven Dwarfs*, is an adaptation of the well-known story by the Italian writer Carlo Lorenzini (under the name Carlo Collodi), although a number of changes were introduced. For example, the role of Jiminy Cricket was significantly expanded.

In contrast to *Snow White and the Seven Dwarfs*, Disney's *Pinocchio* depicts a wide array of well-developed characters, as well as a storyline with a more heightened emotional charge. The story revolves around the efforts of a wooden figure to become a "real boy," despite the challenges he faces from mean characters and dangerous situations. Musical elements of the score—by Leigh Harline, Ned Washington, and Paul Smith—were also further developed, including such classics as "Hi Diddle Dee Dee (An Actor's Life for Me)" and "When You Wish upon a Star." It seems that no expense was spared in the production of the film: it cost more than two-and-a-half million dollars, which was a huge amount by the standards of the time, and it failed to make back its costs in ticket sales. It has been speculated that audiences found it harder to relate to *Pinocchio*'s characters, and perhaps the novelty and draw of animation in a feature film had worn off. In any case, Disney's

6.14 Walt Disney Pictures, *Pinocchio*, 1940

box-office problems were compounded
by the low revenues of its next film:
Fantasia, released later in 1940.

 Fantasia began as a short film,
The Sorcerer's Apprentice (dir. James
Algar), starring Mickey Mouse as a novice
magician who sets off a chain of actions
he cannot control, accompanied by the
score of the same name by Paul Dukas
(*L'Apprenti Sorcier*, 1897) **(6.15)**. As the
project's production costs soared, Disney
decided to expand it into a feature-length
film, adding a number of other animated
shorts; they were held together by live-
action sequences featuring the conductor
Leopold Stokowski and music critic
Deems Taylor. *Fantasia* can be described
as an elaboration of the studio's "Silly
Symphony" films, in that the visuals in its
short sequences are closely linked to the
music they accompany. It also showcased
changes in the studio's technology, being
enhanced by the development of an audio
system called Fantasound, which created
a sophisticated stereo effect in the theater.
The idea was to present a film-viewing
experience that would rival that of a live
symphony, but unfortunately the system
was far too costly and technically complex
to be widely adopted by theaters. In the
end, only two Fantasound systems were
installed, one in the Broadway Theater in
New York City and the other in the Carthay
Circle Theater in Los Angeles. Each cost
$85,000 and involved fifty-four speakers.

 Fantasia's distributor, RKO, was
understandably concerned about the
financial performance of Disney's work,
and it demanded a re-edit of the two-hour film,
reducing its running time by removing much of the
live-action footage and releasing it with a normal
mono (rather than stereo) soundtrack. The film has
therefore appeared with varied visual edits and sound
mixes throughout its history. Although today it is a
celebrated example of the studio's achievement, at the
time of its release it got mixed reviews: some members
of the art community questioned the combination of
classical scores with cartoon imagery, whereas general

6.15 Walt Disney Pictures, *Fantasia*, 1940

6.16 Walt Disney Pictures, *Dumbo*, 1941

viewers were perhaps unprepared for Disney's departure
from its traditional stories and comedy shorts.

 Dumbo and *Bambi* moved Disney back to more
familiar territory, as both tell the story of an endearing
character who is separated from family and cast into
peril—much as in the scenario of *Snow White and the
Seven Dwarfs*. Running just over an hour, *Dumbo* **(6.16)**
was a relatively quick project, and it was made as an
overt attempt to earn back money lost on the studio's
previous two features. Based on a children's story by

6.17 Walt Disney Pictures, *Bambi*, 1942

Helen Aberson and Harold Pearl, the film depicts a baby elephant with big ears. Despite being bullied by his circus cohorts, Dumbo eventually finds his self-confidence. Financially and critically, it was a success and helped Disney's cash flow, not to mention its relationship with its distributor.

Bambi is an adaptation of a novel of 1923, *Bambi, A Life in the Woods*, by the Austrian author Felix Salten, which tells the coming-of-age story of a male deer, his mate, and his forest friends (**6.17**). The film represents stylistic diversification at Disney in various ways, beginning with the relatively realistic portrayal of deer and other animals, in contrast to the "cartoony" look of these creatures in *Snow White and the Seven Dwarfs*. The Chinese art director Tyrus Wong (1910–) created remarkable backgrounds that frame the characters with relatively minimal amounts of detail, including subtle forest scenes that are enhanced by the use of the multiplane camera. The realism and drama of the story are so powerful that the film has been seen as a strong statement about environmentalism, depicting the fragile relationship between nature and humanity.

During the early 1940s, The Walt Disney Studios continued feature production with the films *Saludos Amigos* (1942), *Victory through Air Power* (1943), and *The Three Caballeros* (1944), all created against the backdrop of World War II.

Conclusion

The 1930s were a time of great change at The Walt Disney Studios. Not only did it develop two series that were important to its early years, "Mickey Mouse" and the "Silly Symphony" films, but it also geared up for production of its first feature. Although *Snow White and the Seven Dwarfs* was a great success for the studio, the film also brought on economic hardships. It had gone far over budget in production, and then its profits were put back into the business, funding the building of a new studio. Disney's financial challenges were exacerbated by the low revenues of the studio's subsequent features, which put a strain on its relationship with its distributor, RKO. Tired of low wages, disgruntled employees went on strike in 1941 and many of them left or in some manner were pressured to leave.

Disney also faced competition from other studios, such as Fleischer and Leon Schlesinger, which produced work for Warner Bros. Each of these studios had its own visual style and form of humor, resulting in part from their different modes of management. These and others contributed to a "golden age" of animation during the mid-twentieth century, creating work that we recognize as art, iconic elements of twentieth-century culture.

Notes

1 Michael Barrier, *Hollywood Cartoons: American Animation in its Golden Age* (New York: Oxford University Press, 2004), 64.

2 In 1916, the Technicolor Corporation was founded by Herbert Kalmus and his associates. The form Disney used is "three-strip," meaning that it reflected a full spectrum of color. David Bordwell, "Technicolor," David Bordwell, Janet Staiger, and Kristin Thompson, *The Classical Hollywood Cinema: Film Style & Mode of Production to 1960* (New York: Columbia University Press, 1985), 353–57.

3 Naum Kleiman, "Introduction," ed. Jay Leyda (trans. Alan Upchurch, 1985), *Eisenstein on Disney* (London: Methuen, 1988), x.

4 Kleiman, "Introduction," 21.

5 Ibid., xi.

6 Ibid., 10.

7 See "Promotional Strategies," Maureen Furniss, *Art in Motion: Animation Aesthetics* (Sydney: John Libbey, 1998), 124–27.

8 Linda Simensky, "Selling Bugs Bunny: Warner Bros. and Character Merchandising in the Nineties," in Kevin Sandler, ed., *Reading the Rabbit: Explorations in Warner Bros. Animation* (New Brunswick, NJ: Rutgers University Press, 1998), 172–92.

9 L. H. Robbins, "Mickey Mouse Emerges as Economist," *New York Times Magazine*, March 10, 1935. Cited in Jack Doyle, "Disney Dollars: 1930s," *PopHistoryDig.com* (July 31, 2008). Online at http://www.pophistorydig.com/?p=508

10 Doyle, "Disney Dollars."

11 Bill Mikulak, "Disney and the Art World: The Early Years," *Animation Journal* 4:2 (Spring 1996), 124.

12 Ron Barbagallo, "Discovering Helen Nerbovig," *Animation Magazine* (August 1997), 37–39. Barbagallo describes the training period as originally being seven months long and unpaid. Evidently, Helen's sister started the program before her and Helen started after the studio began to pay the dollar-a-day compensation.

13 Barrier, *Hollywood Cartoons*, 104.

14 Ibid., 66.

15 Ibid., 105.

16 Ibid., 115. In naming Cottrell and Colvig, Barrier points to the specific example of *The Grasshopper and the Ants* (1933).

17 Ibid., 72.

18 Martha Goldman Sigall, interview with the author, date unknown.

19 J. B. Kaufman, "Who's Afraid of ASCAP? Popular Songs in the Silly Symphonies," *Animation World Magazine* 2:1 (April 1997). Online at http://www.awn.com/mag/issue2.1/articles/kaufman2.1.html

20 Barrier, *Hollywood Cartoons*, 101.

21 Ibid., 73.

22 Ibid., 69.

23 Ibid., 104.

24 David Johnson, "The Disney Art School—Part One," *Animation Artist Magazine* (2000). Online at http://animationartist.com/InsideAnimation/DavidJohnson/SchoolPart1.html

25 Jake Friedman, "Art Babbitt: A Class of His Own," *Animation World Network* (May 12, 2011). Online at http://www.awn.com/animationworld/art-babbitt-class-his-own

26 Walt Disney composed a spate of memos to Graham on December 23, 1935. All references to these memos fall into this group. They are printed collectively online at (n. a.), *Animation Meat* (n. d.), http://www.animationmeat.com/pdf/nineoldmen/MemoFromWalt.pdf

27 Transcripts of some of these lectures can be found at the blog of Michael Sporn, *Michael Sporn Animation* (various dates). Online at http://www.michaelspornanimation.com/splog/index.php?s=action+analysis&submit=Search

28 Frank Thomas and Ollie Johnston, *Disney Animation: The Illusion of Life* (New York: Abbeville Press, 1981).

29 The Disney historians Russell Merritt and J. B. Kaufman have noted that, in the films created by the studio during the period 1932–34, following the shift to United Artists distribution, one is able to "find the origins of many of Disney's most famous storytelling traits," including the "fascination with sharply individualized character animation." Russell Merritt and J. B. Kaufman, *Walt Disney's Silly Symphonies: A Companion to the Classic Cartoon Series* (Gemona: La Cineteca del Friuli, 2006), 12.

30 Barrier, *Hollywood Cartoons*, 102.

31 Ibid., 89.

32 Ibid., 89.

33 Ibid., 114.

34 Robin Allan, *Walt Disney and Europe* (Bloomington, IN: Indiana University Press, 1999), 38.

35 Merritt and Kaufman, *Walt Disney's Silly Symphonies*, 160–61.

36 Barrier, *Hollywood Cartoons*, 200.

37 Ibid., 201; 207.

38 In 1952, the company was renamed Photo-Sonics. (n. a.), "Photo-Sonics Inc. Company History—A Brief Synopsis" Photo-Sonics (2008). Online at http://www.photosonics.com/company_history.htm#history_4

39 Allan, *Walt Disney and Europe*, 45.

Key Terms

Big Five	Little Three
caricature	multiplane camera
cel	pencil test
cinematic	personality animation
feature	pre-production
in-betweener	rubber-hose style
ink and paint	score

CHAPTER 7

Style and the Fleischer Studio

Global Storylines

The Fleischer aesthetic, which favors gags, adult themes, and improvised, humorous dialogue, is influenced by Dave Fleischer's management style

Technical innovation becomes a hallmark of Fleischer production, which features rotoscoping, early sound experiments, and three-dimensional sets

Fleischer characters, such as Betty Boop and Popeye, are popular with audiences; the studio's feature films do not enjoy the same success

Introduction

The studio system played an important role in supporting the production of American animation. During the 1930s, the Big Five and Little Three studios distributed animation of various sorts, standardized at about seven minutes in length (although running as long as ten), as a way to fill out their lineup in mixed programs similar to variety shows on stage, where short routines preceded headliner acts. Without the support of the major studios, it seems unlikely that American animation would have attained the worldwide popularity that it enjoys to this day. The benefits did not flow only one way, however. American animated series were very popular and added to the overall prestige of 1930s studio-era production.

Every studio's relationship to animation was a bit different, and often changed over the years, with the style of work and series they represented shifting accordingly. Most of the Big Five and Little Three provided distribution for independent studios on a contract, though some developed their own in-house animation departments. Paramount makes a good example because it had one of the longest and most diverse histories as a distributor of animation; it had done so since its early years, having contracted with John R. Bray between 1915 and 1919, within a studio called Paramount-Bray Pictograph. When Bray left Paramount, Pat Sullivan came on board. He created the "Paramount Screen Magazine" series, working under contract with the studio until 1921; in this series, Felix the Cat was born. In 1927, Paramount signed contracts with both Charles Mintz (working with George Winkler) to distribute "Krazy Kat" and the Fleischers to distribute their "Inkwell Imps" series. Mintz and Winkler left for Columbia Pictures in 1929, but the Fleischers continued to distribute with Paramount through the

early 1940s, producing series involving such memorable characters as Koko the Clown, Betty Boop, Popeye, and Superman. After that, Paramount worked with other studios. For example, in 1940, it began distributing the stop-motion shorts of the Hungarian émigré George Pal, who created work ranging from comedy to drama. His "Puppetoon" series included such films as *Tulips Shall Grow* (1942), a parable about World War II told through the story of a sweet puppet couple who are attacked by militaristic hardware called the "screwball army" (7.1), and *John Henry and the Inky-Poo* (1946), about a black character, based on American folklore, who proves himself to be more powerful than a steam engine.

The Universal Film Manufacturing Company (Universal Studios) is even older than Paramount, having been founded in 1912 by Carl Laemmle through a merger of several companies. It did not distribute animation until 1929, however. At that time, it became the first Hollywood studio to run its own animation production unit. This unit was headed by Walter Lantz and Bill Nolan, when in 1928 Universal took over production of "Oswald the Lucky Rabbit" from Charles Mintz. In the mid-1930s, Lantz began producing work independently as owner of Walter Lantz Productions—his own company, though it remained on the Universal Studios lot (7.2). There,

7.1 George Pal, *Tulips Shall Grow*, 1942

in 1940, he introduced Woody Woodpecker, his most famous character to date. Lantz continued to make animation for Universal almost continuously until 1972.

The Radio-Keith-Orpheum (RKO) film studio was established as a merger of several smaller studios in October 1928, to capitalize on RCA Photophone Synchronization sound technology owned by the Radio Corporation of America. This system was used in one of America's first sound-on-film animated shorts, *Dinner Time* (1928), directed by Paul Terry. In the late 1920s and early 1930s, RKO worked with other producers, including Charles Mintz, the onetime distributor for Walt Disney (see p. 61). RKO distributed The Walt Disney Studios' pictures itself, beginning in the mid-1930s and continuing until 1954. In the animation world, RKO is also remembered for producing *King Kong* (dir. Merian C. Cooper and Ernest B. Schoedsack, 1933) (7.3, see p. 112), a film famous for its stop-motion animation by Willis O'Brien (see p. 65), which inspired many future animators.

As these examples make clear, the development of American animation studios was closely tied to the major Hollywood film studios that distributed their work. Within this fluid system, individuals could certainly make their

7.2 The Walter Lantz studio at Universal Studios, 1930

7.3 Merian C. Cooper and Ernest B. Schoedsack, *King Kong*, 1933

mark on the content and style of the productions, but there were many additional factors—including new technologies, labor practices, and the regulation of content through censorship—that also played a part. The previous chapter discussed the development of a new style at The Walt Disney Studios, a style that has had a great impact worldwide. This chapter focuses on Disney's biggest competitor: the Fleischer studio. It details the components of the Fleischer studio's style in the context of the 1930s film industry and the range of its series and feature films.

The Development of Style in the 1930s

Influences on Style

Stylistic development results from a variety of influences and parallel developments. For example, Disney's rise in popularity was accompanied by related shifts in American popular culture. The studio's influential move from gag to narrative and increasingly differentiated characters mirrored the waning of vaudeville, with its

series of short "modular" gag formats, and the rise of classical Hollywood cinema, featuring star performers and longer, more complex narratives.[1]

In comparing the styles of American animation productions of the 1930s, the historian Mark Langer has proposed two approaches. One of them grows out of geographical location. The "New York" style contains relatively risqué content and more ethnic, working-class characters, emphasizing their drawn nature and origin in comics; the "West Coast" style was more middle class, small town, rural, and Protestant in morality.[2] The former could be found at the Bray, Fleischer, Sullivan, and other studios that had been established in the New York area, as well as at the California studio of Walter Lantz, who began his career in New York and then moved West. The West Coast group included Disney, Harman-Ising, and Iwerks—in other words, individuals who emerged from Kansas City (in effect, theirs was a Midwestern style). Langer's other critical model stresses the significance of "innovation and differentiation," in an effort to promote a studio's products over those of its competitors.[3] He shows that there was a kind of race between the Disney and Fleischer studios to implement new technologies in their films, including color, sound, and three-dimensionality.

7.4 Ub Iwerks, *Fiddlesticks*, 1930

Some technological innovations, such as the introduction of clear cels used for animation production or color film stocks, have the potential to create changes system-wide, but their impact on individual studios depends on when they were adopted. For example, when Fleischer moved to cels in 1930, a shift occurred in visual design: there was greater development of detail in the studio's backgrounds, including the grayscale that was enabled through variations in cel paint.[4]

In the 1930s, innovation was often promoted as a novelty through series titles or other indications on title cards. For instance, Ub Iwerks's film *Fiddlesticks* (1930) notes it is a "Color and Sound Cartoon, starring Flip the Frog" **(7.4)**. In fact, it was the first animated short to use an early version of Technicolor; its version emphasized red and green, as opposed to the full-spectrum "three-strip" Technicolor process that came out a few years later and dominated the US industry. Between 1933 and 1936, Iwerks used another process, Cinecolor, to create his "ComiColor" series, which was distributed by MGM and Pat Powers. The Fleischer studio employed Cinecolor in its "Color Classics" films for Paramount and it was used at Warner Bros. as well. Cinecolor films were limited to reds, blues, and shades of brown. In the late 1920s and early 1930s, when sound, too, was new, many related titles appeared: for example, Fleischer's "Ko-Ko Song Car-Tunes" (from 1924) **(7.5)**; Disney's

"Silly Symphonies" (from 1929); Fleischer's "Screen Songs" and "Talkartoons" (from 1929); Warner Bros.'s "Looney Tunes" and "Merrie Melodies" (from 1930 and 1931); Walter Lantz's "Cartune Classics" (from 1934); and Harman-Ising's "Happy Harmonies" (from 1934).

Style is a fluid concept and may differ within a studio, within a series, or even within a single film. Porky Pig, the first "star" character at Warner Bros., underwent many design modifications after he was introduced in 1935, partly because animators on each film, such as Frank Tashlin or Bob Clampett, worked somewhat autonomously.[5] It was not until the late 1930s that Porky's look was relatively stabilized. Style is commonly attributed to a film's director, but here again there are many factors to consider, including the amount of freedom a director gives to his or her artists. Chuck Jones spent most of his career at Warner Bros., where he traveled up the ranks of the animation workforce. As a director, he delegated a lot of creative control to

7.5 Title card for *Tramp, Tramp, Tramp*, from the Fleischer studio's "Ko-Ko Song Car-Tunes" series, 1924

his collaborators, such as Michael Maltese in story and Maurice Noble in layout. Consequently, Maltese and Noble made important contributions to many of Jones's productions, including one of the director's most iconic films, *What's Opera, Doc?* (1957). At Disney, Sylvia Holland and Mary Blair were among those artists hired to provide inspirational art to keep the studio's concepts fresh; their influence cannot be overlooked in a number of films, including *Fantasia* (1940) and *The Three Caballeros* (1944) **(7.6)**, respectively.

The Fleischer Studio: Style and Structure

The Foundation of the Studio

The Fleischer studio was already producing popular work before it was contracted to Paramount in the late 1920s. The two brothers, Max and Dave, had left their distributor, Margaret Winkler, in 1923, after they set up their own distribution company, Red Seal Pictures Corporation, in partnership with the inventor Lee DeForest. Among the films represented by Red Seal

7.6 Norman Ferguson, *The Three Caballeros*, 1944. In this still from the film, Donald Duck, José Carioca, and Panchit sing the "Three Caballeros" song

were their own "Out of the Inkwell" live-action and animation combination films starring Koko the Clown, which were produced at their studio, Out of the Inkwell Films, Inc. The studio moved around as it expanded in size, finally settling in late 1923 at 1600 Broadway, in the heart of Manhattan; it soon became the largest animation studio in the city, with a staff numbering around 250 at its high point.[6] During this period, the Fleischers produced their animated sing-a-long "Song CarTunes" (1924–27), which employed the DeForest Phonofilm sound system.

In 1923, Out of the Inkwell Films, Inc. also released two forty- to fifty-minute science documentaries that combined live-action with animation: *The Einstein Theory of Relativity* and *Evolution*. Both were created in partnership with well-respected scholars in the field. The latter film is a kind of prelude to the "Monkey Trial" in 1925 of the Tennessee schoolteacher John Scopes, which drew international attention. Scopes had insisted on teaching Darwin's theory of evolution, breaking a state law that forbid it in the classroom; he was found guilty, though the case was appealed and the conviction set aside. Shorter versions of both films exist, running about twenty minutes each (including mainly the live-action portions).

Unfortunately, increasing expenses eventually over-extended the Fleischers' finances, and in 1926 they faced bankruptcy. An investor, Alfred Weiss, took over the company as president, while Max served as vice-president and Dave became art director. Weiss renamed the production facility "Inkwell Studios" and forged a distribution deal with Paramount Pictures, discontinuing Red Seal. Koko continued to star in the studio's productions, but under the new series title of "Inkwell Imps."[7] The brothers soon left Weiss's studio, however, taking Koko with them and modifying his name by adding a hyphen to make it "Ko-ko." They floundered for a while, until someone offered them free studio space in the Carpenter-Goldman building (a film-processing lab) on Long Island in New York.

Thus, in 1929, the Fleischer studio was founded. Paramount offered the brothers another distribution deal, and within a few months the company had moved back to its Broadway location. Once again it experienced a period of growth, despite the onset of the Great Depression.[8]

Fleischer Studio Personnel

Like The Walt Disney Studios, Fleischer had been family run since the early 1920s. Max Fleischer was head of the studio and functioned as producer, Dave was credited as the director. Charlie Fleischer was chief engineer, Lou was in charge of the music, and Joe was head of the electrical department.[9] By the end of the 1920s, a group of experienced artists were working at the studio, but, in a further parallel with Disney, in 1930 a number of them left. At that point, several in-betweeners, including Al Eugster, Rudy Zamora, and Shamus Culhane, were promoted to animators, with their work overseen by two longtime employees: the cameraman Bill Turner and Nelly Sanborn, who was Dave Fleischer's secretary.[10] Sanborn and another woman, Alice Morgan, later headed the timing department and were given a relatively significant amount of creative input.[11]

Nelly Sanborn may have had a hand in promoting the first female animator in the American studio system, Lillian Friedman.[12] After studying commercial art in high school, Friedman began working at animation studios in the New York area in 1930. The following year, she was referred to Fleischer and hired as an in-betweener. Culhane promoted her to assistant animator in 1932, and the following year Friedman moved into the role of animator. Although she was certainly talented, money undoubtedly played a part in her promotion; her contract was for $40 a week, a small amount in comparison with the earnings of the men in her position, who typically were paid $125 a week.[13] Other female employees of note at Fleischer included the in-betweeners Lillian Oremland and Edith Vernick, who had been with the studio since the mid-1920s; Vernick was head of the department and sometimes animated as well.[14] Fleischer had continued using the slash-and-tear system until late into the 1920s, but by 1930 the studio had made the transition to cels. During the early part of that decade, the cel-painting department was headed by Max's daughter, Ruth Kneitel.

Classifying Content

When the American studio system matured in the 1930s, it was largely built around **live-action genre** pictures, such as westerns, horror films, and musicals—with categorizations based on repeated content, which may be visual (the look of individuals and settings), aural (the types of sounds heard), or narrative (patterns of action). In contrast, animated studio productions were not particularly diverse in terms of genre; most were linked to comedy in one way or another, to the extent that animated shorts of other kinds were generally seen as anomalies. So, while genre plays an important role in the way we understand live-action feature films, animation is not usually described in the same way. Nonetheless, the look, sound, and storyline of an animated short are still, of course, useful elements to analyze.

Creators are significant in the public's conception of animation, so that we may describe a film as, say, a "Chuck Jones short" or a "Walter Lantz production." Animation also tends to be identified with various studios, as in "a Fleischer cartoon," or by a series title, such as "Looney Tunes." During the 1930s and 1940s there were some instances of stand-alone animated films, such as the **Modernist** films of Oskar Fischinger (see pp. 80–83) or the stop-motion effects in live-action features being released from Hollywood studios, but the majority of theatrical animation was distributed as part of a series, much as in television programming today. Some series included recurring characters and others were built around one-offs, meaning that each episode had unique characters.

The Fleischer Aesthetic

Disney animation of the 1930s was affected by its artists' study of the "real world," with stories increasingly built around linear narratives and figures drawn to reflect an understanding of human and animal movement. These developments were guided by Walt Disney: his input into the story development process was significant, strengthened by his reviews in the "sweatbox," pencil-test screenings, and formal study that would cultivate a group aesthetic unified through shared experience under his leadership (see p. 101). At Fleischer, story was also a concern for the studio director, Dave Fleischer, but compared with

Disney, during the 1930s there was relatively little pre-planning of narrative elements and much less concern with the linear "through story."[15] When creating their "Out of the Inkwell" films, the Fleischers did not use **exposure sheets** (which some studios had been using since the mid-1910s) to guide the cameraman during photography, so timing was determined primarily under the camera, during the process of shooting images. As a result, the form of Fleischer films remained fluid until the final stages of production, with movement being prioritized over narrative.[16] Story details were also developed in an idiosyncratic way. Inspecting the work of artists individually, Dave Fleischer tended to focus on the particulars of a scene, rather than its link to the central storyline. Specifically, he looked for the development of comedy; by 1932, throwaway gags proliferated,[17] forming a real contrast to Disney's rejection of "arbitrary elements" during the same period (see p. 101).[18] Dave Fleischer also disliked still images. Animators were instructed to "bounce them up and down to a beat," resulting in constant movement of characters and sometimes environments as well.[19]

Fleischer films were popular with audiences worldwide, thanks to their adult-oriented plot elements, creative sound, and technological inventiveness. These qualities are found in two of its series dating from the 1920s. One of them, "Screen Songs" (1929–38), is a continuation of their sing-a-long "Song CarTunes" audience-participation concept of the mid-1920s. The other, "Talkartoons" (1929–32), features **synchronized dialogue** that was recorded after animation. This method allowed voice performers to add their own impromptu dialogue, sometimes in a sort of mumble that became a distinctive quality of Fleischer animation. The first of the "Talkartoons," *Noah's Lark* (dir. Dave Fleischer, 1929), provides an irreverent twist on the Biblical story by allowing the animals to get off the ark to visit an amusement park. The action occurs as a series of gags showing the animals making music, with crowd scenes accompanied by laughter or general noises and a few sentences of dialogue. To end the story, the large number of animals getting back on the boat sinks it, and they apparently all drown—except Noah, who swims off after a mermaid. The ending is as unpredictable as the rest of the film, creating an oddly humorous, dreamlike effect. In the 1930s, other Fleischer series grew to be even more popular, featuring characters such as Betty Boop and Popeye, as well as new effects.

Censorship

In America, the Supreme Court's decision in 1915 that the film industry was "a business, pure and simple" denied cinema the protections of free speech that were granted to other media, including newspapers and fine art. As a result, formalized censorship procedures and bodies to enact them developed throughout the 1920s and into the 1930s. Trying to avoid federal regulation, the film industry had established the Motion Picture Producers and Distributors Association (MPPDA) in 1922 to mediate complaints about film content and to offer filmmakers "suggestions" for creating more wholesome products. Censorship regulations continued to be developed, but they were not taken too seriously, and citizens continued to be wary of the cinema.

Between 1929 and 1932, research generally known as the Payne Fund Studies examined the impact of movie-going on children, finding that it affected their learning, attitudes, emotions, and behavior. In 1933, religious leaders associated with an organization called the Legion of Decency advised members that a boycott

Famous Fleischer Creations
Betty Boop

The Fleischer character Betty Boop was first introduced in 1930—as a dog—in the "Talkartoon" *Dizzy Dishes*, alongside Bimbo the dog. The following year she appeared in her own series—as a woman—and quickly became a star. One of the primary influences for her design was Helen Kane, an American singer famous for her song "I Wanna Be Loved by You," which was first performed onstage in 1928 and includes Betty's signature phrase, "boop oop a doop."[20] Betty Boop, who was primarily voiced by Mae Questel (**7.7**), was unique among female characters in American animation of the time, because of her sexualized persona. By 1934, however, Betty Boop had been subjected to censorship in terms of her design: her skirt, short enough to reveal a garter (**7.8**), was restyled to a longer length, and her actions were toned down, with fewer hip shakes and winks. The "Betty Boop" series lasted until 1939, but the character has never lost her appeal.

Released in 1933, *Snow-White* (dir. Dave Fleischer) is probably the best-known film in the "Betty Boop" series. Animated entirely by Roland Crandall, it

against what they saw as continued immorality in film content was imminent. The film industry took note, which was not at all surprising, considering that 1933 was the worst year of the Great Depression and several studios were already teetering on the brink of bankruptcy. A new industry body, the Production Code Administration (PCA) was established in 1934 with one of those religious leaders, Joseph I. Breen, in charge. Whereas the previous review boards had primarily monitored scripts, allowing filmmakers to sneak offending material into films during production, the PCA also viewed the final films before awarding a "Seal" that allowed them to play in theaters. The PCA enforced what is known as the "Production Code" (or the "Hays Code"), which were guidelines restricting sexual content, nudity, language, alcohol and drug consumption, depictions of religious content and political perspectives, certain **stereotypes** (especially those related to countries that purchased US films, but sometimes race and ethnicity in general), criminal activity, and other content to varying degrees (and changing throughout its history). Technically, the PCA was in place until 1968, when it was replaced by a rating system. The code was applied to features and shorts, both live-action and animated, but it mainly affected live-action features.

In order to abide by the code and its shifting requirements, producers often had to alter character types, storylines, and design elements, such as costuming, or face limitations in exhibition. There were censorship organizations in most US states and also in many countries, each of which could demand their own changes before a film was shown in its territory. For example, a censorship organization in England had concerns about frightening elements in Disney's *Snow White and the Seven Dwarfs* (see p. 105) and originally gave the film an "adults only" rating. In America, the PCA counseled Walt Disney about ways to handle African American characters and language in *Song of the South* (see p. 262), so as not to offend black viewers. Production Code Administration files for feature films are now housed at the Academy of Motion Picture Arts and Sciences Margaret Herrick Library in Los Angeles.

illustrates the visual aesthetics for which Fleischer became known in the 1930s: constant gags, relatively little concern for linear narrative, improvised dialogue, and rotoscoped imagery. The film tells the classic story of a princess who is driven into the forest, pursued by her spiteful stepmother, the queen. In this version, however, Ko-ko and Bimbo serve as the guards asked to kill the beautiful girl, and toward the end of the film the story turns into a music promotion (similar to what we would call a "music video" today).

7.7 Mae Questel, c. 1930s

7.8 Betty Boop, c. 1933–34

Snow-White is filled with constant movement, gags, and unpredictable story twists from start to finish. At the beginning, as Betty Boop sings to the queen about her magical looking-glass, both characters' heads bob up and down to the music. At one point in the scene, for no apparent reason, the queen's head turns into two eggs in a frying pan. Later, when Betty prepares to have her head chopped off, she absurdly sings "Always in the way, I can never play . . ." as both her body and the axe being sharpened move to the beat. As part of a scene transition from the forest to the dwarfs' home, poor Betty somehow becomes a human snowball. At the end of the film, the narrative completely departs from the "Snow White" premise as Ko-ko takes on the persona of the singer and bandleader Cab Calloway **(7.9)**, who is rotoscoped, identifiable by his unique body movements and the song he sings, "St. James Infirmary Blues." Calloway was under contract with Paramount, which wanted to promote his music. We can see that *Snow-White* entertains in much the same way as a **Surrealist** "exquisite corpse," with the pleasure coming largely from the element of surprise, as incongruous aspects of the story build upon each other in a relatively random way.

The Fleischer studio worked in black and white until the debut of its "Color Classics" in 1934, with the "Betty Boop" film *Poor Cinderella* made using Cinecolor. *Poor Cinderella*, the only "Betty Boop" film made in color, also showcased a new invention from the studio, the Stereoptical process, or **setback** camera **(7.10)**, which created three-dimensional backgrounds. This dimensionality was achieved by shooting a cel horizontally with an arced painted background behind it; foreground elements could be used to frame the images, and objects could be placed within the curved deep space of the background artwork.

Color, dimensionality, and style are foregrounded throughout *Poor Cinderella*. For example, an elaborate reddish-and-bluish drapery frames the title cards, and in the first scene the king's men march through the street with a three-dimensional city behind them. In most of the film, however, cels and movement are employed in the conventional way. For example, Betty Boop (playing the part of Cinderella) appears in a normally cel-animated setting as she sings her lament, voiced by Bonnie Poe. Betty's two evil stepsisters beckon her, and when they appear their arms stretch in rubber-hose style, much like the fairy godmother later in the film. A visual break occurs when we see a short stylized montage of

7.9 Cab Calloway, 1930s

Betty working at various tasks, framed within a clock and its spinning hands. Betty mumbles in an impromptu way as she gathers the various items she needs to make it to the ball, and she and other characters continually bounce up and down—familiar components of the Fleischer aesthetic. The film ends with the prince and Betty driving out of the town with a three-dimensional backdrop behind them, decorated with miniature trees to enhance the sense of depth and capped with an elaborate frame at the end.

In this film of 1934, one can see that censorship has not yet had its full impact on the studio, since Betty is undressed down to her undergarments, including her familiar garter. This action is a weak attempt to make Betty's character more appealing, and it is oddly aggressive in exposing Betty before the viewer. When the fairy godmother makes her entrance, it is evident that Fleischer is no better at realizing a "real" female character than Disney at this point; the figure's arms float and twist like spaghetti noodles and end in fin-like hands (see a similar look in Disney's "Silly Symphony"

Sept. 15, 1936. M. FLEISCHER 2,054,414

ART OF MAKING MOTION PICTURE CARTOONS

Filed Nov. 2, 1933

7.10 Fleischer's patent for the Stereoptical process, 1936

Popeye

Since its beginnings, animated film has had a close relationship with print comics. When the Fleischers licensed the Popeye figure from King Features in the early 1930s, they continued this tradition, banking on the "pre-sold" (already popular) character to build upon the success of their previous original characters, Ko-ko and Betty Boop.[21] Popeye was a character from Elzie Segar's "Thimble Theatre" comics, a strip dating from 1919 that included Olive Oyl and a number of other characters. The Fleischers introduced Popeye in the "Betty Boop" film *Popeye the Sailor* (1933). Later that year—in *I Yam What I Yam* (dir. Dave Fleischer, 1933)—he moved into his own series, which lasted more than twenty years and rivaled Mickey Mouse in popularity. Jack Mercer was the best-known performer of Popeye's voice, but the famous "I'm Popeye the Sailor Man" song, written by Sammy Lerner, was sung by the character's original voice performer, William "Billy" Costello.

Popeye the Sailor opens with live-action footage of a printing press announcing the character's move to film: "Popeye a Movie Star." The character then enters the scene singing his now well-known song, "I'm Popeye the Sailor Man," while he busts up random items aboard his ship, demonstrating his strength. The film reflects various aspects of the Fleischer style, including mumbled, non-lip-synced utterances from various characters. Characters also display constant movement, and gags abound. At the fair, a peacock guards the entrance with his expanded tail feathers, folding them up to allow characters to pass after they have paid. A gag is set up when Popeye walks up with Olive and has to find the money in her shoe, followed by a further gag when their nemesis, Bluto, walks up and does not pay at all—he just uses brute force to gain entrance, blowing the bird's feathers away. Later, when Bluto walks up to the "hammer" attraction, where Popeye and Olive are standing, the characters all bob up and down to the music. Bluto hammers the machine, using the previous patron attached to the hammer. The marker climbs up the post slowly, so we can read each humorous level. When Popeye steps up, he turns the hammer to dust and just

The Goddess of Spring, dir. Wilfred Jackson, also from 1934). The rotoscoped prince moves with a floaty stiffness, and the couple's lifelike dance movement is at odds with Betty's highly stylized look. In fact, much of the film is mechanical in its depictions of character, with no attempt to incorporate personality animation to differentiate the animals and most of the humans. Unlike *Snow-White*, *Poor Cinderella* did not create appealing characters; instead, it relied heavily on a well-known narrative—the traditional "Cinderella" fairy tale—to guide the film. Betty Boop just temporarily inhabited a role in that story.

7.11 Dave Fleischer, *Popeye the Sailor Meets Sinbad the Sailor*, 1936

uses his fist, sending the marker airborne so it hits the moon, which cries about its black eye. Spinach plays a part, as Popeye prepares for his final, calm domination of both Bluto and the train that threatens to run over poor Olive, as her rubber-hose arms flail about and she cries for help. The series is quite self-aware, poking fun at its own depictions of virility, femininity, and other social conventions. These are not really throwaway gags, rather they tell the audience about the characters.

The "Popeye" films, like the "Betty Boop" series, were mainly filmed in black and white. But in 1936 a longer, full-color "Popeye" animation with three-dimensional, Stereoptical backgrounds was released: *Popeye the Sailor Meets Sinbad the Sailor* (dir. Dave Fleischer) **(7.11)**. It utilized the three-strip Technicolor process, which by then was no longer limited in use to the The Walt Disney Studios. Two other special episodes in the series were released in subsequent years: *Popeye the Sailor Meets Ali Baba's 40 Thieves* (1937) and

Aladdin and His Wonderful Lamp (1939), both directed by Dave Fleischer. These "two reelers" (running sixteen, seventeen, and twenty-two minutes, respectively) were about two to three times the length of the normal animated shorts being produced in Hollywood. Jazz scores by studio composers, including Sammy Timberg and Sammy Lerner, added to the high-quality feel of the work.

The specials were expensive to produce relative to their length and the amount the Fleischers could charge for them, so it was difficult to make them profitable. At the same time, Disney had been at work on a feature, *Snow White and the Seven Dwarfs*, which was released in 1937. The Fleischers decided to follow with their own feature concepts, *Gulliver's Travels*, a seventy-six-minute film released in 1939, and *Mr. Bug Goes to Town*, a seventy-eight-minute film released in 1941. These two features appeared after the studio had endured its lengthy labor strike and moved to Miami, Florida.

The New Deal and the Rise of Unions in the US Animation Industry

During the Great Depression, largely as a result of government arts programs, a **Social Realist** art movement known as **Regionalism** emerged in America. This type of work is exemplified by the genre paintings of Thomas Hart Benton, such as *The Arts of the West* (1932), or those of John Steuart Curry and Grant Wood **(7.12)**. With a focus on local views of America and its people at work and performing familiar activities, Regionalism was embraced by politically engaged artists, and was compatible with the shift toward organized labor throughout the country. Efforts to unionize affected the animation studios as their workers joined in.

During the early 1930s, when unemployment was very high, workers were in a relatively weak position. One way they sought to improve their conditions was through the formation of trade unions. Many organizers, however, were fired by their employers and even blacklisted, and so unable to gain other employment. In support of labor, President Franklin D. Roosevelt (FDR) signed legislation that offered protection, and in 1933, as part of the New Deal, he created organizations to uphold the right of workers to enter into collective bargaining (i.e. by forming unions).[22] After violent uprisings nationwide in 1933 and 1934, Congress passed the National Labor Relations Act, usually called the "Wagner Act" after Senator Robert R. Wagner, and in 1935 it was signed into law. This act led to the formation of the National Labor Relations Board, which arbitrated in deadlocked disputes and investigated unfair practices.[23]

Attempts to unionize American animation studios occurred throughout the 1930s and 1940s.[24] When the Wagner Act was upheld by the Supreme Court in 1937, it was only a month before a sizeable number of Fleischer employees allied themselves with the Commercial Artists' and Designers' Union (CADU). They filed a complaint against Max Fleischer for long working hours and the lack of paid vacations and sick leave.[25] Resentment escalated when several employees belonging to the union were fired, in violation of the Wagner Act, and a strike was called on May 8, 1937 **(7.13)**.[26] An agreement signed on October 13 of that year allowed employees to have the option to be represented by CADU. Shortly after this settlement, in 1938, the Fleischers announced a relocation to Miami—presumably partly because Florida was not very supportive of unions, but also because the studio was expanding to move into feature production, and space in New York City was too expensive.

In 1938, a union specifically for animation—the Screen Cartoon (later Screen Cartoonists) Guild, Local 852—was chartered by the Painters, Decorators, and Paperhangers Union. Three years later, it signed contracts with MGM, Walter Lantz (at Universal), and Screen Gems (at Columbia). Walt Disney had set up an in-studio union to

7.12 Grant Wood, *Young Corn*, 1931

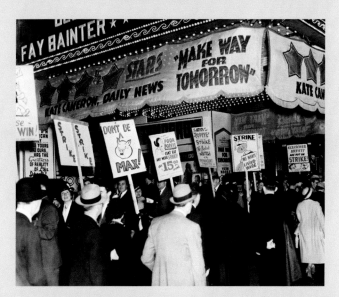

7.13 Fleischer employees protest outside the New Criterion Theater, New York City, 1937

address complaints from his artists, who wanted to share in the profits from *Snow White and the Seven Dwarfs*. Disney became angry when his highest-paid animator, Art Babbitt, resigned as president of the company union and joined the guild.[27] Disney fired Babbitt, and three days later, on May 29, 1941, the studio's strike began: it lasted for five weeks before being settled by mediators. Also in 1941, Leon Schlesinger (the founder of the Warner Bros. animation studio) eventually unionized, joined by the rest of Warner Bros. in 1945.[28]

Fleischer's Animated Feature: *Gulliver's Travels*

In 1939, at its Florida studio, the Fleischers completed work on the studio's first fully animated feature film: *Gulliver's Travels*, based on the book of the same name from 1726, written by the Irish author Jonathan Swift (**7.14, 7.15**). The film focuses on the wayward traveler Gulliver, who finds himself in Lilliput, a land of little people, where King Little is negotiating with King Bombo of neighboring Blefuscu about the marriage of their children, Glory and David. When the two kings disagree on aspects of the ceremony, they declare war on each other. The film was meant to compete with *Snow White and the Seven Dwarfs* and is in some ways similar, with dwarfish characters, love between a prince and princess, and small forest animals and birds. Fleischer strays from its normal aesthetic, attempting to tell a tightly developed, Disney-like linear narrative. The characters are still, rather than constantly moving to music, and a form of squash and stretch replaces the Fleischers' rubber-hose style of animation.

It would be difficult to sustain a feature using gags, so a shift to a linear narrative is not surprising. But Fleischer was not Disney: the studio personnel seemed to lack an understanding of long-form storytelling, timing, and development of an emotional

7.15 *Gulliver's Travels* in production at the Fleischer studio, 1939

center. The betrothed prince and princess are drawn generically, without a sense of personality. More time is spent developing the personalities of their fathers, the two kings, as they talk about the marriage. When Glory sings "Faithful," barely any time is spent on the couple; of more interest are a pair of lovebirds and an interaction between the kings, who talk over the song—one of them even blows his nose while Glory is singing. In the film, the use of rotoscoping proves problematic too. The central character, Gulliver, is dependent on his rotoscoped status for his personality: he is a "real

7.14 Fleischer studio, *Gulliver's Travels*, 1939

man" in a world of small people, but he ends up being stiff and unrealistic. The people of Lilliput (and King Bombo of Blefuscu) hold most of the interest, while the romantic couple, whose figures are loosely rotoscoped to be more "lifelike" than the others, are much less appealing. In short, when it came to feature production, the Fleischer studio changed its approach, but did not develop a viable substitute for its earlier aesthetic.

The Fleischers continued production in Florida for about two years. A second feature, *Mr. Bug Goes to Town* (later distributed under the name *Hoppity Goes to Town*), was released in December 1941; it tells the story of a community of bugs who must band together to protect their homes from humans.[29] Some of the characters from *Gulliver's Travels* reappeared in later short films produced by the studio. One example is Gabby, the town crier, who starred in eight Technicolor shorts created between 1940 and 1941; other characters appeared in shorts under the series heading "Animated Antics." The studio created other series and some

specials as well, including the two-reel *Raggedy Ann and Raggedy Andy* (dir. Dave Fleischer, 1941).

Downfall of the Studio

Unfortunately, the 1940s brought great instability to the Fleischer studio, as tensions escalated between the brothers. Their company slipped into financial and organizational troubles due to a combination of forces, including, for example, the expense of building the new studio in Florida; the need to pay higher wages in order to attract talent to this location; the costs of creating their feature-length film, *Gulliver's Travels*; low profits on their second feature, *Mr. Bug Goes to Town*; and the closure of European markets because of war.

During the turmoil, the Fleischer studio was in production on a new theatrical series, "Superman" **(7.16)**, based on the comic created by Jerry Siegel and Joe Shuster, which first appeared in *Action Comics* No. 1 in June 1938. The initial animated film in the

7.16 Fleischer studio, "Superman" series, episode 1: *The Mad Scientist*, 1941

series, simply titled *Superman*, runs about ten minutes in length. Promoted as a "Max Fleischer Cartoon" and directed by Dave Fleischer, it was released to theaters in September 1941. The film first relates how Superman was sent to Earth as a baby when his own planet, Krypton, was destroyed. It then moves on to his job as a reporter at the *Daily Planet* and the story—about a mad scientist intent on destruction—begins. Animation throughout most of the film is **limited**, using voice-over narration and any opportunity to frame action so that moving mouths could be avoided, as well as a lot of still imagery, relying on camera moves rather than changes in drawings to create motion. When the intrepid Lois Lane foolishly takes on a dangerous assignment, confronting the diabolical criminal in his lab, things get more exciting—beginning with the backgrounds. Twisting knobs and pulling levers, the madman sets off a series of electrical charges over futuristic-looking technologies. The voice-over narration is gone, and the scientist and his vulture reveal their reactions through relatively fluid body language. The film returns to more limited action as a radio blasts the voice of an announcer and reporters gather around it, moving stiffly. It takes off again when the scientist's evil plan is set in motion: as a building topples, Superman takes to the sky. Spectacular lighting effects illuminate the superhero as he is batted down to earth by powerful electrical rays, and then fill the screen as the lab is destroyed.

Max and Dave Fleischer supervised only the first nine episodes of the "Superman" series, as they soon found themselves out of a job. In May 1942, their contract with Paramount Pictures ended and the studio did not renew it. The brothers had been deeply in debt to the studio, having signed over most of their assets—including a number of patents—as collateral. Paramount assembled a new management crew and moved the operation back to its Broadway location in New York, under the name Famous Studios. Production continued partly under the supervision of Max Fleischer's son-in-law, Seymour Kneitel. Max and Dave Fleischer were left to find jobs at other studios and eventually engaged in legal proceedings related to contractual issues with Paramount.[30] Famous Studios continued production on "Superman" through 1943, for a total of seventeen episodes, along with other animated works.

Conclusion

The 1930s saw significant changes in the styles, technology, and labor force of American studio animation. Leading the way were the Disney and Fleischer studios, which engaged in a creative one-upmanship that resulted in constant innovation. Both studios struggled financially, owing to the Great Depression as well as the costs of their experimentation; while Disney barely pulled through, the Fleischers lost their studio in the early 1940s. The 1930s also saw MGM's first ventures into animation as well as the birth of the Leon Schlesinger studio, which provided animation for Warner Bros. All these studios had their own brands of humor: there are many ways to make people laugh, and animation exploits most of them.

Notes

1 Hank Sartin, "From Vaudeville to Hollywood, from Silence to Sound: Warner Bros. Cartoons of the Early Sound Era," Kevin Sandler, ed., *Reading the Rabbit* (New Brunswick, NJ: Rutgers University Press, 1998), 67–85.

2 Mark Langer, "Polyphony and Heterogeneity in Early Fleischer Films," Daniel Goldmark and Charlie Keil, eds., *Funny Pictures: Animation and Comedy in Studio-Era Hollywood* (Berkeley, CA: University of California Press, 2011), 29–50.

3 Mark Langer, "The Disney–Fleischer Dilemma: Product Differentiation and Technological Innovation," *Screen* 33:4 (1992), 343–60.

4 Michael Barrier, *Hollywood Cartoons: American Animation in its Golden Age* (New York: Oxford University Press, 1999), 177.

5 Tim White, "From Disney to Warner Bros.: The Critical Shift," Sandler, ed., *Reading the Rabbit*, 38–48.

6 Richard Fleischer, *Out of the Inkwell: Max Fleischer and the Animation Revolution* (Lexington, KY: University Press of Kentucky, 2005), 32–33.

7 Fleischer, *Out of the Inkwell*, 46–47.

8 Ibid., 47–48.

9 Ibid., 33.

10 Barrier, *Hollywood Cartoons*, 176.

11 Ibid., 177.

12 Barrier writes that Sanborn encouraged Friedman to animate some images and showed the results to the Fleischers (Barrier, *Hollywood Cartoons*, 177). The Fleischer historian Ray Pointer, however, says that Myron Waldman assisted in Friedman's promotion (Ray Pointer, email to the author, August 28, 2011).

13 Jeff Lenburg, *Who's Who in Animated Cartoons* (New York: Applause Theatre & Cinema Books, 2006), 96.

14 Vernick is said to have animated without credit on *The Great Vegetable Mystery* (1939) (Fleischer, *Out of the Inkwell*, 87). In interviews from 1994 and 2000, the animator Berny Wolf told Ray Pointer that Vernick taught him animation and had worked at the studio from 1923 or 1924 (Ray Pointer, email to the author, August 28, 2011). Oremland apparently died of tuberculosis before her thirtieth birthday.

15 Barrier, *Hollywood Cartoons*, 27.

16 Ibid., 28.

17 Ibid., 170. Barrier cites his interview with Al Eugster, March 17, 1978.

18 As noted earlier in Barrier, *Hollywood Cartoons*, 73.

19 Barrier, *Hollywood Cartoons*, 179.

20 The following year, in 1929, Kane signed a contract with Paramount Pictures—the same year the Fleischer studio also contracted with the studio. A few years later, in 1932, Kane filed a lawsuit against both the Fleischers and Paramount, but a judge ultimately ruled against her, saying that the "boop" was not uniquely hers.

21 For an overview of Popeye's career, see Mark Langer, "Popeye from Strip to Screen," *Animation World Magazine* 2.4 (July 1997). Online at http://www.awn.com/mag/issue2.4/awm2.4pages/2.4langerpopeye.html

22 In 1935, the NIRA was found to be unconstitutional by the Supreme Court. "An act to encourage national industrial recovery, to foster fair competition, and to provide for the construction of certain useful public works, and for other purposes, June 16, 1933," *Enrolled Acts and Resolutions of Congress, 1789–1996*, General Records of the United States Government, Record Group 11, National Archives (n. d.). Online at http://www.ourdocuments.gov/doc.php?flash=true&doc=66

23 "An act to diminish the causes of labor disputes burdening or obstructing interstate and foreign commerce, to create a National Labor Relations Board, and for other purposes, July 5, 1935," General Records of the United States Government, Record Group 11, National Archives (n. d.).

Online at http://www.ourdocuments.gov/doc.php?flash=true&doc=67

24 Attempts were made at Iwerks in 1931, Van Buren in 1935, Fleischer in 1937, Schlesinger and Disney in 1941, and Terrytoons in 1947, with strikes lasting from three to eight months with varying degrees of success. Tom Sito, "Guild History: The '30s," *The Animation Guild: I. A. T. S. E. Local 839*" (n. d.). Online at http://animationguild.org/guild-history/; Karl Cohen, *Forbidden Animation: Censored Cartoons and Blacklisted Animators in America* (Jefferson, NC: McFarland, 1997), 156.

25 Leslie Carbaga, "Strike at the Fleischer Studio," in Gerald Peary and Danny Peary, eds., *The American Animated Cartoon: A Critical Anthology* (New York: Dutton, 1980), 201–6.

26 Carbaga, "Strike at the Fleischer Studio," 203.

27 Tom Sito, "Guild History: The Disney Strike, 1941," *The Animation Guild: I. A. T. S. E. Local 839*" (n. d.). Online at http://animationguild.org/disney-strike-1941/

28 Tom Sito, "Guild History: The Screen Cartoonists Guild & Looney Tune Lockout," *The Animation Guild: I. A. T. S. E. Local 839*" (n. d.). Online at http://animationguild.org/scg/

29 Barrier, *Hollywood Cartoons*, 294–96.

30 Ibid., 304.

Key Terms

Big Five
cel
distribution
limited animation
Little Three

patent
Regionalism
rotoscope process
setback
synchronized dialogue

CHAPTER 8

Comedy and the Dominance of American Animation

Chapter Outline

Global Storylines

Humor comes in many forms, and these variations are found throughout the history of American studio animation

Warner Bros. animation is developed in units, allowing individual directors to have a high degree of creative control over storylines and the development of characters, such as Bugs Bunny and Daffy Duck

Animators Bill Hanna and Joe Barbera develop their reputations with the series "Tom and Jerry" at MGM, before they move into television

Introduction

The genre of comedy is very broad and, therefore, difficult to define precisely, but a general definition might be "something that makes us laugh, intentionally." The style of comedy can vary from piece to piece and is dependent on cultural context and point of view. Comedy sometimes involves a perpetrator, who initiates an action that plays for humor, and a target, on which the action is enacted. Many animated comedy duos fit this description, including Max Fleischer and Koko the Clown, Tom and Jerry, Elmer and Bugs, and the Coyote and Road Runner. Comedy may involve a quest for power within a system—for example, when Donald and Goofy do battle with technology in *Clock Cleaners* (dir. Ben Sharpsteen, 1937) **(8.1)**—or an eccentric manner of behavior—as seen in Felix the Cat—that is at odds with the surrounding environment. Comedy may be physical, involving the body, or verbal, using dialogue. It may be subtle and witty, or broad and outrageous enough to provoke belly laughs. Humor may be built up through the repetition of gags or in a series of events that culminate in a punchline. Some forms of comedy, such as **parody** and **satire**, are **intertextual**: that is, they require the audience to have knowledge of external sources in order to appreciate the joke fully. The roots of animation comedy lie in many sources, taking in traditions of caricature, print comics, variety theater, and more.

 Since the early years of cinema, there has been some fluidity between the comedy produced for live-action and animation, owing to the crossover of writers, producers, directors, and others. One of the most versatile figures in this respect was the American comedy director Frank Tashlin (born Francis Fredrick von Taschlein, also known as "Tish Tash," 1913–1972),

8.1 Ben Sharpsteen, *Clock Cleaners*, 1937

Duck—is remembered for its zaniness and intertextuality: gag-filled, often highly energetic short films that at times shattered the illusions of cinematic space or playfully referenced Hollywood stars and other well-known figures. Though united under the same studio logo, Warner Bros. shorts of this "golden age" strongly reflected the sensibilities of their individual creators, who were relatively free to draw upon their own imaginations in structuring their work. Unlike the Disney and Fleischer studios, where animators operated under the relatively strict control of a dominating studio head, at Warner Bros. management was comparatively less involved in the creative process. During the 1930s, Warner Bros.'s animation was created at the studio of Leon Schlesinger, who did not tend to supervise the animation himself. Rather, production took place within units directed by various individuals at different points in history. Among the unit leaders was Isadore "Friz" Freleng, who became the studio's most prolific animation director, eventually winning four Oscars. He was well known for developing the characters of Yosemite Sam, Sylvester, Tweety, and Speedy Gonzales. Fred (later known as "Tex") Avery was another leader; he had a highly exaggerated, wacky animation style, which was embraced and some would say even extended by Bob Clampett, who worked in Avery's unit for some time. Chuck Jones, on the other hand, is usually associated with animation that is relatively more cerebral, rational, and calculated. Avery, Clampett, and Jones put their individual stamps on various Warner Bros. characters, as well as on the "one-off" films they sometimes created.

This chapter surveys the varied types of comedy represented in American animation, focusing mainly on the Warner Bros. studio. It also discusses animation produced at MGM, where Tex Avery (see p. 138) created some of his classic animated shorts, and two individuals who would become legends of the television world, William Hanna and Joseph Barbera (see p. 138), directed their highly acclaimed "Tom and Jerry" shorts.

whose comedy work spanned comic strips, animation, and live-action production. He had begun by working for Paul Terry in 1930, before proceeding to move between Warner Bros., Iwerks, the Hal Roach Studios, Disney, and Columbia for more than a decade. In 1942, he returned to Warner Bros. to direct a number of films, including four in the "Private SNAFU" series for the war effort. By the mid-1940s, Tashlin had become a gag writer for comedians, and in the 1950s he began writing and directing for live-action comedy, making a number of feature films.[1]

Warner Bros. animation of the 1930s and 1940s—starring such characters as Bugs Bunny and Daffy

Key Elements of Comedy

Physical and Verbal Comedy

Physical comedy features relatively violent actions played for humor, including pratfalls, punches, and interactions with props or environments. It had been a staple of variety theater before finding a ready welcome in the world of live-action silent-film comedies, where, in the absence of speech, the body was used to convey meaning. Perhaps the best-known physical comedians of the silent-film era are Charlie Chaplin (see p. 44), who got his start in cinema at Mack Sennett's Keystone studio, and Buster Keaton, whose work was distributed through Metro Pictures Corporation (part of what would become the MGM studio) starting in the early 1920s.

Animation embraced physical comedy in the 1910s, and continued to employ it when sound technology appeared; this form of humor remains widely characteristic of animated shorts today. The highly malleable bodies of drawn characters easily metamorphose into new forms, such as a flattened body, taking the "gag" of physical violence much further than a live performer could. Animation studios have been able to push the limits of physical assault in the name of humor especially far by employing anthropomorphized animals, rather than realistic humans. Physical comedy often uses repetition to increase the comic effect of a given situation and is therefore closely associated with gag structures, rather than with linear storytelling.

Verbal humor flourished when sound cinema became the norm during the 1930s; a common form was the fast-paced repartee found in a live-action genre known as "screwball comedy," which had a close relationship to romantic comedies. Stricter censorship during the 1930s restricted references to sexuality, creating tensions as live-action filmmakers attempted to show adults becoming attracted to each other without overtly addressing the topic of sex. This led to a new emphasis on witty dialogue, sometimes including dual meaning, or subtext.

In studio animation of the 1930s and 1940s, romantic comedy is depicted in various ways: by hyper-sexuality on the one hand (for example, the wolf lusting over a sexy singer in Tex Avery's *Red Hot Riding Hood* (1943) (see p. 138) or in the guise of friendship on the other (in the relationship between Mickey and Minnie Mouse, for example). Disney's *Snow White and the Seven Dwarfs* (supervising dir. David Hand, 1937) (see p. 104) includes the pursuit of romance as a central plot point, but it is not played as comedy. Disney's *Lady and the Tramp* (dir. Clyde Geronimi, Wilfred Jackson, and Hamilton Luske, 1955) (8.2) includes both romance and comedy between the two dogs, but those genre elements are balanced by the drama and suspense generated by the menacing figure of the dogcatcher.

Parody and Satire

Parody and satire are linked forms of comedy, but they represent different intentions. A parody entails a critique of established expectations, while satire is more specifically focused on social criticism. Parody tends to be seen as ideologically neutral (a view that can be questioned), while satire is generally overtly politicized. In both cases, the comedy targets a subject outside itself, requiring the audience to have certain cultural knowledge or familiarity with the original source in order to understand which elements of the comedy are intended to be mocking.

8.2 Clyde Geronimi, Wilfred Jackson, and Hamilton Luske, *Lady and the Tramp*, 1955

Warner Bros. animation was known for both parody and satire. For example, the director Bob Clampett's *Porky's Movie Mystery*, from 1939, is constructed around a parody of a character called Mr. Moto from mid-1930s detective fiction written by John P. Marquand, and a series of related films. It begins with a title card explaining "any resemblance this picture has to the original story from which it was stolen is purely accidental," humorously connecting itself to the source of the parody. *What's Opera, Doc?* (1957), directed by Chuck Jones, is a loving parody of operas by the nineteenth-century German composer Richard Wagner. In the film, the predictable conflict between Elmer Fudd and Bugs Bunny is shifted to the setting of an operatic drama featuring the mythological figures Siegfried and Brünnhilde (8.3). Satire, on the other hand, can be seen in Disney's World War II-era production *Der Fuehrer's Face* (dir. Jack Kinney, 1943), which in the context of the war provided a commentary on the enemy in a politically motivated film: Donald Duck experiences life as a Nazi, working at an impossible job in order to please Hitler, but ultimately realizes that it was all a bad dream and he is lucky to be an American.

Individual characters can be parodied, as the Lone Ranger was, or satirized, as Hitler was, when they appear frequently enough that the public has become familiar with them. Humor is achieved by identifying the particular characteristics that represent the individual (speech, physical appearance, behavior, and so on) and amplifying them in a form of caricature. Groups of individuals can also become the focus of humor. As one might imagine, it is harder to distill a set of particular characteristics for an entire group, yet this does happen in all forms of cultural production, through repetition over time. During the 1920s, before the widespread use of personality animation, it was normal to find animation containing similar-looking or generic animal characters. Examples are found in *Alice's Wonderland* (Walt Disney, 1923), where the town contains many animal spectators that look the same. Human characters who look or act the same from film to film are generally known as "types," and they are part of the formula of comedies and all other genres. Such factors as age, race, body type, nationality, and gender are built into our expectation of types—for example, which characters and performers we expect to be funny, heroic, or an object of affection.

Type and Stereotype

There can be a fine line between the notions of "type" and "stereotype." A character actor in a live-action film or theatrical performance may be associated with a type, sometimes related to comedy, action dramas, or any other scenario. In some cases, typecasting limits a performer to a particular kind of role (for example, it can be difficult for a comedian to play a gangster). Typecasting may be based in part on stereotyping, or thinking in an oversimplified way about groups so that individual people are viewed as all being similar. The stereotype is an image that appears so often, reinforced in multiple ways, that the public believes it to be real on some level. Stereotypes can be thought of as an element of traditional storytelling, and, like the characters in fairy tales and legends, they are composed more of fiction than of fact. They are different, however, in that stereotypes are attempts to encapsulate the individual characteristics of a large number

8.3 Chuck Jones, *What's Opera, Doc?*, 1957

of real, living people, and are mainly negative, rather than—in the case of legendary figures, for instance—descriptions of individuals from history who are perhaps magical or heroic. A sleepy person clad in sombrero and poncho is automatically read within a well-known narrative to be a lazy Mexican who would rather take a siesta than work. A girl in a red cape bringing cookies to her grandmother, on the other hand, does not represent a segment of society, but rather a unique individual associated with another type of well-known story, the fairy tale *Little Red Riding Hood.*

Stereotypes limit the amount of back-story necessary to set up a narrative. They can also create derogatory humor through repetition, as they form classifications around a particular characterization (e.g., "You know you're a redneck when . . ." or "How many lawyers does it take to . . . ?"). Stereotypes have been widely present in animation, growing out of long traditions of racial and ethnic gags worldwide. The Bob Clampett short *Porky's Movie Mystery* provides a good example. In the live-action series adaptation of Marquand's books, the Mr. Moto character is played by a white man (Peter Lorre) made to look "Japanese," following industry practices of excluding non-white performers from starring roles. In Clampett's animated short, Porky Pig plays the role, wearing heavy round glasses and introduced by a section of "Asian" music in the score. Later in the film, he delivers dialogue, including his familiar stutter, with "oriental" overtones and distorted grammar. Other examples of stereotypes can be found in some of George Pal's stop-motion "Puppetoons," which involve a black boy named Jasper. Episodes clearly exploit stereotypes of African Americans, as one can see from such a title as *Jasper and the Watermelons,* and from the character's spooked reaction to ghosts in *Jasper and the Haunted House* (both 1942) **(8.4)**. These associations were so ingrained in society that they seemed natural, as evidenced by a guide published in 1928: *How to Draw Funny Pictures,* by E. C. Matthews, which identifies "colored people" as "good subjects for animated pictures. They are natural born humorists and will often assume ridiculous attitudes . . ." Matthews suggests playing "on the colored man's love of loud clothes, watermelon, crap shooting, fear of ghosts, etc."[2]

8.4 George Pal, *Jasper and the Haunted House,* 1942

Racial, ethnic, gender-based, or other forms of stereotype jokes work only if they conform to the listener's perception of the truth: this style of humor typically elevates the teller and those who identify with him or her in comparison to the object of the joke, who is seen as inferior in some respect. Quite often the basis of the joke is related to intelligence or "sophistication," which may be further delineated in terms of particular traits, such as sexual prowess and uneducated or animal-like instincts. Stereotypes typically offer a kind of shorthand for joke telling, as they come pre-loaded with simplified character traits.

During the 1930s some film censorship was put in place to minimize stereotyping of individuals from

other countries, as a way to assure broad international distribution.[3] This kind of regulation, aimed mainly at live-action films, was enacted for economic reasons, ultimately to protect the studio's business interests, not out of any sense of decency. By the late 1940s and 1950s, probably to avoid controversy, studios seemed to reduce the number of black characters depicted in their films. It was not until the 1970s that they returned to American animation in a significant way.[4]

Animation at Warner Bros.

The Warner Bros. studio had been in Hollywood for a number of years before it began distributing animation; it went on to develop many beloved characters and setting high standards for comedy, while also attracting its share of controversy. The studio was established

and run by four brothers from Ohio, who started in distribution in 1905 and expanded into producing live-action films by the mid-1910s. In 1924, they incorporated their business, and within a few years it had become one of the Big Five studios, largely through its early adoption of sound technology. The release of Warner Bros.'s film *The Jazz Singer* (dir. Alan Crosland) (8.5) in 1927, using the studio's Vitaphone sound-on-disk technology (developed with Western Electric), signaled to the world that the silent era had ended: sound film was the way of the future, and anyone who did not embrace it would be left behind.

Warner Bros. started releasing animation in 1930, the year it signed a contract with Leon Schlesinger (1884–1949). Schlesinger, who owned the film-titling company Pacific Title and Art Studio, had apparently contributed to the financing of *The Jazz Singer*. In addition, his brother was head of the Warner Bros. foreign department. For these reasons, he probably found

8.5 Crowds outside a theater showing *The Jazz Singer*, 1927

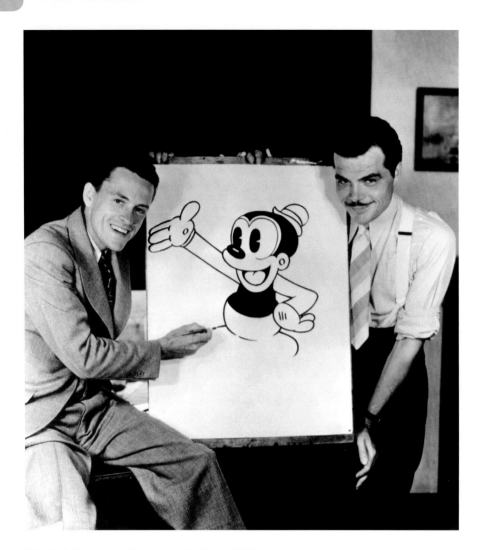

8.6 Hugh Harman and Rudy Ising with Bosko, 1930s

favor when he went to the studio with a proposal to distribute Hugh Harman and Rudy Ising's animation. In the years following their departure from Disney, the two had worked for Charles Mintz and then established their own studio. There they developed a black male character, Bosko, who had been conceived while they were still at Disney. He first appeared in *Bosko and the Talk-Ink Kid* (1929) **(8.6)**, which opens with Ising at a drawing table, much like Max Fleischer in the "Out of the Inkwell" films featuring Koko the Clown. By means of the hand-of-the-artist convention, the viewer sees Ising drawing the rounded forms used to create the character. This film was one of the first to include tightly synchronized dialogue. The character's first words, delivered in a caricatured African American dialect by Carman Maxwell, are "Well, here I is, and I sure feel good!" He then adds, "I just got out of the pen!," pointing to the pen in Ising's hand and chuckling at his joke, which suggests he had been

in a penitentiary, or prison. Later in the film, the character refers to Ising as "boss" and demonstrates the range of what he can do, which includes a Jewish caricature in a dance sequence. An interesting aspect of this film is its self-referential component, as Bosko asks Ising about all the people out there in the dark and is informed that they are the audience. After Bosko plays music on a piano and begins to sing badly, Ising jabs the protesting character's clothing with the ink pen and sucks him back in, finally returning him to a bottle of ink—the same ending faced by Koko in the Fleischer "Out of the Inkwell" series.

In 1930, another film featuring Bosko, *Sinkin' in the Bathtub*, directed by Harman and Ising with animation by Friz Freleng, became the first animated short to be distributed by Warner Bros., launching the "Looney Tunes" series. In this film, there is no live-action component; instead, the film opens on Bosko in

the shower, and a series of gags are synchronized to the score. Bosko has only one line of dialogue in the film, delivered in the same dialect as the pilot film; in later films, the accent is gone. Schlesinger started a second series, "Merrie Melodies," in 1931. Two years later, Harman and Ising left, heading for MGM. Schlesinger opened a studio bearing his name and continued working with Freleng, along with a new team of artists. Some of these individuals, among them Tex Avery, Bob Clampett, and Chuck Jones, populated the famous Warner Bros. production unit that came to be known as "Termite Terrace" for its poor conditions.

In the years that followed, these people would have a strong hand in developing the characters for which the Leon Schlesinger studio, under the Warner Bros. banner, became known. Starting in the mid-1930s, the studio introduced a string of true stars: Porky Pig in 1935, Daffy Duck in 1937, and Bugs Bunny in 1940. Eventually, Warner Bros. films would include many other popular characters, such as Yosemite Sam, Road Runner, Wile E. Coyote, Tweety, and Sylvester. These characters appeared in short films, often engaged in outrageous stunts aimed at creating physical comedy. But the studio's humor also evolved through sound elements: film music, sound effects, and skillful delivery of dialogue. For a number of years, the Warner Bros. music department was largely anchored by one-time Disney composer Carl Stalling, who joined Warner Bros. in 1936. Another important figure was the editor Tregoweth "Treg" Brown, who arrived in 1940. He developed the unique sound effects that characterized the studio's work, using cowbells, jet engines, skidding car tires, and similar devices from the Warner Bros. live-action sound library, as well as sounds he recorded himself. In terms of voice performance, the legendary Mel Blanc (see p. 95) made many of the characters come alive. Blanc got his start in radio during the late 1920s; he was so talented that he became known as "the man of a thousand voices."

Since the directors at the Schlesinger studio could work with relative independence, they expressed their individual comic sensibilities in ways that might not have been possible at other studios with more centralized control, such as Disney or Fleischer. As a result, Warner Bros. animated shorts tend to differ in their aesthetics, depending on which artist was at the helm. To illustrate this point, it is useful to compare two of the studio's best-known directors, Bob Clampett and Chuck Jones.

Bob Clampett

Bob Clampett (1913–1984) originally intended to go into print comics, but in 1931 he got a job as an in-betweener at Warner Bros. animation and he stayed on to work for Schlesinger when Hugh Harman and Rudy Ising left in 1933. In 1935, Clampett became principal animator for one of the animation directors, Tex Avery, with Chuck Jones installed as in-betweener. Clampett was promoted to a director's role in 1937 and remained in that position until 1946, creating some of the most beloved and often controversial animated shorts in Hollywood history. Much of his output involved Porky Pig, including the film *Porky in Wackyland* (1938) **(8.7)**. In it, Porky travels in search of the rare Do-Do bird, finding himself in an exotic landscape filled with objects and creatures in scenarios that reflect Clampett's wild imagination: the fight between an unusual cat and dog

8.7 Bob Clampett, *Porky in Wackyland*, 1938

8.8 Bob Clampett, *The Great Piggy Bank Robbery*, 1946

including references to the comedians the Three Stooges and singer Al Jolson.

An even more extreme example of Clampett's wild animation style is found in the opening to *The Great Piggy Bank Robbery* (1946) and throughout the rest of the film **(8.8)**, which stars Daffy Duck in a parody of a Dick Tracy crime story, where "Duck Tracy" has to do physical battle with a host of unusual characters. The film opens with a pan over an idyllic country setting and soothing music, cutting to Daffy Duck pacing impatiently by the mailbox to the sound of a Raymond Scott score, the frenetic *Powerhouse*. The zaniness commences when the mailman arrives in the form of two oversized hands gingerly placing mail into the box, accompanied by a bit of Sanford Faulkner's jaunty *Arkansas Traveler* score. Meanwhile, Daffy impossibly hides behind a skinny post, eventually appearing as two eyes stretching around it. This opening provides a key to much of Clampett's comedy, which features rapid timing, a total disregard for physical reality, and exaggerated poses within the main line of action. These exaggerations blend almost seamlessly, and yet there is just enough hint of them to be noticeable, informing the characterization of the drawn figure. As Daffy runs home with his special delivery, which we find is a set of "Duck Tracy" comic books, he quickly traverses large spans of countryside, and is depicted in a range of sizes and moving in various directions, before finally arriving home.

Very much a product of its time, *Coal Black and de Sebben Dwarfs* (1942) is a parody of the Snow White story that demonstrates the extremes of stereotyping and caricature. Despite the inclusion of elements that some find offensive, the film features the voice talents of accomplished African American performers, including the radio personality Ruby Dandridge (the queen), Dandridge's daughter, the actress and singer Vivian Dandridge (So White); and the singer and musician

(which Porky gets pulled into); the manic actions of a drummer, which end when he clangs himself on the head with a cymbal; and especially the actions of the zany Do-Do. *Porky in Wackyland* also demonstrates the potential of animation to create fantastic, dreamlike scenarios. An ominous voice reads a telling sign on the edge of town: "It can happen here," and that seems to be the truth. Near the end of the film, the bird thwarts capture by building doors, windows, and alternate backgrounds, which provide it with the ability to go to a secondary zone, beyond the original background. There are also a number of intertextual elements,

Leo Watson (the prince). Supplementing the traditional story, the film draws upon a range of popular culture and topical issues that are also parodied. The film opens with the silhouette of a woman rocking a child near a fireplace, laughing in a jolly way and then saying "Oh, honey child, what story would you like to have Mammy tell you tonight?" The silhouetted child replies in a perky voice, "I would like to hear 'bout So White and the sebben dwarfs, Ma-mmy," and so the tale commences and we are introduced to the cast. The rich old queen is clearly unattractive, ape-like in build, while "Prince Chawmin'" is a zoot suiter, wearing a large jacket and sporting two dice in his mouth in place of front teeth. So White is introduced from behind, as she leans over hot coals and bobs her shapely, scantily clad behind in the air in sync with the music. As she begins to sing, her loose limbs and big eyes suggest that she is, as she later states, "dumb."

In the context of World War II, the queen's stockpile of white-wall luxury car tires and sugar and the prince's roomy zoot-suit jacket, which would have required a lot of fabric, both signal bad behavior, as these items were all in short supply. When the queen wants So White "blacked out," she contacts a crew called Murder Inc., which promises to kill anybody for a dollar, with "Midgets—1/2 price" and "Japs—free," in a topical reference to the Japanese as the enemies of America who had bombed Pearl Harbor. Clampett's signature exaggerated style of drawing is not only integrated into the dance of the prince and So White, but also in the characters hired to murder the young woman, whose necks stretch thinly across the screen as their car speeds away from the woods. Next, the seven dwarfs are introduced, all suited up for joining the army (one of them is clearly modeled on Dopey from The Walt Disney Studios' production). So White does her patriotic duty by serving up breakfast for the troops, though she is interrupted by the conniving queen. Discussing the poisoned apple, the two characters bob up and down on screen, synced to the music, in a way that is not unlike the constant movement of Betty Boop in *Snow-White* from 1933 (see p. 116). Eventually, Prince Chawmin' arrives to deliver the cure for So White's sleeping death, drawing on his special "Rosebud"; the reference is to Orson Welles's famous film *Citizen Kane* (1941), which had been released the previous year, and implies a sexual *double entendre*.[5] The end of the film is a kind of "wish fulfillment" in response to the Disney version, and alludes to a "real ending" emerging from the suppressed sexuality of that film's dwarf characters. Aesthetically, Clampett's film is the opposite of Disney's version in just about every way, with the exception of depicting Snow White as the beautiful object of male desire.

Chuck Jones

Chuck Jones (1912–2002) worked in the same unit as Bob Clampett for some time, but eventually he developed quite a different aesthetic sensibility. Jones was born in Spokane, Washington. After his family moved to Los Angeles, he was drawn to the movie industry and appeared in some Mack Sennett Studios films. He dropped out of high school and enrolled at the Chouinard Art Institute, becoming part of the new generation of animation artists who trained in schools before entering the industry. He began his animation work at the Ub Iwerks studio as a cel washer, and then went on to other studios, working in ink and paint and as an in-betweener. In 1933, he joined Leon Schlesinger; he stayed at Warner Bros. until 1962. He began directing in 1938, becoming especially well known for work with Bugs Bunny and also the Wile E. Coyote and Road Runner films produced in the "Looney Tunes" and "Merry Melodies" series.

At Warner Bros., Jones worked in a range of creative partnerships. The writer Michael Maltese was one of Jones's collaborators for many years. Maltese began working at the Schlesinger studio in 1937 as an in-betweener, but he moved into the story department within a couple of years, remaining there more or less until the early 1950s. Jones also worked closely with the layout artist and background designer Maurice Noble, another graduate of Chouinard. Noble had contributed backgrounds and other art to such Disney films as *Snow White and the Seven Dwarfs* (1937), *Dumbo* (1941), and *Bambi* (1942) before participating in the strike and then leaving the studio. He subsequently worked on the wartime series "Private SNAFU" and in 1952 moved to layout at Warner Bros.

Jones's love of music prompted him to write a critical article, "Music and the Animated Cartoon," published in 1946 in an issue of the academic journal *Hollywood Quarterly*. It described the ways in which sound can be used creatively in animated films,[6] by wedding graphics and music in a studied manner; the Disney film *Fantasia* (1940) provided his examples.

8.9 Chuck Jones, *The Dover Boys*, 1942

Certainly, Jones was inspired by music in many ways. For example, his particular interest in opera informed the production of his "Merrie Melodies" film *What's Opera, Doc?* (1957), built around Richard Wagner compositions arranged by the studio's music director Milt Franklyn, with story by Michael Maltese, and dramatic backgrounds by Maurice Noble.

From the beginning, *What's Opera, Doc?* suggests its sophistication as Bugs is introduced in the starring role and the film's crew is listed on what appear to be programs for a theatrical performance; in the meantime, we hear an orchestra warming up. The film opens with a blare of trumpets and a crack of thunder, the score creating the impression of a huge storm, and the silhouette of a towering figure appearing on a gigantic, jagged rock. The first visual gag appears when the camera **zooms** out to reveal that this giant is actually a tiny character: Elmer Fudd in a Viking costume. This joke perfectly reflects the comedy in Fudd's persona, as a little man aspiring to do big things that he will never achieve. Not surprisingly, we find that his central problem here is Bugs Bunny, as he first softly and slowly sings, "Be vewy quiet, I'm hunting wa-bbits," and then proceeds to holler "Kill the wabbit!" several times to the strains of "Ride of the Valkyries," from Wagner's opera *Die Walküre*. Part of the scene's comedy comes from the fact that this imposing and well-known score is used to emphasize Fudd's almost crazed desire to hunt down his nemesis. Playing this score and other Wagner pieces at

a relatively rapid pace, and accompanying them with the funny voices of Fudd and Bugs, creates humor through contrast. The same is true throughout the film, as both characters play their operatic roles while preserving their distinct personas. Donning the costume of lovely Brünnhilde, Bugs stays true to character as a "wascally wabbit" bent on shaming Elmer Fudd, who falls for his tricks every time.

Jones's interest in modern art influenced his work, especially the strong graphic look and stylized limited animation he was using in the 1940s, which would become more widely popular in the next decade. Jones sought out sympathetic designers, including John McGrew, Gene Fleury, and Bernyce Polifka, who helped him transform the function of backgrounds at Warner Bros. before he began working with Maurice Noble in the 1950s. One example of Jones's modern work is *The Dover Boys at Pimento University or The Rivals of Roquefort Hall* (also known as *The Dover Boys*), a "Merry Melodies" film from 1942 with backgrounds by Fleury (**8.9**). The film, about three college men protecting the virtue of the woman they all love, is a parody of an early twentieth-century book series, *The Rover Boys*, and draws heavily on conventions of melodrama. It opens with old-style titles, written with curled ink lines and framed by a lace doily. A manly **voice-over** introduces Pimento University, abbreviated "PU" or, as we hear, "good ol' pee-ewe," a pun on the shorthand way of describing something that smells bad. This gag is extended as the Sportsmen Quartet, a group well known from radio, sing an *a cappella* ode to the school to the tune of *Sweet Genevieve*, a classic serenade by Henry Tucker written in 1869. The score continues under the narrator's introduction of the main characters, which occurs after a goofy man momentarily interrupts the scene: we meet the three Rover brothers, one muscled, one thin, and one round.

Stylized and relatively restrained movements allow the viewer to appreciate the strong design elements in this film. In the opening scene, the men—Tom, Dick, and Larry—cycle across the landscape on bicycles, on their way to see their collective fiancée, the dainty Dora

Standpipe. Both the men and Dora move in stylized ways—in her case with a tilted slide across the floor. The film includes long, still shots that are accompanied by narration: for example, a still image of the academy where Dora lives, during which the boys remain mainly or completely off screen. The film's central conflict comes in the form of the villain—the coward, bully, cad, and thief Dan Backslide—as he pursues Dora for his evil ends. Though he also holds poses on screen, at times he moves with a speed indicated through the use of a kind of "**smear**" **technique** of wiping exaggerated action over a small number of frames. The humor of his character is developed through the funny way he moves, as well as his over-the-top melodramatic voice acting, provided by Mel Blanc. The film was animated by Robert "Bobe" Cannon, who would become one of the central figures at the influential United Productions of America (UPA) studio in the 1950s (see p. 210).

Animation at MGM

Tex Avery made his mark on animation history with a zany sensibility that seemed to have influenced the work of Bob Clampett while they were working together at Warner Bros. But it was after Avery left that studio and spent a number of years at Metro-Goldwyn-Mayer that he made probably his best-known work. MGM was the grandest of the Big Five studios during Hollywood's golden age in the 1930s and 1940s. It was formed in 1924 through a merger of several studios and a theater chain, and it grew into the most prestigious studio in Hollywood by aspiring to have "all the stars in heaven" on its lot. MGM was known for lavish live-action features, including big Technicolor spectaculars, and for contracting a range of top performers. During the early 1930s, it also released popular comedies from the Hal Roach Studios, and in 1939 it produced two very famous films, *Gone with the Wind* and *The Wizard of Oz* (both directed by Victor Fleming).

MGM first distributed animation in 1930, when it contracted with Pat Powers's Celebrity Pictures for the "Flip the Frog" series, animated by Ub Iwerks. Iwerks had left Disney that year, lured away by Powers's offer of representation, and he set up a studio that eventually employed fellow Disney deserter Carl Stalling, as well as Grim Natwick, Shamus Culhane, and Chuck Jones (who began his career there as a cel washer). The first "Flip the Frog" film, *Fiddlesticks* (1930) (see p. 113), is in two-color (red and green) Technicolor, and uses the Powers Cinephone sound system. It is reminiscent of the films Iwerks made for Disney in the late 1920s, including *Steamboat Willie* (1928) and *The Skeleton Dance* (1929). In the film, Flip and some other characters dance to music in a continual kind of stage show, generally facing the camera. Flip lacks personality, and cycles of action are used to fill out the film's six minutes. Iwerks's *Spooks* (1932) **(8.10)**, from a few years later, has even stronger parallels to his work at Disney, with dancing skeletons closely recalling those in *The Skeleton Dance*. "Flip the Frog" continued for three years, from 1930 to 1933, after which MGM contracted with Powers for one year of a new Iwerks series, "Willie Whopper."[7] In 1934, as Iwerks's contract was ending, Hugh Harman and Rudy Ising began production for MGM. The Bosko character, which was their property and so had traveled with them, was included in some episodes of their new music-centered series, "Happy Harmonies." These films began in Cinecolor and then were produced in Technicolor

8.10 Ub Iwerks, *Spooks*, 1932

(following the end of Disney's exclusive deal to use the process in animation).

In the late 1930s, MGM revamped its animation offerings. Not only did it contract Oskar Fischinger to create the Modernist short *An Optical Poem*, which was released in 1937 (see p. 82), but it also set up its own studio, headed by the producer Fred Quimby. Quimby had been in charge of MGM's live-action shorts units; though he had little experience with animation, he nonetheless remained in the position until 1955. Offering large salaries, the studio hired away some of Harman and Ising's staff, including the director Bill Hanna (1910–2001) and storyman Joe Barbera (1911–2006), artists who would later make a huge contribution to the studio's legacy. In 1939, Harman and Ising were themselves hired back, in an effort to spark production. First, they developed a successful new series, "Barney Bear," which debuted with Ising's *The Bear Who Couldn't Sleep* in 1939. The following year, in 1940, the studio's most successful series, "Tom and Jerry," was introduced with a film called *Puss Gets the Boot*, which originally introduced the characters as a cat named Jasper and a mouse named Jinx; although Ising gets the director credit, the film was directed by Bill Hanna and Joe Barbera, who would develop the adversaries into a seven-time Oscar-winning duo.

"Tom and Jerry"

Eventually, more than a hundred "Tom and Jerry" shorts would be released by MGM in the 1940s and 1950s (up until 1957, when the animation unit closed and Hanna and Barbera moved on to create their own studio and enter the field of television). Although the films are ostensibly about the rivalry between the cat and mouse, other characters have regular roles and contribute to the story in significant ways. One of them is Mammy Two-Shoes, a black woman voiced by the actress and singer Lillian Randolph; she was shown mostly as a pair of legs walking through a scene, and was possibly a maid or the homeowner (8.11). She is already present in *Puss Gets the Boot*, in which she kicks the cat out of the house after the antagonistic mouse causes him to shatter a number of plates. In the 1960s, Mammy Two-Shoes was the subject of censorship as the studio prepared the series to show on televison; her legs were painted in a lighter shade and she was given a new voice, which no longer suggests that the character is African American.[8]

8.11 Mammy Two-Shoes in *Puss Gets the Boot* (dir. Rudy Ising; Bill Hanna and Joe Barbera are uncredited), 1940

A characteristic of the "Tom and Jerry" films is a tendency to combine relatively sentimental material with extreme violence. One example is the Oscar-winning *The Two Mouseketeers* (1952) (8.12), set in a French castle, in which the mice leave the scene of destruction knowing that Tom is about to be guillotined; the baby-like mouse character Nibbles shrugs off the fate of the poor pussycat with a complacent shrug, exclaiming, "C'est la guerre!" ("That's war!"). The Nibbles character was voiced by the child actor Françoise Brun-Cottan, which added authenticity to the mouse's youth. The success of *The Two Mouseketeers* prompted development of three more Mouseketeer adventures, including *Touché, Pussycat!* (1954), *Tom and Chérie* (1955), and *Royal Cat Nap* (1958) as part of the larger "Tom and Jerry" series.

The MGM animation studio composer Scott Bradley (1891–1977) provided scores for the series and almost all the other animated shorts made during his tenure at MGM. He had begun his career in the early 1920s, composing for theater in Houston before moving to Los Angeles in 1926 and working in radio and local concert performances. He scored a number of films at the Iwerks studio before moving to MGM, where he worked from 1934 to 1957, when the studio closed. Bradley thought highly of cartoon music and considered it an art form with largely untapped potential.[9]

Tex Avery

By 1942, Tex Avery (1908–1980) had joined MGM's animation studio and begun directing such films as *Red Hot Riding Hood* (1943) and *King Size Canary*

8.12 Bill Hanna and Joe Barbera, *The Two Mouseketeers*, 1952

(1947), featuring highly stylized images and dynamic storytelling. *Red Hot Riding Hood* **(8.13)** showcases the talents of the animator Preston Blair, who remarkably drew the sexy singer Red without reference to live-action footage. The film follows a lusty wolf who longs to be with Red but has to contend with a grandma who has similar feelings for him. The original ending of the film, where grandma and the wolf are married with children, was changed—likely because of the Production Code's reading of the material as an allusion to bestiality.[10]

Avery also directed a number of parodies of promotional films, all focusing on technology: these include *The House of Tomorrow* (1949), *The Car of Tomorrow* (1951), *TV of Tomorrow* (1953), and *The Farm of Tomorrow* (1954) **(8.14**, see p. 140**)**. Avery showed that animation could break every law of reality in terms of movement, and he catered to an adult sensibility, subverting expectations and taking an irreverent look at contemporary culture. Although Hanna and Barbera were at the studio at the same time, the directors' sensibilities differed greatly and there was little

8.13 Promotional cel painting for *Red Hot Riding Hood* (dir. Tex Avery), 1943

8.14 Tex Avery, *The House of Tomorrow*, 1949

interaction between the two units.[11] While he was at MGM, Avery also created the characters Droopy and Screwy Squirrel. Droopy, who first appeared in 1943, was lethargic, but still smart enough to outwit antagonists. Avery's completely unpredictable and ultra-violent Screwy Squirrel lasted for just five films, which were released between 1944 and 1946. Avery's final films at MGM were released in 1955, after which he worked at the Walter Lantz studio for a few years.

Conclusion

The 1930s and 1940s saw the development of the golden age of American animation, largely around the comedy styles of such studios as Disney, Fleischer, and Warner Bros. At the same time, however, the world as a whole was going through a period of great darkness. The events that would lead to World War II were unfolding in Europe and Asia for much of the 1930s, culminating later in that decade in battles on a number of fronts. America was largely on the sidelines until 1941, when its territory, Hawaii, was bombed by the Japanese at Pearl Harbor. At that point, the momentum building in the Hollywood film industry in the 1930s was channeled into patriotic support of America and the war effort. During the period of 1942–45, the animation industry did its part to belittle the enemy and keep spirits up, encouraging support among both troops abroad and citizens at home.

Notes

1 Ethan de Seife, "Frank Tashlin," *Senses of Cinema* 29 (December 2003). Online at http://sensesofcinema.com/2003/great-directors/tashlin/

2 E. C. Matthews, *How to Draw Funny Pictures* (Chicago, IL: Drake, 1928). Cited in Terry Lindvall and Ben Fraser, "Darker Shades of Animation," Kevin Sandler, ed., *Reading the Rabbit* (New Brunswick, NJ: Rutgers University Press, 1998), 121–36.

3 Ruth Vasey, *The World According to Hollywood 1918–1939* (Madison, WI: University of Wisconsin Press, 1997).

4 Karl Cohen, *Forbidden Animation: Censored Cartoons and Blacklisted Animators in America* (Jefferson, NC: McFarland, 1997), 70–71.

5 *Citizen Kane* is an unauthorized dramatization of the life of William Randolph Hearst, and the term "Rosebud," uttered in a close-up of Kane's mouth, is part of its central mystery. It is said that the term was a reference to Hearst's nickname for part of his girlfriend's body.

6 Chuck Jones, "Music and the Animated Cartoon," *Hollywood Quarterly* (1946), 69–76.

7 In 1934, Iwerks was also working on another series, the "Comicolor" cartoons, using the two-strip Cinecolor process (resulting in blue-green and red-orange hues), which Powers released independently. By 1936, Iwerks was working for others, including Warner Bros. and Charles Mintz, who distributed the "Color Rhapsodies" series through Columbia from 1937 to 1940. In 1940, he returned to Disney, where he mainly worked on technology development.

8 Karl Cohen, *Forbidden Animation*, 57.

9 Ian Allison, "Cartoons as Modern Art: A Scott Bradley Retrospective," *Spitfire Audio* (2012). Online at http://www.spitfireaudio.com/cartoons-as-modern-art-a-scott-bradley-retrospective.html

10 Michael Barrier, *Hollywood Cartoons: American Animation in Its Golden Age* (New York: Oxford University Press, 1999), 410.

11 Leonard Maltin, *Of Mice and Magic: A History of American Animated Cartoons* (1980. New York: New American Library, 1987), 414.

Key Terms

anthropomorphic	parody
caricature	satire
cycle	smear technique
intertextual	stereotype
limited animation	synchronized dialogue
melodrama	voice-over

3

Japanese Americans are
relocated to be housed in
internment camps in the US
1942–46

"Private SNAFU" series
is produced by the US
War Department
1943–45

World War II (US joins December 7, 1941)
1939–45

1929
Felix the Cat is selected
for the first experimental
television broadcast in
the US

1935
The New Gulliver (Aleksandr
Ptushko), a live-action and
animation feature, is made
in the USSR

1936
The Soyuzmultfilm studio is
established in Moscow

1937
In Munich, the Nazis
hold the Degenerate Art
Exhibition, which includes
many abstract works

1939
The National Film Board of
Canada (NFB) is established
by the documentary
filmmaker John Grierson

1940
Britain's leading animation
studio, Halas & Batchelor
Cartoon Films, is founded

1941
Walt Disney and studio
artists, including Mary
Blair, participate in a
"Good Neighbor" tour of
Latin America

The NFB's animation
division begins when
Norman McLaren is hired

1941
*Boogie Woogie Bugle Boy of
Company "B"* (Walter Lantz)
reflects the integration
of African Americans into
the military, using familiar
stereotypes

Princess Iron Fan (Wan
Guchan and Wan Laiming)
is China's first animated
feature

1942
Draftee Daffy (Bob
Clampett) uses comedy to
address the fears of the
American home front

The Dover Boys (Chuck
Jones), from Warner Bros.,
demonstrates a modern
aesthetic

1943
The Japanese film
Momotaro's Sea Eagle
(Mitsuyo Seo) depicts the
bombing of Pearl Harbor

1944
The Negro Soldier (Stuart
Heisler), a documentary
film, aims to improve
attitudes to black
servicemen in America

1945
The United Film and Poster
Service, established in
1943, is renamed United
Productions of America
(UPA)

The Bŕatri v Triku
studio opens in Prague,
specializing in 2D animation

1945
The House Committee on
Un-American Activities
(HUAC) investigates
Communist sympathizers
in America

1945 August 6 and 9
America drops atomic
bombs on Hiroshima
and Nagasaki

1947
Studio Loutkoveho Filmu
is established in Prague,
specializing in stop-motion
animation

1947
Cold War tensions
develop between the two
superpowers, America and
the Soviet Union; they last
until 1991

1948
A US Supreme Court ruling
makes the practice of
block-booking films illegal

artime and Midcentury

■ Technological development ■ Development of the animated medium ■ Development of the film industry as a whole ■ Landmark animated film, television series, or game ■ Historical event

1966–76 Cultural Revolution in China

1949
Jay Ward Productions produces the first American made-for-television animated series, "Crusader Rabbit"

1951
Gerald McBoing Boing (Bobe Cannon) accentuates UPA's modern, graphic style

1952
In France, Marie-Thérèse Poncet writes the first academic dissertation on animation

1952
Neighbours (Norman McLaren) is released as an anti-war film

1953
Toot, Whistle, Plunk, and Boom (Ward Kimball and C. August Nichols) reflects the influence of modern design on Disney artists

1954
Animal Farm (Joy Batchelor, John Halas) is Britain's first animated feature film

1954
French film criticism promotes the notion of the auteur and the director-driven work

1954
"Disneyland" television series begins

1955
Disneyland theme park opens in Anaheim, California

1957
The Shanghai Animation Film Studio is founded

Hanna-Barbera studio is founded

1960
The Hanna-Barbera series "The Flintstones" debuts in primetime

1961
Walt Peregoy uses the xerography process in the backgrounds for Disney's *One Hundred and One Dalmatians*

1961
Ersatz (Dušan Vukotić) is the first animated film outside the US to win an Oscar

1963
Ray Harryhausen creates the innovative stop-motion skeleton fight sequence for *Jason and the Argonauts* (Don Chaffey)

1963
Osamu Tezuka's "Astro Boy" series appears on Japanese television

1963
Filmation Associates is established

1965
The Hand (Jiří Trnka) includes commentary on government oppression

1970
UPA studio closes

1972
Hanna-Barbera Australia opens

Animation in World War II

Chapter Outline

Global Storylines

During the war, animation becomes
an essential tool, used for propaganda,
to inform the public, and to educate
the troops

Popular characters (such as Donald Duck)
are used to "sweeten" messages about
fulfilling patriotic duty, while stereotypes
and caricatures are used to ridicule
enemy forces

In Germany, occupied France, and Japan,
animators strive to produce alternatives
to the popular animated films from the
United States

Introduction

World War II was a global event in which both civilian
and military resources were combined in a "total war."
In this context, the media were used—on the home front
of the engaged countries as well as the front lines of
military battles—to entertain and inform audiences, as
well as to persuade them. As part of the overall war
effort, governments harnessed posters, magazines,
newspapers, radio, and both animated and live-action
films to assist their work, monitoring and dictating
content to a great degree, not only in order to shape
the messages being disseminated, but also to prevent
sensitive material being leaked.[1] As a result, in countries
across the world, media censorship and regulation
were tightened.

In 1918, Germany had entered into its highly
creative Weimar period, a time that saw the development
of Modernist animation, including abstract works (see
p. 71). During this period, films were reviewed by the
Filmprüfstelle (Film Censorship Office), but relatively
lightly, and otherwise there was virtually no censorship
of German media. Things began to change in 1933,
when Adolf Hitler and the Nazis took control of the
country. Under this Fascist regime, all media were
placed under the jurisdiction of the Minister of
Propaganda, Joseph Goebbels. Abstract art of any
kind—including animation—was labeled "degenerate"
and forbidden, in part because it did not have a clear
message and was therefore potentially subversive, as
censorship became more deeply concerned with both
aesthetic and political content.

In the United Kingdom, the British Board of
Film Censors, an industry organization, had been
established in 1912 to monitor film production, but
after the country declared war in September 1939,

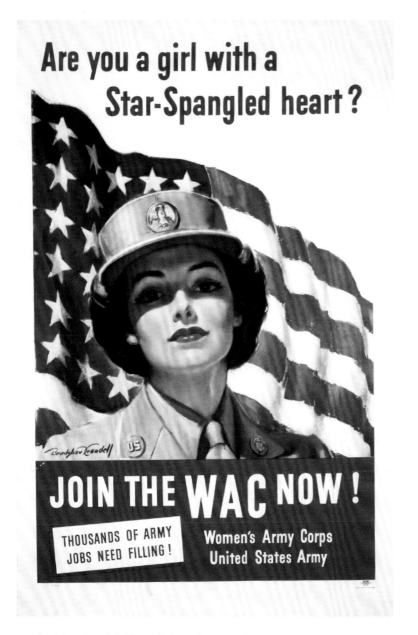

Are you a girl with a Star-Spangled heart?

JOIN THE WAC NOW!

THOUSANDS OF ARMY JOBS NEED FILLING!

Women's Army Corps United States Army

9.1 Bradshaw Crandell, Women's Army Corps recruitment poster, 1943

animation was to play an important role in the war effort by instilling patriotism in viewers both at home and abroad and boosting morale in the face of the many sacrifices being made not only by troops, but also by those left behind to support them and await their return. In America, the first World War II-related animated shorts appeared in late 1940,[2] at a time when the US government was already preparing its citizens for the likelihood of war, and with it the enlistment of soldiers. The Selective Service (known as "the draft") had been around since World War I, but the Selective Training and Service Act of 1940 established the first peacetime conscription in US history; all men between the ages of eighteen and sixty-five had to register. Although they were not required to serve, many women also signed up to work as nurses, or to take on relatively simple clerical duties to liberate male military personnel for other tasks. Some women joined a variety of military services **(9.1)**; others assisted the military through their work with such organizations as the American Red Cross, the United Service Organizations (USO), and the Civil Air Patrol.

This chapter surveys the developments of World War II and the ways in which animation was used in wartime. It focuses on characterizations of the enemy and the use of satire to mock the opposing forces. It also shows how such characterizations were problematic for the US, as they drew attention to some of the social problems being faced within its own borders. One of the most obvious of such problems was racial discrimination, especially in the oppression of black citizens, but clearly extending to other people of color. Steps toward the integration of American society came during the war, but such changes were largely motivated by the need for soldiers to populate the armed forces, rather than any obligation to right past wrongs. Latino soldiers were largely integrated with the white troops, but Asian American and African American troops were placed in segregated units.[3]

a new organization, the Ministry of Information, was set up, and its Films Division took over that role. In America, the Office of War Information (OWI) was created in 1942 to consolidate government information services. Operating from June of that year until September 1945, it coordinated the release of war news for domestic purposes and took on many of the functions of previous censors, including the Production Code Administration, established in 1934 (see p. 117). The OWI also maintained an overseas branch that produced a large-scale international information and **propaganda** campaign, making use of all available media. In the United States, as in other countries,

9.2 Stuart Heisler, *The Negro Soldier*, 1944

Black soldiers had had at least a small presence in virtually all American military conflicts, even while facing great discrimination. In 1925, however, an Army War College report, "The Use of Negro Manpower in War," revealed that black Americans were not considered suitable for the front line because they were thought to lack sufficient intellect and bravery: they were effectively banned from the military as "unfit for service."[4] The realities of World War II forced the military to look for enlistees wherever it could find them, and various organizations and individuals were demanding that the government improve its standards of equality. An important milestone was the release of the live-action film *The Negro Soldier* (dir. Stuart Heisler, 1944), which summarized the contributions

of black soldiers throughout American history and helped change attitudes toward black servicemen (**9.2**).

Animation and the War Effort

During World War II, the American government monitored the work of Hollywood film studios and other commercial media producers; however, it also generated its own productions at military studios, where filmmakers were enlisted to serve their country. Animators at these facilities created short films and **motion graphics**, such as animated maps and moving diagrams, for documentaries. Many films for the war effort were produced through the Army Signal Corps., an organization that had been formed many years before to disseminate information throughout the American armed forces. To meet the increased requirements of wartime production, in early 1942 military officials met with Jack L. Warner, the vice-president in charge of production at the Warner Bros. studio, to develop the First Motion Picture Unit (FMPU), a US Army Air Force organization that would produce documentary and training films (**9.3**).[5]

At this time, all motion-picture studios were called on to contribute to the war effort. For instance, the Detroit-based Jam Handy Organization was a major producer of advertising, training films, and motion graphics for General Motors and many other clients, but during World War II it made about two thousand

9.3 Warner Bros. studio, left: *The First Motion Picture Unit*, 1943. Right: *Photographic Intelligence for Bombardment Aviation*, 1943

The Events of World War II

Following World War I, which ended in 1918, a lingering economic crisis led to unrest in many countries across the world. These unstable economies prompted changes in governmental power, including the growth of Fascism and authoritarian national rule. During the 1920s and 1930s, several Fascist dictators rose to power and initiated policies of aggressive militarism. Among them were Benito Mussolini (called "Il Duce"), who became the Italian prime minister in 1922, and Hirohito (Emperor Shōwa) of Japan, who ascended to the throne upon the death of his father in late 1926. In Germany, the Fascist leader Adolf Hitler was sworn in as chancellor in 1933, ending the liberal period known as the Weimar Republic, while in Spain, the civil war, instigated by the country's Nationalists and fought between 1936 and 1939, brought Francisco Franco to power, with the support of Mussolini and Hitler.

Three of these Fascist leaders—Hirohito, Mussolini, and Hitler—shared similar goals, which they eventually pursued as a coalition of Axis powers during World War II (Franco remained neutral). The Axis leaders were set on expanding their empires and began their advances separately during the early 1930s. In 1931, Japanese forces invaded Manchuria and then, from 1937 to 1941, engaged in the brutal Second Sino-Japanese War with China. In 1936, Mussolini led Italy in an invasion of Ethiopia. At the end of the decade, political tensions escalated as Hitler formulated aggressive policies in an attempt to regain the national pride lost by Germany during World War I. The antagonism reached breaking point when Germany invaded Czechoslovakia and Poland in 1939, prompting France and most of the British Commonwealth to declare war.

Soon there were two sides drawn. Germany, Italy, and Japan were the leaders of the Axis, supported by such countries as Hungary, Romania, Bulgaria, Finland, and Iraq. Opposing them were the Allies, eventually under the leadership of the British Commonwealth, the Union of Soviet Socialist Republics, and the United States of America. Many European countries, along with the Union of South Africa, Brazil, China, and others, were aligned with the Allies in fighting against the Axis powers, and pockets of resistance developed in countries that had been taken over by Fascists. For example, Germany occupied France for four years, beginning in 1940. There, the French Resistance used guerilla fighting tactics to help defeat the Nazis. In Italy, resistance fighters known as Partisans also battled against Nazi occupation of their country.[7]

America entered World War II after Japan attacked European and US territory in the Pacific Ocean, including Hawaii. More specifically, the US joined the Allied forces when the Japanese bombed Pearl Harbor on the Hawaiian island of Oahu on December 7, 1941. The following year, with America's entry into the war and advances in military strategy, the Axis was halted in its advance and began to retreat, but the war did not end until three years later. In Europe, Germany surrendered unconditionally on May 8, 1945. Later that year, Americans dropped atomic bombs on Hiroshima (August 6) and Nagasaki (August 9) and made a series of devastating attacks on other cities. Those events led to Japan's surrender on September 2, 1945.

It took many years to bring war criminals to international courts, and some of the most notorious—including Hitler and Mussolini—were never prosecuted. Hitler took his own life to avoid capture, while Mussolini was jailed, but escaped and was later murdered by the Partisans, who unceremoniously displayed his nude body, hanging it upside down in a public place. Hirohito lived on for many years, to die of cancer in 1989; that he was never held accountable for war crimes generated a great deal of controversy.

animated productions for military purposes, probably more than any other American studio.[6] The Walt Disney Studios served as an actual military facility as it produced many war-related productions. These films were frequently in the form of animated shorts, but the studio also released the seventy-minute live-action and animation film *Victory through Air Power* (dir. H. C. Potter; supervising animator, David Hand) in 1943. It is based on the bestselling book of the same name, written in 1942 by Alexander P. de Seversky, a Russian-born naval pilot who had served in World War I. After that war, De Seversky had established an aviation company, and he became a leading voice in arguing for the expansion of military aircraft in America.

Identifying the Enemy

One of the most important aims of war propaganda was to make victory seem achievable. To do so, it was important to emphasize the weaknesses in the enemy's leadership and to portray the enemy as not only inhuman, but also of low intelligence. Given

their satirical tradition, animated shorts were an ideal medium to use during World War II to belittle the enemy. The three Axis leaders were usually reduced to a laughable trio, with Hitler as the inept leader and Mussolini and Hirohito as his mindless lackeys. This kind of depiction is found in a Soviet film of 1942, *Kino-Circus* (9.4), which mocks Hitler in three acts, performed on a stage and introduced by a figure reminiscent of Charlie Chaplin. For example, Act I begins with "Adolph the dog trainer and his two pooches," which gnaw on bones in the New Europe Restaurant. The film was directed by L. Amalrik and O. Khodataeva at Soyuzmultfilm (see p. 172).

Two films from 1943, Lou Bunin's *Bury the Axis*, produced in England (9.5), and *Der Fuehrer's Face*, directed by Jack Kinney at The Walt Disney Studios, were also effective propaganda tools. Using stop-motion puppets, *Bury the Axis* creates grotesque caricatures of the three enemy leaders, and features a musical number in which they sing about their exploits. The film opens with baby Hitler appearing as a stork's bundle dropped from the sky before emerging from his swaddling shooting a gun. He then goose-steps along with a small flock of geese and brags of his accomplishments, until he reaches Russia, returning in bandages after his "goose is cooked," a reference to his unsuccessful attempt to invade the country in 1942. Mussolini and Hirohito, are similarly mocked, and it seems clear that this trio is no match for the Allied powers, as the voice-over narrator declares in a heavy New York accent.

In *Der Fuehrer's Face*, Donald Duck faces a crisis when he wakes up in a Nazi world, where he is forced to do hard labor. In this film, Hitler is once again the main target of derision, as he and his Nazi soldiers are mocked through the lyrics of the accompanying Spike Jones song; raspberry sounds and descriptions sung in an effeminate manner mock these "super-duper super men." In Donald's oppressive world, everything is decorated with swastikas, and objects all around him perform "Heil Hitler" salutes. In his home, food and drink are in short supply, and later he is prevented from taking time off to enjoy himself. Instead, Donald is forced to work on a factory line, building more and more bombshells for Hitler, until he finally explodes in a frenzy of hallucinatory images.

Disney's *Education for Death* (dir. Clyde Geronimi, 1943) takes a strongly propagandistic approach to explaining the enemy to its audience. The infamous film opens with an allusion to a book of the same name by Gregory Ziemer, a swastika, and a stern male voice-over asking the ominous question, "What makes a Nazi? How does he get that way?" The ten-minute documentary shows how the sweet child of a powerless German couple is thrown into a system of government-mandated "education" that eventually warps his mind and turns him into a killer. Although much of the film is educational in tone, it also incorporates parody—for example, in mocking Germany and Hitler, which are respectively represented as a "sleeping beauty" who is really an unsophisticated,

9.4 L. Amalrik and O. Khodataeva, *Kino-Circus*, 1942

9.5 Lou Bunin, *Bury the Axis*, 1943

ugly Brünnhilde, and a snorting "knight in shining armor," who is weak, ineffectual, and pompous.

The objective of such propaganda films as *Der Fuehrer's Face* and *Education for Death* is to show how bad life is for the enemy, but this is an approach that works equally well for both sides of a conflict. After all, citizens of Allied nations—like Donald in his Nazi nightmare—were themselves being asked to work long hours creating weapons, and to make sacrifices as far as food and travel were concerned, following the dictates of military leaders. It is therefore not surprising that films created by the Axis targeted the lifestyle and leadership of the countries they were fighting. An example is found in *Dr. Churkill* (dir. Luigi Liberio Pensuti), released in Italy in 1940. Relatively serious in tone, the film presents the British prime minister Winston Churchill as a monstrous creature, who uses a potion labeled "democracy" to keep him looking human while he grabs money from hardworking laborers everywhere he goes—until he is confronted by swastika-wearing forces and their weapons.

The Enemy Within

During World War II, the enemy was not only defined in terms of opposing nations, but also as groups of individuals who were found within a country's own borders, a xenophobic mentality that resulted in imprisonment and death. For example, the persecution of individuals under German regulations became increasingly codified after 1935, when the country initiated its Nuremberg Laws, limiting the rights not only of Jews, but also of the disabled, homosexuals, and Romani people, among others, all of whom were liable to extermination in concentration camps.

There were many ways that fear of such cultures was spread, including animation in the guise of entertainment. A well-known example is the film *Van den Vos Reynaerde* (*About Reynard the Fox*, dir. Egbert van Putten, 1941), which was produced at Nederland Film with the support of occupying German forces, though it was never publicly screened and today exists only in fragments. It is based on an anti-Semitic book from 1937 by the Flemish author Robert van Genechten. The sly character Reynard the Fox is familiar from traditional stories involving forest creatures; however, both the book and the film give prominence to a rhinoceros, Jodocus, who subordinates

the other animals, encourages different races to mix, and generally presents a threat to the natural order—in effect, representing an insidious Jew (9.6).

Among the aspects of World War II that remain most vivid in the human memory are the Nazi concentration camps, a network of more than forty facilities where Hitler enforced slave labor and the Nazis killed about 11 million people in an attempt to assure the supremacy of the Aryan "master race." Ironically, Hitler's vision was fueled by a movement that had grown out of the UK and America in earlier decades: eugenics. This concept was introduced in 1883 by the English scientist Francis Galton, who was a cousin of the evolutionist Charles Darwin. Eugenics is the belief that one's genealogy, or family tree, can dictate an individual's mental and physical health, behavior, and overall contribution to society. In America, the movement resulted in more than 60,000 compulsory sterilizations of disabled individuals, who were seen as a drain on the genetic pool. America's engagement in World War II eventually caused many in the country to re-evaluate their nation's own history of racism, discrimination, and violence, but significant change was slow to come.

During the war, there was a question of how to deal with "the enemy," including individuals of German, Italian, and Japanese descent who were living in America. After the bombing of Pearl Harbor, the Japanese were seen as a particularly significant threat to America's safety, and even American citizens of Japanese descent were not above suspicion. This way of thinking is illustrated in the Famous Studio production *Japoteurs* (dir. Seymour Kneitel, 1942) (9.7), which is part of the "Superman" series (see p. 123). The animated short shows how an ordinary businessman of Asian appearance changes his allegiance from the Statue of Liberty to the Japanese flag, saluting it with a bow. He is easily identified as Japanese because he sports the small eyes and thick, round glasses that were part of a stereotyped look. In addition, his actions are accompanied by the "Oriental riff," or conventionalized Asian-sounding music, which features a gong. Later, when the character makes an attempt to take over a new American plane, Lois Lane reports, "Japs are stealing the giant bomber." The man is also a kamikaze—one of the Japanese pilots commanded to fly their planes into their targets, causing their own deaths—and so

9.6 Egbert van Putten, *About Reynard the Fox*, 1941

9.7 Seymour Kneitel, *Japoteurs*, 1942

conforms to a stereotype about the tenacity of Japanese soldiers. This depiction helps us understand how American society could accept the existence of internment camps—called "relocation centers"—that were used in America to isolate individuals perceived

to be a threat to national security. They were initially established in early 1942, when the American military relocated more than 110,000 individuals living within 200 miles of the West Coast, mostly Japanese Americans but also Japanese nationals, to encampments across the country (ironically, young Japanese men from such camps would be encouraged to enlist in the US military). England also relocated its undesirables, in some cases sending them to Canada or Australia.[8]

The "Looney Tunes" short *Tokyo Jokio* (dir. Norman McCabe, 1943) takes a different look at the enemy. It is a "mockumentary" of Japanese life, beginning with a voice-over explaining that the film was captured from the enemy and provides a "typical example of Japanazi propaganda." In a newsreel-style format, the film features a series of short, gag-oriented vignettes. The first depicts a rooster about to crow, until a vulture breaks through its skin, saying "Eh, cock-a-doodle-do please," as a Japanese sun appears behind it. The voice-over continues to mock Japanese diction, while character designs conform to the convention of small eyes behind big glasses, and buck teeth in a constant smile. Topics in the newsreel cover incendiary bombs, food rationing, fashion, sports, and technology, in each case suggesting that the Japanese are not nearly as good as they pretend to be. Hitler and Mussolini are also mentioned, in the same mocking way.

African Americans in Wartime Animation

German, Italian, and Japanese characters were highly caricatured in American wartime animation, but it is interesting to note that some of its strongest stereotypes were reserved for black Americans. Laziness, ineptness, watermelon-eating, and other stereotypical attributes were applied in the name of humor, and singers in blackface remained common as well. A good example is *Any Bonds Today?*, a Warner Bros. release from 1941, directed by Bob Clampett and starring Bugs Bunny, with a song by Irving Berlin adapted for the film. In the one-and-a-half-minute short, Bugs does a simple dance while singing his song, encouraging viewers to "step right up and get them," meaning war bonds, in order to support freedom. But then, mid-dance, he suddenly shifts to singing "Mammy" in blackface, as if he were Al Jolson, for no apparent reason. This sort of casual embrace of a blackened face reflects just how ingrained the tradition was in American culture. From about 1830

9.8 Walter Lantz, *Boogie Woogie Bugle Boy of Company "B,"* 1941

until World War II, minstrel shows were a popular form of variety theater, generally starring white performers who performed as blacks; many of the stock characters of these shows contributed to long-standing stereotypes, including the strong-willed Mammy, the good-hearted Uncle Tom, and the uneducated pickaninny children.

From Universal, Walter Lantz's *Boogie Woogie Bugle Boy of Company "B"* (1941) provides a glimpse of the changing role of African Americans in society, even as it perpetuates stereotypes that undermine this progress **(9.8)**. The film, which was animated by Alex Lovey and (La)Verne Harding, is based on the hit song of the same name popularized by the Andrews Sisters. In the film, the main character is an accomplished trumpeter from Harlem, an area of New York City that had been the site of great social, cultural, and intellectual developments by African Americans during the 1920s and early 1930s. This character, known as "Hot Breath Harry, the Harlem

Heatwave," is blowing his horn center stage one night when he receives a notice from the draft board. Although he resists at every step, he ends up in the military, in an all-black unit: as he is told, "You is in the Army!"

In the film, the character designs and voices of black characters are relatively varied, although stereotypes are used to suggest humor: dice instead of teeth, upturned eyes that emphasize the whites, or a lowbrow manner of speaking, combined with timidity, as when Harry sees a man on a stretcher and nervously asks, "Who dat?" Although characters range widely in body type and facial appearance, many sport enlarged lips suggestive of blackface. When three dark-skinned women come to the camp, however, they are all of the same model, sexualized through thin waists and jaunty breasts according to the stereotype of an attractive female. These ladies display none of the small measure of diversity afforded to the male

characters, who not only look different but are also responsible for a variety of duties, from kitchen help to weapons training. Though these activities might not seem like much by today's standards, at the time, a lot of the American public was still getting used to the simple notion of black soldiers in its military.

Animation with an Agenda

Donald Gets Drafted: America Prepares for War

Although America had initially remained outside the conflict of World War II, by 1940 government leaders were preparing for the country's entry into war and began to bolster its troops, initiating the draft that required all able-bodied young men to serve. Understandably, this development caused a great deal of concern among American citizens. Though it was difficult to put a positive spin on recruitment, animated shorts seemed well equipped to address the public's anxiety about the process. Examples are found in *Donald Gets Drafted* (dir. Jack King, 1942), a Disney production released by RKO, and *Draftee Daffy* (dir. Bob Clampett, 1945) **(9.9)**, released by Warner Bros., two films that express the potentially frightening realities of the draft in different ways. *Donald Gets Drafted* is the first of Donald's wartime films, and in it he is inducted into service. Donald cheerfully receives his conscription

papers, buying into lyrics that state "The Army's not the Army anymore," while posters promise that he will get breakfast in bed and that he will be more attractive to ladies. Things begin to go awry during the physical exam, when a doctor apparently finds he has "nothing" in his head, and his other exams are clearly rigged—but he still gets in. Though he is a relatively willing soldier, Donald has the misfortune of having Disney tough-guy character Pete as a drill sergeant, and things go downhill from there. In *Draftee Daffy*, an initially patriotic Daffy makes all kinds of exaggerated efforts to evade the "little man from the draft board" who shows up on his doorstep. He barricades the door and window, runs away, and even tries to bomb him, but the draft man is relentless and apparently indestructible. Daffy never accepts his fate and continues to run scared until the end.

Of course, the draft was just the beginning, the entry into military service. Next came active duty, which was not only dangerous but could also be boring and plagued by bureaucracy. At Disney, Donald Duck appeared in a wide range of service-related films, such as *Sky Trooper* (1942), *Home Defense* (1943), and *Commando Duck* (1944), all directed by Jack King. Other Disney characters also donned military uniforms; for example, Pluto appears in *Private Pluto* (dir. Clyde Geronimi, 1943), where he has to protect military equipment from two mischievous squirrels (who would later become Chip and Dale), and Goofy presents a mock history of sailing in *How to Be a Sailor* (dir. Jack Kinney, 1943).

9.9 Bob Clampett, *Draftee Daffy*, 1945

Lessons Learned through Animation

Animation was embraced as a means of teaching important lessons to troops, many of whom lacked literacy skills. Some of the training materials contained sensitive information and so were considered "classified," or secret; for instance, this status was given to the biweekly newsreel, "Army–Navy Screen Magazine," produced by the Army Signal Corps between 1943 and 1945. Included in it was an animated series known as "Private SNAFU," which was mainly directed by individuals at Warner Bros.'s Schlesinger studio (9.10). The series taught the troops about such topics as rumors, booby traps, and camouflage; "SNAFU" stands for "situation normal, all fouled up," to suggest the many mishaps that can confront a military soldier who is not careful. For instance, the *Spies* episode, directed by Chuck Jones in 1943, emphasizes the importance of keeping military secrets. In the film, the half-witted central character, Snafu, voiced by Mel Blanc, leaks information to the enemy with devastating results. Written by Theodore Geisel (1904–1991), later better known as Dr. Seuss, this film and some others in the series have rhyming lyrics that are lighthearted and told almost like a children's story. The content is definitely intended for adults, however: after getting drunk, Snafu meets a "babe" whose breasts become radio transmitters, and later he finds himself in Hell, looking at the behind of a donkey.

A different approach was taken by the British animation studio Halas & Batchelor, which made many films for the war effort (9.11). Its animated short *Six Little Jungle Boys* (1945) warns troops of the myriad dangers waiting for them on the battlefield. At the beginning of the film, six identical men kiss their six

9.11 Joy Batchelor, of Halas & Batchelor, working at her studio in London, England, c. 1954

identical girlfriends before proudly marching off to war. In the jungle, one by one, the troops fall away, succumbing to such ailments as foot rot, scrub typhus, dysentery, malaria, and, when a beautiful woman enters the story, venereal disease. The one soldier who took all the proper precautions earns a medal of valor, when he returns home, all the girlfriends run to him—but his own girlfriend pulls him away, and he follows her with a twinkle in his eye. Whereas Snafu represents a laughable caricature without an equivalent in real life, the jungle boys are the everyman who could easily encounter these problems. The only characters in the film that are distinctive are the exotic temptress and the enemy, who appear in the form of gorilla-like creatures.

9.10 Chuck Jones, *Spies*, from the "Private SNAFU" series, 1943

Rallying Forces on Two Fronts

After the soldiers left for war, the individuals who stayed behind formed the "home front," the people fighting the war from home. They were asked to do their part in support of the troops "over there," in the name of patriotism and freedom. Taxes were raised to generate income, food was rationed, and it was difficult to buy certain products, such as car tires, because they were made from materials that were needed for the war effort. People were encouraged to drive no faster than 35 miles per hour in order to conserve gasoline, which was also rationed, and they were advised to ask themselves, "Is this trip really necessary?" whenever they traveled. Extravagant clothing was discouraged because cloth, too, was needed for the war. Although a thriving black market developed in such goods as meat and sugar, it was illegal, and worse, unpatriotic, to procure things that way. Animated films provided an ideal platform from which to address these and other subjects, often adding a spoonful of sugar to wash down the bitter taste of reality.

In America, every able-bodied adult not on active duty was expected to contribute to the war effort as part of the home front. In the film *Swing Shift Cinderella* (1945), directed by Tex Avery, a nightclub singer must get home in time to do her part **(9.12)**.

Many people worked the late-night "swing shift" at a second job, often involving the manufacture of war equipment. Since these employees were not trained factory workers, they had to be educated in an efficient and thorough manner. The Walt Disney Studios saw the situation as an opportunity: it had begun to receive military contracts by 1942, and was soon creating films, animated graphics, and insignia for the military. Disney also started releasing animated instructional films for other clients that year, with *Four Methods of Flush Riveting*, made for the Lockheed Aircraft Corporation.

This film, along with a number of others from Disney, was also purchased by the National Film Board of Canada (NFB, see p. 177), which produced many of its own wartime productions, both live-action and animated, to rally its own home front.[9] The NFB had been operating since the late 1930s, with the documentary filmmaker John Grierson (1898–1972) leading its development. To gear up production of its own animated shorts, Grierson asked the Scottish animator Norman McLaren (1914–1987) (see p. 177) if he would join the organization and make films for the war effort. McLaren accepted and created *V for Victory* (1941) **(9.13)** (see p. 156), *Five for Four* (1942), and *Dollar Dance* (1943)—all related to wartime finances (bonds, savings, and so forth)—as well as *Keep Your Mouth Shut* (1944), a dramatic

9.12 Tex Avery, *Swing Shift Cinderella*, 1945

9.13 Norman McLaren, *V for Victory*, 1941

film about the importance of keeping information secret. It features a stop-motion skull **intercut** with scenes of disaster resulting from the secrets it hears.

In the US, life on the home front inspired many animated shorts—for instance, dealing with the subject of rationing, as in the "Popeye" film *Ration fer the Duration* (dir. Seymour Kneitel, 1943), a twist on the "Jack and the Beanstalk" story that leads Popeye to a hoarding giant. Shortages are the topic of *Donald's Tire Trouble* (dir. Dick Lundy, 1943), where the duck's fast, reckless driving leads his already patched tires to spring yet another leak. In the "Woody Woodpecker" film *Ration Bored* (dir. Emery Hawkins, 1943), we see Woody blatantly disregarding restrictions on unnecessary travel, going so far as to steal gas from other cars when he runs out. After he takes some from a policeman, he pays a high price, but he remains his wisecracking self, disregarding rationing rules to the end.

The war effort was supported through taxation and the purchase of war bonds, which were sold to the public and then repaid several years later with interest. Reminders to buy war bonds were everywhere, including in animation. One example is *Seven Wise Dwarfs* (dir. Dick Lyford and Ford Beebe), which was created at Disney in 1941 using footage from *Snow White and the Seven Dwarfs*; it was commissioned by John Grierson for exhibition in Canada, but later also screened in US theaters. The film depicts the dwarfs

at work in their diamond mine, and then depositing their hard-earned cash into the bank in order to buy war bonds.

Convincing the public to spend its money "wisely" (that is, in support of the war) was among the more difficult tasks that the government faced, as was ensuring people paid taxes, which had risen considerably when America entered the conflict. A series of government-sponsored films emphasized the importance of patriotic duty and the threat of the enemy to encourage people to pay—and to pay on time. These films could be awkward in structure, sometimes combining lighthearted material with serious information in an uneasy mix. In *The New Spirit* (dir. Wilfred Jackson and Ben Sharpsteen), a film from 1942, a voice from the radio informs a somewhat reluctant Donald Duck that it is "your privilege, not just your duty" to support the war through income taxes. After overcoming his initial reluctance, Donald then demonstrates the process of filling out the form. Suddenly, the comical mood of the film shifts as the voice-over rather ominously explains how tax money is used to create "guns, all kinds of guns" and shows them being manufactured in a factory.

In a sequel, *The Spirit of '43* (dir. Jack King, 1943), Donald confronts the dilemma of how to spend his money. One side of his personality urges him to save some of his cash, although it is quite literally burning a hole in his pocket. Donald's more adventurous side encourages him to spend his money on girls and booze. Then Scrooge reminds Donald of his duty and a series of calendar pages show the fifteenth of each month. A voice-over explains that these dates are when "every American should pay his or her income tax gladly and proudly," adding that, "this year, thanks to Hitler and Hirohito, taxes are higher than ever before." The voice then goes on to say that every dollar a person spends on something unnecessary is a dollar that goes to support the enemy, so the choice is to "spend for the Axis or save for taxes," which conveniently provides a memorable

rhyme. The film then includes the same gun-manufacturing footage as is seen in *The New Spirit*.

The American film industry served its country by integrating wartime messages into its entertaining productions and boosting morale. Many celebrities participated in United Service Organizations (USO) performances, singing and dancing in shows held overseas, and there were other opportunities for them to show their patriotism as well. For example, in 1941, Walt Disney and several of his artists toured a number of Latin American countries in a "Good Neighbor" tour financed by the American government, in an effort to spread pro-American sentiment. Disney then produced some "Latin-American themed" films, including *The Three Caballeros* (supervising dir. Norman Ferguson), a feature released in 1944 and starring the well-known Latina entertainers Aurora Miranda, Carmen Molina, and Dora Luz (see p. 114). Animated characters, too, had star power that could be useful in the wartime context: Bugs Bunny, Mickey Mouse, and Bambi appeared on patches representing achievement in various branches of the armed forces, and sometimes animation-related characters were painted on military aircraft.

Wartime Animation outside the United States

German and Occupation Animation

By the time America entered World War II, its film industry had long ago won the battle of world popularity. American studio animation was widely favored by audiences, and within the context of ideological war, leaders of the Axis powers sought a means to break its hold. It would not be easy, but German and Japanese studios were called to the task.

The German studio Universum-Film-Aktiengesellschaft (UFA) had attempted to counteract the dominance of American animation by producing a number of animated shorts in the early 1930s. Some of them were directed by Paul Peroff (1886–1980), a Russian-born artist who had lived in America, studied at the Art Students League in New York, and worked in the print comic and film industry before moving to Germany in 1929.[10] He and other artists, such as

Hans Fischerkoesen, directed animated advertising at the studio. UFA curtailed production of its animated shorts by the mid-1930s, however, possibly owing to economic problems and the difficulty of competing with American production, since the US produced films more inexpensively than German studios could. In any case, American work was still welcome in Germany; in 1935, Walt Disney went to Munich and possibly Berlin to meet with industry and government officials, as part of a larger tour of Europe he had undertaken. In 1938, *Snow White and the Seven Dwarfs* (see p. 104) was widely screened in Germany to critical acclaim, though it had to be acquired through a special arrangement with the film's distributor, RKO.[11]

After coming to power in 1933, Hitler tasked Joseph Goebbels, his Minister of Propaganda, with overseeing all cultural production, including cinema. Around this time, the supportive policies and artistic institutions of the Weimar Republic came to an end, and many of its leading filmmakers fled. Among them was the abstract filmmaker Oskar Fischinger (see p. 80), who made his way to the United States in 1936. The following year, in 1937, Nazi officials collected several hundred confiscated abstract works and showed them in an exhibition, "Entartete Kunst" ("Degenerate Art"), which opened in Munich and then traveled through Germany and Austria. Oskar's brother, Hans (1909–1944), had stayed in Germany and continued to work on abstract film productions, despite increasingly harsh government censorship. Hans Fischinger finished his film *Tanz der Farben* (*Dance of Colors*) and screened it for about two weeks in 1939, until the rights were purchased by a government-controlled company that suppressed the film in Germany (but did show it in other countries).[12] He attempted to make another film, but in 1940 his work was interrupted when he was called for military service, from which he never returned.

Several noteworthy animators remained in Germany during the later 1930s, sometimes attempting to create narrative works that would compete with American films. Some efforts are clearly propagandistic; one example is *Der Störenfried* (*The Troublemaker*, 1940) a film by Hans Held in which a group of forest animals and insects drive away a fox through militaristic force. Many others were more neutral in tone. For instance, the German animator Hans Fischerkoesen (1896–1973), who worked in

advertising, did not produce animation that was overtly "pro-Nazi" (some of it may have been just the opposite). One of his better-known ads is the stop-motion film *Worthy Representation* (1937) **(9.14)**, a promotion for the Philips company, which demonstrates a valuable use of its light bulbs. In 1942, Fischerkoesen completed the animated short *Scherzo–Verwitterte Melodie* (*Weather-beaten Melody*), which introduces a jazz song into its narrative as it plays on a broken-down record player **(9.15)**. Since jazz was also considered degenerate by the Nazis and forbidden, some critics have seen this work as an example of resistance.[13]

France was occupied by Germany between 1940 and 1944, and occupation forces created the Comité d'Organisation de l'Industrie Cinématographique (COIC) to control every aspect of cinema in its territory. They banned double features (two long-format films shown together), but created rules that favored the inclusion of short subjects, which were not necessarily propagandistic in nature. American films were banned in the early 1940s, which meant that Disney, Fleischer, and Warner Bros. animation was no longer found in French cinemas, giving a boost to France's own production. The government stepped up training programs for animators and other studio personnel, and created a new financial structure that allowed profits to feed back into production of animated shorts.

Paul Grimault (1905–1994) and André Sarrut (1910–1997) had formed the French studio Les Gémeaux in 1936, intending to compete with American animation. It created advertising as well as short films and, eventually, longer works. The studio remained small, with around twenty employees, but it benefited from the new policies of the Occupation and the COIC. In 1943, it produced the critically acclaimed *Les Passagers*

9.14 Hans Fischerkoesen, *Worthy Representation*, 1937

9.15 Hans Fischerkoesen, *Weather-beaten Melody*, 1942

de la Grande Ourse (*The Passengers in the Big Dipper*, dir. Paul Grimault) **(9.16)**. The film, which was partly funded by the aviation company Air France, tells the story of a boy and his dog as they accidentally launch a large airship into flight and then encounter a number of mishaps, which range from humorous to suspenseful. The movements of the boy and his dog are loose and flowing, slightly recalling the animation of the earlier French classic *La Joie de Vivre* (*The Joy of Life*, 1934), which was directed by Hector Hoppin and Anthony Gross and reflects the Art Deco style (see p. 86). In Grimault's film, the design and animation of the boy and dog, with its curved lines and metamorphic quality, contrast with the stiff delineation of the robot character they meet on the ship, showing that the director was working with a range of visual styles. Shot in Agfacolor, the film features music by the well-known French conductor Roger Désormière.[14]

Cultural Identity in Japanese Animation

In 1936, Japanese animation artists, government officials, and scholars met at an event called the Manga Eiga Zadankai (Cartoon Animation Symposium) to discuss the challenging question of how a unique quality in Japanese animation could be preserved in the face of the domination of American work, due to its great popularity among Japanese audiences. The positive reception that Disney and Fleischer productions had enjoyed worldwide had by that time created a kind of cultural imperialism by setting a stylistic standard that others sought to match; as a result, the tendency for Japanese artists to use stop-motion cutouts was criticized as old-fashioned. The pioneering Japanese animator Shinshichiro (Noburō Ōfuji) (1900–1961) had worked in this way, and was famous for his cutout paper figures in the *chiyogami* style, which employed designs printed with woodblocks. This technique is used in two of his "record talkie" films (projected with synchronized sound on an accompanying record) from 1931, *Kuro Nyago* (*The Black Cat*) **(9.17,** see p. 160), which features dancing cats, and *Haru no Uta* (*Song of Spring*), a kind of sing-along and stage performance.

9.16 Paul Grimault, *The Passengers in the Big Dipper*, 1943

Two of Japan's well-known cel-animated films from the World War II era feature the fabled character Momotarō (Peach Boy), who was born from the pit of a peach and found by an elderly couple. As legend has it, the child and his companions—a dog, a pheasant, and

a monkey, which are lured to his side by millet cakes—all go to a place called Devil's Island, where Momotarō's strength and intelligence overcome the devils, and he takes home their riches. The thirty-seven-minute film *Momotarō no Umiwashi* (*Momotarō's Sea Eagle*, 1943) **(9.18)** provides a variation of this story, in which cute, fun-loving, brave little animals take on the role of fighters under Momotarō's direction, acting out a story that is based on the bombing of Pearl Harbor. In this scenario, the little animals fly airplanes and enact great gymnastic feats while overpowering American characters clearly modeled on Bluto and Popeye, who had been widely popularized in Fleischer animation (see p. 114). Two years later, in 1945, Momotarō and his animal friends appeared in the seventy-four-minute *Momotarō: Umi no Shinpei* (*Momotarō's Divine Sea Warriors*), which is considered to be the first feature-length animated film made in Japan. In this story, they are in higher-ranking positions and they participate in plans to invade British and American targets. Both films were directed by Mitsuyo Seo (1911–2010).

Conclusion

Animation was just one part of the arsenal that governments drew upon in fighting World War II. It provided an effective means of imparting information and developing support for the war effort, as one element in a larger agenda of propaganda aimed at uniting citizens in their respective countries. By the time the war ended, however, the world had become a different place, one that was marked by deep divisions and lingering distrust, not to mention horror at the many atrocities that had occurred. The United Nations, which was founded in 1945, attempted to chart a course to world peace, a monumental task. Many countries had literally to rebuild themselves, but for Americans, restructuring was mostly concerned with social change. Among the most pressing issues to be resolved was that of civil rights, which affected every sector of society. In the world of animation, it meant acknowledgment of racial biases in hiring and a long history of stereotyping. It was therefore remarkable when, in 1953, Disney hired probably its first black animator: Frank Braxton (1929–1969). He stayed only a short while before moving to Warner Bros., where

9.17 Noburō Ōfuji, *The Black Cat*, 1931

9.18 Mitsuyo Seo, *Momotarō's Sea Eagle*, 1945

he was employed in Chuck Jones's unit, and he later
worked at MGM, Hanna-Barbera, and elsewhere.

After the war, the world of animation flourished in
various ways. Internationally, it expanded as animation
studios spread across the globe, producing both drawn
and stop-motion work. New audiences emerged, as for
the first time a distinct youth market was identified.
It would become the consumer base of both television
production and visual effects for feature films. College
programs prepared young artists to enter the field,
and some of them produced short works that fueled
the establishment of festivals featuring innovative
animation. Many changes in technology would have
a great impact as well. Animation in the first half
of the twentieth century progressed in a relatively
orderly manner, but this was not the case in the latter
decades. The remaining chapters of this book reflect this
diversification, taking a less chronological approach and
putting more emphasis on animation in its varied forms.

Notes

1 Michael S. Shull and David E. Wilt, *Doing Their Bit: Wartime American Animated Short Films 1939–1945* (Jefferson, NC: McFarland, 2004), 3.

2 Shull and Wilt, *Doing Their Bit*, 37.

3 For more information, see Masayo Duus, *Unlikely Liberators: The Men of the 100th and 442nd* (Honolulu: University of Hawaii Press, 1987).

4 The study is available from the National Underground Freedom Center. Online at http://www.fdrlibrary.marist.edu/education/resources/pdfs/tusk_doc_a.pdf

5 Douglas Cunningham, "Imaging/Imagining Air Force Identity: 'Hap' Arnold, Warner Bros., and the Formation of the USAAF First Motion Picture Unit," *The Moving Image* 5:1 (Spring 2005), 95–124, 96.

6 Brian Oakes, "Building Films for Business: Jamison Handy and the Industrial Animation of the Jam Handy Organization," in *Film History: An International Journal* 22:1 (2010), 95–107, 100.

7 Cinzia Bottini, correspondence with the author, May 2014.

8 Sharon Meen, "'Enemy Aliens' & Internment in England, 1939–40," *Their Voices Live On—Jewish Life in Themar* (2011). Online at http://www.judeninthemar.org/?page_id=740

9 Bella Honess Roe, "The Canadian Shorts: Establishing Disney's Wartime Style," in A. Bowdoin Van Riper, ed., *Learning from Mickey, Donald and Walt: Essays on Disney's Edutainment Films* (Jefferson, NC: McFarland, 2011), 15–26.

10 Jeanpaul Goergen, "Discovering Paul N. Peroff," *Animation Journal* (Spring 1998), 42–53.

11 Rolf Giesen and J. P. Storm, *Animation under the Swastika: A History of Trickfilm in Nazi Germany, 1933–1945* (Jefferson, NC: McFarland, 2012).

12 Moritz, *Optical Poetry: The Life and Work of Oskar Fischinger* (Eastleigh: John Libbey, 2004), 65.

13 William Moritz, "Resistance and Subversion in Animated Films of the Nazi Era: The Case of Hans Fischerkoesen," *Animation Journal* 1:1 (Fall 1992). Online at http://www.animationjournal.com/abstracts/essays/Moritz.html

14 Richard Neupert, *French Animation History* (Malden, MA: John Wiley & Sons, 2011), 99–102.

Key Terms

caricature
motion graphic
parody

propaganda
satire
stereotype

CHAPTER 10

International Developments in Postwar Animation

Chapter Outline

Global Storylines

For Czechoslovakia, France, and Japan, occupation is a barrier to the development of a national animation style because the media is controlled by the occupying power

In China and the Soviet Union, animation production during this period is strictly regulated by the government

In Great Britain, as part of the country's postwar recovery, the government commissions animated films to explain political policies to the public

The National Film Board of Canada, including the filmmaker Norman McLaren, raises the international profile of the country's animation in the 1940s and beyond

Introduction

World War II left much of the world in turmoil. In Canada and the US, however, life was relatively good. Returning military troops were greeted with programs encouraging them to attend college and buy homes. A baby boom occurred, and factories that had been making weapons were adapted for the manufacture of various new products, including home appliances. Many people purchased cars, which were becoming an important form of transportation and facilitated travel across large expanses of the country. But these lifestyle changes did not mean that the hostilities had been forgotten. During the 1950s, the United States maintained the world's strongest military and was determined to defend its way of life, especially against the perceived threats of Communist infiltration and of the nuclear weapons acquired by the USSR (in 1949) and China (in 1964). These concerns were linked in part to unionization efforts that took place in America during the 1930s, giving strength to workers and undermining the power of business owners and management; some of the union organizers had Communist affiliations.

These tensions resulted in the so-called Cold War of ideologies, which turned nations against each other and caused such countries as the United States and Canada to begin investigating their own citizens, looking for Communist ties, often with dire implications. In the US, some of these investigations were initiated by the House Committee on Un-American Activities (HUAC), part of the US House of Representatives. These government leaders feared that Communists were attempting to infiltrate America to create an uprising among the working class and replace America's capitalist way of life. Today, this notion might sound implausible or even laughable, but at the time it was a very serious matter.

10.1 Anton Gino Domenighini, *The Rose of Baghdad*, 1949

In the film industry, many individuals were blacklisted for supposed Communist ties, and some were even jailed for up to a year for refusing to cooperate with the committee after being subpoenaed. Communist investigations were at their most public from 1945 through the mid-1950s. Equivalent investigations were held in Canada at about the same time.

While the American government was trying to prevent subversive elements from entering the country, its own culture was flowing into many nations across the world and leaving an indelible mark. There was no doubt that American animation dominated worldwide, especially after European markets reopened to a flood of entertainment films that Hollywood had released during the early 1940s. Attempts to challenge this domination spurred the development of animation in a number of countries, which often sought to rival the Disney style. This influence is clear in the production

of Italy's first feature-length animation, in 1949, *La Rosa di Bagdad* (*The Rose of Baghdad*), directed by Anton Gino Domenighini (1897–1966) **(10.1)**. The film tells the story of a princess living in Baghdad who must foil an evil plot in order to be united with the one she loves; stylistically, it can be seen as a response to Disney's *Snow White and the Seven Dwarfs* (1937), though it had been released more than ten years earlier.[1]

American animation had developed largely according to a capitalist business model, in which films were financed through competition in a commercial marketplace, but in some countries, government funding was offered to initiate production. Governments that supported the production of cinema in general and animation in particular were generally aware of the potential of the cinema, both economically and culturally, to counter the pervasiveness, or imperialism, of American values. This chapter provides a survey

of the animation produced in such diverse locations as Czechoslovakia, France, Japan, China, the USSR, Yugoslavia, England, and Canada, as filmmakers contended with the dominance of the American media and its ideology, as well as the challenge of finding a culturally distinct form of expression.

Occupation and Animation

The Nazis recognized the power of the media, subjecting it to severe restrictions and using the death penalty against those who dared to voice opposition. Within very limited contexts though, the regime built up film studios, including animation facilities, in the countries it occupied,[2] with the aim of creating a strong system of production that would rival that of America. The Atelier Filmovych Triku (AFIT) in Prague and Les Gémeaux in Paris are two studios that were part of that plan.

Animation in Czechoslovakia

The Czech animation industry was established during the late 1920s,[3] mainly oriented toward advertising. Karel Dodal (1900–1986), the first Czech filmmaker to specialize in animated production,[4] learned to animate by studying American shorts, including those starring Felix the Cat—which he then appropriated for use in a series of animated ads. These short films were made at the Prague studio Elekta Journal, which was founded in 1925; Dodal was hired to be its specialist in effects and animation. Probably his first animated short was a drawn commercial for a bank, *Poučeni Kocoura Felixe* (*Felix the Cat Receives a Lesson*), which was released in 1927. It depicts Felix pacing back and forth, until a sign reading "Work and save" prompts him to deposit some money, at which point a message appears, advising the viewer, "Keep safe and best deposit your savings."[5]

Felix also appears in *Plavčíkem na Slané Vodě* (*A Cabin Boy on Salty Water*, 1929). In this film, the character is sailing a small boat on the stormy sea when he and the boat's captain get shipwrecked on an island inhabited by black natives, who are described as cannibals. The two travelers are saved from being eaten by two things: the tribal chief's daughter, who appears to be in love with Felix, and the promise they make to bring the men of the tribe many Western

luxury goods, including a fur coat and a European suit, which are delivered by some magical insects. When Felix asks where all the nice things came from, he finds the answer is the Brouk & Babka department store in Prague, which is having its Christmas sale. The latter half of the film is live-action, in which the store is filmed using a kind of artistic multiple exposure; included in the shot are crowds of people on the street, some staring into the camera. In another Dodal work, the influence of the Fleischer studio's "Out of the Inkwell" films is evident. *Bimbov Nesrečni Pripetljaj* (*Bimbo's Unfortunate Adventure*, 1930) (10.2) stars Dodal as the live artist alongside a drawn clown character who is clearly rotoscoped. It was his first story-based, animated short not created as advertising.

While Dodal was at Elekta Journal, his then wife Hermína Týrlová (1900–1993) animated the films he directed. The two divorced in 1932, but they continued to work together at the IRE-Film studio, which Dodal co-founded in 1933 with his future wife (as of 1935) Irena Leschnerová (later Dodalová, 1900–1989). Their studio, which is named after Irena, was located in Prague, but eventually a second office was set up in Paris. Dodal usually directed solo, while he and Irena Dodalová generally shared credit for scripts and sets, though they sometimes co-directed. Meanwhile, Týrlová continued as animator (10.3, see p. 166). One of the studio's highlights is *Všudybylovo Dobrodružství* (*The Adventures of a Ubiquitous Fellow*, 1936), which employs a stop-motion figure designed and fabricated by the legendary puppeteer Jiří Trnka (see p. 189)—the first film-related

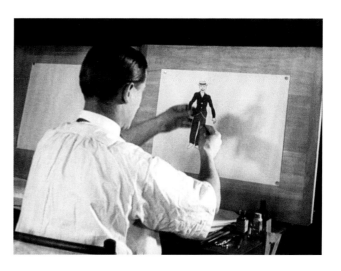

10.2 Karel Dodal, *Bimbo's Unfortunate Adventure*, 1930

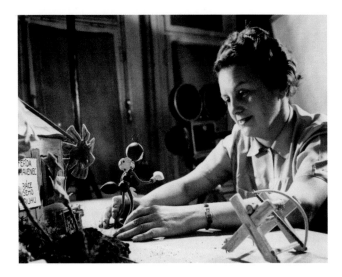

10.3 Hermína Týrlová working on *Ferda the Ant*, 1944

abstract *Myšlenka Hledající Světlo* (*Ideas in Search of Light*, 1938). It is an anti-war statement in which a ray of light is joined by others in order to overcome the darkness. Both films were animated by Týrlová.

During the 1930s, America was not just a source of creative inspiration for many artists, but also a place of refuge. In the summer of 1938, Karel Dodal and Irena Dodolová had to close their studio because of the events of World War II, when Czechoslovakia was essentially dissolved as a country and then occupied by the Nazis. At the end of the year, Dodal traveled to the US alone, seeking job opportunities and leaving Dodolová to return to Prague. As the situation worsened, travel became impossible, and she continued living there until 1942, when both women were transported to the Theresienstadt Ghetto, in the city of Terezin. Despite the fact that more than 30,000 individuals died there between 1941 and 1945, the German government promoted it as a "model ghetto," and commissioned a documentary film, *Theresienstadt 1942* (*Terezin 1942*, 1943), to be made by its prisoners. Dodolová, who was identified as having filmmaking skills, most likely worked as the writer, producer, and editor.[6] Having beaten the odds and survived, Dodolová was liberated from Terezin in February 1945 and from there was transported to Switzerland. She was reunited with her husband and they lived in the United States for three years, before moving to Argentina in 1948.

work he had done. It is an adaptation of the famous Czech theatrical puppet Hurvínek, voiced by its creator, Josef Skupa, one of Czechoslovakia's greatest puppeteers (**10.4**) (see p. 189), who explains concepts related to radio broadcasting. Among IRE-Film's many other works is a stop-motion production that advertises Krása shoes within a detective story, *Tajemství Lucerny* (*The Secret of the Lucerna Palace*, or *The Secret Lantern*, dir. Irena Dodalová and Karel Dodal, 1936) (**10.5**). The last film that the Dodals made in Prague was the mixed-media,

In 1935, the small studio Atelier Filmovych Triku (AFIT) had been founded in Prague, with the intention of creating visual effects and other commissioned work. When Czechoslovakia was occupied during the late 1930s, however, AFIT was put under the direction of the German Joseph Pfister, who was charged with making the studio a competitor with American production, and so expanded the facilities. They had a ready workforce because, as universities were closed, art students, including Břetislav Pojar (1923–2012) (see p. 190) and Zdenka (Pavlína Hrachovcova) Najmanová (later Deitchová,

10.4 Josef Skupa shows his puppets to children in London, 1948

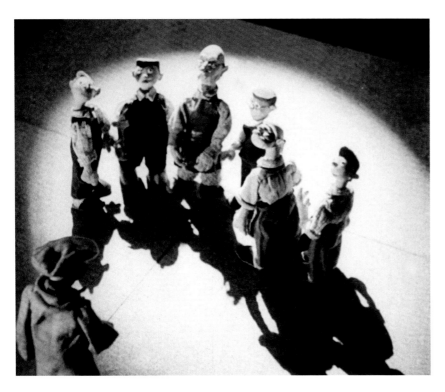

10.5 Irena Dodalová and Karel Dodal, *The Secret of the Lucerna Palace*, 1936

1928–), came to AFIT to work. Pojar eventually became an accomplished animator and director, while Deitchová worked her way from painter, to inker, to in-betweener, to animator, and into studio management.[7]

By 1939, the Nazis had closed many Czech puppet theaters, sensing that they were spreading subversive material as one component of a larger resistance movement. Nonetheless, anti-Fascist performances continued underground, even though they were given at great risk; many puppeteers were sent to concentration camps (where they continued to put on makeshift shows) and eventually killed. Even Josef Skupa was imprisoned, though he escaped during Allied bombing. He had created popular comedy figures, most notably a character named Spejbel and his mischievous son Hurvínek, in the 1920s, and was strongly influenced by traditional Czech culture.

After the war, with the Allied victory, both puppetry and animation emerged again. The AFIT studio was closed, but its artists opened two new studios. The first was Břatri v Triku,

which opened in 1945 and specialized in 2D animation. The name of the studio translates literally as "Brothers in Tricot," the material for T-shirts—the studio's logo includes three boys wearing striped T-shirts—but the name is also a play on the idea of "trick films."

Two years later, in 1947, the stop-motion Studio Loutkoveho Filmu (Studio of the Puppet Film) was established; it would be headed by the famous puppet-theater director Jiří Trnka, and today is commonly known as the Jiří Trnka Studio (**10.6**). Both studios were later nationalized, coming under the auspices of a Czech film organization, Krátký Film (Short Film), which was formed in 1957 (it was eventually privatized in 1991 and is now known as Krátký Film Praha). In 1959 Krátký Film established another studio in Prague to fulfill international contract work; it was coordinated by the American Gene Deitch, who had moved there.

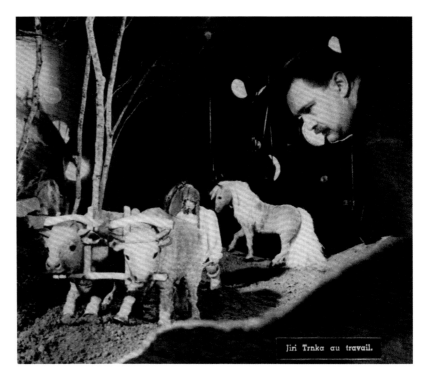

10.6 Jiří Trnka at Studio Loutkoveho Filmu, published in *Ciné Revue*, 1953

French Animation in the Postwar Period

The French animation industry was relatively small during the 1930s. Among the best-known studios of this period was Les Gémeaux; founded by Paul Grimault and André Sarrut in 1936, it was supported by the German occupation forces during the war. At war's end, Grimault worked with the poet and screenwriter Jacques Prévert on adapting Hans Christian Andersen's *Le Petit Soldat* (*The Little Soldier*, 1946) into an animated short, and, years later, in 1979, Grimault completed their animated feature *Le Roi et l'Oiseau* (*The King and the Bird*).

During the war, the popular French cartoonist, illustrator, and painter Albert Dubout (1905–1976) began work on a series featuring Anatole, a thin character, and his plump, overbearing wife: *Anatole Fait du Camping* (*Anatole Goes Camping*) was begun in 1942 and finished in 1945 **(10.7)**, followed by *Anatole à la Tour de Nesle* (*Anatole at the Nesle Tower*). The release of both films was stalled until 1947.

Jean Image (1910–1989) appeared on the French scene a few years after the war had ended. He had collaborated with fellow Hungarian filmmaker János Halász (later known as John Halas, see p. 176) (1912–1995) in England during the 1930s before opening an animation school and studio in France, Jean Image Productions, in 1948. In 1950, Image premiered *Jeannot l'Intrépide* (*Johnny the Giant Killer*), the first color, feature-length animated film made in France, and in 1953 he released a second animated feature, *Bonjour Paris* (*Hello Paris*), before moving into TV production in the 1960s.

The Development of Japanese Animation

In Japan, occupation came after the war, as a new order was enforced by the Allied Forces from 1945 to 1952; a central role was assumed by the American general Douglas MacArthur, who was Supreme Commander of the Allied Powers (SCAP), a title also given to the

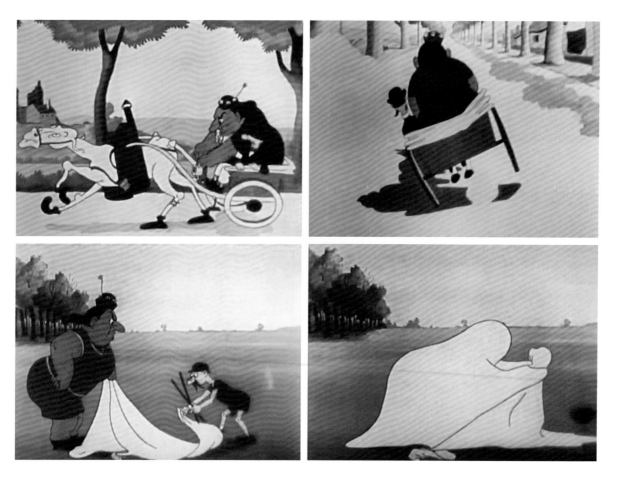

10.7 Albert Dubout, *Anatole Goes Camping*, 1947

offices where his work was carried out. The Japanese army was dismantled and former military officers were not allowed to become political leaders in the new government. Feudal culture was denounced and the emperor became a figurehead with no political control; at the same time, the parliamentary system was expanded. The SCAP's mandates affected virtually all aspects of Japanese society, including the production of animation, which already had a long history by the time of World War II.

Beginning in 1917 and continuing through the 1920s, Japanese animation was produced by such animators as Sanae Yamamoto, Noburō Ōfuji, Yasuji Murata, and Kenzō Masaoka, who made films in varied styles. For example, Ōfuji (see p. 159) became known for cutouts made of traditional Japanese chiyogami paper. In his film *Kujira* (*The Whale*, 1927), however, he used a different approach to tell the story of some arguing shipwrecked passengers: silhouette animation, which he created after he saw examples of such work from Europe. Both films employed pre-recorded sound on a record device and thus are described as "record talkies." This approach was used in the early days of talking pictures, which were still a great novelty in the late 1920s.

The filmmaking environment became much more restrictive during the 1930s, when Japan was engaged in military struggles. For example, in 1934, the Film Control Committee was initiated to put film production under the jurisdiction of the government, and it became increasingly difficult to import foreign films. After the war, SCAP subjected the Japanese film industry to consolidation and reorientation, and films deemed feudalistic or anti-democratic were denigrated and sometimes destroyed.[8] By the early 1950s, Japan was gaining back its independence, and at that time many industries began to flourish, including film production.

One of the country's most important studios, Toei Doga (Toei Animation Company), was formally established in 1956, but its origins can be traced back to the immediate postwar period. Just two months after the war ended, many artists had been hired by the animation studio Shin Nihon Dogasha (New Japan Animation Company), led by Sanae Yamamoto, Yasuji Murata, and Kenzō Masaoka, and later renamed Nihon Manga Eiga Kabushiki Kaisha (Japan Manga Film Corporation). One of its earliest productions is the short *Sakura: Haru no Gensou* (*Cherry Blossom: Spring Fantasy*, 1946). This beautifully lyrical film, directed by Masaoka, depicts a group of fairies who oversee a scene of blossoms softly falling on young ladies, puppies, kittens, and the landscape. A series of changes and mergers in the studio ensued before 1956, when it was purchased by the live-action studio Toei, which itself had developed through various incarnations since the late 1930s.[9]

Shortly after it was established, Toei Animation began creating work for theatrical distribution. Its first features, made with the cel-animation process and **full-animation** techniques similar to those used by Disney, include *Hakujaden* (*The Tale of the White Serpent*, or *Panda and the White Serpent*, dir. Taiji Yabushita and Kazuhiko Okabe, 1958) **(10.8)**, *Shonen Sarutobi Sasuke* (*The Adventures of Little Samurai*, or *Magic Boy*, dir. Akira Daikuhara and Taiji Yabushita, 1959), and *Boku no Songokû* (*My Songokû*, or *Alakazam the Great*, or *The Enchanted Monkey*, dir. Daisaku Shirakawa, Taiji Yabushita, and Osamu Tezuka, 1960). These works were ambitious and foreshadowed the great growth that Japan would experience over the next two decades and onward, eventually making it a world leader in animation production.

10.8 Taiji Yabushita and Kazuhiko Okabe, *The Tale of the White Serpent*, 1958

Postwar Animation in Communist Countries

The Wan Brothers and Chinese Animation

The end of the war liberated China from the Japanese, but it also saw renewed fighting between two political groups within China, the Kuomintang (Nationalists), led by Chiang Kai Shek (1887–1975), and the Communists, led by Mao Zedong (1893–1976). When Mao's army prevailed in 1949, Chiang fled and became president of Taiwan, known as the Republic of China, while Mao ruled mainland China, or the People's Republic of China. Mao envisioned a class-free society, but his policies were implemented through authoritarian rule, and his government was fraught with corruption. After some disastrous economic decisions in the late 1950s, Mao and a small circle of political leaders, known as the Gang of Four, launched the Cultural Revolution in an effort to purify China of Western influence. Beginning in 1966, the Cultural Revolution lasted until 1976. During this period, universities were closed, and lawyers, engineers, professors, artists, and other people described as intellectuals were sent to collective farms to be "re-educated" and live the simple life of peasants. Groups of youths known as the Red Guard were formed to indict anyone accused of being disloyal, and such dissidents were executed.

As a result of these purges, much of China's history has been destroyed. Accordingly, copies of animation made before 1940 are scarce and the history of Chinese animation is difficult to trace.[10] It is possible that the country's first animation is found in advertising films created in the early 1920s by the four Wan brothers: the twins Wan Laiming (1900–1997) and Wan Guchan (1900–1995), along with Wan Chaochen (1906–1992) and Wan Dihuan. Probably the first of them was *Shūzhèngdōng Huáwén Dǎzìjī* (*Comfortable Shuzhendong Chinese Typewriter*), which was created in 1922 for a printing company, the Shanghai Commercial Press. The Wans worked on a range of projects, from advertising to entertainment and anti-Japanese propaganda. One of their early works, *Uproar in the Art Studio*, is a combined

live-action and animated film, made for the Changcheng (Great Wall) Film Studio in 1926, that is clearly influenced by the Fleischers' "Out of the Inkwell" films (see p. 114). True pioneers, the Wans also made China's first animated short with sound, *The Camel's Dance*, in 1935; it is an adaptation of an Aesop's fable, "The Camel and the Monkey," in which a camel becomes jealous of a monkey's skill at dancing and tries to do better, with bad consequences.

Although the Wans seem to have been influenced by Western content, they were intent on establishing a national style, which they felt would help them confront the dominance of work from the United States in particular. In 1936, they published an article that dismissed American models in favor of German and Russian animation. They noted that animated films from all of these countries reflected their individual cultures and stressed that a Chinese film should do the same, embracing the country's own traditions and humor, with the objective of being both educational and entertaining.[11] Moving from place to place in order to escape Japanese militaristic takeovers, the brothers ended up in Shanghai. This is where they saw Disney's *Snow White and the Seven Dwarfs* in 1939 and vowed to make China's first feature film—*Tiě Shàn Gōngzhǔ* (*Princess Iron Fan*, dir. Wan Guchan and Wan Laiming, 1941)—despite a number of hurdles, including a lack of trained artists (10.9). The film is based on a character from the well-known story *Xiyou Ji* (*Journey to the West*), written by Wu Cheng'en in the sixteenth century (Ming Dynasty). It tells the story of the Monkey

10.9 Wan Guchan and Wan Laiming, *Princess Iron Fan*, 1941

King, named Sun Wukong, who is not only fast and super intelligent, but also able to transform into many different beings. Partly motivated by a quest for immortality, he battles multiple opponents and outwits them with his superior skills and endurance. Confucian, Taoist, and Buddhist principles are embodied in the story, as the monkey is faced with challenges of human nature that he must overcome in order to achieve his goals.

When Japan controlled Manchuria, a large, state-of-the-art, live-action studio—Man'ei (Manchukuo Film Association)—had been set up in what is now the city of Changchun. In 1946, after the Chinese Communist Party regained power over the region, Man'ei was absorbed into the Dongbei (Northeast) Film Studio and its animation facility became a gathering place for some of China's most important early animators. Included was Chen Bo'er (1907–1951), one of the central creative and administrative figures there. She was a writer and actor, and the first woman to direct an animated film in China: *Huang di Meng* (*The Emperor's Dream*, 1947), a stop-motion propaganda film critical of Chiang Kai Shek and the Nationalists. Chen Bo'er also served as a writer on the project and Fan Ming (Tadahito Mochinaga) was its animator. Other important figures at the Northeast Film Studio included Jin Xi, a painter, and Te Wei, a print cartoonist. They were also brought into the studio's leadership, becoming central figures in its history.

In 1950, after the Northeast Film Studio was reorganized as the Changchun Film Studio, its animators were relocated to Shanghai, and seven years later, the Shanghai Animation Film Studio was officially founded. Eventually, the Wan brothers joined the prestigious studio, which aimed to create films that were entertaining, educational, and Chinese in character. Such qualities can be found in Jin Xi's stop-motion film *Shćn Bĭ* (*The Magic Paintbrush*, 1955) and Te Wei's *Jiao ao de Jiang Jun* (*The Conceited General*, 1957). Other noteworthy examples from the studio include the film *Xiao ke Dou Zhao Ma Ma* (*Where's Mama?*, 1960), directed by Te Wei and Qian Jajun, using the Chinese ink-brush style, adapted for use in animation (10.10). In the film, newborn tadpoles approach a wide range of creatures, in search of their mother. The images recall the ink paintings of Qi Baishi, who was born a peasant and became one of China's best-known artists in the late nineteenth and early twentieth centuries. His paintings often focus on small creatures, testimony to his love of the natural world.

10.10 Te Wei and Qian Jajun, *Where's Mama?*, 1960

10.11 Wan Laiming, *Havoc in Heaven*, 1964

Also notable is the studio's production of Wan Laiming's second feature film, *Dà Nào Tiān Gōng* (*Havoc in Heaven*), released in two parts, in 1961 and 1964; it also tells the tale of the Monkey King, who is called to Heaven so he can be supervised (10.11). As Sun Wukong skillfully engages in battles with many warriors, the film incorporates acrobatic acts and martial arts movements reminiscent of those used in Beijing opera. Despite good reviews, the film's distribution was curtailed by the events of the late 1960s, when the Cultural Revolution came about. At that time, the animation industry, like many other aspects of Chinese culture, nearly ground to a halt.

The Soviet Union: Consolidation under Soyuzmultfilm

The 1930s marked a low point in Soviet history, as many people suffered under the brutal dictatorship of Joseph Stalin (born Iosif Vissarionovich Dzhugashvili, 1878–1953). Stalin's policies, which were first implemented in 1928, enforced collectivization in the Soviet Union, consolidating resources owned by various individuals into single enterprises. Many officials in the government and military, as well as religious leaders and intellectuals, were identified as dissenters and killed. These killings depleted the Soviet military leadership, but its soldiers nonetheless played a decisive part in ending World War II, and especially in the capture of Berlin in 1945. Stalin died in 1953, after transforming the Union of Soviet Socialist Republics, or USSR, into one of two world superpowers; the other was the United States of America.

As of 1934, **Socialist Realism** had been the required style of Soviet art, since it was compatible with the government's efforts to educate and inspire the masses and to impart a sense of national pride and identity. Art of this type glorified the Communist agenda, combining propaganda with a validation of social concerns, delivered in a clear message typically involving optimism, bravery, and patriotism (10.12). Portraying a positive view of Soviet life and elevating the proletariat to hero figures, it was found in all forms of art, including cinema, and persisted as an official style until the breakup of the USSR in the early 1990s. Soviet leaders saw films as an especially important means of educating their people, and animation was supported along with live-action production.

During the period of Stalin's collectivization, the animation industry, too, was consolidated into centralized units.[12] In Moscow, the government-run animation studio Soyuzmultfilm (originally Soyuzdetmultfilm) was founded in 1936 by merging personnel from a number of smaller enterprises to

ВНЕС ЛИ ТЫ СВОЮ ДОЛЮ ТРУДА В ВОССТАНОВЛЕНИЕ ЛЕНИНГРАДА?

10.12 Soviet Union poster, 1944. The text reads: "Are you doing your share of the work to rebuild Leningrad?"

the government in the same way as any other workers, and it did not matter if their films were commercially viable or not. As a result, artists were free to develop their ideas outside the constraints of the marketplace, although they were still beholden to the censor. Adaptations of traditional stories were common because these tended to gain approval more easily. With the rise of nationalism and the consolidation of media production under Stalin, Soviet ideology looked back to its own history, including folklore. Traditional stories were seen as a means of promoting the national identity and were also a relatively neutral form, appealing to all ages.

Soyuzmultfilm has produced many popular films throughout its long history. Among them is the cel-animation production *Ivashko i Baba Yaga* (*Ivashko and Baba Yaga*, 1938), directed by the Brumberg sisters, Zinaida (1899–1975) and Valentina (1900–1983). Based on a folk tale, it is the story of a boy named Ivan who is captured by a witch but escapes before she can eat him. The witch, Baba Yaga, is a well-known supernatural figure from Russian folklore, known for her hideous appearance and mysterious nature. The Brumberg sisters began their careers as background artists, and then moved into directing and writing. They are best known for

form what would become the largest studio in the USSR (**10.13**); at first, it produced only drawn (2D) animation, but stop-motion was also incorporated into production in 1953. Soyuzmultfilm employed hundreds of practitioners, some of whom came from Mezhrabpom-Rus', a studio that had been formed in 1923 and was known as the "Russian Hollywood."[13] The stop-motion animator Władysław Starewicz had worked at Mezhrabpom-Rus' for a short time before Ivan Ivanov-Vano and others established its animation production unit in 1925.

During the Soviet era, Soyuzmultfilm animators were paid by

10.13 Yuri Norstein working on animation at the Soyuzmultfilm studio, 1966

10.14 Lev Atamanov, *The Snow Queen*, 1957

a number of children's films they made in the 1940s and onward. The studio's other notable films include the hour-long *Konyok Gorbunok* (*The Humpbacked Horse*, dir. Ivan Ivanov-Vano, 1947), which was adapted from a nineteenth-century story about a boy and his magical horse by the Russian author Pyotr Yershov. In the late 1950s, Soyuzmultfilm released *Snezhnaya Koroleva* (*The Snow Queen*, dir. Lev Atamanov, 1957), seventy minutes in length **(10.14)**. It is based on a well-known story by Hans Christian Andersen about the struggle between good and evil, told in seven parts.

The Zagreb School of Animation

The USSR comprised Russia and fourteen other Soviet Socialist republics. There was also a group of neighboring countries in Eastern Europe that shared Soviet ideologies to various degrees; these nations and the USSR collectively formed the Eastern Bloc (also known as the Communist Bloc, the Soviet Bloc, or the Iron Curtain), which existed from 1945 until approximately 1991. One of these nations was Yugoslavia. The country had been formed after World War I by unifying several states, including Serbia and Montenegro, which had been independent, and Slovenia, Croatia, and Bosnia Herzegovina, which had been part of the Austro-Hungarian Empire. During the war, the Communists rose up to form a major part of the country's resistance to Germany, and they later took control, led by Josip Broz (1892–1980), known as Tito. As a dictator, Tito established tight military control, including surveillance and the execution of dissidents, but he did not follow a strict Communist party line, and Yugoslavia was regarded as relatively liberal in its atmosphere, providing a kind of gateway to the West. In fact, Tito split with the Soviet Union in the late 1940s; as a result, Soviet policies, including adherence to the aesthetic of Socialist Realism, were not strictly enforced. Tito headed the government until his death in 1980.

During the 1950s, the so-called "Zagreb School" of animation became recognized for its artists' use of a modern-art style and subject matter that was geared toward mature viewers. These artists worked in the city of Zagreb, in the country now known as Croatia,

at the state-run, live-action production studio Zagreb Film. The roots of the Zagreb Film animation studio can be traced to 1949, when its first animated short was completed. An allegory for Yugoslavia's political situation, as it broke away from Stalinism, *Veliki Miting* (*The Big Meeting*, 1949) was directed by the brothers Walter and Norbert Neugebauer. The film was financed by Fadil Hadžić, who published humor magazines.[14] In 1951, Hadžić received government support to found an animation company, Duga Film. One of the challenges it faced was a shortage of skilled artists, which was compounded by a lack of training programs. At the time, animation artists trained by watching the few films available in the country—for instance, those of the Czech animator Jiří Trnka, and by reading the few animation-related books that circulated in Zagreb.[15]

A handful of films were produced at Duga Film, but within a year the company folded, and for the next several years, its artists found work largely in advertising. After creating a number of commercials in 1955, they returned to the idea of forming a studio where a wider range of work could be produced. The following year, the Animated Film Studio was founded at Zagreb Film.[16] This studio operated like an artist's workshop, producing many creator-driven, short personal films, as well as animated series and educational films.

Its emerging directors rejected Disney methods and instead seemed to look ahead to a new aesthetic that developed in the 1950s: **midcentury modern,** which in animated productions would be characterized by the use of streamlined, geometric forms, stylized characters, graphically oriented layouts, and a limited-animation aesthetic. When a number of their films were shown at the Cannes film festival in 1959, the French film historian Georges Sadoul referred to them using the term "l'École de Zagreb" ("Zagreb School") to describe the studio's aesthetic, though it is not a teaching institution.

One of the best-known Zagreb animators, Dušan Vukotić (1927–1998), who came from the region now known as Bosnia and Herzegovina, learned to animate at Duga Film, where he directed his first film, *Kako se Rodio Kico* (*How Kiko Was Born*) in 1951. It opens with the familiar convention of the hand of the artist (though an inked-and-painted image is used rather than footage of a real hand) creating a character on a drawing surface, an acetate cel, in an artist's studio. The character jumps off the page, runs around the city, interacts with bureaucrats, and returns home by jumping into a house that has been drawn for him, rather than an inkwell.

Almost ten years later, in 1961, Vukotić's film *Ersatz* became the first from outside the US to win an Oscar for an animated short in the category that was at that time called "Short Subjects, Cartoons." It tells the story of a materialistic man whose life is filled with artificial substitutes for everything he encounters. The action takes place at the beach, where the man inflates one blow-up thing after the next, while continually humming the same energetic tune. He even inflates a female companion. In the film, spaces and objects are defined using color and abstract forms **(10.15).** For instance, the background is a tan space, representing sand, bordered by blue for the sea. The "man" is actually a teardrop-shaped form created with simple lines, with a chest that collapses into a pot belly and flexible

10.15 Dušan Vukotić, *Ersatz*, 1961

stick legs and arms. There is no attempt to create naturalistic movement—he often pops on and off screen, moving from one spot to the next.

Like many of the Zagreb animators, Borivoj "Bordo" Dovniković's (1930–) career spanned various media. He began directing animation in the early 1960s, and his work displays the same midcentury modern aesthetic embraced by many of his contemporaries. In his film *Znatizelja* (*Curiosity*, 1966) a man is constantly disturbed by people passing by and trying to look inside his bag, a simple premise that enables multiple caricature styles to be employed. The images are created from relatively simple line drawings on white paper, allowing for a lot of experimentation with depth and changing environments, which are drawn into the scene and then removed. Bordo is also well known for his work as a cartoonist and illustrator. In 1972, he helped to establish the Zagreb International Animation Festival, one of the oldest and most respected animation festivals worldwide.

Postwar Animation in Great Britain and Canada

Halas & Batchelor Dominate British Animation

England had been a world leader in the development of filmmaking in the late 1890s, but by the mid-1920s, British cinema was struggling to counteract the dominance of American production. During the 1930s, the government stepped in, developing initiatives to support the growth of filmmaking in the UK—for example, in 1933, it launched both the General Post Office (GPO) Film Unit, which produced documentaries and animation, and the British Film Institute, to support various aspects of the cinema in Britain, including production.

Private production was also growing, however. In fact, in the 1940s, England became home to what would be the largest private animation studio in Europe: Halas & Batchelor Cartoon Films. In the late 1930s, the Hungarian John

Halas (born János Halász) (1912–1995) and the British Joy Batchelor (1914–1991) had met and begun working together; they married and in 1940 established the studio as a unit within the London office of the J. Walter Thompson advertising agency. Over the next fifty years, Halas & Batchelor became one of the most prolific and longest-running studios in history, balancing work in advertising and government-sponsored projects with entertainment films and more personal productions. Many of its first works were created for the Ministry of Information during World War II: from 1941 to 1945, the studio created seventy war-themed films.

Once the conflict was over, Halas & Batchelor moved into educational and public-relations films, including the development of a series based on a character named Charley. This series was sponsored by the Central Office of Information in Britain to explain new government initiatives, such as urban planning. In the first installment, *Charley in New Town*, released in 1948 (10.16), the character celebrates a bright new day, recalling how things in the city used to be: dirty, dangerous, and depressing. As he rides his bicycle, the jaunty Charley lightheartedly explains the negative effects of the Industrial Revolution on city centers, and the ways in which new residential areas will be master-planned to allow for better living.

10.16 Halas & Batchelor, *Charley in New Town*, 1948

Halas & Batchelor also created work for the US government, including two productions in 1949, *The Shoemaker and the Hatter* and *Think of the Future*. Both films explain the Marshall Plan, in which the US gave billions of dollars to European countries for rebuilding their cities after the war, in an effort to stem the growth of Communism and to encourage peace among neighboring countries. The Central Intelligence Agency (CIA) in the US supported the production of the studio's feature of 1954, *Animal Farm*, although the money was filtered through a producer named Louis de Rochement, so that the directors, Halas and Batchelor, did not know of the CIA's involvement. The film is an adaptation of the George Orwell novel of 1945, which tells the story of an uprising among "worker" farm animals that have been mistreated by a mean, "business owner" human farmer. In the book, the story ends with the pig leaders of the revolt consorting with the humans, so that the other animals are barely able to tell the difference between the businessmen and the radicals. At the end of the film, the pigs leading the uprising do not mix with the humans and are clearly in it for their own benefit, exposing their apparent Communist values as corrupt. *Animal Farm* became the first widely released British animated feature; the British censor originally rated the film as for adults only, but it is now rated suitable for all audiences.

Norman McLaren and the National Film Board of Canada

Canada did not have to rebuild, as many European countries did, but the memory of the Great Depression lingered and government leaders embarked on plans for modernizing its industry and strengthening its economy. They did so by making various changes to Canada's policies and infrastructure, including modifying its immigration laws to encourage more specialized, skilled workers to move to Canada—although at the same time the government had reservations about diluting Canadian culture and was concerned about the threat of Communism. Canadians were on the lookout for left-wing agitators, and actively investigated and deported them.

Since the 1910s, Canada had provided support for film production that represented the country's unique national character. To further this effort, John Grierson (1898–1972) was invited to set up a film-production

10.17 Norman McLaren, *c.* 1950

facility in Canada, after he had administered a number of similar organizations in Britain, and, in 1939, the National Film Board of Canada (NFB) was established.[17] At first, the NFB focused on documentary films, but Grierson also laid the foundations for an animation unit by hiring Norman McLaren (1914–1987) **(10.17)**, whom he had previously employed at the British GPO Film Unit (see p. 86). McLaren had been living in New York since 1939 to avoid the war in Europe.

In 1941, McLaren came to the NFB to create some films that would assist the War Savings Committee in raising money for Canada's war effort. To meet the labor needs of production, he began to hire additional animators, and the first NFB animation unit was born. McLaren served as its head for about three years, and then stepped down to focus on his own work.[18] He stayed at the NFB for the rest of his career and became one of the most influential animators in history, bringing immeasurable prestige to Canada. During his time at the NFB, he experimented with and mastered several techniques, including drawing, painting, and scratching on film; **pixilation** (animation created using the movements of animate figures, usually people,

10.18 Norman McLaren, *Now Is the Time*, 1951

photographed in increments); modified-base techniques (drawing, erasing, and redrawing on a single surface); variable-speed shooting (generally, filming and acting in slow motion and then projecting the footage back at normal speed); optical printing; and stereoscopy. Fortunately, McLaren documented all of his films in a series of notes, which explain his technical processes in detail and are available for free from the NFB website.[19]

Norman McLaren not only created effective public-information films for the war effort and the General Post Office, but he also made personal films exploring approaches that were of interest to him, such as Surrealism. In addition to his other work, McLaren also served as an important ambassador for the NFB and for Canada in general, making goodwill trips to other countries and creating projects to help communities with pressing problems. For example, he took a year-long leave to work for the United Nations

Educational, Scientific and Cultural Organization (UNESCO), which promotes world peace and human rights through collaborative projects. McLaren went to China in 1949, where he taught a group of Chinese artists in the Szechuan province how to make animated films around the theme of a "healthy village," addressing such issues as vaccinations and hygiene. There has been speculation, however, that McLaren's decision to leave Canada was not only for philanthropic reasons, but also to avoid an investigation into his very left-leaning political past. The NFB as a whole was a significant target of investigation for Communist infiltration, and some of its employees lost their jobs as a result.[20]

In the early 1950s, McLaren did groundbreaking work in the realm of stereoscopic filmmaking, completing *Now Is the Time* (**10.18**) and *Around Is Around* (**10.19**), two abstract films commissioned to debut at the Festival of Britain in 1951. The films were

so successful that two more stereoscopic films were requested for exhibition the following year. As McLaren was already committed to other work, he split the commissions with his longtime creative partner Evelyn Lambart (1914–1999), who made a film called *O Canada* (1952), and a first-time animator, Greta Eckman, whose direct-animation sequence was used in creating *Twirlygig* (1952). Three of these stereoscopic films languished for many years until their restoration in 2014 for the Edinburgh International Film Festival that year. The other, *Twirlygig*, had been considered completely lost—though not by accident. We now know that Eckman was suspected of being a security risk, associated with the Communist scare at the time, and was ousted from the NFB. Not only that, but her name was removed from her film. In protest, both McLaren and the composer Maurice Blackburn, who had been involved with *Twirlygig*'s sound production, also removed their names. After the screening in

1952, the film was destroyed. In 2014, however, the researcher Alison Loader found its original color separations—the components needed to restore the film correctly—in the British Film Institute's National Archive. The names of the three artists—Eckman, McLaren, and Blackburn—were on the separations, and so were included on the film when it was printed.[21]

McLaren had delegated his commission for the second set of films partly because he was already involved with another production, and in 1952 the NFB released what is probably his most famous film, *Neighbours* (1952), in which two men argue over a flower **(10.20**, see p. 180**)**. The conflict escalates until the flower is long forgotten and the men have resorted to total destruction. The film ends with the moral, written in several languages, that it is important to "love your neighbor." *Neighbours* was shot using the techniques of pixilation, moving the actors across the set frame by frame, and variable-speed shooting, recording

10.19 Norman McLaren, *Around Is Around*, 1951

10.20 Norman McLaren, *Neighbours*, 1952

continuous movement at an altered camera speed, both of which create a strangeness in the motion. As it proceeds, the film turns from lighthearted to dark and even gruesome; one part of the film, where women and children are attacked, was actually edited out of some versions. Throughout the film, the actors' mechanical-looking movements are complemented by the sound that McLaren designed for the film. He used a direct-sound technique, creating images on cards that were photographed into the optical-sound region of the filmstrip, where they could be read by the projector. The result is a **synthetic soundtrack** that sounds somewhat like early video-game "blips." McLaren was very interested in drawn and photographed sound, and his many experiments at the NFB allowed him to become exceptionally skilled in these techniques.

In 1953, McLaren went to India, again with UNESCO. This time he led three-month workshops in two different cities: Delhi and Mysore. He was greatly affected by the poverty he witnessed, and became even more introspective regarding his role as an artist. The trip to India made a strong impression on him in other ways as well. For example, he employed Indian music (played by Ravi Shankar) in one of his well-known films of the 1950s, *A Chairy Tale* (1957), co-directed by Claude Jutra and with the assistance of Evelyn Lambart **(10.21)**. This film seems to be about the need for mutual understanding, as a man attempts to sit on a chair that evades him until he proves he can empathize with the chair's experience of "being sat upon." During the span of his career, McLaren made more than sixty films at the NFB, along with many more experimental tests.

McLaren was, of course, only one of many accomplished filmmakers to work at the NFB. Evelyn Lambart, who came to the Film Board in 1942, was one of his close collaborators, working with him on twelve productions, although she made her own films as well. Lambart had contributed to some industrial films prior to directing independently, beginning with *The Impossible*

Map (1947), a film about the challenges of depicting the round world on a flat map. Her other work includes a series of fables created using cutout animation: *Fine Feathers* (1968), *Mr. Frog Went A-Courting* (1974), *The Lion and the Mouse* (1976), and *The Town Mouse and the Country Mouse* (1980) **(10.22)**.[22]

In 1966, the NFB established its French-language Animation Studio, which was initially led by René Jodoin (1920–2015). Jodoin was among the first animators to join Norman McLaren and the Film Board in the mid-1940s; he stayed for a few years and then returned to the NFB in 1954. While he was there, Jodoin co-directed two films with McLaren, the sing-along *Alouette* (1944) and the abstract film *Spheres* (1969), which has a soundtrack by the celebrated Canadian pianist Glenn Gould. In addition to a number of informational films, Jodoin also directed four abstract animated shorts of his own; they include *Ronde Carrée* (*Dance Squared*, 1961) **(10.23**, see p. 182**)**, *Notes on a Triangle* (1966), *Rectangle*

& Rectangles (1984), and *A Matter of Form* (1984). These engaging works explore movement and form, using simple geometric shapes in shifting patterns.

10.21 Norman McLaren, *A Chairy Tale*, 1957

10.22 Evelyn Lambart, *The Town Mouse and the Country Mouse*, 1980

10.23 René Jodoin, *Dance Squared*, 1961

Conclusion

The period immediately after World War II was one of profound mistrust internationally. America was among the countries that feared Communist ideology was infiltrating its borders; meanwhile, others were equally concerned about keeping out Western, and particularly American, propaganda. One way for a country to counteract the power of external influence is to build up its own media enterprises; so it is not surprising that this era saw a great deal of growth in international film production, including animation. This chapter has provided a brief survey of developments in just a few of these contexts, as artists in various locations attempted to forge an identity through the materials, methods, and content of their work.

For most of animation history, 2D drawn animation has dominated studio production, in part because it lent itself to rapid production schedules. Stop-motion animation has been popular too, in Eastern Europe, Japan, and other countries. Even in the US, where Disney's 2D cel animation had long been the bellwether of production, stop-motion had a presence, especially as used in visual effects for live-action feature films. The following chapter surveys some of the best-known stop-motion animators, who worked in a range of techniques and sometimes developed social connections across national borders, forging friendships as individuals that were not always found between countries.

Notes

1 Giannalberto Bendazzi, "The First Italian Animated Feature Film and Its Producer: La Rosa di Bagdad and Anton Gino Domeneghini," *Animation Journal* 3:2 (Spring 1995), 4–18.

2 Rolf Giesen and J. P. Storm, *Animation under the Swastika: A History of Trickfilm in Nazi Germany, 1933–1945* (Jefferson, NC: McFarland, 2012), 132–133.

3 For more on early Czech animation history, see Eva Struskova, *The Dodals: Pioneers of Czech Animated Film* (Prague: National Film Archive, 2013).

4 A partial list of related works can be found at "Call number: DVD-3861," UCL Library Services, UCL School of Slavonic & East European Studies website. Online at http://www.ssees. ucl.ac.uk/videos/dvd3861.htm

5 Struskova, *The Dodals*, 63–64.

6 Eva Struskova, "Ghetto Theresienstadt 1942: The Message of the Film Fragments," *Slideshare.net*. Online at http://www.slideshare.net/bterezin/ eva-article-dodalova-1942-film-english

7 Andrew Osmond, "Czech Animation: Two Perspectives," *Animation World Network* (10 September 2003). Online at http://www.awn.com/animationworld/ czech-animation-two-perspectives

8 Tze-Yue G. Hu, *Frames of Animation: Culture and Image-Building* (Hong Kong: Hong Kong University Press, 2010), 78–81.

9 Hu, *Frames of Animation*, 79.

10 Ying Zhu and Stanley Rosen, eds., *Art, Politics, and Commerce in Chinese Cinema* (Hong Kong: Hong Kong University Press, 2010), 10. The authors were summarizing an essay by John A. Lent and Ying Xu, "Chinese Animation Film: From Experimentation to Digitalization," included within the anthology.

11 Lent and Xu, "Chinese Animation Film," 111–125, in Zhu and Rosen, *Chinese Cinema*, 114.

12 David MacFadyen, *Yellow Crocodiles and Blue Oranges: Russian Animated Film since World War Two* (McGill-Queen's University Press, 2005).

13 Boris Pavlov, "Animation in the 'Russian Hollywood' of the 1920s–1930s," *Animation Journal* 6:2 (Spring 1998), 16–27.

14 Borivoj Dovnikovic Bordo, "Letter to the Editor: In Memory of Dušan Vukotić," *Animation World Magazine* 3:7 (Oct 1998). Online

at http://www.awn.com/mag/ issue3.7/3.7pages/3.7letters.html

15 Ingo Petzke, "40 Years of Animation Made by Zagreb Film," *LJETOPIS 7* (March 1996). Online at http://www. hfs.hr/hfs/ljetopis_clanak_detail_e. asp?sif=32384. It has been speculated that Zagreb animators were greatly influenced by parallel aesthetic developments at the American UPA studio in the late 1940s and 1950s, but it would have been difficult for those works to have been circulated in Zagreb at that time.

16 Nenad Pata, *A Life of Animated Fantasy* (Zagreb: Zagreb Film, 1984), 15.

17 Its mandate, specified in the National Film Act, 1950, is "to produce and distribute and to promote the production and distribution of films designed to interpret Canada to Canadians and to other nations." National Film Board of Canada, "Mandate." Online at http://onf-nfb.gc.ca/en/about-the-nfb/organization/mandate

18 Terence Dobson, *The Film Work of Norman McLaren* (Eastleigh: John Libbey, 2006), 137.

19 The film notes are available at http:// www.urchard.com/teaching/exp_anima/ mclaren_norman_tech_notes.pdf. See also Donald McWilliams, ed., *Norman McLaren: Creative Process* (Montreal: National Film Board of Canada, 1991), an online book of McLaren's writing at http://onf-nfb.gc.ca/sg/100122.pdf

20 David MacKenzie, "Canada's Red Scare 1945–1957," in *The Canadian Historical Association Historical Booklet* 61. Online at http://www. collectionscanada.gc.ca/cha-

shc/008004-119.01-e.php?&b_id=H-61&tps_nbr=1&brws=y&&PHPSESSI D=ncvsn87i5a8425m11nn95muob3

21 Alison Loader, "3-D Convergence and Collaboration in the Cold: Norman McLaren and 1950s Stereoscopic Animation at the National Film Board of Canada," *Animation Journal* 22 (2014), 19.

22 Kerry McArthur, "The Fine Touch of the 'Country Mouse': Evelyn Lambart at the National Film Board," *Animation Journal* 22 (2014), 27–45.

Key Terms

direct-sound technique
full animation
midcentury modern
pixilation
propaganda

Socialist Realism
stereoscopy
stop-motion
synthetic sound

CHAPTER 11

Stop-Motion Approaches

Chapter Outline

Global Storylines

Stop-motion animation does not lend itself to rapid studio production, as drawn animation would do; but it continues to be produced on a smaller scale, sometimes through international collaborations

Many approaches are used in stop-motion productions, employing natural objects, puppets, cutout figures, clay, and human actors

Theatrical traditions in Eastern Europe and Japan, including puppetry, influence the development of stop-motion animation in those countries

American stop-motion flourishes in the postwar years: Ray Harryhausen and Wah Ming Chang produce pioneering work in special effects, and Art Clokey creates the popular Gumby character for television

Introduction

The term "stop-motion" encompasses a wide range of practices that all involve capturing the frame-by-frame movement of a material object that is reused over and over. The objects employed in stop-motion are diverse, ranging from random "found" **objects** and such natural materials as sand particles, to hinged paper cutouts (lit from the front or from behind in **silhouette**), pixilated humans, and puppets. Puppets can be made from a variety of materials, including latex or fabric, wood, or plasticine.

By the early 1930s, stop-motion production had become quite sophisticated. Good examples from the early years include Willis O'Brien's animated dinosaurs in *The Lost World* (dir. Harry O. Hoyt) in 1925, created with the help of his assistant Joseph Leland Roop, and his infamous gorilla in *King Kong* (dir. Merian C. Cooper and Ernest B. Schoedsack) in 1933 (see p. 111). Also in 1933, the prolific stop-motion animator Władysław Starewicz, known for his *Mest' Kinematograficheskogo Operatora* (*The Cameraman's Revenge*) from 1911 (see p. 83), released *Fétiche Mascotte* (*The Mascot*). This film, which has become a kind of cult classic, is about a group of toys that set out to get a gift for the sick child who owns them. Led by a stuffed dog, the toys fall into a dark, frightening world where they must defend themselves against the violence of their fellow creatures. In this instance, as in many others, Starewicz worked with his daughter, Irène Starewicz, as co-producer and co-director.[1]

In the earliest years of cinema, stop-motion had dominated over drawn and painted forms, but once the American studio system developed and became so successful internationally, the situation reversed. Whereas a large crew could generate the thousands

11.1 Lou Bunin, *Alice in Wonderland*, released in the US in *c.* 1951

of images needed for animation on paper or cels, which would be quickly photographed in succession, it was more likely that a single person—spending many hours under a camera—would toil over the animation of a single stop-motion figure. These two types of animation developed on separate tracks to a great extent, partly because animators could not easily shift from one realm to the other, as the two working methods are so very different. In some ways, stop-motion is more like live-action production, as shooting might take place on a set using cinematic lighting; in these contexts, puppet and clay figures can be kept upright with an internal **armature** and anchored to the floor using **tie-downs** (such as wires or bolts). Animation of puppets may occur through **replacement** (for example, using a series of different heads that are put on and taken off) or through direct manipulation (as in clay figures that are modified under the camera).

After World War II, stop-motion production remained popular and its techniques diversified. At that time, it took on an increasingly international profile, reflecting wider changes in the film world. One example of this growth can be seen in the international collaboration that took place on the feature-length, combined live-action and stop-motion animation film *Alice in Wonderland*, co-directed by the Russian Lou Bunin, which was released in *c.* 1951 (11.1). In the late 1940s, Bunin, who was working for the MGM studio in Hollywood, was approached by a French writer hoping to collaborate on the project. The film was therefore produced in Paris but a number of artists from Hollywood studios worked on it, including Art Babbitt

(see p. 101), who drew pre-production reference art for the animators, and Bernyce Polifka and Gene Fleury, who created background designs (see p. 205). Another example can be found in the work of Arthur Rankin, Jr. and Jules Bass, who were pioneers of animated television programming in America, and also joined forces with international studios to create their films. Initially using the company name Videocraft International and a stop-motion process they called "Animagic," the Rankin-Bass studio worked with Japanese artists to animate their holiday specials (see p. 233), such as *Rudolph the Red-Nosed Reindeer* (dir. Kizo Nagashima and Larry Roemer, 1964) and *Frosty the Snowman* (dir. Jules Bass and Arthur Rankin, Jr., 1969).

This chapter focuses on stop-motion in the period after World War II, providing an overview of its diverse aesthetics and applications. Whereas drawn animation has strong links with cartooning and illustration, stop-motion has roots in puppetry in all its forms, including marionette, full-body (wearing costumes), hand, mask, and rod-and-silhouette, as well as in other theatrical traditions. It also has a strong association with live-action film production, especially in the area of visual effects; within the genres of fantasy and science fiction, stop-motion figures have enabled the development of futuristic devices and scary creatures that have entertained audiences worldwide. In all of its incarnations, stop-motion practice has evolved through social networks, with experienced animators passing knowledge on to younger practitioners, sometimes across national boundaries.

Experiments in Stop-Motion

The postwar period saw a surge in the production of independently produced, experimental films of varied kinds, using specialized methods. While working in Paris, the Russian Alexandre Alexeieff (1901–1982) and the American Claire Parker (1906–1981) created stop-motion animation using their own invention, the pinscreen: a frame lit from the sides and punctured with pins that could be adjusted to catch more or less light, producing darker or lighter shadows (see p. 85). They had first used it to create *Une Nuit sur le Mont Chauve* (*Night on Bald Mountain*, 1933) (11.2), which used an adaptation of a work by the Russian composer Modest Mussorgsky. During the war, they went to North America and in 1943 they accepted a commission from the National Film Board of Canada, at the invitation of Norman McLaren (see p. 177). There they created their second pinscreen film, *En Passant* (1943), depicting a squirrel's romp through the countryside, accompanied by a Canadian folk song. Although much of their professional

11.3 Gisèle and Ernest Ansorge, *The Chameleon Cat,* 1975

lives involved the production of advertising and book illustration, they continued to see the pinscreen as a technique with great potential, and used it in other films, including *Le Nez* (*The Nose*, 1963), an adaptation of the story by Nikolai Gogol about a man who loses his nose. Some years later, in 1973, Alexeieff and Parker returned to the NFB to lead a workshop on the pinscreen. The event was captured as a documentary, which inspired the NFB animator Jacques Drouin, a Canadian artist, to use the pinscreen in his own work.[2]

The Swiss couple Gisèle (1923–1993) and Ernest "Nag" Ansorge (1925–2013), who lived in Zurich, were known for their numerous sand animations. To create complexity in their visual designs, they used a **multiplane rig** and devised methods for incorporating color on the underside of glass layers, applying paint or color acetate, as they did in *Le Chat Caméléon* (*The Chameleon Cat*, 1975) (11.3), a film about a shape-shifting cat. Colored sand, sometimes lit from below, could also be used, keeping colors separated on different levels. The Ansorges also used sand to create a number of other independently produced films, and Nag used stop-motion animation as art therapy for patients at the psychiatric clinic where he worked.

The Canadian Leonard Tregillus (1921–1989) started to work in clay animation immediately after World War II, while he was a graduate student at the University of California, Berkeley, where he earned a doctorate in chemistry. The films he made during that period (with the assistance of Ralph Luce and Jack Chambers), including *No Credit* (1948) and *Proem* (1949), place him within the active, experimental postwar film scene that was growing in the San Francisco Bay area. Both films employ abstract imagery, along

11.2 Alexandre Alexeieff and Claire Parker, *Night on Bald Mountain*, 1933

with a kind of character performance. For example, *Proem* is set in the context of a chess match, which is confirmed at the end of a film with a cut to show actual chess pieces and a checkered board. In 1950, Tregillus moved to Rochester, New York, to work on high-level photographic research for Eastman Kodak, but he continued to make clay-animation films as well.

Stop-Motion in Advertising

From its inception, stop-motion has been a staple of advertising films. The Hungarian George Pal (1908–1980) (see p. 111) is well known for his promotional works for sponsors, such as *Philips Broadcast of 1938*, made for Philips Radio in Holland (11.4). This cinematic film employs intricate replacement animation to depict a range of Latino and black performers, embracing familiar stereotypes. One scene is shot from above, in the style of the American musical choreographer Busby Berkeley, creating geometric forms that move around the stage. George Pal's puppets, which tend to be made of wood, have replacement heads to create various reactions that are emphasized by the figure's eyes: a large area of white around each pupil makes them very expressive. Some of Pal's puppets have round heads, while other heads are long and narrow; they are not exactly the same, and yet there is some similarity in style. This style was sustained during the 1940s, after Pal moved to the US and his "Madcap Models" stop-motion shorts series began to be distributed by Paramount. In the 1950s, Pal shifted his career somewhat, as he began producing live-action science-fiction features, such as *Destination Moon* (1950) and *The War of the Worlds* (1953).

The Dutch producer Joop Geesink (1913–1984) is another important figure in the history of stop-motion advertising. Geesink entered the media world in the early 1930s, when he opened an agency and was commissioned to promote and decorate big events and to develop set pieces for theatrical productions. In the early 1940s, he moved into drawn animation, learning the process by studying American films frame by frame,[3] and partnering with the Netherlands' most famous cartoonist at the time, Marten Toonder. In 1947, with the addition of the puppet-maker Harry Tolsma, the studio earned an international reputation for producing high-quality stop-motion films, and Geesink began to call his

business "Dollywood," a combination of "dolls" and "Hollywood." The studio's quality and popular appeal can be seen in such films as *The Big Four* (1946), which shows diplomats from the US, UK, France, and the USSR entering discussion behind closed doors,

11.4 George Pal, *Philips Broadcast of 1938*, 1938

while a number of humorous reporters, including a monkey on a chandelier, remain in the lobby to record what they hear. At the end of the film, it is announced that an agreement has been reached. This is the point where an advertising slogan would be inserted: for example, "They agree that Van Nelle Coffee and Tea are a class apart" or "They all agree that you can not do better than buy from Holland." The film was designed at Geesink's studio, but its ending was modified when it was sold to different advertisers.

Stop-Motion in Eastern Europe

There has been a long tradition of stop-motion animation in Eastern Europe, owing to the legacies of toy-making and puppeteering in that part of the world. One relatively early highlight was the sixty-eight-minute film *Novyy Gullivyer* (*The New Gulliver*), directed by the Ukrainian Aleksandr Ptushko at Mosfilm in Moscow and released in 1935 (11.5). A Communist revision of Jonathan Swift's famous satirical novel

of 1726, *Gulliver's Travels*, the film combines a live actor with a large cast of animated puppets to tell the story of a boy who finds himself in Lilliput, which is suffering as a result of its capitalist system.

Estonian Animation

Estonian animation dates to the 1930s, when it began to be produced within the Soviet state-run studio Tallinnfilm, located in Estonia's capital city, Tallinn. In 1957, Elbert Tuganov, who had worked at Tallinnfilm for about ten years, established a separate stop-motion studio, Nukufilm, in the same city. That same year, Nukufilm released Estonia's first puppet film, *Peetrikese Unenägu* (*Little Peter's Dream*), directed by Tuganov, with art direction by Rein Raamat. The film is based on the story *Palle Alene i Verden* (*Palle Alone in the World*, 1942), by the Danish writer Jens Sigsgaard, about a boy who can do anything he likes, but is all by himself and so becomes very lonely. In 1971, Raamat founded a cel-animation studio, Joonisfilm, also in Tallinn. Tallinnfilm remained in operation until the breakup of the Soviet Union in the early

11.5 Aleksandr Ptushko, *The New Gulliver*, 1935

1990s, but Nukufilm and Joonisfilm (re-established as Eesti-Joonisfilm in 1994) have continued. Both studios have been well supported by the government and are regarded as a vital part of Estonian culture.

Puppetry and Animation in Czechoslovakia

The eighteenth century is considered a golden age of Czech puppetry; it was a time when itinerant puppeteers traveled through Eastern Europe, performing well-known theatrical works and occasionally operas or other productions written specifically for their puppets. Since they were itinerant, performances were difficult to censor and, as a result, puppetry provided an ideal opportunity for political commentary. During the golden age, Czech puppets were typically intricately crafted, wooden marionettes, with a detailed, exaggerated Baroque aesthetic. Traditionally, they had nondescript facial expressions, requiring the puppeteer to create feeling through their movements, using skills that were passed down from generation to generation, as puppeteering tended to be a family business. The twentieth century saw a resurgence of interest in Czech puppet traditions, which led to the development of permanent theaters to house performances.

Two of the most famous figures in Czech puppetry are Josef Skupa (1892–1957 (see p. 166)) and Jiří Trnka (1912–1969) (see p. 166), whose histories intertwine: in the late 1920s, Trnka was a student in an art program where Skupa was teaching. Recognizing the young man's talent, Skupa encouraged him to pursue a career in the arts and became a kind of mentor to him. Trnka learned about puppetry while working with Skupa, but began his career as an illustrator, after attending courses in Prague at what is now the Academy of Arts, Architecture and Design. He continued to work on the stage, however, creating his own puppets and forming a puppet theater in the mid-1930s. Trnka turned to animation in the mid-1940s, with the development of two new studios in Prague.

Stop-Motion Masters in Prague
Founded in 1935, Atelier Filmovych Triku (AFIT) became a base for the expansion of Czech animation production in the postwar years. AFIT could be described as a kind of all-purpose animation and visual-effects studio, supplying subtitles, effects for live-action films, animated advertising, and other

11.6 Jiří Trnka, *The Hand*, 1965

types of work. During the German occupation, the studio was taken over and charged with creating 2D films that would rival those of America. After the war, Trnka and other AFIT animators reorganized, forming studios specializing in 2D and stop-motion.

Jiří Trnka's accomplishments in puppet theater have elevated him to the status of a national hero because of the kudos he brought the nation, but he was also an accomplished illustrator, employing a wide range of techniques in more than a hundred books, mainly stories for children. Trnka's career as an animation director began in 1945, at the 2D studio that emerged from AFIT, Bratři v Triku (Brothers in T-shirts), on the film *Zasadil Dědek Řepu* (*Grandfather Planted a Beet*, 1945). Two years later, he and other animators interested in stop-motion broke away to form Studio Loutkoveho Filmu (Studio of the Puppet Film," see p. 167), now generally known as the Jiří Trnka Studio, because his influence was so great. Trnka created the figures used in his films, but he was never an animator; he relied on others to set his drawn animations and puppets into motion. Since he did not create replacement heads for his puppets to show changes in emotion, his stop-motion animators had to express feelings through movement, following the tradition of Czech puppetry.

Trnka became well known for directing a wide range of films, such as the short *Arie Prerie* (*Song of the Prairie*, 1949), a parody of American western films, and the feature-length *Sen Noci Svatojánské* (*A Midsummer Night's Dream*, 1959), an adaptation of Shakespeare's play. His final film, *Ruka* (*The Hand*, 1965), is his most famous (11.6). It depicts an artist who is harassed by a large hand, which represents an oppressive government that forces him to do

its bidding. As the story begins, a potter is happily spinning his wheel, creating containers for a little plant he is nurturing—but then the ominous hand knocks at his door and, try as he might, the artist cannot keep it away. Although *The Hand* alludes to various political systems, the story is generally read as Trnka's statement about his own position in Czech society, as an artist who was valued only as long as he obeyed the authorities. The Czech government apparently interpreted the film as subversive and would not distribute it. Trnka died a few years after it was finished, in 1969, having never made another film.

Břetislav Pojar (1923–2012) was Trnka's animator on *A Midsummer Night's Dream* and other films, but he also directed work of his own. One example

is *O Sklenicku Víc* (*A Drop Too Much*, 1954) (11.7), a film about a motorcyclist facing problems that are complicated when he stops at a bar for a drink. Trnka served as art director on this project. The human puppets, the countryside and interior settings, and the small props that drive the story are intricately detailed and brought to life through a combination of animated movement, camerawork, and editing. The film is very cinematic in its framing of action, varied **depth of field** (allowing shifts in focus), and point-of-view shots (reflecting what a character sees). A moving camera, often used for long takes, allows the countryside and the sky above it to look vast, while the inside of the bar appears tiny and cramped. Another of Pojar's much-loved works is a series of films involving two bears, made with a cutout-animation technique: the first series starring the bears is called "Pojd´te, Pane, Budeme si Hrát" ("Hey Mister, Let's Play") and has six episodes. One of them, *K Princeznám se Nečuchá* (*Don't Smell the Princess*, 1965), depicts the efforts of one character to convince the other that the delicious fish he has caught is really a princess and should not be eaten; in the meantime, they go through many playful antics. The films, visually designed by Miroslav Štěpánek, are charming, made with brightly patterned cloth, soft fabrics, and detailed small props, as well as cute animal characters.

11.7 Břetislav Pojar, *A Drop Too Much*, 1954

The Zlín Studio

The city of Zlín (known as Gottwaldov from 1948 to 1990) became home to another of Czechoslovakia's early animation studios. This one had been founded during the mid-1930s, partly to promote the famous Bata Shoe Company, which had established its base in the city as far back as 1894 and strongly influenced the region. After working as an animator in Prague, Hermina Týrlová (1900–1993) (see p. 165) had moved to the Zlín studio (later Ateliery Bonton Zlín), and mainly created films for children, her first being released in 1944: *Ferda Mravenec* (*Ferda the Ant*), based on a character created by the Czech illustrator Ondřej Sekora during the 1930s. It tells the story of a friendly, industrious fellow who, along with his girlfriend, falls

11.8 Karel Zeman, *Mr. Prokouk, Filmmaker*, 1948

11.9 Dziga Vertov, *The Man with a Movie Camera*, 1929

into the clutches of an evil spider—but fortunately, other garden creatures come to their aid. The sets and figures have a very handcrafted look, with clay hillsides clearly reflecting the nature of the medium, including cracks and sculpted marks. Another of Týrlová's films, *Vzpoura Hraček* (*Revolt of the Toys*, 1947), tells the story of a Nazi guard who enters a toymaker's shop and is driven out by toys that reside there. This film, which was co-directed by František Šádek, features two live performers, as well as numerous stop-motion figures. It is, for Týrlová, uncharacteristically political in content, since she typically directed films that focused on childhood and the home. A good example is *Uzel na Kapesníku* (*The Knotted Handkerchief,*

1958), which depicts the adventures of various pieces of fabric that come to the rescue when a boy neglects his duties at home.

Karel Zeman (1910–1989) had begun his career in advertising and worked for the Bata Shoe Company before moving to the Zlín film studio in 1945, as an assistant to Týrlová. Their best-known work is the stop-motion film *Vanocni Sen* (*Christmas Dream*), released in 1947; it tells the story of an old toy that is cast away for new ones. Zeman later embarked on his own work, including a series of films created between 1947 and 1964 involving a humorous character named Mr. Prokouk, who takes on various roles. In *Pan Prokouk Filmuje* (*Mr. Prokouk, Filmmaker,* 1948) (11.8), he is an aspiring filmmaker who is booted out of a studio after he presents his story concept to an executive; undeterred, he decides to make his own film, using a music box that he buys from a street performer and converts into a camera. Along with wooden puppets and minimal sets, the film includes such effects as smoke and filming in reverse. Other effects include a transition between shots created by panning across a set into what appear to be sprocket holes from the edge of the film and into another piece of film running beside the first. These images occur in the context of an uprising of the working class (specifically, porters) staged by the animated cameraman and filmed as it transpires. Viewers get a surprise at the end of the film, when the cameraman appears to turn the camera back on them. The final images show the cameraman in a split-screen effect, dividing the image into multiple parts, reminiscent of Dziga Vertov's *Chelovek s Kinoapparatom* (*Man with a Movie Camera*, 1929) (11.9).

Zeman is well known for directing feature-length live-action fantasy films with animated effects. One of his most famous is the children's adventure film *Cesta do Praveku* (*Journey to the Beginning of Time*, 1955), in which a group of kids encounter dinosaurs and other stop-motion creatures.[4] Also popular is his version of *Baron Prášil* (*The Fabulous Baron Munchausen*, 1961), based on a story about a real-life German nobleman who lived in the eighteenth century (11.10, see p. 192). Munchausen was known to recount exaggerated tales of

11.10 Karel Zeman, *The Fabulous Baron Munchausen*, 1961

his exploits, which were further expanded on by various writers later in the century. Zeman's treatment relates the comedic adventures of the baron and a space-traveling man from Earth whom Munchausen believes is from the moon. Animation is combined with live performance to create a fantastic atmosphere—for instance, when animated horses carry the duo's sailing ship through the sky. Some of the film's imagery is spectacular, as when Munchausen and the Earthman engage in battle with palace guards, in a flickering montage of images including swords, guardsmen, explosions, billowing smoke, and the roaring head of a lion, all tinted red. In one of the shots, miniature guardsmen are felled by the swoop of a sword. Synchronized to the musical score, the sequence takes on the quality of an energized, choreographed interlude, which seems to incorporate the aesthetics of Soviet montage (see p. 84), with a rapid succession of different images. Tinting is used in scenes throughout the film to add dramatic color to backgrounds. Among other beautiful effects in the work is a **split screen** used to depict a three-day horseback chase. It is framed at an angle, with the bright moon occupying a position in the dark upper third of the image, the riders silhouetted in the middle, and the dark lower third completing the composition.

Pioneering Efforts in Japan and China

Despite the highly charged political climate of the postwar world, animation production found ways to cross borders. The Japanese artist Tadahito Mochinaga (1919–1999), for instance, made important contributions in both China and Japan, first working in 2D production but eventually becoming a central figure in the realm of stop-motion animation. Mochinaga had attended art school in Tokyo during the mid-1930s, studying animation techniques, and after being employed as a set designer for the Tokyo Takarazuka Theater, in 1938 he was hired by the animation department of Geijutsu Eigasha (Art Film Company). He began as a background artist for director Mitsuyo Seo, working on some short films for children that were sponsored by the Ministry of Education, as well as *Momotaro's Sea Eagle* (1943), the thirty-seven-minute film directed by Seo for the Imperial Navy (see p. 160). In 1944, Mochinaga began

to direct his own films, beginning with *Fuku-chan's Submarine*, employing a well-known character from Japanese comics in a patriotic, war-themed story.

After his home in Tokyo was destroyed in an air raid in 1945, Mochinaga left for Japanese-controlled Manchuria (known as Manchukuo by the Chinese), where he had lived as a child. He then began working at the Man'ei (Manchukuo Film Association), which had been established by Japan in 1937 as probably the most sophisticated film studio in Asia. After the Chinese Communist Party regained control of the region following World War II, in 1946 Man'ei was absorbed into the Dongbei (Northeast) Film Studio. Many of the Japanese and Korean employees who had been at Man'ei stayed on, however. Mochinaga was among them, integrating himself by taking the Chinese name Fan Ming. Under this name, he worked as an animator for Chen Bo'er's stop-motion film *Huang di Meng* (*The Emperor's Dream*, 1947, see p. 171) and he also directed his own films, in both cel and stop-motion animation. In 1950, when the Northeast Film Studio was reconfigured, he moved with other animators from the studio to Shanghai, where he helped train a new generation of artists and continued directing animation. When Mao Zedong brought in hard-line Communism in 1953 (see p. 170), Mochinaga returned to Japan, where he continued working in animation.

Mochinaga's first puppet film in Japan was released in 1956: *Uriko Hime to Amanojaku* (*Melon Princess*), a traditional story about a girl born from a melon and her encounter with an *amanojaku*, or demon. He also began creating stop-motion animated commercials for the new medium of television, which by the mid-1950s was widely available in Japan; he worked with the puppet-maker Kihachiro Kawamoto, who later became one of the country's great stop-motion animators. By 1960, Mochinaga had co-founded the MOM Film Studio, which made stop-motion films for the American company Videocraft International (later known as Rankin-Bass Productions, Inc.). Its best-known work for the company is the popular Christmas special *Rudolph the Red-Nosed Reindeer*, which was released in 1964 and continues to be played annually. For this film, MOM created puppet figures and animated them. Mochinaga kept in contact with the Shanghai animators and in the late 1970s, after the Cultural Revolution (see p. 170) had ended, he returned to the studio and acted as a consultant on productions.

The Japanese–Czech Connection

During the 1960s, it was very difficult for Japanese citizens to travel internationally, and it was equally hard for any outsiders to enter Eastern Europe, much less stay for an extended period. Nonetheless, two of Japan's top stop-motion animators of the postwar period, Kihachiro Kawamoto and Tadanari Okamoto, did just that. During the mid-1950s, Kawamoto had seen a screening of Jiří Trnka's *A Midsummer Night's Dream* (1949) and decided to contact the filmmaker. He went to Prague in 1963 to meet him and lived in the city for a year. Soon after, Okamoto made his own trip to Prague to see the great stop-motion animator Břetislav Pojar.

Kihachiro Kawamoto

Kihachiro Kawamoto (1925–2010) had learned the art of puppet-making from his grandmother, but he studied architecture at Yokohama National University. After serving in the military during the war, he found a job as an assistant art designer at the Tōhō studio in Tokyo, where he worked between 1946 and 1950. He then revived his interest in creating doll figures, sculpting versions of celebrities that were photographed for the widely-read *Asahi Graph* magazine.[5] He also created characters for a set of photographic books that he made with the author and illustrator Iizawa Tadasu. Kawamoto's career in animation began in 1953, when he and Iizawa made commercials with Tadahito Mochinaga. Kawamoto worked with Mochinaga for about ten years, before tiring of commercial work and traveling to Prague for inspiration, hoping to learn from Trnka.

Kawamoto's experience in Prague affected him deeply, leading him to balance his commercial productions with such independent works as *Hanaori* (*The Breaking of Branches Is Forbidden*, 1968), *Oni* (*Demon*, 1972), *Dojoji* (*Dojoji Temple*, 1976), and *Kataku* (*House of Flame*, 1979), all of which reflect traditions of Japanese theatrical performance styles and designs (see Box: Japanese Theatrical Traditions, p. 194). For example, the origins of the puppet film *House of Flame* (11.11, see p. 194), which tells the story of a serene young woman who is loved by two jealous suitors, can be traced to the *noh* play *Motomezuka* (*The Seeker's Mound*), written by Kan'ami Kiyotsugu in the late fifteenth century.[6]

Kawamoto also used cutouts and collage to create independent films. In one of them, *Tabi* (*The Trip*, 1973),

11.11 Kihachiro Kawamoto, *House of Flame*, 1979

a woman moves through a surreal environment in search of some form of inner experience or understanding. His *Shijin no Shōgai* (*A Poet's Life*, 1974) is an adaptation of a story by the novelist Kōbō Abe. It is about an old woman who is woven into the yarn she is spinning and eventually knitted into a sweater; in this form, she aids

Japanese Theatrical Traditions

The theatrical traditions of *kabuki*, noh, and *bunraku* have informed Japanese animation to varying degrees, in the forms of familiar storylines and characters, visual designs in costuming, masks, makeup, and even sound. Kabuki dates from the early seventeenth century and noh is even older. Both are types of live theater, performed by actors on a stage. Kabuki began as a form that catered more toward laborers and the working class, and so tends to be more boisterous, incorporating loud dialogue, dance, and stories about passion and morality; whereas noh was for the upper class of society and so more reserved, embracing themes related to moral values and spirituality. Both forms use stylized costuming, including facial decoration, though noh actors don a set of masks to show varied expressions, whereas kabuki actors paint their faces. Noh sets are generally quite sparse, keeping attention on the performers' wardrobe and actions, whereas kabuki sets may rotate and can feature a variety of stage devices that figure in the storytelling.

her son's meditations on workers, international relations, and war, as he realizes the importance of his role as a poet to inspire others. It is filmed in mainly sepia tones and employs a stylized, limited-animation approach, typical of cutout animation. Kawamoto's multifaceted career also includes two historical television series: "Sangokushi" ("Romance of the Three Kingdoms," 1982–84) and "Heike Monogatari" ("Tale of Heike," 1993–95).

Tadanari Okamoto

Tadanari Okamoto (1932–1990) had studied law and worked in that field for two years before deciding to abandon it for film school at Nihon University. When he graduated in 1961, he went to work at Mochinaga's studio, MOM, but he did not stay long; in 1964, he founded his own company, Echo, which remained in production until 1990. Okamoto's first film there, *Fushigina Kusuri* (*The Mysterious Medicine*, 1965), tells the story of a visitor who goes to a laboratory where a man and his young assistant seem to have invented a wonderful potion. The stop-motion film suggests the influence of MOM's Rankin-Bass productions, with character designs fashioned from wood and fabric; the puppets feature comical expressions painted on their

Bunraku, which also originated in the early seventeenth century, is a form of puppet theater that relates legendary and historical stories, many of which were written by the great Japanese dramatist Chikamatsu Monzaemon (1653–1724). In bunraku, each one of the central puppets is operated by three puppeteers—one a master and two more junior—who are all on stage during the performance. Only the master's face is seen; the two assistants are dressed in black and hooded to become "invisible." The story is told by a single chanter, who performs all the parts, using different qualities of voice to represent each character. The chanter is assisted in his or her delivery by an individual playing a three-stringed, traditional Japanese instrument, the *shamisen*; the emphasis for both of them is on the expression of feelings, which, together with the movement of the puppets, blends into a singular, dynamic performance.

faces and thin limbs supporting large bodies and heads. Movements are stylized and entertaining: as some of the characters talk, their mustaches (rather than their lips) move up and down in sync with the dialogue, and as the visitor speculates about what the potion can do, he goes through a range of funny, extreme poses.

Beginning in 1972, Okamoto teamed with Kawamoto to produce traveling "Puppet Animashows,"[7] screening their works together in programs that went from city to city throughout Japan. By this time, the two animators had become quite popular. While both of them emphasized Japanese culture in their films, they also appealed to international audiences at festivals.

American Stop-Motion in the Postwar Period

Landmarks in Visual Effects

During the period after World War II, 2D cel production dominated the American animation world. Pockets of stop-motion continued to exist, however, laying the foundation for future generations of animators. Many stop-motion works were produced in the context of developing visual effects for live-action films, and in this Ray Harryhausen was a giant. Although not as well known, Wah Ming Chang also made a great contribution to the field of visual effects.

Ray Harryhausen

Ray Harryhausen (1920–2013) had wanted to be a stop-motion animator since he was a child, after seeing Willis "Obie" O'Brien's animation in *The Lost World* (1925) and *King Kong* (1933). Harryhausen researched animation and learned some fundamental techniques and, in 1938, at the age of eighteen, began an ambitious dinosaur film he called *Evolution of the World*. He then sought out his idol, who was working at MGM, bringing some models to show him. O'Brien thought they were weak in their anatomy, and suggested that the budding animator take art classes. Harryhausen took his advice and attended Los Angeles City College and the University of Southern California (USC), where he learned about film production. After responding to a "help wanted" advertisement in the newspaper in about 1940, Harryhausen was hired by the stop-motion animator George Pal (see p. 111), who was making short subjects for Paramount.[8]

During World War II, Harryhausen was called to military duty, serving in the First Motion Picture Unit, where he created propaganda films and some stop-motion effects (see p. 146). Then, when the war was over and he was back on his own, he produced and directed four stop-motion nursery rhymes that he released as one ten-minute film, *Mother Goose Stories*, in 1946. He also made some commercials. A few years later, Harryhausen got his big break when O'Brien asked if he would be his assistant on the feature *Mighty Joe Young* (dir. Ernest B. Schoedsack, 1949). The film won an Oscar for best special effects.

The following year, Harryhausen returned to making his own films, beginning with *Little Red Riding Hood* in 1950, and then moving on to *The Story of Hansel and Gretel* (1951), *The Story of Rapunzel* (1952), and *The Story of King Midas* (1953). A final film in this "Mother Goose Tales" series, *The Story of the Tortoise and the Hare*, was started in 1952, but not completed until 2002 because Harryhausen embarked on a feature-film project, *The Beast from 20,000 Fathoms* (dir. Eugène Lourié, 1952). He created

effects for the film using a new split-screen system that he called "Dynamation"; it employed **rear-screen projection** (projecting a film behind the actors, to serve as a background), mattes (or blocked-off areas), and double exposures to combine live-action and animation. The first step involved filming live-action performers reacting to animated characters they could not yet see. Harryhausen used this footage in the production of his animated sequences. A camera was set up in front of his animation table, which was situated between two panels, in front and back: the foreground one contained a matte, and the rear panel was a screen for the live-action footage, projected onto it frame by frame, as the animation occurred. Harryhausen would move through his entire animated sequence, projecting the live-action and creating the animation. The live-action footage was rewound and the camera then shot again, using a second matte that covered the areas previously exposed. At the end, he had achieved a single print that featured both the live and animated components.

11.12 Ray Harryhausen working on a model for *The Seventh Voyage of Sinbad* (1958)

Harryhausen's career is closely tied to a producer from Columbia Pictures, Charles H. Schneer, who was his business partner for more than twenty-five years and twelve feature films. Their titles include *It Came from beneath the Sea* (dir. Robert Gordon, 1955), which was the first film they made together, *Earth vs. the Flying Saucers* (dir. Fred Sears, 1956), and *The Seventh Voyage of Sinbad* (dir. Nathan Juran, 1958) **(11.12)**. They also collaborated on *Jason and the Argonauts* (dir. Don Chaffey, 1963), a film that stands out for Harryhausen's feats of animation, which include the giant bronze statue Talos, a seven-headed hydra, and several skeletons moving in unison during a sword-fighting sequence **(11.13)**. The story is based on the Greek myth of Jason and the Golden Fleece, a hero's quest in which a young man battles various entities to regain his rightful place on the throne.

The skeleton fight sequence toward the end of the film is a highlight not only of *Jason and the Argonauts*, but also of Harryhausen's career and the entire history of visual effects. In it, Jason and some of his Argonaut soldiers watch as seven skeletons rise up from the ground and march toward them, swords drawn. When the skeletons break into a run, the men are forced to retreat to a ledge, where they engage in battle. To create the sequence, the men first rehearsed with live actors, who enacted the motions of

11.13 Don Chaffey, *Jason and the Argonauts*, 1963

11.14 George Pal and Henry Levin, *The Wonderful World of the Brothers Grimm*, 1962

the skeletons to be animated. When the performers knew their actions precisely, the scene was filmed without the stand-ins, so the warriors were battling unseen opponents, which were later replaced by the animated characters. Harryhausen explained that although the original myth featured rotting corpses rather than skeletons, the content was changed to ensure that the film would not be rated as too violent for children. The seven skeleton puppets were eight to ten inches high; one of them had been made for a previous film, *The Seventh Voyage of Sinbad*, but the other six were constructed specifically for use in *Jason and the Argonauts*.[9]

Wah Ming Chang

The visual-effects artist Wah Ming Chang (1917–2003) was of Chinese descent and was born in Hawaii, when it was still a US possession and not a state. He spent his youth in San Francisco, where he met the artist Blanding Sloan (known for his etchings, and also the owner of a puppet theater), who mentored him. Chang's mother, who was also an artist, supported her son's interest, but died when he was eleven. The boy, who was already showing great artistic promise, was left in Sloan's care.

Chang began to design murals and after high school was hired to create sets at the Hollywood Bowl, an entertainment venue in Los Angeles. Following this experience, he worked in a variety of places, including The Walt Disney Studios' visual-effects department, which he joined in 1939, at the age of twenty-one, contributing to the features *Pinocchio* (1940) and *Bambi* (1942). His employment there was interrupted when he contracted polio, which required a lengthy rehabilitation process. Chang faced other hurdles as well. In 1941, his engagement to be married was complicated by the start of the war and the fact that his fiancée was white. Until 1948, it was illegal for an Asian and a Caucasian to be wed in California, so the couple had to marry in Texas instead and then move back to California.[10]

During the 1950s, Chang worked on various commissioned films and, in 1956, with Gene Warren and Tim Barr as partners, he formed a company specializing in stop-motion and visual effects, Projects Unlimited. The emerging animator Jim Danforth was among the artists they hired to work on a range of ambitious films. For example, the studio contributed to several George Pal-directed features, including *Tom Thumb* (1958), *The Time Machine* (1961), *The Wonderful World of the Brothers Grimm* (co-dir. Henry Levin, 1962) **(11.14)**, and *7 Faces of Dr. Lao* (1964). It also made contributions to *Planet of the Apes* (dir. Franklin J. Schaffner, 1968) and the television series "The Outer Limits," among other titles. Later, Chang created props and costumes for the original "Star Trek" series and costume elements used in the feature films *The King and I* (dir. Walter Lang, 1956) and *Cleopatra* (dir. Joseph Mankiewicz, 1963). Much of Chang's work went uncredited.

Stop-Motion Stars

By the 1950s, there were many widely merchandized stars of 2D animation, but there were also a few

famous stop-motion figures across the world. One of the earliest characters to achieve widespread popularity was Mecki, a hedgehog created by the German Diehl brothers—Paul, Ferdinand, and Hermann—in 1940. With a wife and children added to the lineup in later years, Mecki became very popular in Europe, especially after the Steiff toy company licensed the character in 1951 and created stuffed animals (11.15).

Gumby began life as a little green slab of clay, but he grew to be America's first stop-motion television star. The character was invented by Art Clokey (born Arthur Farrington, 1921–2010), who created a series around Gumby and his "pony pal" Pokey during the early years of television (11.16). The show embodied a spirit of clean fun and imaginative creativity aimed at young viewers, which was strongly influenced by the creator's personal values and childhood experiences. When Clokey was a child, his father had died, and his mother remarried and placed him in a children's home. Fortunately, he was adopted by Joseph Clokey, a teacher at Pomona College, California, who introduced him to the visual arts and music. After serving in World War II, Clokey wanted to become an priest and so went to Hartford Seminary in Connecticut. There, he met his future wife, Ruth Parkander, and the two decided to make films based on their faith.

Clokey's plans changed, however, after he returned to California and enrolled at the University of Southern California (USC). There he met the experimental filmmaker Slavko Vorkapich, an immigrant from Yugoslavia, who had a great impact on Clokey's

11.16 Pokey and Gumby, created by Art Clokey

aesthetic, introducing him to such masters of cinema as Sergei Eisenstein and theories of abstract art (see p. 76); it is also likely that he helped him find his first employment in the film industry, animating commercials. In between jobs, Clokey constructed a makeshift set in his adoptive father's garage and shot a short film, *Gumbasia* (1953) (11.17), using Vorkapich's principles of kinesthetic sensory effects, which explore the ways that movement within cinema creates various visceral perceptions in the mind. Clokey's film employs clay shaped into textures, forms, and planes, shot from various angles or upside down, in an attempt to separate the objects from the viewer's experience of them.[11]

At the same time, Clokey was teaching at what eventually became the Harvard School in Los Angeles. The father of one of his students, Sam Engel, who was a producer at 20th Century Fox, invited Clokey to the lot, asking him to bring *Gumbasia*. Engel Sr. liked what he saw, and asked Clokey if he could produce a series for children using clay. In 1956, after a pilot episode was screened for Tom Sarnoff at NBC, the "Gumby Show" series was put under contract. It went into production that year, and Gumby made his debut on the popular "Howdy Doody Show," beginning in June 1956 (see p. 220). In a pilot episode made for NBC, *Moon Trip* (c. 1956), Gumby finds himself on the moon, which is a roughly made clay surface bordered by simply constructed peaks. Vorkapich's influence related to abstract imagery can be seen in the triangular, geometric "moon men" that pursue Gumby, as well as in the overall textures of the set pieces.

11.15 Mecki and his wife, stuffed toys from c. 1959

Before her marriage to Art, Ruth had worked for the Lutheran Church, and in the late 1950s it commissioned a television series from the Clokeys: "Davey and Goliath." Aimed at a youth audience, the show included a boy and his dog, and a mixed-race cast of friends, who developed their spirituality through day-to-day activities. The series ran from 1960 to 1965; after Art and Ruth divorced in 1966, Ruth continued to produce it. Art Clokey subsequently remarried and he and his second wife, Gloria, continued production on a variety of other television projects and personal films. Clokey's work, like that of O'Brien, Harryhausen, and others, inspired the growth of stop-motion for years to come, both indirectly, through its huge fan base, and directly, in the decision to hire such up-and-coming artists as Jim Danforth, who began his stop-motion career in about 1958 working on the "Gumby" series.[12]

Conclusion

The 1940s and 1950s saw the emergence of stop-motion animation on a wider scale and in different contexts, as new studios were established after World War II. Much of this work was done within changing ideological boundaries. Although the stop-motion animators discussed in this chapter worked in different national contexts, they sometimes forged connections across countries, despite political differences and the suspicions and fear caused by the Cold War.

In the United States, the decade of the 1950s brought significant change to the animation industry, as studios picked up on an international design trend from the larger art world, midcentury modern. Its clean, graphic look was ideal for the new medium of television, which had poor resolution, small screens, and at first was in black and white. From this context, an influential new studio arose: United Productions of America, better known as UPA. Its success was tempered, however, by the Cold War and by lingering resentment over union struggles in the early decades of the century. The next chapter focuses on these and other developments.

11.17 Art Clokey, *Gumbasia*, 1953

Notes

1 The two also collaborated on the twenty-four-minute film *Le Roman de Reynard* (*Reynard the Fox*), released in German in 1937 and in French four years later, among other projects. Reynard the Fox is a well-known figure from traditional storytelling; he is a trickster who targets the weaknesses of those around him to get what he wants. Richard Neupert, *French Animation History* (West Sussex: Wiley, 2011), 65–66.

2 Marcel Jean, "Pinscreen," *National Film Board of Canada*. Online at http://www3.nfb.ca/animation/objanim/en/techniques/pinscreen.php

3 http://www.dutch-vintage-animation.org/index.php/en/joop-geesink-dollywood-startpagina/joop-geesink-biografie

4 The film was dubbed and partly re-filmed for US release in the 1960s.

5 Jasper Sharp, "Kihachiro Kawamoto obituary," *Guardian* (September 5, 2010). Online at http://www.theguardian.com/film/2010/sep/05/kihachiro-kawamoto-obituary

6 Nurul Lina Mohd Nor, "House of Flame: Construing Gesture in Kihachiro Kawamoto's Animated Film." Online at http://www.academia.edu/3856905/House_of_Flame_Construing_Gesture_in_Kihachiro_Kawamotos_Animated_Film

7 Ben Ettinger, "Tadanari Okamoto: The Heart of Animation," *AniPages* (January 9, 2005). Online at http://www.pelleas.net/aniTOP/index.php/tadanari_okamoto_the_heart_of_

animation; Catherine Munroe Hotes, "The Kawamoto + Okamoto Puppet Anime-Shows (1972–1980), Part I," Nishikata Film Review. Online at http://nishikataeiga.blogspot.com/2011/11/kawamoto-okamoto-puppet-anime-shows.html

8 The Ray & Diana Harryhausen Foundation and Tony Dalton, "Biography," *The Official Ray Harryhausen Website*. Online at http://www.rayharryhausen.com/index.php

9 Ray Harryhausen, "Model Heroes," *Guardian* (December 19, 2003). Online at http://www.theguardian.com/books/2003/dec/20/featuresreviews.guardianreview16

10 Don Coleman, "Wah Ming Chang 1917–2003," *The Time Machine Project*. In *Perez v. Lippold* and *Perez v. Moroney*, the Supreme Court of California recognized that interracial bans on marriage violated the Fourteenth Amendment of the US Constitution. Online at http://colemanzone.com/Time_Machine_Project/wah_chang.htm

11 "Art on the Art of Film and Animation," *Gumby*. Online at http://www.gumbyworld.com/art-clokey/art-on-art-of-film-and-animation

12 Michael Frierson, *Clay Animation* (New York: Twayne, 1994), 125.

Key Terms

armature
cutout
depth of field
matte
pixilate
plasticine
pre-production

propaganda
rear-screen projection
replacement
silhouette
stop-motion
tie-down

CHAPTER 12

Midcentury Shifts in American Design

Chapter Outline

Global Storylines

During the 1950s, the midcentury modern aesthetic filters into animation, starting with background design

An increasing emphasis begins to be placed on the role of the designer

The influential United Productions of America (UPA) helps popularize the midcentury modern aesthetic in animation

Animated advertising sees great growth following World War II

Cold War tensions lead to the blacklisting of animators suspected of Communist involvement

Introduction

During the 1940s and 1950s, changes took place in the American animation industry as a result of larger shifts in the interconnected worlds of fine art, film production, and political thought. Immediately following World War II, America was the most powerful country in the world, promising its citizens a lifestyle that no other nation could match. Amid the prosperity and optimism, however, the country faced many challenges, both internal and external. Internally, the nation struggled against unrest associated with grassroots social movements, such as civil rights and women's rights, while externally it faced a Cold War of political anxieties that seemed to threaten its way of life, especially as the Soviet Union was making advances in the fields of nuclear weapons and space exploration.

Culturally, America had a chip on its shoulder. Although its native peoples had a rich and ancient heritage, the settlers who dominated the country by the nineteenth century had demeaned and largely destroyed it. On the whole, American artists were not taken seriously. European countries, by contrast, were seen as culturally sophisticated; they had long histories of painting, music, architecture, and other art practices. In the mid-twentieth century, the situation in America began to change, partly through the influx of modern art into New York museums, such as the Museum of Modern Art, during the 1930s. As a result of these influences, Modernism (see p. 73) eventually found its way from Western Europe into American art, tipping the scales away from the conservatism of the prevailing Regionalist aesthetic (see Box: The New Deal and the Rise of the Unions, p. 121), which reflected American nationalism and isolation from other parts of the world.

12.1 Jackson Pollock at work at his studio in Long Island, NY

American artists made a breakthrough in the form of **Abstract Expressionism** in painting, which developed during the late 1940s; the country's first modern art movement of international influence, it combined abstract imagery with artist-centered creative processes linked to the unconscious. Probably the best-known Abstract Expressionist is Jackson Pollock (1912–1956), who created **gestural** works, aiming to capture movement and form through a process known as "action painting," in which he would cast paint onto a canvas with a minimum of conscious intervention (**12.1**). Modern art impulses spread to other art forms—such as cinema—and even industrial applications, with a creative director or designer at the center of creativity.

The enthusiastic reception of abstract art in America during the period after World War II led to the development of a broader aesthetic known as "midcentury modern." The midcentury modern style was eclectic, but it tended to embrace abstract or organic shapes, sculptural forms, and a "designed" sensibility in everyday objects, as well as bold colors ranging from bright to

earthy. Embedded in the postwar design aesthetic were the influences of the International Style of architecture and the Bauhaus school (see p. 71), both of which emerged from the Europe of the 1920s and 1930s and valued clean lines and functionality; it emphasized the importance of living spaces and everyday items being designed in a streamlined way, to be practical rather than resembling museum pieces. A good example of this aesthetic is found in the furniture design of the husband-and-wife team Charles (1907–1978) and Ray (1912–1988) Eames, whose work was at the center of the American midcentury modern design movement. Their reputation was established through the creation of now iconic objects, such as the fashionable Eames Lounge (670) and Ottoman (671), made of molded plywood and leather (**12.2**) and first marketed in 1956.

The Eameses worked in Venice Beach, California, from the early 1940s, when Charles was a set-painter at the MGM studio. During their careers, the two designed architecture, furniture, logos, toys, books, photographs, paintings, and more than a hundred films. The range of work evinces their great talent; it also reflects the increasingly eclectic nature of the American art world and the social circles that would emerge from it, as directors and designers from different realms rose to prominence and influenced and supported each other. For instance, the experimental filmmaker John Whitney, Sr. (see p. 251) aided the production of some of the Eameses' films, such as *Toccata for Toy Trains*, a film

12.2 Lounge chair and ottoman designed by Charles and Ray Eames, 1956

12.3 Saul Bass and John Whitney, Sr., titles for *Vertigo* (dir. Alfred Hitchcock, 1958)

as the "auteur theory," referring to directors who demonstrated a clear style in their films, even if they were made within the commercial studio system. During the postwar period, directors pushed the boundaries of form and content, producing creatively daring films that appealed to certain segments of the population and were screened in "art cinemas" or by film societies. French critics were also among the first to embrace animation in scholarship. In 1952, Marie-Thérèse Poncet (1911–2009) wrote the first dissertation on animation; it was later published as *L'Esthétique du Dessin Animé* (*The Aesthetic of Animation*).[2]

As this chapter explains, there were a variety of stylistic shifts in the American animation industry during the late 1940s and early 1950s. Innovation began at the margins, which in this case involved the layouts and backgrounds; it took longer to change the look and movement of characters, because the stars at studios like Disney and Warner Bros. had been conventionalized and were viewed as important assets that brought in profits. The impetus for change quickened as new animation studios arose: United Productions of America (UPA, see p. 210) was the most influential of them, but it was joined by many others that also embraced a new style in animation, in the growing field of advertising and other contexts; to this day, the graphic look and the limited-animation style of the midcentury modern period continues to have a great influence on creators, especially in the realm of television.

At the time, television represented a significant threat to the livelihood of Hollywood filmmakers, in both the realms of live-action and animated production. To meet this challenge, studios in the 1950s incorporated some stylistic shifts intended to draw audiences to theaters, including the use of widescreen formats and stereoscopic imagery and sound, leading to more room for backgrounds and actions and giving the impression of greater space and depth. But television was not the only threat to the industry establishment: investigations into the political pasts of filmmakers—the postwar search for Communist infiltration—resulted in blacklists targeting many innovators.

of 1957 that celebrates the forms and materials of old toys. This live-action short was inspired by a gift—a toy train—that Charles Eames received from the well-known film director Billy Wilder, who was a close friend; the two had met at MGM (see p. 137), after being introduced by the designer Alvin Lustig (1915–1955). Later, Eames would introduce Wilder to Saul Bass, who would become one of Hollywood's foremost title designers; his titles for Wilder's *The Seven Year Itch* (1955) were among his first.[1] Some of Bass's best-known titles were for Alfred Hitchcock: they include *Vertigo* (1958; a collaboration with John Whitney, Sr.) (**12.3**), *North by Northwest* (1959), and *Psycho* (1960). Bass had attended the Art Students League in New York City and later studied graphic design at Brooklyn College with the Hungarian painter and art theorist György Kepes (1906–2001), who had a strong affiliation with the Bauhaus and greatly influenced graphic design in the period following World War II.

The Modernist concern with the creator was underscored by film criticism that developed during the postwar period, with a major strand focusing on the film's director and the notion of the "author" in cinema. In 1954, the emerging French filmmaker François Truffaut wrote an essay called "Une Certaine Tendance du Cinéma Français" (A Certain Tendency in French Cinema), which promoted this notion. Some years later, this concept was extended and described

Finding the Artist in the Animation: Developments at the Major Studios

During the late 1940s and 1950s, many people in the animation industry had started thinking of themselves as fine artists who worked at the studios as a day job. A growing number had been educated in art schools and therefore had a relatively broad frame of reference for their works. Some were inspired by developments that arose in the 1950s, especially jazz, which seemed to validate an improvised, free-form approach to image-making that flowed from the creator. At Disney, in particular, in-house training had contributed to the elevation of the artist; during the mid-1930s, its instruction came from accomplished individuals, heavily referencing European design. A revolutionary shift in thinking occurred in the animation industry as increasing emphasis was placed on the role of the designer. The change reflected the rise of design and the growing visibility of the artist in American culture as a whole. Such developments affected the sensibilities of creators within the animation community, even if they were not always free to experiment in the work they produced.[3]

Background Design at Warner Bros.

The introduction of modern design into the US animation industry was gradual, applied first to backgrounds in the 1940s and then to characters by the early 1950s. At Disney, Warner Bros., and other studios, directors and animators took center stage; other departments, such as layout and backgrounds, had been seen as relatively peripheral, although the artists there were generally just as talented. This is not to say that backgrounds were deemed insignificant. On the contrary, there were various technological developments that affected their design and function. Disney and Fleischer had used the multiplane camera and the **stereoptical** process, respectively, to give depth to their pictures; however, the imagery itself was not particularly innovative, in the artistic sense. When stereoscopic film production became popular in the early 1950s, it was used mainly to move characters and objects toward the viewer, but in the process gave a fuller sense of space. Examples are found in Disney's film *Adventures in Music: Melody* (dir. C. August Nichols and Ward Kimball, 1953); the Famous Studios "Stereotoons" *Popeye, The Ace of Space* (dir. Seymour Kneitel, 1953); and *Boo Moon* (dir. Izzy Sparber and Seymour Kneitel, 1954), starring Casper the Friendly Ghost **(12.4)**. The adoption of widescreen processes, such as **CinemaScope** (which nearly doubled the width of the movie screen), enlarged background areas and enabled characters to move through space in different ways.

At Warner Bros., backgrounds were at first handled in a centralized department, with little input from directors. By the early 1940s, however, backgrounds had started to become more than just a setting in which action occurred. Chuck Jones (1912–2002) (see p. 135) was instrumental in developing their function, encouraging experimentation within his unit and seeking collaborators who could contribute innovative ideas. As a result, in Jones's films, backgrounds became a site for deeper exploration of design, where form and color were vital to the construction of the

12.4 Izzy Sparber and Seymour Kneitel, *Boo Moon*, 1954

12.5 Chuck Jones, *Wackiki Wabbit*, 1943

story. His characters tended to remain conventional in their form, since he was pressured by studio management to continue working with animal characters and to stay on model with studio stars.

To create modern design elements for his films of the early 1940s, Jones worked with the accomplished background artists and layout designers John McGrew (1910–1999), Eugene Fleury (1913–1984), and Bernyce Polifka (1913–1990) (the latter two were married). McGrew had studied psychology as well as art, and was interested in the effects that design could have on story. His inventive backgrounds are showcased in Jones's "Merrie Melodies" film *The Aristo-Cat* (1943), for example: squares on the ceiling frame the butler as he leans over to feed the annoying animal, wavy forms frame his hand as he turns on bathwater, and a barrage of patterns fill the bathroom floor and walls. The design features become even more pronounced as the feline walks down the stairs, which are merely suggested with graphic forms, into a room that becomes increasingly visually complex as the cat's frenzy grows.

Despite the innovations in its backgrounds, the characters in *The Aristo-Cat* remain traditional in their design and movement. This is true of a number of other films Jones created in the 1940s, also in the "Merrie Melodies" series, such as *The Case of the Missing Hare* (1942), in which McGrew's color fields are used to define spaces, sometimes changing within a given background, and *The Unbearable Bear* (1943), for which he created background spaces using angular forms of solid color. For Jones's *Wackiki Wabbit* (1943) **(12.5)**, Polifka developed complex layouts that were realized

by Fleury as the background artist; the film features boldly patterned colors that suggest flattened spaces and create unconventional surroundings for a conventional Bugs Bunny and two human, male characters, all of whom find themselves on a deserted island.

Jones's "Merrie Melodies" *The Dover Boys at Pimento University* (1942) (see p. 136), with layouts by McGrew, backgrounds by Fleury, animation by Bobe Cannon, and narration by John McLeish, is somewhat different than his other films of the early 1940s. In this case, Jones used an all-human cast, including three college men (Tom, Dick, and Larry), the woman they all pine for (Dora Standpipe), and an evil villain (Dan Backslide), set within a melodramatic plot. These characters move stiffly, in stylized ways that add humor to their story. For example, Dora does not walk, but rather dramatically sways around each curve of the stairway in her home. At times, Dora and her three suitors strike and hold "hard poses"—for instance, when they pass the bar and lift their arms in dismay, shielding themselves from its debauchery; such actions are reminiscent of old-fashioned acting techniques, such as the Delsarte method (see Box: The Ideas behind "Disney Style" Movement, p. 103), an appropriate choice for the film's turn-of-the-twentieth-century story. Dan Backslide sometimes moves in stretches and smears, emphasizing his shift from pose to pose. The nostalgic mood of the film is heightened through the backgrounds depicting key locales, such as Dora's countryside home, which is softened by the use of an airbrush.[4]

McGrew, Fleury, and Polifka helped to pave the way for other innovative designers in layout and

backgrounds, such as Maurice Noble (1911–2001), who worked with Jones at Warner Bros., beginning in the 1950s (see p. 135). Noble was known for creating playful environments, often including exaggerated perspectives, dramatic shadowing, and inventive painting styles. During his time at the Chouinard Art Institute, he specialized in watercolor painting, and by 1934 he was working at Disney on backgrounds for "Silly Symphonies" films and later *Snow White and the Seven Dwarfs* (1937). After participating in the Disney strike of 1941, he was no longer welcome at the studio, and, along with many other animators at that time, he enlisted in the Army Signal Corps. Noble began working at Warner Bros. in 1952, and collaborated with Jones as a layout artist for many years, into the 1970s, even after the studio closed and the two moved on to other positions. *What's Opera, Doc?* (1957) (see p. 129) is one of the highlights of this partnership, which spanned more than sixty films.

Disney's Modern Look

The style of Walt Disney's studio was strongly guided by his personal aesthetic, shaped by such factors as his interest in live-action cinema, his business sense, and his travels outside the US. During the 1930s, he had taken a trip to Europe and returned with design concepts that found their way into his feature films, including *Snow White and the Seven Dwarfs* (1937, see p. 104). In 1941, while a strike was being arbitrated at the studio, Disney and a group of artists went to Brazil, Argentina, and Chile on a "Good Neighbor" tour sponsored by the US government. This program was instituted in part to retain good relations with Latin American countries during wartime, in order to counter the efforts of Axis powers in the same regions. By agreeing to the trip, Disney was assured of some much-needed funding as long as he produced work incorporating related cultural content—*The Three Caballeros* (supervising dir. Norman Ferguson, 1944) was among the results (see p. 114).

Mary Blair (born Robinson, 1911–1978) was a painter who had attended San Jose State College (now University) and the Chouinard Art Institute, embracing the Regionalist style in her watercolors of the 1930s. She and her husband, Lee Blair, had worked for other studios before she joined him at Disney in 1940. She left the studio within the year, but was re-hired before the trip took place. As a result of her travels, Blair's work was transformed, turning toward the abstract and modern with a bold use of color. She then emerged as a significant creative force at The Walt Disney Studios, where she remained until the early 1950s.

12.6 Conceptual artwork by Mary Blair for *Alice in Wonderland*

12.7 Clyde Geronimi, Hamilton Luske, and Wilfred Jackson, *Alice in Wonderland*, 1951

Blair contributed inspirational art and color design to a number of films, including *The Three Caballeros* and three films of the 1950s: *Cinderella* (1950), *Alice in Wonderland* (1951) **(12.6, 12.7)**, and *Peter Pan* (1953), all directed by Clyde Geronimi, Hamilton Luske, and Wilfred Jackson. She also contributed to Disneyland, in murals and designs for the "It's a small world" attraction. Blair's career in illustration and design continued in other contexts as well; for example, she is well known for illustrating children's literature in the "Little Golden Books" series.

Walt Disney never really embraced the modern aesthetic, though it was developed in some of the studio's short films. One is *Toot, Whistle, Plunk and Boom* (1953) **(12.8)**, directed by Ward Kimball and C. August Nichols, with character design by Tom Oreb and a color-styling credit for Eyvind Earle, an accomplished painter who

12.8 Ward Kimball and C. August Nichols, *Toot, Whistle, Plunk and Boom*, 1953

12.9 Clyde Geronimi, Hamilton Luske, and Wolfgang Reitherman, *One Hundred and One Dalmatians*, 1961

came to Disney in 1951. This film was the first Disney short to be released using the widescreen technology CinemaScope, which showcases the film's aesthetic. The new look in the backgrounds and layout is evident as soon as the film begins, as a teacher–a wise owl–flies into a classroom that has an elongated, forced perspective. Most of the characters are traditionally designed and animated, but soon a group of band members drawn in outline appear on screen. They move up and down in a stylized way, collapsing at the end of their brief performance. The film continues with a mixture of animated characters rendered in different art styles, situated in backgrounds that are flattened or created with inventive perspectives. A second example, *Pigs Is Pigs* (1954), directed by Jack Kinney, is based on a book by Ellis Parker Butler. This film employs rhyming verse in its voice-over narration, and flattened perspective and graphic style in both its backgrounds and its characters. Earle was background artist on this film, along with Al Dempster, who had started working in the background department at the studio in 1939. Designed in the late 1950s, but released in 1961, *One Hundred and One Dalmatians* (dir. Clyde Geronimi, Hamilton Luske, and Wolfgang Reitherman) demonstrates the influence of modern aesthetics on a Disney feature **(12.9)**. In this film, for the first time at Disney, xerography (a photocopy process), rather than inking, was used to create the lines of images on

cels. This process was embraced by Walt Peregoy, the film's color stylist, who used the system to develop a new approach to painting backgrounds, with bold photocopied outlines on a cel, laid over and roughly connected to areas of color that define the objects being depicted. Peregoy was a fine artist who was influenced by modern art trends, especially abstract art.

United We Stand: The Influence of the UPA Studio

The Road to UPA: Disney Strikers Find New Opportunities

The Disney strike of 1941 marked a turning point not only for that studio, but also for the development of animation style in America. At one time, animators had learned their craft through an apprenticeship at a studio, but during the 1930s, more of them had an art-school education. Disney had attracted some of the best talents in the field and, beginning in the mid-1930s, he, too, had nurtured them with art lessons and introductions to the work of influential artists. Many of the artists who embraced modern art also had strong political beliefs, which were echoed in the rise of unions during this period. Tensions escalated at The Walt Disney

Studios when profits from *Snow White and the Seven Dwarfs* (1937) were used to construct a new building that segregated the once unified crew into separate floors based on their position in the hierarchy and their pay. To make matters worse, working conditions were difficult and asking for a raise could result in dismissal.

When more than two hundred strikers were fired by the studio, a flood of these artists entered the marketplace, looking for a new studio and, in some cases, seeking a new style. A number of these individuals found their way to Columbia Pictures, which had purchased Charles Mintz's (see p. 61) animation studio and renamed it Screen Gems. Frank Tashlin (1913–1972) (see p. 126), an accomplished writer and cartoonist, became production supervisor there in 1941. He joined the studio after leaving Disney, following a salary dispute a short time before the strike. A casualty of that strike, John Hubley (1914–1997), was also hired at Screen Gems, first as a designer, working closely with the writer and voice actor John McLeish, and later as a director. Zack Schwartz (1912–2003), who had been fired from Disney in 1940 when he also asked for a raise, came to the studio after spending a year at the Art Center in Los Angeles, where he had focused on drawing and painting. Later, David Hilberman (1911–2007) came on board as well; he too had been at the Art Center. Despite its accumulation of talent, Screen Gems' output at this time was of mixed quality: probably their best-known work is "The Fox and the Crow," a short-lived gag series featuring Fauntleroy Fox and Crawford Crow. Tashlin left in 1942, and was replaced by Dave Fleischer, who had been fired by Paramount the year before. Columbia closed Screen Gems in 1946, though film titles under this label continued to be released for several more years, and in 1948 the name was brought back for television production.[5]

Other artists found their alternative to Disney in an unlikely place: the military. By 1943, a number of animators were working in the First Motion Picture Unit (see p. 146). Ironically, this proved to be a liberating experience. The military had no preconceived ideas about how a studio should be run or the scope of practices handled by any given person. Since its primary motive was to relay information, it was also relatively unconcerned with character development, and the "Disney style" was not particularly valued as a model. As a result, these artists found themselves calling upon new skills and improvising to solve problems.[6] It was in

12.10 Stephen Bosustow with Mr. Magoo, a character from his UPA studio

this context that three innovators, all disenfranchised Disney artists, decided to create the alternative studio that they and others had longed for. Working after hours, Stephen Bosustow (12.10), Zack Schwartz, and David Hilberman founded the studio that came to be known as UPA, or United Productions of America.

Innovation and Idealism at UPA

During the 1910s, the studio run by animation pioneer John Randolph Bray (see p. 43) had helped to establish the methods of the American animation industry by providing a training ground and introducing efficient production methods in a field that had yet to be clearly delineated. In the 1930s, The Walt Disney Studios had made a great impact on animation design with its studio style, which was influenced in part by Walt Disney's affinity for live-action cinema. In the 1950s, UPA also made a great impression on the animation world,[7] one that reflected the involvement of its three founders in modern design and the desire to provide an alternative to the social, industrial, and artistic modes that American animation had fallen into. UPA's roots lie in the wave of

artists entering the animation industry via art schools as well as in the political context of unionization and the Disney strike. The free-thinking artists liberated from that studio hoped to find a better way at UPA.

The Development of the Studio

In 1943, the Canadian-born Stephen Bosustow (1911–1981) was working as an illustrator at Hughes Aircraft and teaching at the California Institute of Technology (CalTech) when he took on a project to create an

12.11 Robert "Bobe" Cannon, *The Brotherhood of Man*, 1946

instructional filmstrip, *Sparks and Chips Get the Blitz* (1943). He enlisted the help of the animators Zack Schwartz and David Hilberman, and the three formed a company that would eventually be named Industrial Film and Poster Service, and, still later, in 1945, United Productions of America, or UPA. Other commissioned works followed, including two films for the United Auto Workers union (UAW). The first, *Hell-Bent for Election* (1944), was created as a show of support for the re-election of President Franklin Delano Roosevelt; it was art-directed by Schwartz and directed by Chuck Jones, working after hours alongside his job at Warner Bros. The UAW also commissioned *The Brotherhood of Man* (dir. Robert "Bobe" Cannon, 1946) (12.11). This film is based on a controversial pamphlet made in 1943 for the US Army, "The Races of Mankind," written by university professors Ruth Benedict (1887–1948) and Gene (born Regina) Weltfish (1902–1980). The film's designer, John Hubley, was influenced in part by the publication's illustrator, the New York-based abstract painter and minimalist Ad Reinhardt. The pamphlet dispels myths about differences between the races, citing IQ tests in which blacks scored higher than whites, and it argues for equal opportunities. It was banned, and in 1953 Weltfish was subpoenaed by HUAC (the House Committee on Un-American Activities, an organization formed to investigate groups considered to be undermining the government, see p. 214); blacklisted, she was unable to teach for several years (Benedict had died in 1948).

The Graphic Revolution at UPA

György Kepes's publication of 1944, *Language of Vision*,[8] made a significant impact on the American postwar art world and the role of the designer in it. Analyzing line, form, and perspective as a visual language that impacts on human consciousness, the book proposed new ways of creating dynamic images while still emphasizing functionality. At about the same time, the concept of the UPA studio was incubating. Coinciding with the beginnings of the design movement, the studio formed a creative hub that brought like-minded individuals together, advocating modern art principles in the realm of American studio animation.

Though it was considered a style leader, UPA had no studio style per se. This is partly because it did not have a typical production pipeline; since the studio conducted itself in a democratic way, avoiding

the hierarchical divisions that
defined The Walt Disney Studios,
individuals across the organization
(and not only from the higher
ranks) were free to make a creative
contribution. As a result, the process
could be influenced by anyone,
even the usually lowly ink-and-
paint department, which at UPA
was headed by Mary Cain, a well-
known figure who later worked
in ink and paint for a number
of other studios and also ran her
own company. At UPA, style was
determined by subject matter, and
the flow of artists in and out of the
studio contributed to its variations.

Warner Bros. had experimented
with backgrounds and design
elements, but UPA went further in
also developing graphically oriented
character design and stylized movement.
The studio was known for its use of limited animation,
which emphasizes aural elements over movement and
minimizes the number of drawings employed to depict
the action. Since the beginning of animation history,
limited animation had been used to create movement
economically, but UPA showed how it could be done
in conjunction with design: for example, such devices
as cycles and holds could reduce the number of images
needed, but they could also give meaning to the visuals,
adding depth or humor to a character by showing it
moving in a distinct manner or posed in an expressive
way. "UPA style" animation was therefore relatively
less expensive to produce—but it was still stylish.

UPA's aesthetic is apparent even in its early
works, which were produced when the studio was
still developing and taking on varied commissions.[9]
For instance, between 1945 and 1947, the US Army
commissioned the "A Few Quick Facts" series, including
A Few Quick Facts: Fear (dir. Zack Schwartz, 1945),
which includes a cameo appearance from Private Snafu
(see p. 154). Through the use of silhouettes, flattened
space, and diagrammatic images, the film explains
that fear is a normal reaction and that the body is
prepared for it. The studio's work for the government
continued with a Navy contract from 1945 to 1947;
it produced sixteen animated short films on the topic

12.12 John Hubley, *Flight Safety: Landing Accidents,* 1946

of flight safety, including *Flight Safety: Landing
Accidents* (1946), which explains what happens when
a pilot is daydreaming instead of preparing to land a
plane. The film's images are realized through limited
animation, stylized characters, and backgrounds that
are flattened and sometimes defined by abstract forms
in grayscale **(12.12)**. It was directed by John Hubley,
who became the creative head of the studio in late
1946, when Bosustow bought out his two partners,
Hilberman and Schwartz, and became its sole owner.

John Hubley had studied painting at the Art
Center in 1934, before being hired by Disney in
1936 to be an assistant background painter for *Snow
White and the Seven Dwarfs.* He later became an
art director, working in layout for *Pinocchio* (1940),
Fantasia ("The Rite of Spring," 1940), *Dumbo* (1941),
and *Bambi* (1942) (see p. 107). Hubley brought an
intensely modern, creative spirit to UPA. The studio's
image was sealed with a stylish logo by Alvin Lustig,
one of America's top designers. In his version of
1947, the monochromatic, wire-like curves of the UPA
letters, capped by dots, recall the sleek lines of modern
furniture design. In 1950, however, Lustig updated it
to the familiar three-color version, with each letter in
its own oval—which worked better for film titles.[10]

In 1948, Bosustow signed a contract to produce
shorts films for Columbia, which had closed its

in-studio animation unit. During its collaboration with Columbia, UPA worked on various series, including "The Fox and the Crow" and "Mr. Magoo." The origins of "Mr. Magoo" lay in a **theatrical short** called *The Ragtime Bear* (1949), the original episode in a series called "Jolly Frolics"; however, the following year a separate "Mr. Magoo" series was launched. Mr. Magoo, voiced by Jim Backus, is elderly and cannot see well, and as a result he blunders through occasionally dangerous situations without any awareness at all. In *When Magoo Flew* (dir. Pete Burness, 1954), the character walks on the wings of an airplane in flight, but manages to return to his seat unscathed.

The accomplished designer Sterling Sturtevant (1922–1962) was assigned to "Mr. Magoo" in 1953. She had graduated from the University of Redlands in 1944 and then continued at the Chouinard Art Institute. Sturtevant's first job was in Disney's story department, beginning in 1947, but by 1950 she was working with the director Bill Hurtz at UPA. In 1954, she left for Playhouse Pictures, another leading production house.

Breaking New Ground with "Jolly Frolics"

Beginning with *The Ragtime Bear* in 1949, UPA's "Jolly Frolics" was a series of one-off productions. Probably the most famous of them is *Gerald McBoing-Boing*, directed by Bobe Cannon and released in 1951 (12.13). The film tells the story of a "noise-making boy" who cannot speak, but makes sounds instead. He has a hard time fitting in until he is discovered by someone who can use his unique talents. The film was adapted from a story by Theodore "Dr. Seuss" Geisel.

Before World War II, Geisel had published some children's books and worked in drawing for cartoons, advertising, and promotions. During the war, he served as commander of the Animation Department of the First Motion Picture Unit of the United States Army Air Forces. In this position, he scripted live-action films as well as several episodes of the "Private SNAFU" series, and he met some of the future employees of UPA. In the late 1940s, Geisel created the Gerald McBoing-Boing character as part of a children's record, and in 1950, UPA developed the concept into a script.

12.13 Robert "Bobe" Cannon, *Gerald McBoing-Boing*, 1951

The resulting film, *Gerald McBoing-Boing,* demonstrates the principal qualities for which UPA became known. Foremost of these is the prioritization of design in the work, with a focus on color, patterning, and the judicious use of lines to create a sense of space and define borders. It also demonstrates UPA's preference for humans over animals, situational humor over physical comedy, and abstract and suggestive forms over literal and representational imagery. Included, too, is the studio's signature editing style of cutting away from a scene using an object that becomes a transitional device. For instance, the stool Gerald stands on in his kitchen morphs into a scooter; there is a hold on this image while the scene dissolves to a playground and, after a pause, the boy starts to ride around. UPA's modern visuals were guided in part by the studio's colorists Herb Klynn (1917–1999) and Jules Engel (1909–2003). A great example in the film is the nighttime escape scene, which is rendered mainly in cold-black and dark-blue hues; these contrast with the mostly warm colors of Gerald's home and the yellows of the light from the train and the jacket of the man who finds him. Klynn and Engel were painters and close associates, and in 1959 they left UPA and set up their own company, Format Films, where they focused mainly on television production.

Gerald McBoing-Boing was a valuable property and was reused in different ways. He appeared in three additional theatrical shorts: *Gerald McBoing-Boing's Symphony* (1953), *How Now Boing-Boing* (1954), and *Gerald McBoing-Boing on the Planet Moo* (1955). He also inspired an anthology television series, "The Boing-Boing Show," which ran for thirteen episodes on the Columbia Broadcasting Network (CBS) from 1956 to 1957; it was hosted by the Gerald McBoing-Boing character and incorporated previously released, short theatrical films and new animation into a half-hour format. Faced with the need to create numerous short films for the series, UPA hired new staff, diversifying the talent pool even further. Among the recruits were the experimental filmmakers John Whitney, Sr. and Sidney Peterson, as well as such emerging talents as George Dunning (see p. 269), Jimmy Murakami, and Delores Cannata. Films in "The Boing-Boing Show" varied significantly owing to the range of people hired to create them, and included some relatively experimental work, such as *Blues Pattern,* co-directed by the jazz trumpeter Ernest Pintoff (1931–2002) and Whitney, and *Performing Painter,* co-directed by Pintoff,

12.14 John Hubley, *Rooty Toot Toot,* 1952

Whitney, and Fred Crippen. Released in 1956, both films attempt to create visual equivalents to jazz music.

Some of UPA's most acclaimed films are adaptations of well-known classics. Examples from the "Jolly Frolics" series include *Madeline* (dir. Bobe Cannon, 1952), based on a story by Ludwig Bemelmans that was first published in 1939; *A Unicorn in the Garden* (dir. Bill Hurtz, 1953), from a short story by James Thurber, also published in 1939; and *Rooty Toot Toot* (dir. John Hubley, 1952), based on an American blues ballad from the early twentieth century **(12.14)**. UPA gained a great deal of prestige for its theatrical shorts and by the end of the 1950s it was also renowned for its advertising. Branches in New York and London were opened during the 1950s to handle the expanding business.

During its history, UPA made ninety theatrical shorts for Columbia, numerous training films and "industrials" (films promoting a business and its practices), and hundreds of television commercials. One of the studio's most famous advertising campaigns was for Pabst Beer, featuring a popular comedy duo, Bob (Elliott) & Ray (Goulding).

It was designed by Gene Deitch when he was creative director at UPA's New York studio. But unfortunately, UPA's heyday was relatively short.

The Red Scare Threatens UPA Artists

In the context of the nuclear arms race and continued militaristic actions, "Communism" became a stand-in term for anything related to the Soviet Union or its allies, or more generally anything "un-American": to be labeled a "commie" or a "Red" could have dire consequences, both personally and professionally. To a great extent, the ensuing "Red Scare" and government investigations were rooted in labor-related developments of the 1930s. In the context of massive unionization and the rallying of the working class, big business and the government alleged that subversive leadership intended to undermine the fundamentals of American society in favor of a radical reorganization based on the principles of Communism. These subversive individuals had to be ferreted out, especially if they were in a position of influence. The film industry—most notably, its writers—became a major target of such investigation. It was reasoned that they were creating stories that were viewed by millions, with a powerful potential for persuasion. It was also glamorous and sensational to call Hollywood celebrities to testify. This scandal grabbed headlines.

The first investigations into Communism egan before World War II, but were interrupted when the conflict began. In 1945, however, the House of Representatives formed its House Committee on Un-American Activities (HUAC) to resume this work, analysing a broad spectrum of American society. Two years later, in 1947, HUAC began to scrutinize the Hollywood film industry, including animation, in a highly publicized series of hearings. At these meetings, subpoenaed witnesses were asked if they had Communist backgrounds and were told to name individuals who did. From the animation world, the designers Eugene Fleury and Berenice Polifka became central figures in the HUAC investigations, as their testimony was used to indict several individuals as being members of the Communist party. Incidentally, these events are often referred to as the "McCarthy hearings," but Senator Joseph McCarthy was not involved: he was a member of the Senate, not the House of Representatives. But in 1950 he took matters into his own hands and joined the melee, claiming that he had

a list of known Communists serving in the government, and launched his own inquiry.

In the wake of HUAC's investigations, hundreds of people in the film industry were blacklisted, which made it very hard, if not impossible, to work in their profession; in other fields, too, people suffered the same fate. Witnesses who were not willing to participate were classified as "unfriendly" and could be jailed for contempt, while those who cooperated were largely shunned as traitors by dissenting filmmakers. Among the "friendly" Hollywood witnesses was Walt Disney, who had suspected that Communist influences were partly to blame for the unionization efforts at his studio in the early 1940s. Blacklisting continued until the early to mid-1960s, as Cold War tensions began to lessen; by then, some of the affected artists had relocated, moving into more anonymous production roles, or had changed profession completely.

During HUAC's investigations, a number of individuals affiliated with UPA were identified as Communists. David Hilberman was among them; he had been a member of the Communist party for three years and lived and studied in the Soviet Union. In the mid-1940s, he sold his shares in UPA and with Bill Pomerance established Tempo Productions, which became one of the leading producers of animated advertising in the US. Pomerance, also an ex-Disney animator and a one-time employee of the Screen Writers' Guild, was also identified as a Communist; as a result, Tempo's clients withdrew their contracts practically overnight, causing the studio to close. Many innovative artists were similarly targeted; for instance, John McGrew was identified as a Communist and blacklisted, and moved to France.

Even before they were officially identified by HUAC, several individuals left UPA in an effort to keep the studio alive: John Hubley, Bill Scott, Bill Melendez, and Phil Eastman, among others. Hubley was obviously a liability: he had been politically active throughout his career, and had traveled to the Soviet Union during the 1920s. After he left UPA in 1952, Hubley opened a company named Storyboard, Inc., where he specialized in advertising, using as frontman Earl Klein to represent the studio in securing contracts. Before he was subpoenaed to testify in 1955, Hubley had made plans for an animated feature, an adaptation of *Finian's Rainbow*, a long-running Broadway play that had opened in 1947; however, all the financial backers pulled

out when he was identified as an unfriendly witness. He and his wife, Faith Hubley, relocated to New York and worked on a variety of commissioned projects and independent films at Storyboard in its new location.[11]

Farewell to UPA

In 1957, Columbia stopped distributing UPA's work and instead contracted with the new Hanna-Barbera studio for its television series. Three years later, Bosustow sold his studio to Henry Saperstein, who continued to produce "Mr. Magoo"-related properties and an animated feature, *Gay Purr-ee* (dir. Abe Levitow), in 1962 (see p. 264). The animation division of UPA was closed permanently in 1970. Other animation studios suffered a similar fate, being shut out of theatrical production by their parent studio; for example, MGM closed its in-house studio in 1957. The closures came about partly because of ongoing antitrust investigations (actions against monopolistic practices) that eventually changed the nature of Hollywood's production, distribution, and exhibition. A Supreme Court decision of 1948, *U.S. v. Paramount Pictures, et al.*, found the major studios of the film industry to be monopolistic, not allowing fair competition. Specifically, the practice of block-booking (see Box: Distribution Options, p. 54) was found to be illegal, because it required theaters to show a studio's entire range of films, essentially prohibiting smaller producers from finding exhibition space. As a result of the change, theaters no longer had to purchase a program of animation or other shorts along with features, and film studios began to close their theatrical shorts units because they were no longer profitable. Attention shifted to television, including advertising.

The Rise of Animated Advertising

With the rise of social sciences in the mid-twentieth century, postwar efforts to sell products took on a revolutionary sophistication and energy.[12] One of the landmarks of advertising occurred in the mid-1950s, with the phenomenal success of the rebranding of Marlboro cigarettes. Although it was originally a small brand aimed at women, when the concept of the "Marlboro Man" was introduced, the product shot to the top of the international cigarette market. With this amazing feat as a model, businesses tried to harness the power of promotion to appeal to consumers in target groups based on age, gender, and other factors.

In the context of this need for greater specialization, the designer took on a relatively more significant role than the animator, whose primary task was to set the concept into motion. For modern designers, animated advertising was an ideal venue for graphic experimentation, since it was not subject to the traditions of physical comedy and anthropomorphic animals that dominated American theatrical series. Clients liked it, too: employing animation in creative ways enabled advertisers to "soft sell" their products by developing a memorable scenario that resulted in a positive impression of their brand. Eventually, new animated icons emerged: for example, Tony the Tiger, created by Eugene Kolkey for Leo Burnett, who made his debut in 1951 to represent Kellogg's Sugar Frosted Flakes cereal. Animated characters offered definite advantages over human promoters, in that they never aged and they could be used over and over without demanding more pay. In addition, the fact that they were graphics meant it was also easy to merchandise them.

As advertising needs grew, animation studios catering to the market expanded. They often embraced the kind of modern art aesthetic associated with UPA. For example, Ernest Pintoff began his career in animation in 1955, working at UPA with John Whitney, Sr. and Fred Crippen to create shorts for "The Boing-Boing Show." After working for Terrytoons for a short time, he opened Pintoff Productions, a studio based in the Los Angeles area, in 1957, attracting many top advertising clients. He also created personal short films, such as *The Violinist* (1959), which was designed with Jimmy Murakami and reflects Pintoff's strong interest in jazz music. His best-known film is *The Critic* (1963), a Pintoff-Crossbow Production, distributed by Columbia: this Oscar-winning short features a voice-over by Mel Brooks, who plays a disgruntled spectator watching an abstract film that makes no sense to him. From 1958 to 1962, Pintoff collaborated with Leonard Glasser on various projects. Glasser then opened his own studio, Stars and Stripes Productions Forever, in 1962, and produced more than 300 live-action and animated commercials over the next nine years, establishing offices in Chicago, Toronto, and New York City. Glasser had studied advertising design

12.15 John Sutherland, *A Is for Atom*, 1953

at the Philadelphia Museum School of Industrial Art (later University of the Arts); like Pintoff, he was also a jazz musician, having played drums for trumpeter Dizzy Gillespie and other high profile musicians.

Another Los Angeles-based studio, Playhouse Pictures, was among the most successful in animated advertising at the time. It was founded in 1952 by Adrian Woolery (1909–1997), who had been a cameraman and production manager at UPA. Playhouse attracted a host of accomplished artists, including Bill Melendez, Bobe Cannon, Bill Littlejohn, Sterling Sturtevante, and Mary Cain. It also collaborated with

talent at other studios, on such projects as the industrial film *Energetically Yours* (1957) for Standard Oil Company. Designed and illustrated by Ronald Searle, the film relates the different ways in which mankind has made use of energy throughout history. It was directed by David Hilberman, with animation by Art Babbitt at Quartet Films and Bill Melendez at Playhouse Pictures.

Many new studios appeared in New York City. One of them, Elektra Films, was founded by Abe Liss (1916–1963) and his business manager Sam Magdoff in 1956. Liss entered the field of art by studying sculpture at the Art Students League. During the Great Depression, he worked for the Civilian Conservation Corps and created art for the Works Progress Administration's Federal Arts Project. Liss moved to Los Angeles in the mid-1940s and later got a job in layout at UPA. In 1951, after he had worked on several films, he became the creative director of UPA's new office in New York City. His own company, Elektra, attracted many top designers to work on projects for such clients as NBC (its peacock logo), the Chevrolet car company, Chevron Oil, and the US Army. Among the employees at Elektra was the character designer Delores Cannata, who was away from UPA after "The Boing-Boing Show" was cancelled. Cannata later worked with Charles and Ray Eames on various projects, including their first entirely animated production: *The Information Machine: Creative Man and the Data Processor* (1957), commissioned by Eliot Noyes, Jr. to screen in the IBM Corporation's pavilion at the Brussels World's Fair in 1958.

John Sutherland (1910–2001) was a big name in the world of industrial film production. After graduating from the University of California, Los Angeles (UCLA) with a degree in politics and economics, he was hired by The Walt Disney Studios and worked on *Bambi* (1942). During World War II, he created live-action training films for the military, and directly after the war, in 1945, he opened his own Los Angeles-area studio. To make sure it got off to a good start, he offered large salaries—sometimes twice the going rate—to attract top talent, including Bill Melendez and Maurice Noble. Taking a "hands-off" approach, he let them assert their own styles. Some of the studio's best-known work deals with conservative American values in a Cold War context. Two examples are *Make Mine Freedom* (1948) and *Meet Joe King* (1949), produced by the Extension Department of Harding College to, as the film explains, "create a deeper understanding of what has

made America the finest place in the world to live." Both films argue that Communism cannot fulfill its promise of a better life to the American worker. John Sutherland's *A Is for Atom* (1953) explains through limited animation that, although there are dangers associated with atomic power, it also holds a promise of many wonderful things **(12.15)**.

Conclusion

Modern design in animation emerged throughout the 1940s and 1950s, seeping in through layouts and backgrounds and eventually influencing character design as well. In this context, the designer took on increasing significance. In America, the United Productions of America (UPA) studio is most strongly associated with the modern aesthetic in animation, but during the period many other design-oriented studios sprung up, often to take advantage of the burgeoning realm of animated advertising. This was a transitional time for the industry, as it contended with lingering political concerns over unionization and the Cold War, competition from the emerging television industry, and the demise of block-booking of its films, virtually ending short-subject distribution to theaters.

Limited-animation techniques translated well to the new medium of television, which began to spread through America in the mid-1950s. Although UPA employed limited animation as a design element, the approach was embraced by other studios as a way to make productions more quickly and less expensively. Television was a vast new enterprise, in need of both animated programming and advertisements; as the theatrical market for animated shorts closed down, many people shifted into this new terrain. The film industry challenged its competitor with such technical innovations as widescreen and stereoscopy, trying to keep audiences watching the "big screen" in theaters, rather than at home watching the "small screen" of television and its low-budget productions. Nonetheless, the television industry continued to grow, and by the early 1960s, animated television series represented a significant portion of animation production. Many thought it was a great step backward for the art of animation.

Notes

1 Michael Neault, "The Films of Charles & Ray Eames," *Snore and Guzzle* (September 11, 2008). Online at http://snoreandguzzle.com/?p=149

2 Marie-Thérèse Poncet, *L'Esthétique du Dessin Animé* (Paris: Nizet, 1952). See also Marie-Thérèse Poncet, *Le Génie de Walt Disney* (Voiron: Marie-Thérèse Poncet, 1995).

3 Amid Amidi, *Cartoon Modern: Style and Design in Fifties Animation* (San Francisco: Chronicle, 2006), 1.

4 Michael Barrier, *Hollywood Cartoons: American Animation in Its Golden Age* (New York: Oxford University Press, 1999), 443–44.

5 Jerry Beck, "Columbia Screen Gems," *Cartoon Research*. Online at http://cartoonresearch.com/index.php/columbia-screen-gems/

6 Barrier, *Hollywood Cartoons*, 503.

7 Amidi, *Cartoon Modern,* 112; Michael Barrier, quoted in Amidi, 112.

8 György Kepes, *Language of Vision* (Chicago: P. Theobald, 1944).

9 Ibid., 113.

10 Steve Moore, "Modern Design God Alvin Lustig," Flipanimation.com (August 18, 2013). Online at http://flipanimation.blogspot.com/2013/08/modern-design-god-alvin-lustig.html

11 Karl Cohen, *Forbidden Animation: Censored Cartoons and Blacklisted Animators in America* (Jefferson, NC: McFarland, 1997), 181–83.

12 For an overview, see Arthur Ross, "The Animated Comercial: A Retrospective View," *Millimeter Magazine* (animation issue of 1977), reprinted in Michael Sporn, "Commercials History," *Michael Sporn Animation Splog* (July 1, 2010). Online at http://www.michaelspornanimation.com/splog/?p=2293

Key Terms

Abstract Expressionism
block-booking
industrials
limited animation

midcentury modern
Regionalism
stereoptical
theatrical short

CHAPTER 13

Early Television Animation

Chapter Outline

Global Storylines

After World War II, television becomes the ideal medium for advertisers, who use animated advertisements to promote consumer culture

Early children's programming is produced inexpensively by using puppets, live hosts, and very limited animation

Children's shows in the US become regulated by the government, resulting in the development of such educational series as the animated "Schoolhouse Rock!"

To keep production costs low, American studios outsource animation to other countries

As American animated television series dominate in most of the world, Japan and other countries also develop their own programming

Introduction

Levittown, a planned community built in Long Island, New York between 1948 and 1951, helped to launch one of the most emblematic elements of postwar society in America: suburban living. Troops returning from the war were able to move to the suburbs thanks to assistance from the Servicemen's Readjustment Act of 1944, known as the G. I. Bill, which offered financial support to pursue both a college education and home ownership, among other benefits. Life in the suburbs promised to be modern, clean, and safe, allowing mainly white, middle-class families the chance to move away from city centers, to homes equipped with garages for their newly acquired cars and yards for their children to play in. In these new developments, which sprang up across the nation, families stayed close to home, seeking entertainment in local playing fields, shopping malls, and the multiplex theaters that developed around them, as well as on sprawling plots of land that accommodated drive-in movies. As the 1950s and 1960s progressed, yet another form of entertainment kept families and their young children close to home: television.

In America, limited television programming began to appear in about 1939, but it did not gain momentum for some time. The development of TV had been stalled by the events of World War II, but it resumed immediately after the war; TV began to grow in popularity in 1947, and by the mid-1950s it was relatively common in American homes (it spread to other countries through the 1970s). During the early years of American TV, there were three main national networks: the National Broadcasting Company (NBC) and Columbia Broadcasting System (CBS) began in the 1920s as radio networks, while the American Broadcasting Company (ABC) emerged as

a radio network subsidiary that separated from NBC in 1943. There were also many local stations that were not affiliated with the big three networks; these independents aired self-produced and **syndicated programming**. The development of television was a central component in efforts to jump-start the postwar economy in America. When the conflict ended, many industrial plants stood idle, but they were brought to life again through the manufacture of home appliances, which created the promise of an improved modern life. Television was the most important appliance in shaping the "American way" of life, and in invigorating the economy, because it was based on advertising—getting people to buy things from the sponsors who supported the production of TV shows.

At first, television programming was presented live, so records of its earliest years are scarce. Live programs were sometimes filmed from a monitor, however, using specialized 16mm or 35mm film equipment **(13.1)** to create a document known as a **kinescope** (or "kine") in the US or a **telerecording** in the UK; this practice carried on until about 1956, when videotape was introduced. Initially, television screens were small and resolution was very low, and at times images would not come through in sharp focus because reception was unpredictable. TV programs could be transmitted via the airwaves in major industrial

13.2 Felix the Cat in the first experimental TV broadcast, 1929

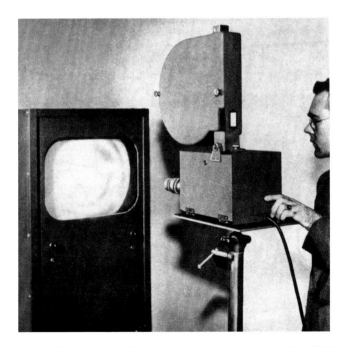

13.1 A kinescope, recording programs directly from the monitor, 1948

centers, using antennae on a rooftop or two-pronged metal "rabbit ears" inside a home to obtain a signal. Outside big cities, cable service began during the late 1940s as a way to deliver broadcasts. Until about 1965, most television programming was viewed in black and white. Color technology was available before then, but at a high cost, so the public was slow to adopt it.

Animation had been part of this new medium from its beginnings, when, in 1929, an image of Felix the Cat (see p. 53) was selected for the first experimental broadcast in the US **(13.2)**. Ten years later, the first network, NBC, debuted the Disney film *Donald's Cousin Gus* (dir. Jack King, 1939) on its first night of broadcasting out of New York City.[1] It was some years later that The Walt Disney Studios became one of the first film studios to embrace television production, beginning in 1950 with "One Hour in Wonderland," followed four years later by regular programming in the form of a series called "Disneyland." Episodes from this series included whole or edited versions of past theatrical productions, and also promoted upcoming work. As the title suggests, some of the content related to the opening

13.3 "Mickey Mouse Club": television series, 1955–59

also aesthetic: TV animation used fewer drawings, less movement of characters, more dialogue, and a higher number of camera moves in place of the fluid animation that was typical of theatrical production.

The Beginnings of Made-for-Television Animation in America

Puppets in Programming

Early children's television shows, developed to fill morning and afternoon time slots, were frequently created in the form of hosted programs, which were relatively inexpensive and easy to produce. Puppets often figured in these shows, alongside the live host. One of the best-known is "Kukla, Fran, and Ollie," which was created by the puppeteer Burr Tillstrom (1917–1985) and starred the famous actor Fran Allison (1907–1989) as the host (13.4). The half-hour episodes were unscripted, but featured witty conversation between Fran and a puppet cast that appealed to adult viewers too. The show ran for about ten years in its original run, from 1947 to 1957; it began on a local Chicago station, and in 1949 moved to national distribution on NBC.

Another NBC series, "Howdy Doody," was hosted by the radio personality Bob Smith, also known as Buffalo

of the Disneyland theme park in Anaheim, California in 1955, and was televised live. The "Mickey Mouse Club" (13.3) appeared on television the same year, and Disney soon expanded production into other live-action series. Disney's shows were popular because they were well made, adhering to the studios' high standards.

Television needed a lot of material, and it welcomed animation, but there was a problem: for the most part, TV-show budgets were extremely low. To fill airtime cheaply, it was convenient to air films that had originally been screened in theaters, animated shorts that would otherwise languish in the studio vaults. Paul Terry (see p. 55) sold his film library to CBS in 1955 and retired; his series, including "Mighty Mouse," could be found on television for decades to follow. In 1960, Warner Bros. theatrical shorts began to be aired on ABC within a program called "The Bugs Bunny Show."

Having lost their jobs in theatrical studio units, many animators moved into the new field of television production. This chapter focuses on the new studio context, in which artists were faced with a series of challenges, including tiny budgets, rapid production schedules, the eventual loss of jobs to subcontractor studios outside the US, the increasing pressure to sell products, and—at least in the early years—the poor state of television technology. For many, the problems were

13.4 Burr Tillstrom, "Kukla, Fran, and Ollie," (L–R: Kukla, Ollie, and Fran), 1948

Bob (born Robert Emil Schmidt, 1917–1998) **(13.5)**. Smith also provided the voice of the Howdy Doody marionette, a freckle-faced young boy first designed by Frank Paris and then redesigned by the Australian-born Velma Wayne Dawson. The series originally ran from 1947 to 1960, but because it was first performed live, records of the earliest shows are scarce. A kinescope dating from 1948 opens with title cards reading "Puppet Playhouse presents 'Howdy Doody'," as the show's theme music plays in the background. The puppet then appears on screen, welcoming Mr. Smith; he sits in another part of the set with a mute clown named Clarabell, who communicates by honking a horn, and an audience of young viewers. Smith leads the kids in singing an off-key rendition of "It's Howdy Doody Time" as he plays the piano, and then turns to the camera and addresses the children watching from home, asking them to yell "Howdy Doody" along with the audience. When Smith interacts with the puppet, intercutting is used to disguise the fact that he is providing its voice. "Howdy Doody" combined such live interactions with filmed

13.6 Bob Clampett, "Time for Beany" (L–R: Beany and Captain Horatio Huffenpuff), 1950

segments, which were woven into the overall narrative of the show. In the kinescope from 1948, the kids watch newsreel-type footage of circus acts. In 1956, "Howdy Doody" debuted Art Clokey's clay animation "Gumby" (see p. 198), which went on to become a television series in its own right. "Howdy Doody" was very popular and was heavily merchandized.

Puppets are also the main attraction in "Time for Beany," developed by Bob Clampett (1913–1984) after he left Warner Bros. **(13.6)**. The series employed hand puppets, voiced by Stan Freberg (Cecil and Dishonest John) and Daws Butler (Beany and Uncle Captain), but was not hosted. It first aired on a local Los Angeles area station in 1949 and was then nationally televised between 1950 and 1955 on the Paramount Television Network, a venture by Paramount Studios that existed between 1948 and 1956. Later, Clampett's show was adapted into a cel-animation series, eventually known as "Beany and Cecil," which first appeared in 1959 as part of a series called "Matty's Funday Funnies," sponsored by Mattel Toys. In 1962, it aired on ABC as "Beany and Cecil" in primetime, as one of the first color animated series on American television.

13.5 Bob Smith and Howdy Doody star in NBC's "Howdy Doody" series (1947–60)

New Studios for the New Medium

The first venture into the unknown realm of made-for-television animated series was "Crusader Rabbit," produced in 1949 by Jay Ward Productions. The concept for the series came from Alex Anderson (1920–2010), who was an animator at Terrytoons and the nephew of Paul Terry, and his friend Jay Ward (1920–1989), who had earned an MBA from Harvard University. The two opened a company called Television Arts Productions, and together they produced "Crusader Rabbit," which aired on NBC stations (1949–55). The series began with an episode called *Crusader vs. the State of Texas*, in which the plucky rabbit, voiced by Lucille Bliss, comes to the aid of his many cousins, accompanied by his slow-witted sidekick Rags the Tiger, voiced by Vern Louden. The animation is extremely limited; in fact, the vast majority of the episode consists of still drawings, which are narrated in voice-over by Roy Whaley, who provides melodramatic details and a cliffhanger ending.

In subsequent years, the studio produced other series, including "Rocky and His Friends," which—like "Crusader Rabbit"—featured a small, smart character, Rocky J. Squirrel, in this case voiced by June Foray, and a big, not-so-smart character, Bullwinkle J. Moose, voiced by Bill Scott. These two are pitted against two spies, Boris Badenov and Natasha Fatale, voiced by Paul Frees and Foray, whose satirical "Russian" personas reflect the Cold War context. Their exploits are intercut with a series of recurring vignettes, such as "Fractured Fairytales" and "Peabody's Improbable History." Throughout each episode, witty dialogue and voice-over narration provide plenty of subtextual humor to balance the lack of movement in the limited animation. "Rocky and His Friends" was aired on ABC for two years, after which it moved to NBC for four years under the name "The Bullwinkle Show," before being sold in syndication. The studio also produced other memorable animated productions, such as "George of the Jungle" (1967), and several iconic characters that appeared in animated commercials, including Cap'n Crunch, who promotes a children's breakfast cereal of that name. Jay Ward Productions was closely affiliated with the General Mills Company, which manufactured the cereal.

Another company, Total TeleVision productions, also had a very close relationship with General Mills. In 1959, it was created by William Watts "Buck" Biggers (1927–2013) with assistance from Chester "Chet" Stover (1925–), two advertising executives who handled the General Mills account at the Dancer Fitzgerald Sample agency. Seeing an opportunity to market to children, they left the agency to produce such series as "Tennessee Tuxedo and His Tales" (1963–65) and "Underdog" **(13.7)** (1964–67), based on characters that encouraged kids to buy General Mills breakfast cereals and other products. Total TeleVision productions used a Mexican studio, Gamma Productions S. A. de C. V., for the realization of almost all its animation; Jay Ward also used that studio for the animation of "Rocky and His Friends." Gamma Productions was originally named Val-Mar Productions. It had been established by a Mexican investor, Gustavo Valdez, and was run by his brother-in-law Jesus Martinez, who supervised a large crew of seasoned artists, some of whom were Americans.

Soon the horizon was dotted with new production houses that were dedicated solely to television.

13.7 Total TeleVision productions, "Underdog," 1964–67

13.8 DePatie-Freleng, animated titles for *The Pink Panther* (dir. Blake Edwards, 1963)

Some of the new studios were headed by individuals who had risen through the ranks of theatrical film-studio production, but were forced to adapt to the new production context of TV. Others were led by businesspeople looking to take advantage of an emerging market, with little or no concern for traditional animation methods or aesthetics. In order to compete in this industry, studios increasingly embraced a form of international co-production, using subcontracted studios—such as Gamma Productions—mainly to complete the labor-intensive tasks of inking and painting and photography, in large part because they could pay those workers less than American crews. Rembrandt Films, founded by William L. Snyder in 1949 as an importer of European films, was one of the studios working to this new model; when it eventually moved into production of such series as "Tom and Jerry" and "Popeye" in the early 1960s, it subcontracted with the Czech studio Krátký Film Praha, under the supervision of Gene Deitch, as well as the Halas & Batchelor studio in the UK, among others.

With its cartoon films under distribution by Columbia's Screen Gems television division, UPA had made a transition to television with "The Boing-Boing Show," a series that ran on CBS from 1956 to 1957 (see p. 213). In 1957, however, Columbia stopped distributing UPA's work and instead contracted with the new Hanna-Barbera studio for its television series. At that point, some of UPA's artists left to start their own ventures. For example, Herb Klynn and Jules Engel founded Format Films in 1959. It produced a wide range of work, including advertising and animated titles for TV shows. It also animated several Warner Bros. shorts after that studio closed its in-house theatrical shorts unit in 1963, the last of the major Hollywood studios to do so.

When Warner Bros. Animation closed, many of its artists moved to the DePatie-Freleng studio, founded the same year, 1963, by the producer David DePatie (1929–) and director Friz Freleng (1906–1995). As an independent studio, DePatie-Freleng then created films for Warner Bros., and also took on work for other clients. Among its best-known animation is a line of "Pink Panther"-related productions that began with animated titles for the feature *The Pink Panther* (1963) **(13.8)**, directed by Blake Edwards and with music by Henry Mancini. The iconic panther character then starred in a series of DePatie-Freleng theatrical shorts, which were aired by NBC on Saturday mornings in 1969 and then compiled into a television series, "Think Pink Panther," in the mid-1970s.[2]

The Mexican-born Bill Melendez (1916–2008), who was raised in the US and graduated from the Chouinard Art Institute, had worked at Disney, Warner Bros., UPA, Playhouse Pictures, and John Sutherland

13.9 Bill Melendez Productions, *A Charlie Brown Christmas*, 1964

Productions before forming his own studio in 1963. Bill Melendez Productions produced a range of work, including features and many commercials, but it is best known for a string of television specials based on the "Peanuts" comics created by Charles Schultz, beginning with *A Charlie Brown Christmas*, which first aired in 1964 **(13.9)**. A few years later, in 1970, Melendez formed a subsidiary in London, Melendez Films, run by his son, Steven Melendez.[3] It also subcontracted animation to the Mexican studio Gamma Productions.

Selling to Children

The shift toward a commodity culture in the 1950s was initiated in various ways. From an industrial perspective, the growth of social science research in the post-World War II period promised to explain why people act as they do, socially and in terms of buying products. Buying became easier and easier, with the growth of suburban shopping malls that gathered many stores in one place. By the late 1950s, consumers had the option to "pay with plastic" using an American Express card, followed by early manifestations of both Visa and Mastercard in the mid-1960s. At home, too, consumer culture infiltrated all aspects of life: examples can be seen in the popularity of the TV dinner, which offered an alternative to home-cooked meals, and the widespread appearance of company logos on apparel.

Because animation is graphic in form, its stars are particularly suitable for merchandizing as part of product design, and since the 1920s animated characters have been licensed to appear on various items. At that time, Felix the Cat was among the first animated characters to appear on merchandise, while product sales have been a component of The Walt Disney Studios since the early 1930s. With the rise of television, the promotion of products became an even more integral part of animation production, especially as a means of selling to children. An interesting example comes from the mid-1950s program "Winky Dink and You," a series that aired on CBS from 1953 to 1957. The show featured a live host, Jack Berry, who led children through stories involving the animated character Winky Dink (voiced by Mae Questel) and her dog Woofer. Children were encouraged to purchase a kit containing a "magic screen," which adhered to the television through static electricity, and a set of crayons they could use to draw missing parts of animated figures, story elements, and secret messages **(13.10)**.

13.10 "Winky Dink and You," with host Jack Berry, 1953–57

The Rise of Children's Animated Television Series

Hanna-Barbera Dominates Television Production

By the late 1950s, William Hanna (1910–2001) and Joseph Barbera (1911–2006) were famous for directing "Tom and Jerry" theatrical shorts at MGM (see p. 138). When that studio closed its doors in 1957, the duo moved into television, that year opening the studio that became Hanna-Barbera Productions, Inc. Their first series, "The Ruff and Reddy Show" (1957–60), stars a dog and a cat, voiced by Don Messick and Daws Butler respectively. Episodes were introduced by a live host, Jimmy Blaine, and a series of puppets. The "Ruff and Reddy" shorts were only one segment of the total program; Screen Gems theatrical cartoons were also aired to fill out the half hour.

The studio abandoned the live-host concept for its second series, "The Huckleberry Hound Show" (1958–62). It features a blue dog, voiced by Daws Butler, who is more lucky than calculating as he contends with adversaries, taking on various occupations (**13.11**, see p. 226). For example, he is a truant officer in *Hookey Daze* (1958), while in *Pony Boy Huck* (1959) he delivers mail for the Pony Express. The series pilot, *Huckleberry Hound Meets Wee Willie* (1958), finds the star working as a police officer when he gets a call about a huge gorilla, described as a "Caucasian male." Though the episode relies on physical comedy, such interactions

13.11 Huckleberry Hound, from Hanna-Barbera's "Huckleberry Hound Show," 1958–62

movements, such as eye blinks or energy lines emitting from the radio.

"The Huckleberry Hound Show" was popular, but within a couple of years, Hanna-Barbera had moved on to an even bigger success: "The Flintstones," an animated family sitcom featuring a Stone Age married couple, Fred and Wilma Flintstone, and their neighbors, Barney and Betty Rubble. Originally conceived as "The Flagstones" for its pilot show in 1960, the series borrows heavily from the model of a popular live-action series starring the celebrated Jackie Gleason: "The Honeymooners," a sitcom featuring two brash working-class husbands and their long-suffering wives. "The Flintstones" was first aired on ABC from 1960 to 1966. It debuted in primetime, which was a first for an animated series, and its appeal to adult viewers was reinforced by the decision to hire writers who had worked on Gleason's series. "The Flintstones" is considered one of the most successful animated series in history, and it helped cement Hanna-Barbera's position in the emerging field of made-for-television animated series production. It also proved valuable to the series' sponsors, as the characters promoted such products as Winston cigarettes (13.12), One-a-Day Vitamins, and the antacid Alka Seltzer.

Some of Hanna-Barbera's other early successes include "The Yogi Bear Show," from 1961, starring a character who first appeared in "The Huckleberry Hound Show," and "The Jetsons," a series featuring a space-age family, which debuted in 1962. Other classics, such as the action-adventure "Jonny Quest" (1964) and the mystery-based "Scooby-Doo" (beg. 1969)

occur off screen; for example, the gorilla pounds a large metal beam up and down, but the resulting damage to the bar (being deformed in the shape of Huck's head) is only evident in a subsequent shot. The imagery shown on screen, for example Huck driving the car and getting a radio broadcast, is mostly still, accented with subtle

13.12 Characters from "The Flintstones" in a promotion for Winston cigarettes, 1960

followed, as serics content increasingly focused on human characters rather than animals. This trend grew in the 1980s, with spin-offs of live-action series and shows developed around superheroes—or any figure that could be heavily merchandised.

Hanna-Barbera developed more and more series, and it came to dominate children's television internationally; through sheer volume and economics of scale, it was difficult for studios in other countries to compete. As time went by and characters increased

Media Regulation

There have been many attempts to legislate and control popular media through laws, industry self-censorship, ratings systems, and parental controls. In their early years, theatrical films were widely considered to be immoral (see p. 117) and were subject to censorship through the Production Code and other regulations. In the 1950s, comic books stirred controversy in America because they were mainly targeted at children and teens; adolescent boys were easily attracted by comics that exploited sexual and horror themes in lurid cover art and storylines. In response, cultural guardians argued that comic books contributed to the delinquency of the young. In 1954, the psychiatrist Dr. Fredric Wertham published his cautionary book on this topic, *Seduction of the Innocent*; the same year, the Comics Code Authority was formed to set standards for content. It officially lasted until 2011.

Both radio and television were regulated as well.[4] In America, these media are broadcast over what are considered to be "public airwaves," meaning that they were owned by the citizens of the country. The Communications Act of 1934 established a government organization that would regulate interstate and international communications by radio and television— and later wire, satellite, and cable—on behalf of the American people: the Federal Communications Commission (FCC).

Long before the FCC was established, however, in the 1920s, broadcasters had already formed a trade organization, the National Association of Broadcasters (NAB), to establish policies for various aspects of its industry. In 1951, it initiated the Code of Practices for Television Broadcasters as a set of ethical standards for television, partly to minimize the implementation of external censors.[5] It addressed concerns related to the advancement of education and culture, responsibility toward children and the larger community, general program standards, and advertising. A "Seal of Good Practice" in the closing credits of most television programs reflected compliance with the document (13.13). This code lasted until the mid-1980s.[6] At that point, networks took over the duty of monitoring content in their own Broadcast Standards and Practices departments (or variations on that name), which

13.13 The Comics Code Authority's "Seal of Good Practice"

normally approved all scripts before production. Following the proliferation of cable networks in the 1980s and 1990s, the rules have been stretched considerably in the areas of language, violence, and sexual content. Partly as a reaction to changing standards, the US television industry (in conjunction with the FCC) implemented a ratings system known as "TV Parental Guidelines" in 1997. Other countries worldwide have developed their own ratings systems.

Special-interest groups have also had a say in the regulation of television, particularly in terms of children's media. In 1968, Action for Children's Television (ACT), formed over concern about the quality of programming for kids, and, led by its founder Peggy Charren, lobbied the FCC about this issue. One of its main preoccupations was advertising: the amount of it, its content (particularly related to sales of vitamins), and the separation between the program and the advertisement through the development of **"bumpers"** (for example, "we'll be back after this word from our sponsor").

in value, a surge in **franchising** resulted in spin-offs that were at times quite odd—for example, the series "Josie and the Pussycats" (1970–71) was reworked in 1972 into "Josie and the Pussycats in Outer Space." Top-selling animated series, such as "The Flintstones" and "Scooby-Doo," appeared in various incarnations throughout the 1970s and 1980s. Hanna-Barbera also contributed to the common practice of converting successful live-action series into animation. The studio developed animated series around a family of monsters in "The Addams Family" (1973) and a family of musicians in "The Partridge Family" (1974), for example. With so much work to do, Hanna-Barbera led the way in outsourcing productions, hiring workers in Australia, Taiwan, Spain, Poland, and other locations where it could pay lower wages than in the US.

Aside from its animated series, the studio created quite a bit of advertising, particularly in an Australian facility it opened in 1972. By the mid-1980s, Hanna-Barbera had more than a thousand employees and was producing vast quantities of animation.[7] Throughout its history, however, budgets for TV production remained small, nowhere near the levels Hanna and Barbera had enjoyed at MGM while working on the "Tom and Jerry" theatrical shorts (see p. 138). To stay within these constraints, they not only relied on cheaper workers outside US borders; they also enforced rapid production schedules, relying on extremely limited techniques, emphasizing dialogue and minimizing or recycling movement. Despite their aesthetic limitations, Hanna-Barbera animated series are nostalgic favorites for many viewers. One of the more endearing conventions of many Hanna-Barbera series was the use of laughter tracks, which are clearly ironic, given that there could not be a live audience for animated action. The practice occurred at other studios as well, to varying degrees.

Innovative Animation from "Sesame Street"

There was a lot to disdain in children's programming of the 1960s and 1970s, but fortunately there were also some bright spots. One of them is the largely live-action children's series "Sesame Street," from the Children's Television Workshop; it began in the US in 1969 and has since been produced and distributed internationally, in more than 120 countries, as the most widely watched children's television series in the world (**13.14**).[8] Its success is due in large part

to the popularity of Jim Henson's muppets, which interact with a diverse group of actors, who represent residents of the street. The series has been praised for its presentation of educational content, including pro-social life lessons that help kids interact with others, in an entertaining yet effective way. Some of the most popular elements of "Sesame Street" came in the form of short, animated pieces that appear between segments of live-action and puppet performance.

Many accomplished artists and performers were involved in the production of these animated shorts, though some of the contributors have been surprising. For example, Grace Slick of the **psychedelic** rock group

13.14 Children's Television Workshop, characters from "Sesame Street," beg. 1969

Jefferson Airplane provided vocals for a series of animated counting films that appeared during the first season, in 1969. Featuring the numbers two through ten, the films are titled individually as "Jazz #x," where x is the number being featured. The music for these films was performed by accomplished jazz musicians: Denny Zeitlin, who composed the scores and played both piano and Clavinet, with Bobby Natanson on drums and Mel Graves on bass. The series was animated at the San Francisco studio Imagination, Inc., owned by John Magnuson.

13.15 The ABC network's "Schoolhouse Rock!," c. 1979

"Sesame Street" animations are consistent with the diversity of the series itself, in form as well as content. A stop-motion technique involving animated sand on glass was used in the "Sand Alphabet" series. Animated by Eliot Noyes, Jr., bluegrass music accompanied the letters, which appear in both upper and lower case, read by adult and child voices. Each letter appears in its own short film, designed and animated a bit differently. Years before Pixar became a household name, its computer animation appeared in "Sesame Street." In 1990, a series of short segments, co-directed by John Lasseter and Andrew Stanton, built upon the concept of the studio's short *Luxo Jr.* (dir. John Lasseter, 1986), a film that features two table lamps, one an adult and the other a child who plays with balls (see p. 374). In the "Sesame Street" series, the little lamp, with the help of the older one, explores various ideas, such as opposites. Many other well-known animators contributed segments as well. For example, after John Hubley moved his Storyboard studio to New York, he created short pieces for "Sesame Street" between 1969 and 1972, including *E-Imagination* (1969) and *Penguin Rhythms* (1971).

"Schoolhouse Rock!"

Following up on the success of "Sesame Street" as an educational program, in 1972 the ABC television network began to run educational "Schoolhouse Rock!" **(13.15) interstitial shorts**—short films that were shown between a TV series segment and an advertisement. The series was thought up by the advertising executive David

McCall (c. 1928–1999), as an effective way to reach young learners through music, hoping it would attract the attention of advertisers wanting to sell to kids. The concept for "Schoolhouse Rock!" developed out of a sound recording, *Three Is a Magic Number*, composed and performed by Bob Dorough, a bebop and cool jazz composer and performer who had worked with Miles Davis, among others. It was then made into an animated short that illustrates the song, focusing on a family of three, along with other examples in multiples.

McCall pitched the idea to Michael Eisner, who was vice-president of ABC's children's programming division, and he gave it the green light. Large advertisers, including General Foods, Nabisco, and Mattel, sponsored the series, which aired from 1973 to 1985 in its original run, and from 1993 to 1999 was broadcast again, combining old and new episodes. Dorough continued to compose and perform music for most of the original episodes, working with a variety of designers and animators, including Tom Yohe, who had been an art director at McCall's New York advertising agency, McCaffrey & McCall, in 1971. Yohe's own children provided voices for some of the series' characters. "Schoolhouse Rock!" eventually diversified into various subjects, including "Grammar Rock!" (1973), "Science Rock!" (1979), and "America Rock!" (various dates, beg. 1975). These well-produced series engaged children and won critical acclaim with a wide range of memorable music that resulted in enjoyable and effective educational programming.

American Animated Television Production in the 1980s

Political Shifts in Television Regulation

Unsurprisingly, shifts in political leadership have affected the extent to which television has been regulated or restricted. Though regulation was relatively strong during the 1970s because of pressure from the ACT (see Box: Media Regulation, p. 227), among other forces, things changed when Ronald Reagan became president in 1981. He supported deregulation of the industry, allowing the chairman of the FCC to lift some of the rules that had affected the production of children's television series, including animation. One result was the proliferation of the "half-hour commercial," or a television series that is product driven, promoting the sale of toys. The term "toyetic" emerged to describe concepts that are particularly conducive to merchandizing, in terms of show content that could be sold as toys. Consequently, the majority of made-for-television animated series appearing from American studios in the 1980s were designed to sell products of some kind.

Some of the biggest merchandizing deals in early television history centered on the "G. I. Joe" and "Transformers" series, both of which promoted toys manufactured by the American corporation Hasbro, which in the 1980s became the world's largest toy company. The term "G. I. Joe" came from a comic of the 1940s of that name by (Irving) David Breger, but during World War II it came into popular use to describe the norm of a "government-issue Joe," or average guy, in the military. In 1964, Hasbro released a set of twelve-inch G. I. Joe toys that have been described as the first action figures. They were a huge success, and several years later, in 1982, they were followed by three-and-three-quarter-inch scale models. At about the same time, Marvel Comics featured the figures in comic books, and then an animated series, "G. I. Joe: A Real American Hero," came out in the mid-1980s: first as two five-part mini-series, released in 1983 and 1984, and then as a regular syndicated series in 1985, all co-productions between Marvel Productions and Sunbow Productions, distributed by Claster Television. These products were just some among many: aside from the toys, there was also a feature film, subsequent television series, other

13.16 "Transformers" toy by Hasbro, 1984

comics, and even breakfast cereal, just to name a few "G. I. Joe"-related items. Such expansion is consistent with the business model of franchising, or building a line of products around a successful enterprise. In the realm of entertainment, franchises are generally structured around central characters, which appear in a range of stories and often in different media. Franchising quickly became an integral part of mass-media production in the 1980s and beyond, with toys having a central part in the creative process—or perhaps more accurately, in the business of children's television programming. For instance, Hasbro created its highly merchandizable animated series "The Transformers" (1984–87) using science-fiction vehicles, humanoids, and other figures from the Diaclone and Microman toy lines produced by the Japanese toy manufacturer Takara Tomy. These transforming products were redesigned and then rebranded under the name "Transformers," and in 1984 became toys sold by Hasbro (**13.16**), spawning not only the animated series, but also many related media and licensed products.

The strategies of American made-for-television animation production during the 1980s greatly influenced not only young viewers and their families, but also the people making the series: the employees in animation studios. One of those strategies, outsourcing production, allowed products to be made more cheaply by employing lower-paid workers in other countries; by the end of the 1970s, many American workers had already been displaced, but the situation got worse.

In 1982, the floodgates opened when the union lost ground and representatives of studio management were allowed to overturn requirements prioritizing domestic workers. As a result, from that point much of animation production was sent overseas.[9] Not every big studio was in favor of outsourcing, however: one of the largest, Filmation, was a notable exception.

By the Power of Animation: Filmation Associates

Filmation Associates, which was founded in 1963 by the producers Norm Prescott (born Norman Pransky, 1927–2005) and Lou Scheimer (1928–2013) and director Hal Sutherland (1929–2014), had a relatively complex history; its roots were in a number of former partnerships and it was sold multiple times before it closed in 1989. During the mid-1960s, Filmation entered television series production with "The New Adventures of Superman" (1966–70), half-hour programs including two six-minute "Superman" cartoons with a "Superboy" cartoon in between them. Eventually, Filmation grew to be Hanna-Barbera's biggest rival, as it also produced a large number of animated series, but in at least one way the studio was significantly different. Rather than rely on outsourcing, as Hanna-Barbera did, Scheimer attempted to keep production in-studio. He felt so strongly about using American labor that when TV-animation studio workers went on strike in 1982, he showed his support by joining the picket line around his own building.[10] His values undoubtedly influenced the studio's choice of implementing very limited techniques, including reusing images from episode to episode, since the cost of employing American workers was relatively high and production schedules were rapid.

Despite its cost-cutting measures, Filmation also produced series that were widely popular and today remain nostalgic milestones in television history. The 1970s saw many tie-ins to live-action series, such as "Fat Albert and the Cosby Kids" (1972–84), which benefited from the popularity of "The Bill Cosby Show," airing 1969–71. Bill Cosby's (1937–) involvement in "Fat Albert and the Cosby Kids" was a landmark, as this was the first time a star of his stature had been associated with a Saturday-morning show.

Cosby had a great influence on the topics covered in the series, which included episodes devoted to pro-social content—for example, in *Lying* (1972), the first episode, demonstrating that lies will be discovered—and covered such serious issues as cancer and child abuse. The show's development was guided by a group of educators that included Dr. Gordon Berry, a professor of psychological studies and assistant dean in the Graduate School of Education at the University of California, Los Angeles (UCLA).

Filmation was among the companies that benefited from the liberalized government regulation of the 1980s, which allowed for more merchandizing tie-ins. Perhaps most famous in that respect is the studio's series "He-Man and the Masters of the Universe," which began in 1983, and its counterpart "She-Ra: Princess of Power," which started two years later (13.17). These series were product-driven, having arisen from a deal between the toy manufacturer Mattel

13.17 Filmation Associates, "He-Man and the Masters of the Universe," still from the film *The Secret of the Sword*, 1985

and Group W (a company affiliated with Westinghouse, the parent company of Filmation at the time).

"He-Man and the Masters of the Universe" centers on the character of Adam, Prince of Eternia and defender of the Castle Grayskull, and his large, tiger-like cat, Cringer. As Adam explains to the audience, fabulous secret powers were revealed to him the day he held aloft his magic sword. When he does this, and utters the words "By the power of Grayskull—I have the Power," the timid Cringer becomes Battle Cat and Adam becomes "the most powerful man in the Universe," He-Man. Much of the show revolves around conflicts with the evil Skeletor and a range of strange beasts. Some storylines also dealt with the softer side of He-Man, however, as in *Prince Adam No More* (dir. Gwen Wetzler, 1983). In this episode, the warrior is saddened that his father, King Randor, only values him for his super-masculine He-Man incarnation and frets about revealing the true secret of his identity. "He-Man" was a huge financial success for Mattel, with the franchise covering print comics, features, and spin-offs, as well as toy lines. The animated series broke ground in being relatively violent, although He-Man was not allowed to fight with the sword he raised over his head in a signature move. At the end of each episode, a moral was appended, to put a positive spin on the storylines.

The Studios Expand

By the 1980s, other studios, including Ruby-Spears Productions, DiC, and Disney, joined DePatie-Freleng, Hanna-Barbera, and Filmation as significant forces in the production of American made-for-television animation. Ruby-Spears Productions was founded by Joe Ruby (1939–) and Ken Spears (1942–) in 1978. The two had worked together at Hanna-Barbera, where they had created the popular "Scooby-Doo" series, among others. They had also partnered at DePatie-Freleng, where they had developed "The Barkleys," featuring a family of dogs, and "The Houndcats," an investigative team of three dogs and two cats. Both series were aired on CBS in 1972 and were inspired by popular, live-action television series: "Archie Bunker" and "Mission Impossible," respectively. After they formed Ruby-Spears Productions, the two began to work with the ABC network, releasing a number of animated series. One of them, "Fangface," combined adventure, mystery, and comedy in stories about four teenagers, one of

whom occasionally transforms into a werewolf and attempts to eat one of the other characters, accompanied by lots of zany sound effects. A number of Ruby-Spears series were based on live-action productions, such as "Mr. T," which aired from 1983 to 1985, and "Police Academy," from 1988 to 1989.

DiC was founded in Burbank, California in 1982, as part of the French entertainment firm RTL (Radio-Television Luxembourg) Group, but four years later it was purchased by an American, Andy Heyward. Some of DiC's many productions include early episodes of "The Care Bears," from 1985, a co-production with the greeting-card company American Greetings and the Canadian studio Nelvana (which later took over the series); "The Real Ghostbusters," produced between 1986 and 1991 in association with Columbia Pictures Television; and a continuation of "G. I. Joe: A Real American Hero" (see p. 230) from 1989 to 1992, as a mini-series and as a regular series in syndication, distributed by Claster Television.

The Walt Disney Studios moved into production of animated series for television in 1984, after Michael Eisner joined studio management as CEO and implemented many changes. To bulk up its operations, Disney purchased the Hanna-Barbera Australia studio from its then owner, the Taft Broadcasting Company. Disney also outsourced work to the Japanese studio Tokyo Movie Shinsha, founded in the early 1960s with Yutaka Fujioka as president.[11] "Ducktales," which debuted in 1987 and ran for four seasons, was the studio's first big hit. The series' adventures mainly involve the characters Scrooge McDuck and his three grandnephews, Huey, Dewey, and Louie, in stories that are a combination of original writing, scenarios from the "Donald Duck" comic books by Carl Barks, and adaptations of well-known stories from popular culture.

International Developments in Made-for-Television Animation

Although America clearly dominated the television market internationally by the 1980s, studios in a number of other countries had also produced widely successful series. Some came from the Canadian studio Nelvana Ltd., which was founded in 1971 by the Belgian Michael Hirsch (1948–) and the Canadian Patrick Loubert (1947–),

who had met as students at York University in Toronto, along with the Englishman Clive A. Smith (1944–), who had animation experience from his work on the Beatles-themed *Yellow Submarine* (1968), directed by Canadian George Dunning in the UK (see p. 269). When Nelvana got its start, it focused largely on animated and live-action productions for the Canadian Broadcasting Corporation (CBC), including a number of holiday specials. The first was *A Cosmic Christmas* (dir. Clive A. Smith) in 1977, a story about a boy and a goose who help three alien visitors find the real meaning of Christmas. Nelvana's animation production expanded greatly from the 1980s onward, as it developed series around such licensed properties as "Care Bears" (1986–88), "Babar" (1989–91), and "Franklin" (1997–2004), with much of its work distributed worldwide.

In the UK, Halas & Batchelor was very active in television series production. During the 1960s, the studio produced its own animated series, such as the cel-animated "Foo Foo" and the stop-motion "Snip and Snap" (13.18) (both 1960). It also accepted contract work, such as "Popeye" (1955) for Rembrandt Films, and various series for Hanna-Barbera and Rankin-Bass, for instance. In his London-based studios, the Australian animation director Bob (born Roland Frederick) Godfrey created advertising, children's programming, and

13.18 Halas & Batchelor, Snap the Dog in *Top Dogs*, episode from the "Snip and Snap" series, 1960

personal films, such as *Do It Yourself Cartoon Kit* (1961), a satirical look at the animation process employing cutouts and drawn images with a voice-over narrator who attempts to sell the kit. This concept led to the development of a television series, the "Do-It-Yourself Film Animation Show," on BBC1 beginning in 1974. Each episode features different animators talking about their work, demonstrating varied media. Guests included the American Terry Gilliam, who became famous after animating for "Monty Python's Flying Circus," which first aired in 1969 on the BBC network, and the Canadian Richard Williams, who was a successful director of animated commercials but would become most famous as the animation director of *Who Framed Roger Rabbit* (dir. Robert Zemeckis, 1988, see p. 342). Both Gilliam and Williams had used Godfrey's cameras to create animated productions early in their careers, when they did not yet have their own facilities.

Advertising was a mainstay of many British animation studios, including those of Halas & Batchelor, Godfrey, and Williams. But two of the biggest names in the field were the British directors Ron Wyatt and Tony Cattaneo. They worked at Williams's studio beginning in 1962, but left three years later to set up their own company. Wyatt Cattaneo became the largest producer of animated advertising in the UK, creating a series of commercials for Tetley tea, Homepride flour, and many other clients.

Television Animation in Japan

In the early 1960s, Japan was developing its animation industry, and television offered new opportunities for growth. One of its largest studios, Toei Doga (Toei Animation Company), shifted in that direction, commencing with "Ōkami Shōnen Ken" ("Ken the Wild Boy"; 1963), an action-adventure series about a boy who becomes part of a wolf pack. Among Toei Doga's early hits are programs built around Shotaro Ishinomori's **manga** "Saibogu 009" ("Cyborg 009"), which include two television movies (1966 and 1967) and a television series of the same name that debuted in 1968; the story focuses on a group of humans who become cyborgs with unique abilities that they use to fight off evildoers. In the same year, the studio released the popular series "Kaitei Shōnen Marin" ("Marine Boy"), about a boy in a future world who is part of the Ocean Patrol, policing the sea with the aid of various inventions.

13.19 Hiroshi Sasagawa, "Speed Racer," beg. 1967 in Japan and the US

Japanese studios subcontracted a lot of work from American studios. For example, Rankin-Bass Productions had hired Tadahito Mochinaga (see p. 192), one of Japan's most accomplished puppet animators, to create stop-motion for its Videocraft International production *Rudolph the Red-Nosed Reindeer* (1964, see p. 193). America also turned to Japan for cel animation, contracting such large studios as Toei and Topcraft, founded by Toru Hara in 1972. But things shifted, and by the late 1980s, Taiwan had become the center of outsourced animation, with the vast majority of production taking place at a studio owned by James Wang—Wang Film Productions Co. Ltd.—which had been founded in 1978 as Cuckoo's Nest.

During the 1960s, as the Japanese industry developed, American distributors began to import series from Japan and reformat them for US audiences, editing content and creating an English-language soundtrack. One example is the action series "Mach Go Go Go," known as "Speed Racer" in the US, which depicted the adventures of a racecar driver named Speed and his best friend and mechanic, Sparky **(13.19)**. The concept originated in the late 1950s, in a manga by Tatsuo Yoshida (1932–1977), who went on to found the animation studio Tatsunoko Production Co. Ltd. a few years later, in 1962, with his brothers, Kenji and Toyoharu Yoshida. The studio transformed the manga into an animated series directed by Hiroshi Sasagawa, and the English rights to it were acquired by the American syndicator Trans-Lux. The series premiered in both Japan and the US in 1967. For the US version, editing and dubbing were largely undertaken by the producer Peter Fernandez, who also provided voices for characters, including the lead, Speed.

The American series "Robotech," which debuted in 1985, provides another example of Japanese productions edited for broadcast in the US. It is based on three series that Tatsunoko-Pro produced in the early 1980s: "The Super Dimension Fortress Macross" (dir. Noboru Ishiguro, 1982, a co-production with the Japanese studio Artland); "Genesis Climber MOSPEADA" (dir. Katsuhisa Yamada, 1983); and "Super Dimension Cavalry Southern Cross" (dir. Yasuo Hasegawa, 1984). These three science-fiction series focus on stories of transformable *mecha* figures that are interwoven with battles and romance. "Robotech," which resulted from the adaptation of these works into a single series, was produced by Harmony Gold USA. The transformation, which took place over a period of six months in late 1984 and early 1985, was supervised by Carl Macek (1951–2010). In his adaptation, Macek altered the content of the original series significantly by emphasizing action sequences, rather than romance or other "softer" content, in an attempt to aim the series

at the young male viewer.[12] During the process, Macek was mindful of regulations against overt violence at that time: for example, he had to remove images of blood coming out of a body part, and he also modified references to suicide. Macek's adaptation of the series in "Robotech" was one of the turning points in the rise of Japanese animation in America, as it reached a wide audience in the US and was very popular.

Osamu Tezuka and Mushi Production

The Japanese director Osamu Tezuka (1928–1989) is a seminal figure in both print comics and animation. In the mid-1940s, as a teenager, Tezuka began drawing print comics, including *Maachan no Nikkich* (*Diary of Machan*, 1946), about a small child in postwar Japan, and *Shin Takarajima* (*New Treasure Island*, 1947),

an adventure story about a boy and a pirate (13.20), effectively commencing the "golden age" of manga. Tezuka's manga later provided the inspiration for one of Japan's first animated feature films, *Boku no Songokū* (*My Songokû*, also known as *Alakazam the Great*, or *The Enchanted Monkey*, dir. Daisaku Shirakawa, Taiji Yabushita, and Osamu Tezuka), which is a story about the monkey king Alakazam and the journey he takes to become a true leader. It was released by the Toei animation studio in 1960. Tezuka founded his own animation studio, Mushi Production, in 1961, and began directing animated series for television shortly after that.

Among the many achievements credited to Tezuka is the development of the oversized eyes that became common in Japanese manga and **anime**. This style, which was influenced by Tezuka's love of early American animation, including the work of Paul Terry and the Fleischers, can be found in his "Tetsuwan

13.20 Osamu Tezuka's printed manga comic *New Treasure Island*, 1947

13.21 Osamu Tezuka, "Astro Boy," beg. 1963 in Japan

Atomu" ("Mighty Atom") manga, originally published in print between 1952 and 1968, and appearing in Japan as an animated series he directed, released in 1963 **(13.21)**. The story centers on a robot boy built by a scientist to look exactly the same as his son, who died in a car accident. This robot boy has many powers, including the ability to fly. He undergoes some hardships, but on the whole is destined to be a righter of wrongs who is called upon to fight evil-doers of various kinds.

The American company NBC Enterprises (a division of the NBC broadcast network) acquired the rights to the series, which they put into syndication as "Astro Boy" from 1963 to 1965. To prepare it for television, they contacted Fred Ladd (born Laderman, 1927–), and he transformed 104 episodes of the series by adding an English-language voice-over. After "Astro Boy" was successful, NBC Enterprises acquired another of Tezuka's series, "Jungle Taitei" ("Jungle Emperor"), which had originally appeared in a manga beginning in 1950 and was distributed in Japan as an animated series from 1965 to 1966. Ladd also adapted that series, calling it "Kimba the White Lion." It was distributed in the US beginning in 1966.

Tezuka and his studio personnel produced a number of television series, as well as other forms of animation, including movies for television and **original video animation** works (OVA) not released theatrically. They also created hundreds of volumes of manga and a number of short **festival films.**

Conclusion

In America, the years following World War II were undoubtedly a time of increasing conformity, partly as a result of identities proscribed and reinforced by the media. With the rise of television, from a young age, children were being exposed to similar experiences and products on a level unknown to previous generations, as part of a commodity culture that equated spending and material goods with happiness. Animation production for television, in such major studios as Hanna-Barbera and Filmation, was to a great extent tied into the business of marketing to children. To meet the needs of the growing industry, still other studios across the world did a significant business as subcontractors, providing labor to large American studios at a lower cost than that of workers in the US.

Despite the growing conformity, the 1960s and 1970s revealed cracks in the facade created by individuals who did not wish to join the mainstream or were prohibited from doing so. Artists found ways to express both perspectives through the use of concepts and techniques not associated with traditional production. While made-for-television animation reached out to families in their suburban living rooms, experimental filmmakers gathered in classrooms, art-house theaters, festivals, and other venues, harking back to the days of Europe in the 1920s, when Modernist animators found inspiration in each other's work.

Notes

1 Giannalberto Bendazzi, *Cartoons* (London: John Libbey, 1944), 234.

2 In 1978, ABC commissioned a new series starring the character, developing thirty-two additional episodes (some reworking the content of past theatrical films). Dave Mackey, "DePatie-Freleng Cartoons, 1964–1969," *DaveMackey. com* (June 5, 2010). Online at http://www.high-tech.com/panther/source/dfe60s.html

3 Jennifer Howard, "Bill Melendez," *Archive of American Television* (n. d.). Online at http://www.emmytvlegends.org/interviews/people/bill-melendez

4 Via the Museum of Broadcast Communications, George Dessart explains that, in terms of radio, "the broadcasters' insistence on setting and maintaining their own standards goes back to the very beginning of the medium in 1921, when engineers were instructed to use an emergency switch in the event that a performer or guest used language or brought up topics which were held to be unsuitable." George Dessart, "Standards and Practices," *Museum of Broadcast Communications* (n. d.). Online at http://www.museum.tv/eotv/standardsand.htm. For more on media self-regulation, see Angela J. Campbell, "Self-Regulation and the Media," *Federal Communications Law Journal* 51:3 (June 15, 1999), 711–71. Online at http://www.repository.law.indiana.edu/cgi/viewcontent.cgi?article=1207&context=fclj

5 Campbell, "Self-Regulation and the Media," 722; Dessart, "Standards and Practices."

6 Campbell, "Self-Regulation and the Media," 724.

7 Bendazzi, *Cartoons*, p. 235; Tom Sito estimates 2,000 employees at its various locations. Tom Sito, interview with the author, January 2, 2014.

8 (n. a.), "Sesame Street," *Archive of American Television* (n. d.). Online at http://www.emmytvlegends.org/interviews/shows/sesame-street

9 Tom Sito, "The '50s through the '90s," *Animation Guild, IATSE Local 839* (n. d.). Online at http://animationguild.org/the50s-the90s/

10 Tom Sito, interview with the author, January 2, 2014.

11 Ibid.

12 Carl Macek, interview with the author, September 12, 1996.

Key Terms

bumpers	limited animation
distribution	original video animation (OVA)
festival film	syndicated programming
franchise	telerecording
interstitial shorts	toyetic
kinescope	voice-over

■ Technological development ■ Development of the animated medium ■ Development of the film industry as a whole ■ Landmark animated film, television series, or game ■ Historical event

"Art in Cinema" series shows
at San Francisco Museum
of Modern Art, CA

1946–54

Korean War

1950–53

Vietnam War
(US withdraws in 1973)

1955–75

Heaven and Earth Magic (Harry Smith)

1957–62

1943–44

"Five Abstract Film
Exercises" (John and
James Whitney)

1948

The first stored-program
electronic digital computer
is created

1950

Enclaves of Beat culture
develop in Los Angeles,
San Francisco, and New
York City

1950s

Film clubs and art-house
theaters appear in America,
showing experimental and
foreign films

1950s

Oscilloscope imagery
appears in experimental
films by Hy Hirsh and
Mary Ellen Bute

1951

Hy Hirsh uses oscilloscope
imagery and optical
printing in his film
Divertissement Rococo

1952

The US Supreme Court
reverses its decision of
1915 and grants theatrical
films freedom of speech

The satirical magazine
MAD is first published

1957

The LA-based Creative Film
Society (CFS) is formed to
distribute independently
produced films

1958

John Whitney and Saul
Bass create the animated
titles for *Vertigo* (Alfred
Hitchcock)

1958

John Whitney shows the
capabilities of his motion-
control system in his
film *Catalog*

1960

Studio Loutkoveho Filmu
is established in Prague,
specializing in stop-motion
animation

1963

Mothlight (Stan Brakhage)

1963

Ken Knowlton develops the
first specialized computer-
animation language, Beflix,
at Bell Labs

CHAPTER 14
Postwar Experimentation

CHAPTER 15
New Audiences for Animated Features

Experimental Modes

1964
The Civil Rights Act prohibits discrimination based on "race, color, religion, or national origin" in employment, education, and public facilities

1966
John Whitney becomes the first artist-in-residence at IBM

1966
Lapis (James Whitney) features transcendent imagery

1966
Walt Disney dies suddenly

1966
Mosaic (Norman McLaren, Evelyn Lambart) reflects formal experimentation

1968, May
Protests take place in Paris, France and other cities around the world, unifying the youth movement

1968
Ratings system put in place for American films, replacing the Production Code

1968
Yellow Submarine (George Dunning) capitalizes on the popularity of the Beatles to attract the youth audience

1968
Isao Takahata and Hayao Miyazaki meet and work together on *Hols: Prince of the Sun*

1968
R. Crumb begins publishing his popular countercultural "Zap Comix," featuring Fritz the Cat and Mr. Natural

1971
The Point (Fred Wolf), from Murakami Wolf Productions, is the first made-for-television animated special in America

1972
Fritz the Cat (Ralph Bakshi) earns an "X" rating for its scenes of pornography and violence; it is wildly popular

1975
Arabesque (John Whitney) is released, programmed by Larry Cuba

1977
The Australian feature *Dot and the Kangaroo* (Yoram Gross) reflects indigenous environments and content

1978
Watership Down (Martin Rosen) appeals to older viewers

The Lord of the Rings (Ralph Bakshi) is made with a relatively low budget, but makes a large profit

CHAPTER 14

Postwar Experimentation

Chapter Outline

Global Storylines

Film clubs flourish in the 1950s and 1960s, often screening independent productions, including the work of experimental animators

Avant-garde animators of the post-World War II period commonly explore themes of expanded consciousness and transcendence

The oscilloscope, which depicts the wave shapes of electrical signals, is used by some animators to produce abstract images

The 1950s and 1960s see the advent of videotape and the computer, which would revolutionize all aspects of modern life, including animation

Introduction

During the 1950s and 1960s, increasing access to media technologies—especially in the form of 16mm film and cameras—fueled growth in independent production, including animation. This growth occurred on various levels, by the avant-garde art world, a few educational programs, and widespread amateur filmmaking, including home-moviemakers and hobbyists. These groups were aided by the development of specialized distribution and the emergence of film festivals, art-house theaters, movie clubs, and college courses, where both new work and classics were shown. Alongside the vital film scene, new technologies—in the form of videotape and early computers—suggested intriguing new aesthetic possibilities.

During World War II, many American servicemen were trained as cinematographers, charged with recording events of the war. After they returned home, their interest in filmmaking continued, prompting the development of film clubs across the country. Film clubs had begun in France during the early twentieth century, and spread internationally. One of them, the influential (London) Film Society in England, was formed in 1925 to show films from Europe that would not be screened in regular theaters. Such activities nurtured critical discussion of cinema as an art and as a political medium.

In the US, film clubs thrived in the post-World War II years, showing a wide range of movies and encouraging many of their members to create and screen their own films. In 1965, amateur filmmaking was given a boost by the emergence of inexpensive, easy-to-load "Super 8" 8mm film technology, but it was mainly used by families for home movies. For the avant-garde and the more serious amateur, 16mm was the preferred film gauge. By the 1970s,

14.1 Nam June Paik, *Global Groove*, 1973

videotape offered another option, though it was largely out of reach for the home consumer until the 1980s. The artistic potential of video was explored by Nam June Paik (**14.1**), Ed Emshwiller (see p. 254), and the other artists-in-residence at the experimental Television Laboratory, run by the New York public television station WNET/13 between 1972 and 1984.

By the 1920s, the Hollywood film industry had developed an elaborate system for distributing and exhibiting its films. In the 1930s and 1940s, alternative systems opened to independent filmmakers (albeit on a much smaller scale), allowing their works to find audiences, even if they did not make much of a profit. Since 1935, the Museum of Modern Art in New York City had provided a circulating film library that included not only the "great works" of the world's film industries, but also independent productions. The New York Film Council had been formed in the 1940s to support production and distribution, and during the same decade the Museum of Non-Objective Painting, established in 1939, had financed abstract animation by Oskar Fischinger (see p. 80), Norman McLaren (see p. 177), and others. In London, the British Film Institute had been founded in 1933, to promote film production, education, and exhibition, while in Paris,

the Cinémathèque Française had been established with similar objectives in 1936 on the back of a film club formed by Henri Langlois and Georges Franju.

In the post-World War II period, distribution spread to grassroots organizations. For example, the Los Angeles-based Creative Film Society (CFS) was formed in 1957 by Robert Pike, primarily to distribute independent and experimental short films. It placed an emphasis on filmmakers in the Southern California region, such as John Whitney, Sr., although others was also represented, including the animators Stan Brakhage, Mary Ellen Bute, Len Lye, and Stan VanDerBeek. Another distributor, Canyon Cinema, was based in San Francisco and formally incorporated in 1967, but before then had consisted of a loose gathering of filmmakers who screened work at their homes. In the 1960s and 1970s, these and other distributors supplied films for the classroom and film clubs. These organizations played an important role in developing the canon of works that are now deemed historically significant, in an era long before the Internet opened up distribution to everyone.

During the 1950s, as art-house theaters and museums showcased experimental and foreign-language cinema, Americans became more accepting of the idea that film—both live-action and animated—could

14.2 "Art in Cinema" exhibition catalog, 1947

be an art form as well as a source of entertainment. One of the most significant early "art film" screenings in the US took place at the San Francisco Museum of Modern Art; it showed the "Art in Cinema" series, which ran from 1946 to 1954 under the direction of Frank Stauffacher, who was aided by the filmmaker Harry Smith. The first of these events, which took place in September 1946, was promoted as "a series of avant-garde films in modern art forms—Surrealist, non-objective, abstract, fantastic . . . being jointly sponsored by the Museum, the California School of Fine Arts, and Circle Magazine."[1] Its catalog included articles by Oskar Fischinger and John and James Whitney (all of whom were featured in the screenings), among others **(14.2)**.[2]

Animation and the Avant-Garde

The first period of avant-garde film history, in respect to both live-action and animated production, took place within Europe in the 1920s and early 1930s, and developed in relation to modern art movements there. But after World War II, when the experimental animation scene began to prosper again, it became international

in scope. Later periods of avant-garde film production, beginning with the 1940s and 1950s, even spread to America, influenced by contemporary developments in modern art.

Much of American culture in the 1950s was conformist, characterized by a shift to suburban life, the Cold War, and the rise of the white middle class. But at the same time, pockets of resistance did exist, and from within them, experimentation in film and other arts flourished. Enclaves of "Beat culture," which formed in New York, the San Francisco Bay area, and Venice, California, were characterized by an interest in free-form art production, poetry and jazz performance, unfettered sexuality, drug use, and elements of Eastern or "alternative" spirituality. These themes and inclinations informed the work of the affiliated artists, who included the well-known Beat writers Jack Kerouac (author of *On the Road*, 1957), William S. Burroughs (who wrote *Naked Lunch*, 1957), and Allen Ginsberg (famous for his poem "Howl," 1955). They also influenced such filmmakers as Harry Smith in his early works.

Harry Smith (1923–1991) became a filmmaker in the mid-1940s, after he helped Frank Stauffacher with the "Art in Cinema" series of film screenings in San Francisco. As a result, Smith would go on to produce both short- and long-format films that employed direct-film practices (including a kind of batik process), cutouts, and other techniques. Smith had an interesting background and an even more interesting personality. As a child, he had been influenced by his mother's work with Native Americans living near his home in the state of Washington; later, he became an ethnomusicologist, recording elements of Native American tribes of the Northwest and other cultural groups in the United States. In 1952, he released a highly regarded multi-disk set of recordings, *The Anthology of American Folk Music*, which would go on to win a Grammy almost four decades later; it had a great influence on the rise of folk music in America, including the work of Bob Dylan and Joan Baez. Smith was also an eclectic collector of various items, and held the largest known collection of paper airplanes, which he donated to the Smithsonian Institution's Air and Space Museum. In addition, he was an authority on string figures.

In the 1940s, Smith began painting, influenced by Kandinsky and other Modernist artists, and his work drew the attention of Hilla von Rebay, the director of the Museum of Non-Objective Painting (later the

14.3 Harry Smith, *Heaven and Earth Magic*, c. 1957–62

Guggenheim Museum) in New York (see p. 88). She arranged Smith's move to the city in 1950, as the recipient of a Solomon Guggenheim grant. Smith's filmmaking also began in the mid-1940s, though the dates of his productions are not entirely clear, given that he frequently edited his works and also made contradictory statements about them in interviews and written notes, enjoying his role as a trickster. The films are named by number, spanning *No. 1: A Strange Dream* (c. 1946–48) to *No. 19* and *No. 20* (compiled in 1981, using elements from *No. 16* and *No. 19*).[3]

Smith took inspiration from a range of spiritual and pseudo-scientific practices, including theosophy, with which his parents were affiliated, and both Kabbalism and alchemy, which he studied. He thought of his work as a kind of alchemical practice, as it blended elements together in an act of transformation. In keeping with a kind of Beat sensibility, which advocated improvisation and transience in art, he had relatively little concern for the preservation of his work, at least in any single form; he often re-cut his films and typically used a range of different types of music

to accompany them. He also designed many of his films for "expanded performance" using special screens, masks, and other environmental elements. Smith's earliest works were made by working directly on the surface of film to create color abstract patterns, and in later films he employed cutouts, shot under a camera. Probably his best-known film is a feature created during the 1950s–60s, variously known as *No. 12 The Magic Feature*, and *Heaven and Earth Magic* (14.3), that was made with cutout figures taken from Victorian catalogs. Smith described a narrative involving a woman with a toothache, dental care, a watermelon, and transportation to and from Heaven, among other things. These images and events combine to create a dreamlike scenario.

Larry Jordan (1934–) was another of the experimental animators who settled in the San Francisco Bay area. From 1951 to 1953, Jordan had attended Harvard University, where he joined the school's film society and also became interested in the work of the eclectic modern artists Max Ernst and Jean Cocteau. A few years later, in 1955, he met up with his high-school friend and fellow filmmaker Stan Brakhage, in

New York. At that time Jordan was also introduced to the artist Joseph Cornell, who was well known for his collage boxes and experimental films, and the two worked together for ten years. During this period, Jordan produced a number of films, both live-action and animated. His animation employs representational cutout imagery in telling arcane, loosely structured stories. In *Duo Concertantes* (**14.4**), a nine-minute film released in 1964, Jordan creates a Surrealistic dreamworld built around themes of resurrection, rebirth, and the transition into higher planes, as figures transform and move upward.[4] The flow of images, including a man moving about a city and recurring orb-like forms, was created through free association, as Jordan progressed in filming. *Our Lady of the Sphere*, which he released in 1969, was inspired by the Tibetan Book of the Dead and relates the experiences of a boy confronting death and traveling through the underworld.[5]

James Whitney (1921–1982) was an abstract filmmaker who began making films with his brother John Whitney, Sr. (1917–1995) (see p. 251) in the mid-1940s, before embarking on his own projects, which were inspired by his interest in alchemy and meditational practice. His best-known work is a mandala film, or meditational piece, called *Lapis*, which was released in 1966 (**14.5**). In the film, small particles

14.5 James Whitney, *Lapis*, 1966

whirl and metamorphose into circular forms on the screen, pulling the eye into the perceived deep space created in its center. The film ends with a nirvana-like experience in a flood of light, which opens the pupil of the eye and suggests the kind of "expanded consciousness" that one might find through introspective practices (such as meditation) or the use of drugs that induce visionary hallucinations. The concept of expanded consciousness propelled many activities of the avant-garde at the time, as artists sought ways of enhancing perceptual abilities and understanding.

14.4 Larry Jordan, *Duo Concertantes*, 1964

14.6 Norman McLaren, *Mosaic*, 1966

Examining Structures in Animation

As film clubs, college courses, and other sources of film criticism grew in number, questions arose about the nature of cinema as an art form: the defining characteristics that separated it from other arts. The pioneering experimental animators Norman McLaren and Len Lye (see p. 86), who continued their work into the 1960s and beyond, were among the filmmakers who explored aesthetic issues related to sound and image. At the National Film Board of Canada, McLaren's interrelated trilogy *Lines Vertical* (1960), *Lines Horizontal* (1962), and *Mosaic* (1966) **(14.6)**, made with Evelyn Lambart, are studies in design related to the basic element of a straight line. *Lines Vertical* was created by engraving lengthwise into the surface of black film, using precision knives and metal rulers, to allow light to shine through; the film is accompanied by music by Maurice Blackburn. The same images were printed across the frames to create *Lines Horizontal*, with music by Pete Seeger. The first two films in the trilogy were then combined in a printing process to get the third, *Mosaic*; dots appear where the two sets of lines intersect, accompanied by McLaren's own engraved soundtrack.[6] In this way, McLaren and Lambart demonstrated how the same material, arranged differently, could create very different expressions. Another of McLaren's films, *Synchromy* (1971), is an elaboration of his direct-sound research, in which shapes photographed into the film's soundtrack area are used as the basis for its visuals **(14.7)**. This work encourages expanded perception by suggesting the kind of sound an image can make and the sort of image a sound can produce, resulting in an integration of the normally separate aural and visual realms.

14.7 Norman McLaren, *Synchromy*, 1971

14.8 Peter Kubelka in front of an installation of *Arnulf Rainer*

The series of dots in *Mosaic* create a strong visual impression as they pop on and off the screen in rapid succession. Watching films of this sort, known as "flicker films," can have a strong impact on a viewer, to the extent of possibly triggering seizures, because of the physiological effect of flashing light. During the 1960s, a number of filmmakers began to explore flicker in particular ways, as part of an investigation of the film medium itself or in order to experiment with perception. Peter Kubelka was among the first to create this kind of film. His *Arnulf Rainer* (1960), which was made by alternating black and clear frames, demonstrates the barest essence of the film medium in patterns of darkness and light **(14.8)**. *Arnulf Rainer*'s images are accompanied by either a lack of sound or "white noise," creating a sound flicker, developing patterns in which the visual and aural could be described as alternately on or off. In 1958, Len Lye created the scratch film *Free Radicals*, which was revised in 1979 **(14.9)**. It contains elements of flicker, but in this case many of the film's abstract images, created from light showing through a black background,

14.9 Len Lye, *Free Radicals*, 1979

seem to hang in suspension and rotate, suggesting a ritual dance; this impression is strengthened by chanting and a percussive soundtrack, which Lye identifies with the Bagirmi tribe of Central Africa.

Robert Breer (1926–2011) made films using a variation on the flicker effect, as he often worked at the level of individual frames, with each image occupying only one frame; these images can be identified when a piece of film is examined by hand, but they blend together when that same filmstrip is projected, one image quickly replacing the next, owing to the speed at which images appear (twenty-four frames per second). The result is a kind of collage, but not on a single surface—rather it is created through time **(14.10)**. His work acknowledges the frame as the foundation of film, as opposed to a series of frames blended together in one seamless viewing experience. As a painter living in Paris during the 1950s, Breer absorbed the influences of various modern art movements and was exposed

to the work of early experimental animators, such as Hans Richter (see p. 78), Viking Eggeling (see p. 78), and Walther Ruttmann (see p. 79), as well as the Beat poet Allen Ginsberg. Breer began animating some of the abstract images of his paintings using a Bolex 16mm camera, resulting in a series of four "Form Phases" films that were released between 1952 and 1956.

His film *Recreation* (1956) reflects the direction he took in some of his subsequent experimentation. It employs single frames and short sequences of images, including 2D abstractions and both still and moving objects. The visuals are accompanied by an intermittent, monotone voice-over narration in French by the film theorist Noël Burch, creating an oddly humorous juxtaposition, especially as mechanical chicks hop across the screen.[7] Breer continued his experimental approach in such films as *A Man and His Dog Out for Air* (1957), in which a drawn line moves about the frame, shifting from abstraction to representation, and in *Eyewash* (1959), which also employs the collage-in-time approach, bombarding the viewer with a continual stream of visual stimuli, including flicker. Breer's style, which is analytical and playful in equal measure, has appealed to a wide range of viewers. During the 1970s, he was among the numerous independent filmmakers who were commissioned to create innovative children's programming for the Children's Television Workshop, creating segments for "The Electric Company" in 1971.[8]

Experiments with Perception

Seeing the World Anew: the Films of Stan Brakhage

Like many of his contemporaries, Stan Brakhage (1933–2003) used the film medium to explore his interest in perceptual issues. In fact, he thought of film as an ideal means for expanding our understanding of the world, using projected live-action and animated visuals to help the viewer return to a purer, more immediate form of perception. In such a state, we can investigate the ideological implications of how we see or are made to see by the culture around us. Brakhage made more than 450 films, some of them only seconds in duration, but others hours long, and many of them completely or partly made directly on the surface of film; almost all of

14.10 Robert Breer, *Fist Fight*, 1964

his productions were without sound. Because of the scale of his work, the theoretical and aesthetic breakthroughs he achieved in his films and his writing, and his great influence as a filmmaker, among other factors, Stan Brakhage has been described as the most important figure of the post-World War II film avant-garde.

Brakhage made his first film in 1952 at the age of nineteen. The following year, he moved to San Francisco and then in 1954 moved again, this time to New York City, where he met a wide range of filmmakers and formed creative partnerships with individuals central to the art world. For example, in 1955, Brakhage collaborated on film projects with both the artist Joseph Cornell and the Modernist composer John Cage. In New York, Brakhage also met Jonas Mekas, with whom he (and others) would co-found the Anthology Film Archive in 1969. Still active today, this organization is one of the most important institutions devoted to the study and preservation of avant-garde film.

Much of Brakhage's work focuses on intimate personal experience; for example, his film of 1959, *Window Water Baby Moving*, documents his wife Jane giving birth to their first child in 1958. In this film and others, Brakhage is centrally concerned with perception, asking the viewer to really "see" rather than just "look."[9] He achieves this goal partly through distorting the images on screen so that they are no longer familiar and easily recognizable, using techniques such as close shots and surface treatments on the filmstrip itself. When a viewer cannot clearly perceive what is on the screen, he or she may be transported to the realm of "pure experience" removed from linear narrative, or story.

During the early 1960s, Brakhage completed his well-known film *Mothlight* (1963), for which he adhered a range of organic matter (leaves, moth wings, and so forth) to strips of 16mm **splicing tape** (normally used to edit pieces of film together in sequence), and printed them to film **(14.11)**. The result is a projection of many small objects that are enlarged and move by so quickly that they lose their individual meanings and exist at the level of total perception, not unlike the objects that surround us in real life, as we cannot possibly comprehend every detail of our environments.

The same year as *Mothlight* appeared, Brakhage published "Metaphors on Vision," reflecting his personal aesthetic and containing what has become a very well-known passage in the history of film:

14.11 Stan Brakhage, *Mothlight*, 1963

Imagine an eye unruled by man-made laws of perspective, an eye unprejudiced by compositional logic, an eye which does not respond to the name of everything but which must know each object encountered in life through an adventure of perception. How many colors are there in a field of grass to the crawling baby unaware of "Green"? How many rainbows can light create for the untutored eye? How aware of variations in heat waves can that eye be? Imagine a world alive with incomprehensible objects and shimmering with an endless variety of movement and innumerable gradations of color. Imagine a world before the "beginning was the word."[10]

In this statement, Brakhage describes a pre-linguistic state, before language, when humans experience the world with curiosity and wonder. Accordingly, it is not important for us to recognize the origin of images in *Mothlight*, be they moths or otherwise, or to be entertained by some sort of story tying the production together. Rather, we are intended to appreciate the play of light and color before us, as a document of the sensual world.

Looking into the Future: New Imagery from the Oscilloscope

The allure of early science-fiction films lies partly in the "space age" equipment used in their production. Often, this hardware included an **oscilloscope**, a cathode-ray-tube instrument developed in the early twentieth century **(14.12)**. Its original purpose was as a test device in laboratories and other settings, depicting the wave shapes of electrical signals. In the postwar era, the oscilloscope also provided appealing imagery for experimental abstract filmmakers, including Hy Hirsh and Mary Ellen Bute, filmmakers who incorporated this technology and others into their animated productions.

Hy Hirsh (1911–1961) began to work as a still photographer in 1932, with an interest in social documentary.[11] At that time he lived in Los Angeles, but in 1937 he moved to San Francisco, where he lived

14.12 Oscilloscope

for almost twenty years. In the mid-1940s, Hirsh became involved with experimental cinema as he assisted various filmmakers, and in 1951 he started making films of his own, beginning with *Divertissement Rococo*. Hirsh was interested in incorporating new technologies into his work, as this film shows: its abstract forms came from an oscilloscope, as moving images that were multiplied and colored through the use of an optical printer. His next two films, *Eneri* **(14.13)** and *Come Closer*, both from 1953, include stereoscopic imagery, creating

14.13 Hy Hirsh, *Eneri*, 1953

a three-dimensional effect. In 1955, he moved to Europe, living in the Netherlands and Paris, in the company of many artists, including the Polish poster designer and filmmaker Walerian "Boro" Borowczyk (see p. 270).[12] Hirsh continued making films, including *Scratch Pad* from 1960, made by scratching onto **found footage**.

Mary Ellen Bute (1906–1983) (see p. 89) brought a longstanding interest in electronic media to her filmmaking in the early 1950s. In the final two animated abstract films of her career, *Abstronic* (1952) and *Mood Contrasts* (1953), she incorporated oscilloscope imagery. In the seven-minute *Abstronic*, these images were filmed, combined with painted backgrounds, and synced to musical scores by Aaron Copland (the "Hoe Down" from *Rodeo*) and Don Gillis (*Ranch House Party*). Bute often combined abstract imagery with relatively recognizable forms; for example, in *Mood Contrasts*, swirling oscilloscope images were placed over a background that appears to be a brick road receding into the distance. In that film she also incorporated physical effects, such as colored liquids swirling in water to create cloudy images.[13] These visuals are accompanied by music from two operas by the Russian composer Nikolai Rimsky-Korsakov, "Hymn to the Sun" from *The Golden Cockerel*

and "Dance of the Tumblers" from *The Snow Maiden*. Bute saw her work as a kind of equivalent to composing, using light to develop visual compositions in time as the musician uses sound to produce music. To create images, she "drew" with a beam of light by adjusting knobs and switches on a control board, a process she equated with the use of a brush; to achieve the appearance of movement through space, the oscilloscope's images could be moved horizontally or vertically on the screen, or made larger or smaller to appear closer or further away.[14]

The Beginnings of Animated Computer Art

The Contributions of John and James Whitney to Computer Graphics

During the 1950s, the oscilloscope may have provided the "look" of the future, but computers were the future itself. A German engineer named Konrad Zuse has been credited as the inventor of modern computers, after his seminal work with programmable calculators in the

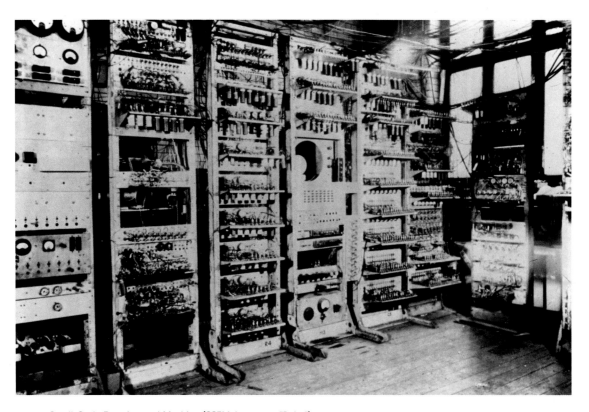

14.14 Small-Scale Experimental Machine (SSEM, known as "Baby"), 1948

14.15 John and James Whitney, "Five Abstract Film Exercises," 1940s

1940s. In the UK, the first stored-program electronic digital computer, the Small-Scale Experimental Machine (SSEM, known as "Baby"), was unveiled in 1948, at the University of Manchester **(14.14)**. Advances in computing technology in subsequent years were sustained by large companies, universities with substantial endowments, and the deep pockets of governments able to finance such projects. But it was not long until artists also got access to the technology, and were able to build on its potential as a new form of expression. One of them was John Whitney, Sr.

John Whitney, Sr. and his brother James (see p. 244) traveled to Europe as students just before the outbreak of World War II. John visited Paris, where he was greatly influenced by the twelve-tone compositions of Arnold Schoenberg,[15] and James went to England to focus on painting. After they returned home to Pasadena, California, they embarked on a number of experimental films, using equipment mainly developed by John. John Whitney was technically skilled, building tools and patenting processes throughout his career, including optical printers and a method of composing and recording synthetic sound through a graphical system.[16]

Using this synthetic sound system, in the mid-1940s the two brothers made a series of films—their "Five Abstract Film Exercises"—accompanied by

rhythmic electronic sounds **(14.15)**. John described his system as consisting of a series of pendulums linked mechanically to an optical wedge. The function of the optical wedge was the same as that of the typical light valve of standard optical motion-picture sound recorders. No audible sound was generated by the instrument. Instead, an optical soundtrack of standard dimensions was synthetically exposed onto film, which could be played back with a motion-picture projector.[17]

By adjusting the drive speed of the mechanism that printed the film with light, the pendulums delivered a wide range of futuristic, electronic-sounding compositions. In respect to visuals, James cut shapes out of a heavy stock of paper and lit them from behind; these mattes allowed the brothers to photograph direct light (rather than light reflected off surfaces), creating an intense, glowing effect. The brothers worked on different parts of the series individually: John made Nos. 1 and 5 in the series, while James made Nos. 2 and 3, which were combined into a single film, along with No. 4 **(14.16)**.

During the 1950s and 1960s, James Whitney pursued other art practices, including pottery and painting, as well as intensive work on films that reflected his growing interest in spiritual themes. John Whitney, Sr. went on to become one of the founding figures in computer animation, struggling through much of his early career to find commercial applications for

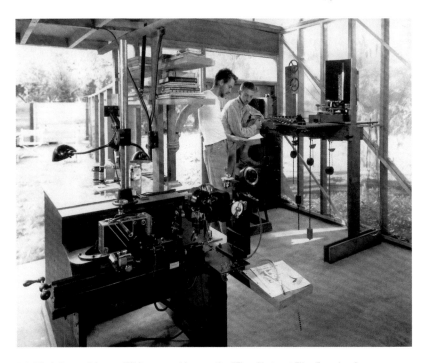

14.16 John and James Whitney working on the "Five Abstract Film Exercises"

his work. He did make his mark in Hollywood from time to time, for example when he created animation for the title sequence of the Alfred Hitchcock film *Vertigo* (1958), developed in partnership with the title designer Saul Bass (see p. 203). The spiraling background imagery emerging from the eye of Kim Novak, pictured in a close shot, provided one of the earliest examples of film titles that were thematically linked to the content of a film and also reflected the state of the art for electronic motion graphics at the time.

By 1958, John Whitney had designed a kind of **motion-control system** using surplus military equipment: analog plotting devices for anti-aircraft weaponry, which was sold cheaply by the government.[18] He developed this equipment as a design tool and demonstrated the range of its potential in a work he called *Catalog*, which was completed in 1961. It allowed him to do mechanically what an oscilloscope could achieve, in visual terms. Soon he realized that similar

effects could be created on a cathode-ray-tube computer terminal, and in the mid-1960s he made a proposal to International Business Machines (IBM), asking for a grant to conduct research in this area.

Whitney was able to make this proposal after he presented his work at the University of California, Los Angeles (UCLA) in 1966, to an audience that included a man named Jack Citron, who was employed at IBM. That year, Citron helped Whitney to obtain a position in the company as its first artist-in-residence and then served as a programmer for him: Whitney provided the design elements and Citron worked with IBM's computers to develop their **graphical** potential. One of the outcomes of this relationship was the film *Permutations*, completed in 1968. Its images were developed through the use of a pen tool that allowed Whitney to input design information by touching the computer screen with it. After the images were rendered, a process that took a long time, they were filmed from

14.17 John Whitney, *Arabesque*, 1975

the monitor on which they appeared. The filmed images were then re-filmed with color using an optical printer. Later in his career, John Whitney, Sr. taught courses at the California Institute of Technology (Caltech) and UCLA. He continued working in the field of computer animation as it expanded during subsequent decades. His film of 1975, *Arabesque*, is a high point of his career (14.17); it expresses Whitney's theorization of "harmonic progression" in its animation of images, which are inspired by Islamic architecture and accompanied by the Persian classical music of Manoochehr Sadeghi.

Other Pioneers of Computer Animation Art

By the early 1960s, a number of institutions were making inroads in computer graphics, paving the way for growth in animation. For example, at MIT, the doctoral student Ivan Sutherland made a breakthrough in this area by writing the Sketchpad program (also known as Robot Draftsman); published in 1963, it was a great step forward in human–computer interaction, allowing users to draw on a computer monitor using a light pen, among other innovations. By the 1970s, research in the field was growing rapidly. In 1970, the Xerox Corporation founded the Xerox Palo Alto Research Center (PARC) as a private research facility devoted to computing. A few years later, at the University of Utah, the "Utah teapot" became an iconic image of early visual development, used for experiments in modeling and rendering; it was created by Martin Newell in 1975, and for two decades the figure provided a base from which developers explored the application of light, shade, and color.[19] The New York Institute of Technology (NYIT), co-founded by Alexander Schure in the mid-1950s, would also play an important role in the development of computer animation. Schure served as the institute's first president and he helped set up its Computer Graphics Lab (CGL) in the mid-1970s.[20] The CGL's employees, including Ed Catmull, who had recently finished his Ph.D. at the University of Utah, and Alvy Ray Smith, who had been at Xerox PARC, worked on expanding the potential of computer graphics by developing television commercials, sports promos, and titles for TV shows. Eventually, Catmull, Smith, and others left the studio and headed for George Lucas's Industrial Light & Magic (ILM), known for its groundbreaking visual effects.

Bell Labs, at American Telegraph and Telephone (AT&T), also supported the development of computer animation. The gigantic communications company allowed its employees and some others, such as Mary Ellen Bute (who had access to an oscilloscope there), to use its facilities after hours in developing personal projects—an ideal situation for the artists, who had no other way to access such high-powered technology. Company employee Ken Knowlton (1931–) had developed the first specialized computer-animation language, Beflix, in 1963, and it was used to create a number of short films. For instance, Lillian Schwartz, who was also an AT&T employee, partnered with Knowlton in creating some of her experimental pieces. Schwartz's films typically employ found images that were recorded and manipulated by the computer; a good example is *Olympiad* (1971), which was created using frames from the motion studies of Eadweard Muybridge (see p. 21).

Knowlton collaborated with Stan VanDerBeek (1927–1984) to create a series of eight "Poemfield" films, in which poetry—mostly written by VanDerBeek—is processed by an IBM computer, resulting in text that emerges from and returns to graphic patterns on the screen. VanDerBeek, who had begun making films in 1955, had an interest in exploring the integration of media into day-to-day life; he thought of the computer as an extension of the mind and so felt it was a vital artistic tool.[21] He also produced theatrical and multimedia pieces, incorporating **happenings** and dance into his film and video work, which included multi-projector screenings at his Movie-Drome theater in Stony Point, New York. VanDerBeek's "Poemfield" animations were among the works screened there.

Larry Cuba

Larry Cuba (1950–) entered the field of computer animation as technology was becoming more accessible to individuals willing to learn programming. In the early 1970s, he was a graduate student in the animation program at California Institute of the Arts, but the computers there were not sophisticated enough to support his work. He therefore began working at Caltech, and while he was there he met John Whitney, Sr. When Whitney asked him to work as programmer on the film *Arabesque*, Cuba agreed, while continuing to work on his own productions.

Whitney broke the process of filmmaking into phases, regarding programming as a means of creating images that would be further manipulated with an

optical printer, whereas Cuba saw programming as the site of experimentation, preferring not to make changes to the resulting images after they appeared on the monitor. His film *First Fig* was completed in 1974, while he was a student, and was followed by others: *3/78 (Objects and Transformations)* in 1978, *Two Space* in 1979 **(14.18)**, and *Calculated Movements* in 1985. In all his work, Cuba investigates perception by looking at the relationship of image to musical structures. In *3/78*, named after the date when the film was completed, a series of objects metamorphose in rhythmic patterns, accompanied by a *shakuhachi*, a Japanese bamboo flute. In *Two Space*, images resembling the tiles of Islamic temples are created through a series of transformative actions, accompanied by Javanese gamelan music. The black-and-white imagery creates perceptual effects through the impact of after-image, resulting in violet figures that we "see" on screen, but are in fact illusory.

Though the majority of Cuba's film work has been personal and experimental, he has also done some commercial production—for example, an animated sequence for George Lucas's film *Star Wars IV: A New Hope* in 1977. For the film, Cuba created a graphical display of the Death Star space station and its trench, using still images of the film's in-progress sets; he animated it at the Electronic Visualization Laboratory (EVL), then known as the Circle Graphics Habitat, at the University of Illinois at Chicago.[22] The sequence is used in a pivotal part of the film: as the general explains his strategy for attacking the Death Star to a room full of fighters, Cuba's animation is rear-screen projected onto a large screen in the meeting area. Cuba also provided visuals for monitors that appear in other parts of the film, as aspects of the background set design.

Ed Emshwiller

During the 1950s, Ed Emshwiller (1925–1990) established himself as an artist in the realm of science-fiction-themed comic-book covers, but he would later also be known as an important figure in experimental animation. His filmmaking practice commenced in 1959,

14.18 Larry Cuba, *Two Space*, 1979

14.19 Ed Emshwiller, *Sunstone*, 1979

with *Dance Chromatic*, involving dancers and animation of his abstract paintings. Emshwiller embraced both videotape and emerging computer technologies in his productions, including *Scape-Mates* (1972). He created this work using an early analog video synthesizer called "Scan-i-mate," depicting dancers who become objects floating about the screen; at times their disembodied limbs move around a series of frames and abstract patterns. A few years later, in 1979, at the New York Institute of Technology, Emshwiller made *Sunstone* **(14.19)**, a short piece that broke new ground in its development of three-dimensional, electronically produced animation, partly through the subtlety with which the images are rendered.[23] He collaborated on the project with the computer-art pioneer Alvy Ray Smith (see p. 373). Emshwiller continued his experimentation as an artist-in-residence at the Television Laboratory WNET/13 in New York. He then began to work at the California Institute of the Arts, serving as dean of the School of Film/Video from 1979 to 1990, as well as provost.

Peter Foldes

In 1946, the Hungarian animator Peter Foldes (1924–1977) came to England to study art and began his career as a painter. He took up animation in the mid-1950s, but continued painting for a number of years after he moved to Paris. In the early 1970s, Foldes began working with scientists at the National Research Council of Canada, using an application called "Key Frame," which was created there by two pioneers of computer animation, Nestor Burtnyk and Marceli Wein; it enabled animators to draw only key-frame drawings, allowing the computer to fill in, or "tween," the in-between drawings.

Foldes's films *Metadata* (1971) and *La Faim* (*Hunger*, 1974) **(14.20,** see p. 256**)** were made using that system. *Metadata* served as a test of the software, emphasizing its ability to metamorphose from image to image. Created a few years later, *Hunger* is a more refined use of the application, reflecting its development. The film depicts stylized line-drawn images and silhouettes, which grow and shrink, rotate in space, and metamorphose into other forms, in a story about

14.20 Peter Foldes, *Hunger*, 1974

greed and its chilling effects.[24] *Hunger* was remarkable for its relatively fluid movement, at a time when computer animation was still in development and not easy for artists to use. One particularly smooth sequence, which depicts a go-go dancer, is animated through rotoscoping; every twelfth frame was traced and the computer **interpolated**, or drew, the images between them. Metamorphosis is employed throughout the film to suggest the inner lives of its characters and to move them within the screen space. The computer-animation component of *Hunger* was completed in 1973, but the film was released a year later, after additional work on the images took place at the NFB in Canada. Foldes also worked on developing 3D computer animation within the research department of the Office de Radiodiffusion Télévision Française (ORTF), in Paris.

Conclusion

During the 1950s and 1960s, experimental animation began to flourish internationally, exploring diverse themes and approaches. But as with Modernist animators in Europe after World War I, much of the production and exhibition continued to take place in relatively small social circles, where peers shared ideas and encouraged work that was far outside the mainstream culture. These animators often explored the aesthetics and material nature of film, as well as changes in technology. Ironically, big corporations were among the early supporters of computer art, though artists in these contexts were also on the margins, as they were typically obliged to squeeze in work on these projects after hours.

By the 1960s, a growing youth movement had manifested itself in many ways, as young adults reacted to contemporary events, especially the war in Vietnam. This generation was quite different than previous ones, which had lived through the Great Depression and World War II. A significant counter-culture developed, but at the same time these young people were identified as a new market for products—including films. Studios sought their business by presenting animated features that appealed to their sensibilities.

Notes

1 n. a., "Program Announcement for Art in Cinema's First Series, 9/46," in Scott MacDonald, Frank Stauffacher, and Art in Cinema Society, *Art in Cinema: documents toward a history of the film society* (Philadelphia, PA: Temple), 2006, 37.

2 Ibid.

3 Harry Smith, "Curriculum Vitae," *Harry Smith Archives*. Online at http://harrysmitharchives.com/1_bio/cv.html

4 Larry Jordan, "Duo Concertantes," *EM Arts* (n. d.). Online at http://www.em-arts.org/it/film/duo-concertantes

5 Jackie Leger, "Larry Jordan," *Animation World Network* 1:6 (1996). Online at http://www.awn.com/mag/issue1.6/articles/leger1.6.html

6 Aimee Mollaghan, "An Experiment in Pure Design": The Minimalist Aesthetic in the Line Films of Norman McLaren," *Animation Studies* 6 (Sepember 12, 2011). Online at http://journal.animationstudies.org/aimee-mollaghan-an-experiment-in-pure-design-the-minimalist-aesthetic-in-the-line-films-of-norman-mclaren

7 P. Adams Sitney, *Visionary Film: The American Avant-Garde 1943–1978* (Oxford: Oxford University Press, 1979), 280.

8 Jackie Leger, "Robert Breer: Animator," *Animation World Magazine*, 1:4 (1996). Online at http://www.awn.com/mag/issue1.4/articles/breer1.4.html

9 Brian L. Frye, "Stan Brakhage," *Senses of Cinema* 23 (December 2002). Online at http://sensesofcinema.com/2002/great-directors/brakhage/

10 Stan Brakhage, "Metaphors on Vision," reprinted in "The Opening Paragraph of Stan Brakhage's First Book, *Metaphors on Vision . . .*" *Fred Camper* (n. d.). Online at http://www.fredcamper.com/Brakhage/Metaphors.html. See also P. Adams Sitney, "Stan Brakhage," *Fred Camper* (2003). Online at http://www.fredcamper.com/Brakhage/Sitney.html; *Photographs* (San Francisco: Paul M. Hertzmann, n.d.), posted at *Center for Visual Music*. Online at http://www.hertzmann.net/pages/catalogs/79.pdf

11 Hy Hirsh, "Curriculum Vitae," *Center for Visual Music*. Online at http://centerforvisualmusic.org/Hirsh/HIRSH_CV2.jpg. Dennis Reed, *Hy Hirsh: Color*

12 Computer Graphic Timeline: 1945–2000 (2008). Online at http://wizspace.com/cgi/1951%20Hy%20Hirsh.html

13 William Moritz, "Mary Ellen Bute: Seeing Sound," *Animation World Magazine 1:2* (1996). Online at http://www.awn.com/mag/issue1.2/articles1.2/moritz1.2.html. See also n. a., "Excerpts from a 1954 article in *Film in Review* magazine written by Mary Ellen Bute," *Projects About* (n. d.). Online at http://otherfilm.org/seeing-sound/a-hundred-light-years-to-here/

14 Mary Ellen Bute, "Abstronics: An Experimental Filmaker [*sic*] Photographs the Esthetics of the Oscillograph," *Center for Visual Music*. Online at http://www.centerforvisualmusic.org/ABSTRONICS.pdf

15 John Whitney, "Moving Pictures and Electronic Music," in Robert Russett and Cecile Starr, *Experimental Animation: Origins of a New Art* (New York: Da Capo, 1988), 173.

16 Whitney, "Moving Pictures and Electronic Music," 171.

17 Ibid.

18 John Whitney, quoted in Austin Lamont, "An Interview with John Whitney," in Russett and Starr, *Experimental Animation*, 180–87.

19 Crystal Eastman, "From the Teapot to the Human: The Impact of 3D Computer Graphics on Medical Imaging and Medical Illustration," *Animation Journal* 20 (2012), 30–50.

20 Schure intended to direct a feature-length, computer-animated film, but the project, *Tubby the Tuba*, released by MGM in 1974, was made with conventional cel animation.

21 Andrea Rosen Gallery, "Stan VanDerBeek," from an exhibition May 1 to June 20, 2015. Online at http://www.andrearosengallery.com/exhibitions/stan-vanderbeek_2015-05-01

22 Larry Cuba, dir., "*Star Wars: Episode IV: A New Hope*: Making of the Computer Graphics for Star Wars," *Movieweb* (1977). Online at http://www.movieweb.com/movie/star-wars-episode-iv-a-new-hope/making-of-the-computer-graphics-for-star-wars

23 Mike Seymour, "Alvy Ray Smith: RGBA, the Birth of Compositing & the Founding of Pixar," *FXGuide* (July 5, 2012). Online at http://www.fxguide.com/featured/alvy-ray-smith-rgba-the-birth-of-compositing-the-founding-of-pixar/

24 Éric Barbeau, *René Jodoin* (2005). Online at https://www.nfb.ca/film/rene_jodoin

Key Terms

abstract
avant-garde
collage
direct film
distribution
found footage
graphical

happenings
Modernism
motion-control system
oscilloscope
splicing tape
synthetic sound

New Audiences for Animated Features

Chapter Outline

Global Storylines

The 1960s and 1970s are a time of political turbulence, with young people rejecting established values and seeking new forms of entertainment

Disney's output remains fairly traditional, with an emphasis on live-action films that sometimes feature animated segments

Other studios make greater efforts to adapt their films to youth audiences

The work of the director Ralph Bakshi becomes famous for its provocative treatment of sex, race, and gender

Introduction

In 1952, the US Supreme Court reversed its decision of 1915—which had described film exhibition as a business and so not guaranteed freedom of speech (see Box: The Development of the Hollywood Studio System, p. 44)—and consequently granted theatrical films protection under the First Amendment to the American constitution. As a result, like newspapers and books, films could be produced without the threat of censorship. Eventually, in 1968, a ratings system was put in place, using such indicators as "G" for general audiences and "X" for adults only. This was an important step forward in allowing more diverse subject matter to be featured in theatrical films, including animation. Following this decision, theatrical animated features would begin to appeal to a wider audience—not just to children, but also to the increasingly influential youth market of viewers, including both teenagers and young adults.

During the 1960s, the Beat subculture spread into the mainstream, as a wider band of society appropriated its sensibilities and transformed it into the hippie movement. Many people embraced the values of Timothy Leary, a psychiatrist who in the late 1960s advocated the use of the psychedelic drug LSD, telling them to "turn on, tune in, and drop out," and "make love, not war." Other aspects of youth culture were more politically active—especially as far as the Vietnam War and civil rights movement were concerned. Boycotts, sit-ins, and violence checkered this period, and, in America, resulted in such achievements as the passage of the Civil Rights Act of 1964, which prohibited discrimination based on "race, color, religion, or national origin" in employment practices, education, and public facilities. The women's movement was also developing at this

time, in a "second wave" of feminism, following early twentieth-century attempts at equality, largely aimed at suffrage, or the right to vote.

During the 1950s and 1960s, America was engaged in two wars, in Korea and Vietnam. The Korean War, which took place between 1950 and 1953, was a conflict between two politically opposed parts of the formerly united country: the US-backed south and the Communist north, which was aided by China, adding fuel to growing Cold War animosity. Vietnam, too, was split into a Communist north and a more democratically run south. The war in that country is generally traced back to 1954, as the north, which was backed by China and the USSR, attempted to take over the south. By the early 1960s, America had become heavily involved in combat; it finally withdrew from Vietnam in 1975, while hostilities continued.

The spread of television during the 1950s meant that the Vietnam War is considered to be the first "living-room war": families could watch what was happening on the evening news. Its images contributed to worldwide discontent, as many viewers witnessed the atrocities taking place. Consequently, Vietnam was the first war in which returning veterans were subject to disrespect, as anti-war protestors saw them as part of the problem. Television was a force unlike any before it, combining sound and image with relative immediacy, in a way different than newspapers, radio, or newsreels in a theater. Television had the ability to engage large audiences simultaneously and so was a powerful social agent in an era that saw much change. It was the means by which many people learned of the assassinations of several great cultural figures of this period, such as the American president John F. Kennedy in 1963, and his brother, Robert Kennedy, five years later, as well as the civil rights leader Martin Luther King, Jr., also in 1968. These shocking events had a deep impact on society, which seemed to have reached new depths of depravity. Protests of various kinds took place worldwide, including the general strikes and violent clashes of May 1968, during which riots and protests, partly against the Vietnam War, took place in Paris, France and in other cities across the world. This political engagement unified the youth movement internationally.

Within this environment, young adults sought new forms of media that challenged established values, especially in respect to sexuality, violence, and politics. Some of them turned to cartoon culture, which had

15.1 R. Crumb, "Zap Comix," No. 1, 1968

diversified by this time to appeal to these older and politically edgier readers. Beginning in 1952, the satirical magazine *MAD*, which was originally published by EC Comics, took aim at society's most deeply held values, both social and political, lampooning them with its sharp wit. Its first issue was written almost entirely by Harvey Kurtzman (1924–1993), who continued as editor for the next four years. Around the same time, the underground **comix** movement took root. Comics have always been on the borders of acceptable society, but underground publishers began to take their outsider status to extremes. These small-press publications featured drug use, sex, and social criticism, using the term "comix" to distinguish themselves from mainstream comic books and as a suggestion of scandalous, X-rated content. The best-known of the underground creators, R. (Robert) Crumb (1943–), became popular after the successful debut of his self-published "Zap Comix," beginning in 1968 **(15.1)**. His work included a range of countercultural characters, such as the promiscuous Fritz the Cat and the mystical guru Mr. Natural, as well

15.2 The designer Peter Max sitting on his posters, photographed for *LIFE* magazine, *c.* 1968

as his iconic Keep on Truckin' figure, who takes large, strutting steps while giving a "thumbs-up" gesture.

New design trends also reflected this countercultural spirit. The German-born Peter Max is one of the most iconic graphic designers of the 1960s and 1970s **(15.2)**. The psychedelic forms and

color palettes he favored were perfectly suited to the sensibilities of the time. In the live-action film world, too, style became an increasingly important commodity, especially after critical writing on cinema began focusing on directors as "authors" with a personal aesthetic; the period also witnessed the rise of the "New

New Voices in Popular Media

By the 1970s, teenagers and young adults felt they had a distinctly different point of view than that of the older generation and they expected those differences to be reflected in the media they chose to engage with. The many protests taking place at this time found a voice in popular culture, including music and cinema, which increasingly catered to youth.

A youth market began to develop as part of a diversification of the music industry as a whole, which took place over several decades. Back in the 1940s, popular music had been dominated by big band and swing, but by the end of the decade another strain was seeping in. This new music reflected the increasingly mixed social milieu of 1950s culture, blending different ethnicities and races. Rhythm and blues, country, gospel, and other forms of music combined to form the early strains of rock and roll, in the music of such 1950s superstars as Elvis Presley, Fats Domino, Chuck Berry, and Buddy Holly. The spread of this music was enabled in part by the invention of the transistor, patented by Bell Labs, which led to the development of small, portable radios that teenagers could carry with them. By the 1960s, the youth music industry was firmly established in a range of new genres of varied natures: surf music (e.g. the Beach Boys), Motown (e.g. the Temptations), and folk (e.g. Bob Dylan), on the one side, and psychedelic, heavy metal, and hard rock (such as the Rolling Stones, the Doors, the Grateful Dead, and Led Zeppelin) on the other. The Beatles became the best-known group of the "British Invasion," with music ranging from sentimental love songs to folk music, calls for peace, and psychedelia.

As far as cinema was concerned, such films as *Bonnie and Clyde* (dir. Arthur Penn, 1967), *The Graduate* (dir. Stanley Kramer, 1967), and *Easy Rider* (dir. Dennis Hopper, 1969) not only addressed the specific angst felt by young people in America, but also represented the force of the newly independent director, freed from the constraints of the studio system, which was greatly weakened by the early 1960s. After the adoption of the ratings system in 1968, these mavericks were able to treat a wider range of subjects, as it introduced categories for films containing sex and violence. Those categories were put to use by a number of daring films, such as Sweet Sweetback's *Baadasssss Song*, an independent production directed by and starring Melvin Van Peebles (1932–) and released in 1971. The film's X rating was earned by several actual sex scenes, which were all the more groundbreaking for presenting some of the first images of a sexualized black man in film. This film led to the development of a whole new action genre known as "Blaxploitation," aimed at urban black audiences, mostly acted by black performers, and generally dealing with race relations in one form or another. It also influenced the expansion of X-rated film production. The following year, in 1972, the first mainstream, plot-driven pornographic film, *Deep Throat* (dir. Gerard Damiano), was released; this X-rated feature was the subject of much controversy and was widely banned.

Directors in what emerged as the New American Cinema were inspired by the development of "New Wave" film movements across the world. The best-known examples came from France. There, such directors as François Truffaut (1932–1984) and Jean-Luc Godard (1930–) focused on youth-related topics and incorporated political themes into their films, which include, respectively, *Les Quatre Cents Coups* (*The 400 Blows*, 1960), a documentary-like story about a young boy who faces a difficult life in the city, and *À Bout de Souffle* (*Breathless*, 1960), which examines the structures of Hollywood cinema through a revisionist gangster story. Continuing their work into the 1960s and beyond, these directors were active in the fields of film history and theory, writing persuasively about creative authorship in film production. Their perspectives were later expanded on by the American critic Andrew Sarris, into what has become known as the auteur theory, emphasizing the creative control of the director.

American Cinema," made by feature-film directors who were influenced by French, Italian, and other mainly European productions as well as documentary films. Animation, too, went through a period of stylistic realignment, including the development of features that were aimed at the burgeoning youth market. This chapter examines animated features of this period, beginning with Disney productions, and then moving on to productions from other studios in the US and abroad. Included is the renegade animator Ralph Bakshi, whose work clearly appealed to the young-adult market, as it pushed animated imagery into new realms.

Disney Animation from the Postwar Era

For The Walt Disney Studios, the 1950s and 1960s were a time of transition, with a move into television and the opening of the first Disney theme park. These ventures were not only fabulous merchandizing opportunities for promoting Disney's characters and films; they also allowed the studio to diversify and buffer its frequently uncertain financial situation in regard to animated features. It seems that Walt Disney may have diversified for personal reasons as well. The bitter taste of the strike among his animators in 1941 (see Box: The New Deal and the Rise of Unions, p. 121) stayed with him for some time, and during the 1950s the studio embraced live-action production. At the same time, Disney remained firmly fixed on family fare; it would be many years before it pursued the youth market, with its eventual development of the Touchstone Pictures distribution label in the mid-1980s (see p. 140).

The studio's reputation was built around its animated shorts and features, but Walt Disney had been interested in live-action from his earliest days as a studio owner: his first successful series, the "Alice Comedies" (1923–27, see p. 60), had combined live-action with animation. But after the almost four-year run of the series came to an end, the studio focused on wholly animated shorts and features until the 1940s, when the concept of live-action and animation combination films resurfaced, in the form of **package films** combining several animated shorts. In 1940, *Fantasia* (see p. 107) featured a series of animation films set in the context of a live-action concert. In 1941, *The Reluctant Dragon* (dir. Alfred Werker and Hamilton Luske) included a live-action studio tour and four short animated films—developments set within a story about the author Robert Benchley, who wanted Disney to buy the rights to his book. Two Latin American-themed combination films

emerged after Disney's government-sponsored "Good Neighbor" tour (see p. 206): *Saludos Amigos* (1943), which includes documentary footage of Latin American cities, and *The Three Caballeros* (dir. Norman Ferguson, 1944), featuring appearances by the performers Aurora Miranda, Dora Luz, and Carmen Molina. In both films, Donald Duck and his pal José Carioca tour various actual locations, among other activities.

After World War II ended, the studio continued to make live-action and animation combination films, such as *Song of the South* (dir. Harve Foster and Wilfred Jackson, 1946) **(15.3)**, which is based on the "Uncle Remus" folk stories. *Song of the South* brought its share of problems to The Walt Disney Studios, mainly because of its live-action sequences, which stirred up controversy for the way they showed

15.3 Harve Foster and Wilfred Jackson, *Song of the South*, 1946

African American culture in the South; the film's depiction of Uncle Remus reflected the stereotype of happy black cotton-field workers at a time when the issue of civil rights was on the minds of many. The film focuses on a young white boy who is staying at his grandmother's plantation. When his father leaves, the boy tries to run away, but his plan is thwarted by the charming Uncle Remus, played by James Baskett (1904–1948), who spins an imaginative story about Brer Rabbit, Brer Fox, and Brer Bear to capture the child's attention. The boy returns home, but has other misadventures, and Uncle Remus steps in with other stories about Brer Rabbit. The three animated segments in the movie make up about twenty-five minutes of the film's ninety-four-minute running time.

The film is based on a series of stories by Joel Chandler Harris, published in the *Atlanta Constitution* beginning in 1876 and set during the time of slavery. Although Disney had moved the narrative to a post-civil war setting, the live-action elements of the film were roundly criticized. Opening the film in Atlanta, Georgia, was probably not the wisest publicity move, since strict segregation laws there restricted the participation of Baskett or any of the film's black cast.[1] Across America, theaters showing the film were picketed, and the National Association for the Advancement of Colored People (NAACP) widely registered its complaints as well. Nonetheless, *Song of the South* was relatively successful at the box office, and did garner critical acclaim. Its song "Zip-a-Dee-Doo-Dah" won the Oscar for best song at the 20th Academy Awards in 1948, and an Academy Honorary Award was given to James Baskett for his portrayal of Uncle Remus. Although the film remained largely out of distribution in America in subsequent years, it was released in other countries. The animated sequences were not problematic and some of the characters appear on a popular Disney theme-park ride, Splash Mountain, even today.

The Walt Disney Studios had been known for family entertainment, and its productions in the postwar period conformed to this expectation, making little contribution to emerging youth media. During this time, the majority of Disney animated features were adaptations of fairy tales and traditional stories, such as *Cinderella* (1950), *Alice in Wonderland* (1951), and *Peter Pan* (1953), all directed by Clyde Geronimi, Hamilton Luske, and Wilfred Jackson; and *Sleeping Beauty* (1959), directed by Geronimi with Les Clark,

Eric Larson, and Wolfgang Reitherman. Eventually the studio diversified the look of its films by selecting more modern stories and incorporating new production methods: for instance, *Lady and the Tramp* (1955) used the widescreen process CinemaScope, while *One Hundred and One Dalmatians* (1961) employed the xerography process to duplicate lines onto acetate cels (both films were co-directed by Geronimi, Jackson, and Luske).

Walt Disney also broadened the output of his studio in the mid-1950s by opening his first theme park, Disneyland, in Anaheim, California in 1955, an event he celebrated in a ninety-minute live broadcast on the ABC television network. Plans for the park had been developed by a creative team formed on The Walt Disney Studios lot in 1952; known as WED Enterprises—from the initials of his name, Walter Elias Disney—it was the forerunner to Walt Disney Imagineering, which would later handle theme-park development. To fund the project, Disney looked to the emerging television industry, striking a deal with ABC. The network agreed to help finance the venture in return for part ownership of the park and a Disney television series to be aired weekly. The series, simply named "Disneyland," was hosted by Walt Disney himself; it began in October 1954, and included updates on the park's progress. Finally, on Sunday July 17, 1955, Disneyland's first guests walked through its gates, captured on live television.

By the early 1950s, Disney was already producing wholly live-action features, beginning with *Treasure Island* (dir. Byron Haskin, 1950), and followed by *20,000 Leagues under the Sea* (1954), a CinemaScope widescreen film directed by Richard Fleischer (1916–2006), the son of Max Fleischer. While Disney continued to create combination films, its emphasis in such works was largely on live-action performance. These films include *Mary Poppins* (dir. Robert Stevenson), released in 1964, as well as *Bedknobs and Broomsticks* (dir. Robert Stevenson), released in 1971. Both are stories about children and a magical woman who enters their lives, adapted from books by P. L. (Pamela Lyndon) Travers and Mary Norton, respectively. While these films have become classics of the studio, they predictably held little appeal for the emerging youth market. Disney films were typically given a "G" rating for general audiences, owing to their lack of potentially offensive material, and it was not until

1979 that the studio began to release live-action films that had crept up to the next level, "PG," or "parental guidance suggested." *The Black Hole* (dir. Gary Nelson, 1979) a live-action science-fiction film, was the first of Disney's productions to be given that rating.

The Sword in the Stone (dir. Wolfgang Reitherman), a comic adventure based on the legend of King Arthur, is the last animated feature that Disney supervised through completion. It was released in 1963; three years later, in 1966, Walt Disney died suddenly, following surgery for lung cancer. The studio had lost its creative center, but it nonetheless pushed ahead with its various projects. These included *The Jungle Book* (dir. Wolfgang Reitherman), a film based on Rudyard Kipling's story about a boy raised in the wild, which Walt Disney strongly influenced; it was released in 1967. Walt Disney had signed off on *The Aristocats* (dir. Wolfgang Reitherman), approving it for production, but he was not involved with its development. This film, about a cat heiress who finds herself in trouble, was released in 1970. The Walt Disney World Resort in Florida opened the following year. Walt Disney had been working on the site since the mid-1960s, and after his death his brother, Roy O. Disney, came out of retirement to supervise the park's construction.

Robin Hood (dir. Wolfgang Reitherman, 1973) was the first animated feature film of the new era—that is, following Walt Disney's death. Four years later, in 1977, the studio released two more animated features: *The Many Adventures of Winnie the Pooh* (dir. John Lounsbery and Wolfgang Reitherman), based on the well-known children's books by A. A. Milne, and *The Rescuers* (dir. Wolfgang Reitherman, John Lounsbery, and Art Stevens), a story about an international mouse organization, based on books by Margery Sharp. The Walt Disney Studios' work continued to attract audiences, but it seemed that it might be losing its touch. *The Many Adventures of Winnie the Pooh*, for example, was created by compiling three featurettes that had already been released.

Stepping out of Disney's shadow, other studios were eager to fill the void with alternatives of various kinds, and, as a result, began to threaten Disney's position as the leader in animation production. Some of these rival films were created by ex-Disney animators, but the surge in feature production was international and included both commercial studios and independent filmmakers.

Creative Work from Disney's Rivals

The Walt Disney Studios had always faced challenges from other studios, though for many years it was dominant, forming the public's idea of the epitome of animated storytelling. The competition began to increase, however, chipping away the studio's lead in the realm of animated feature films aimed at children and families. For example, United Productions of America (UPA, see p. 210) released its first feature, *1001 Arabian Nights* (dir. Jack Kinney), in 1959. It starred the popular character Mr. Magoo in the role of Aladdin's uncle, an appearance that came at the end of the character's ten-year "Mr. Magoo" series (1949–59), which was produced for Columbia studios. Like Disney, UPA aimed its animated feature toward the family market, appealing to children rather than a teen or young-adult audience.

UPA released a second animated feature in 1962: *Gay Purr-ee* (dir. Abe Levitow), a love story involving cats that live in the city of Paris. The hand of Chuck Jones (1912–2002), who co-wrote the script with his wife Dorothy Webster Jones (1907–1978), is evident in references to modern art. They come in the form of commissioned portraits of the main character, Mewsette, in the style of such artists as Claude Monet, Henri Rousseau, Vincent van Gogh, and Pablo Picasso. After Warner Bros. closed its animation studio in 1963, Jones set up his own studio, Sib Tower 12 Productions, with the producer Les Goldman, releasing films through MGM. Eventually, Jones returned to feature films, co-directing the live-action and animation combination film *The Phantom Tollbooth*, which was released by MGM in 1970 (15.4). Based on a book by Norton Juster from 1961, it tells the story of a boy who drives through a magical tollbooth into a fantasy world, where he becomes an animated character and embarks on various adventures. This film, too, was aimed at young viewers.

By the 1970s, television offered opportunities for long-format animation released as special programs. In America, the first of these specials was produced by Murakami Wolf Productions in 1971: *The Point* (dir. Fred Wolf) tells the story of a boy named Oblio who is expelled from his kingdom because he does not fit in, a plot that is developed around a series of songs by the American singer-songwriter Harry Nilsson. Oblio

15.4 Chuck Jones, *The Phantom Tollbooth*, 1970

and asking the travelers if they can "dig" it, all delivered with a "cool cat" musician's bravado. Originally, the production was narrated by Dustin Hoffman, but it was subsequently re-recorded with the voice of Beatles legend Ringo Starr. *The Point* aired in primetime in 1971 as an "ABC Movie of the Week." Although the special's story centers on a child, in its design this animation reflects the sensibilities of contemporary youth culture.

At his Storyboard studio, founded in 1953, John Hubley (1914–1977) primarily created work related to advertising, but he and his wife, Faith Hubley (1924–2001), also devoted much time to the production of personal films

and his dog travel through terrain populated by unusual characters, which were designed by Gary Lund. One of them is Rock Man, who is voiced by William E. Martin. Rock Man advises the boy to "open your mind, as well as your eyes," and employs a range of terms with a kind of *double entendre*, referring to "stone[d] folks"

mainly shown at festivals. Some, like *Moonbird* (1959), were short films involving family members—in this case, their two young sons hunting for an imaginary bird. A few of them were long-format works, including *Of Stars & Men*, a fifty-three-minute animated documentary released in 1964 that explores the place of humankind

15.5 John and Faith Hubley, *Everybody Rides the Carousel*, 1975

15.6 John Hubley and Martin Rosen, *Watership Down*, 1978

in the cosmos; it is based on a book of 1959 with the same name, written by Harlow Shapley, who narrates the film. In the mid-1970s, the Hubleys completed another long-format film, *Everybody Rides the Carousel* (1975) (**15.5**, see p. 205), which runs seventy-two minutes and is based on the writing of Erik Erikson, who described the "eight stages of man," beginning with infancy and ending with old age. The production aired on CBS in 1976. These films reflect the Hubleys' personal style and represent another direction for the animated feature at this time, as it broke away from the Disney model.

In 1977, John Hubley died unexpectedly, while he was in production on the animated feature *Watership Down* (**15.6**); the film's producer and writer, Martin Rosen, took over its direction and receives directing credit, though some of Hubley's work remains in the film. Based on a book by Richard Adams published in 1972, *Watership Down* tells the story of a community of rabbits that is displaced and struggles to find a new home. The film references epic themes and features well-respected actors, such as John Hurt and Nigel Hawthorne.

The Rise of International Production

The expansion of animation to new audiences in the 1960s and 1970s occurred worldwide, involving both established and emerging directors. Two eventual superstars of Japanese animation, Isao Takahata (1935–) and Hayao Miyazaki (1941–), were among them (see p. 393). Takahata's first feature had been made while he and Miyazaki were working at Toei Animation: *Taiyō no Ōji: Horusu no Daibōken* (*Hols: Prince of the Sun*), released in 1968 (**15.7**). The film tells the story of a boy who is protecting his village from an evil force and meets a mysterious girl along the way. Many accomplished animation artists were involved with the project, including Miyazaki, as well as Yasuo Ōtsuka, Yoichi Kotabe, and Yasuji Mori. About ten years later, in 1979, Miyazaki directed his first feature, *Rupan Sansei: Kariosutoro no Shiro* (*The Castle of Cagliostro,* or *Lupin III: Castle of Cagliostro*). This film was co-written by Miyazaki and Haruya Yamazaki as an adaptation

15.7 Isao Takahata, *Hols: Prince of the Sun*, 1968

of a comic by Monkey Punch (born Kazuhiko Katō); also entitled *Lupin III*, it was a story centering on the adventures of a master thief. Miyazaki would go on to become Japan's most famous animation director. He and Takahata opened their Studio Ghibli in 1985 (see p. 395).

On a smaller scale, animators in other countries were also venturing into feature-length production. In China, the pioneering Wan brothers continued to be leading figures in production, having made the first feature-length animation in the country, *Tiě Shàn Gōngzhǔ* (*Princess Iron Fan*, dir. Wan Guchan and Wan Laiming), in 1941 (see p. 170). Then, in the early 1960s,

Wan Laiming directed *Dà Nào Tiān Gōng* (*Havoc in Heaven*) in two parts; part one was completed in 1961 and part two in 1964 (see p. 172). These films were all inspired by the well-known story of the Monkey King.

Meanwhile, Australia was feeling the domineering pressures of the American animation industry, especially through the presence of Hanna-Barbera Australia, after it was established in the early 1970s. More localized production was on the horizon, however, partly through the efforts of Yoram Gross Film Studios. Born in Krakow, Poland, Yoram Gross (1926–) first worked in live-action film production in his home country and then in Israel, after he moved there in 1950 at the age of twenty-four. He began to work in stop-motion animation in 1958, while he was still in Israel, creating a number of films, including the first feature-length animated film in that country, a stop-motion biblical story, *Joseph the Dreamer*, in 1961 (**15.8**). In 1968, Gross emigrated to Sydney, where he opened a studio with his wife Sandra Gross and made many advertisements and short films. The studio became well known internationally for its feature films starring a girl named Dot, commencing with *Dot and the Kangaroo* in 1977, using a live-action and animation combination approach and focusing on indigenous environments and content (**15.9**, see p. 268).

During the 1960s, in Czechoslovakia, the filmmaker Karel Zeman (1910–1989) (see p. 191) continued production of feature-length fantasy films, such as

15.8 Yoram Gross, *Joseph the Dreamer*, 1961

15.9 Yoram Gross , *Dot and the Kangaroo*, 1977

Ukradená Vzducholod (*The Stolen Airship*), released in 1967 (**15.10**). The story is based loosely on the French writer Jules Verne's novels *L'Île Mystérieuse* (*The Mysterious Island*, 1874) and *Deux Ans de Vacances* (*Two Years' Vacation*, 1888), which tell the story of some boys who make off with a flying ship. By this time, Zeman was well known for his visual effects and complex production methods. *The Stolen Airship* demonstrates these qualities, combining live-action and many types of animation, including stop-motion, drawings, and optical-printing effects. For example, animation and live-action flow seamlessly as the boys try to outrun another ship that is pursuing them, and the scene cuts to a fortress, introduced through cutout architecture placed on a multiplane surface in a continual zoom into the setting. When the shot reaches the interior area where several men are gathered around a table, they are composited into a background space and visual effects take place during their conversation. Fantastic designs are blended with real and animated figures to create an imaginary world, offering an engaging alternative to the aesthetics of cel animation.

15.10 Karel Zeman, *The Stolen Airship*, 1967

Attracting the Youth Audience

During the 1960s and 1970s, a number of animated features were developed specifically for the youth market, tapping into subjects, visual design, and soundtracks that appealed to the tastes of young adults. The film *Yellow Submarine* (1968) provides a great example, as it features the likenesses of George Harrison, Paul McCartney, John Lennon, and Ringo Starr, and promotes their music (15.11). Directed by the Canadian George Dunning (1920–1979) in England, the film's art direction and character design were guided by the Czech-born graphic designer Heinz Edelmann (1934–2009), favoring a psychedelic sensibility. In the film, evil music-haters called the Blue Meanies have descended on the idyllic Pepperland, and the four band members are enlisted to save the day. Sequences exist side by side in a relatively loose way, tied together mainly as a group of songs. The film's production company, TVC of London, had already made a number of short films based on Beatles music, as early forms of music videos.[2] To create this film's images, it hired top animation talent from the UK and abroad—including Paul Driessen, Dianne Jackson, Anne Jolliff, Gerald Potterton, and Alison de Vere. The characters were actually voiced by actors; the Beatles themselves appear only at the end of the film.

The design work of the French illustrator Roland Topor (1938–1997) defines the surrealistic characters and landscape of the feature film *La Planète Sauvage* (*Fantastic Planet*, 1973) (15.12), directed by René Laloux (1929–2004). Both Topor and Laloux contributed to its script, which is an adaptation of a science-fiction novel by the French writer Stefan

Wul, *Oms en Série* (generally known as *Fantastic Planet* in English). The film tells the story of a futuristic society of large creatures, known as Draags, who keep humans, known as Oms, as domesticated playthings, and widely exterminate any wild ones as pests. The dystopian story includes adult-oriented topics related to humanity, spirituality, and sexuality, as well as genocide; the film's imagery and movement are relatively sparse, creating a dreamlike space. In the US, the film was

15.11 George Dunning, *Yellow Submarine*, 1968

15.12 Roland Topor and René Laloux, *Fantastic Planet*, 1973

distributed by Roger Corman, who became well known for catering to the youth market. The animation, which employs unjointed paper cutouts, was carried out in Prague, at the Jiří Trnka studio (see p. 167).

The Polish poster designers Jan Lenica (1928–2001) and Walerian "Boro" Borowczyk (1923–2006) worked together for a number of years, resulting in collaborations on several short, animated films. One of them, *Byl Sobie Raz* (*Once upon a Time*), from 1957, is made with childlike drawings, animated cutouts, and live-action imagery; the film engages the viewer in constructing a narrative out of these varied abstract and representational forms, only to pull back on the scene at the end to reveal the constructed nature of all the parts. In 1967, after they had gone their separate ways, Boro completed production of his first feature, *Théâtre de Monsieur & Madame Kabal* (*The Theater of Mr. and Mrs. Kabal*) (15.13), which would be his last animated production; it stars two line-drawn characters from a short film, *Le Concert de Monsieur et Madame Kabal* (*Mr. and Mrs. Kabal's Concert*), which he had released a few years before, in 1962.

15.13 Walerian "Boro" Borowczyk, *The Theater of Mr. and Mrs. Kabal*, 1967

The film's Modernist aesthetic is apparent from the beginning, as Madame Kabal is drawn on the screen and throws off a series of heads until the correct one is found. She then has an encounter with the director, as he walks onto the screen and introduces himself. Emitting a series of electronic-sounding tones, the woman addresses Boro, while on-screen type in the middle of the frame translates her words into English, French, and German. After he is hit on the head, Boro transforms into an animated character, Monsieur Kabal, and the film progresses with the animated couple engaging in a nonsensical dance number. The rest of the plot progresses in a stream-of-consciousness style, led by the couple as well as some butterflies and small creatures. The action is sometimes punctuated with live-action images of beautiful ladies and a strange man, though animals, a speeding train, and the detonation of an atom bomb are among the others. When the story takes the man into a cinema, we see disturbing images of a large human eye and internal body parts. The sound is minimal and often incongruous with the action, being applied in a self-conscious way. In this film, Boro acknowledges the constructed nature of the cinema experience.

The groundbreaking British television series "Monty Python's Flying Circus" also showcased innovative creator-driven animation (15.14). The mostly live-action show, which was in production from 1969 to 1974, includes short animated segments by Terry Gilliam (1940–), who was originally from the US but became a naturalized British citizen in the 1960s. In surreal, frequently violent scenarios, Gilliam animated cutout stop-motion figures that at times reference the world of fine art. Gilliam was influenced by Boro's work—sharing his fellow animator's love for the bizarre and obtuse—as well as by the broadly satirical magazine *MAD*, a range that suggests just how eclectic popular culture had become by this time.

Ralph Bakshi's Renegade Animation

The films of the director Ralph Bakshi (1938–) are perhaps most emblematic of efforts to interest the youth market in animated features, effectively reaching these viewers by being provocative in both content and form. Bakshi drew audiences to his animated features partly through controversy,

15.14 Eggs Diamond from "Monty Python's Flying Circus" (1969–74), series 2, episode 8, *Archaeology Today*

with complicated depictions of racial issues, gender, sexuality, and violence. Though there were plenty of negative reviews of his films, he gained many steadfast fans, who were drawn to his bold storytelling and not put off by his economical production methods, which included the use of bare-bones rotoscoping, found footage, and other cost-saving techniques.

Bakshi was born in Israel but his family emigrated to New York shortly thereafter, in the late 1930s. As a teenager, his animation career began at Terrytoons, where he worked his way up through the ranks and began directing "Heckle and Jeckle," "Mighty Mouse," and "Deputy Dawg" shorts, eventually becoming the studio's creative director. In 1967 he accepted a position as director of Paramount Cartoon Studios, which had been Famous Studios and formerly the Fleischers' operation; however, the studio closed within a few months. After later opening his own studio, Bakshi Productions, he worked on commercials and some television series, including the second and third seasons of "Spider-Man" (1967–70) for the ABC television network.

Bakshi's first feature, *Fritz the Cat*, made at his own studio and released in 1972 (**15.15**), was an adaptation of R. Crumb's "Fritz the Cat" comix. The film opens with a tomcat named Fritz and some friends playing music in the park in order to attract girls. In the following scene, Fritz lures the girls to a drug-filled orgy, where he has sex with three of them simultaneously—enough

15.15 Ralph Bakshi, *Fritz the Cat*, 1972

15.16 Ralph Bakshi, *The Lord of the Rings*, 1978

to earn the film its X rating, meaning that no one under the age of eighteen would be admitted to a theater screening the film. Scenes of violence surrounding a race riot also make an impact. This film's character design closely follows that of Crumb's comix, but later the underground cartoonist would criticize Bakshi's film, saying that his wife—not he—had signed over the rights. Crumb was so unhappy with the film version of Fritz that he actually killed the character in his comix. Nonetheless, the film was wildly popular, to the extent that a sequel, *The Nine Lives of Fritz the Cat* (dir. Robert Taylor, 1974), was released two years later. Unlike its predecessor, however, it was not popular.

Incidentally, there were in fact earlier precedents for sexually-oriented animation. Perhaps the first was *Eveready Harton in Buried Treasure* (1929), which was probably made in New York during the late 1920s by artists from Fleischer, Paul Terry, and other studios, though the film's exact origins are not known. It tells the story of a man with a huge penis who witnesses creatures all around him having sex and goes out to find some of his own. As a pornographic film, it would not have been shown in normal theaters; it was probably limited to private screenings by someone with access to the print.

Just a few days before *Fritz the Cat*'s opening in New York, *Kureopatora* (*Cleopatra*), a 1970 film by Osamu Tezuka and Eiichi Yamamoto, was released, with "Queen of Sex" added to its title. Its distributors themselves gave *Cleopatra: Queen of Sex* an X rating, without going through an official review, undoubtedly hoping to draw audiences anxiously waiting for Bakshi's film. It was the kind of marketing that Bakshi himself might have undertaken. Throughout his career, he attracted viewers by daring to bring bold images to the screen, finding that controversy could help at the box office. His film *Coonskin*, a live-action and animation combination film from 1975, depicts a number of African American animals that become part of a crime syndicate in New York. Playing off the "Blaxploitation" genre popular at the time, in which black characters were engaged in action-oriented narratives, it satirizes many stereotypes and traditional images; however, the film did not always play as comedy and was largely condemned, adding to Bakshi's reputation as a renegade. In 1977, he released his first fantasy film, *Wizards*: set in a post-apocalyptic society, it focuses on the battle between two brothers who are wizards—one representing magic and peacefulness and the other

technology and war. The film was considered a great success, since it cost a little over $1 million to produce but grossed about $9 million at the box office.

Bakshi had become familiar with the J. R. R. Tolkien story *The Lord of the Rings* at around the time it was published in 1954, but it was a number of years before he could secure the rights to the material, and his animated feature *The Lord of the Rings* was not finally released until 1978 (15.16). The film follows the story of various characters—including hobbits, elves, men, dwarfs, and wizards—in a location called Middle Earth. Produced on a very small budget, it earned back many times its cost and so was considered a great box-office success, and an encouragement for the production of other low-budget, independently produced films. Bakshi kept production costs low by filming live-action reference footage in Spain and having his artists rotoscope that footage very closely, with a minimum of creative intervention. The film also incorporated manipulated live-action footage and cel animation. Bakshi's varied production techniques enabled him to depict large battle scenes involving different groups of characters that were clearly differentiated through their design. He continued making independent features into the 1980s and beyond.

Conclusion

During the 1960s and 1970s, animated features began to target a newly identified segment of viewers, the youth market, including teenagers and young adults, and the landscape of animation production began to change as a result. Significantly, Disney went through transitions that diversified its creative base, so that production of its animated features occurred alongside developments in television programming and theme parks. At the same time, the company's dominance in animated features was challenged not only by the death of its head, Walt Disney, but also by the increasing number of productions appearing both domestically and across the world—works that attracted the youth market more effectively than Disney's family-oriented fare.

In the background, another form of animation was developing, one that would become a major component of the animation world: electronic games, which emerged first from research facilities and then from a host of companies, both large and small, wanting to capture some element of a new, lucrative market. Electronic games have largely been geared toward teens and young adults, who have had the disposable income, time, and inclination to play them in arcades, on home consoles, and eventually online. The growth of games during the 1980s continued in subsequent decades, ushering in many developments in visual effects as well as questions related to representation, violence, and sexuality.

Notes

1 n. a., "Song of the South (1946)", *Turner Classic Movies* (n. d.). Online at http://www.tcm.com/tcmdb/title/90871/Song-of-the-South/notes.html

2 Bob Hieronimus, "Heinz Edelmann Interview Transcript, Art Director and Designer on 'The Beatles Yellow Submarine,'" *21st Century Radio* (October 28, 1993). Online at http://www.21stcenturyradio.com/NP-8-28-99.1.html

Key Terms

comix
distribution
feature
found footage
psychedelic
rotoscope process
satire

Following Stalin's death, Khrushchev's reforms lead to a liberal period or "thaw" in the Soviet Union

1953–64

1956
The Pannonia Film Studio, specializing in animation, is founded in Hungary

1958
The first computer game, *Tennis for Two*, is created at the US-government-owned Brookhaven National Laboratory nuclear facility, New York

1960
A group of animators form the International Association of Animated Film, or ASIFA, at the inaugural Annecy International Animation Festival in France

1961
Great Troubles (Zinaida and Valentina Brumberg) reflects on Soviet life

1966
Walt Disney dies

1969
SIGGRAPH is founded (the first conference is held in 1974)

1970s
Increasing numbers of colleges offer animation programs; more experimental films and films by women are produced

Festivals of animated short films begin traveling through the US

Video games flourish in arcades all around the US

The blockbuster mentality in the US film industry shifts production toward big budgets, high profits, and franchising

1970s and 80s

1972
Ralph Baer releases the Magnavox Odyssey home-game system using cartridges in the US

1973
Atari creates *Pong*, and the game is played in bars, arcades, and other locations

1975
Faith Hubley completes her first solo film, *W.O.W.* (*Women of the World*)

1975
George Lucas founds Industrial Light & Magic

1976
Apple Computer Company is founded

1979
The Soviet film *Tale of Tales* (Yuri Norstein) is released and receives international critical acclaim

1980s
Home game systems become widespread

1981
Launch of MTV, which showcases animation in music videos, station IDs, and series

1982
Dimensions of Dialogue (Jan Švankmajer) released and banned in Czechoslovakia for subversive content

1982
Tron (Steven Lisberger) combines about fifteen minutes of CGI with traditional special effects

1983
Video-game crash in America aids the growth of the Japanese game industry

1983–84
Don Bluth's innovative arcade games *Dragon's Lair* and *Space Ace* are released, featuring high-quality images enabled by a laserdisc player

1984
The Quickdraw Animation Society (QAS) is founded in Calgary, Canada to support independent production

1984
Alexey Pajitnov creates *Tetris* in the Soviet Union

1984
Michael Eisner, Frank Wells, and Jeffrey Katzenberg are hired as Disney executives; they will lead the studio into a renaissance

1985
Gorbachev's policies of *glasnost* and *perestroika* encourage freedom of information and reduced censorship in the Soviet Union

w Contexts and Voices

■ Technological development ■ Development of the animated medium ■ Development of the film industry as a whole ■ Landmark animated film, television series, or game ■ Historical event

1986
Steve Jobs purchases the Graphics Group from George Lucas and names the new company Pixar

1988
The Czech feature *Alice* (Jan Švankmajer) is made with support from Channel 4

Who Framed Roger Rabbit (Robert Zemeckis) is released under Disney's Touchstone label, appealing to broad audiences

1989
"The Simpsons" debuts in primetime on the Fox Network

1989
Disney releases *The Little Mermaid* (Ron Clements and John Musker)

1989
Nintendo's hand-held Game Boy is introduced, expanding the demographic of game players

1989
Introduction of CAPS, a digital ink-and-paint system developed by Disney and Pixar, into feature animation

1990–93
Tim Berners-Lee's World Wide Web is developed, leading to the creation of the Internet

1991
Disney releases *Beauty and the Beast* (Gary Trousdale and Kirk Wise)

1991
Sonic the Hedgehog is released; it transforms Sega into a leading game company

1991
Dissolution of the Soviet Union

1992
The Cartoon Network is founded

1993
Tim Burton's *The Nightmare before Christmas* is one of the most influential stop-motion films of all time

1993
Weta Digital is formed in New Zealand

1994
Disney releases The Lion King (Allers and Minkoff)

1994
Beauty and the Beast is Disney's first Broadway theatrical production

1994
Jeffrey Katzenberg leaves Disney to co-found Dreamworks SKG with Steven Spielberg and David Geffen

1995
Pixar's *Toy Story* (John Lasseter), the first fully CGI animated feature, is released

1996
The Nintendo 64 console is released alongside the action-adventure platform game *Super Mario 64*, which employs 3D animation

1996
"Pokémon" franchise debuts on Game Boy

1997
"South Park" debuts on Comedy Central, pushing boundaries for content

2000
Disney initiates layoffs of artists in its 2D divisions

Dreamworks acquires Pacific Data Images to produce 3D CGI features

2001
The Tricky Women Festival is founded in Vienna, Austria

2006
Disney acquires the Pixar studio

2009
Avatar (James Cameron) showcases advances in motion capture

2013
Disney's *Frozen* (Lee and Buck) is the first animated feature to gross more than one billion dollars

The Emergence of Electronic Games

Chapter Outline

Global Storylines

Games have a long history, but in recent decades technological advances have diversified them, resulting in complex graphics, animated movement, and immersive game play

Many types of game exist, including puzzle games, platform games, action-adventure games, first-person shooter games, and educational games and simulations

Animated game development is open not only to big companies, but also to small-scale producers; modifications can even be made by individual game-players

Despite the technological progress that has been made, games can still be regressive in terms of their representations of gender, since gaming companies tend to prioritize appealing to male players as the latter represent the majority of their customers

Introduction

At the heart of games is the notion of play, a natural activity for humans that functions both as entertainment and education. Curiosity causes us to want to try new things, learning what should or should not be repeated depending on whether the results are positive or negative: we take risks and assess outcomes. When play is codified through a series of rules, a game is created. Traditionally, games have included relatively simple, inexpensive components, such as balls, sticks, game pieces, boards, cards, or dice, all of which could be accessed by just about anyone.

By contrast, the first animated games, which were developed in the mid-twentieth century, were housed on large **mainframe computers** that only universities, big business, and the government could afford. Yet they were created in response to the same urge for play. Most historical sources trace the first computer game to 1958, when it was made at the US-government-owned Brookhaven National Laboratory nuclear facility in New York. For an open-house event the company was staging, an employee, Willie Higginbotham, developed the game *Tennis for Two* using gigantic mainframe computers and a re-programmed oscilloscope. By that time, researchers at MIT had also begun developing games on their own mainframes. Their early research resulted in *Spacewar*, in which two players controlled spaceships and attempted to shoot each other down (16.1). The game was completed in early 1962.

These examples were created by scientists and engineers who were able to manipulate technology in playful ways for the enjoyment of their peers, but it did not take long for animated games—or what became known as video games—to find their way to the general public, initially through arcades that mainly housed

16.1 MIT, *Spacewar*, 1962

pinball machines and other entertainments. Nolan Bushnell and Ted Dabney created what is considered to be the first arcade video game, *Computer Space*, based on MIT's *Spacewar*. They completed it in 1971, while working at an arcade game company, Nutting Associates, and it was not a big seller. Bushnell and Dabney left that company in 1972 to form their own business, which they named Atari. A year later, the company introduced *Pong*, in which two players bat an animated ball across the screen at each other, using a rectangular paddle that moves left and right (16.2). *Pong* was placed in bars, arcades, and other locations, helping to pave the way for the golden age of arcade games, which began in the mid-1970s.

By 1977, the nascent animated game industry was becoming sluggish, as people sought more variation and excitement. Manufacturers responded with a range of products that have since become icons of popular culture. Included were a number of shooting games, such as Taito's *Space Invaders*, released in 1978, and two from

16.2 Atari, *Pong*, 1973

16.3 Namco, *Pac-Man*, 1980

Atari: *Asteroids*, released in 1979, and *Missile Command*, released in 1980. Some of game history's most famous characters appeared at this time as well. For example, 1980 also saw the release of *Pac-Man*, an immensely popular and profitable arcade game developed by Tokyo-based Namco, in which a round character is guided through a maze, chased by enemies, and gains power from items on its path **(16.3)**. Nintendo's *Donkey Kong*, released in 1981, involves a large ape, a damsel in distress, and platforms that must be traversed by an early version of the now famous Mario character, then known as "Jump Man." The *Mario Bros.* arcade game followed in 1983 and quickly became a top-selling franchise. Shigeru Miyamoto (1952–) is the creator behind both these Nintendo classics, as well as many of the company's other titles. These early games are characterized by blocky graphics and blip sounds.

The popularity of arcade games drew the attention of a broad range of entrepreneurs, including the American Don Bluth, who thought the aesthetics of

"Disney-style" studio animation could be incorporated into game play. Consequently, his arcade games *Dragon's Lair* (1983) **(16.4)** and *Space Ace* (1984) were stylistically innovative; they used a **laserdisc player** in an arcade cabinet to allow interactive variations in the narrative, with high-quality animation **cut-scene** vignettes (see p. 282) inserted into game play. These developments fueled the growth of arcades, which fostered social interaction and competition among game-players.

At the same time, a shift toward personal game technology was taking place, and by the 1980s, home systems were widespread. In America, their development can be traced back to the mid-1960s, when Ralph Baer (1922–2014) began research that would earn him the title "father of the video game." His first console system, the Magnavox Odyssey, was released in 1972; employing graphics displayed on a television monitor,

16.4 Don Bluth, *Dragon's Lair*, 1983

16.5 Ralph Baer's Magnavox Odyssey console, 1972

it included **cartridges** for more than a dozen games, including table tennis, roulette, and hockey (16.5). The growing popularity of arcade games and home consoles created a lucrative industry that fueled production, much of it in Japan, which along with the US was a leading manufacturer of these products at the time.

By 1983, so many game producers had joined the field that the market became over-extended and a crash occurred; this mainly affected America, where numerous manufacturers had brought out their own type of console, each using a different technology. Games were appearing in large numbers, but often at the expense of quality, leading the public to grow weary. One of the most infamous examples was in the marketing of the adventure game *E.T. The Extra-Terrestrial* (1982), designed by Howard Scott Warshaw for the Atari 2600 console. Banking on the success of the Steven Spielberg film of the same name, also released in 1982, the game had been rushed to market. Fans were disappointed by the poor quality of its images, plot, and game play, and returned the product, resulting in a huge loss of revenue for Atari. This event seems to have initiated a ripple effect in the over-extended US industry, resulting in what is now known as the "video-game crash of 1983."

Before long though, animated games were back with renewed force. In fact, Japan had not been as badly affected as America, and as a result it began to dominate world production of animated games. In 1983, while American firms were suffering, the Japanese company Nintendo launched its industry-changing Nintendo Entertainment System (NES) in Japan. Two years later, in 1985, the NES was introduced in North America,

helping to jump-start the American game industry after two somewhat bleak years. Meanwhile, Nintendo became one of the most powerful game companies worldwide.

Nintendo's introduction of the small, hand-held Game Boy in 1989 further boosted the field, as it appealed to a wide range of players—including females and users of all ages—and it offered a range of games in the form of interchangeable cartridges (16.6). One of the highlights of Game Boy's history came in 1996, when Nintendo launched one of the most profitable franchises in game history: "Pokémon," created by Satoshi Tajiri (1965–) for Game Freak. The series focuses on creatures

16.6 Nintendo Entertainment System (NES), 1983

known as Pokémon that are collected and trained to fight each other. There are many different kinds of Pokémon, depending on the generation of the game and the platforms they appear in. The words of the series theme tune, "Gotta catch 'em all," motivated game-players to buy more and more products, in an artful merchandizing concept. The highly successful franchise also includes manga and animated television series, as well as feature films.

From these varied beginnings, the animated-game industry has grown into a vast enterprise. Its history is now so multifaceted that it is difficult to distill even a very concise account of animated games into one chapter of a book. The general overview provided here first focuses on the role of technology and then looks at varied genres, including examples of some significant works and creators, as well as controversies in the field. Because animated games are interactive, they have varied trajectories and outcomes, or **branching narratives**, guided by the rules of game play and subject to player decisions, rather than a set plot that can be easily described. Their aesthetics also vary within a given title, in terms of design elements and movement, for example, because they are electronic and therefore affected by the changes in technology that drive each new generation of game production. The game industry certainly overlaps with that of animated TV and film production, but its technological orientation and interactivity also set it apart.

16.7 Sega Genesis, 1989

The Impact of Technology on Games

The popularity of animated games has been tightly allied with advances in technology, in the form of processing power and related visual and audio capabilities, screen resolution, **peripheral devices**, and more. Nonetheless, games in every era of technological development have created fun experiences and they often continue to

appeal to players long after their technologies have been abandoned by the industry; for example, today some game-players are nostalgic for the relatively rudimentary "8-bit" games of the NES and other systems that were popular from around 1983, despite the small size of their moving 2D characters and objects (known as **sprites**), the **pixels** appearing in blocky visuals, unrefined movement, and limitations in color and sound.

Nostalgia aside, there is no denying that technological change—especially as it relates to console development—has fueled the industry. For example, in North America, when the 16-bit Sega Genesis came out in 1989 it challenged the NES with the promise of arcade-quality game play (16.7). Nintendo countered with its 16-bit Super Nintendo Entertainment System in 1991, giving rise to escalating competition between the two. By the mid-1990s, these systems had been bypassed by 32-bit systems, such as the Sony Playstation, which was released in 1994.

Only two years later, consumers were being lured by 64-bit systems, such as the Nintendo 64, launched in 1996, and more complex game scenarios. One of the highlights of this release is Nintendo's action-adventure **platform game** *Super Mario 64*, which employs 3D animation (16.8). In the game, Mario is able to move freely through the landscape from foreground to background, which adds excitement to his stunts, such as the leaps he makes and the many ways in which the character can dramatically die. Every new generation

16.9 Nintendo Entertainment System "Zapper," mid-1980s

16.8 Nintendo, *Super Mario 64*, 1996

of home-game console increased the amount of data that could be processed at any given moment, which in turn extended the visual and audio possibilities. Other opportunities came about with the growth of home computers and the World Wide Web, which was flourishing by the early 2000s.

Game technology can also be discussed in terms of peripheral devices, which contribute to a more immersive experience, allowing the player to feel as if he or she is within the game world. Some early text-based games—especially in the adventure genre—included props known as "**feelies**," or game pieces. For example, a button, glasses, and some print materials accompanied Infocom's *The Hitchhiker's Guide to the Galaxy* (1984), designed by Douglas Adams and Steve Meretzky. In text-based games, the player types in directions and is met by a written response generated by the game, and in this context feelies provide otherwise absent visual components. They served another purpose as well: early in their history, electronic games were distributed on **floppy disks** and so were easily reproducible, and these objects helped assure the player assure that he or she had purchased a legitimate copy.

Controllers are peripheral devices, in many shapes and sizes, used within game play to direct a character's movement, aim a weapon, record dance movements, and more. In the mid-1980s, the Nintendo Entertainment System began to sell the "Zapper," a gun-shaped controller that could be used to shoot objects on a television display **(16.9)**. The popular game *Dance Dance Revolution*, first released by Konami in 1999, uses a floor-pad controller that records dance steps, while *Guitar Hero*, first released by RedOctane in 2005, employs a guitar-like controller, containing buttons that activate sounds. In 2006, the Nintendo Wii brought added excitement to game play, as it enabled the measurement of motion in three dimensions, using its Wii Remote controller; its first release title, *Wii Sports* (2006), allows players to engage in tennis, baseball, golf, boxing, and bowling, and became one of the bestselling titles in game history.

Virtual reality holds great promise in the development of immersive game play, as it makes a player feel as if he or she is literally within a given environment. For many years VR has been out of reach for most consumers, owing to its high cost, but

16.10 Oculus VR Rift headset, 2012

more accessible devices are on the horizon. Oculus VR, a company founded by Palmer Luckey, initially put its Rift headset **(16.10)** into development in 2012 through crowd-sourced funding, promising to bring added three-dimensionality in a form that was inexpensive enough for game-players to afford. In 2014, Facebook purchased the company for more than a billion dollars in stock, cash, and future developments—an example that demonstrates just how lucrative this industry can be.

Types of Game

The scope of animated game production is vast, with games falling into many different types, which often overlap: they include puzzle, platform, role-playing and adventure, simulations and education, **open world**, and first-person shooter. Within these genres, game play may be configured differently, as "**emergent**," reacting to the exploratory path taken by the game-player, or "**progressive**," proceeding in a predefined, linear way from start to finish. In some games, players can design characters as **avatars**, which allow them to assume any identity and constitute another aspect of creative play within a game. Such avatars may interact with characters beyond the player's control: non-player characters (NPCs) built into a story by its designer or, in the case of a multi-player game, an avatar controlled by someone else.

Story elements, too, may be developed in a range of ways. Animated games are interactive, and generally include branching narratives or a multitude of paths that allow players to go in various directions. Some players want to interact with their surroundings, while others may engage in a "speed run," moving as quickly as possible from start to finish. The interactive portion of a game's story may be supplemented with stand-alone animated sequences known as "cut scenes," which are generally presented as a reward for reaching a certain point in the game. Some players find them frustrating, however, as they cause a break in the action and constitute passive exposition rather than active game play. Some games lack stories altogether, and instead offer the satisfaction of solving a puzzle, winning a battle, or perhaps just experiencing an environment.

Puzzle Games

There are many types of puzzle game involving pattern recognition, sequence solving, word completion, or other types of logical thinking. Some of the most widely popular, such as the tile-matching game *Tetris*, enthrall players with a relatively simple, repetitive task that is easy to do at first but becomes increasingly challenging. In this game, differently shaped tiles drop from top to bottom of the screen at an increasingly rapid pace, as the player attempts to rotate each piece in an effort to fit them together **(16.11)**. Alexey Pajitnov (1956–) created *Tetris* in 1984 while he was working for the Computing Center of the Soviet Academy of Sciences, a government-founded research and development center, and it quickly spread to an emerging group of computer users throughout Moscow. Pajitnov did not initially profit from his work, as there was no copyright in the USSR and his work was essentially owned by the state, which freely distributed it. Soon Tetris became international: a version of it was among the games distributed with the first Game Boy system in 1989.

The challenge of many games—the fun—is in discovering hidden rules that govern what can happen, in what order, and how things work; these rules represent the game's "mechanics," or the framework

16.11 *Tetris*, developed by Alexey Pajitnov at the Computing Center of the Soviet Academy of Sciences, 1984

Platform Games

Donkey Kong, Mario Bros., and *Sonic the Hedgehog*: these are some of the great platform games that have carved a niche in animation history (16.12; 16.13, see p. 284). In a platform game, the player guides an avatar over obstacles on the playing field in **progressive game play** that usually features multiple levels, moving from start to finish in a direct way. These characters at first displayed relatively simple mechanics, basically limited to jumping from place to place, but their abilities grew with advances in technology. The Mario character, which first appeared in arcade games in the early 1980s, had gained a great deal of mobility by the time *Super Mario 64* was released in 1996, enabling long-jumping, crouching, somersaulting, punching, and kicking.

Sega's platform game *Sonic the Hedgehog*, created by Yuji Naka, was first released in 1991. In the game, Sonic, who is an anthropomorphic blue hedgehog, enlists the help of friends to defeat Doctor Eggman, an evil character bent on world domination. Sega's origins are in Honolulu, Hawaii, in a company named Service Games, founded by Raymond Lemaire and Richard Steward in 1940. In 1951, it relocated to Tokyo, where it specialized in jukeboxes, arcade games, and slot machines, many of which were sent to American military bases in Japan. After a merger in the mid-1960s, the company was renamed Sega, using letters from

for game play. Adventure games, for instance, often insert puzzles along a path taken by the player in pursuit of a certain goal. This is the case in *Myst*: designed by Robyn and Rand Miller, developed at Cyan, and published by Brøderbund, it was first released in 1993. This game's player traverses a landscape from a first-person point of view, with the aid of special books, clicking on various elements to interact with them and solving puzzles as he or she moves through different ages in time. *Myst* was one of the first games to be released on CD-ROM, rather than floppy disk, and its success aided the development of the then-new technology.

Even as technology has advanced, the concepts found in such "casual games" as *Bejeweled* have continued to attract a great number of players. *Bejeweled*, first released by the San Francisco-based PopCap Games in 2000, is a good example of a casual game because of its relatively simple parameters, its appeal to a wide public, and its short playing time. This casual game uses the "match three" puzzle formula, which requires the player to align at least three images in the same color in order to gain points. *Bejeweled* grew in popularity after it was included as a game on mobile phones, and by 2004 its success had fueled the growth of PopCap—originally a small startup, founded by Jason Kapalka, Brian Fiete, and John Vechey—into a hugely successful business that was eventually purchased by Electronic Arts for more than a billion dollars.

16.12 Nintendo, *Super Mario Bros.*, 1985

16.13 Nintendo, *Donkey Kong*, released in 1981

the company's former name: SE-rvice GA-mes. After it entered the home-console market in the 1980s, Sega became an animated game superpower, with Nintendo as its main competitor. The initial release of *Sonic the Hedgehog* in 1991 was part of a campaign to promote the company's 16-bit home-video game console, the Sega Genesis (known as the Sega Mega Drive outside North America). *Sonic the Hedgehog* was envisioned as Sega's equivalent to Nintendo's "Mario Bros." franchise, and it proved to be a worthy competitor, selling millions of units in its various game entities. Throughout the years and its escalating success, Sega has remained close to its roots, retaining its involvement with arcade games. In Japan, where "game centers" are popular, Sega maintains a six-story complex called GiGO, located in Tokyo.

Role-Playing and Adventure Games

Central to animated game culture is the vast genre of role-playing games (RPG), in which a player takes on the persona(s) of one or more characters. One of the best known RPGs is *Dungeons & Dragons* (*D&D*), which first appeared in the mid-1970s as a tabletop (sometimes called "pen-and-paper") game designed by Gary Gygax and Dave Arneson **(16.14)**. A player of this game takes on a particular character's role to

join with a group of other players in an adventure featuring battles in fantasy settings, the development of knowledge, earning points, and the collection of various items. In 1987, the first license to use *D&D*'s rules and settings in a video game was awarded to Strategic Simulations, Inc. (SSI), a northern California-based company established in 1979 and specializing in war games. The franchise eventually expanded to other companies as well, and today it remains one of the most widely played role-playing games.

Before *Dungeons & Dragons* appeared in its animated forms, such games as *Wizardry* and *Ultima* used similar scenarios and had a strong influence on the role-playing genre's development. The *Wizardry* franchise began in 1981, when *Wizardry: Proving Ground of the Mad Overlord* was released by Sir-Tech Software. This challenging game was written by Andrew Greenberg and Robert Woodhead, and is considered a pioneering effort in the realm of computer RPGs. Although its graphics look simple by today's standards, compared to the games of the time they were relatively advanced: the screen is mainly occupied by text, but there is also a small window for images in a first-person viewpoint, and the use of perspective creates the look of three-dimensionality—plus it offered color imagery. The characters in the

game include humans and a range of fantasy figures that can be controlled, including an elf, a dwarf, a hobbit, and a gnome. In search of a powerful amulet, these characters carry weapons to fend off attacking monsters, and acquire treasures and various objects that help them advance; this type of game play, taking place in a labyrinth, is known as a "dungeon crawl."

Ultima is a series of fantasy role-playing games created by Richard Garriott, who is known to his fans by the name of a character in the series, Lord British. The first game in the series, *Ultima 1: The First Age of Darkness*, was released by the California Pacific Computer Company in 1981. In this game, a character known as the "Stranger" (later as "Avatar") is called on to go back in time to change history, in order to defeat an evil wizard. In contrast to the initial *Wizardry* game, which takes place in one multi-level dungeon, *Ultima* has an open-world structure, which includes several locations and various ways to travel through them, though the game play itself consists largely of hacking and slashing at opponents. Since this early version, the *Ultima* concept has been franchised into several games within the main series, as well as spin-offs. After making his fortune in the gaming industry, Garriott became part of the emerging business of space tourism, as one of the first people to travel to the International Space Station; he flew there in 2008 as a privately funded traveler, following in the footsteps of his father, who was an astronaut.

The mid-1980s also saw the introduction of other popular RPG-related games that would turn into substantial franchises, including the series "Legend of Zelda", designed by Shigeru Miyamoto and Takashi Tezuka and first published by Nintendo in 1986, and "Final Fantasy," created by Hironobu Sakaguchi and published in Japan by Square (now Square Enix) in 1987. In "Legend of Zelda," the player guides a boy named Link though a fantasyland called Hyrule, where he solves puzzles and fights off enemies, typically in an effort to save the princess Zelda. The series built a foundation for the action-adventure genre, featuring an open world the player can traverse and non-linear game play, so that tasks can be completed in any order. The "Final Fantasy" franchise consists mostly of stand-alone stories involving dramatic battles against supernatural forces. As the series progressed, it provided an even greater adrenaline rush with the introduction of real-time battle action in *Final Fantasy II* (1991), also directed by Sakaguchi, as enemies continued to attack while the player selected his or her tactics.

During the 1980s, video games developed alongside the rapid growth of blockbuster visual-effects films in Hollywood, many of them in the adventure genre. Master of the realm George Lucas made his name with the "Star Wars" and "Indiana Jones" franchises at his studio, Lucasfilm, and he later created his own effects company, Industrial Light & Magic. In 1982, he established a game division as well, originally called Lucasfilm Games and renamed LucasArts. Research and development into scripting languages and other advances made this studio one of the leading producers of adventure games in America, starting with the release of *Labyrinth* in 1986, which was based on the Lucasfilm movie of the same name released that

16.14 *Dungeons & Dragons* players participating in the tabletop game during the 40th annual Gen Con game convention, 2007

16.15 Nintendo Game Cube, *The Legend of Zelda: The Wind Waker*, 2002

year, directed by Jim Henson. Other highlights of the studio's production include *The Secret of Monkey Island* (1990), designed by Ron Gilbert, a puzzle game about a character who wants to be a pirate, set on a tropical island. The studio's *Dark Fandango* (1998), directed by Tim Schafer, is also a puzzle game, but this time set in the Land of the Dead and incorporating dark comedy. Among LucasArts' other offerings are games based on the "Star Wars" and "Indiana Jones" franchises. LucasArts closed in 2013 after its parent company, Lucasfilm, was sold to Disney in 2012.

Usually, it is in the best interest of franchise owners to offer ongoing technological and aesthetic advances to fans, who will continue to buy new products in their favorite series. Changes are not always welcomed by the game community, however. For instance, a controversy arose when *The Legend of Zelda: The Wind Waker* was released in 2002 for the Nintendo GameCube, because its graphics were created using cel-shading, a lighting and texturing technique that gave the game's environment and its characters a cartoon-like appearance **(16.15)**, as opposed to the relatively realistic look of previous games in the franchise. Likewise, the majority of "Final Fantasy" players were disappointed with the spin-off theatrical feature *Final Fantasy: The Spirits Within* (2001), written and directed by Sakaguchi for Square Pictures. The film had been touted as a great advance for its use of motion-capture technology to create highly realistic characters, but it fell short in terms of its story.

Big-budget video games played a significant role in furthering the development of effects in the larger motion-picture industry, especially in developing motion-capture technology to heighten the realism of stunts featured in action-related genres. Motion capture bases the form and movement of animated characters on the recorded motions of live subjects, in processes that can be seen as an extension of

nineteenth-century motion studies (see p. 21) and rotoscoping, patented by Max Fleischer in the 1910s (see p. 46). It involves the measurement of an actor's position and orientation in physical space and the transmission of that data to a computer, where it is transformed into moving characters through the skills of animators who manipulate the data. Early methods required actors to wear a bulky outfit attached to an intricate system of wires, but as systems became more sophisticated, they could wear flexible suits and wireless markers, allowing for easier movement. Motion-capture technology continues to develop, becoming ever more sensitive to movement, even that of the face and hands, which had been hard to track in its early years.

Simulations and Education

Part of the power of animated games is their ability to immerse players deeply in an experience, whether it be intense swordplay with an opponent, a walk through a multiplayer community, or an attempt to solve a puzzle. It is therefore not surprising that the same technology has been harnessed for educational purposes, to pull participants into learning activities taking place anywhere from a child's classroom to the top ranks of the military. For example, the US government has been using some form of flight simulator to train its pilots since the 1930s, and it turned to digital simulations as soon as they became available. One of the leading companies in this area, the Evans & Sutherland Computer Corporation, was founded in 1968; at the time, it was headed by its founders, David Evans and Ivan Sutherland, both of whom were teaching computer science at the University of Utah. The company's products have included air, sea, and land simulation systems for the military, preparing users for missions in potentially dangerous scenarios, as well as for industrial

applications. Eventually, simulation technologies moved into the consumer market, allowing players to have the experience of a racecar driver or pilot, to participate in skiing or other sports, or to play in a tournament of poker or another game. One of these simulations, *Gran Turismo* (GT), depicts real-world high-performance cars in racing scenarios, with great care given to the physics of such a driving experience; it was developed by Polyphony Digital for PlayStation systems.

By the early 1980s, a new market had opened up for educational titles that could be integrated into school curricula. One of the first and most successful, *The Oregon Trail* (16.16), was initially developed in 1971 by Don Rawitsch, a senior at Carleton College in Northfield, Minnesota. This game takes players on a trek by covered wagon from Independence, Missouri to the Willamette Valley, Oregon in 1848; along the way, the player must hunt for food and prevent members of the travel party dying from injury or disease. Rawitsch created the program on a small scale for his job as a student teacher in an eighth-grade history class, working with two friends and fellow student teachers, Paul Dillenberger and Bill Heinemann. Three years later, in 1974, Rawitsch was hired by the Minnesota Educational Computing Consortium (MECC), a state-funded organization. At that time, he expanded the software and uploaded it into the MECC network, so that other schools in Minnesota could access it. By the 1980s, the game was being used by an even wider array of schools.

The popular educational game *Where in the World Is Carmen Sandiego?* (16.17) was first released in 1985, to teach geography. In the game, players try to capture a thief, Carmen Sandiego, along with her associates, as they flee to different parts of the world. Later versions include other subjects, such as English and math. The title, which grew into a large franchise of related products, was distributed by Brøderbund Software. Brøderbund was also known for such

16.16 Don Rawitsch at Carleton College, *The Oregon Trail*, 1971

series as "SimCity," a city-building game developed by Will Wright and first released in 1989, and "Myst." Eventually, both MECC and Brøderbund were merged into another big name in educational software, the Learning Company, which was formed in 1980 by the educators Ann McCormick, Leslie Grimm, and Teri Perl, along with Warren Robinett from Atari.

As technology progressed, interactive media have been implemented in far-ranging educational contexts. Virtual reality now allows engineers to create prototypes of cars and other complex machines, while individuals

16.17 Brøderbund Software, *Where in the World Is Carmen Sandiego?*, 1999

in medicine and the sciences can use technology to simulate views inside living things. For example, in about 2010 the California-based "e-learning" company Emantras, Inc. first released inexpensive frog- and rat-dissection applications to be used in classrooms as humane alternatives to dissecting live creatures.

Open World

Games with an open-world structure, sometimes called "sandbox games," are set in an expansive universe, rather than having levels that need to be moved through. These games feature **emergent game play**, which develops based on the player's decisions rather than linear beginning-to-end progressive play. In open-world games there are relatively few artificial barriers to block the player, though a character may come into contact with NPCs or possibly avatars controlled by other players, and such entities can affect the game play. These games have become more complex as technology has progressed, allowing for more complex environments and types of action and often blending into the widely varied genre of action-adventure. The "Elder Scrolls" franchise provides one example. This series of action role-playing games was first developed by Bethesda Game Studios and published by Bethesda Softworks in 1994, with the initial title *The Elder Scrolls: Arena*. In the series, the player explores an immense and complicated world, gaining strength, acquiring treasure, embarking on adventures, and slaying dragons. It is played in the first-person perspective, and incorporates magic and many battles as the player explores dungeons, towns, and rural environments on a quest to find a number of important objects.

The "Grand Theft Auto" ("GTA") franchise, introduced in 1997, also falls into the genre of open-world games. "GTA" was primarily developed by Edinburgh-based DMA Design, founded in 1988 (later known as Rockstar North), and it was published by BMG Interactive (later Rockstar Games). *Grand Theft Auto III*, released in 2001, is the most influential game in the series. It begins with the player in the role of a small-time car thief who has the ability to move up the crime ladder in the larger-than-life, satirically exaggerated world of Liberty City. He does so by fulfilling various car-related achievements that are sometimes timed and could earn him the money he needs to move on to another city and another level of game play. One of the noteworthy elements of the game is the player's ability to participate in activities outside plot-motivated criminality—activities that include the random killing of people. The "GTA" franchise games have sparked controversy for their high levels of violence and concerns that they would inspire real-world crime.

A kinder, gentler open-world game, *The Sims*, was introduced in 2000. It is a life-simulation game created by Will Wright, developed by EA Maxis, and first published by Electronic Arts. It has no defined goals, so the user is free to build communities independently, using characters developed within the game. The popular open-world franchise "Minecraft" was first released in 2009 by its creator, the Swedish programmer Markus Persson at his company, Mojang. In the game, the player interacts with a wide range of environments, on land and employing water, and engages in construction using blocks. Time cycles between day and night, and the player encounters other beings, both hostile and friendly. Game play is made more versatile by the player having different modes of action and levels of difficulty that provide more or less protection from danger. In 2014, Mojang was sold to Microsoft for more than two billion dollars.

First-Person Shooter

In the early 1990s, the genre of "first-person shooter" (FPS) games came about: this type of game is portrayed through a first-person point of view and is closely aligned with the action-adventure genre, specifically in the incorporation of armed combat and weapons. The early forms of the genre can be traced to Id Software, which published the first-person shooter game *Wolfenstein 3D* (developed by Apogee Software) in 1992 as shareware, meaning that it was essentially free to the public.[1] The game involves the attempts of a World War II spy to escape from a Nazi prison, working through a variety of levels of progressive game play (16.18). It employs direct combat and a multiplayer mode, using imagery and sound that are fairly realistic, resulting in a relatively immersive experience.

Propelled by the success of *Wolfenstein 3D*, the following year, in 1993, Id Software released the first-person shooter *Doom*. Both titles were largely created by company co-founder and lead programmer John Carmack (1970–). In *Doom*, the player takes the role of an unnamed space marine who has to gun down

16.18 Apogee Software, *Wolfenstein 3D*, 1992

demons from Hell that go on a rampage and surround him, finding his way through treacherous environments. Millions of people played the game, and its popularity sparked the development of other FPS games. One of them appeared in 1998: *Half-Life*, the first game developed by Valve Corporation, a company founded in 1996 by former Microsoft employees Gabe Newell and Mike Harrington. In the game, the player takes on the role of a physicist, Dr. Gordon Freeman, fighting his way out of a secret underground research facility where experiments have gone awry. Woven into the narrative are puzzles that the player must solve in order to advance.

Added degrees of realism were incorporated into games by setting their action within real-world contexts, as technological developments allowed for more complexity in storytelling. First released in 2003, "Call of Duty" originally simulated warfare during World War II (16.19). Since then it has diversified into modern warfare contexts, becoming one of the most extensive FPS franchises. It was developed by Infinity Ward and first published by Activision.

Though games of this genre are typically associated with violence, some of them allow—or even encourage— "pacifist runs," in which non-violent game play is rewarded. Examples include the long-running "Metal Gear" series (created by Hideo Kojima and published by Konami), which was first released in 1987, and *Dishonored* (developed at Arkane Studios and published by Bethesda Softworks), which was released in 2012. In these games, the player can complete all missions without killing anyone.

The Online Game Community

Like-minded game-players once found opportunities to socialize at arcades, but as these businesses have waned, they are more likely to meet at a game convention, where

16.19 Activision, *Call of Duty: Advanced Warfare*, released 2014

they can see new products and meet people from the industry, or online, perhaps in a multiplayer game. Today, there are millions of online gamers, with particularly large numbers of players in South Korea and China; many of them are players of Massively Multiplayer Online Games, or MMOGs. For the gaming world, as well as other aspects of society, the World Wide Web has become a social hub and site for innovation.

The Internet became widely used by Americans in the late 1990s, but its history begins decades earlier, in infrastructure provided by the Advanced Research Projects Agency Network (ARPANET), an American government initiative with the primary goal of linking various databases across the country, in order to maintain operations in case of a Cold War catastrophe. This text-only network became functional in 1969, allowing its users to connect with one another. Multiplayer online games can be traced back to 1978; that year, a student at the University of Essex in the UK, Roy Trubshaw, created a text-based game site where his fellow students could type in their locations and actions while participating in a Multi-User Dungeon (MUD) role-playing game. When Trubshaw's school linked to the ARPANET in 1980, players from around the world were able to join in.

A major expansion of the Internet occurred with the invention of the World Wide Web by the software engineer Tim Berners-Lee, who was working at CERN, a large particle-physics laboratory near Geneva, Switzerland. The Web—in its basic form—became a reality in 1990, after Berners-Lee put all the parts in place: he wrote a browser and set up a server to hold the web pages he created. By 1993, graphical browsers allowed the viewing of images, and by the late 1990s many people and businesses were developing their own websites.

During this time, the concept of multiplayer gaming was still in its early stages, with such FPS titles as *Quake III Arena* and *Unreal Tournament* appearing in 1999. The "Quake" franchise, owned by Id Software, was started in 1996, at first offering single-player and multiplayer modes. *Unreal* appeared in 1998, as the first title in the franchise developed by Epic MegaGames and Digital Extremes, and published by GT Interactive; it included enhanced graphics and the use of a scripting language that allowed players to develop modifications to game play. Several years later, the acclaimed FPS *Halo* came out in multiplayer mode

as well. It had been developed by Bungie before the company was acquired by Microsoft in 2000 and used as the launch title for the Xbox in 2001. In 2004, *Halo 2* was released with an online multiplayer service via Xbox Live, allowing players to fight against an alien alliance known as the Covenant in a distant-future setting.

Freedom of Expression

Game culture is like any other, with various sub-groups and differing interests. Socially, there are divisions between so-called hardcore gamers and casual game users, determined through such criteria as the type of games played, the mastery achieved in them, and knowledge of specialized vocabulary that has developed over time. Every society has its disruptive fringe elements, and in online communities they are known as "griefers." These players spread hateful speech, destroy property, or do other harm to fellow players and their property. Moderators may interact with these individuals, but they sometimes contend that their behavior falls under the purview of free speech.

Freedom of speech is of concern to the game industry as a whole, insofar as it is frequently condemned for purveying content that is violent or in other ways offensive. In the United States, games were given the protection of free speech in 2011, in the Supreme Court case *Brown v. Entertainment Merchants Association*, but they are still subject to evaluation. In America, the Entertainment Software Rating Board (ESRB) provides information about the content of video games to consumers. This non-profit self-regulatory body was established in 1994 by the Entertainment Software Association. Other countries across the world have reacted to video games in a wide range of ways, from banning seemingly offensive titles to allowing distribution under a ratings system.

Video-game violence is generally analyzed within a framework that questions how it desensitizes the viewer, or how it leads to aggressive thoughts and violent acts. But violence can be investigated from a number of perspectives, such as the context in which it is carried out and its purpose, including any consequences, rewards, or necessity. It is also important to consider historical context: for example, how shifts in technology can cause displays of violence to lose their impact, appearing cartoonish with the passage of time and changes in game aesthetics.

Creating and Modifying Games

Game creators fall into roughly three categories: those affiliated with large companies, independent producers, and the players themselves. In the early years of animation history, films tended to be promoted by the names of studios, rather than directors. The same has generally been true of animated games, where creators were for a long time absent from credits. One famous rebellion came from Joseph Warren Robinett (1951–) (later co-founder of the Learning Company), who worked on the design for Atari's *Adventure*, which was released in 1979. He placed a hidden message, or "Easter egg," into the artwork, revealing the words "created by Warren Robinett" (16.20). Game creators have faced other labor-related problems as well. Beginning in the early 2000s, game companies began to rely on outsourcing production, letting go of their employees and instead relying on studios overseas that paid their workers less—much as the larger animation industry had been doing since the 1960s. Within the game world, this practice was fairly widespread by 2010.

The game industry is dominated by a number of recognizable franchises, but small-scale independent productions also have a significant presence. Historically, it has been difficult for small developers to distribute their titles, but entrepreneurs have found ways to promote their games. In the early 1990s, the distribution of shareware had allowed small studios to get their products to consumers, who would play a free version and determine for themselves whether to purchase additional titles in the series. Often these trials were downloaded from bulletin board systems (BBS), which were online meeting points in operation before the World Wide Web was fully developed. Shareware was also made available at computer conventions. Such practices helped to promote the work of fledgling studios that sometimes grew into significant game producers; for example, the now major company Id Software got its start this way. In recent years, independent producers have funded development through crowdfunding, in the form of Kickstarter campaigns, for example, in which members of the public are asked to donate money. "Indies" can sell their products through online app stores or via compilers, such as HumbleBundle.com, which puts together a selection of titles that are offered to consumers at whatever price they wish to pay, with a promise to send some of the money to a charity.

16.20 Warren Robinett's "Easter Egg," placed inside Atari's *Adventure*, 1979

New platforms have opened up new opportunities, as one can see from iOS, a mobile-operating system unveiled by Apple, Inc. in 2007 for use with its hardware, including the iPad and iPhone. Google's operating system, Android, was announced the same year and evolved significantly in the early 2010s, becoming widely used in mobile devices and attracting many new developers. Subsequently, millions of apps have come from creators of all sizes. One of the most successful to date is "Angry Birds," a game franchise created by the Finnish developer Rovio Entertainment and first released on the Apple site in 2009. The game is built on a very simple premise: the player must launch disgruntled birds, slingshot-like, at encampments of pigs. Within months, millions of copies had been sold and the product was adapted for other operating systems and platforms.

The line between player and creator is often blurred, now that industrious gamers have found ways to modify software and hardware, and even invent whole new productions out of existing games. These modifications, or "mods," can come in a variety of forms, such as unlocking region locks for other countries, creating unofficial patches to fix bugs, discovering hidden content or adding their own, and remaking assets for use on a different platform. The Id Software game *Doom*, released in 1993, was one of the first actively to support mods, encouraging players to take a role in developing game play. Minh Le and Jess Cliffe, fans of the "Half-Life" series, used it to create *Counter-Strike*, a competitive first-person shooter video game completed in 1999. The two were then hired by "Half-Life" developer, Valve, which acquired their game and released it the following year. In some cases,

16.21 Corey Arcangel, *Super Mario Clouds*, 2002

mods created by fans have outlasted the game itself. For instance, game-players furthered development of the incomplete, bug-ridden action-adventure *Vampire Bloodlines*, which had been developed for Activision and released in 2004 by the now defunct Troika Games. Yet another manifestation of game mods is found in the work of the artist Corey Arcangel, whose *Super Mario Clouds* (2002) (16.21) was made using a "Mario Bros." game cartridge. To create the piece, he erased everything on the cartridge but the clouds and sky. His other mods are applied to such games as "Tetris" and "Space Invaders."

A practice known as **machinima** has developed around the use of **game engines** to create new works within real-time animated game environments. For example, the FPS *Halo* provides the basis of the machinima series "Red vs. Blue," created by Burnie Burns at Rooster Teeth Productions and first released online in 2003 (16.22). The science-fiction comedy involves soldiers facing combat in a desolate stretch of land. It parodies the FPS and sci-fi genres as strange things happen to the characters, who talk to each other more often than they engage in fights. The machinima community is now large, and is supported by various institutions. In 2000, Machinima.com was founded by Hugh Hancock as a hub for this kind of work. It is now a massive undertaking, featuring scripted series, original content, weekly and daily shows, game-play videos and more, seen by millions of viewers monthly. An online event, the Machinima Expo (or "MachinExpo"), was launched in 2008 as an annual international machinima festival that includes a juried competition of productions.

The field of machinima has evolved in interesting ways as artists bring experimental attitudes to their productions and explore their individual voices using materials intended for mass consumption. A great example is Phil Solomon, whose *Untitled (for David Gatten)* (2005), made with Mark LaPore, and *Rehearsals*

16.22 Burnie Burns at Rooster Tooth Productions, "Red vs. Blue," 2003

16.23 Peggy Ahwesh, *She Puppet*, 2001

for Retirement (2007) were created from the game *Grand Theft Auto: San Andreas* (2004). These works refigure the action-oriented material into a place of introspection and atmospheric environments. A related example comes from Margaret "Peggy" Ahwesh (1954–). Her video of 2001, *She Puppet*, provides a critique of Lara Croft's female identity in the *Tomb Raider* video game (see p. 294), fitting into the artist's broader interest in gender issues and sexuality **(16.23)**. *She Puppet* employs scenes from game play that emphasize Croft's alienation, accompanied by individuals reading passages from three sources: Fernando Pessoa's *The Book of Disquiet* (1984), Joanna Russ's science-fiction story *The Female Man* (1975), and thoughts from the musician and philosopher Sun Ra.

Heroes and Damsels in Distress

In the mid-twentieth century, the American writer Joseph Campbell introduced his influential model of "The Hero's Journey," or "monomyth," a pattern found in stories worldwide. It features a male character who passes through a series of stages along his journey, facing tests and receiving rewards, and returning home transformed—having saved someone or something—ready to rejoin humanity. Certainly, the hero monomyth can be found in many game narratives; from their earliest days, animated games have prioritized a masculine point of view, and quests of that nature are a mainstay of the industry. Female characters, when they have appeared, typically have been passive objects to be saved by the hero, rather than active characters. Even after female avatars were increasingly being incorporated into games during the 1990s, the vast majority of titles continued to represent mainly male characters in active roles.[2] Game publishers develop their products based on the logic that an overwhelming majority of their players are boys and men. To capture the largest portion of that market, therefore, they create games that they believe favor a male point of view.

Even the seemingly innocuous game *Frogger*, designed by Konami and released as an arcade platform game in 1981, reflects this pattern. The player begins with a set of frogs that must jump around to avoid cars, natural obstacles, and enemies, such as snakes. The male gender of the characters becomes clear through the introduction of lady frogs, identified by being pink, which can be escorted to safety in order to earn points. In some versions of the game, there is even a specific "Lady Frog Rescue" mode. *Frogger* is just one example; other early arcade games, such as Don Bluth's *Donkey Kong* and *Dragon's Lair*, released in 1984, also feature the rescue of female characters.

Ms. Pac-Man, released as a coin-operated arcade game in 1981 by Midway Manufacturing, made one of the first gestures toward representing an active female character: it added a "Ms." to the front of the Pac-Man identifier, and its main character has a bow on her head and red lipstick. The ghosts that chase her were modified, too, as one of them is named Sue. This version of the game also brought added features to the original Pac-Man, making it popular among both male and female players. Also significant is the debut of Carmen Sandiego in 1985, the female criminal mastermind who takes players on a worldwide adventure in the educational game *Where in the World Is Carmen Sandiego?* (see p. 287). The following year, in 1986, the adventure game *Metroid* was developed around the athletic female character Samus Aram, a bounty hunter in space; it was created by a team at Nintendo and first released in 1986. One software company, Her Interactive (which started as a division of American Laser Games in the mid-1990s, but later became an independent company), has focused on games for female players and aims for a more realistic representation of women and girls. Its best-known titles feature the adventurous character Nancy Drew in mystery adventure games that were first released in 1999.

16.24 Lara Croft in *Tomb Raider*, developed by Core Design and released by Eidos Interactive in 1996

hostility and threats. The case of the "Feminist Frequency" blogger Anita Sarkeesian is well known. Sarkeesian launched a Kickstarter campaign in 2012 to finance a series of online videos called "Tropes vs. Women in Video Games," with the intention of calling out stereotypes related to women. As a result of her fundraising campaign, Sarkeesian was the subject of online harassment, including emailed images of her being raped by game characters and an online game inviting players to beat her up. Outspoken game developers Zoe Quinn and Brianna Wu have faced similar threats for advocating change in the game community. Beginning in 2014, a movement known as "Gamergate," which developed through online forums, became known for an intensive misogynistic harassment campaign, including hacking of the women's accounts and the release of personal information, and even death threats. As a result of this very public assault, much more attention is being paid to the issue of women in games; nonetheless, it has been hard to integrate game culture or protect victims, since perpetrators can operate somewhat anonymously online.[3]

The mid-1990s saw the introduction of a brave female action figure, the British archeologist Lara Croft, who appeared in *Tomb Raider*—a very successful title released in 1996 (16.24). This game and several of the first properties in its franchise were developed by Core Design and distributed by Eidos Interactive. But despite her bravery, a big part of the character's popularity could be attributed to her unrealistic, sexualized proportions, especially after someone developed a patch known as "Nude Raider" that caused Lara to appear naked. The puzzle game *Portal*, developed by Valve and released in 2007, is based on a female character named Chell, but because she does not speak and the game is from a first-person point of view, players may not necessarily identify her as a woman. In the game, Chell is led through a facility by a computer, GLaDOS, which is also female.

It can be very difficult for women to enter the culture of games or for players to find games that provide balanced views of male and female characters; and those who argue for such things may meet with

The Future of Animated Games

Over a period of many years, animated games have become entrenched in society, with each year bringing new products for consumers to buy. The game industry is driven in large measure by evolving technology that enables increasing sensitivity to player input and, especially, more complexity in design. But at the same time that the form moves forward, there has been a nostalgic looking back, as game-players relive the simpler pleasures of early games, with their blocky graphics and relatively restricted movement. Contemporary designers have at times embraced a retro aesthetic, coming up with modern games that have the look and feel of earlier ones. The website 8bit.com includes this kind of work, which can be played online.

Franchises dominate the animated game landscape, so it seems innovation in form and content may be a challenge; and yet—as in any art form or industry—independent voices arise from the margins, suggesting new directions. Some good examples come from Thatgamecompany, co-founded in 2006 by Kellee Santiago and Jenova Chen. As students at the

University of Southern California, the two had headed the production of a downloadable puzzle game, *Cloud*, which was released in 2005. The game captures the experience of a boy asleep in a hospital bed, imagining himself flying through clouds. The designers wanted to inspire an emotional investment different than the experience offered by most action-based games, and to measure how popular such a work would be. The studio, which was housed on campus, had been financed by Sony Computer Entertainment, under a contract to develop three downloadable games for its PlayStation Network service. These included *Flow* (2007), *Flower* (2009), and *Journey* (2012), all experiential games meant to create an emotional immersive context for the player. For example, in *Journey*, he or she moves along sand dunes, among natural landscapes and old ruins, accompanied by the sounds of wind and music, in a quest to climb to a mountaintop, gaining personal knowledge along the way. When the contract with Sony ended, Thatgamecompany sought other funding and became an independent studio.

Conclusion

The impact of games on the animation industry and society as a whole can be described as revolutionary, in respect to technological advances, scale, and earnings. By the 1990s, games represented a huge segment of the animation field, as a distinct industry joining animated television series, feature films, and visual effects, for example. Genres formed and franchises grew up around them, with fortunes made even by small companies that developed successful properties. The growing presence of animated games raised concerns, however, especially about growing realism in conjunction with violence, as well as the representation of women.

In America, the growth of animated games during the 1980s and 1990s reflected a consumerist lifestyle that was not shared by much of the world. Indeed, the period saw tumultuous changes in political leadership and lifestyles in many countries. These were facilitated in part by the growth of the Internet, which opened up lines of communication between formerly separated communities. One of the biggest changes came with the breakup of the Soviet Union, which occurred in the early 1990s. Artists in the Eastern Bloc had

a long history of animation practice, creating work that appealed to children and adults, supported by government funding. The potential power of animation had worried the Eastern European authorities, however, especially in the hands of artists who dared to create politically subversive work. Once political systems changed, Soviet artists were freed of the censor, but they faced another problem: how to finance their productions in a newly commercialized marketplace.

Notes

1 Did You Know Gaming, "Doom: Did You Know Gaming?" *YouTube* (June 28, 2014). Online at https://www.youtube.com/watch?v=MCPJGt3m_v8

2 Sheri Graner Ray, *Gender Inclusive Game Design: Expanding the Market* (Hingham, MA: Charles River Media, 2004).

3 Susan Kelleher, "'This Has Got to Change': Women Game Developers Fight Sexism in Industry," *Pacific Northwest* (August 13, 2015). Online at http://www.seattletimes.com/pacific-nw-magazine/game-on-women-are-developing-new-video-games-and-a-new-culture/

Key Terms

3D animation
avatar
branching narrative
cartridge
cut scene
emergent game play
feelies
franchise
game engine
laserdisc player

machinima
mainframe computer
motion capture
open world
peripheral device
pixel
platform game
progressive game play
sprite

CHAPTER 17

Voices from the Eastern Bloc

Chapter Outline

Global Storylines

During the Cold War, animation from
such Communist countries as China
and the USSR is largely inaccessible
to Western audiences

Animation from Eastern Bloc countries
undergoes significant changes between
the 1950s and 1960s, as the Soviet Union
experiences a "thaw" in the mid-1950s, and
an eventual breakup by the early 1990s

Censorship in the Soviet Union encourages
stories based on folk tales, promoting
traditional culture and national identity

In the 1970s, such accomplished animators
as Yuri Norstein and Jan Švankmajer
challenge censorship restrictions

In the 1960s, Eastern Bloc animators begin
to embrace a modern art style, shifting away
from the aesthetics of Socialist Realism

Introduction

The countries of Eastern Europe, which had largely
been cloistered from the West under the politics
of the Cold War and the hard rule of Communism,
experienced great change in the 1980s and 1990s as
they began to break free from Soviet control. Even
before this period, there had already been some cracks
in the armor of the Soviet Union. They began with a
relatively short liberal period in Soviet history—from
the mid-1950s through the early 1960s—described as
the "thaw," when Nikita Khrushchev was in power
following the death of Joseph Stalin in 1953. As First
Secretary of the Communist Party of the Soviet Union
(and thus the political leader of the USSR) from 1953
to 1964, Khrushchev initiated a series of reforms that
sowed the seeds for change in decades to come.

In politics and in art, Khrushchev allowed critical
commentary aimed at economic and social issues,
in an effort to revise Stalinist values. Many felt that
he went too far, and he was eventually dismissed,
but attempts to restore former levels of control faced
many problems. The USSR was suffering from a weak
economy and struggling to remain insular in a period
of globalization, which made the old notions of a
Soviet state unworkable. As a result, in 1985, the Soviet
leader Mikhail Gorbachev instituted policies known as
"glasnost" (openness) and "perestroika" (restructuring),
building upon Khrushchev's reforms from three decades
earlier. Glasnost encouraged freedom of information,
reduced censorship, and allowed critical discussion
about the country's governance. Perestroika led to
numerous changes in the way the government was run,
including more democratic elections. These changes
meant the end of the USSR and with it, effectively,
the end of the Cold War between the US and Russia.

The fall of the Soviet Union meant that former Soviet states and countries within the Communist-controlled Eastern Bloc achieved their independence. For some, this had been a long time coming. When Hungary had ousted its pro-Soviet government in 1956 in an attempt to bring about political change, it had been invaded by the Soviet Red Army. Similarly, Czechoslovakia was invaded after the "Prague Spring" of 1968, when it had gone through a period of liberalization. By the late 1980s, these and other countries were forging their own identities and breaking down ideological barriers. This was evident from such events as the fall of the Berlin Wall in 1989, which marked the end of the physical separation of East Germany and West Germany that had been in place since 1961 and had a history of violent enforcement. By 1990, Poland, East Germany, Czechoslovakia, Bulgaria, Romania, and Hungary had all abandoned Communist rule without Soviet intervention. In mid-1991, full independence was declared by the former Soviet states of Latvia and Estonia. The impact of these events was augmented by the official dissolution of the USSR in December that year. Boris Yeltsin became Gorbachev's successor as the first president of the newly formed Russian Federation.

During roughly the same period, the world of animation was experiencing its own moves toward globalization and a more international infrastructure, largely through the development of international festivals that gave Westerners a peek behind the Iron Curtain. The most important in this respect was the Annecy International Animation Festival, which came about in 1960. At this inaugural event, a group of animators formed the Association Internationale du Film d'Animation (International Association of Animated Film, or ASIFA), installing Norman McLaren (see p. 177) as its president, a position he would hold until 1979. This organization was established in conjunction with the United Nations Organization for Education, Science, and Culture (UNESCO) to support the art of animation worldwide, partly out of concern for artists who were being kept apart by the politics of their countries. The international group oversaw a range of local chapters worldwide, providing social networks for independent production. ASIFA-International also supported the development of other major international festivals, in Zagreb, Hiroshima, and Ottawa.

As a result of these core events, other initiatives were set in motion, such as the Vermont Visiting Animators Program founded by the American animator David Ehrlich (1941–) in 1982, after he saw how talented artists from both Eastern Europe and China were restricted from coming to the West because of political barriers and the high cost. His program involved creative workshops in his own community, which were followed by screening tours in East Coast cities, and it provided sponsorship for animators in Communist countries to travel to the West. They included the Russian Yuri Norstein, Estonian Priit Pärn, Chinese animator A Da, Piotr Dumala and Jerzy Kucia from Poland, and Borivoj Dovniković from Yugoslavia.

In the 1970s and early 1980s, before home entertainment and then the Internet provided access to a huge range of international films, festivals were the main venue where such work could be seen. Among the most intriguing were works from countries that Americans had learned to mistrust over a period of many years. For example, A Da's *Three Monks* (17.1),

17.1 A Da, *Three Monks*, 1980

released in 1980, was one of the first animated shorts to emerge from China after the end of the Cultural Revolution in the mid-1970s; it won several international awards after it was screened in festivals. The humorous tale depicts a struggle between three monks as they all try to avoid doing their chores. Animation from Eastern Europe was equally engaging, providing a great alternative to the sensibilities of much work coming from North America, in terms of both content and technique. Some of the most surprising productions came from artists who struggled within the political systems of their countries, defying notions that the people from these lands were somehow enemies of the West; in the festival context, animators were united as fellow artists, beyond the restrictions of any political system. This chapter focuses on the state of animation in the Eastern Bloc from the 1950s onward, giving special attention to artists who spoke out against government oppression.

The Introduction of a Modern Style in Soviet Animation

Since 1932, the role of art in Soviet society had been strictly defined by Socialist Realism, an approach conceived by Stalin and other Soviet leaders; that year it became the mandated style, which supported and elucidated the Communist revolution and Socialism through strict adherence to party doctrine and a Realist aesthetic. In the film industry, the State Committee for Cinematography, Goskino, assessed scripts for suitability and planted informers at studios. Animation was less closely monitored than live-action cinema, however; it was deemed to be less of a threat than other forms of art that were more closely linked to real life.[1] Nonetheless, many animators played it safe by keeping to well-known traditional stories, which were likely to get through the censor.

The state-run studio in Moscow, Soyuzmultfilm, mainly focused on films running ten to twenty minutes in length with children as the intended audience, and it produced relatively few animated features during its history. Some early examples of its long-format films have been mentioned already (see p. 172). For example, in 1947, Ivan Ivanov-Vano directed the fifty-five-minute *Konyok Gorbunok* (*The Humpbacked Horse*), based on Pyotr Yershov's poem of the same name. The story is about a boy who is pressed into service to tend some wild horses for the Tsar, and is then asked to find him a beautiful maiden, with mixed results. It was remade in a seventy-minute version, also directed by Ivanov-Vano, in 1975. A dubbed version of this film, called *The Magic Pony*, has been distributed in North America. The early animated feature *Snezhnaya Koroleva* (*The Snow Queen*, 1957), directed by Lev Atamanov (1905–1981) and running seventy minutes, was also dubbed into English and widely distributed in the West. It is based on the story of the same name by Hans Christian Andersen, about a girl who goes in search of her companion, after the boy is taken by the Snow Queen.

Other long-format films made at the studio include two directed by Atamanov, the forty-two-minute *Alen'kij Cvetochek* (*The Scarlet Flower*, 1952), about a man and his three daughters—two vain and one pure of heart—based on a well-known story by Sergei Aksakov, and the thirty-one-minute *Zlatna Antilopa* (*The Golden Antelope*, 1954), which is an adaptation of an Indian story about a boy, a magical antelope, and a greedy Raja. From the sisters Valentina Brumberg (1899–1975) and Zinaida Brumberg (1900–1983), *Noch Pered Rozhdestvom* (*The Night before Christmas*, 1951) runs forty-five minutes and is based on a holiday story by Nikolai Gogol. Ivanov-Vano's forty-two-minute *Levsha* (*Lefty*) from 1964 is an adaptation of a story by the nineteenth-century novelist Nikolai Leskov and is made with cutouts animated by Yuri Norstein (see p. 299).

As political powers ebbed and flowed, some Soviet animators—especially those with long histories in the system and solid reputations—found opportunities to introduce more daring visual styles and even social commentary into their productions. Working at Soyuzmultfilm, the Brumberg sisters (see p. 173) were the first to embrace a modern, minimalistic approach to design, which can be seen in their *Bol'shie Nepriiatnosti* (*Great Troubles*), released in 1961, during the thaw (17.2). The film illustrates the rhyming narration of a girl talking about her family in a funny story that appeals to an adult audience. She explains that her freeloading brother was held back in school, could not make it through college, and then shook all the money out of his father's pockets, while her pretty sister cannot seem to land a wealthy husband. Brought down by the pressure of his kids, her father enters

17.2 Zinaida and Valentina Brumberg, *Great Troubles*, 1961

17.4 Fyodor Khitruk, *Man in the Frame*, 1966

the black market. When he is caught, he attempts to bribe an official, but he cannot come up with enough "grease" and is eventually thrown in jail. The visuals of the film are created with the look of a flat, childlike drawing, and animated movement is limited. This film was a turning point in Soviet animation style, and probably influenced the aesthetic of Fyodor Khitruk (1917–2012), who was an animator on the production.

Fyodor Khitruk released his first film, *Istoriya Odnogo Prestupleniya* (*The Story of a Crime*), the following year, in 1962, also during the thaw (17.3). The film tells of a man who patiently goes through his day-to-day life as an accountant, but is driven to crime by the goings-on in his neighborhood, as people continually disturb his peace while he is trying to rest. It has a very modern look, and also

17.3 Fyodor Khitruk, *The Story of a Crime*, 1962

helped inspire a move toward stylization in Soviet animation. Photographic images are at times cut into frames within the frame, helping to define different spaces—for example, one for a massive entertainment system owned by a neighbor, who plays it loudly, and another for the accountant, who cannot hear his own television. Although the film can be read as a humorous reminder to be kind to your neighbors, it is also an indictment of government housing, which brought many frustrations to the average resident.[2]

After the thaw, Khitruk continued to include criticism in some of his work, such as *Chelovek v Ramke* (*Man in the Frame*, 1966) (17.4), about a bureaucrat who constructs a frame that mediates his experience of life. This film also combines photographic stills with stylized animation, as the man encounters other individuals within their own frames, often more elaborate than his own, pushing him up and down in the social hierarchy. Khitruk's *Film, Film, Film* (1968) reveals the bureaucracy of the filmmaking system, using a modern art style to depict the factory-like processes of a film studio that has pretensions to high art and carries on despite the interruptions of military tanks that sometimes roll through. To the general public, Khitruk is best known for directing the Russian classic "Vinni Puh" films, which began in 1969, based on A. A. Milne's "Winnie the Pooh" stories.

The Films of Yuri Norstein

The Brumberg sisters and Khitruk had been in the animation world for many years by the time they

directed their groundbreaking films in the early 1960s, and it is quite likely that it was this seniority that allowed them to stray from the conventions of Realism. At the same time, there was a newcomer at the studio, Yuri Norstein (born Yuriy Borisovich Norshteyn) (1941–), who would challenge many rules himself in future years. Norstein had developed a strong sense of identity during the thaw period, when he had been able to view international art exhibitions allowed into the USSR and political debate had opened up. As a teenager he had also developed an interest in Japanese poetry, which led to an appreciation of Asian philosophy and art.[3] Norstein had hoped to pursue fine art in college, but failed his admission tests; instead, he would bring his fine art sensibilities, as well as his political voice, to the world of animation.

17.5 Yuri Norstein, *The Fox and the Hare*, 1973

Norstein entered a vocational animation program at Soyuzmultfilm in 1959, and then two years later, upon graduation, he went to work at the studio. There, he moved up the ranks, sometimes working on the projects of the veteran animator Ivan Ivanov-Vano (see p. 298). Norstein began directing during the early 1970s, when, as part of a commissioned series, he was asked to create a film based on a folk tale. The result, *Lisa i Zyats* (*The Fox and the Hare*, 1973), tells the story of forest animals who come to the aid of a hare when its home is invaded by a greedy fox, with narration by Viktor Khokhryakov (**17.5**). The film reflects techniques that would be employed in Norstein's later films: unhinged, painted-cel cutouts that allow for fluid movement and easy replacement of body parts, as well as multilayered backgrounds. This consistency developed through the partnership of Norstein's wife, Francesca Yarbusova (1942–), who acts as art director for his films, creating initial character design sketches as well as the actual figures that Norstein then animates. She also designs the backgrounds, preferring a method of layering images and the use of a multiplane setup to create depth and enable Norstein to move elements in various ways. Yarbusova's aesthetic is greatly influenced by her study of the natural world, including animals, plants, and different environments.[4] She came to animation after studying design at the All-Union State Institute of Cinematography (VGIK) and then, in 1967, being assigned to Soyuzmultfilm as an animation designer.

She and Norstein married the same year and have maintained a creative partnership since that time.

The Fox and the Hare is a film about a conniving fox that takes over a rabbit's home, and the community's efforts to remove him. The story is told in a visually interesting way, employing ornately decorated backgrounds, as well the use of a framing technique that defines different spaces through the use of obvious borders. The camera sometimes pans from one frame to the next, as Hare interacts with the other characters. At one point, the camera pulls back to reveal all the characters in separate frames, observing the struggle at Hare's home. Although themes of inequality and the power of endurance over size are central to the film, it ends with only a slight sense of justice being served. Norstein's later works would have stronger political messages woven into the storytelling.

During the mid- to late 1970s, Norstein and Yarbusova created a series of films that became increasingly complex thematically and in their design: *Tsaplya i Zhuravl* (*The Heron and the Crane*, 1974); *Yozhik v Tumane* (*The Hedgehog in the Fog*, 1975); and *Skazka Skazok* (*Tale of Tales*, 1979). The first of them, *The Heron and the Crane*, like so many Soviet films of the time, is based on a traditional tale. It tells the story of two birds who try to form a romantic relationship, but the efforts of each are constantly rebuffed by the other. Despite the seemingly innocent story, Norstein's original script was not approved by Soyuzmultfilm's administrators: the veteran director Roman Kachanov

17.6 Yuri Norstein, *The Hedgehog in the Fog*, 1975

figures on a multiplane setup, allowing animation on multiple levels of glass. *The Heron and the Crane* reflects the influence of Asian art in its flat, theatrical look, found in traditional Chinese and Japanese painting.[5]

Norstein's next film, *The Hedgehog in the Fog*, continued his technical exploration, with advances introduced by cameraman Alexander Zhukovsky **(17.6)**. A great deal of attention is given to atmospheric effects, which add to the beauty of the film and also enhance its shrouded meaning. The film tells the story of a hedgehog's journey through a fog bank to meet his friend, a bear. The creature's sense of disorientation, and its encounters with mysterious strangers, suggest the existence of alternative ways of life, experiences that change the hedgehog's outlook for ever. Once he has seen the other world, he can never go back to the old one, which the bear still occupies. This scenario surely suggests the perspective of the Soviet people in the 1970s, looking westward to a world outside their borders.

was assigned to serve as project supervisor and asked to write an acceptable version. Having gained approval, Norstein then reverted to his original script, a decision that resulted in numerous conflicts with studio management. With support from Fyodor Khitruk, *The Heron and the Crane* was approved for distribution, despite criticism from studio officials. It is easy to see how the story of fickle, fighting lovers could be intended to represent the fruitless energy expended in Soviet life, where nothing was as it appeared and no one prospered in the end. To create the film, Norstein again used cutout

Tale of Tales

Tale of Tales (1979) is Norstein's best-known work **(17.7)**. It arose from the director's nostalgia for a Russia that had all but vanished, something he felt even more deeply about after the births of his two children made him recall his own childhood. The State Committee for Cinematography, Goskino, required films to be written

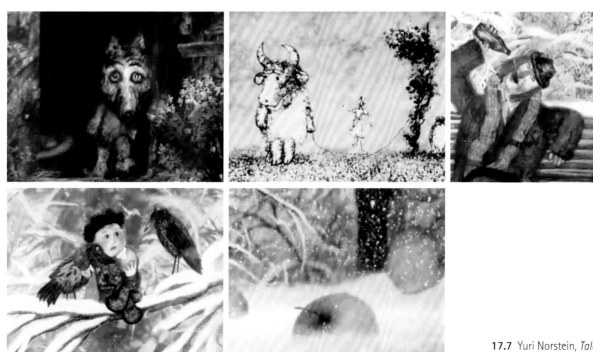

17.7 Yuri Norstein, *Tale of Tales*, 1979

by a member of the proper union, so Norstein asked the prominent author Lyudmila Petrushevskaya to write its proposal and subsequent treatment. But to his mind at least, her writing provided only a starting point, and the film changed significantly during production.[7] An early description divides it into four parts: the first dealing with childhood and memory, the second characterizing a poet and the contexts in which he works, the third concerned with the poet observing a small group interacting at the beach, and a final section including a series of actions that wrap up the film. The poet is a semi-autobiographical figure—that is, part based on Norstein.[8] The completed work is not as easily described, but a thread that runs through it involves a shy wolf, who opens the film by observing with wonder a suckling baby. He also witnesses various forest scenes involving human technologies and activities, all in a chilly autumnal environment. Mixed into the wolf's quiet observations are other sequences, including a family at the beach and couples dancing before the men leave for war, sometimes not to return. The film is more of an experience than a story, and is therefore difficult to relate in words.

Norstein also improvised material based on memories and visual impressions that came to mind spontaneously during production. One example is a winter outing in the park, in which a small boy is yanked out of his idyllic imaginary world to fall into his drunken father's shadow.[9] Both the interaction of the parents and an apple eaten by the boy were derived from moments the filmmaker recalled from his past. *Tale of Tales* also reflects on larger, more public memories, such as the great losses experienced by the Soviet Union in military actions, which left thousands of men dead or gravely wounded. The small wolf stands back as an observer, connecting the varied scenes in the film. Although the character had appeared in the original plans, it took on a larger, significantly more enigmatic role in the final film. At one point, the wolf accidentally kidnaps the baby, who cries loudly. Uncertain of what to do, it tries to rock the child to sleep with a traditional Russian lullaby, which contains an ominous warning that a wolf will come to get any children who do not behave: this is easily seen as a parallel to Norstein's views of Soviet society, consistent with his other work.

In technique, too, *Tale of Tales* is similar to Norstein's other films: backgrounds are intricately layered and cutout cels are used for the wolf and other characters. The film also uses the technological experiments developed by the cameraman Igor Skidan-Bosin (1947–).[10] Among the innovations is the combination of live-action and animation—for example, in one scene, fire is created using mirrors to reflect actual flames onto the animated imagery. But the film's aesthetics were not enough to satisfy Soviet officials, and when it was completed, *Tale of Tales* drew criticism. Norstein staged screenings to garner support from journalists domestically, and Soyuzmultfilm sent the film abroad to festivals, where it won significant prizes, including the top spot on a survey, conducted in Los Angeles in 1984, of the greatest animations of all time.

In 1981, Norstein received the initial go-ahead to work on another project, an adaptation of *Shinel* (*The Overcoat*), published as a story in 1842 by the Ukrainian-born author Nikolai Gogol. In 1986, before the film was finished, Norstein was ousted from Soyuzmultfilm, partly because he was taking so long to complete it. In 1993, after the breakup of the Soviet Union and the spread of privatized production, Norstein partnered with other leading animators—Khitruk, Andrey Khrzhanovsky, and Eduard Nazarov—to found Shkola Animatsionnoi Rezhissury (SHAR), a highly acclaimed animation school and studio in Moscow. He continues to work on *The Overcoat* alongside various commissioned projects.

Animation after the Fall of the Soviet Union

During the time of the Soviet Union, artists were funded by the government and did not have to worry if their films had money-making potential or not. They operated under censorship, of course, but well before the Soviet Union dissolved, more animators were becoming bolder in their criticism. Among them was Nina Shorina, who had studied acting and documentary filmmaking at the State Institute of Cinematography (VGIK). She began working at Soyuzmultfilm in 1972, and then started directing films for children in 1976. The first of her animations to be seen in the West, *Door* (1984), is clearly a commentary on Soviet society. In the film, the door to an apartment is broken, so its tenants start to take elaborate measures when they leave: being lowered in suitcases, traveling down rain pipes, and even jumping from high windows.

The problem is, when the door has been fixed, they are too afraid to use it and choose to return to their homes the same way they left them.

After the breakup of the USSR, Eastern European animation as a whole was privatized, and production was funded by profits rather than government support. Directors were no longer guaranteed funding to make their films, and they also faced competition as the marketplace began to develop. Soyuzmultfilm had to adapt to producing work alongside other enterprises, such as the Pilot Studio, the first private animation studio in the Soviet Union, founded by Aleksandr Tatarskiy, Anatoliy Prokhorov, and Igor Kovalyov in 1988, supporting production of both commercial projects and independent films.

17.8 Igor Kovalyov, *Hen, His Wife*, 1989

By the mid-1990s, artists used to the Soviet system had either left animation production or learned to adapt. Sometimes they were able to establish partnerships with Western funding sources that were interested in the varied styles emerging from Eastern Europe. Igor Kovalyov (1963–) found opportunities in the American studio system after his enigmatic work—featuring pocked, tension-filled characters that live in unsettling domestic spaces—drew attention at film festivals. At Pilot, he directed a series of animated shorts, including a trilogy that began with *Ego Zhena Kuritsa* (*Hen, His Wife*, 1989), a beautiful yet disturbing film about a man who does not realize that his wife is a hen **(17.8)**. Kovalyov finished the second film in the series, *Andrei Svislotsky* (1991)—an enigmatic story involving a man and his servants—and then moved to Los Angeles. There he began working at the Klasky Csupó studio, directing episodes in the television series "Rugrats" (1991–94), created by Paul Germain, Gábor Csupó, and Arlene Klasky; "Ahhh! Real Monsters" (1994–97), created by Csupó and Klasky; and "Duckman" (1994–97), created by Everett Peck. Kovalyov later directed *The Rugrats Movie*, released in 1998. Meanwhile, he also finished the final film in his trilogy, *Bird in a Window* (1996), employing the same visual style and disconcerting story elements to capture a sense of horror in everyday life, this time focusing on a man and

a woman, as well as a small child, Chinese twins, and a gardener. The film was executive-produced by Klasky and Csupó. The studio run by the American Klasky and her Hungarian husband, Csupó dates back to 1982, and by the time Kovalyov had arrived, they were already well known for work on early episodes of the television series "The Simpsons" (see p. 354) and music videos.

Through festivals, the Russian artist Alexandr Petrov (1957–) also found opportunities in the West. Petrov is well known for his mastery of the **paint-on-glass** technique, using his fingers to create sequential images on panes of glass **(17.9)**. In 1990,

17.9 Alexandr Petrov teaching a class on painting animation in the Yekaterinburg History Museum, Russia, 2010

17.10 Alexandr Petrov, *The Old Man and the Sea*, 1999

the Canadian producer Pascal Blais saw a screening of Petrov's *Korova* (*The Cow*, 1989), adapted from a story by Andrei Platonov, at the Ottawa International Animation Festival. This experience moved him to produce Petrov's twenty-minute *The Old Man and the Sea* (1999) (**17.10**), based on Ernest Hemingway's novel of 1952; financing also came from a number of Japanese investors, who stipulated that the film had to be made in the widescreen IMAX format.[11] *The Old Man and the Sea* won many competitions, including an Oscar for best animated short.

Estonian Independence

Even before Estonia established its independence from the Soviet Union in 1991, censorship of animation produced there had been weakening. As a result, in 1987, the Estonian animator Priit Pärn (1946–) (see p. 297) was able to release a fairly blunt criticism of Soviet life: *Eine Murul* (*Breakfast on the Grass*), in which four ordinary people struggle and work the system to secure basic necessities (**17.11**). At the end, they come together in a symbolic moment, referencing Edouard Manet's painting *Le Déjeuner sur l'Herbe* (*Luncheon on the Grass*, 1863), a revolutionary work at the time of its

debut, which helped bring about the advent of modern art (see Box: Modern Movements in Painting, p. 72).

Pärn's film was made at the state film studio in Estonia, Tallinnfilm, which operated between 1947 and 1998. By 1993, after the breakup of the USSR, two animation studios had emerged from it: Eesti Joonisfilm, which specialized in cel animation, and Nukufilm, for stop-motion (see p. 188). Both studios produce stylish films for children and general audiences, as well as

17.11 Priit Pärn, *Breakfast on the Grass*, 1987

creator-driven films meant for festival distribution. At Eesti Joonisfilm, the directors Priit Pärn, Olga Pärn, Ülo Pikkov, Priit Tender, Kaspar Jansis, and others are known for humorous films that combine interesting character design, a sense of the absurd, a playful spirit, and a wide range of visual and narrative approaches. In their work for children, such filmmakers as Janno Põldma, Heiki Ernits, and Andrus Kivirähk create stories that entertain without the use of violence. Nukufilm has supported the animated productions of Rao Heidmets, Riho Unt, Mati Kutt, Mait Laas, Jelena Girlin, and Mari-Liis Bassovskaja, among others. One example is Mati Kutt's *The Institute of the Dream* (2006), which depicts a large sandman character and his small helpers spewing sand to bring about sleep. As he does so, he encounters many strange creatures of the night.

Like many other Eastern European countries, Estonia has a long history of puppet theater, which fueled the development of its stop-motion animation production. Today, Nukufilm produces work using varied techniques, including puppets, cutouts, and pixilation, as well as **computer-generated animation or imagery (CGI)**. The studio also runs an animated film workshop that gives children an opportunity to view animation and create their own animated images, as a way of introducing the next generation to the practice.

Czechoslovakia's Changing Political Identity

Animation in Czechoslovakia (today two countries—the Czech Republic and Slovakia) developed against a turbulent political backdrop. After falling under Nazi control during World War II, the country went through a period of political reorientation. In 1948, it came under Communist rule, with dissidents purged from all levels of society. As a satellite state of the USSR, it had a close relationship with Moscow, whose political and militaristic control enforced Communist rule.

In the period immediately after World War II, Czechoslovakia had begun to make strides in the development of its national cinema. In 1946, the government opened the state-run Filmová a Televizní Fakulta Akademie Múzických Umění v Praze (Film and Television School of the Academy of Performing Arts, or FAMU) in Prague, one of the first film schools in

17.12 Jiří Trnka

the world. After Communism was established in the country, the Czech film industry was centralized under the Ministry of Culture in an agency called Statni Film (State Film). It included a sub-group, Krátký Film (Short Film), which oversaw Studio Animovaného Filmu (popularly known as Bratři v Triku, see p. 67), founded in 1945 and specializing in drawn animation. Although Jiří Trnka (1912–1969) (see p. 166) **(17.12)** was a founding member of that studio, in 1947 he and others broke away to form Studio Loutkoveho Filmu (Puppet Film Studio, also under Krátký Film), which later became known as the Jiří Trnka Studio. Trnka headed one unit within the Puppet Film Studio, while Břetislav Pojar (see p. 190) led another, with the two groups based in different areas of Prague. Krátký Film also supervised Studio Prometheus in Ostrava and the Zlín studio (see p. 190). As a result of this nationalization, animation crews enjoyed stable employment with government funding and the ability to explore a wide range of techniques, although they were always subject to the censor's watchful eye in varying political contexts.[12]

Within their units, artists generally worked peacefully, remaining within permitted boundaries

of expression. Dissent did appear from time to time, however, and one of the best-known examples came from Trnka. Although his films of the 1950s had appealed to young viewers and had been in keeping with government regulations, toward the end of his career he produced a film that was quite different: *The Hand* (1965, see p. 189), a commentary on the oppression of artists by the state. This film was created during a relatively relaxed period in Czech history, which saw increasing interaction with the West; in respect to animation, this contact included subcontracting work for producers in other countries.

The American Gene Deitch worked with a unit at Bratři v Triku that was supervised by a woman he later married, the producer Zdenka Deitchová (see p. 167), to fulfill contracts with American producers. Such companies as Rembrandt Films and Weston Woods, and the Dutch children's author Hendrik Magdalenus "Dick" Bruna, paid the Czech Filmexport Agency directly for the use of production facilities,[13] while Deitch worked as their representative; he retained his US citizenship and was paid by the Western producers who hired him, but he continued to work in Prague from 1960, through ongoing political turmoil. By the mid-1960s, Czechoslovakia was experiencing serious economic problems and underwent another phase of political and social change. Democratic reforms—including an end to media censorship—were introduced, culminating in the short-lived Prague Spring of 1968. In August that year, Soviet troops invaded and Czechoslovakia fell under the control of the USSR, and a period of what was called "normalization" began.

Political Dissent in the Films of Jan Švankmajer

The Czech filmmaker Jan Švankmajer (1934–) has had a long history of creating provocative live-action and animated works. He attended college from 1950 to 1958, when it was illegal to display and study modern art, which was seen as Western and bourgeois; instead, he studied Soviet avant-garde theater and film.[14] As the thaw began in the Soviet Union, in the late 1950s, modern art filtered into publications and classrooms. Upon leaving school, Švankmajer collaborated with avant-garde theater groups, such as Laterna Magika.

A few years later, in 1964, when Švankmajer entered the film industry and began directing short

17.13 Giuseppe Archimboldo, *Vertumnus*, c. 1590–91

works, Czech filmmaking was at a high point, gaining an international reputation through the production of live-action features collectively known as the Czech New Wave. Committed to the Surrealist aesthetic, he joined the Prague Surrealist group in 1970; his wife, Eva Švankmajerová (1940–2005), a painter, poet, and ceramicist, was a member as well. Švankmajer has also been strongly influenced by Mannerism, a decorative style of image-making that emerged in the sixteenth century; a well-known practitioner was Giuseppe Archimboldo (c. 1526–1593), who created portraits of his patrons out of images of fruit, vegetables, flowers, and other items (17.13). A third influence comes in the form of political environments, reflecting the varied ideological contexts in which Švankmajer has lived. Švankmajer's embrace of these realms marked him as a subversive for much his career.

As a result, a number of Švankmajer's early films were banned and he was effectively exiled from filmmaking between 1972 and 1980. During this time, he moved into other forms of art. But no matter, when he returned to animation. Among his well-known films is *Možnosti Dialogu* (*Dimensions of Dialogue*, 1982), which is a not-at-all subtle commentary on social and

17.14 Jan Švankmajer, *Dimensions of Dialogue*, 1982

political breakdown **(17.14)**. Švankmajer's Mannerist sympathies are clearly demonstrated in the film, which is structured in three episodes. The first of them depicts opposing heads—built out of vegetables, hardware, and other materials—that eat and regurgitate heads in other forms. At the end, the heads turn into identical copies, reflecting both the violence and the ineffectiveness of political domination. The other two episodes in the film also explore political themes, while demonstrating Švankmajer's skill as a stop-motion animator and his Surrealist attraction to materials that are intended to evoke a visceral response. Predictably, *Dimensions of Dialogue* was banned— in fact, it was shown to the ideology commission of the Czech Communist party as an example of what had to be avoided.[15]

Despite the sanctions against his work, or partly because of them, Švankmajer has managed to have a long and luminous career making both live-action and animated short films and features, as well as sponsored films. Czechoslovakia eventually followed the path of other Eastern Bloc countries, breaking down the ideological and physical barriers that separated it from the West. Its Communist era finally ended in 1989 with the Velvet Revolution, a non-violent transition of power brought

about by student protests and a general strike. Meanwhile, during the 1980s, Švankmajer had been funded by organizations outside his own country and so was able to continue his work. For example, the British television network Channel 4 supported production of his Surrealist live-action and animation feature *Něco z Alenky* (*Alice*), released in 1988 **(17.15)**. This film captures the disturbing nature of the original *Alice in Wonderland* story, as the precocious Alice is subjected to all sorts of strange experiences. Švankmajer was also commissioned to create short works by other clients, such as MTV, resulting in *Flora* and *Meat Love*, both from 1989.

Many of Švankmajer's films involve food or the act of eating, which are effective means for stimulating sensory reactions in an audience, beyond sight and hearing. *Flora*, which runs half a minute, depicts a disturbing scene of a woman's body, made of food items, decomposing as she lies tied to a bed. In the one-minute *Meat Love*, two pieces of beef share a doomed romance. Yet another example is *Tma, Světlo, Tma* (*Darkness, Light, Darkness*, 1989), based on a story by Edgar Dutka, in which clay body parts are joined with a real tongue and brains that are captured by the hands

17.15 Jan Švankmajer, *Alice*, 1988

and stuffed into the head. The film starts in a dark room, which grows increasingly suffocating as the body forms itself and gets larger, in an apparent allegory of the problems faced by gaining knowledge within a context where growth cannot be accommodated. In his most overtly political film, *Konec Stalinismu v Cechách* (*The Death of Stalinism in Bohemia*, 1990), pig entrails are used as visuals, as Švankmajer shows the repeated birth of new leaders, one replacing the next. The film traces the political shifts following World War II, which include liberation from Fascism in 1945, the Communist takeover in 1948, the mid-1950s thaw, the Prague Spring in 1968, normalization after 1969, and the Velvet Revolution in 1989, which marked the death of Stalinism.[16] A few years later, in 1993, Czechoslovakia was dissolved into two independent countries, the Czech Republic and Slovakia.

Varied Directions for Czech Animation

In recent times, the climate of Czech film production has changed dramatically. The shift is evident in the work of the director Michaela Pavlátová (1961–), who has become internationally known for films that mark space and time in interesting ways, generally pursuing themes of love and sexuality. Her film *Reci, Reci, Reci* (*Words, Words, Words*, 1991) depicts a relationship between a man and a woman (and a waiter who loves her) through typography that fills the air (**17.16**). Her

17.16 Michaela Pavlátová, *Words, Words, Words*, 1991

film of 1995, *Repete* (*Repeat*), shows the patterns people fall into, especially as couples tire of each other's habits and then move on to other routines. Pavlátová has become known for developing erotic contexts within her animated films, such as *Karneval Zvířat* (*Carnival of Animals*), completed in 2006 with the aid of her husband, Vratislav Hlavatý; the film depicts variations of erotic scenes inspired and accompanied by elements of the late nineteenth-century musical suite *Le Carnaval des Animaux* by Camille Saint-Saëns. Pavlátová's film *Tramvaj* (*Tram*), completed in 2012, reveals the erotic fantasies of a woman who drives a tram. Between 1998 and 2001, Pavlátová lived part-time in San Francisco, where she worked as a director at the animation company Wild Brain, which was founded in 1994 by John Hays, Phil Robinson, and Jeff Fino.

As an international co-production involving the Czech Republic, Japan, and Slovakia, Jiří Barta's (1948–) stop-motion film of 2009, *Na Pudě Aneb Kdo má Dneska Narozeniny?* (*In the Attic: Who Has a Birthday Today?*) also reflects the changing times (**17.17**). Written by Barta and Edgar Dutka, the film tells the story of a number of toys and how their joyful life is disrupted by an evil villain, Hlava—a man's head on a platform (performed through pixilation by Jiří Lábusa)—aided by his minions, including a devious black cat that appears in both live-action and puppet forms. For distribution in North America, the film was licensed by Hannover House. The company edited the film and recorded a new dialogue track for it, releasing it as *Toys in the Attic*; it debuted at the New York International Children's Film Festival in 2012.

Beginning in 1969, Barta studied in the Animation Department at the University of Applied Art in Prague. In 1978, he began working at the Jiří Trnka Studio, and directed his first film, *Hádanky za Bonbon* (*Riddles for a Candy*), in the same year; this imaginative short employs stop-motion and drawn figures that constantly metamorphose, posing riddles as the central character tries to eat a candy. Barta's film of 1982, *Zaniklý Svět Rukavic* (*The Extinct World of Gloves*), draws upon film history to demonstrate his mastery of stop-motion animation. The story begins when a junkyard worker discovers a film about a past world. When he watches it, it becomes apparent that gloves once led interesting lives, as Barta shows them engaging in slapstick comedy, the Surrealist films of Luis Buñuel and Salvador Dalí, a kind of wartime propaganda, and

17.17 Jiří Barta, *In the Attic: Who Has a Birthday Today?*, 2009

a sci-fi encounter, among other scenarios. Barta's other films include *Krysař* (*The Pied Piper*, 1985) **(17.18)**. *The Pied Piper* uses puppets, mostly carved from dark wood, and real animals to tell the story of a man who rids a town of rats, which in this case include the citizens themselves, in an adaptation of the famous German folk tale incorporating the theme of moral corruption. Although there is dialogue in the film, it is meaningless—created in a made-up language. Stylistically, *The Pied Piper* reflects the strong influence of German Expressionism, especially in the use of perspective and irregularly angled sets, which are captured through a range of cinematic methods.[17] Barta has also been influenced by the dreamlike scenarios of such animators as Jan Švankmajer, Yuri Norstein, and Priit Pärn.

17.18 Jiří Barta, *The Pied Piper*, 1985

Animation from the Visegrad Group

The Czech Republic is one country among the four members of the Visegrad Group (V4), an alliance of Central European states that also includes Hungary, Poland and Slovakia; the group, which was formed after the disbanding of the Soviet Union, collectively joined the European Union in 2004. For these countries, the 1990s had been a time of great optimism, as the former Soviet states and other countries of the Eastern Bloc began to redesign their economic and social systems: like all other aspects of life, their animation industries underwent changes at that time. Today, studios in these countries rely on international co-production to a large extent, but even when productions are financed, distribution can be a challenge.

Slovakia

The history of animation in Slovakia dates back to 1965, when the Group of Animated Film was founded at Koliba Studio in the city of Bratislava. Animation flourished during the next two decades, and when Slovakia's self-rule began in 1993, a Department of Animation was opened at the Vysoká Škola Múzických Umení v Bratislave (VŠMU, the Academy of Performing Arts in Bratislava). But the Koliba Studio, which had been the center of film production in Slovakia, suffered financially after being privatized in 1995, and its artists scattered to new locations, some of them becoming teachers. In 2001, a private arts high school, Súkromná Stredná Umelecká Škola Animovanej Tvorby, or SSUSAT (known as the Academy of Animation, or UAT, in English), was founded in Bratislava by Viera Zavarčíková. Its faculty includes individuals who worked at the Koliba Studio, such as Jaroslav Baran, Stefan Martauz, and L'udmila Pavolová.

The animator and director Ivana Laučíková (1977–) formed a magazine, *Homo Felix*, published in both Slovak and English, to promote the work of V4 countries (**17.19**). Her company, Feel Me Film, also produced the *Virvar* DVD collection to showcase Slovak production since 1989.[18] Included in the collection is the work of Vanda Raýmanová and Katarina Kerekesová, at the forefront of a wave of women's animation. Their films include, respectively, *Kto je Tam?* (*Who's There?*, 2010), about the adventures of two boys (**17.20**), and

17.19 *Homo Felix* magazine cover

17.20 Vanda Raýmanová, *Who's There?*, 2010

17.21 Katarina Kerekesová, *Stones*, 2010

the puppet film *Kamene* (*Stones*, 2010), in which the experience of men working in a quarry is interrupted by a woman who enters their world (**17.21**). Veronika Obertová and Michaela Čopíková, with the studio they founded in 2010, Ové, are also included in this wave; they specialize in music videos, for example *Free to Be Me* (2010), for the folk singer Haroula Rose.

Hungary

Hungary has a strong tradition of animation production. Since the 1950s, it centered on what became known (in 1956) as the Pannonia Film Studio; in the Soviet Bloc, it was second in size only to Soyuzmultfilm in Moscow. Many highly acclaimed works were produced, including the films of Ferenc Rofusz. *A Légy* (*The Fly*, 1980), which won Rofusz an Oscar, explores a fly's experience from the point of view of the insect (**17.22**). The use of sound

17.22 Ferenc Rofusz, *The Fly*, 1980

17.23 Marcell Jankovics, *Son of the White Mare*, 1981

ensures that the viewer identifies with the experience, which mixes humor and anxiety.

In 1960, Marcell Jankovics joined the studio, where he later directed the country's first animated feature, *János Vitéz* (*Johnny Corncob*, 1973), based on a nineteenth-century epic poem about a brave shepherd. His second feature, *Fehérlófia* (*Son of the White Mare*, 1981) has attracted a cult following with its psychedelic imagery and fantasy concepts (**17.23**). The film, based on ancient folk tales collected by László Arany (1844–1898), tells the story of three boys born of a white mare who seek a path to the underworld, where three princesses have been trapped. Jankovics directed many short films as well, including *Sisyphus* from 1974, which uses impressively animated bold black lines to depict the mythical struggle of a man compelled to push an enormous boulder up a hill. He has also authored a number of books and articles, largely reflecting his interests in mythology and culture.[19]

17.24 Csaba Varga, *Luncheon*, 1980

Pannonia suffered from the dismantling of the Soviet Union, surviving this turbulent event in the form of one of its subsidiaries, Kecskeméti Animációs Filmstúdió, which had been established in 1971. Under the new name Kecskemétfilm Kft, that studio became an independent company in 1991, headed by Ferenc Mikulás (1940–). It produces a wide range of animated productions for international distribution. It is also known for the Kecskeméti Animation Film Festival, which it launched in 1985. The Varga Studio, founded in 1989 by the director Csaba Varga (1945–2012) and producer Andras Erkel (1962–2014), is another of Hungary's major animation producers, completing much of its production as contract work for European and US studios. It has been competitive internationally in part because it adopted computer animation early in its history. Csaba Varga himself was known for an outgoing clay character named Augusta, who first appeared in the film *Ebéd* (*Luncheon*) in 1980 **(17.24)**. In 2005, Erkel founded Studio Baestarts, another of Hungary's leading animation studios. While its focus was industrial series production, it also supported smaller scale projects; notably, Alexey Alexeev's *KJFG No. 5* (2007), a short festival favorite in which a trio of animal musicians outwit a hunter and his dog.

Poland

Unlike other countries of the Eastern Bloc, Poland never centralized its animation industry, and in the 1990s, amidst political change, it continued to support individual proposals by providing funding. Piotr Dumala (1956–) is among the accomplished animators in Poland's history of innovative production. He became known for his engraving technique, which involved carving onto a plaster tablet coated with dark paint, using sandpaper and sharp tools. His best-known films are adaptations of writing by the Russian author Fyodor Dostoyevsky: *Łagodna* (*The Gentle Spirit*, 1985), based on a short story, and *Zbrodnia i Kara* (*Crime and Punishment*, 2000), a thirty-minute loose adaptation of the novel of the same name. Dumala's *Franz Kafka* (1991) focuses on the writer, who was born in Prague to a German-speaking Jewish family in 1883.

The Polish artist Jerzy Kucia (1942–) trained as a painter and graphic artist at the Krakow Academy of Fine Arts before entering the field of animation. His film of 1978, *Krag* (*The Ring*), is a dark, eerie depiction of figures that are often only semi-recognizable, taking the form of dream or memory. Created the following year, his film *Refleksy* (*Reflection*, 1979) is a meditation on life and death, as an insect struggles to emerge from its cocoon, only to be immediately pursued by a predator. It is an epic struggle that is later quashed by a man, who gives it no thought whatsoever. A few years later, Zbigniew Rybczyński became the first Polish artist to be awarded an Oscar. It went to his short film of 1982, *Tango*, which was animated using an optical printer and thousands of painted cels used as mattes, to depict thirty-six individuals repeatedly going through separate actions in a single room, forming a continuous, complex loop of action **(17.25)**.

With the changes that occurred in Hungary and other countries in the Eastern Bloc during the 1980s and 1990s, established artists were thrown into uncharted waters. In contrast, the generation that began making films in the 1990s walked directly into this new order, incorporating technological tools that redefined production and distribution. A computer allowed the Polish animator Tomasz Bagiński (1976–) to create the seven-minute *Katedra* (*Cathedral*, 2002) all by himself, at relatively little expense. The film received many awards at festivals and was nominated for an Oscar. It tells the story of a man who wanders into a mystical place, filled with large pillars and shafts of light, not realizing that he would soon be absorbed

17.25 Zbigniew Rybczyński, *Tango*, 1982

into it. The concept is based on the work of the Polish science-fiction writer Jacek Dukaj (1974–), who wrote the original story and adapted it for the film.[21]

Conclusion

Film festivals provided the first means for Eastern European animators to be introduced to audiences in other parts of the world, especially as the Soviet Union began to weaken in the late 1980s and early 1990s. The works that came out of these contexts demonstrated something that often seemed to be missing in contemporary American production: the presence of the "author," or artist behind the work. For years, animators in the Eastern Bloc, such as Yuri Norstein and Jan Švankmajer, had created films without much concern for their commercial value, and they developed a mastery of techniques that went beyond the scope of industrial production. Films by these

animators were noticeably different: they appeal to adult viewers to a great extent and helped to change the Western public's perception of the medium. They left no doubt that animation was an art form.

The popularity of such festival films encouraged the development of traveling shows that brought innovative work to communities across America, including a lot of college campuses. During the 1980s and 1990s, interest in animation swelled and college programs became bigger than ever before. Many of the students entering this field envisioned themselves as directors, artists with a unique voice. Quite a few of these animators rose to prominence after their works also did well on the festival circuit, and they later found opportunities in television and feature animation, both of which experienced a renaissance during the 1990s. This decade ushered in the phenomenon of creator-driven animation, eventually leading to the explosion of animated media in the twenty-first century.

Notes

1 Clare Kitson, *Yuri Norstein and Tale of Tales: An Animator's Journey* (Bloomington, IN: Indiana University Press, 2005), 29, 33.

2 Kitson, *Yuri Norstein*, 34; Pontieri, *Soviet Animation*, 100.

3 Kitson, *Yuri Norstein*, 27.

4 Ibid., 66.

5 Mikhail Iampolski, cited in Kitson, *Yuri Norstein*, 90.

6 Kitson, *Yuri Norstein*, 46.

7 Ibid., 51.

8 Ibid., 57–58.

9 Ibid., 76–77.

10 Mikhail Iampolski, cited in Kitson, *Yuri Norstein*, 90.

11 Alyson Carty and Chris Robinson, "The Old Man and the Sea: Hands above the Rest?" in *Animation World Magazine* 4:12 (March 2000). Online at http://www.awn.com/mag/issue4.12/4.12pages/robinsonoldman2.php3

12 Lucie Joschko, "The Golden (C)age of Czech Animation," 9–12, in Miriam Harris, ed., *24 Czech & Polish Animators* (Auckland, New Zealand: Rim, 2011).

13 Information on the organization of the Czech industry was provided by Gene Deitch, correspondence with the author, July 28, 2014. Deitch occasionally did English-language translation and recording for Czech producers and in those instances he was paid directly in Czech crowns (*koruna*). Incidentally, the Barrandov studio was also government owned. A huge complex, it included a film lab where the animation studios processed their work. Because of its close proximity to the Bratři v Triku studio, Zdenka Deitchová would often take the film rolls from the cameras and personally walk them over to the lab for processing.

14 Jan Švankmajer, in Peter Hames, "Interview with Jan Švankmajer," 104–39, in Peter Hames, ed., *The Cinema of Jan Švankmajer: Dark Alchemy* (1995. London: Wallflower, 2008).

15 Švankmajer, in Hames, "Interview," 108.

16 Wakagi Akatsuka, "The Wager of a Militant Surrealist on Jan Švankmajer's *The Death of Stalinism in Bohemia*," *Slavic Research Center* (1998). Summary online at http://src-h.slav.hokudai.ac.jp/publictn/45/akatsuka/akatsuka-E.html

17 Ivana Košulićová, "The Morality of Horror: Jiří Barta's Krysař (The Pied Piper, 1985)," Kinoeye. Online at http://www.kinoeye.org/02/01/kosulicova01_no2.php

18 Eva Sosková, "Uproar in Slovak Animated Film," *Homo Felix* (2014), 64–67.

19 "Marcell Jankovics," World Cultural Council. Online at http://www.consejoculturalmundial.org/winners-arts-marcelljankovics.php

20 Erzsi Lendvai, "Animated Cartoons in Hungary," *Filmkultura*. Online at http://www.filmkultura.hu/regi/articles/essays/anim.en.html

21 Anonymous, "Tomek Baginski on *The Cathedral*," *Filmnosis*. Online at http://filmnosis.com/interviews/tomek-baginski-on-the-cathedral/

Key Terms

computer-generated animation (CGI)
drawn animation
multiplane setup
paint on glass
Socialist Realism
stop-motion
Surrealism

Authorship in Animated Shorts

Chapter Outline

Global Storylines

During the 1980s and 1990s the animation world grows, with developments in feature and television production, as well as games

A new focus on creator-driven animation develops in the 1990s, supported by the growth of festivals, traveling animation showcases, college programs, and writing on animation history

It is generally difficult for animators to finance production of animated shorts, but these works are nonetheless vital to the creative development of the field

Introduction

The 1980s and 1990s were periods of great growth in varied aspects of the animation world: Disney experienced a renaissance (see p. 339), leading to increased feature production internationally; television programming diversified; and games became a big industry. At the same time, college programs were multiplying, resulting in an increased number of short films being produced by students, some of whom continued in production independently, after graduation. Festivals and, eventually, traveling programs of these short works showcased animation by future creative leaders in the field, as well as influential artists of the past. These events, combined with college animation history courses, fueled the development of academic writing that began to record the history of animation.

Contributing to the rise of animation in all its forms and contexts was a new emphasis on the director—in other words, creator-driven work. Early in animation history, the hand-of-the-artist convention (see p. 33) had signified to the audience that animated images were indeed linked to a real person, who drew them and made them come alive; but in subsequent years, animation creators working at studios became largely anonymous, hidden behind company and producer names. By the late twentieth century, things were changing, and innovative animators were drawn to the field with the promise of more opportunity to create original works. Such shifts in production were first witnessed at festivals, because they sought out innovation: new stories, a wide range of techniques, and diverse creators, including women and artists from across the world, mostly took the form of short films, running under ten minutes in length. Without

a doubt, animated shorts are an important site for artistic expression and personal storytelling, helping bring new ideas into the industry–though in most of the world it remains difficult to finance their production. Students make such films as part of their courses, and so may be supported to some extent through the schools they attend, but independent animators without institutional support often struggle over long periods of time to realize their works. Nonetheless, there are now more opportunities to produce and exhibit than ever before.

Since 1932, the Academy of Motion Picture Arts and Sciences (AMPAS) has been acknowledging animated shorts with special awards. That year, it began to recognize the category of "Short Subject, Cartoon," focusing on industrial productions. In 1970, the award was changed to "Short Subjects, Animation," probably because animated shorts were diversifying in approach, becoming more serious in tone or oriented toward adult audiences in their form and content; by that time, both industrial and independent productions were considered. Just four years later, another name-change came about, and today the winner is given an Oscar for "Short Film (Animated)." Recognizing the growth of college film programs and the range of creative animation being produced, in 1973 the Academy began to award a separate Oscar for student achievement, which includes a specialization in the field of animation. The first student-animation award was shared by Lewis Hall and Carlos Guiterrez-Mena for their film *Anti-Matter* (1973), which they made at the University of California, Los Angeles Animation Workshop. John Lasseter (see p. 373)–later to become famous at Pixar as a director of computer-generated animation–was among the other students to win this award: in fact, he won it twice, for drawn animation in *Lady and the Lamp* in 1979 and *Nitemare* in 1980, films he made at the California Institute of the Arts (CalArts). Incidentally, it was not until 2002 that the Academy gave an award for best animated feature, after it decided that there were enough animated features being produced to support competition. Other countries recognize innovative animated films as well: for example, in the UK, the prestigious BAFTA Awards from the British Academy of Film and Television Arts includes a category for British short animation, among other areas, such as animated features and work for children.

Prestigious awards can be life-changing for animators, but obviously they are very rare. More important to short-form animators, as a whole, are opportunities provided by festivals in their various incarnations: competitive, where juries award prizes, and non-competitive, offering career retrospectives, workshops, social gatherings, and other opportunities to see new work and meet fellow artists. Prize money, when available, is rarely enough to subsidize a creator's ongoing independent work, but many animators have launched careers on the success of their films at competitive festivals, in some cases because they have created animated shorts that have led to feature-film production or commissions for advertising. These events are so important to creative development and professional advancement that artists often design work with festivals in mind: the term "festival film" may be applied to animated shorts that are specifically created for competitive events, where they may win prizes or attract attention for their makers. Festival films tend to be organized in ways that are quite different than mainstream norms, perhaps in terms of the techniques used, the storytelling (or lack thereof), and the treatment of space and time, and are thus seen as having a unique voice, as a creator-driven expression. Such films not only attract audiences to festivals and inspire creative growth in the animation industry, but also play an important role in sustaining the energy and productivity of animation creators, who rely on festivals to help acknowledge and publicly validate their work in the large, industrially dominated world of animation.

To recognize and promote the status of animation as art, the international animation organization ASIFA (see p. 297) was founded in 1960. Its inaugural meeting took place at the first Annecy International Animation Festival–now one of the world's largest and most important events for independent, student, and industrial production. A number of ASIFA chapters have since formed worldwide in order to organize small-scale, local gatherings. To give just one example, the GSFA (Groupement Suisse du Film d'Animation) was founded in 1968 as the Swiss branch of ASIFA, with the goal of uniting its members, mostly for supporting independent production. Its founding members were Bruno Edera, Nag and Gisèle Ansorge (see p. 186), Georges Schwizgebel, Claude Luyet, and Daniel Suter. In the United States, there are individual chapters in the San Francisco, New York, Hollywood, and Central-Midwest regions.

Originally, the Annecy festival was one of four officially sanctioned by ASIFA, along with the Zagreb

18.1 Poster for the Hiroshima International Animation Festival, 1985

International Animation Festival (established in 1972), the Ottawa International Animation Festival (established in 1976), and the Hiroshima International Animation Festival (established in 1985) (18.1). Today, ASIFA-International is not as closely involved with supporting festivals, though local chapters often hold their own events. Many other competitive festivals and non-competitive screening events have been established worldwide since the 1970s, however, including programs of innovative short films that move from city to city. The youth market, including a growing number of college students studying animation, has turned out to be an excellent audience for such events.

Entrepreneurs who recognized the growth of creator-driven short films saw a good business opportunity in screening them at college campuses and other venues. Among them was Prescott Wright (1935–2006), who began producing a touring series called the "International Tournée of Animation" in the early 1970s. This was just one of Wright's many

accomplishments. He also helped establish the Ottawa International Animation Festival and an ASIFA chapter in San Francisco, and he was director of the Olympiad of Animation in Los Angeles in 1984. In the mid-1980s, the producer Terry Thoren took the Tournée screenings further, developing their potential through his company Expanded Entertainment, which also launched the publication *Animation Magazine* in 1986. By the mid-1980s, Tournée shows were appearing at venues across the US, aided by Jerry Beck, who joined the company as a distributor, also in 1986.

In the early 1970s, the Americans Craig "Spike" Decker and Mike Gribble (1951–1994) began promoting a series of animated shorts called "Spike & Mike's Festival of Animation" through their company Mellow Manor Productions, Inc. (18.2). Their screenings, held at the La Jolla Museum of Contemporary Art in San Diego and at other venues, included early films by such directors as Tim Burton, John Lasseter, Pete Docter, Andrew Stanton, Peter Lord, and Nick Park, all of whom

18.2 Poster for "Spike & Mike's Festival of Animation," 1988

18.3 The CalArts Character Animation class of 1976 was attended by prominent future animators, including John Lasseter, Nancy Beiman, Brad Bird, and John Musker

the University of California, Los Angeles (UCLA) Animation Workshop had begun in 1948. The University of Southern California (USC) started offering animation courses in the early 1960s, and in the 1970s it established its Film Graphics and Animation Program; today it is known as the John C. Hench Division of Animation and Digital Arts (DADA). In 1969, the California Institute of the Arts (CalArts) founded an animation program, first known as Motion Graphics and later divided into two areas: Experimental Animation and Character Animation **(18.3)**. Other programs appeared internationally—for example, in 1971, Sheridan College, located near Toronto, began offering courses in animation. Students in these programs created short films on their courses and as graduation requirements, generally having a great deal of control over every component of production; the influx of these works added to the diversity of creator-driven productions entering the animation world.

became important figures in the animation industry. In 1990, the two promoters began a midnight movie selection, "Spike & Mike's Sick and Twisted Animation Festival," for works that were violent or in other ways potentially offensive. This series premiered significant new films, such as Mike Judge's *Frog Baseball* (1992), which introduced Beavis and Butt-Head to the world, and Danny Antonucci's *Lupo the Butcher* (1987), about a crazy meat-cutter. Spike and Mike also financed production of some of the films they screened, producing them through contracts with a number of associates based in Vancouver, Canada, including the animator Al Sens and the production company Bardel Entertainment.

Later, Mike Judge co-produced his own animation-festival events. He and Don Hertzfeldt first distributed "The Animation Show" in 2003, followed by three additional programs under this title in subsequent years. The Acme Filmworks producer Ron Diamond has distributed another traveling festival of short films, "The Animation Show of Shows," beginning in 1998. Diamond launched the venture two years after establishing Animation World Network online, with its affiliated *Animation World Magazine* and other Web publications, in 1996. AWN developed into an important online hub for news and information about all aspects of the animation world.

By the 1960s and 1970s, cinema schools were being established around the world and some of them—especially in film-industry centers—began to offer courses or entire degrees in animation. In the Los Angeles area,

Support for Short Films

Animation organizations and events have been essential for supporting the development of short, independently produced animation—if not financially, then through social networks. Artists feel a sense of accomplishment when they have finally completed an animated short and can show it in a festival venue among their peers and larger audiences. Some of these films go on to develop quite a following and gain notoriety for the creator; for example, one of the early cult classics is the one-gag comedy *Bambi Meets Godzilla*, an animated short of 1969 that is, as the film's title suggests, very dissimilar to the classic Disney movie starring the unfortunate deer. It was directed by the American Marv Newland, who later founded a Vancouver-based company, International Rocketship. Big studios, too, value festival participation. The National Film Board of Canada (NFB, see p. 177), probably the world's largest producer of festival films,

promotes its short works by entering them in events worldwide. To take but one example, the Canadian director Richard Conde's *The Big Snit* (1985) was a big festival favorite **(18.4)**. In this NFB film, a married couple argue while playing a game of Scrabble, unaware of the state of affairs just outside their home. Similarly, the NFB's *When the Day Breaks* (1999), co-directed by Wendy Tilby and Amanda Forbis, was highly awarded at festivals and became well known as a result **(18.5)**. The film, which focuses on a chance meeting and its impact on a character's life, was

18.6 Bill Plympton, *One of Those Days*, 1988

18.4 Richard Conde, *The Big Snit*, 1985

18.5 Wendy Tilby and Amanda Forbis, *When the Day Breaks*, 1999

created by first videotaping actors and then printing individual frames of action to paper. These images were modified by using oil-based drawing sticks to cover the figures and transform them into characters. For the NFB, participation in festivals helps in its mission to promote the culture of Canada worldwide, and in that respect its award-winning films have brought the country a great deal of prestige.

The American Bill Plympton's (1946–) films are also festival favorites and as a result have attracted the attention of advertisers wanting to promote their products using his unique style. For most of his career, Plympton created his films virtually single-handedly, using the most basic of materials: white bond paper, an ordinary No. 2 pencil, and whatever colored pencils he could buy at a low cost. These methods allowed him to work independently, alternating commercial production with self-financed shorts, such as *One of Those Days* (1988), which depicts the worst day in someone's life from a first-person point of view **(18.6)**, and *25 Ways to Quit Smoking* (1989), a guide to the most dangerous ways to kick the habit. These films tell their stories with deadpan humor and violent physical comedy. Plympton is unusual because he has been able to produce and direct a number of long-form films, beginning with his forty-two-minute *The Tune*, released in 1992, about a songwriter under

18.7 Cyriak, *Welcome to Kitty City*, 2011

he was a student at the University of California, Santa Barbara, was a great success on the festival circuit; it shows what happens when a child's toy turns bad. His next film, *Rejected* (2000), did equally well. It is a mock production reel showing sequences that were supposedly rejected by clients. The vignettes become increasingly absurd until the end, when the characters start to interact with the paper on which they are drawn. Hertzfeld prefers to shoot his films on 35mm, but he self-distributes it on DVD.

The Internet has become an important venue for the distribution of all types of animation, including short animated works. Because of it, every animation creator can exhibit his or her films to a potential audience, and also find others who share common interests. For example, in 2000 and 2001, respectively, the websites brickfilms.com and bricksinmotion.com were established as communities for LEGO animators, both beginners and experts; the sites include tutorials and interest groups, as well as links to brickfilms (stop-motion animations made with LEGO bricks) that appear elsewhere on the Web. Some animators choose to post work on the high-resolution video channel Vimeo, founded in 2004 by Jake Lodwick and Zach Klein, or the all-purpose YouTube, founded in 2005 by Steve Chen, Chad Hurley, and Jawed Karim. These channels highlight popular content-creators by organizing work and notifying subscribers when new films have been posted. Even though the amount of animation now on the Web is staggering, some animators have become online stars after posting their videos. One of them is the British artist Cyriak (Harris) (1974–), whose work is generally described as dreamlike and bizarre. As an example, the one-and-a-half-minute *Welcome to Kitty City* (2011), made with After Effects software over a two-week period, received almost one-and-a-half million views in the first two weeks it was online **(18.7)**. It features a caterpillar-like cat and parts of cats meandering down a street, accompanied by electronic sounds reminiscent of an early video game. Cyriak counts among his influences Terry Gilliam (see p. 270), Jan Švankmajer (see p. 306), Raoul Servais, and Zbigniew Rybczyński. Apart from uploading his films, Cyriak does not self-promote; his offers of work come as a result of people viewing this content online.[1]

The creation of web animation was facilitated by the development of the software known as Adobe Flash, which originated in the mid-1990s. Although it began

pressure and the odd characters he meets, and *I Married a Strange Person*, about a man who acquires unusual powers, released in 1997. At the heart of his practice, however, are the short films that he made at the start of his career and continues to make today. They are relatively fast to produce and so keep his work in the public eye, for both fans and potential employers to see.

Like Plympton, Don Hertzfeldt's (1976–) commitment to independent production has been aided by festivals. He uses simplified characters, generally consisting of stick-figure humans or outlines, and, also like Plympton, his films lean toward absurd or surreal humor, often incorporating violence. His film *Billy's Balloon* (1999), made while

as software more suited to simple graphics, over the years it has been updated to make it robust enough for series production. Among its early users online is John Kricfalusi, who employed it in one of the first animated series produced for the Internet: "The Goddamn George Liquor Program" (1997), which grew out of his Nickelodeon series "The Ren & Stimpy Show" (1991–96). By the late 1990s, several other studios were specializing in Flash production for the Internet. They include the Augenblick Studio, which has produced many animated series, and JibJab, which creates a number of animated products (such as cards and videos, many of them politically oriented) at its website. Both studios were founded in 1999.

Many animators who create short films work in relative solitude, with limited resources over long periods of time, basically doing everything on their own. These circumstances can take a toll, and many give up. For this reason, it is easy to see the value of arts organizations that have developed to support artists in the creation of animated films, providing a social network and moral support to independent production. For example, in Canada, the Quickdraw Animation Society (QAS) in

18.9 Helen Hill, *Recipes for Disaster: A Handcrafted Film Cookbooklet*, 2001

Calgary, Alberta (launched in 1984) and the Independent Imaging Retreat (known as "Film Farm," started in 1994) in Mount Forest, Ontario offer support for independent filmmakers by providing facilities and an opportunity to work with like-minded artists (18.8). The American filmmaker Helen Hill (1970–2007) attended Film Farm retreats in 1999 and 2000 before moving to New Orleans and continuing production on various projects there. Hill was a filmmaker who valued grass-roots, community-based filmmaking and a DIY (do it yourself) spirit. One of her projects was the compilation of *Recipes for Disaster: A Handcrafted Film Cookbooklet* (2001), a print collection of experimental techniques submitted by her filmmaker friends, revealing their personal approaches to working directly on film stock and hand-processing (18.9); the manual was funded by and launched at the SpliceThis! Super 8 Film Festival in Toronto in 2001.

Documentary and Autobiography

When they are below the radar of industrial production, creator-driven short films are free to explore any topic, and quite frequently that freedom results in introspective works focusing

18.8 Film Farm participants, 2015

on the artist's own life or issues of particular concern to the artist. Helen Hill's film *Madame Winger Makes a Film: A Survival Guide for the 21st Century*, from 2001, details methods of film production, but at the same time is highly personal. Her husband appears in the film, along with her pet pigs, and she also communicates her vegan values **(18.10)**. The director Sheila Sofian has specialized in documentary production tackling important social issues, at first with such animated shorts as *Survivors* (1997), a film about domestic violence, made in Conté crayon, and *A Conversation with Haris* (2001), rendered with paint on glass, in which an eleven-year-old Bosnian discusses his experiences in that country during wartime. Sofian's latest production, *Truth Has Fallen* (2013), is feature-length and uses paint on glass to tell the stories of three people who were convicted of murders they did not commit **(18.11)**. She worked on the film for many years, relying on a small community of fellow artists to assist her, and completing the film through a crowd-funding campaign.

Back in the 1950s, John (1914–1977) and Faith Hubley (1924–2001) had created a kind of social hub in New York City, in which both seasoned animators and a new generation came together and were encouraged to pursue independent animation. The Hubleys worked on personal films that often incorporated family

18.11 Sheila Sofian, *Truth Has Fallen*, 2013 (top image shows the artist at work)

18.10 Helen Hill, wearing a Super 8 T-shirt, and pet pig

members into both the stories and the production. One of their earliest independent works, the Oscar-winning *Moonbird*, released in 1959, relates a playtime adventure featuring the voices of their young sons Mark and Ray "Hampy" Hubley, as they try to trap an imaginary bird using candy **(18.12)**. The Hubleys' two daughters, Georgia and Emily, eventually became

18.12 John and Faith Hubley, *Moonbird*, 1959

animators; as children, they were featured in the Hubleys' films *Windy Day* (1968) and *Cockaboody* (1973), also built around their imaginative play.

Frank Mouris's *Frank Film* (1973) tells the director's life story through complex collages of magazine images accompanied by a dual soundtrack using his own voice (**18.13**); this film was made when he was a graduate student at Yale University, and it won an Oscar for best animated short. Joanna Priestley's *Voices*, released in 1985, is a cel animation that is also autobiographical in nature, but its visuals feature a rotoscoped image of the director's head, which metamorphoses according to the statements in her voice track (**18.14**); she made it as a graduate student at CalArts. George Griffin was part of the independent film community in New York City, where he worked with John and Faith Hubley, Michael Sporn (see p. 360), Tissa David, Candy Kugel, and Vincent Cafarelli, among others. Like Helen Hill, he published an anthology of fellow animators' works: *Frames: Drawings and Statements by Independent Animators* (1978) contains contributions from many short-film creators. Griffin's personal work often incorporates references to himself, as in *Head* from 1975, which employs a wide range of techniques to represent himself on screen.

Chris Landreth's short *Ryan* (2004) ostensibly documents an interview between the filmmaker and Ryan Larkin, an animator who had fallen victim to

18.13 Frank Mouris, *Frank Film*, 1973

18.14 Joanna Priestley, *Voices*, 1985

18.15 The character Ryan Larkin in *Ryan*, dir. Chris Landreth, 2004

substance abuse **(18.15)**. But the film veers toward autobiography as the interview progresses and the filmmaker realizes that it has been motivated by his own unresolved issues. Rather than relying on live-action reference footage, the film's 3D computer-generated imagery was all created through the imagination of the filmmaker in a highly subjective form of documentary known as "psychological realism." Produced by the National Film Board of Canada, *Ryan* won more than sixty awards, including an Oscar for best animated short film. Its producers include Steven Hoban, Marcy Page, and Mark Smith.

Also at the NFB, Torril Kove (1958–) has created a number of films that are based on personal, biographical stories. Her film *My Grandmother Ironed the King's Shirts* (1999) **(18.16)** is a humorous look back at her grandmother's life in Oslo, Norway during World War II,

18.16 Torril Kove, *My Grandmother Ironed the King's Shirts*, 1999

while *Me and My Moulton* (2014) tells of the pained existence she and her sisters endure because their artistic parents are "different" than those of normal families. Her Oscar-winning *The Danish Poet* (2006), a story set in the 1940s, is seemingly about the poet Kaspar Jørgensen and his search for love and meaning, but it also ties into Kove's own history; the film is an international co-production involving Mikrofilm AS in Norway, and was co-produced by Marcy Page and Lise Fearnley.

Many filmmakers embed personal experience in characters and narratives. For example, the German animator Andreas Hykade (1968–) did so in an autobiographical series, "The Country Trilogy"—*We Live in Grass* (1995), *Ring of Fire* (2000), and *The Runt* (2005)—based on his difficult childhood in the Bavarian countryside. His films are inhabited by bare-bodied, stick-like women and children and big, blocky males with their genitalia exposed. These characters live in a simply rendered, harsh land, surrounded by elements of horror, such as the killing of animals and other violence, as well as innocence and dark humor. *We Live in Grass* was created when Hykade was a student at the Filmakademie Baden-Württemberg and was well received in festivals, as were the other two films, made after he graduated. The film begins with harsh words from his father, narrated by a child, as the scene quickly zooms into a domestic space, where a mother unwillingly breastfeeds her three hungry offspring. The father sits apart, surrounded by a number of objects, until the mother enters his space with yet another child—the narrator—swaying from its umbilical cord. The film continues to explore this tension-filled world, using images that are at times beautiful, providing a mixed experience for the audience.

Women and Authorship

In the field of animation, women have historically been less prominent than men. Since the 1970s, however, they have had a growing presence as students in college animation programs and at festivals. Some efforts were made to support women through such organizations

as the Women's Independent Film Exchange (WIFE), founded by Cecile Starr (1921–2014) in 1977 to raise public awareness of female filmmakers, including Mary Ellen Bute, Tissa David, and Storm de Hirsch. A few years later, in 1982, a number of women from the Los Angeles area united to create a guide they called WANDA, for Women's Animation Network Directory Alliance. Its objective was to share expertise and job-search information.[2] One of the women involved was Ruth Kissane (1929–1990), who was among the most accomplished women in the Hollywood animation industry at the time. She had been employed by all the major studios, including Disney, Playhouse Pictures, Film Roman, and Chuck Jones Enterprises, but she may be best known for her work on the "Peanuts" TV specials at Bill Melendez Productions. Kissane worked in design, layout, animation, and even directing. Another WANDA participant was the Croatian artist Marija Miletić Dail, who had begun working at Zagreb Film (see p. 175) before opening her own studio, Animation Cottage, in the Los Angeles area in 1989. Miletić Dail was also employed by Universal Studios, Marvel, Hanna-Barbera, Film Roman, and DiC Entertainment. In 1993, another organization, Women in Animation, was founded by the American Rita Street, onetime editor of *Animation Magazine*; WIA is now international in scope, with branches in several cities.

During the 1970s, animation programs saw an increase in the enrollment of women, and many of them, including Christine Panushka and Kathy Rose, were interested in making films that focused on gender issues, identity, and domestic or creative spaces. One example is the American animator Suzan Pitt (1943–), whose short film *Asparagus* (1979) features a character who is rotoscoped and has no face—only a mask she ties on her head when she leaves her room—and phallic images of asparagus stocks. The film employs mixed-media animation techniques, from drawn animation to stop-motion. The French-born Monique Renault (1939–) studied painting at the École Nationale Supérieure des Beaux-Arts in France, learned to animate in Prague, and became an animation director at Studio AAA, founded in Paris in 1973. Renault's personal films are generally engaged with issues of gender. Examples include *All Men Are Created Equal* (1987), produced by Channel 4 in the UK for a series called "Blind Justice," exploring women's experiences with the law in the UK, and *Salut Marie* (1997), which is a revisionist version of the biblical story of the Annunciation.

Faith Hubley's first solo film, *W.O.W. (Women of the World)* (1975) **(18.17)** looks at the role of gender in the history of the world, incorporating images from many cultures. Ruth Kissane worked as an animator on this film and other Hubley work, as

18.17 Faith Hubley, *W.O.W. (Women of the World)*, 1975

18.18 Emily Hubley, *Delivery Man*, 1982

did members of Hubley's family. From 1977 to 2001, Emily Hubley worked on her mother's films and began pursuing her own career in the field. Her first film after college, *Delivery Man* (1982), was based on a dream diary she was keeping, and focused on the death of her father (18.18). After creating short films on varied topics, many of them personal in nature, she embarked on a feature-length live-action and animation combination film, *The Toe Tactic* (2008), which also tells a story about grief, focusing on a young woman

and the animated dogs that try to help her. Much of Emily Hubley's work is in the permanent collection of the Museum of Modern Art in New York City.

Sally Cruikshank (1949–) was an animator at the San Francisco Bay Area production house Snazelle Films when she directed her film *Quasi at the Quackadero* (1975) (18.19). The film's aesthetics are an amalgamation of classical animation of the 1930s and a modern, psychedelic sensibility, as her characters— Quasi, Anita, and Rollo—visit an unusual amusement park where they experience time travel, machines that are able to visualize thoughts and dreams, and a huckster psychic who claims to be able to see past lives. In the course of these experiences, Anita takes care of a bad relationship with Quasi, aided by her sidekick Rollo. The constant movement of the characters recalls the early aesthetic of the Fleischer studio (see p. 110), while the boldly patterned environments and adult humor reflect the contemporary, mid-1970s context. The underground cartoonist Kim Deitch, son of the director Gene Deitch, was Cruikshank's partner; he was an animator on the film and provided the voice of the Quasi character. It is now included in the National Film Registry in the United States.

The American Caroline Leaf (1946–) is another groundbreaking female animator. Her short films emerged on the festival circuit in the 1970s, after she had the opportunity to work at the NFB in Canada, where she made a paint-on-glass film, *The Street* (1976). Based on a short story of the same name by Mordecai Richler, it tells of a child's perspective on

18.19 Sally Cruikshank, *Quasi at the Quackadero*, 1975

18.20 Caroline Leaf, *Two Sisters*, 1991

the death of his grandmother through images painted on a pane of glass. Leaf went on to create other films, using a variety of techniques. By scratching images directly onto 70mm color-film strips, she created an ideal setting for her direct film *Two Sisters* (1991), which tells the story of siblings who will not leave their house **(18.20)**. One of them, an accomplished author, has a facial disfigurement, but in fact it is the other sister who is afraid of the world outside. The scratch method allows Leaf's characters to emerge out of a dark space that defines their interior environment. Before working at the NFB, Leaf had attended Harvard University, where she made her first animated film in 1968, using sand. Aptly named *Sand, or Peter and the Wolf*, it retells the classic story of a boy and his confrontation with the fearsome creature, found in Sergei Prokofiev's musical composition of 1936. The same story is told in a completely different way by the British stop-motion animator Suzie Templeton (1967–). Templeton's *Peter and the Wolf* (2006) won an Oscar for best animated short. Her figures act through the hands, head, and especially eyes, relating story information through the visual cues of body language.

During the 1990s, the British TV network Channel 4 commissioned a number of British women to make animated shorts for broadcast that were later successful at many festivals. As a result, Joanna Quinn and Candy Guard created films that explore female experience, such as *Girls' Night Out* (1987) **(18.21)** and *I Want a Boyfriend . . . Or Do I?* (1992). Guard's short films led to a commission for a Channel 4 series, "Pond Life" (1996), in which a neurotic character, Sally Pond, has a lot to complain about. The character is voiced by Sarah Ann Kennedy, an actor and animator, who created her own series, "Crapston Villas" (1996–98), an animated soap opera that aired on the same channel. Allison de Vere (1927–2001) was another of the Channel 4 animators. She began her career doing backgrounds for the Halas & Batchelor studio in 1951. Later, she joined London's TVC studio, and in 1967 she worked on backgrounds for *Yellow Submarine* (dir. George Dunning, 1968, see p. 269), based on designs by Heinz Edelmann. The development of her almost twenty-minute film *The Black Dog* (1987), produced by Channel 4, was a process of self-discovery for de Vere; in the film, she explores her own sense of identity, led by a dog that enters her dream world. The relatively large number of animated shorts produced by women at the time was the result of the efforts of Clare Kitson, who was the Commissioning Editor for Animation at Channel 4 during this period.

18.21 Joanna Quinn, *Girls' Night Out*, 1987

18.22 Nazlı Eda Noyan, *A Cup of Turkish Coffee*, 2013

Nazlı Eda Noyan's (1974–) autobiographical short *A Cup of Turkish Coffee* (2013), co-directed by Dağhan Celayir, tells of a girl who is forced into an early marriage but nonetheless remains strong **(18.22, see p. 328)**. Many years later, as an old woman, she drinks a cup of coffee with her granddaughter, and looks through photographs, somewhat unwillingly discussing her past. This film was an international co-production, involving resources in both Turkey and France. Pre-production (including video shoots for rotoscoping and storyboard) and **post-production** (including sound design, music, dubbing, and color) were done in Istanbul by Gulen Guler, at her company Yalan Dunya. The animation was carried out at JPL films, located in Rennes and headed by Jean-Pierre Lemouland.

After creating a number of animated shorts, the filmmakers Nina Paley (1968–) and Signe Baumane (1964–) have brought their exploration of personal themes into long-form productions. Paley's eighty-two-minute *Sita Sings the Blues* (2008) was almost completely self-created using Flash animation and was largely funded through donations **(18.23)**. The film depicts an adaptation of the Ramayana, the ancient Sanskrit epic about the separation of Rama from his wife, Sita. The work combines historical details surrounding that text with the animator's own real-life situation after her husband move to India to work on animation, and then declared their relationship to be over. Accompanying the visuals are Jazz Age vocals by Annette Hanshaw, which ultimately caused Paley a great deal of much-publicized difficulty relating to the rights and her inability to pay a licensing fee for the music.

The Latvian animator Signe Baumane has worked in New York City for many years, assisting on the production of films by Bill Plympton (see p. 319) and other filmmakers as well as creating many of her own, often dealing with nature and sexuality. Her feature-length *Rocks in My Pockets* (2014), promoted as "a funny film about depression," focuses on the battle against the condition that she shares with other women in her family **(18.24)**. Baumane created the eighty-eight-minute film over a period of four years, using hand-drawn characters placed on photographs of

three-dimensional sets that were made of painted papier-mâché, cardboard boxes, and plywood. She narrates the film herself. Baumane is among the animators who have been featured at the Tricky Women Festival in Vienna, Austria. Since 2001, this event has showcased the work of female artists, and it also runs workshops and an artist-in-residence program. Organized by a team of women including its directors, Waltraud Grausgruber and Birgitt Wagner, the event is held in March each year.

As women find it easier to enter mainstream production in America, short films serve as stepping-stones for their advancement as well. The stop-motion director and animator Kirsten Lepore (1985), for example, began with short subjects, such as her CalArts thesis film *Bottle* (2010), which shows an ill-fated romance between a creature made of snow and another made of sand. Partly based on her success at festivals, she was hired to create stop-motion promotions for Google, Motorola, Nestle, and other clients. She also was commissioned by the

18.24 Signe Baumane, *Rocks in My Pockets*, 2014

Nickelodeon TV network to direct the *Bad Jubies* (2015) episode of its popular "Adventure Time" television series, using stop-motion figures rather than the show's normal 2D approach, as the two main characters, Jake and Finn, face some very bad weather.

Formal and Technical Experimentation

The content of short films has been notably wide-ranging, since its producers are freed from the constraints of industrial production. Aesthetically, animated shorts have explored a variety of design concerns, playing with laws of gravity, geographic proximity, continuity of time, and perspective, which are all subject to investigation and reinterpretation. For example, the German director Raimund Krumme's characters move through the frame in ways that alter our understanding of perspective.

18.23 Nina Paley, *Sita Sings the Blues*, 2008

In his film *Die Kreuzung* (*The Crossroads*, 1991) his characters—identical men in black suits—meet at the intersection of lines, walking under, over, and through areas of constantly shifting space. The Dutch animator Paul Driessen also directed a series of films that explored space, but this time by breaking narratives into scenes that are both separate and united. His films *Ter Land, ter Zee en in de Lucht* (*By Land, by Air and by Sea*, 1981) and *The End of the World in Four Seasons* (1996) **(18.25)** divide the frame into parts, using sound design to guide the audience's attention, whereas *3 Misses* (2000) weaves together three thematically linked narratives. Space is manipulated in *Fast Film* (2003), directed by the Austrian Virgil Widrich (1967–), who in this case creates a single narrative by seamlessly blending images from a number of sources into one. Widrich's characters are taken from classic live-action films, in the form of still frames printed onto paper; these photographic images were then cut and folded before being employed as animated figures. The film was an Austrian–Luxembourgian co-production.

While the running times of industrial animated productions are prescribed by the context in which they are to be screened (perhaps ninety minutes for an animated feature, twenty-three minutes for an American half-hour television episode, and so on), creator-driven short films may be virtually any length. Alexey Alexeev's two-minute *KJFG No. 5* (2007) would not necessarily fit into a traditional television time slot, but it is perfect for a festival. The film is a comedy involving a bear, a rabbit, and a small wolf who put together a band in the forest. The Internet now offers the same kind of flexibility for short works. The animator PES (Adam Pesapane) (1973–) has posted his numerous short stop-motion films on his website, but also enters them in competitions. His two-minute *Fresh Guacamole* (2012) was nominated for an Oscar, the shortest film in history to be so honored. It shows the making of an avocado dip using incongruous ingredients, such as a grenade that has a soft green inside and a tomato pin-cushion that is sliced into tiny red dice. Both of these short films tell stories only in the most minimal ways, and yet they are crowd-pleasers because of their ingenuity.

Technical variety has been another hallmark of festival films, with some creators becoming well known for their use of particular techniques. Who can forget the German animator Thorsten Fleisch, whose short film, *Blutrausch* (*Bloodlust*, 1989), was made by

18.25 *The End of the World in Four Seasons*, directed by Paul Driessen and produced by Marcy Page, 1995

adhering his own blood to the surface of filmstrips? In contrast, to create *Peyote Queen* (1965), Storm de Hirsch used a range of techniques, including scratch-on-film abstractions and live-action footage composited through optical printing. It was a favorite at midnight movie screenings, as it celebrated psychotropic drug use and the concept of expanded consciousness—popular topics of the 1960s. Adam Beckett (1950–1979) was known for his expertise in optical printing, which he used first in his animated shorts, such as *Flesh Flows* **(18.26)** and *Sausage City*, both student films from CalArts made in 1974; they reflect his style of perpetual metamorphosis in organic imagery. Beckett later employed his printing skills professionally, creating visual effects for *Star Wars IV: A New Hope* (1977) and other films. Stacey Steers worked in the traditions of collage animation. Her *Phantom Canyon* (2006) uses more than 4000 figures from Eadweard Muybridge's nineteenth-century studies of human and animal locomotion (see p. 21) in depicting a woman's experience of memories **(18.27)**.

18.27 Stacey Steers, *Phantom Canyon*, 2006

The Welsh painter Clive Walley is known for his use of a multiplane rig of his own design, which not only facilitates the animation of imagery, but also becomes part of the visuals. His film *Brushwork* (1993), which explores the process of painting, begins with a view of the artist's easel **(18.28)**. After some strokes of paint are quickly brushed into view, the camera zooms into the surface, in fact shifting to his multiplane rig. By constantly pulling planes of glass toward the camera, after removing the top ones in succession, Walley creates the impression of travel in deep space.

The cel method dominated the production of industrial animation for many years. The Austrian Frédéric Back used a different kind of cel in a different way: frosted sheets with a toothed surface he could draw on, using colored pencils, and varnishing them to make them clear. Using this technique, Back created magnificent drawn animation for Radio-Canada, the

18.26 Adam Beckett, *Flesh Flows*, 1974

18.28 Clive Walley, *Brushwork*, 1993

18.29 Frédéric Back, *The Man Who Planted Trees*, 1987

French-language service of the Canadian Broadcasting Corporation (CBC). His short film *Crac!* (1981), and the thirty-minute *The Man Who Planted Trees* (1987) (18.29), which both won Oscars, reflect Back's longtime devotion to environmental issues. *Crac!* shows how the rich natural environment of Quebec has been all but destroyed by modern development. His most famous film, *The Man Who Planted Trees*, depicts a story by Jean Giono about a shepherd in France who reforested a vast barren region. Back planted many trees on his own property and also devoted personal resources to education and action related to the environment.

Developing Stop-Motion Worlds

A final topic to consider is stop-motion, a vast realm in terms of short films in general and festival films in particular. In recent years it has been more widely used for feature productions: for example, in Wes Anderson's *Fantastic Mr. Fox* (2009) and several from Aardman, commencing with *Chicken Run* (dir. Peter Lord and Nick Park) in 2000. One of the most influential stop-motion features of all time is *Tim Burton's The Nightmare*

before Christmas, a film of 1993 directed by Henry Selick, employing a story and design elements from Tim Burton (1958–). Burton's style in this film was manifest in animated shorts he had directed more than ten years before. As a student at CalArts, he had made the 2D animated film *Stalk of the Celery Monster* (1979), about a crazed doctor. Although it was made in 2D, rather than stop-motion, its design looks ahead to Burton's mature style, which emerges in two short films he made at Disney, *Vincent* (1982) (18.30) and *Frankenweenie* (1984). Both films are dark comedies involving diabolical experiments on a dog, animated through stop-motion. *Vincent* tells the story of a boy who is obsessed with the stories of Edgar Allan Poe and imagines he is Vincent Price—the actor who narrates the film. The character of the boy, Vincent, which was animated by Stephen Chiodo, bears a resemblance to Burton and is typical of his characters, with large eyes, small pupils, an elongated, heart-shaped head, and thin arms and legs. This design style is apparent in Tim Burton's later stop-motion features, *Corpse Bride* (co-directed with Mike Johnson, 2005) and the feature-length *Frankenweenie* (2012). Incidentally, this stylistic consistency also applies to Burton's live-action features: for example, *Edward Scissorhands* (1990), which also involves Vincent Price.

In contrast, some artists draw on vastly different styles when developing their short films and their industrial, commissioned work. Like Burton, Henry Selick (1952–) attended CalArts. His hand-drawn student film *Phases* (1977) is powerful in its graphic design; it depicts stylized humanoid figures walking across the screen in cycled movements, reflecting Selick's

18.30 Tim Burton, *Vincent*, 1982

skill in drawing as they metamorphose into a series of animals engaged in stylized battles. Selick's independent short *Seepage* (1982) features human-size articulated puppet figures, paranoid characters who engage in a disjointed conversation. The experimentation evident in these two films contrasts greatly with his character-driven stop-motion features, including *James and the Giant Peach* (1996) and *Coraline* (2009).

The Brothers Quay and Barry Purves intricately design and film their stop-motion shorts as though their characters were on a live-action set. If you have seen their films, the fact that these animators are also engaged in theatrical stage design comes as no surprise. Stephen (1947–) and Timothy Quay (1947–), twins known as the Brothers Quay, had been making animated shorts for about seven years when their twenty-one-minute stop-motion film *Street of Crocodiles* brought them international attention in 1986. It is based on a short novel of the same name by the Polish author and artist Bruno Schulz, who was killed by the Nazis in 1942, focusing on his memories of childhood and experiences in his father's shop. *Street of Crocodiles* is a highly cinematic film, with space and lighting utilized in sophisticated ways and fluid cinematography of images cut to a haunting score by Lech Jankowski and sound design by Larry Sider. The film depicts a strange male puppet figure who wanders inside a decaying world, confronted by eerie dolls that dance around him, as well as a range of other disconcerting images. Like the Quays' other animated productions, it reflects the influence of Eastern European artists, including the Czech animator Jan Švankmajer (see p. 306) and the Polish poster designer and animator Jan Lenica (see p. 270). *Street of Crocodiles* was made at Koninck Studios, which the brothers formed in 1980 with the producer Keith Griffiths, whom they met as students at the Royal College of Art in London.

Working at the Aardman studio in the late 1980s, the British animator Barry Purves (1955–) started to create a series of stop-motion films inspired by theater. He began with a performance by the Bard himself, William Shakespeare, in *Next* (1989), which was commissioned by Channel 4. In it, Shakespeare transforms into various characters within a relatively simple stage space, trying to impress another character—the theater director, representing Sir Peter Hall, who founded the Royal Shakespeare Company and directed the National Theatre in England. By

18.31 Barry Purves, *Rigoletto*, 1993

the time Purves directed *Rigoletto* (18.31) in 1993 for the British TV network S4C/BBC2, his stage had become much more elaborate, including a number of characters moving in unison to the music of Giuseppe Verdi, performed by the Welsh National Opera.

In 1989, the twin brothers Wolfgang (1962–) and Christoph Lauenstein (1962–) demonstrated that minimal set design and sound could also be compelling. Their Oscar-winning film *Balance* depicts five almost identical characters standing on a platform suspended in space. Using only a few sounds and movements, the men go through their routine activities until their placid lives are interrupted by a new object that throws their world into chaos.

The term "claymation" is now widely used to describe animated productions made with plasticine, but the term actually originated at a studio run by Will Vinton (1947–) in Portland, Oregon. In 1974, Vinton co-directed the clay animation *Closed Mondays* with Bob Gardiner (1951–2005), and the duo won an Oscar for their animated short (18.32, see p. 334). The film tells the story of a drunken man who stumbles into a gallery and interacts with the paintings there. Vinton and his studio may be best known for a series of commercials promoting California raisins, which began in 1986 and featured caricatures of such music stars as Ray Charles and Michael Jackson. The ads employed the song "I Heard It through the Grapevine," sung by Buddy Mills, and the characters (four raisins, named

18.32 Will Vinton and Bob Gardiner, *Closed Mondays*, 1974

AC, BeeBop, Stretch, and Red) **(18.33)** went on to star in a variety of television entertainment projects.

Clay has been used in various ways, reflecting the style of individual animators. Joan Gratz (1941–) was among the artists who worked at the Vinton studio, and she specialized in a technique she calls "clay painting," which employs oil-based clay that moves relatively frequently, somewhat like paint. She received much recognition for her short *Mona Lisa Descending a Staircase* (1992), which depicts great works of twentieth-century art linked through metamorphic transitions **(18.34)**. Gratz won an Oscar for the film, and continued using the clay-painting technique in other works, including commercials. She also used it in *Pro and Con* (1993), a short mixed-media film she co-directed with

Joanna Priestley—an animated **docudrama** about prison life seen through the eyes of a prisoner and a corrections officer.

The metamorphic quality of clay is also emphasized in the work of Bruce Bickford (1947–), but with very different results. Bickford became well known for his collaboration with Frank Zappa on the rock star's Baby Snakes music video, released in 1979, but his personal aesthetic is most apparent in *Prometheus' Garden*, the almost half-hour-long film he completed in 1988. Images in *Prometheus' Garden* transform in unpredictable ways, as clay figures emerge out of landscapes, change into other forms, and implode. Often, the camera is brought in so close to the clay that its material nature is emphasized through cracks and a clear view of its

18.33 Will Vinton, The California Raisin Band, c. 1989

18.34 Joan Gratz, *Mona Lisa Descending a Staircase*, 1992

18.35 Nick Park, *Wallace & Gromit: The Wrong Trousers*, 1993

surface texture. The soundtrack, composed of a variety of sound effects, is futuristic and not synced, creating additional ambiguity. The world Bickford creates is intense, hallucinatory, and even nightmarish.

During the late 1980s and 1990s, the British animator Nick Park (1958–) brought clay animation into the spotlight with a series of films including *Creature Comforts* (1989), a short featuring interviews with zoo animals. Also celebrated are his series of four thirty-minute films involving the characters Wallace and Gromit, which he developed when he was a graduate student at the National Film and Television School in the UK. Among them is *Wallace & Gromit: The Wrong Trousers* (1993), which depicts a jewelry heist organized by a conniving penguin **(18.35)**.

Adding to the swell in stop-motion's popularity are a number of shorts by the Australian animator Adam Elliot (1972–). Elliot's films bring us into his personal world, beginning with a trilogy based on his family: *Uncle* (1996), *Cousin* (1998), and *Brother* (1999), films the artist made by himself, working alone on sets constructed in his father's storage unit. Each film relates a story about challenges faced by these individuals, and all three are narrated in voice-over by the Australian actor William McInnes. *Uncle*, running six minutes in length,

was created while Elliot was a student at the Victoria College of the Arts (VCA) and won an Australian Film Institute (AFI) Award in the short film category. In this film, he established his minimalistic aesthetic, with sparse backgrounds and lighting, and little animated movement; he also set the tone for his future work, which takes on the theme of disability directly, in both poignant and lovingly humorous ways. He shot on color film stock, but used a grayscale palette for his set, to create the effect of a black-and-white film; however, certain

18.36 Adam Elliot, *Cousin*, 1998

18.37 Adam Elliot, *Mary and Max*, 2009

objects (like the red tongue of a lizard in *Brother*) were highlighted by being in color. Despite its pared-down aesthetic, the work remains compelling, partly owing to its strong character development and storytelling, including McInnes's performance. Elliot's trilogy was very successful at festivals, winning top prizes in Australia and worldwide, and increasing his ability to get government funding for future projects. Based on the success of *Uncle*, the AFI funded Elliot's following film, *Cousin* (18.36, see p. 336). It, too, was shot on film in his father's storage unit, but it was edited digitally. Elliot's next, *Brother*, was funded by the Australian Film Commission and SBSi, an organization formed in 1994 to commission work from independent Australian filmmakers. *Brother* was awarded AFI prizes for Best Australian short and best Australian short screenplay.

Elliot then began to embark on longer-format films. First came the twenty-three-minute *Harvie Krumpet* (2003), also based on a real person, Harvek Milos Krumpetzki, who was born in Poland in 1922, struck by lightning, and afflicted with Tourette syndrome.

Thematically, the film remains in Elliot's style, presenting an intimate study of his character's condition with compassion and humor, but widespread color is used, and for the first time a video-assist system allowed tracking of animated movement by keeping a record of every shot he took. Also new, this film is narrated by the Australian actor Geoffrey Rush. Elliot gained a crew as well: a full-time producer, Melanie Coombs, and two model-making assistants, Michael Bazeley and Sophie Raymond. After *Harvie Krumpet* won an Oscar (and more than a hundred other accolades), Elliot was approached by several industrial studios wanting to work with him, but he was determined to remain independent. And he did, even though his next project, *Mary and Max*, released in 2009, is a feature-length film, this time inspired by Elliot's real-life pen pal (18.37). It tells the story of a lonely young Australian girl who finds a pen-friend in an autistic man living in New York City and their correspondence over a period of twenty years. *Mary and Max* premiered at the Sundance Film Festival on the event's opening night.

Conclusion

The perseverance and accomplishments of animators creating short, independently produced works sustains the vitality of the animation world. Displayed at festivals, animated shorts provide a link to innovators who are guiding the future of the field and inspire newcomers to develop their own works. Ironically, this important sector of animation production is difficult to sustain, owing to a lack of funding and the lack of venues outside the festival circuit for their exhibition. Some far-sighted institutions, such as the National Film Board of Canada, have a history of financing animation and as a result have enabled production of significant works in the field that have garnered prestige for both the NFB and the country as a whole.

There was no single development that sparked the growth of animation that occurred in the 1980s and 1990s. At the same time that short film production and festivals were increasing in number, there were big changes taking place in features, television, and games. In the realm of features, The Walt Disney Studios emerged from a number of years of relative stagnation to re-imagine itself under new leadership. A period known as the Disney renaissance ensued, resulting in renewed interest in animated-feature production at the studio, but also a push into a multitude of new directions. As Disney's profits increased, newcomers flocked to the field to try to cash in on what appeared to be a very lucrative opportunity. Meanwhile, the public became familiar with the names behind new developments in industrial animation, in a return to a kind of creator-driven sensibility that can be traced back to the days of Winsor McCay and the hand of the artist.

Notes

1 Hugh Heart, "The Cyriak Method: How to Turn Madness into Millions of Youtube Views," *Fast Company.* Online at: http://www.fastcocreate.com/1679134/the-cyriak-method-how-to-turn-madness-into-millions-of-youtube-views

2 WANDA information courtesy of Prescott Wright. The women on "The Committee" were Kathy Barrows, Carole Beers, Marija Dail, Ruth Kissane, and Rosemary O'Conner.

Key Terms

2D animation
cel
collage
docudrama
festival film
multiplane rig
post-production
stop-motion
voice-over

CHAPTER 19

The Disney Renaissance

Chapter Outline

Global Storylines

The Disney studio loses direction after Walt Disney's death in 1966, but in the 1980s new management brings about significant changes

The Disney renaissance occurs between 1989 and 1999, when the studio's animated features experience renewed popularity

Beauty and the Beast and *The Lion King* are the most prominent and profitable films of this period

Animated features become less profitable by the late 1990s, and the Disney management opts to close its 2D animation studios and concentrate on distributing CGI animated features, beginning with the landmark Pixar film, *Toy Story*

Introduction

The history of The Walt Disney Studios is characterized by many pivotal events, but among the most significant, surely, was Walt's death in 1966, which set off a chain reaction that was to propel the studio into a new era of media production. The changes at the studio were mirrored by larger shifts in the Hollywood film business. During the 1970s and 1980s, the industry as a whole had been overtaken by a new breed of executive—not the old-time, family-style owners, such as the Warners, Fleischers, or Disneys, but money-minded executives who collectively ushered in the "blockbuster generation" of high-profit filmmaking. At Disney and elsewhere, these new administrators thought about films in different ways and promoted them differently as well. For one thing, they paid more attention to the increasingly significant youth market, looking for projects that would appeal to its interests. Another important change came in the form of promotion, as advertising budgets rose dramatically to bring in big box-office returns. At the same time, promoters suddenly realized the potential of merchandizing products to bring in significant revenue, especially after the concept of franchising became important to Hollywood production. The home-video market, which grew in the mid-1980s, opened up entirely new revenue streams.

The blockbuster mentality was introduced largely with the live-action feature films of Steven Spielberg (1946–) and George Lucas (1944–), two directors of a new film-school generation that had studied filmmaking in college rather than training as apprentices in the industry. Spielberg's *Jaws* (1975) was unique for the time because it was widely promoted on television as

well as through the normal channels of print advertising; it was also "released wide," meaning that it was screened in many theaters at the same time. As a result, it quickly brought in more than $100 million, the biggest, fastest return Hollywood had ever seen, setting the bar for future blockbusters. Two years later, George Lucas's *Star Wars IV: A New Hope* far surpassed even *Jaws'* accomplishments. Not only was it a huge blockbuster in terms of box-office returns, it also proved the great value of merchandizing and franchising **(19.1)**. Relatively little value had been placed on merchandizing rights until Lucas, who had retained them, made a fortune with "Star Wars" products. He wisely retained the rights for "Star Wars" sequels, too, and as a result eventually created one of the most profitable franchises in history.

Walt Disney had certainly been aware of the benefits of promotion and merchandizing since Mickey Mouse products were first created in the early

19.2 Hong Kong Disneyland Resort, 2005

1930s. But, in the mid-1950s, he launched his most sophisticated marketing development, the Disneyland theme park in Anaheim, California (see p. 263). After Walt died, the company continued to develop theme parks, opening the Florida-based Walt Disney World Resort in Orlando in 1971 and the EPCOT Center in 1983, both of which Walt had helped to plan. In 1983, the first international destination was established with the Tokyo Disneyland Resort, in Japan, followed in 1992 by the Euro Disney Resort outside Paris, France, and in 2005, by the Hong Kong Disneyland Resort **(19.2)**, with yet another park due to open in Shanghai, China in 2016. Disney also began offering a resort experience on the open sea, eventually in its own cruise ships: *Disney Magic* (from 1998), *Disney Wonder* (from 1999), *Disney Dream* (from 2011), and *Disney Fantasy* (from 2012) **(19.3)**. The theme parks and cruise ships are very profitable, and at the same time they

19.1 "Star Wars" collectible figures, 1977

19.3 The cruise ship *Disney Magic* off St. Thomas Island, USVI, Caribbean

develop a loyal consumer base for Disney products: for the public, these attractions represent the "happiest place on earth," where such characters as Mickey Mouse and Cinderella become more than drawings: they come alive and interact with visitors, creating an immersive, memorable, pleasing experience that is evoked whenever consumers encounter their products.

Much of Disney's expansion came about after the studio experienced a period of growth known as the Disney renaissance, guided by new studio executives, including Michael Eisner, who was The Walt Disney Company's chief executive officer from 1984 to 2005, and Jeffrey Katzenberg, who was chairman of The Walt Disney Studios from 1984 to 1994, overseeing the production of films. They helped usher in this prosperous period, which marks a window of development for Disney 2D animation, beginning with *The Little Mermaid* (dir. Ron Clements and John Musker) in 1989 and ending with *Tarzan* (dir. Chris Buck and Kevin Lima) in 1999, with two of its high points being the release of *Beauty and the Beast* (dir. Gary Trousdale and Kirk Wise) in 1991, and especially *The Lion King* (dir. Roger Allers and Rob Minkoff) in 1994.

At the same time, Disney's new executives initiated an expansion. For example, they acquired and established a number of animation studios across the world, including Disney Animation Australia in Sydney (the old Hanna-Barbera shop) in 1988; Disney Animation France in Paris and Disney Animation Japan in Tokyo, both in 1989; and Disney Animation Canada in Vancouver and Toronto in 1996. These studios created a range of animated productions, from television series to **direct-to-video (DTV)** releases and features. In 1989, Walt Disney Feature Animation Florida opened in the back lot of the Disney-MGM Studios theme park, part of the Walt Disney World Resort, allowing visitors to watch animators at work. Among the most significant moves of the renaissance period came in 1995, when The Walt Disney Company merged with Capital Cities/ABC, in one of the largest corporate takeovers ever, paying $19 billion to create an extremely powerful media and entertainment conglomerate. Gone were the days when animation production was central to Disney's profits—or even understood by most of its executives. Reconfiguring company goals and even releasing employees or closing entire production units quickly became a business strategy, undertaken with little regard for the studio's legacy.

The 1980s and 1990s were a time of great change in the animation world, and Disney was affected along with the rest of the industry. As the popularity of animation soared in the early 1990s, new studios emerged to cash in on the promise of big profits; and just as quickly, many of them were forced to close. During this time, The Walt Disney Studios experienced great shifts in production methods and leadership, as it transitioned from a family-owned, animation-focused entity into a complex corporate enterprise.

Before the Renaissance: Challenges to Disney's Reputation

The End of a Family Business

After Walt Disney died in 1966, the studio suffered a long period of difficulty. His brother, Roy O. Disney, who had been an executive in the studio from its start, returned to the studio to take over Walt's role, but when he died in 1971, the positions of chief executive officer and president were filled by two men from outside the family, first Donn Tatum and then Card Walker. They were followed by Walt Disney's son-in-law, Ron Miller (1933–), in the position of president (1980–84) and CEO (1983–84). Under Miller's leadership, the company successfully broadened its audience by establishing a new brand name, Touchstone Films, in 1983; the label, later renamed Touchstone Pictures, represented PG-rated (parental guidance recommended) films containing potentially scarier or more mature content, as opposed to Disney's usual fare of G-rated films for general audiences. But in other ways the company floundered, to the point where some of its top artists—including Don Bluth—made a dramatic exit in 1979, opening their own studio and declaring that they would restore animation to the level of Disney's work in the past. This was just the beginning, however: by 1984, the company had become economically vulnerable, and was subjected to an aggressive hostile takeover attempt by the corporate raider Saul Steinberg, which was only averted through an expensive buyout of his stocks. In the process, it had become evident that Ron Miller would be replaced.

At the time of Walt Disney's passing, Ron Miller had been an executive in the studio, and he continued moving up, becoming president of Walt Disney Productions in 1980 and CEO in 1983. When Miller started at the company in the mid-1950s, shortly after he married Disney's daughter, Diane, he had no background in business or the film industry. He had dropped out of college, spent time in the military, and started a career as a professional football player, though he gained experience in both producing and directing when he started working on the development of Disneyland and then continued to move higher in the organization. The move to replace Miller in 1984 had been organized by Roy E. Disney (1930–2009), the son of Roy O. Disney, who had a seat on the board of directors and would continue to play a significant role in studio management through the Disney renaissance.

Competition from Outside: Don Bluth

Throughout film history, the word "animation" has been synonymous with Disney in the minds of many people. More specifically, it suggests the 2D full-animation style employed in the studio's feature-length animated films. But despite this popular impression, the Disney studio was not above reproach. Indeed, the departure of Don Bluth (1937–) and other artists from the studio in 1979 had sent a strong message to its board of directors, as well as the financial community, that Disney was having trouble. Bluth had begun his career in animation at Disney in the mid-1950s, working on *Sleeping Beauty* (1959), though he left and had various other jobs, including a stint at Filmation in the late 1960s, before returning to Disney a few years later, in 1971. In 1979, when he left again to start his own company, Don Bluth Productions, he was accompanied by a number of other Disney artists, including Gary Goldman and John Pomeroy.

Bluth had ambitious plans, but from the start he faced many obstacles. Three years after setting up his studio, in 1982, Bluth had completed *The Secret of NIMH* (19.4). The animated feature, an adaptation of Robert C. O'Brien's novel *Mrs. Frisby and the Rats of NIMH* (1971), was decidedly unlike Disney's work in its content, as it told a disturbing story of animals subjected to scientific testing. In creating the film, Bluth aimed to surpass the aesthetics of contemporary Disney production, taking great care with the design and the rendering of animated movement. The film received good reviews, but it did not do well financially. The film's distributor, MGM-UA, had not advertised it very widely and it was shown in relatively few theaters.

19.4 Don Bluth, *The Secret of NIMH*, 1982

19.5 Don Bluth, *Anastasia*, 1997

In 1983, Bluth decided to bring his aesthetic sensibilities to the realm of video games, creating *Dragon's Lair* and *Space Ace* (see p. 278). These games included full-animation-style graphics, which set them apart from most others of the time, but again Bluth was unlucky: they were not very profitable either, in this case because of a crash in gaming that occurred that year. A few years later, his reorganized studio, Sullivan Bluth, took a more positive turn when it collaborated with one of the by-then top box-office directors in Hollywood, Steven Spielberg, whose company, Amblin Entertainment, subsequently produced Bluth's *An American Tail* (1986) and *The Land before Time* (1988). Bluth later relocated to Ireland, motivated by its favorable business climate, and there he directed *All Dogs Go to Heaven* (1989); unfortunately, it was released at the same time as Disney's comeback film *The Little Mermaid* (dir. Ron Clements and John Musker, 1989) and, again, did not do well at the box office.

Bluth's film of 1997 *Anastasia* was produced at Fox Animation in Arizona **(19.5)**. It was a commercial success and received positive reviews, despite the once again typically dark theme, in this case, a story about the imagined escape of the Russian Czar Nicholas II's young daughter when the rest of the family was executed in 1918. Unfortunately, the financial failure of Bluth's next film, *Titan A.E.* (dir. Don Bluth, Gary Goldman, and Art Vitello), released in 2000, brought an end to his arrangement with Fox that same year.

Competition from Inside: Touchstone Pictures

During the 1980s and 1990s, some of Disney's competition was internal, coming from Touchstone Pictures, which Ron Miller had founded in 1983 in an effort to reinvigorate the failing company. This label launched a crop of adult-oriented pictures, beginning in 1984 with the live-action film *Splash* (dir. Ron Howard), starring Tom Hanks and Daryl Hannah in a story about a man who falls in love with a mermaid; the film received a daring PG rating for a brief shot of Hannah's bare behind. Four years later, Disney released the live-action and animation combination film *Who Framed Roger Rabbit* (dir. Robert Zemeckis, 1988) under the Touchstone label, executive-produced by Steven Spielberg **(19.6)**. This adult-oriented, noir-themed

19.6 Robert Zemeckis, *Who Framed Roger Rabbit*, 1988

19.7 Henry Selick, *Tim Burton's The Nightmare before Christmas,* 1993

film was sophisticated and even sexy, with a beautiful, buxom leading lady, Jessica Rabbit, who memorably tells viewers,' "I'm not bad. I'm just drawn that way." The animation, set in the seedy Toontown, was directed by Richard Williams. Bob Hoskins stars as a live-action private detective who is hired to solve a mystery there.

In 1993, Disney released yet another relatively unusual—for Disney—animated film, under the Touchstone label: *Tim Burton's The Nightmare before Christmas,* directed by Henry Selick, employing Burton's story and designs **(19.7)**. The story follows the Pumpkin King of Halloween Town, Jack Skellington, as he tries to understand the allure of Christmas, and incorporates a host of creepy yet endearing characters along the way. By the time of the film's release, Burton had gained an immense following as a director of such live-action features as *Pee-Wee's Big Adventure* (1985), *Beetlejuice* (1988), *Batman* (1989), *Edward Scissorhands* (1990), and *Batman Returns* (1992), all reflecting his unique, relatively dark world view. The inclusion of Burton's name in the title of *The Nightmare before Christmas* was an instant draw for audiences, and particularly the coveted youth market, which was also the perfect demographic for the film's hip score by

Danny Elfman. This highly cinematic and intricately designed film was a game-changer in the American animation industry, in that it attracted a whole new generation to the field of stop-motion animation. Its great success showed the viability of stop-motion for a feature-length film, diluting the dominance of cel animation and the traditional Disney style.

Competition from Other Media

By the time *Tim Burton's The Nightmare before Christmas* was released, the world had already witnessed the popularity of "The Simpsons," a television series created by Matt Groening that had first aired in 1989 (see p. 354); the growth of cable networks featuring animation, which took place throughout the 1980s and into the 1990s; the spread of anime fandom, which expanded significantly during the early 1990s; increasingly sophisticated animated games; and the building momentum of the Internet as it began to infiltrate society worldwide. There would be no returning to the simpler days when Disney was the virtually undisputed leader in the field of animation, but in other ways—under its new management—it would become exceedingly powerful.

Key Administrators at the New Disney

New hires in management initiated great changes at Disney. In 1984, three key executives—Michael Eisner (1942–), Frank Wells (1932–1994), and Jeffrey Katzenberg (1950–)—began to take The Walt Disney Company and its films into the complex world of modern media production, with Peter Schneider (1951–) hired a year later to head up animation in particular. To varying degrees, these individuals played roles in the Disney renaissance of the 1990s, when the studio's 2D animated features flourished again, as well as in subsequent turn toward 3D digital production.

19.8 Former Walt Disney CEO Michael Eisner (right) standing beside former COO Frank Wells

Michael Eisner

Michael Eisner **(19.8)** was brought in by Roy E. Disney; the two knew each other because they were both members of the California Institute of the Arts board of trustees. Before Eisner came to Disney, he had worked at all three of the major TV networks in the US: NBC, CBS, and ABC. He was then hired as president of Paramount Pictures. When he was passed over for the position of that studio's CEO, he left and was hired in the role at Disney, replacing Ron Miller in 1984. In that position, he quickly assumed the kind of leadership stance that had previously been associated with Walt Disney. In fact, in the late 1980s, Eisner even hosted the "Wonderful World of Disney" television program, as Walt Disney had done. There were significant differences in Eisner's background, however, and they accounted for some of the developments at the new Disney studio of the 1980s and 1990s. For one thing, he had experience in theater, which influenced his hiring of Disney executives and creative personnel, as well as the movement toward theatrical productions of Disney's animation feature concepts.

Eisner's worldliness with respect to modern entertainment was a great asset in his new role. Unlike Miller or Roy E. Disney, he had worked for a range of different companies and was accustomed to business practices that were much more dynamic, fluid, and daring than those he found in the insular universe of The Walt Disney Studios. Under Eisner's leadership, between 1984 and 2005 Disney grew from a small, relatively isolated theme-park operator

and movie studio into a gigantic, diversified corporate entity. During this period, it acquired Miramax, a company that made its name distributing independent US features and films from across the world—just one sign of its shifting demographic.

Eisner initially had little interest in promoting the studio's legacy of 2D animation, and in fact the Disney renaissance occurred almost spontaneously, at the end of the 1980s, a few years after he joined the company. 2D production was supported over the next decade, but after its earnings began to wane, priorities quickly changed. Believing that 3D digital techniques would dominate future production, under Eisner's leadership the company closed most of its 2D animation divisions in the early 2000s. The move came after the success of Pixar computer-animated feature films, which were being distributed by Disney, and other CG productions (see p. 373).

The decision to close the 2D studios, along with a series of problems beginning in the late 1990s, diminished Eisner's reputation as a company leader. In 2005, he was forced out by shareholders, in a move led by Roy E. Disney, the same person who had brought him into the company. Roy E. Disney had been so unhappy with Eisner that in 2003 he had dramatically resigned from The Walt Disney Company, both as chairman of the Feature Animation Division and as vice-chairman of the board of directors. Although his letter of resignation congratulates Eisner on more than ten successful years at the company in partnership with Frank Wells, it also complains that, subsequently, "the Company has lost its focus, its creative energy, and its heritage," lamenting the "creative brain drain"

of the talented artists who had been leaving or were forced out.[1] Disney felt Eisner had traded short-term profit goals for the long-term health of the studio, not to mention its legacy of 2D feature animation, and that he had showed no regard for its employees. Aside from the closing of the studios, Eisner had promoted franchising through the production of relatively low-quality straight-to-video features, television series, and an expansion of home-entertainment distribution of the classic films. These approaches had the effect of diluting the brand, so that the release of a Disney product was no longer considered a special event.[2] After Eisner left in 2005, his position was given to Bob Iger. Iger had been president and CEO of Capital Cities/ABC when Disney purchased it in 1999. In 2000, he had become president at The Walt Disney Company and, after Eisner left, he added the title of CEO in 2005. Meanwhile, Roy E. Disney returned to the Disney board.

Frank Wells

Frank Wells (19.8) came to Disney with a background in entertainment law and about ten years' experience as president of Warner Bros., Inc. Wells was part of the management team put in place by Roy E. Disney in 1984, but the two had already been acquainted for a number of years. Wells was vital to the company not only because of his business acumen, but also because of his humanitarian values. Known as a great deal-maker, as president and chief operating officer of The Walt Disney Company he oversaw huge financial gains in its theme parks, resorts, and consumer products, among other areas. He was also adventurous, having developed a passion for mountain climbing and scaling the world's highest peaks. He had been with the company for ten years when, in 1994, he died in a helicopter crash on his way to a ski trip. His death destabilized the leadership team that had successfully guided Disney into its period of growth, and the company experienced a political crisis. Wells's position was eventually filled by Michael Ovitz, one of the founders of the Creative Artists Agency (CAA), but this appointment fell apart after about a year, further undermining Eisner's shaky leadership. Yet more problems arose from the very public legal battle with Jeffrey Katzenberg that erupted during the late 1990s, after he left Disney, believing that Wells's position should have gone to him.

19.9 Jeffrey Katzenberg, former chairman of The Walt Disney Studios

Jeffrey Katzenberg

Jeffrey Katzenberg (1950–) (19.9) had been president of Paramount Studios before he became the third element of the Disney creative team (along with Eisner and Wells) brought in following Miller's departure. In his new role, from 1984 to 1994 he held the position of chairman of The Walt Disney Studios. At that time, he handled the worldwide production, marketing, and distribution of all of Disney's filmed entertainment, including motion pictures, television, and interactive material. To a greater extent than Eisner and Wells, however, Katzenberg focused on the potential of animation, encouraging a return to the values of Disney's earlier work, particularly to stronger storytelling. In 1991, facing the difficulties of a recession in the American economy, Katzenberg had drafted a letter stressing the need to bring back the magic of Disney entertainment. His comments primarily related to such live-action productions as *Pretty Woman*, which was released in 1990 on the Touchstone label, but a string of animated features, beginning with *The Little Mermaid* in 1989, certainly brought back the magic as well. Katzenberg had been a stranger to the animation process when he joined the company, first experiencing it through the production of *The Black Cauldron* (1985), a dark fantasy film that marked a low point in the studio's history. Moving forward, Katzenberg strove to understand animation production processes better, although he also drove the artists hard to meet deadlines and achieve both creative and financial success for the studio, culminating in the Disney renaissance of 2D animated features. Along the way, he claimed much of the limelight and, as a result, animosity developed among the leadership.

When Frank Wells died, Katzenberg wanted to be promoted to the position of company president. But Eisner refused, evidently as a result of the bad blood that had developed between the two men. In 1994, with two years left on his contract, Katzenberg left Disney, and later that year he formed the company that would become Disney's biggest competitor in the realm of animation, DreamWorks SKG, with partners Steven Spielberg and David Geffen. Katzenberg then sued Disney for profits he believed were promised him under the terms of his contract. Eisner refused to settle, leading to the initiation of a highly publicized court battle that in 1999 ended in a settlement awarding Katzenberg far more money than he had originally demanded.

Films of the Disney Renaissance

Disney's animated features of the early 1980s, *The Fox and the Hound* (1981) and *The Black Cauldron*, were very mixed in terms of critical reaction, and the latter was a financial failure. The studio's next film, *The Great Mouse Detective* (1986), was more promising, but the new Disney leaders were still not certain how animation fit into the media empire they were building. Under the direction of Eisner, Katzenberg, and Roy E. Disney, in 1985 the animators had been moved out of their building on the studio lot to work in remote trailers, without much direction. The younger artists were happy to learn from the old masters, even if the films they worked on were not particularly interesting, but mostly, the two groups were united in their mistrust of the new management. Left to their own devices, however, the Burbank animators embraced their work and began to turn out films of which Walt himself would have been proud. The resulting ten-year period, known as the Disney renaissance, began with *The Little Mermaid*, which was released in 1989. Other highlights include *Beauty and the Beast*, released in 1991, and *The Lion King*, released in 1994.

The Little Mermaid

Disney management's view of animation began to change in 1989, after the release of *The Little Mermaid*, a retelling of the Hans Christian Andersen story about a mermaid who leaves the sea to pursue her true love, a prince (19.10). It was directed by Ron Clements and John Musker. At first, Katzenberg had resisted the idea of another feature film about a mermaid, given the studio's recent production of the highly successful live-action feature *Splash*. The film went ahead, however, making a respectable profit and garnering critical attention, including two Oscars: for best music, original song and best music, original score. The lyricist Howard Ashman (1950–1991) and composer Alan Menken (1949–), both with experience from Broadway, were responsible for its accomplishment in sound. The overall success of *The Little Mermaid* was likely related to its return to a mainstay of Disney animation: a musical format centered on a princess story. A long time had elapsed since its previous princess film, *Sleeping Beauty* (dir. Clyde Geronimi, 1959). The film's catchy tunes were soon memorized by young children, who could play the film over and over on home video just a few months after its release.

This film was the first of Disney's animated features to be released on video so quickly, but the move paid off financially, as *The Little Mermaid*

19.10 Ron Clements and John Musker, *The Little Mermaid*, 1989

became the biggest video seller of the year. It had been Disney's policy to release its animated classics in theaters every seven years, to appeal to each new generation of children, and only a few of its previous films had been released on video. The success of *The Little Mermaid* in this format caused a change: it resulted in more comprehensive video sales of Disney films, quickly following theatrical releases.

Beauty and the Beast

The Little Mermaid's success helped boost the budget for the studio's next animated feature, *Beauty and the Beast*, based on a French fairy tale of the same name by Jeanne-Marie Leprince de Beaumont (19.11). The Disney feature, directed by Gary Trousdale and Kirk Wise, tells the story of a young woman who lives with a beast, but sees beyond his frightful exterior, with adventures enlivened by the presence of many memorable sidekicks. The film's success was foreshadowed at an early screening in unfinished form held at the New York Film Festival in 1991, where it was well received and garnered great press coverage. It went on to earn high profits and seemed to promise that classic Disney animation had returned. It is notable that this successful franchise was the first to be extended into a new territory for Disney, live theater, with a test run in late 1993 and a Broadway show opening the following year. Also significant was the involvement of a woman, Linda Woolverton, in the upper levels of the development process, which had always been dominated by men; she has writing credits for both the screenplay and the Broadway musical version.

Although not obvious to the average viewer, the film also represented a big change in animation production practices, as it incorporated a **digital ink-and-paint** system that effectively ended the employment of a legion of manual laborers: ink-and-painters in the US and abroad. The **Computer Animation Production System** (CAPS, see p. 376), developed by Disney in conjunction with a then emerging company known as Pixar, was first used in a few scenes of *The Little Mermaid*, but in *Beauty in the Beast* it was employed throughout the film. One sequence, where Belle dances with the Beast in a three-dimensional setting, utilized the system's 2D–3D integration capability, creating an impression of depth as the two characters swirl about the room.

Music played a pivotal role in *Beauty and the Beast*, although Howard Ashman tragically died eight months before the film's release, leaving Menken to work with the well-known English lyricist Tim Rice.

19.11 Gary Trousdale and Kirk Wise, *Beauty and the Beast*, 1991

Profits were even higher than they were for *The Little Mermaid*, and the film set a new milestone as the first animated feature to be nominated in the best picture category of the Academy Awards. Altogether, the film received six nominations, and it won two Oscars, for best music, original song and best music, original score.

The Lion King

Disney's blockbuster *The Lion King* (1994), directed by Roger Allers and Rob Minkoff, is a coming-of-age story (19.12). It focuses on a young lion cub, Simba, who is overcome with guilt when he thinks his father, Mufasa, the king of the jungle, has died as a result of his actions. In the course of the film, the cub comes to understand that he was tricked, and as he grows into an adult, he ultimately secures his rightful position as king. Linda Woolverton was again engaged as a writer, along with Irene Mecchi and Jonathan Roberts. The songs are by the composer Elton John and lyricist Tim Rice, with an original score by Hans Zimmer. Rising through the ranks of the Disney organization, Brenda Chapman (see p. 378) was head of story, overseeing both writers and story artists.

CAPS was used throughout the film for digital ink and paint of hand-drawn images, but computer-generated characters were also used in some scenes, including a dramatic wildebeest stampede. The use of a computer allowed for the multiplication of hundreds of animals, which ran in varied paths across the terrain and were visually stunning for theater audiences. In many ways, *The Lion King* set new standards that Disney executives would aspire to in future work: aesthetically, technologically, and, perhaps most important, financially. When *The Lion King* went into production, no one predicted how successful it would be, but it quickly became one of the highest-grossing pictures in history and won many awards. As a result, Disney leadership subsequently had higher expectations for the box-office earnings of the company's animated features, as well as their merchandizing potential.

Disney Theater

In 1985, Peter Schneider was hired to head the animation department at The Walt Disney Studios, becoming the first president of Walt Disney Feature Animation and staying with the company until 2001. In 1984, he had made a name for himself by producing the spectacular Olympic Arts Festival in Los Angeles, involving both visual arts and performance. Like Michael Eisner, he brought a strong interest in theater to bear on animation. The backgrounds of these executives set the scene for a new departure for The Walt Disney Company: theatrical productions based on its popular films.

At first, Disney's efforts on Broadway were met with skepticism from the critical establishment, but in more ways than one the studio's productions helped to revitalize theater in New York City, specifically in Times Square. Disney's involvement in the rehabilitation effort came in 1993, after Michael Eisner was shown around the broken-down New Amsterdam Theater by an organization dedicated to renovating the area, the 42nd Street Development Project. After he agreed to fund the restoration, many other companies rushed to be involved, wanting to get in on the ground floor of a revitalized Times Square community led by Disney. Aside

19.12 Roger Allers and Rob Minkoff, *The Lion King*, 1994

19.13 *Beauty and the Beast* on stage, Milan, Italy, c. 2014

from bringing in investors, Disney also attracted new audiences, especially families that might not otherwise have been part of a theater-going crowd.

Disney's first Broadway production, *Beauty and the Beast*, premiered at the Theatre under the Stars in Houston, Texas in 1993, before opening at the Palace Theatre in Times Square the following year **(19.13)**. It later played at the Lunt-Fontanne Theatre in New York City for a run of about thirteen years in total. Although the show was a big success, it was far out-grossed by Disney's musical version of *The Lion King*, directed by Julie Taymor (1952–) **(19.14)**. The show debuted in 1997, at the Orpheum Theatre in Minneapolis, Minnesota before moving to its locations in New York City, first at the New Amsterdam Theater and later to the Minskoff Theatre. The musical of *The Lion King* became the highest-earning Broadway production of all time, and continues to run after more than twenty years of performances in venues all over the world. Experimental by Broadway standards, the show features actors in elaborate animal costumes, large puppets, and performance involving traditional African instruments and South African choral arrangements, as well as music by Sir Elton John.

19.14 *The Lion King* on stage, Mexico City, Mexico, 2015

After the Renaissance

Two films, *Waking Sleeping Beauty* (2009) **(19.15)**, directed by Don Hahn and produced by Peter Schneider, and *Dream On Silly Dreamer* (2005), directed by Dan Lund, document the renaissance period at Disney in different ways. The first focuses on the rise of 2D, culminating in the release of *The Lion King* and focusing mainly on management, whereas the second continues with the decline of Disney 2D animation as the studio made the move to CGI, documenting the experience of the animation crew at the Burbank studio. The release in 1995 of Pixar's CGI feature *Toy Story* (dir. John Lasseter), which was distributed by Disney, had initiated a major shift and, within a few years, there were claims that 2D was dead, after a hundred-year life span.

Disney executives saw *The Lion King* as a success in every way, but that kind of phenomenon was not easy to reproduce. Only three of the studio's subsequent 2D films made even half of its profit: *Pocahontas* (dir. Mike Gabriel and Eric Goldberg, 1995), a fictionalized story about two real figures, the seventeenth-century Native American Pocahontas and the Englishman John Smith; *Tarzan* (dir. Chris Buck and Kevin Lima), an adaptation of Edgar Rice Burroughs's early twentieth-century stories known as *Tarzan of the Apes* (1912); and the post-renaissance *Lilo & Stitch* (dir. Chris Sanders and Dean DeBlois, 2002) **(19.16)**, a story of two Hawaiian sisters who contend with a rambunctious creature from another planet.

Rising production costs affected the income of these films, diminishing their bottom line. Nonetheless, with its eyes and wallets suddenly turned toward animation, Disney produced, acquired, and distributed in various ways a wide range of animated productions—as the following list of selected feature titles from the late 1990s suggests. In 1995, it released *A Goofy Movie* direct-to-video from DisneyToon Studios; the 2D film *Pocahontas*, from Walt Disney Feature Animation; and the first fully CGI animated feature *Toy Story*, from Pixar. The following year, in 1996, it released the stop-motion film *James and the Giant Peach*, directed by Henry Selick at Skellington Productions, and *The Hunchback of Notre Dame* from Walt Disney Feature Animation. In 1997, it

19.15 Don Hahn, *Waking Sleeping Beauty*, 2009. Jeffrey Katzenberg (see p. 345) is shown blowing up the Walt Disney castle

released *Hercules* from Walt Disney Feature Animation, and the DTV (direct-to-video) *The Brave Little Toaster Goes to Mars* from the independent production house Hyperion Pictures, as a sequel to Disney's *The Brave Little Toaster*, released ten years earlier. In 1998, it released Hayao Miyazaki's *Kiki's Delivery Service* from Studio Ghibli (see p. 393); the Disney Feature Animation *Mulan*; and the CGI film *A Bug's Life* from Pixar.

Disney's expansion in the field of animation continued, with more emphasis being placed on direct-to-video work, for films that never had a theatrical screening, as well as computer animation. In 1999, Disney released the DTV *Doug's 1st Movie* from DisneyToon Studios; the DTV *The Brave Little Toaster to the Rescue* from Hyperion Pictures; the Disney

19.16 Chris Sanders and Dean DeBlois, *Lilo & Stitch*, 2002

Feature Animation *Tarzan*; *Princess Mononoke* from Studio Ghibli; and the CGI feature *Toy Story 2* from Pixar, originally planned to be a DTV, but given a theatrical release. It also premiered the long-awaited *Fantasia 2000* in December 1999, promoting it as part of the many new millennium celebrations. The year 2000 saw Disney's release of the DTV *The Tigger Movie* from DisneyToon Studios, and *The Emperor's New Groove* from Walt Disney Feature Animation, as well as the studio's first CGI film not produced by Pixar: *Dinosaur*, from the computer-graphics unit of Walt Disney Feature Animation, showing 3D CGI characters in mostly real-life locations.

As it realized profits from so many other forms of animation, Disney questioned the relevance of its 2D Feature Animation units and it began to shut them down. Its final string of 2D animated features released during this period include *Lilo & Stitch* (2002), *Brother Bear* (2003), and *Home on the Range* (2004). Layoffs occurred as early as 2000 on the instructions of the then president of Feature Animation, Thomas Schumacher, who explained that the company was reorienting itself toward computer-generated 3D animation. Within a few years, the legendary 2D Feature Animation studio in Burbank was closed, along with the studios in Paris, Tokyo, and Orlando.

Disney's shift toward CGI was underscored by a string of films it distributed for the emerging Pixar Animation Studios, including *Toy Story* (1995); *A Bug's Life* (1998); *Toy Story 2* (1999); *Monsters, Inc.* (2001); *Finding Nemo* (2003); *The Incredibles* (2004); and *Cars* (2006). The culmination of these efforts was evident in 2006, when Disney purchased Pixar for more than seven billion dollars, installing John Lasseter (see p. 373) as chief creative officer of Pixar Animation Studios and Disney Animation Studios, and principal creative advisor for Walt Disney Imagineering.

Conclusion

Over a period of about ten years, beginning in the late 1980s, Disney 2D animated features experienced a rebirth, a renaissance that recalled the great studio's artistry of the past. Unfortunately, the success of the studio's films at that time also proved to be their undoing, as expectations for profits became unrealistic, and their traditional look was undermined by new technologies emerging on the scene. Convinced that the novelty of 3D CGI technology provided a long-range vision of what the public wanted, in view of the profits being made by computer animation, 2D animated features and their artists were purged from the Disney studio.

In reality, 2D animation was far from dead. For example, it was the mainstay of an entire segment of the animation industry: television production, which—like Disney feature animation—also experienced a renaissance in the 1990s. This was initiated by the combined influences of cable-television growth in the 1980s and 1990s and the phenomenon of the debut of "The Simpsons" in the late 1980s. These developments opened the eyes of the public and TV networks worldwide to the potential for television to show new kinds of work, especially animation that appealed to viewers of all ages, and adults in particular. For the first time, graduates of animation courses looked forward to the possibility of working in television, which had been much less attractive to them in the past. Combined with a growing focus on creator-centered work in general, TV offered enterprising young artists the chance to develop their own shows, rather than working for years in feature production, hoping to get the chance to direct at some distant time.

Notes

1 Roy E. Disney, "Text of Roy Disney's Resignation Letter," *USA Today*. Online at http://usatoday30.usatoday.com/money/media/2003-12-01-disney-letter_x.htm
2 Rich Drees, "Disney Closes Florida Animation Studio." Online at http://www.filmbuffonline.com/News/2003-2004/DisneyClosesStudio.htm

Key Terms

2D animation
3D animation
anime
cel
Computer Animation Production System (CAPS)
computer-generated imagery (CGI)
digital ink and paint
direct-to-video animation (DTV)
distribution
feature
franchise
score

CHAPTER 20

Television as a Creative Space

Chapter Outline

Global Storylines

During the 1980s, divisions between popular culture and fine art blur, as consumer culture grows more pervasive

The development of cable television allows for animated programming aimed at different age groups, ranging from pre-school series to adult-oriented shows containing violence

Launched in 1981, MTV becomes a showcase for innovative animation in its music videos, station IDs, and animated series that are of interest to the youth market

"The Simpsons" debuts on the Fox Network in 1989 and becomes the most influential animated series in history

Nickelodeon, Cartoon Network, and other networks support the development of creator-driven animation

Introduction

The 1970s and 1980s saw a rise in big business, as corporate takeovers and industrial consolidation resulted in large, powerful conglomerate companies. Such corporations could control markets by selling a series of similar products nationally under varied brand names, providing only the appearance of difference among items that were essentially the same. Such homogeneity led to increasing cultural mediocrity, as goods began to look, sound, and taste the same, with little concern for quality, well-being, or true value. Made-for-television animated series of this period were part of this larger system: designed mainly to sell toys to children, they were animated as cheaply as possible. Change was on the horizon, however, bringing new opportunities for creative expression during the 1990s, a decade when animation in many forms gained a great deal of cultural cachet, alongside comic books and other forms of popular culture.

In fact, the allure of popular culture became so strong that even fine artists began to explore its varied dimensions. In 1961, Roy Lichtenstein (1923–1997) completed his oil painting *Look Mickey*, using the style of Ben-Day dotted images found on enlarged comic book figures (20.1). It depicts Mickey Mouse and Donald Duck on a fishing boat, with Donald's exclamation, "*Look* Mickey, I've hooked a *big* one!!" appearing in a speech bubble. This work is cited as the turning point in the artist's shift from Abstract Expressionism to Pop Art, a change that was reflective of larger trends in the art world. Consumer culture, in general, was growing in volume, becoming ubiquitous in modern life, and artists increasingly used it as a point of creative departure. For example, Claes

20.1 Roy Lichtenstein, *Look Mickey*, 1961

Oldenberg (1929–) became known for exhibiting sculptures of everyday objects, such as his *Giant BLT (Bacon, Lettuce, and Tomato Sandwich)* of 1963 and *Clothespin* of 1976, created in large scale to suggest how vapid society had become, so that ordinary things were perceived to be precious commodities.

In this context, anything could be legitimized as art, even the former detritus of society, including graffiti and tagging, which by the late 1970s were already being re-envisioned as "street culture" with inherent value. Comic books, too, had been seen as low or popular culture, not the stuff of museum-level fine art. It was therefore surprising to see this kind of imagery appear in the work of such a highly respected painter as Lichtenstein. The impact was similar to that made by Pablo Picasso and Georges Braque when they incorporated newsprint and other low-culture materials into their collaged paintings of the mid-1910s. Underground comics, such as R. Crumb's "Zap Comix" (see p. 259), beginning in the late 1960s, had helped nurture a flourishing scene of creators that grew through the following decades to offer unique voices. Some notable examples include the Hernandez brothers (Gilbert, Jaime, and Mario) in "Love and Rockets" ("L&R") and Lynda Barry in "Ernie Pook's Comeek," both of which began in the 1980s. Longer works known as "graphic novels"—for being a mix of comic books and novels—rose in profile during the 1990s, especially after Art Spiegelman's *Maus* (1991) related the experience of his father, a Holocaust survivor, in the form of a cat-and-mouse story.

Eventually, animation was widely acknowledged as a legitimate art form—but one that had broad appeal to consumers in its varied aspects and therefore could bring in a lot of profit. Animation production cels had been displayed in museums since the 1930s, but by the 1980s animation art had become a collectible that the general public could purchase, and a profitable new sector of the industry was born. When Michael Eisner and others on the Disney management team thought to put Disney theatrical performances on Broadway (see p. 348), the arts establishment cringed—at least, until it saw the profits these productions brought in.

In a similar way, a new crop of original animated series on American television attracted the desired youth audience, and along with it came an improved reputation. The remarkable changes in television during the 1990s largely came about because of the success of one television series, "The Simpsons," and were fueled by the development of cable television.

Commercial Broadcast Animation

The Introduction of the Fox Network and "The Simpsons"

"The Simpsons," created by Matt Groening (1954–), is the longest-running and most influential animated television series ever produced (20.2). In America, it is broadcast on the Fox Network, which was launched in 1986. Other networks had been formed in the past, in attempts to join the three dominant US networks (ABC, NBC, and CBS), but none had been successful before Fox. The old networks were conservative, and Fox decided to fill a void in programming by offering something new. Many of its shows were aimed at young adult viewers, such as the live-action series "The Tracey Ullman Show," "21 Jump Street," "Married . . . with Children," and "America's Most Wanted," as well as expanded sports coverage. In 1989, it added "The Simpsons" in primetime, a period of the evening that attracted adult viewers. That in itself was remarkable: very few animated series had been aired at that time of day and none had been as successful for so long. By airing edgy, somewhat controversial programming, in many ways led by "The Simpsons," Fox became a major network, and changed the course of animation history in the process.

The earliest incarnation of "The Simpsons" appeared in 1987, as bumpers on "The Tracey Ullman Show," but soon the concept was developed into a freestanding series. Its creator, Matt Groening, had been a popular underground cartoonist where his strip "Life in Hell," which features angsty rabbit characters, appeared in various alternative newspapers. The producer James L. Brooks (1940–) wanted to include animation in "The Tracey Ullman Show," which he was producing through his company Gracie Films. When Groening was asked for a pitch, he came up with a set of characters, including the boy Bart (whose name is an anagram of "brat"), sister Lisa, baby Maggie, father Homer, and mother Marge (who shares her name with Groening's own mother). These characters appeared in the "Tracey Ullman" segments, but as the concept evolved into its own series, the family was joined by other members of the Springfield community, who span a broad cultural matrix in terms of religion, nationality, age, and sexuality.

The popularity of "The Simpsons" is partly due to its smart writing (the work of many individuals, over more than twenty-five years) and its focus on such contemporary issues as nuclear power and violence in the media, incorporating frequent in-jokes and references that appeal to the savvy viewer. "The Simpsons" is postmodern in style, mixing high- and low-culture references; at the time of its debut, this approach was new and engaging and set it apart from the majority of programming, which expected little from the viewer. The second-season episode *Itchy, Scratchy, and Marge* (dir. Jim Reardon, 1990), for example, takes on the relatively serious topic of censorship and bases gags on Alfred Hitchcock's film *Psycho* (1960), Michelangelo's *David* (1501–04), and a genre of "How To" consumer books that Homer buys but cannot really use. The visual style of the characters was greatly influenced by the producer, director, and animator David Silverman, through character sketches, **model sheets**, and animation, beginning with their first appearances on "The Tracey Ullman Show."

"The Simpsons" also helped popularize the use of celebrity voices in animation. In *Maggie's First Word* (dir. Mark Kirkland, 1992), aired during the show's fourth season,

20.2 Matt Groening, "The Simpsons," 1989–

20.3 Eric Radomski and Bruce Timm, "Batman: The Animated Series," season 1, 1992–95

a curious audience waited to find out that the well-known actress Elizabeth Taylor had been cast to speak the baby's one-word part. A wide range of stars has joined the cast for particular episodes, but even the "regulars" on the series are unique in the field, since the permanent cast—which has included Dan Castellaneta, Julie Kavner, Nancy Cartwright, Yeardley Smith, Hank Azaria, and Harry Shearer—became some of the highest-paid voice actors in the industry, earning as much as $400,000 each per episode after negotiations in 2008.

At the time it debuted, "The Simpsons" was controversial, particularly in terms of its depiction of the mischievous boy and his inept father, who was prone to strangling him out of frustration. Early in the series' history, it faced censorship, as T-shirts depicting Bart Simpson were banned in some schools because he was thought to be a bad role model. In 1992, the American president George W. Bush used the series as an example when he told the Republican national convention that America needed to be a lot more like the Waltons, an idealized traditional American family from another TV series, than the Simpsons. Such detractors did not deter the creators of "The

Simpsons," which proved to be immensely popular. It is one of the longest-running series on US television (live-action or animated) and in the 1990s its success contributed to a major shift in development, which began to favor creator-driven properties. Matt Groening was among the first animation directors to be featured prominently in the media: he was interviewed for television, newspapers, and magazines, and soon became a household name. Other networks, too, very quickly realized the value of developing animated series that could be promoted by their creators, who would attract media attention and make connections with fans.

The Fox Network eventually aired a number of animated series. Among the most popular was the critically acclaimed "Batman: The Animated Series," based on the DC Comics superhero; it was produced by Warner Bros. Animation and originally aired on the Fox Network for three years, from 1992 to 1995 (**20.3**). The series was developed by Eric Radomski and Bruce Timm, who created its brooding "dark deco" style, influenced by the Fleischer studio's "Superman" series of the early 1940s (see p. 123), and the live-action films *Batman* (1989) and *Batman Returns* (1992),

20.4 Mike Judge and Greg Daniels, "King of the Hill," 1997–2010

both directed by Tim Burton (see p. 332). Episodes were animated in Japan by both Sunrise and TMS Entertainment, along with a number of other studios.

In 1993, Fox introduced another influential series, "Animaniacs," developed by Tom Ruegger and executive-produced by Steven Spielberg, in collaboration with Warner Bros. The variety-show format of the series was fairly loose, accommodating a broad range of humor, including lots of classic Warner Bros.-style physical comedy and parody. Spielberg was involved in developing the concepts of each episode, working with Ruegger, Rich Arons, and Sherri Stoner, who were not only producers but also writers for the series. Spielberg, one of the most bankable directors in Hollywood, had a strong interest in animation: by this point, he had been involved with such animated feature films as *An American Tail* (dir. Don Bluth, 1986) and the live-action animation combination *Who Framed Roger Rabbit* (dir. Robert Zemeckis, 1988, see p. 342), along with other projects featuring a range of animated visual effects. Even so, TV production was a surprising crossover for an industry figure who could pick and choose any project that he wanted. His involvement reflected the increasing status of television series.

The popularity of "The Simpsons" opened the doors for many animated productions. One of them, "King of the Hill," was created by Mike Judge (1962–) and Greg Daniels (1963–); running from 1997 to 2010, the series was built around a propane salesman, Hank Hill, his family, and his drinking buddies, and was based partly on Judge's experiences of growing up in Austin, Texas (20.4). In 1999, Fox began airing another series created by Groening, "Futurama," which ran for about four years on its first run and then returned to the Fox Network in 2010. The series follows a New York pizza-delivery boy who is cryogenically frozen for a thousand years. Also in 1999, the Fox Network debuted a stop-motion series, "The PJs," created by Eddie Murphy, Larry Wilmore, and Steve Tompkins (20.5). It ran for about three years, through 2001, and some of its production took place at the Will Vinton studio in Portland, Oregon. The series focuses on a group of mostly black characters living in urban public housing, known as "projects." Although the series received awards, it was also criticized for portraying its black characters in a relatively disparaging way.

20.5 Eddie Murphy, Larry Wilmore, and Steve Tompkins, "The PJs," 1999–2001

SNL's Saturday TV Funhouse

In 1996, the long-running comedy series "Saturday Night Live" began to air short animated segments co-created by Robert Smigel (1960–) and J. J. Sedelmaier Productions, Inc., under the name "Saturday TV Funhouse." Storylines in the series included "The Ambiguously Gay Duo," which examined the relationship between Batman and Robin-type superheroes named Ace and Gary, and "The X-Presidents," a parody of crime-fighting teams, this one involving US presidents Gerald Ford, Jimmy Carter, Ronald Reagan, and George H. W. Bush. These and other series were produced and aired periodically from 1996 to 2011. Airing in such a high-profile context and featuring humor aimed at adults, they, too, boosted the profile of TV animation.

Cable Animation

The Birth of Cable

Cable television existed in the late 1940s, but it was not until the 1970s that it began to develop in a commercial way, and only in the 1980s did it start to resemble the expansive system we have today. Its early growth was fueled partly by the media magnate Ted Turner (1938–), who used the wealth from his family's advertising business to become an early investor in the new medium; in 1970, he founded what became the Turner Broadcasting System (TBS), which distributed a wide range of sports and other programming and in 1976 became one of the first media companies to distribute work via satellite to cable stations. Turner expanded his operation further by acquiring large holdings of classic films. For instance, in 1986 he purchased the MGM Entertainment Company and acquired its library of productions. Turner made a large profit on this investment, as he was able to use the films in the new markets of both home-entertainment videos and cable television.

Turner was a very public figure, stirring up controversy with his attempts to "colorize" classic black-and-white films. He was also politically active, attempting to open up Cold War-era negotiations with the Soviet Union via events called the "Goodwill Games" held in Moscow (1986), Seattle (1990), and St. Petersburg (1994), which he personally sponsored. He revolutionized news coverage with his twenty-four-hour Cable News Network (CNN), which covered the Tiananmen Square uprising as well as the Iraq war from the perspective of reporters on the scene. In 1991, Turner Broadcasting System signed an agreement to purchase the program library of Hanna-Barbera Productions for about $320 million. The following year, its content was used for the start-up of the Cartoon Network cable channel.

MTV

MTV was launched in 1981 as a channel that played music videos guided by on-air hosts known as VJs. The focus of the network has changed through the years, but in the course of its development, it has encouraged production of innovative animation in a variety of ways: through the promotion of the music-video format, which often employs animated images; the commissioning of animated station IDs; and the production and airing of original animated series. MTV's first creative director, Fred Seibert (1951–), guided its early development and its promotional strategies. By commissioning MTV logos from various artists, including Jan Švankmajer (see p. 306), and such innovative studios as Colossal Pictures, he initiated a unique strategy: a company logo that had an ever-changing look (20.6), contrary

20.6 Colossal Pictures, MTV logo, 1984. This version of the logo pays homage to Michelangelo's sixteenth-century painting on the Sistine Chapel ceiling, Italy

20.7 Scenes from the music video for A-ha, "Take on Me," 1985, directed by Steve Barron

Irish filmmaker Steve Barron, it features rotoscoped animation by the Americans Candace Reckinger and Michael Patterson, who had used the technique in his CalArts graduate thesis film *Commuter* (1981) to render black-and-white images of a man stuck in the routine of his day-to-day job. In the A-ha video, rotoscoping is used to capture the story of a comic-book character who comes to life and quite literally leaps off the page to have a romance with a woman from the real world. MTV continued to air innovative videos through the 1980s, as some performers, such as Madonna and Michael Jackson, became iconic figures of music-video culture. In 1991, Jackson's *Black or White* video carved a place in animation history by using the then very innovative technique of feature-based image metamorphosis, or morphing, involving a series of people shown in head shots, shifting from one figure to the next in fluid transitions that create a feeling of unity among them. This film was directed by John Landis, who had previously directed Jackson's immensely popular *Thriller* video (1983), as well as a number of live-action features.

In the early 1990s, MTV commissioned a number of animated shorts for a compilation series called "Liquid Television," which was produced by Colossal Pictures and originally ran for three years, from 1991 to 1994. "Liquid Television" was aired late at night and presented types of animation that were not otherwise being aired on US television, but could be found in the traveling festivals of animation held on college campuses and in art-house theaters across the country. Probably the

to standard practice, where a logo has a fixed identity. The result was increased excitement among viewers, who waited eagerly to see how the MTV logo would be envisioned in each new artist's rendition.

Many people became aware of the creative possibilities of animation while watching music videos on MTV. In the early days, one of the most influential of these was the "Take on Me" video by the Norwegian band A-ha, released in 1985 (20.7). Directed by the

20.8 Mike Judge and Yvette Kaplan, *Beavis and Butt-Head Do America*, 1996

most famous series to come out of "Liquid Television" is Peter Chung's "Æon Flux," featuring a highly stylized, sexy female assassin who works in a futuristic setting. It aired for two years, in 1991 and 1992, and in 1995 as well. From 1997 to 1998, MTV aired another eclectic animation program, "Cartoon Sushi," which was created by Danny Antonucci and Keith Alcorn; it also included innovative animated shorts in a thirty-minute block.

In the late 1980s, the network opened its own studio, MTV Animation, which has released a number of popular shows, including "Beavis and Butt-Head." This series was created by Mike Judge, who served as co-director with Yvette Kaplan (1955–) and also provided voices for some of its characters. It focuses on two boys in the throes of adolescence whose lives revolve around rock music, fast cars, "chicks" and the unlikely prospect of sex, and working as little as possible. "Beavis and Butt-Head" got its start as a short film: Judge's *Frog Baseball* (1992), which had appeared in the "Spike & Mike's Sick and Twisted Festival of Animation" touring festival (see p. 318), and was then aired on "Liquid Television." When the "Beavis and Butt-Head" TV series proved to be quite popular, it was franchised into other forms. MTV co-produced a feature film, *Beavis and Butt-*

Head Do America (1996), also co-directed by Judge and Kaplan **(20.8)**, and developed another series centering on a recurring character, "Daria" (1997–2002), created by Glenn Eichler and Susie Lewis Lynn. Judge went on to create other animated series, including "King of the Hill" and "The Goode Family" (2009), and to direct live-action productions—for example, *Office Space* (1999), about some men who plan to bust out of their tedious jobs.

Other notable series on MTV include the adaptation of Sam Keith's "The Maxx" comic books by Greg Vanzo at Rough Draft animation studio. The short-lived animated television series "The Maxx" (1995) focused on the first eleven books and attempted to retain the design of their layout.[1] "Celebrity Death Match" (1998–2002, 2005), created by Eric Fogel, is a clay-animation series that pits a range of celebrities against each other in outrageous fights to the death.

HBO Animation

HBO (Home Box Office) first aired in 1972, and by the 1980s it was well established in the cable industry. As a pay-to-view channel, HBO promoted original programming, including animation. Some of its critically

acclaimed work came from Michael Sporn Animation, a studio founded in 1980. Michael Sporn's (1946–2014) numerous adaptations of popular children's books for HBO include *Lyle Lyle Crocodile* (1987); *The Red Shoes* (1989); *Mike Mulligan and His Steamshovel* (1990); *The Marzipan Pig* (1990); *Ira Sleeps Over* (1992); *Goodnight Moon and Other Stories* (1999); *Happy to Be Nappy and Other Tales* (2006); *Whitewash* (1995); and *I Can Be President* (2011).[2] The studio operated in a relatively independent, arts-oriented mode, as Sporn encouraged his artists to employ varied, sometimes hand-crafted techniques. As a result, its productions were acclaimed for their aesthetic qualities.

Sporn's sensibilities were influenced by a number of individuals he worked with earlier in his career, including the independent filmmakers John and Faith Hubley. He also animated for Richard Williams, on the feature *Raggedy Ann & Andy: A Musical Adventure* (1977), and at the illustrator R. O. Blechman's Ink Tank studio. Although Michael Sporn Animation focused on commercial projects, its shorts were created in a similar way to festival films, with great attention to artistry. The same approach is evident in *Champagne* (dir. Michael Sporn), an independent animated short produced at the studio in 1996. It arose from an experience of the studio's writer Maxine Fisher, who volunteered at a home for girls, where she met a charismatic young woman named Champagne. This inspiring documentary was the product of a series of interviews, in which the fourteen-year-old discussed her life and her ability to overcome the hardships she faced.[3] This film and others made by Sporn were entered into festivals and widely awarded.

HBO has also aired animated programming aimed at older viewers, including "Todd McFarlane's Spawn," an adaptation of a popular comic-book series by the Canadian cartoonist Todd McFarlane; it ran from 1997 through 1999. In 1997, HBO aired six episodes of Ralph Bakshi's (see p. 270) "Spicy City," set in a futuristic city and promoted as an "adults only" series, dealing with violence and sex. In 2010, HBO began to broadcast "The Ricky Gervais Show," a British animated series that also aired on Channel 4 in the UK. The show, which ran for three seasons, is based on humorous unscripted podcast conversations between Ricky Gervais, Stephen Merchant, and Karl Pilkington. The first episode, *Space Monkey* (2010), begins as the live performers walk into a recording studio and then become animated, carrying on a humorous discussion about technology, reproduction, the first monkey in space, and other topics.

Nickelodeon

Cable television is developed around the concept of niche audiences, in terms of age, gender, interests, and other demographic details, in order to allow advertisers to target their desired consumers more effectively. Among the many specializations are networks aimed at young viewers. One of them is Nickelodeon, which began under the name Pinwheel in 1977 but was renamed two years later. Its owner at the time, Warner Communications, managed it within a parent company called MTV Networks.

At first, Nickelodeon faltered, but things changed in the mid-1980s after Viacom International acquired MTV Networks. Fred Seibert moved from MTV to

20.9 Arlene Klasky, Gábor Csupó, Paul Germain, and Igor Kovalyov, "Rugrats," 1990–2006

20.10 Stephen Hillenburg, production cel from "SpongeBob SquarePants," 1999–present

Nickelodeon and, with his business partner Alan Goodman, revamped the kids' channel and boosted it into a top-rated network. As it grew, Nickelodeon further defined itself with programs aimed at specific segments of the child and youth audience, including pre-school and teenagers. By October 1990, its live-action shows, both original programming and reruns of past series, were being watched in fifty-two million homes across the United States. In the late 1980s, it also aired two half-hour animated specials, Ralph Bakshi's *Christmas in Tattertown* (1988), about a girl who finds herself among discarded dolls and other objects that come to life, and *Nick's Thanksgiving Fest* (1989), which was composed of three holiday-themed segments directed by Joey Ahlbum, Kevin Altieri, and Joe Pearson.

In 1991, Nickelodeon began a move into original animated series, no doubt inspired by the phenomenal success of "The Simpsons." Executive producers Vanessa Coffey and Mary Harrington, along with supervising producer Linda Simensky, oversaw development of the network's first three series: "Doug," created by Jim Jenkins at Jumbo Pictures; "Rugrats," created by Arlene Klasky, Gábor Csupó, and Paul Germain at Klasky Csupo; and "The Ren & Stimpy Show," created by John Kricfalusi at Spumco. "Doug" is about a group of middle-school kids who learn lessons about life and friendships. The series won awards for its ability to promote "pro-social" behavior skills in an entertaining way, and was very popular with pre-adolescent viewers and other ages as well. "Rugrats" is about a group of gregarious babies and toddlers (20.9). Its pilot episode, *Tommy Pickles and the Great White Thing* (1990), in which the kids contemplate the function of a large ceramic fixture they have seen in the bathroom, was directed by Peter Chung before he worked on "Æon Flux" for MTV. "The Ren & Stimpy Show" was controversial for its outrageous storylines, potty humor, and occasional extreme violence involving two characters—one dog-like and the other cat-like. After the success of these series, Nickelodeon initiated additional animation production. Its fourth series, "Rocko's Modern Life," was created by Joe Murray and first released in 1993. It features surreal scenarios involving a wallaby named Rocko and his gang of unusual acquaintances, set in distorted environments that seem to reflect the unstable mindsets of the characters.

"SpongeBob SquarePants" (1999–) has been the most widely distributed and highest-rated animated series on Nickelodeon, and it has evolved into a massive franchise (20.10). The series follows the adventures of SpongeBob SquarePants and his underwater pals in their hometown, Bikini Bottom. It was created by Stephen Hillenburg, who had a background in marine biology before he came to CalArts to study animation as a graduate student. His thesis film, *Wormholes* (1992), reflects his scientific interests,

as it follows a figure driving through a fantastic world in a stylized demonstration of a scientific theory about shortcuts or "bridges" through time. After graduation, Hillenberg had worked on "Rocko's Modern Life," as a writer, creative director, and in other capacities, and when that show was cancelled, he pitched "SpongeBob SquarePants" to Nickelodeon.

The Cartoon Network

In 1991, Turner Broadcasting System purchased the legendary studio Hanna-Barbera Productions. As part of the deal, it acquired large libraries of animated shorts, which it distributed through its Cartoon Network, launched in 1992, and soon original programming was also introduced. In the early 1990s, after Fred Seibert left Nickelodeon, he became president of Hanna-Barbera and created the Cartoon Network's "What a Cartoon!" concept (also known as "World Premiere Toons" in its first season). This series was built around the development of creator-driven shorts. Individuals submitted storyboards to the network in a kind of competition, and almost eighty concepts were selected to go into production as animated shorts. These films were then aired as pilots and sometimes screened at festivals, and the most successful were later developed into series.

This competition provided an opportunity for a whole new generation of animation directors to enter the field, in some cases directly from college programs. Such was the case for Craig McCracken (1971–), Genndy Tartakovsky (1970–), and Van Partible (1971–). McCracken used his CalArts student film *Whoopass Stew: A Sticky Situation* (1992) as the basis of "The Powerpuff Girls," an animated series about three

20.11 Pendleton Ward, "Adventure Time," 2010–

children who fight evil, which debuted in 1998. The series was produced by fellow CalArtian Tartakovsky, who also directed some of its episodes. Meanwhile, Tartakovsky had successfully pitched his own series for "What a Cartoon!": "Dexter's Laboratory," about a boy genius hampered by his bothersome sister. It began to air in 1996, and McCracken was one of its directors. In 1997, the network first aired "Johnny Bravo," a series about a muscular, Elvis-like woman-chaser who is unlucky in love; it was created by Partible, who attended Loyola Marymount University but was friends with McCracken and Tartakovsky.

After his success at Nickelodeon, in 1997 Fred Seibert founded his own animation production company, Frederator Studios. There he continued to develop about a hundred new short works through the **incubator series** "Oh Yeah! Cartoons" and "Random! Cartoons" for Nickelodeon in the late 1990s and early 2000s. One of these shorts was "Adventure Time," about a boy and his magical dog, created by CalArtian Pendleton Ward **(20.11)**. Ward's film became a viral hit on the Internet and caught the attention of the Cartoon Network, which picked up the series and began to air it in 2010.

In 2001, the Cartoon Network cable channel broadened its viewer base by initiating a late-night component called Adult Swim. Programming for this separate network is handled by Williams Street Studios (a Turner Broadcasting System division of Time Warner), which produces its own series and also airs syndicated shows. Some of its popular animated series include "Aqua Teen Hunger Force" (2000–2015), created by Dave Willis and Matt Maiellaro before the start of Adult Swim, following the adventures of anthropomorphic snack foods; "The Venture Bros." (beg. 2003), created by Doc Hammer and Chris McCulloch, a kind of nostalgic take on the "Jonny Quest" series of the 1960s; and "Robot Chicken" (beg. 2005), a stop-motion series created by Seth Green and Matthew Senreich featuring short absurdist scenarios.

Comedy Central

Comedy Central was always envisioned as an adult-oriented channel. Since the network debuted in 1989, by its then owner Time Warner, it has mainly focused on stand-up comedy routines and live-action series. It has aired original animated series, however, including "Dr. Katz: Professional Therapist," which

20.12 Jonathan Katz and Tom Snyder, "Dr. Katz: Professional Therapist," 1995–2002

debuted in 1995 (20.12). Created by Jonathan Katz and Tom Snyder, it is based on therapy sessions that Katz held onstage involving various comedians.

Comedy Central's best-known series is "South Park," created by Trey Parker (1969–) and Matt Stone (1971–), who met in film school at the University of Colorado at Boulder. The series, about a group of foul-mouthed small boys who find many ways of getting into trouble, was based on an outrageous cutout paper animation they had created in 1992, *The Spirit of Christmas*, which shows Jesus fighting Frosty the Snowman. In 1995, the television executive Brian Graden commissioned a remake of it as a video Christmas card. The revised version depicted an all-out brawl between Santa and Jesus, and included prototypes of the series' characters. "South Park" debuted on Comedy Central as a TV series in August 1997, and had the dubious honor of receiving a "TV-MA" rating for mature viewers.

TV for the Very Young

On the other end of the spectrum, television has been catering to even very young viewers. Pre-school audiences are well integrated into the matrix of television viewers, and there are numerous channels devoted to them worldwide, usually falling into two basic types: advertising-supported programming within normal cable-television packages, and commercial-free programming that is purchased individually by the consumer on an à la carte basis.[4] This programming typically includes a mixture of live-action and animated series. In England, the BBC offers pre-school programming on CBeebies (20.13), while pre-school viewers in Israel can watch Hop!, managed by Zebra TV Channels and aimed at children aged one to seven. In the United States, the Public Broadcasting

20.13 Doodle Productions Ltd., *Moon Landing*, from the series "Messy Goes to OKIDO," shown on CBeebies, 2015

System (PBS) launched PBS-Kids Sprout! in 2005
for pre-school viewers; in 2013, it was acquired by
NBCUniversal and renamed as Sprout, though it carries
PBS programming, such as "Sesame Street" and "Bob
the Builder." Other networks, such as Nick Jr. and
Disney Junior, also cater to the pre-school audience.

It may come as a surprise that even younger
demographics can be found, but 2003 saw the launch of
Baby TV, the first television network devoted to babies.
It was founded in Israel by Liran Talit and Ron Isaak,
and it spread to Europe two years later, before eventually
going global. Programming is categorized by function—
for example, "guessing games," "music and art," and
"bedtime"–to demonstrate its purpose to parents. Some
of these series have been produced by the Tel-Aviv studio
PIL Animation, which was founded by Sharon Gazit
and Ido Vaginsky in 1998. Within a few years, other
networks for babies appeared. The next was Baby First
TV, which was created by the Israelis Guy Oranim and
Sharon Rechter in the United States; it first aired in 2006.
The following year, in 2007, Luli–aimed at toddlers and
infants–was launched in Israel by Zebra TV Channels,
following its success with the pre-school channel Hop!

Conclusion

Animated television series were once held in relatively
low esteem, but on the whole the reputation of such
programming has improved. This was brought about
partly by the influx of creative talent that developed
original series for the various new networks that have
appeared since the 1980s. These venues have made the
phenomenon of Saturday-morning cartoons a thing of
the past: animation can now be viewed around the clock.

Another change occurred in the realm of
animated features: with the development of digital
technologies came the birth of 3D CGI films from
Pixar and other studios. The popularity of these films
threatened to displace 2D animated features, at least
in the American industry, and many traditional artists
lost their jobs. While the prediction that "2D is dead"
never came fully to fruition, certainly the scope of CGI
production has continued to grow. Today, computer-
animated features represent another significant
sector of the multifaceted animation industry.

Notes

1 Greg M. Smith, "Shaping *The Maxx*: Adapting the Comic Book Frame to Television," *Animation Journal* 8:1 (Fall 1999), 32–53.
2 Amid Amidi, "Michael Sporn: A Passionate Director," *Cartoon Brew* (February 3, 2014). Online at http://www.cartoonbrew.com/rip/michael-sporn-a-passionate-film-director-rip-95646.html
3 Michael Sporn, "Champagne, the Girl," *Michael Sporn Animation Splog* (March 10, 2007). Online at http://www.michaelspornanimation.com/splog/?p=979
4 Elizabeth Jensen, "A Coming of Age at Nickelodeon: Noggin and the N Will Get Their Own Channels," *New York Times* (August 13, 2007). Online at http://www.nytimes.com/2007/08/13/business/media/13nickelodeon.html

Key Terms

bumpers
incubator series
syndicated programming

CHAPTER 21

Computer-Generated Animation in Features

Chapter Outline

Global Storylines

By the early 1990s, computers are used increasingly to create 3D animated digital effects in live-action features, but only after issues of cost, speed, and compatibility within different systems are overcome

The Pixar studio initially leads development of the technology and aesthetics of 3D CGI animated features, especially in films directed by John Lasseter

The process of motion capture is used to create relatively realistic movements of the human body, hands, and face

In the wake of Pixar's success, other studios, including DreamWorks and Blue Sky, expand their 3D CGI animated features

Stereoscopic technology enhances the appearance of depth in animated productions, and is now commonly used

Introduction

In 1976, high-school friends Steve Wozniak (1950–) and Steve Jobs (1955–2011) both found themselves in Silicon Valley, California working for Hewlett-Packard and Atari, respectively. Determined to break out on their own, the two of them, along with Ron Wayne, founded the Apple Computer Company that year (21.1), with Wozniak creating the components that would become the Apple I: essentially just a circuit board, requiring the user to add a case, power supply, keyboard, and other necessary components (21.2, see p. 366). The business began to experience rapid success the following year, in 1977, as the Apple II became the first desktop-sized personal computer to be packaged in a plastic case and to provide color graphics (21.3, see p. 366), using a monitor that was purchased separately.

By the mid-1980s, home computers had begun to transition from the realm of specialists into the homes

21.1 Steve Wozniak (left) and Steve Jobs (right) in 1976

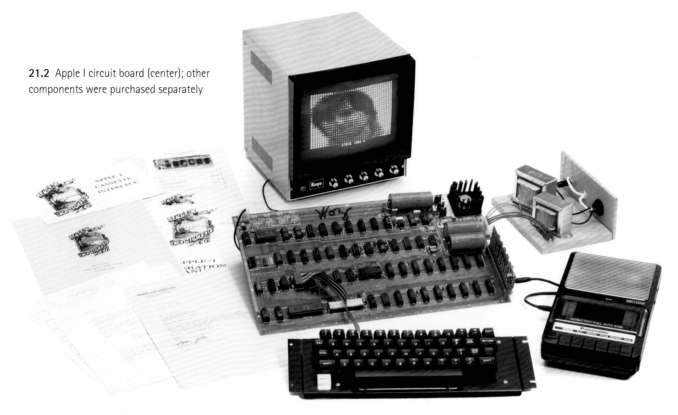

21.2 Apple I circuit board (center); other components were purchased separately

21.3 (below) Apple II (monitor sold separately)

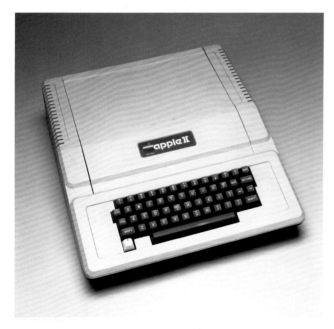

of general consumers, helped in large measure by Apple's outreach to schools, promoting computers to a first generation of consumers who would remain loyal to their products. By the mid-1990s, computers of all sorts became ubiquitous, supporting every aspect of life, including the work of the animation industry. Developments in computing since those early years brought many

advances in memory and processing power, which have enabled enhancements in color, sound, visual details, and number of frames of animation, allowing for increasingly complex and more lifelike environments and characters. These capabilities fueled growth in a number of realms, including games (see p. 276), visual effects, and features.

By the 1980s, the Hollywood film industry had turned toward blockbusters: heavily promoted, extremely lucrative projects that were typically "high concept," or full of spectacle but low on narrative complexity. The plots of such works could be described in a sentence or two, and they were generally based on already popular "pre-sold" properties. Special effects, whether they related to the development of complex sets, fantastic characters, explosions, physical transformations, or any other visual qualities, were essential to this type of film. Since the time of Georges Méliès in the early 1900s (see p. 33), the film industry had relied on a stable of traditional methods for creating these visual sleights-of-hand. As digital technologies percolated into society during the 1980s, their potential for creating effects was clear, and yet they were not immediately embraced. Issues of cost, speed, usability, and compatibility with other systems all had to be resolved before computers could be integrated into day-to-day production.

These problems were tackled by a number of start-up companies, as well as individuals in public and private enterprises, all working on the horizon of a potentially lucrative business. Ongoing research was presented to industry peers through an organization, SIGGRAPH, which was founded in 1969 as the Association for Computing Machinery's Special Interest Group on Graphics and Interactive Techniques. Since 1974, it has hosted annual conferences worldwide, featuring speakers, film screenings, and demonstrations of emerging technologies. By the time these conferences were getting started, small firms had been established, developing hardware and proprietary software that

21.4 Steven Lisberger, *Tron*, 1982

would showcase their unique abilities and separate them from the competition. In these early years, however, digital effects remained strongly associated with motion graphics and television and there was some resistance to their use in other contexts; in the 1970s, it was not easy to convince directors to employ computer-generated effects in their motion pictures, partly because the layman's knowledge of how to use them was limited, but also because they tended to be expensive and time-consuming in an era before blockbusters had brought budgets up considerably.

One of the turning points came with the development of the live-action feature film *Tron*, directed by Steven Lisberger (1951–) and released in 1982 **(21.4)**. This film tells the story of a computer programmer who is sucked into a game and is forced to battle the entities he helped create—an ideal scenario for the integration of computer animation into production. In fact, *Tron* contains 235 computer-produced scenes, resulting in about fifteen minutes of CGI, more than in any previous film.[1] Much of this footage depicts vehicles, such as light bicycles, tanks, and ships. But despite the incorporation of digital effects, *Tron* also includes traditional special effects. One example is the use of hand-painted cel mattes, which were used to make areas on the characters glow; they blocked out all other parts of the shot and were backlit to create the effect. These cels were painted at Cuckoo's Nest in Taiwan.

The film's primary digital effects company, Mathematical Applications Group, Inc. (MAGI), had been founded by Phil Mittelman in 1966 to do government contract work tracking exposure to nuclear radiation. By adapting its system to allow for tracing light, rather than radiation, it was able to create images, and a later component of the company, MAGI/SynthaVision, specialized in outputting high-resolution computer graphics directly to film. In the mid-1970s, *Tron*'s director, Steven Lisberger, had been at a screening of MAGI's work and had also been introduced to the new electronic game *Pong* (see p. 277). These experiences inspired him to create a film about a game, employing computer-generated effects: the result was his concept for *Tron*.

Lisberger began development through his own company, seeking a distribution deal with various studios. The only one that showed an interest was Disney, in 1980, when it was under the leadership of Ron Miller (see p. 341). When production began, Lisberger naturally wanted to work with MAGI, but computer animation was so laborious and time-consuming in the early 1980s that it was necessary to work with several suppliers. He therefore also contracted with other leading companies of the day: Information International, Inc. (Triple-I), Robert Abel & Associates, and Digital Effects. Since studios at the time were still developing proprietary software in-house that showcased

particular styles and was compatible only with their own systems, one of the major challenges for *Tron*'s production was the need to integrate the different visuals and digital approaches from each company.

These and other emerging studios continued to carry out research and development on their own software, but by the 1990s, off-the-shelf products were widely available. These programs increasingly became compatible with other software and hardware being used in the wider industry, smoothing out the production pipeline. They were good for the artists as well; consistency in software allowed specialists to be trained in particular packages, and with those skills they were able to move into positions at any of a growing number of studios. This chapter looks at the spread of digital effects in the film industry, as well as the development of 3D computer animation.

Innovators in the Effects World

Digital visual effects developed out of a larger set of effects practices dating back to the very beginnings of film, and even to the magic tricks and stage performances that came before it. Over the long history of cinema, filmmakers have perfected a wide range of special effects, including miniatures and models; makeup and prosthetics; other types of costume; mattes and optical printing; front- and rear-screen projection; **animatronics**; and special effects taking place on a set.

The traditional techniques of first-generation effects artists—including Willis O'Brien (see p. 49), Ray Harryhausen (see p. 195), Peter Ellenshaw, and others whose work predated computer technology—continued to dominate into the early 1980s. For example, in *Blade Runner* (dir. Ridley Scott, 1982), a complex, futuristic world is created through a combination of models and traditional matte paintings, shot by cinematographer Jordan Cronenweth through multiple passes of a motion-control camera. Visual effects for the film were supervised by Douglas Trumbull (1942–), who had managed the effects for Stanley Kubrick's *2001: A Space Odyssey* (1968) and other films. Trumbull and other individuals in the second generation, including John Dykstra (1947–) and Dennis Muren (1946–), had been drawn to the field by the first generation, which passed down its traditional approaches. The second

generation worked during a transitional period in the effects industry, as they later embraced digital processes as well.

Many of the effects found in big blockbuster films—including the "Star Wars" and "Indiana Jones" franchises, among many others—were created in George Lucas's company Industrial Light & Magic (or ILM), which had been a hub for development since the mid-1970s. At the studio, Dykstra developed groundbreaking effects for the film that became known as *Star Wars IV: A New Hope* (dir. George Lucas, 1977) including an award-winning motion-control process called "Dykstraflex" that allowed for many types of movement. Dykstra later formed his own company, Apogee Film Effects, and eventually employed digital technology to create visual effects in *Batman Forever* (dir. Joel Schumacher, 1995), *Spiderman* (dir. Sam Raimi, 2002), and other films. Muren also worked for ILM, originally as a motion-control camera operator. He rose higher in the ranks of ILM and contributed to a number of projects, including *The Abyss* (dir. James Cameron, 1989), before taking a sabbatical to study the emerging new technologies of the time. He then returned to ILM, where he has had a long career as a visual-effects supervisor working with such innovative directors as James Cameron and Steven Spielberg, both known for the technological achievements of their films.

ILM's films of the late 1980s and early 1990s, such as *The Abyss*, *Terminator 2: Judgment Day* (also known as *T2*; dir. James Cameron, 1991), and *Jurassic Park* (dir. Steven Spielberg, 1993), represent significant steps in digital filmmaking. One of the best-known is *T2*, a science-fiction film in which a cyborg must protect a boy from a more advanced cyborg creature **(21.5)**. To create the villainous T-1000 character, the film applied morphing technology, allowing him to assume the form of "liquid metal." This achievement was remarkable, given the relatively limited scope of digital technology at the time. The Stan Winston Studio created the T-1000 character and other effects using a range of techniques that included puppets, wardrobe, animatronics, morphing, and digital advances to merge 2D and 3D imagery. The film's director, James Cameron, eventually partnered with Stan Winston (1946–2008), as well as Scott Ross, to set up their own studio, Digital Domain, in 1993. Winston had entered the effects field in the late 1960s, after he began to work in the makeup department at Disney and then launched his own studio.

21.5 James Cameron, *Terminator 2*, 1991

From its beginnings in the early 1970s, it seemed as though the career of George Lucas (1944–) was on an unstoppable trajectory. His films and the companies he formed to create them in many ways defined American cinema for at least the next thirty years. It all started in 1971, when George Lucas released his debut live-action feature, *THX 1138*, which was developed out of a student project he had completed at the University of Southern California (USC). The same year, he established his studio, Lucasfilm Ltd., and began work on his breakthrough film, *American Graffiti*, which was released two years later, in 1973. Looking ahead to the production of *Star Wars IV: A New Hope*, which he envisioned as a spectacular effects film, in 1975 Lucas founded two other companies in the Los Angeles area: Industrial Light & Magic, for visual effects, and Sprocket Systems (later Skywalker Sound), for sound design and related effects, mixing, and editing. By 1979, he had also formed the Graphics Group, which was headed by Ed Catmull. An electronic-game division followed in 1983, with the launch of Lucasfilm Games, later renamed LucasArts. Two years later, in 1985, Lucasfilm relocated to Northern California.[2] There, he maintained an expansive property, Skywalker Ranch, and located headquarters for Lucasfilm, Industrial Light & Magic, and LucasArts in the Letterman Digital Arts Center in the Presidio of San Francisco. Throughout a thirty-five year period, ILM produced 275 films and won Oscars for fifteen of them, as well as numerous science and technology awards. In 2012, Lucasfilm was acquired by The Walt Disney Company.

Creating an Authentic Reality

Research and development in the field of animation has devoted much time to the subject of realism, stretching back at least as far as Disney's efforts to depict a believable female character in *Snow White and the Seven Dwarfs* (1937, see p. 104). The digital era posed its own challenges in terms of creating realistic animated visuals, with success hinging on expansion of the available technology. For example, the depiction of naturalistic character movement involved the development of **hierarchical programming**, in which one action sets another in motion. Research into this area took place worldwide. In the Soviet Union, it was undertaken by the mathematician Nikolai Nikolaevich Konstantinov, working with graduate students at Moscow State University; their efforts were demonstrated in the animated *Koshechka* (*Kitty*), created in 1968, depicting a cat that moved across the computer screen in a relatively realistic way.

Other complex figures were in development through the 1970s, culminating in such examples as David Zeltzer's *Jumping George* (1980), a 3D skeleton that was controlled by hierarchical programming, and Rebecca Allen's *Swimmer* (1981), which realistically depicted the movements of a woman swimming across the screen (21.6). Both were presented at SIGGRAPH conferences.[3]

Rebecca Allen (1953–), who had studied at Rhode Island School of Design and completed a graduate program at the Massachusetts Institute of Technology (MIT), brought both fine-art and scientific skills to her work. She was part of MIT's Architecture Machine Group (now MIT Media Lab) and went on to be affiliated with the NYIT Computer Graphics Laboratory, Nokia Research Center Hollywood, and UCLA Department of Design Media Arts, where she was founding chair. Allen became known for her ability to bring the human form to life through motion, a quality that led her into the experimental world of music videos. One of her most famous works is *Musique Non Stop: Kraftwerk Portrait* (1986), which she created for the band Kraftwerk (21.7). Allen later developed art **installations**, CGI films, and live multimedia performances.

The short film *Tony de Peltrie*, screened at SIGGRAPH in 1985, became a landmark of computer animation for its depiction of a human character (in the form of the musician de Peltrie) that expresses emotions; it was co-directed by the Canadians Pierre Lachapelle, Philippe Bergeron, Pierre Robidoux, and Daniel Langlois. The animation was created with a user-friendly 3D interactive graphics system, TAARNA, designing the facial animation around twenty scanned photographs of a real person's expressions. One of the artists involved, Langlois, would found the Montreal-based Softimage the following year, in 1986, aiming to create software that could be used by artists as well as programmers. Softimage produced visual-effects software that was widely employed throughout the film industry.

The year 1985 also saw the release of another landmark in digital character animation, a commercial called *Brilliance* (also known as "Sexy Robot") that was aired during the Super Bowl, paid for by the Canned Food Information Council. This ad, depicting a metallic robot in a futuristic kitchen, glorifying canned food, was created by Robert Abel & Associates for Ketchum Advertising. The production faced many challenges as the studio had to write software to facilitate nearly every component of the production. Underlying the

21.6 Rebecca Allen, *Swimmer*, 1981

21.7 Rebecca Allen, *Musique Non Stop: Kraftwerk Portrait*, 1986

smooth, realistic movement of the shiny female robot was a film of a real woman who had been painted with eighteen dots, representing the various joints of her figure, which would later be used in assembling the character—foreshadowing similar methods of a digital tracking process, motion capture, or "mocap," which would be developed in later years. Abel (1937–2001) had begun his study of visual media at the University of California, Los Angeles, in 1958, obtaining dual bachelor degrees in the Department of Theater's film division and in the School of Design. After he graduated, he worked with John Whitney, Sr. (see p. 251), before starting out on his own in the mid-1960s.

In its continuing quest to create realistic-looking animation of human and animal movement, the entertainment world eventually turned to digital systems that could record the movements of live actors so that they could be used as the basis of animated characters.

Looking back into history, we can see this process is akin to motion studies of the nineteenth century (see p. 21) and Max Fleischer's rotoscope process (see p. 47), in that they all use recorded movement as the basis of animated action. Another related technique, called "Rotoshop," which is based on videotaped live-action footage, was invented by Bob Sabiston in 1997 and employed by the director Richard Linklater in his feature film *Waking Life* (2001) **(21.8)**. The result is scenarios of constantly shifting images that feel both real and unreal at the same time—perfect for a film that explores the boundaries between dream states and consciousness. The story follows a young man who travels from place to place, listening to the philosophical thoughts of various individuals on such topics as self-destruction and free will, with each scene being depicted in a different visual style.

Today, motion capture is commonly used to develop realistic movement in various contexts, including video games and visual effects for live-action features. The process involves placing data markers on a performer so that his or her movement can be tracked digitally through space. At first, systems mainly captured body movements, but eventually they could also record the subtle movements of the hands and face,

21.9 Hironobu Sakaguchi and Moto Sakakibara, *Final Fantasy: The Spirits Within*, 2001

even the lips and eyes, within a performance. In 2001, the use of mocap in the film *Final Fantasy: The Spirits Within* (dir. Hironobu Sakaguchi and Moto Sakakibara) was widely promoted, as it was said to have created the first photorealistic CGI animated feature **(21.9)**. As a result, audiences had high expectations; many were disappointed, however, and the film lost a great deal of money. In fact, the film's hyperrealistic images were off-putting to many viewers, as they actually tended to emphasize the "gaps" in realism that were unavoidable. Some blamed a relatively weak story, which disappointed fans of the popular interactive game on which the film is based. Robert Zemeckis's film

21.8 Richard Linklater, *Waking Life*, 2001

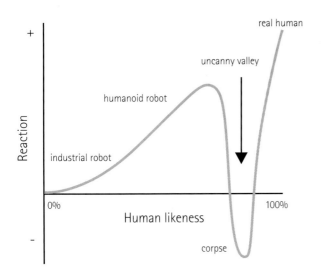

21.10 Graph illustrating the "Uncanny Valley" concept, based on Masahiro Mori's essay from 1970

of 2004, *The Polar Express*, was criticized for similar reasons. The film is a Christmas story based on a book of the same name by Chris Van Allsburg. Complaints about it centered on the characters, who were extremely realistic in many ways, but not in the movement of their eyes and mouths. This resulted in a sense of incongruity between the realistic appearance of the characters and the lifelessness that nonetheless persisted.

The reception of both films demonstrates the limits of our willingness to recognize constructed objects as real. A sensation known as the "uncanny" occurs when a viewer senses an odd disconnect between the images seen and his or her expectations of how they should appear—a subconscious warning that what we see is "not right" **(21.10)**. In 1970, the Japanese researcher Masahiro Mori (1927–) published an essay, whose title roughly translates as "The Uncanny Valley," that explains a theory of perception: how attraction to a constructed human figure diminishes sharply as it approaches a sense of absolute realism in form and movement. His theory has been widely referenced in the current era of robots and advanced digital representation, when it is increasingly difficult to distinguish between the synthetic and the real—and yet we still can.

One studio that is determined to overcome these obstacles is the New Zealand effects house Weta Digital. The roots of this company are in a studio founded by Richard Taylor (1965–) and Tania Rodger in 1987, RT Effects. They began working with director Peter Jackson (1961–) on his puppet film *Meet the Feebles* (1989), and in 1993, the three banded together and created Weta, which has two divisions: Weta Workshop, for physical effects and props, and Weta Digital, for digital effects, including motion capture. The studio has won Oscars for its visual effects in live-action feature films directed by Jackson, including *The Lord of the Rings: The Fellowship of the Ring* (2001), *The Lord of the Rings: The Two Towers (2002)*, *The Lord of the Rings: The Return of the King* (2003), and *King Kong* (2005), as well as James Cameron's *Avatar* (2009) **(21.11)**. *Avatar* made use of a versatile motion-capture system—developed by

21.11 James Cameron, *Avatar*, 2009

Weta Digital, Lightstorm Entertainment, Glenn Derry, and others—that enables recording outside and detailed facial tracking, including eyes and lips. In the film, this technology was used to depict a humanoid race fending off humans who are colonizing their planet. Weta Digital has also created effects for many other blockbusters, including the Superman-based *Man of Steel* (dir. Zack Snyder, 2013) and *Dawn of the Planet of the Apes* (dir. Matt Reeves, 2014). Both Taylor and Jackson have been knighted for their contribution to the industry.

John Lasseter and the Rise of Pixar

John Lasseter's Entry into CGI

Although the feature film *Tron* suffered from a weak story and did not do well at the box office when it was released in 1982, its impact upon the animation industry was great, partly for its influence on the career of the then-emerging filmmaker John Lasseter (1957–). In 1979, Lasseter had graduated in the first class of the Character Animation program at the California Institute of the Arts (CalArts). There, he learned the discipline of classical animation, which he demonstrated in his student films *Lady and the Lamp* (1979) and *Nitemare* (1980), both of which won student Academy Awards for animation achievement. He soon found a job at Disney, working on such animated films as the feature *The Fox and the Hound* (dir. Ted Berman, Richard Rich, and Art Stevens, 1981) and the short *Mickey's Christmas Carol* (dir. Burny Mattinson, 1983). At the studio one day, Lasseter saw some *Tron* footage produced by MAGI, and it sparked his interest in the possibilities of computer animation. When he was contacted by the film's supervisor Tom Wilhite, then vice-president in charge of Production, Motion Pictures & Television at the Walt Disney Company, and asked to help MAGI demonstrate the system, he agreed.[4] Lasseter met with some MAGI personnel, including the systems architect Ken Perlin, when they came for a studio visit, and they decided to create a two-minute sequence based on Maurice Sendak's story *Where the Wild Things Are* (1963).

The resulting "Wild Things Test" of 1983 combined hand-drawn, 2D Disney-style character animation with 3D computer-generated backgrounds.

Perlin returned to MAGI, back in New York, and headed a team working to generate the shaded 3D background animation, while Lasseter and Glen Keane, another CalArts alumnus, produced the hand-drawn character animation. MAGI would later integrate the 2D footage into its 3D backgrounds, developing software to accomplish almost every step of the process, matching lighting, shadows, and camera moves. Aside from Perlin, the MAGI team included Christine Chang, who later went to Don Bluth; Josh Pines, who went to ILM; and Chris Wedge, Jan Carlée and Carl Ludwig, who later founded Blue Sky Studio.

Meanwhile, Lasseter had come across a book by Thomas Disch called *The Brave Little Toaster* (1980), which he thought could be developed using CGI; Wilhite liked the idea and acquired the rights to the story. Things did not go well at the pitch session, however. In retrospect, Lasseter believes he burned his bridges at The Walt Disney Studios by failing to consult his direct supervisors—and as a result, he lost his job in 1983.[6] The studio ended up making *The Brave Little Toaster* (dir. Jerry Rees) in 2D, releasing it in 1987.

While developing his *Brave Little Toaster* concept, Lasseter had visited Lucasfilm in Northern California. There he had talked to two individuals, Ed Catmull (1945–) and Alvy Ray Smith (1943–), founding members of the company's Graphics Group, which was launched in 1979. Catmull and Smith also met with Lasseter on a subsequent trip to Disney. It was therefore no surprise that Catmull recognized the then unemployed Lasseter when they both attended a conference in Long Beach, California, in late 1983. Catmull invited him to work at Lucasfilm as animator on a short film called *The Adventures of André & Wally B* (1984), directed by Alvy Ray Smith, in order to introduce some of his character-animation skills into the team of computer scientists. Lasseter stayed on with the studio and later directed a series of short films that helped propel it into the position of world leader in the production of computer-generated animated feature films.

Pixar Gets Its Start

In 1986, Steve Jobs purchased the Graphics Group from George Lucas and renamed the company Pixar. As the Graphics Group, the unit had developed RenderMan software and high-end technology known as the Pixar Image Computer.[7] It also contributed to the visual

effects of landmark films at ILM, including *Star Trek II: The Wrath of Khan* (dir. Nicholas Meyer, 1982) and *Young Sherlock Holmes* (dir. Barry Levinson, 1985). In 1984, in the midst of this work, the Graphics Group had begun to create character animation, with the release of *The Adventures of André & Wally B* that year. Two years later, as Pixar, the company made advertisements to sustain its cash flow, and began production on a number of short animated films directed by Lasseter for research and development. These films include *Luxo Jr.* (1986), *Red's Dream* (1987), *Tin Toy* (1988), and *Knick Knack* (1989). Along with *The Adventures of André & Wally B*, these early shorts show the studio's progression with respect to evolving CGI technology in the areas of character design, textures, backgrounds, and movement, among other aesthetic concerns. They were all entered in festivals, where they earned awards and drew attention to the studio.

The Adventures of André & Wally B is an ambitious work, an attempt to show that Pixar was not only technically advanced, but that it also had an understanding of film aesthetics and character animation. By demonstrating these qualities, it hoped to improve its prospects for project deals with other studios, such as Disney. The first scene of the film depicts a forest background with many natural forms, and light filtering through the trees. A photorealistic environment would have been impossible, given the state of the technology, so it instead employs patterns of solid colors to indicate branches, leaves, grasses, and gently rolling hills—images created using the same particle-system software that Bill Reeves had employed to make fires in the Genesis Demo of *Star Trek II: The Wrath of Khan.* The Graphics Group had wanted to create a forest scene since it had been approached by the Disney employees, including John Lasseter, who were planning production of *The Brave Little Toaster* as a computer-animated film. This group had envisaged a computer-generated forest that cel-animated characters could move through;[8] however, by the time the short was finished, *The Brave Little Toaster* no longer incorporated CGI, but was slated for production in 2D—and Lasseter had moved to Lucasfilm.

In the film, as suggested by its title, there are two main characters: André and Wally B. As André wakes up, the viewer sees that he is made of smooth geometric forms, generally circular, but with jointed tubes for arms. It is significant that the figure's limbs are articulated, able to bend and move about, unlike the rigid-body

constructions of CG characters standard at the time. The body of the bee, Wally, is built in the same way, although its legs float underneath its body, clearly not attached, as it bobs up and down in space. As André runs away from Wally B, there is a suggestion of **motion blur,** which is inherent in the imagery of live-action films, but must be added to animation. Typically associated with the Tex Avery style of physical comedy (see p. 138), this convention adds humor to the movement. As for the bee, its legs stretch in space as it takes off after its victim, creating a very "cartoony" effect.

The bee's contact with André at the end of the short film occurs off screen, with a slight shake of an imagined camera, sound effects used to create the impression of impact, and a visibly rumpled stinger. The film's sound design was provided by Sprocket Systems's Ben Burtt, best known for the iconic effects heard in ILM's "Star Wars" features. The staging of this action adds to its comedy, but also simplifies things for the animator, since it would have been difficult—given the technology available at the time—to show the force of a big collision between two objects. A brick subsequently thrown at Wally provides a final convincing action, but because it propels the character forward so quickly, the viewer cannot clearly see its impact. *The Adventures of André & Wally B.* was completed using a Cray X-MP/48 supercomputer and ten of MIT's smaller VAX/11 750 microcomputers from the Digital Equipment Corporation: all were needed to prepare the two-minute film for its debut at SIGGRAPH 1984.

In the next four Pixar shorts, all directed by Lasseter, the studio—under the ownership of Jobs and the name Pixar—continued to develop its ability to produce entertaining character animation embracing a cinematic aesthetic. At the same time, it acknowledged its limitations by creating workaround scenarios in films to emphasize its strengths. *Luxo Jr.* demonstrates character animation by bestowing personality onto two inanimate objects: a large desk lamp that watches a smaller one play with a ball **(21.12)**. Using hard-surfaced props, the studio avoided the difficulty of texture. The introduction of self-shadowing creates a sense of gravity and weight, and draws viewers' attention to the bright, shadowed lights at the foreground of the scene, permitting a simplistic background. In the film, the studio made strides in rendering the physical effects of gravity, when the ball squashes and stretches under

21.12 John Lasseter, *Luxo Jr.*, 1986

the weight of the youngster, and secondary action, when the lamp's electric cord ripples behind it as it jumps. The authenticity of the lamp's movements is accentuated by the use of the unique sound that these objects make, with metallic coils flexing as they move. Gary Rydstrom of Sprocket Systems provided sound design for this short and others from the studio.

To create the relatively difficult sequence of the ball rolling, Lasseter turned to **procedural animation**, letting the computer do the calculations, based on a system written by Eben Ostby. The same method was used in other films to show cycle-like movements: for example, the unicycle wheels in *Red's Dream* and the snow-globe particles in *Knick Knack*. One goal remained elusive, however: the creation of a realistic human figure. This is one reason why Lasseter focused mainly on inanimate objects, including lamps, bicycles, and toys, rather than humans. The problem is clear in *Red's Dream*, when the sad unicycle imagines itself at a circus, and the human-like figure of a clown is less convincing than other aspects of the film: wobbly, loosely jointed, and quite stylized, it recalls the two figures in *The Adventures of André*

& Wally B. Likewise, an attempt to create a realistic human character in *Tin Toy* resulted in a monstrous baby. Though it may have worked for the story, in which the infant terrorized toys, it also reflected the limitations of the time. Organic figures were too complex for the existing technology—the fine skin of an infant and its soft yet firm body parts required far more subtlety than the available CGI could provide **(21.13)**. Nonetheless, the studio's accomplishments in *Tin Toy* were rewarded with an Oscar for best animated short of 1988— the first CGI film to win in this category (though *Luxo Jr.* was the first to be nominated, in 1986).

It was much safer for CGI films to avoid realistic characters in favor of more stylized designs, but Pixar continued to work toward a goal of high-quality, intricately shaded, photorealistic imagery, using an algorithm, REYES, that was developed at the studio. It was used on a proprietary basis from 1987, and two years later, under the name Pixar's RenderMan, it began to be licensed to other visual-effects and animation companies. In other ways, too, Pixar continued to

21.13 John Lasseter, *Tin Toy*, 1988

develop its abilities to realize character animation with a move toward feature production. In 1988, the company unveiled a program, Menv (Modeling Environment), used to create 3D computer models of characters with built-in articulation control, allowing a computer to interpolate—or in-between—an entire sequence of fluid animated movement. At around the same time, Pixar was also developing CAPS, a 2D ink-and-paint program, in conjunction with Disney.

CAPS

In the late 1980s, Disney and Pixar invented a digital ink-and-paint process that radically changed the methods of 2D production. Using the Pixar Image Computer, a team of Pixar and Disney developers worked together to create Computer Animation Production System (CAPS) technology, encompassing digital cel-painting and post-production:[9] it combined software programs, scanning camera systems, servers, networked computer workstations, and custom desks, and was used in Disney productions between 1989 and 2006. Visual information normally placed on clear acetate cels was instead compiled in the computer, where it was overlaid onto scanned images of traditionally painted backgrounds. It was such a breakthrough that in 1992 the Academy of Motion Picture Arts and Sciences gave its developers a Scientific and Engineering Award for its use in animated feature films. At the same time, however, this development meant that a lot of artists were no longer needed and lost their jobs.

The 2D cel-animated feature *The Little Mermaid*, released in 1989, was the first feature film to use CAPS, though only in a few scenes, for the film's farewell sequence. In other films, Disney used the process throughout, starting with its next animated feature, *The Rescuers Down Under* (dir. Hendel Butoy and Mike Gabriel, 1990) and ending with the short film *The Little Matchgirl* (dir. Roger Allers) in 2006, the year when Disney acquired the Pixar Animation Studios.

CAPS created a dramatic shift in animation production practices, but much bigger changes were in store. After the immense success of its 2D films in the mid-1990s, profits began to sag. Management believed that the future of animation was in 3D CGI production, and by 2003 Disney had addressed its problems by closing most of its 2D Feature Animation units. *Home on the Range*, released in 2004, was the last of its 2D animated features until *The Princess and the Frog* was released five years later, in 2009.

To *Toy Story* and Beyond

Disney's growing relationship with Pixar in the late 1980s was just another aspect of the company's outward expansion at the time. After the release of *The Little Mermaid* (1989), Disney had begun a quest to diversify the animation titles it offered the public, and in 1991 it entered into a distribution deal with Pixar. It is hard to say whether Disney fully realized the significance of the collaboration, which would change the course of animation production.

The first of Pixar's features was *Toy Story*, directed by John Lasseter and released in 1995 as the first fully CGI animated feature (**21.14**). The film focuses on the relationships between a number of toys that belong to a boy named Andy, expanding on the concept of the studio's short film *Tin Toy* (1988). The toy characters take center stage; they are almost all made of hard plastic materials, reflecting real life but also providing the best surfaces for CG production at that time. In contrast, the boy, Andy, is sidelined for much of the film; he is introduced only by a shot of his arm during the opening sequence, playing down the fact that while the toys are practically photorealistic, the human characters are quite stylized. Since the creation of authentic-looking people was still not possible, all the human characters in the film—Andy, his friends, his mom, and his sister, for example—are given cartoon-style designs. Hair was particularly difficult, so Andy wears a hat and his mother sports a solid ponytail. Quite a bit of effort was put into the curly locks of baby Molly, however, using a procedural texture in a RenderMan shader to stylize the solid form.

Although the rendering of human characters remained difficult, *Toy Story* showcased many other advances that Pixar had made since producing its early short films. For example, the soft, puffy texture of the comforter on the bed moves convincingly up and down under the weight of the toys—though at times it also hides contact points (for example, feet), simplifying the way characters interact with their environment. A trip downstairs reveals a small potted plant that is quite varied in form and color,

21.14 John Lasseter, *Toy Story*, 1995

very different than those in the world inhabited by André and Wally B. Complex environments containing many objects, a range of lighting situations, and a large ensemble cast were also great advances for the time, but they were not the only reason that the film became a milestone in the development of computer-generated animated features: it also has a great story that appeals to viewers of all ages.

Many of the recognizable toys featured in the movie stirred nostalgia in adult viewers, providing an amazing product-placement and merchandizing opportunity for Etch-a-Sketch, Mr. Spell, Mr. Potato Head, Slinky, and many other longtime favorites. The two central characters in the film, the cowboy Woody and the space-ranger Buzz Lightyear, were original designs that later provided opportunity for limitless tie-in promotions and sales of these figures and products bearing their images. In the *Toy Story* feature films, Woody and Buzz were voiced by Tom Hanks and Tim Allen respectively, celebrities who lent their family-friendly appeal to the stories. The performances of these well-known stars helped to develop characters that seemed rooted in reality, even if they were still relatively stylized in design.[10]

Continued Growth at Pixar

While the Disney renaissance was coming to an end, Pixar was rising in power, destined to dominate the industry in a few short years, providing a new path for Disney executives. In 1998, Disney released the 2D *Mulan* (dir. Barry Cook and Tony Bancroft), based on a legendary Chinese warrior, and it would release just one more film, *Tarzan* (dir. Kevin Lima and Chris Buck), its profitable renaissance period, which ended with that 2D film's release in 1999. Meanwhile, in 1998, Pixar had released its second 3D CGI feature, *A Bug's Life*, co-directed by Lasseter and Andrew Stanton (1965–). The film, based on a story by Lasseter, Stanton, and Joe Ranft, is a loose retelling of the fable "The Ant and Grasshopper," in which an inventive ant tries to fend off the aggressive grasshoppers that terrorize his community. It was produced under Pixar's multi-picture deal with Disney, which had commenced with *Toy Story* and was expanded in 1997 after that film's success. A focus on bugs was ideal for CGI, since they are hard-bodied creatures, as opposed to a human cast or creatures covered with fur, which were still beyond the capabilities of a computer-animated

feature. Nonetheless, these insect characters pushed the limits of the technology, partly because their designs were relatively complex. Because they were bugs, similar-looking characters could be reproduced to save time—but crowd scenes featured hundreds of them, and resulted in a huge amount of data to process relative to the power of technology at the time.

In the mid-1990s, Disney had been expanding into the direct-to-video (DTV) market, releasing sequels to its existing animated features. Therefore, when Pixar came up with the concept for a second "Toy Story" franchise film, *Toy Story 2* (dir. John Lasseter, 1999) in 1996, the direct-to-video market was its presumed destination. Management eventually realized that the film had the potential to be even more popular than the original; in fact, it eventually outsold *Toy Story* at the box office.

At the time, sequels had the reputation of being relatively undesirable imitations of the original work, but this one had a strong story and technical advances that appealed to audiences. Randy Newman was again involved with scoring the film, and the original cast was back. There were also some new voice performers, including Joan Cusack in one of the film's few female characters: a sidekick for Woody named Jessie. *Toy Story 2* also incorporated impressive technological feats, especially in terms of character design and complexity of movement. One example is its treatment of human characters, who play a much more central role than in the first film. For instance, the unscrupulous toy salesman, Al McWhiggin, has carefully crafted skin, including hair on his arms, which gives him a realistic look. The dog, Buster, is equally impressive, with a muscular form visible underneath authentic hair that moves in a way that is very dog-like, demonstrating the improvement in the studio's ability to create fluid animation.

For a number of years, Pixar seemed to be unstoppable. The studio continued to make a number of short festival films, such as *Geri's Game* (dir. Jan Pinkava, 1997) and *For the Birds* (dir. Ralph Eggleston, 2001), while it developed feature-length productions that were consistently popular with audiences, thanks to their excellent storytelling and technical attributes. As Lasseter moved up in the studio's hierarchy, a number of new directors were brought into production. Following *Toy Story 2*, Pixar released *Monsters, Inc.* (2001), directed by Pete Docter; *Finding Nemo* (2003), directed by Andrew Stanton; and *The Incredibles* (2004), directed by Brad Bird.

Lasseter stepped in again to direct *Cars*, which was released in 2006—the same year that Pixar was acquired by Disney. When Steve Jobs, Pixar's biggest shareholder, sold Pixar to Disney, this all-stock transaction made him Disney's largest individual shareholder as well; he joined Disney's board of directors. Ed Catmull, who had served as Pixar's president, became president of both Pixar and Walt Disney Animation Studios, while John Lasseter, who had been Pixar's executive vice-president, was named chief creative officer of the two studios and took on other top administrative roles. Pixar continued its string of hits with *Ratatouille* (dir. Brad Bird, 2007); *WALL-E* (dir. Andrew Stanton, 2008); *Up* (dir. Pete Docter, 2009); *Toy Story 3* (dir. Lee Unkrich, 2010); and *Cars 2* (dir. John Lasseter, 2011). These films were unconventional in some ways; for example, the robot characters in *WALL-E* communicate through sounds and movements, rather than spoken language, and *Up* tells the story of an older man, adrift in memories, and a boy who befriends him. As a result, they appealed to audiences in different ways than Disney animated features typically had done.

In contrast to Disney's tendency to create female-centered princess films, Pixar's work was decidedly male dominated. *Brave* (2012) broke new ground at Pixar, as it was the first of its features built around a female lead. It tells the story of a Scottish princess named Merida who creates a stir when she announces that she does not want to marry. An excellent archer, she must use her skills to undo a curse set upon her mother. It was the first time that a Pixar or Disney animated feature was directed by a woman: Brenda Chapman (1962–) created the story, basing the main character on her own daughter. Chapman had begun working at Walt Disney Feature Animation Studios after she graduated from the character animation program at CalArts, contributing to such films as *Who Framed Roger Rabbit*, *The Little Mermaid*, and *Beauty and the Beast*; and she was head of story on *The Lion King*. Chapman was later taken off *Brave*, however, because of creative differences, and replaced by Mark Andrews. Both are credited as directors on the final film. In 2015, Pixar released another female-centered film, *Inside Out* (dir. Pete Docter), which explores the emotional state of a girl, Riley, as she grows up. The film includes a range of female characters representing the complexity of Riley's personality.

Digital Advances at DreamWorks Animation

In 1997, DreamWorks SKG was co-founded by the director and producer Steven Spielberg (1946–), former Disney executive Jeffrey Katzenberg (see p. 345), and music executive David Geffen (1943–). Eventually, it became involved with various types of production: not just live-action, 2D animation, and 3D CGI features, but also music, television, and video games. It experienced checkered success, however, with most divisions eventually closing or being sold off. In 2004, DreamWorks Animation (DWA) broke away and continued under the supervision of Jeffrey Katzenberg, while Spielberg stayed with the live-action film side of the business and Geffen eventually left.

When Katzenberg co-founded DreamWorks SKG, he was intent on challenging Disney's domination. Having been instrumental in that studio's renaissance (see p. 338), he was undoubtedly feeling self-assured as he slated a wide range of animated films, including 2D, 3D CGI, and stop-motion features for release during the company's first few years. In fact, its first CGI feature animation, *Antz* (1998), was put into rapid production so it would be in direct competition with Disney, which released *A Bug's Life* only a month or so later. *Antz*, which follows a colony of ants that is being overthrown by one of its members (**21.15**), thus became the second all-3D CGI animated feature in American

studio history. Here too, insects provide the ideal subject for CG production, as they are hard-bodied creatures with relatively limited movement occurring in their rigid exoskeletons. Also, creating the colony scenes using a multitude of the same ant figures worked well, not only in terms of technological capabilities, but also for the storyline. No one wonders why hundreds of similar-looking insects appear in a scene, while they would probably expect a large group of other animals–dogs, for example–to be more differentiated. The casting of Woody Allen as the central character, Z, alongside Sharon Stone and Jennifer Lopez, suggests an appeal to an older audience. While the film is to some extent still built around a princess story–typical of Disney films–in this case, it is the male character, Z, who falls in love with Princess Zala. This scenario incorporates Woody Allen's acting persona as a somewhat unlikely hero.

An appeal to older viewers was already in evidence in DWA's first 2D animated film, *The Prince of Egypt*, released earlier in 1998. This film was built around a biblical story, the life of Moses. It was unusual in being directed by a team that included a woman: Brenda Chapman, in her first feature-directing role, joined Simon Wells and Steve Hickner. With this film, Katzenberg sought to challenge Disney's tradition of hand-drawn animation. Its financial success was questionable, however; although it did well at the box office, the cost of its production and publicity were high.[11] But DreamWorks certainly made advances in other aspects of animated feature production, releasing the first feature film from Aardman Animations, *Chicken Run* (dir. Peter Lord and Nick Park, 2000), a clay animation about hens that are about to be made into chicken pies, but are rescued by a rooster. DreamWorks Animation had a partnership with Aardman, the popular animation studio located in Bristol, England, and also released its stop-motion clay feature *Wallace & Gromit: The Curse of the Were-Rabbit* (2005) and its CGI feature *Flushed Away* (2006).

DreamWorks' CGI productions, beginning with *Antz* (1998), were created by Pacific

21.15 Tim Johnson and Eric Darnell, *Antz*, 1998

21.16 Andrew Adamson and Vicky Jenson, *Shrek*, 2001

Data Images (PDI), a company it acquired in 2000. PDI had been founded in 1980 by Carl Rosendahl, who was joined two years later by Richard Chuang and Glenn Entis. The company distinguished itself by developing proprietary animation software used largely for animated logos and television commercials, although it also created visual effects. Among its more famous projects was the morphing sequence at the end of the controversial but highly successful Michael Jackson music video *Black or White* (dir. John Landis), released in 1991.

PDI had been preparing for the production of a feature-length film since the late 1980s, gathering a group of artists who had the necessary creative and technical skills. Like Pixar, the studio first honed its skills in a series of short CGI festival films, including one directed by Eric Darnell, *Gas Planet* (1992), which features extraterrestrial characters that were praised for their hand-drawn look, and another by the Hong Kong animator Raman Hui, *Sleepy Guy* (1994), about a man who has trouble meeting the woman of his dreams. PDI was well prepared, therefore, to sign a co-production deal with DreamWorks to create *Antz*, co-directed by Darnell and Tim Johnson. After DreamWorks acquired PDI, under the banner PDI/DreamWorks it began to produce a range of popular 3D CGI features, including *Shrek* (dir. Andrew Adamson and Vicky Jenson, 2001), *Madagascar* (dir. Eric Darnell and Tom McGrath, 2005), and *Kung Fu Panda* (dir. John Wayne Stevenson and Mark Osborne, 2008), all of which spawned franchises. Over the next few years, the studio released a number of sequels, along with one-off feature films.

DreamWorks' second CGI feature, *Shrek*, tells the story of a grumpy ogre whose life is complicated by a donkey sidekick, a princess, an evil lord, and a multitude of fairy-tale characters (21.16). It is based on William Steig's picture book of 1990, *Shrek!*, though with significant modifications to the female character, who in the movie version transforms into a "cute" ogre, rather than an ugly witch. The voices of the central characters are provided by actors the Mike Myers, Eddie Murphy, Cameron Diaz, and John Lithgow, delivering humor that appeals to adults as well as younger viewers. In 2001, this film was the first to win an Oscar in the category of best animated feature, and its popularity initiated the sequels *Shrek 2* (dir. Andrew Adamson, Kelly Asbury, and Conrad Vernon) in 2004 and *Shrek the Third* (dir. Chris Miller and Raman Hui) in 2007. DreamWorks touted these films as markers of its technological progress, including exponentially greater control of character expressions and actions in each subsequent film. Advances were also made in the procedurally driven software used in creating fabrics, including subtleties of threads and varied materials. Fluid simulation had improved, meaning that complex water movements could be rendered, and global illumination (indirect lighting) provided more sophisticated effects within scenes, calculating the level of bounce light cast off various objects more precisely.[12] The high degree of realism in *Shrek*'s characters was achieved by building the skull and body on a computer and layering them with recreations of the muscle structures found in a real human body. This foundation was covered by a skin that was programmed to respond to manipulation of the muscles in a realistic way, with hundreds of controls in the face and similar complexity throughout the body. For each film in the franchise, characters were updated to reflect ever-increasing controllability.[13]

DreamWorks continued to develop its franchises alongside new offerings to the studio's collection—for example, with *Madagascar 3: Europe's Most Wanted* (dir. Eric Darnell, Conrad Vernon, and Tom McGrath, 2012) and *Mr. Peabody & Sherman* (dir. Rob Minkoff, 2014). In 2015, in a sudden move to cut back on production, DreamWorks closed its PDI studio in Northern California, consolidating its operation into a location in the Los Angeles area.

The Illusion of Depth

Throughout the history of art, including the production of films, various methods have been devised for creating the illusion of depth. These methods have been built around the concepts of perspective and depth of field, which have been studied and systematized for centuries. In the fifteenth century, rules of geometry were developed to create drawn perspective based on the use of converging lines at a horizon line; these principles, which were demonstrated by the architect and engineer Filippo Brunelleschi (1377–1446), were quickly embraced by artists in Italy and then spread to other parts of the world. Centuries later, cinema also attempts to achieve the look of real-life perspective, using such processes as multiplane cameras and stereoscopy **(21.17)**.

In real life, one way that the mind processes depth is through "motion **parallax**": as a person moves in any direction, items that move quickly across our field of vision are perceived as nearby, while objects that move more slowly, sometimes imperceptibly, are recognized as distant. A multiplane camera creates depth in this way because it allows different planes of action to move at different speeds. In a "Tricks of Our Trade" television documentary featurette of 1957, Walt Disney explains how his studio's multiplane works, using the opening scene from *Bambi* (dir. David Hand, 1942), which moves through a densely wooded forest, as a prime example. Each plane (for example, foreground, middle ground, and background regions), painted in oil on glass, is placed under the camera on its own level of the rig. As the camera moves into the scene or pans from side to side, the objects on the different levels move at their own rates, as opposed to images on all planes growing larger or smaller to the same degree or moving left to right at the same speed.

A sense of depth is also triggered when the eye and the mind work together in a process called "convergence." This happens in real life when objects are actually at different distances from the viewer, causing the eye to perceive them at slightly different angles. This effect does not happen naturally in films, since objects are all projected onto one plane, a flat screen. Through the principles of stereoscopy, however, a similar effect can be achieved. During the screening of a normal film, the left and right eyes view the same image, but during a stereoscopic film, they are presented with slightly different images. Depending on how far or near a stereoscopic object should be, it is offset in the left and right versions by a greater or lesser degree. During the early 1950s and early 1980s, stereoscopy was employed as a novelty in both live-action and animated films. In the early 2000s, its use became more frequent, with some previously released films even being remade in stereoscope. Although the effect is novel and interesting, it can also lead to discomfort, including eyestrain and headaches.

Virtual reality (VR) takes three-dimensionality a step further than stereoscopy, in that it places the viewer within the setting, allowing interactivity and matching his or her physical movements with perspectives of the environment and resulting imagery, sometimes using a data glove that transmits information. The illusion is achieved through the use of a head-mounted display that covers the eyes, providing an immersive visual scene that seems to surround the viewer. Experiments in VR began in the early 1960s, but only in the 2010s has the idea of using VR for feature films seemed viable. A number of projects have developed out of Oculus Rift technology (see p. 282), which offers the promise of affordability, so consumers can use it. In 2015, the Oculus Story studio started work on an animated short, *Henry* (dir. Ramiro Lopez Dau), about a loveable hedgehog, for release in 2016. But many test projects using drawn, stop-motion, and 3D CGI images have already demonstrated the potential for VR in short films and eventually feature-length storytelling.

21.17 Nineteenth-century stereoscope

Disney Builds Its Digital Empire

In the early 2000s, Disney tried its hand at producing in-house 3D CGI films. These attempts met with varying degrees of success. One effort, *Dinosaur* (dir. Eric Leighton and Ralph Zondag, 2000), combined live-action backgrounds with 3D CGI characters (21.18); the effects were created at an in-house facility known as the Secret Lab. This group had its origins in a leading visual-effects company, Dream Quest Images, which Disney acquired in 1996. Disney's own effects department, Buena Vista Visual Effects—which had been in place since the studio's earliest years—was closed and in 1999, Dream Quest was merged with a part of the Burbank Feature Animation unit to form the Secret Lab. This group produced CGI character animation and visual effects for *Dinosaur* and other projects, including the shelved film *Wild Life*, but its employees began to be laid off and in 2001 the Secret Lab was closed completely. Instead, Disney turned to Industrial Light & Magic for its effects. Several years later, in 2012, the Disney chairman and CEO Bob Iger oversaw the acquisition

of its parent company, Lucasfilm, including ILM and Skywalker Sound, for more than four billion dollars.

Meanwhile, in 2005 Disney Feature Animation released a fully 3D CGI animated feature, *Chicken Little* (dir. Mark Dindal), and for the first time included a stereoscopic version, under the banner of Disney Digital 3D. The following year, in 2006, while it was in production on *Meet the Robinsons* (dir. Steve Anderson, 2007), Disney acquired the Pixar Animation Studios, and John Lasseter had a hand in shaping that film, as well as the 3D CGI features *Bolt* (dir. Chris Williams and Byron Howard, 2008) and *Tangled* (dir. Nathan Greno and Byron Howard, 2010), all produced by Walt Disney Animation Studios.

Disney's animated feature *Frozen* (dir. Jennifer Lee and Chris Buck), released in 2013, represents a culmination of its efforts in 3D CGI—and the most financially successful film in animation history, after it grossed more than one billion dollars in its worldwide box-office earnings. *Frozen* tells the story of a princess who has to break a wintry spell cast by her sister, and the journey she takes with the help of a mountaineer and his sidekick moose, not to mention a zany snowman. One of the film's

21.18 Eric Leighton and Ralph Zondag, *Dinosaur*, 2000

biggest challenges was the representation of snow as a light and fluffy substance that the characters handled and moved through. In order to achieve this new level of realism, Disney artists travelled to Wyoming and studied deep snow and then worked with scientists and technologists to create processes for animating it. Jennifer Lee (1971–), who wrote the film's screenplay and also co-directed it, became the first female director of a Walt Disney Animation Studios feature. She had previously co-written the screenplay for Disney's *Wreck-It Ralph* (dir. Rich Moore, 2012) with Phil Johnston. This film tells the story of a video-game villain who wishes to become a hero.

Other Players Embrace CGI

By the late 1990s, the possibilities of 3D computer animation were clear and a number of studios began to produce computer-animated features. In some cases, 3D CGI figures were integrated into an otherwise 2D setting—for instance, the giant in *The Iron Giant* (1999), which Brad Bird directed for Warner Bros. **(21.19)**. It focuses on a quiet boy who comes across a robot that has dropped from the sky, and the child's efforts to save his new friend from the government, which

wishes to destroy it. The story is based on the Ted Hughes novel *The Iron Man: A Children's Story in Five Nights* (1968), though the book's relatively modern setting was changed to the Cold War context of the 1950s. Some of the era-specific references include the use of the widescreen CinemaScope process, which was developed in that decade, and the inclusion of an educational film called *Atomic Holocaust*, which is based on a real film of the 1950s, *Duck and Cover* (dir. Anthony Rizzo, 1951), funded by the US government to prepare schoolchildren for a nuclear attack. *The Iron Giant* was critically acclaimed, but suffered from a weak marketing campaign on the part of Warner Bros.

Blue Sky Studios was among the major CGI animation companies to emerge in the 1990s. It had been founded in 1987 by several artists and technicians from MAGI/Synthavision, one of the firms that contributed to Disney's *Tron*; these individuals included Alison Brown, David Brown, Michael Ferraro, Carl Ludwig, Eugene Troubetzkoy, and Chris Wedge. The company developed software (such as its proprietary renderer CGI Studio) and through the 1990s produced imagery for animated advertising, feature films, and theme-park effects. By the late 1990s, Blue Sky was also creating effects for such popular films as *Alien: Resurrection* (dir. Jean-Pierre Jeunet, 1997) and *Fight Club* (dir. David Fincher, 1999). At about the same time, it began to expand

21.19 Brad Bird, *The Iron Giant*, 1999

21.20 "Veggie Tales," season 1, Fall 2006

into animated shorts, beginning with the festival film *Bunny* (1998), directed by Chris Wedge. The film was notable partly for the naturalistic fur effects used on its rabbit character; this look was created using radiosity—achieving soft, shadowy, diffused effects—developed with Ludwig and Troubetzkoy's light-rendering techniques. *Bunny* won the 1998 Academy Award for best short film (animated). In 1999, 20th Century Fox bought Blue Sky and started production on the CGI animated feature *Ice Age* (2002), co-directed by Wedge and Carlos Saldanha. Originally, 20th Century Fox intended to produce the film in 2D, with directing by Don Bluth and Gary Goldman, but the sudden rise of CGI animation and the poor performance of its *Titan A.E.* (dir. Don Bluth, Gary Goldman, and Art Vitello, 2000) resulted in the closure of its 2D facility. Blue Sky's later CGI features include *Robots* (dir. Wedge and Saldanha, 2005), *Dr. Seuss's Horton Hears a Who!* (dir. Jimmy Hayword and Steve Martino, 2008), and *Rio* (dir. Saldanha, 2011), which were produced along with a number of shorts.

In 2010, the American animation studio Illumination Entertainment released its first feature, the CGI production *Despicable Me* (dir. Pierre Coffin and Chris Renaud). The studio had been founded by Chris Meledandri (former president of 20th Century Fox Animation) in 2007, under an exclusive financing and distribution partnership with Universal Studios. Although the film had been produced through the US-based studio, it had been animated at a division of a French animation studio, Mac Guff Ligne. The studio's earlier projects include the French feature *Azur et Asmar* (2006), directed by Michel Ocelot (see p. 417), created using 3D technology that was converted to look like 2D silhouette animation. In 2011, Mac Guff was split, with part of the company being acquired by Illumination Entertainment under the name Illumination Mac Guff. This studio continued to develop the "Despicable Me" franchise, releasing *Despicable Me 2* (dir. Pierre Coffin and Chris Renaud) in 2013 and *Minions* (dir. Pierre Coffin and Kyle Balda) in 2015, with plans for future development.

The CGI feature *Jonah: A Veggie Tales Movie* (dir. Mike Nawrocki and Phil Vischer, 2002) came from Big Idea, which had been releasing the computer-generated "Veggie Tales" series direct-to-video since 1993, mainly through Christian stores (21.20). The feature, a present-day story about a veggie family mishap interwoven with the ancient tale of Jonah in the belly of a whale, was a financial success, though a modest one by industry standards. In 2012, the studio became a subsidiary of DreamWorks Animation, which had purchased its parent company, Classic Media.

Conclusion

The late 1990s were a time of great change in the American animation industry. Disney, which had been the flagship studio for animation worldwide, began to radically shift its business practices in a number of ways. Fueled by the blockbuster mentality that strove for higher and higher profits, executives at Disney and elsewhere were no longer content with modest returns. Consequently, they looked for spectacle and novelty, which included sophisticated effects in live-action films and an emphasis on 3D CGI animation, a new technique that was bringing in audiences. As Disney diversified, becoming a huge media conglomerate, it started to distribute a wide range of films from other producers, including *Toy Story*, from the emerging Pixar studio.

Disney also distributed the work of Hayao Miyazaki, a Japanese director who has been likened to Disney himself. Since the 1950s, the Japanese animation industry as a whole had been growing in scale and popularity, and Miyazaki was only one of the directors who had garnered a huge fan base by the 1990s. In Japan, relatively little animation production has been done in 3D CGI, as 2D animation continues to dominate in TV series as well as animated features. It is possible that 2D remains so popular there because Japanese animation production is so closely linked to the country's comic-book industry, and drawn images in one form migrate easily to drawn images in the other. Today, the Japanese animation industry is the main rival of American production, offering fans a different sensibility in various ways.

Notes

1 Bill Hilf, "Digital Entertainment, Art, Technology, and the New Forms of Storytelling in the Digital Era," unpublished thesis, Chapman University, 1996.

2 Lucas Shaw, "A Lucasfilm History: 30+ Years of 'Star Wars,' Indy and THX," *The Wrap*. Online at http://www.thewrap.com/movies/article/lucasfilm-history-30-years-star-wars-indy-and-thx-62886

3 Booth Wilson, "Computer Animation across the Iron Curtain," *Animation Journal* 21 (2013), 4–25.

4 John Lasseter quoted in Brent Schlender, "Pixar's Magic Man," CNN.com (May 17, 2006). Online at http://money.cnn.com/2006/05/15/magazines/fortune/pixar_futureof_fortune_052906/index.htm

5 Ken Perlin, "Wild Things, pt. 1," *Ken's Blog*. Online at http://blog.kenperlin.com/?p=2314

6 All quotations in this paragraph by John Lasseter in Brent Schlender, "Pixar's Magic Man."

7 The hardware division of Pixar, which developed the Pixar Image Computer, was sold in 1990. Anonymous, "Pixar Image Computer," at Rhode Island Computer Museum. Online at http://www.ricomputermuseum.org/Home/equipment/pixar-image-computer

8 Alvy Ray Smith, The Making of André & Wally B., draft, August 14, 1984, of a memo created August 1, 1984. Online at http://alvyray.com/Memos/CG/Lucasfilm/André&WallyB_TheMakingOf.pdf

9 Alvy Ray Smith, "Digital Paint Systems: Historical Overview," Microsoft technical memo 14 (May 30, 1997), 5, originally prepared for the Academy of Motion Picture Arts and Sciences. Online at http://alvyray.com/Memos/MemosCG.htm#PaintHistory

10 For John Lasseter's views on using Disney principles in CGI animation see John Lasseter, "Principles of Traditional Animation Applied to 3D Computer Animation," *Computer Graphics* 21:4 (July 1987), 35–44. (Published for SIGGRAPH 87.)

11 Geraldine Fabrikant, "'Prince of Egypt' Is No King at the Box-Office," *New York Times* (December 28, 1998). Online at http://www.nytimes.com/1998/12/28/business/prince-of-egypt-is-no-king-at-the-box-office.html

12 Bill Desowitz, "A Decade of 'Shrek' Tech," *Animation World News* (May 20, 2010). Online at http://www.awn.com/vfxworld/decade-shrek-tech

13 Joe Tracy, "Animating Shrek," *Digital Media Effects* (n.d.). Online at http://www.digitalmediafx.com/Shrek/shrekfeature04.html

Key Terms

3D computer animation	motion blur
animatronics	motion capture
CAPS	motion-control camera
CGI	motion graphic
cinematographer	parallax
depth of field	post-production
distribution	procedural animation
hierarchical programming	stereoscopy
morphing	

1948

Animation production
in India begins with
Films Division of India, a
governmental organization
that is established
in Mumbai

1953

Amazon Symphony (Anélio
Latini Filho) is Brazil's first
animated feature film

1961

The Japanese director
Osamu Tezuka founds
Mushi Production

The animator Ali Muhib
starts the Film Animation
Department at the national
television station in Egypt

1967

South Korea releases its
first animated features,
Hong Gil-dong (Shin Dong-
heon) and *Heungbu and
Nolbu* (Gang Tae-ung)

1976

The Italian animated
feature *Allegro Non Troppo*
(Bruno Bozetto) parodies
Disney's *Fantasia* (1940)

1978

Animage, Japan's first
manga-and-anime fan
magazine, is established

1978

The animated short Pica
Don (Renzo Kinoshita)
addresses the bombing
of Hiroshima in WWII

1980s

Surge in Japanese
animation production
and fan culture worldwide

1982

The Snowman (Dianne
Jackson), a British holiday
special produced by
Channel 4, airs

1983

The "ARTcade" exhibition
at the Corcoran Gallery
of Art (Washington, D.C.),
showcases video games

1985

Studio Ghibli is founded in
Tokyo by Hayao Miyazaki
and Isao Takahata

Inaugural Hiroshima
International Animation
Festival

1987

CARTOON created to
support animation in
Europe

1988

My Neighbor Totoro (Hayao
Miyazaki) introduces the
Studio Ghibli's iconic figure

Grave of the Fireflies (Isao
Takahata) is released as a
double feature with *My
Neighbor Totoro*

The UK's Channel 4 actively supports production
of innovative short animation under Commissioning
Editor Clare Kitson

1990–99

1989

Akira (Katsuhiro Otomu)
is released in the US,
expanding anime's fan base
beyond Japan

1989

*Wallace & Gromit: A Grand
Day Out* introduces Nick
Park's popular stop-motion
characters

William Kentridge's
animated short
*Johannesburg, 2nd Greatest
City after Paris*, examines
apartheid in South Africa

1990

Shifting political systems
in Latin America embrace
democratic practices

1993

The European Economic
Community is renamed the
European Union

1993

The Walt Disney Company
sets up a subsidiary in
Mumbai, India

1993

The first Anima Mundi
festival is held in Brazil

1993

Michel Gondry collaborates
with the Icelandic singer
Björk, creating a video
for her song "Human
Behaviour"

CHAPTER 22
The Culture of Japanese Animation

CHAPTER 23
A Panorama of World Animation

CHAPTER 24
Animation in the Art World

Animation Worldwide

■ Technological development ■ Development of the animated medium ■ Development of the film industry as a whole ■ Landmark animated film, television series, or game ■ Historical event

1994
End of Apartheid laws, which had facilitated race-based oppression in South Africa since 1948

1995
Animatronics is combined with live animals and digital effects in the Australian-American co-production *Babe* (Chris Noonan)

1995
The "Neon Genesis Evangelion" (Hideaki Anno) television series debuts

1996
Absolut Panushka showcases innovative animation online, including streaming media

1997
Satoshi Kon releases *Perfect Blue* at the Madhouse studio in Japan

2000
Chicken Run (Nick Park and Peter Lord)

2001
Spirited Away (Hayao Miyazaki) becomes the highest-grossing film in Japan's history

2001
The Ghibli Museum opens in Tokyo

2003
Harvie Krumpet (Adam Elliot), an animated short from Australia, wins an Oscar

The Triplets of Belleville (Sylvain Chomet), an animated feature and international co-production between studios in Belgium, Canada, and France, contains almost no dialogue

2004
UNESCO launches Africa Animated!

2005
"Pixar: 20 Years of Animation" opens at the Museum of Modern Art in New York City

2006
Happy Feet (George Miller) is Australia's first CGI feature

2006
The pioneering Indian animator Ram Mohan establishes the Graphiti School of Animation in Mumbai

2008
Guerrilla Kids International Distribution Syndicate (GKIDS) begins distributing international animated features in North America

2009
The Secret of Kells (Tomm Moore) employs Irish iconography

2010
The African television series "Tinga Tinga Tales" and "Bino and Fino" begin

2011
The "Watch Me Move" animation exhibition is held in London, UK, and tours internationally

2012
The "Art of Video Games" exhibition opens at the Smithsonian American Art Museum (Washington, D.C.)

2013
The Pakistani TV series "Burka Avenger" (Aaron Haroon Rashid) empowers girls through the heroics of their female teacher

2014
Pakistan's first animated feature, *Three Braves* (Sharmeen Obaid Chinoy), is released

The Culture of Japanese Animation

Chapter Outline

Global Storylines

Japanese animation is closely linked to the production of manga, or Japanese print comics. Both art forms are available in various genres that cater to all ages and genders

The style and content of animation in Japan is often influenced by the country's visual art, theater, and spiritual practices, and by historical events, including the devastating effects of World War II

Studio Ghibli, founded by Hayao Miyazaki and Isao Takahata, is famous worldwide for such films as *My Neighbor Totoro*, *Spirited Away*, and *Grave of the Fireflies*

Animation is recognized as part of Japan's cultural heritage in such events as the Hiroshima International Animation Festival and the manga and anime museums that have been established in recent years

Introduction

Japan is a world power in the production of animation, an industry strongly linked to a long history of storytelling in print forms. Japanese animation dates back to the 1910s (see p. 169) and has been distributed internationally since the early years of television. Its presence in games, features, and television grew significantly during the 1980s, and by late in that decade it had attracted an escalating fan culture across the world. Its popularity was fueled in part by the accomplishments of Hayao Miyazaki, one of the most beloved animation directors of all time (see p. 266). Into the 1990s, Japanese animation, in popular styles known as anime, enjoyed a broad base of consumers, with top markets forming in South Korea, Taiwan, the United States, France, and Thailand. Japanese production grew until about 2006, when it was hit by an economic downturn in the country that lasted for five years, but in recent years it has begun to thrive again. Although Japan is a relatively small country, it supports hundreds of animation production houses. Almost all of the animation screened in the country is made domestically, with only a small percentage, mostly American-made theatrical features, imported.[1] Over the years, 2D production has remained strong in Japan despite the relatively large gains of 3D CGI animation in other parts of the world.

The Japanese animation industry shares a fan base with print comics, or manga. In this field, as in anime, there is an appeal to many types of consumers through a range of different content and styles; for example, *shōjo* for girls and *shōnen* for boys, while young women are an audience for *josei*, and *kodomomuke* is produced for young children. There are

also a number of clearly defined thematic groups, or genres, which include robot-oriented stories known as mecha and erotic or sexually explicit works known as *hentai*. There is generally a symbiotic relationship between manga and various types of animation, including original video animation (OVA), television series, and theatrical features, as series develop through a combination of these forms, with success in one medium leading to production in another, as franchises form.

Toei Animation, one of Japan's largest studios, demonstrates these industrial practices. For example, its "Dragon Ball" series, which aired from 1986 to 1989, was an adaptation of the first 194 chapters of Akira Toriyama's manga of the same name; based on the Chinese "Journey to the West" stories, it was published in *Weekly Shōnen Jump* in the mid-1980s. Following its success, another TV series was produced, "Dragon Ball Z," which covers chapters 195 through 519 and aired in Japan between 1989 and 1996, as well as many feature films, TV movies, games, and related merchandise. In 1996, the "Dragon Ball GT" series became a sequel to "Dragon Ball Z," not based on the manga series, but rather an original story that featured the same characters and universe.

22.1 "Sailor Moon," *c.* 1992–97, based on the manga by Naoko Takeuchi

In the shōjo genre, Toei produced such television series as "Candy Candy," about an orphaned girl growing up in the American Midwest during the early twentieth century, which aired from 1976 to 1979 and was distributed internationally. It began as a series of novels by Kyoko Mizuki (born Keiko Nagita), who later transformed them into a manga series with Yumiko Igarashi. Also in the shōjo genre, Toei's "Sailor Moon" began as a manga written and illustrated by Naoko Takeuchi (**22.1**). Featuring the adventures of a group of girl superheroes who use magical powers to fight evil in space, it ran for about five years, beginning in 1992.

After World War II, Western society came to know Japan as a leading manufacturer of consumer products, ranging from automobiles to cameras and including electronics; its great successes meant that within a few decades it became a leading economic power. Despite this achievement, the country faced substantial challenges as part of its recovery from the war, and there were elements of the past that remained difficult to deal with directly in media or in other ways—especially the devastation caused by the atomic bombs and other events of the war. Only in relatively rare instances have these incidents been directly addressed in animation, for example. There is a short film of 1978 by Renzo Kinoshita, *Pica Don*, about the bombing of Hiroshima, and two features, *Hadashi no Gen* (*Barefoot Gen*, 1983), directed by Mori Masaki, based on the experiences of the manga-creator Keiji Nakazawa in Hiroshima, and *Hotaru no Haka* (*Grave of the Fireflies*, 1988, see p. 397), directed by Isao Takahata and based on Akiyuki Nosaka's semi-autobiographical manga about two children orphaned and left to starve following the firebombing of Kobe.

22.2 Katsuhiro Otomo, *Akira*, 1989

Generally, references to the war have been more cryptic, coming in the form of post-apocalyptic settings, uncontrollable beasts, and immensely strong psychic phenomena—all probable allusions to the nuclear devastation of World War II. A good example is found in *Akira* (1989), directed by Katsuhiro Otomo, as an adaptation of his lengthy manga. The story, which is set in the future, focuses on a group of mutated children who possess extraordinary psychic powers and are under the control of government forces in a Tokyo that is overrun by street gangs **(22.2)**.

Although the realities of war may be sidelined in anime, more generalized violence has a significant presence. The mecha genre features robots, often bent on destruction or engaging in battles against enemies. Sometimes violence is framed within the history of the samurai, a class of highly skilled warriors found in Japan throughout a long period spanning the seventh to the twentieth centuries. They worked for feudal lords, protecting their employers' property, and they operated under a code of honor, demanding respect from commoners. Eventually, the samurai's role in society shifted; the origins of modern-day gangs of organized criminals, known as *yakuza*, can be traced to the Edo period (1603–1868), when samurai without masters, known as *ronin*, sometimes banded together to rob villages and cause havoc.

Samurai and yakuza are now iconic figures, both in live-action cinema and animation, sometimes updated to reflect a contemporary or futuristic context. One example is the Sunrise production "Kaubōi Bibappu" ("Cowboy Bebop," 1998–99), a highly stylized television series featuring a bounty hunter who chases yakuza using futuristic technology; the programs are accompanied by a jazz score and explore existential themes **(22.3)**. The production team was headed by Shinichirō Watanabe, also known for the series "Samurai Chanpurū" ("Samurai Champloo," 2004–5), which offers an alternative history of the Edo period, told through the actions of a small band of rogue characters. It blends historical elements with modern accents, such as the use of hip-hop music.

Traditional Japanese perspectives on the world and the natural order have been shaped by Buddhist and Shinto philosophy, which commonly find their way into animation. The non-theistic practice of Buddhism was introduced to Japan during the sixth century by Chinese monks spreading the teachings of its founder, Siddhartha Gautama, born in Nepal in 563 BCE and known as Buddha. The Buddha's teachings are practical and emphasize balance; essentially they center on the existence of suffering, its causes in mainly material desires, and the means to its end. The Japanese manga artist and animator Osamu Tezuka (see p. 235)

22.3 Shinichirō Watanabe, "Cowboy Bebop," 1998–99

documented Siddhartha's path in his manga series "Budda" ("Buddha"), published between 1972 and 1983.

Buddhism is largely compatible with Shinto, which is Japan's indigenous faith. Shinto does not have a founder, sacred writings, or a practice of proselytizing. There are no absolutes and in fact there are variations in the way it is interpreted. Shinto embodies a strong relationship with the natural world, including the physical environment and the spirit plane. The concept of *kami* represents the spiritual essence in all things, whether good or evil, gentle or rough, or otherwise varying in type. Kami can be found in such natural phenomena as sacred mountains, trees, and rivers, and can be honored in these forms. When humans die, they become ancestral kami. Shinto shrines provide places for kami to reside and people visit to pay them homage. One finds examples of these figures in Hayao Miyazaki's *Tonari no Totoro* (*My Neighbor Totoro*, 1988), taking the form of statues near the bus stop where two girls wait for their father (see p. 396). Kami also populate Isao Takahata's *Heisei Tanuki Gassen Ponpoko* (*Pom Poko*, 1994), when the shape-shifting *tanuki* take on the form of kami to deter people from developing rural land (see p. 398).

This chapter begins with a brief discussion of traditional Japanese visual culture, which built a foundation for the development of manga and anime.

It then focuses on animated feature films, television series, and festival films from a few of Japan's most successful studios and creators, including Studio Ghibli and Hayao Miyazaki.

Manga and Anime

The Beginnings of Manga

The tenth century saw the introduction of long illuminated scrolls, illustrated with visuals and often containing text, created for monks and the wealthy. Their drawn subject matter ranges widely—from religious and historical subjects to morality tales and fantasies filled with *yōkai*, or supernatural monsters—and human characters are typically depicted as relatively small in comparison with the natural world around them to reflect the relationship between humankind and the environment. A famous early scroll was made by a Buddhist bishop named Toba Sojô (also known as Kakuyu, 1053–1140), whose twelfth-century *chōjugiga* ("animal scrolls") depict anthropomorphic animals in what appears to be playful mockery of Buddhist concepts (**22.4**, see p. 392). Scrolls can be considered forerunners of the manga that are so popular today. Some of them include visual effects,

22.4 Toba Sojô (also known as Kakuyū), *Scroll of the Animals*, twelfth century

American sources for inspiration. He had a background in painting before he turned to manga in the 1930s, but achieved fame in the 1950s after he began publishing children's comics, including adaptations of *Godzilla* and *The Last of the Mohicans*, as well as samurai spy stories featuring the character Sarutobi Sasuka.

Soon a variety of artists had established themselves in the field of manga. Such individuals as Osamu Tezuka and Hayao Miyazaki launched their careers that way, and eventually adapted their drawn comics to animation. Another popular manga artist, Kazuhiko Katō, also known as Monkey Punch, created the immensely successful "Lupin III" series, dating from 1967 and the first issue of *Weekly Manga Action*. This property was the start of a huge franchise, including animated adaptations that were produced through different studios and directors, including Miyazaki. During the 1980s, the all-female artist collective Kuranpu (CLAMP) formed, and through the years it has created a number of widely ranging manga series, starting with the ten-volume "Rigu Vēda" ("RG Veda"), between 1989 and 1996. CLAMP's manga have often been adapted into animation, the first time involving their seven-volume supernatural detective story "Tōkyō Babiron" ("Tokyo Babylon," 1990–93). It was adapted as a TV series of the same name, directed by Koichi Chigira at Madhouse studio and airing between 1992 and 1994.

The Global Reach of Anime

Many viewers outside Japan were introduced to the country's animation through television, in such series as "Voltron" (1984) and "Robotech" (1985), and later "Sailor Moon" (1992) and "Pokémon" (1996), among others from the 1980s onward (see p. 234). Within Japan, a fan base had been developing even earlier, leading to the publication of the country's first large-scale manga-and-anime fan magazine, *Animage*, in 1978. In the mid- to late 1980s, anime fandom was boosted internationally by the spread of home-entertainment media, followed by the Internet in the mid-1990s, allowing followers more access to productions and news about their favorite

such as **parallel action** and a zoom-in, employing separate frames. The calligraphic writing that is also often part of the composition is an art form in itself.

Woodblock prints have also had a long history in Japan. Their original use, to create Buddhist texts, dates from the eighth century. By about 1600, woodblock printing was used to create secular art, including popular prints known as *ukiyo-e*, which depicted literary and historical subjects, along with current and fashionable images of the day.[2] Styled and printed in a wide variety of ways, they appealed to the merchant class, which had money but lacked social power and therefore embraced these images as a reflection of their cultural status. Ukiyo-e woodblocks were also sometimes used to create *ehon*, or picture books of related images; one variety, the *kibyōshi* ("yellow-cover booklets") are captioned and have storylines aimed at adults, which are often political in nature. European and American publishing practices introduced in the mid- to late nineteenth century caused woodblock printing to be abandoned for cheaper methods.

By the mid-1920s, Japanese newspapers featured popular comic strips, which began to be serialized as books of manga during the following decade, and during the 1950s, the manga industry took off alongside the growth of comic books in other countries. One of Japan's most influential comic-book artists, Shigeru Sugiura (1908–2000), created imaginative scenarios that helped to redefine Japanese comics in the period after World War II, drawing upon both Japanese and

works. At the same time, anime conventions provided merchandizing opportunities and a meeting point for fans in various locations. These events started out rather small, but today "anime-cons" are big business. Devotees often attend them wearing the costumes of their favorite characters, in what is known as cosplay.

During the late 1980s, a further surge in Japanese animation occurred. One of the key developments was the international promotion of the feature *Akira*, directed by Katsuhiro Otomo (1954–). It had been released in Japan in 1988; the following year it was given a relatively wide theatrical release by Streamline Pictures in the US, where it drew a lot of attention. The story is adapted from Otomo's immense manga of the same name, which was serialized between 1982 and 1990 and then collected in six volumes. Its dystopian plot takes place in a post-apocalyptic setting—known as neo-Tokyo in manga and anime—and involves psychic experimentation and the unleashing of devastating powers. With its attention to visual detail, high-powered soundtrack, and graphic violence, *Akira* surprised viewers used to the norms of American animated features at the time, as typified by the Disney renaissance film *The Little Mermaid*, which was also in theaters in 1989 (see p. 346). As a result, many people began to explore Japanese animation further, seeking more work to view. Before *Akira*, most Japanese animation had been circulated among relatively clandestine anime clubs, largely located on college campuses, and via underground methods created by fans who subtitled or dubbed video copies themselves. By the mid-1990s, a mail-order company called the Whole Toon Catalog had begun to publish a guide to purchasing animation from Japan, providing one of the first means for general viewers in America to acquire this material.

To the uninitiated, Japanese films probably seemed somewhat exotic. Not only did they feature violence, but there was also more variation in sexual content—not just in the depiction of nude bodies or sexual acts, but also in the ages and gender of the participants. In addition, Japanese history and aesthetics influenced not only the choice of characters and story, but also the way they were presented. References to theatrical traditions, such as noh, kabuki, and bunraku (see Box: Japanese Theatrical Traditions, p. 194), contributed to a stylized look, resulting in slow pacing in animated motions and the use of conventional expressions to signify

meaning in character design and storytelling. It is likely that the traditional use of face masks and narrators in theatrical performance has influenced the way anime characters speak, so that lip-synch may not be as high a priority as it would be in American productions, for example. In fact, most of the Japanese animation industry follows a practice of recording dialogue in post-production, after the animation is complete, so lip sync is not possible. It is also likely that the close relationship between manga and anime has influenced the use of relatively limited animated movement, since characters are still when they are in print, and as a result are familiar to viewers in that form.

Hayao Miyazaki, Isao Takahata, and Studio Ghibli

Hayao Miyazaki Gets His Start

Along with Osamu Tezuka (see p. 235), Hayao Miyazaki (1941–) is one of the best-known figures in Japanese animation. Growing up in the postwar era, Miyazaki was immersed in the modern culture of Japan and attracted to the growing fields of manga and animation. His career path was influenced in part by the Toei studio's film of 1958, *Hakujaden* (*The Tale of the White Serpent*, dir. Taiji Yabushita and Kazuhiko Okabe), which he saw in his final year of high school (see p. 169). Like Tezuka, Miyazaki did not attend art school; instead, he studied political science and economics, writing a thesis on Japanese industry.[3] Nonetheless, after he graduated in 1963, he went to work at Toei Animation as an in-betweener. There Miyazaki met his future business partner, Isao Takahata (1935–), when he was working on a feature being directed by that more experienced animator: *Taiyo no Oji: Horusu no Daiboken* (*Hols, Prince of the Sun*, 1968, see p. 266).

In Takahata's film, a boy named Hols attempts to end an evildoer's curse on a village by using a special sword, while accompanied by a bear sidekick. In a central scene, Hols battles a huge fish in an action-packed full-animation sequence. This imagery stands out especially because the rest of the film mostly employs limited animation, with characters in holds and still artwork captured by a moving camera, as well as hidden lips to obviate dialogue sync. Despite these shortcuts,

22.5 Hayao Miyazaki, *Nausicaä of the Valley of the Wind*, 1984

efforts are made to tell the story creatively, using varied angles, multiplane shots, and such effects as double exposure and decorative patterning—for example, at the end of the film, when Hols falls into a dense forest. There is also an attempt to create complexity in the characters, particularly a young woman named Hilda, who regrets her role in the enemy's evil schemes. Although the film did not do well on its release, it did provide a launching point for some important industry figures, including both Takahata and Miyazaki.

After leaving the Toei studio, the two men worked on a variety of animated television series and other projects. Meanwhile, Miyazaki also produced a number of print comics: "Nagagutsu wo Haita Neko" ("Puss in Boots," 1969), a newspaper serialization of a Toei animated feature; "Sabaku no Tami" ("People of the Desert," 1969–70), a story with a wartime theme for a children's newspaper; and "Doubutsu Takarajima" ("Animal Treasure Island," 1972), another serialization of a Toei Animation feature. It was not until several years later that Miyazaki would embark on a personal manga, "Kaze no tani no Naushika" ("Nausicaä of the Valley of the Wind," 1982–94). Based partly on his reading of various books and articles about the environment, the manga is a complex work about Princess Nausicaä—named after a brave Greek

princess in the epic poem *The Odyssey*, attributed to Homer—who confronts environmental disasters, war, and the dark side of human nature. Miyazaki's manga was published in *Animage* and was very popular.

In 1978, Miyazaki started directing, beginning with the television series "Future Boy Conan" at Nippon Animation. But he left the next year for an even better opportunity: a chance to direct a feature film, *Rupan Sansei: Kariosutoro no Shiro* (*The Castle of Cagliostro*, or *Lupin III: Castle of Cagliostro*), in 1979, adapted from Monkey Punch's successful manga series, "Lupin III." The film was made at Tokyo Movie Shinsha (now TMS Entertainment) and distributed by the major Japanese film studio Toho. Later, Miyazaki also directed episodes of the "Lupin III" television series at the studio, getting credit under the name of Tsutomu Teruki.

After several other projects, Miyazaki was able to write a screenplay for and direct a feature version of his own manga. His film *Kaze no Tani no Naushika* (*Nausicaä of the Valley of the Wind*, 1984), was made at Topcraft and distributed by Toei **(22.5)**. In it, Nausicaä tries to help her community in the midst of devastating environmental conditions and aggressive attacks by hostile forces, expertly navigating the skies by riding on a wind glider. Another skill is her sensitivity to nature, which becomes important as she wards off swarms of

22.6 Hayao Miyazaki, *Princess Mononoke*, 1997

insects that she realizes are mainly trying to save the world. Underlying the film is a strong message about environmentalism, in the form of a warning that humans are poisoning the land they depend on for survival. This theme would be a major characteristic of Miyazaki's work, as would the significance of active female characters. At times, the film shows Nausicaä in real danger: for example, when she slides into a lake filled with acid and burns her foot. And although most of the film's leading roles are male, Nausicaä is aided by a group of women who free her and apologize for her ill-treatment. Aesthetically, the film still relies heavily on limited techniques, especially when it comes to dialogue and the crowd scenes, in which the majority of people remain still. Since the characters mostly wear protective masks, their lips cannot be seen; other characters sport lip-covering moustaches that move only in general ways. Great care is given to the development of the landscapes, however, as they are central to the film's themes—Miyazaki would become known for his detailed background art, revealing the beauty and complexity of nature. The film's score was commissioned from Jo Hisaishi (born Mamoru Fujisawa), an eclectic composer who also worked on subsequent Miyazaki films.

As Miyazaki's career developed, it became apparent that the narrative elements of his works often reflected his own life experiences. For example, the long illness of his mother when he was a child seems to have inspired the character of the sick mother in *My Neighbor Totoro,* while the time he spent around his uncle's airplane company resulted in a common flying motif, as in *Nausicaä of the Valley of the Winds* and *Kurenai no Buta* (*Porco Rosso*, 1992), in which a flyer who has lost his faith in humanity must become a war hero. Miyazaki's experience of war and its aftermath in Japan contributed to his pacifist leanings and concern for the environment, which can clearly be seen in *Mononoke Hime* (*Princess Mononoke*, 1997), a film that depicts the delicate natural environment and the destruction caused by human development **(22.6)**.

Studio Ghibli and Totoro

In 1985, Miyazaki and Takahata founded Studio Ghibli in Tokyo, where they continued to make animated feature films, beginning with Miyazaki's *Tenku no Shiro Laputa* (*Castle in the Sky*, 1986). The concept was inspired by Jonathan Swift's eighteenth-century novel *Gulliver's Travels*, which includes an island that floats in the sky. The film tells the story of two children who are being pursued by air pirates and government officials, and a special gem that appears to have magical powers.

22.7 Hayao Miyazaki, *My Neighbor Totoro*, 1988

Next came what is probably the studio's best-known production, Miyazaki's *My Neighbor Totoro*, in 1988 **(22.7)**. The film opens as two sisters, ten-year-old Satsuki and four-year-old Mei, arrive at a new home in the countryside, where they will live with their father, who goes to work by bus. They have moved there to be somewhat closer to their mother, who is convalescing in the hospital. From the moment they arrive, they are surrounded by mystery and magic, as they explore the old house and its garden. Along the way, they meet what they discover are called "dust bunnies": small, sooty orbs that inhabit dark spaces in the house, and scurry out of sight when they encounter the girls. Before long, Satsuki and Mei meet an even more compelling, mysterious figure: Totoro.

Part of the appeal of *My Neighbor Totoro* lies in its high production values, with great care given to backgrounds. One of the most remarkable scenes occurs when Satsuki first meets Totoro, while she is at a bus stop, in the middle of a downpour, holding her sleeping sister, as well as an umbrella over their heads. The first impression she gets is suggested to the audience through a point-of-view shot showing Totoro's large lower body being scratched by a furry arm that includes five pointed claws. As the two stand silently at the stop, side by side as if they were ordinary commuters, Miyazaki offers visual

details to provide a heightened sense of the surrounding environment: rain falling from the sky, puddles on the ground, and a frog that observes the action. Sound plays an important role as well, as distinct beats in the score suggest drips of rain or perhaps the pounding of a heartbeat, highlighting the delightful electricity of the moment for Satsuki. An actual dripping sound lends texture and authenticity to the scene, and guides the viewer to a drip on Totoro's nose, followed by drips on Satsuki's umbrella. These subtle moments lead to a revelation about Totoro, as, soon after, we observe his childlike joy at playing in the rain. His size makes him appear scary, but his actions show him to be otherwise. The magic of the moment is underscored by the arrival of the Catbus—a large cat-like vehicle that is at once disturbing and delightful, and whisks Totoro away. The scene holds a great deal of thematic meaning for the film, representing the changes that Satsuki will face as she deals with her personal worries over her mother, while trying to keep things together for her sister. She embraces childhood, while nonetheless beginning the journey toward becoming an adult. Miyazaki's love for nature is expressed in the way that his scenes are composed, often emphasizing background elements that surround the sisters and their new home. Like a traditional scroll painting, the film depicts towering trees and billowing

22.8 Hayao Miyazaki, *Spirited Away*, 2001

clouds as the frame for the relatively small humans and other creatures featured in the film, emphasizing the relationship of the natural world to its inhabitants.

In some ways, *My Neighbor Totoro* can be considered the most iconic film the studio has produced. Although it focuses on the girls' experiences, the film's title character, Totoro, has become immensely popular, making cameo appearances in other films and popular media, and being used as the Studio Ghibli mascot. Among the other highlights of Miyazaki's career is the celebrated feature *Spirited Away*, released in Japan in 2001 (**22.8**). The story centers on a ten-year-old girl, Chihiro Ogino, who unhappily accompanies her parents as they move to a new home. Along the way, her father takes a wrong turn, but drives on at full speed, even when the pavement ends and the road becomes bumpy. As they travel, Chihiro is concerned by strange objects she sees along the road, which her mother explains are shrines. Finally, the road ends at a mysterious building and the wind seems to beckon them in. Chihiro hesitates, but her parents enter; too scared to stay by herself, she goes with them. Following his nose, Chihiro's father finds a restaurant and her parents begin to eat, while Chihiro roams the town and meets a boy who warns her to get out. Returning to her parents, she sees that their gluttony has transformed them into pigs. With night falling quickly, Chihiro finds herself among a number of strange creatures and she tries to convince herself that it is all just a dream. Unfortunately, it is not. Chihiro must then devise a way to free her parents—and herself—from the spirit world. She takes a job at a bathhouse owned by the witch Yubaba, where she interacts with a wide range of enigmatic characters, including a destructive creature known as "No-Face." One of the characters is the spirit embodiment of a polluted river, which Chihiro helps to clean. Once again, this film reflects Miyazaki's concern for the natural world and the destruction threatened by excessive human consumption.

Miyazaki wrote, directed, and drew the storyboards for the entire film, building its structure with drawings rather than a regular script. *Spirited Away* was financed in part by The Walt Disney Studios, which eventually arranged to create an English-language adaptation under the supervision of John Lasseter, along with Kirk Wise

and Donald Ernst. An English-language dialogue track was written by Cindy Davis Hewitt and Donald H. Hewitt, and this version was released at the Toronto International Film Festival in 2012. The film's popularity made it the highest-grossing film in Japanese history. Although it was also immensely popular worldwide, its release in America was relatively limited by its distributor, Disney. In 2003, the film won the Oscar for best animated feature, the first time a Japanese animated feature had even been nominated.

Isao Takahata at Studio Ghibli

Isao Takahata's *Grave of the Fireflies* (**22.9**) was released in the same year as *My Neighbor Totoro*, in 1988. These two films were created as a double feature, to be shown together, though Takahata's film is much darker in tone. *Grave of the Fireflies* tells the story of an adolescent boy, Seita, and his young sister, Setsuko, at the end of World War II. The children are faced with the grim realities of a food shortage and becoming homeless after the firebombing of their city. The film is based on a manga of the same name by Akayuki Osaka, who lived through a similar experience with his younger sister; he felt remorse about feeding himself first, because he managed to live, while she died of starvation. *Grave of the Fireflies* is sad, but beautiful to look at, with its warm sepia outlines and enchanting lighting effects, especially when the children in the film are shown among fireflies at night. Although they are in dire circumstances, the moments these characters

22.9 Isao Takahata, *Grave of the Fireflies*, 1988

22.10 Isao Takahata, *Pom Poko*, 1994

share are authentic, those of real siblings. This depiction makes it all the more difficult to comprehend the awful way they are treated by other children and even relatives, who steal from them and cast them out.

Omohide Poro Poro (*Only Yesterday*, 1991), another of Takahata's films, is based on the manga of the same title by Hotaru Okamoto and Yuko Tone: a series of short, coming-of-age tales about an eleven-year-old girl. Takahata brought the stories together within a framing narrative about the character as a grownup looking back on her life. Though the characters are somewhat cartoon-like in style, the experiences depicted in the film—such as the discovery of menstruation, romance, and other topics relevant to girls—are treated realistically. When it came out, *Only Yesterday* was one of the country's highest earners for the year, but it has had limited distribution outside Japan. In the US, Disney owned theatrical distribution rights to this film and other Studio Ghibli works until 2011, when they were taken over by the distributor Guerrilla Kids (GKIDS).

Another of Takahata's films, *Pom Poko*, released in 1994, tells the story of a community of *tanuki*, dog-like creatures that look similar to raccoons, as they try to protect their homes from destruction by aggressive human communities (22.10). According to Japanese folklore, tanuki are tricksters, capable of shape-shifting. In the film, the characters do just that, taking on many different forms. Among them are kami and varying

types of *yōkai* (goblins), including one-footed umbrella monsters known as *karakasa*, which are a form of *tsukumogami*, or a spirit inhabiting an inanimate object that was treated badly, and *nopperabō*, or "no-face" folkloric creatures. The normally docile and playful tanuki make these transformations in an attempt to scare humans away from their forests, which are being developed at such a rate that they are left with nowhere to live. In the film, the irony of revering nature while destroying it becomes clear.[4]

Pom Poko extends the notion of shape-shifting even further by depicting the tanuki very fluidly in terms of their character design. As the film progresses, any given character may appear in one of five ways: as human, or as a realistic tanuki, an anthropomorphic tanuki, a caricatured tanuki, or even a video-game-graphic tanuki. In one scene, a human character bends down to hug her children and after a cut in the action, she completes the hug as an anthropomorphic tanuki. The viewer easily follows these shifts, seeing them not as sequential states but simultaneous ones. In other words, the character is human and many types of tanuki all at the same time. Although the film tackles some serious issues, including tanuki being run over by cars, which is realistically portrayed, there is also a lot of humor. Much of it stems from the depiction of the tanuki's oversized testicles, which is part of the animals' traditional folkloric portrayal: they are used as weapons, the scrotum is

22.11 Utagawa Kuniyoshi, *Mitsukini Defying the Skeleton*, 1845

stretched thin so other characters can stand on it, and more. This eclectic film also depicts babies being breastfed, mating rituals, and a fair amount of violence.

Near the end of *Pom Poko*, the tanuki transform themselves into goblins as they go all-out to scare the humans. They plan an attack almost as if it were an aerial-bombing assault, noting that the sky is clear, as the temperature and humidity are moderate. In this scene, Takahata creates fantastic, dreamlike imagery that recalls visuals from other sources, such as a ukiyo-e woodblock print by Utagawa Kuniyoshi, *Mitsukini Defying the Skeleton*, from 1845 **(22.11)**.

A Survey of Japanese Animation Studios

Toei and Studio Ghibli are among the most famous studios in Japan, but there are hundreds of other animation studios producing work of various kinds. Some of the best-known include Sunrise and Madhouse, both founded in 1972, along with three studios founded in the 1980s, Gainax, STUDIO4°C, and Production I. G.

Founded by former members of Tezuka's Mushi Production, Sunrise, Inc. grew to be one of Japan's largest studios, breaking into several sub-studios that handled individual productions. In part, it was known

for mecha animation that accommodated toy-related tie-ins, some of which was produced in collaboration with Toei Animation. Its best-known franchise is "Kidō Senshi Gandamu" ("Mobile Suite Gundam," created and directed by Yoshiyuki Tomino), which began in 1979. In the late 1990s, Sunrise produced the acclaimed television series "Cowboy BeBop" (see p. 390).

Madhouse, Inc. was founded by Masao Maruyama, Osamu Dezaki, Yoshiaki Kawajiri, and Rintaro (born Shigeyuki Hayashi). The studio made its name through the production of television series and such features as *Jūbei Ninpūchō* (*Ninja Scroll*, dir. Yoshiaki Kawajiri, 1993). Its later collaborations include adaptations of manga by CLAMP, the all-female Japanese manga artist group, such as the television series "Kādokyaputā Sakura" ("Cardcaptor Sakura," or CCS, 1998–2000) and "Chobittsu" ("Chobits," 2000). The innovative director Satoshi Kon (1963–2010) also worked with Madhouse, on the features *Pāfekuto Burū* (*Perfect Blue*, 1997), *Sennen Joyū* (*Millennium Actress*, 2001), *Tōkyō Goddofāzāzu* (*Tokyo Godfathers*, 2003), and *Papurika* (*Paprika*, 2006) **(22.12, see p. 400)**, as well as the television series "Mōsō Dairinin" ("Paranoia Agent," 2004) and the feature *Yume Miru Kikai* (*Dreaming Machine*), left unfinished when he died in 2010. Kon's films tend to deal with identity and are characterized by complex narrative structures. For example, *Paprika* features a technology that allows a therapist to enter the dreams of her patients, while

22.12 Satoshi Kon, *Paprika*, 2006

Millennium Actress relates episodes from the real life of an actress interspersed with her various roles.

Gainax was formed in the early 1980s, under the name Daicon Film, by a number of young artists, including Hideaki Anno, Yoshiyuki Sadamoto, Hiroyuki Yamaga, Takami Akai, Toshio Okada, Yasuhiro Takeda, and Shinji Higuchi. After building its reputation, in 1985 the studio's name was changed to Gainax and it produced *Wings of Honneamise* (dir. Hiroyuki Yamaga, 1987), in which a young astronaut journeys into space, attempting to thwart the efforts of government forces to use the space program as a weapon of war. Hideaki Anno (1960–) worked on the film, and later gained fame as the creator of the studio's "Shin Seiki Evangerion" ("Neon Genesis Evangelion") television series. He wrote and directed every episode of the series in its initial run from 1995 to 1996, as well as several other elements of its extensive franchise. Falling within the mecha genre, "Evangelion" tells the story of a teenage boy named Shinji who pilots a giant bio-machine, the Evangelion, for an organization called NERV, fighting against a series of aliens called "Angels." In addition to an exploration of combat, the series investigates the thoughts and relationships of several of its characters, all of which represent different aspects of the creator's own personality.

22.13 Masaaki Yuasa, *MIND GAME*, 2004

22.14 Mamoru Oshii, *Ghost in the Shell*, 1995

STUDIO4°C, founded in 1986 by Eiko Tanaka, is known for its innovative theatrical animations, original video animation (OVA), video games, commercials, and other short films. Among its most prominent works are nine segments of the "Animatrix" original animation DVD (OAD) released in 2003, following the success of the live-action feature *The Matrix* (dir. Andy Wachowski, 1999) and providing historical context for that film. *MIND GAME* (2004), based on Robin Nishi's manga and directed by Masaaki Yuasa, is a gangster-related film that takes place in varied environments, shifts moments in time, and is presented in a range of visual styles (**22.13**). *Tekkonkinkreet* (2006) is based on a manga by Taiyō Matsumoto and directed by Michael Arias (co-director Hiroaki Ando); it depicts the violent existence of two street kids who try to save their city from redevelopment.

Production I. G. was established in 1987 by Mitsuhisa Ishikawa and Takayuki Goto, who used their initials in the company title. Among its earliest work is the "Kidō Keisatsu Patoreibā" ("Mobile Patlabor Police") series OVA (1988) and *Patlabor 1: The Movie* (1989). A range of other productions ensued, including a second feature in the "Patlabor" franchise, *Patlabor 2: The Movie* (1993), before the studio embarked on *Ghost in the Shell* (1995), directed by Mamoru Oshii and based on a manga by Masamune Shirow (**22.14**). This influential film, a futuristic hunt for a hacker known as the Puppet Master, explores philosophical themes and was widely praised for its aesthetics: a combination of cel animation and CGI. In subsequent years, Production I. G. produced many other works in

the "Ghost in the Shell" franchise. The popular OVA series *FLCL* (dir. Kazuya Tsurumaki, 2000–1), featuring pre-teens and giant robots, was co-produced by Production I.G, Gainax, and King Records; in 2003, it began airing on Adult Swim. In 2007, Production I. G. merged with Mag Garden under the name IG Port.

Innovative Short Film Production

Although most major animation studios are known for their feature films, television series, or even game production, a number of innovative Japanese animators have incorporated short festival films into their practice. Osamu Tezuka spent many years making television series, but also produced a number of animated shorts made for international audiences. His most popular are *Jumping* (1984), depicting the first-person point of view of a person riding a pogo stick in a range of situations, and *Broken Down Film* (1985), a parody of silent films, reflecting the filmmaker's love of early cinema (**22.15**, see p. 402).

Beginning in the 1960s, Yoji Kuri (1928–) made a number of modern animated shorts that were aimed at adult audiences. Known internationally as an experimental artist, he was a member of a collective called Animēshon Sannin no Kai (Animation Association of Three), along with Ryohei Yanagihara and Hiroshi Manabe. Over a period of four years, beginning in 1960, the trio held three screenings of their work in

22.15 Osamu Tezuka, *Broken Down Film*, 1985

the Asakusa Theater in Tokyo, known for its music and film festivals, and inspired a new generation of young artists to pursue animation as an art form. Kuri's short *Ningen Dōbutsuen* (*Human Zoo*, 1962) depicts a series of couples within a cage, with the women prodding or in other ways oppressing their male companions, accompanied by repeated grunts. The film plays in a kind of loop, with relatively little variation. His film of 1967, *Room*, takes place almost entirely within one space, in which disconnected events occur along with non-synchronous sound effects; here, too, we see couples molesting one another, as well as flying birds, body parts, eyeball-like forms, and other images. Both films end when the action stops, without any formal closure to the seemingly random events.

Spouses Renzo (1936–1997) and Sayoko Kinoshita (1945–) founded the Hiroshima International Animation Festival, which was first held in 1985. In the years leading up to the event, Renzo had served as vice-president of ASIFA-International (see p. 297) and had co-founded ASIFA-Japan in 1981. He had worked at Tezuka's Mushi Production on "Astro Boy" (see p. 236), among other jobs, and in the late 1960s established himself as an independent animator. From 1969 to 1971, he developed a popular character, Geba-Geba Ojisan, in short pieces for a TV series, "Kyosen x Maetake Geba-Geba 90-pun." He also became known for a number of festival films, which Sayoko produced. Two of them, *Made in Japan* (1972) and *Japonese* (1977), poke fun at modern Japanese culture. His film *Pica Don* (1978) is much more serious in tone, depicting the bombing of Hiroshima during World War II. Sayoko Kinoshita had a long career in education and has served as president and vice-president of ASIFA-International, as well as president of ASIFA-Japan. She is also director of the Hiroshima International Animation Festival.

Koji Yamamura (1964–), another important figure in the world of animated festival films, has produced a number of innovative works for adults and children. His earliest films reveal his interest in using a variety of techniques, generally within non-linear, dreamlike scenarios. His film *Suisei* (*Aquatic*, 1987) opens with

22.16 Maya Yonesho, *One Door*, 2003

dark imagery accompanied by the sounds of water. By use of an oil-on-glass technique, a circular form metamorphoses into an eye and then the face of a man, who eats an apple and drops it into the water, where the man's reflected profile transforms into a fish. The film continues, shape-shifting in a kind of stream-of-consciousness style, aided by the easily transformed oil paints. Yamamura's best-known film, *Atama-yama* (*Mt. Head*, 2002), tells the story of a stingy man who does not want to waste anything, even the pit of a cherry. As a result, he has the misfortune of having a cherry tree grow out of his head. The story is adapted from the tradition of *rakugo* storytelling, in which a storyteller recounts funny tales employing puns and verbal wit. The film's visuals are narrated by Takeharu Kunimoto, who also plays a shamisen, a traditional Japanese instrument.

Maya Yonesho (1965–) worked as an art teacher for several years before returning to study Japanese painting and conceptual art at Kyoto City University of Arts. She began making independent films in 1998, using flipbook-like art books that she films as animation. Yonesho's film *Üks Uks* (*One Door*, 2003) was made while she was living in Estonia **(22.16)**. Local artists were commissioned to create book covers representing different concepts—such as "mother," "friend," and "love"—to suggest the journey taken through various doors. Books are placed at different levels of a multiplane rig, so Yonesho can create depth and harmonious transitions between the various books.

Preserving a Cultural Legacy

Beginning in the 1990s, efforts have been made to recognize Japanese animation as more than an industrial product and moneymaker by preserving it and showcasing it as an art form. In 1994, the Osamu Tezuka Manga Museum opened in the director's hometown, Takarazuka, near Osaka, Japan. It houses his creative works and provides information about his life, along with a replica of the studio where he worked. In 2001, the Ghibli Museum opened in the Mitaka suburb of Tokyo **(22.17)**. It consists of a series of different rooms containing displays (including a Catbus model), a theater screening original Ghibli films not exhibited elsewhere, a reading room, a gift shop, an organic café, and a rooftop garden.

From March 2003, Toei Animation welcomed guests into its Oizumi studio gallery in Tokyo, where viewers could read (in Japanese) about the history of the company and see a range of production materials and promotional items. The Toei Animation Gallery closed in 2014, but is being rebuilt as part of Toei's new

22.17 Studio Ghibli Museum, Mitaka, Tokyo

Oizumi studio, slated to reopen in 2017. Also in Tokyo, the Suginami Animation Museum includes exhibits on the history of Japanese animation, as well as offering guest speakers and workshops where attendees can create animation. It also houses a library of books and DVDs that can be used by visitors. It opened in 2005.

Eventually museums dedicated to both manga and anime were established, partly to promote tourism but also to preserve what is being recognized as a valuable cultural asset. The country's first center for manga culture, Kyoto International Manga Museum, opened in 2006 through the combined efforts of the Kyoto city government and Kyoto Seika University; it holds about 50,000 manga, which can be read by visitors, despite the relatively fragile nature of the books. The success of this institution has inspired others, including the Tokyo International Manga Library at Meiji University, which houses collections of manga, anime, and game software. These institutions are not only welcomed by the public; they are also important for the research of historians concerned with Japanese culture. In 1999, the Japan Society for Animation Studies was founded, and in that year it published the first issue of the *Japanese Journal of Animation Studies*; since then, members of the organization have helped document Japan's rich history of animation.

Conclusion

It is clear that Japan has played a significant role in the popularization of animation internationally over the past several decades, leading to a great boom in the medium's development in the early twenty-first century. Animation education is growing, and studios across the world are finding ways to enter into production. Even feature films, the most challenging form, are being produced with greater diversity than ever before, often as international co-productions. Funding, a lack of experienced artists, and challenges in distribution are still significant hurdles in some contexts, but inspired animators are nonetheless moving ahead, showing their works at festivals, finding ways to distribute them, and adding to the breadth of animation practice, whether they are working in 2D, stop-motion, or 3D CGI.

Notes

1　Kwanchai Rungfapaisarn, "Japanese Animators Look Abroad as Home Market Ages," *The Nation* (July 23, 2013). Online at http://www.nationmultimedia.com/business/Japanese-animators-look-abroad-as-home-market-ages-30210954.html

2　Library of Congress, "The Floating World of Ukiyo-E." Online at http://www.loc.gov/exhibits/ukiyo-e/index.html

3　Helen McCarthy, *Hayao Miyazaki: Master of Japanese Animation* (Berkeley: Stone Bridge, 1999), 28–29.

4　Jeff Stafford, "Pom Poko," *Turner Classic Movies*. Online at http://www.tcm.com/this-month/article/114171%7C0/Pom-Poko.html

Key Terms

3D CGI animation
anime
distribution
festival film
franchise
genre
manga
original video animation (OVA)
parallel action
score
zoom

A Panorama of World Animation

Chapter Outline

Global Storylines

Since the 1990s, animation has become an increasingly global art form, partly thanks to initiatives from such bodies as the European Union and UNESCO, which promote international collaboration between animators, and help to establish animation facilities in countries that have no indigenous production

Countries with developing animation industries face challenges in creating work that reflects their national identity, rather than the aesthetics of the dominant national industries of the US and Japan

Alongside a worldwide boom in animation, festivals have been founded in South Korea, Brazil, Argentina, India, and many other places, showcasing work from their own countries and celebrating innovative animation with global audiences

Introduction

By the 1990s, the economic and artistic potential of animation was appreciated worldwide. America and Japan were profiting from animation production more than ever before and an increasing number of international festivals were acknowledging productions of all kinds from across the world. These developments inspired many individuals, organizations, and governmental agencies to enter or expand their presence in the animation world. The question was exactly how to go about it.

Whereas the US and Japan had developed strong industries that were self-supporting, in other nations this kind of infrastructure did not exist; as a result there were many interrelated issues to address, including financing, training, facility development, distribution, and even building a domestic audience. There was also the question of technical approaches—for example, whether to favor 3D CGI, 2D, or stop-motion—and the style of the animation. Would audiences used to the techniques and styles dominating US and Japanese animation be receptive to other approaches? Was it important to develop an "indigenous" style, reflecting the cultural values and experiences of the country and its people? Another question was whether to support individual practitioners in realizing art-oriented, creator-driven production, or to prioritize studio features, television series, and games intended to compete in a global marketplace. Were these separate objectives, or could they be reconciled?

The 1990s saw political changes, as previously insular countries across the world determined that they could more effectively develop—politically, financially, and culturally—by adopting capitalistically oriented

policies and embracing the global marketplace. In some cases, shifts toward new political and economic models occurred after years of oppression. By the 1990s, in Latin America (including Chile, Argentina, Bolivia, Brazil, Paraguay, and Uruguay) there was a move away from dictatorships to more democratic systems, while in South Africa, the racial divisions of the apartheid system (see p. 419) began to dissolve. In 1992, the Soviet Union was formally disbanded.

Another significant development of this time was the establishment of the European Union, which provided members with a level of power that they would not have had on their own. Its roots can be traced to 1958, with the formation of the European Economic Community (EEC) by six countries that created economic ties: Belgium, France, Germany, Italy, Luxembourg, and the Netherlands. By the 1970s, they were joined by Denmark, Ireland, and the United Kingdom, and later by other countries, including some former members of the Soviet Union. In 1993, the organization was renamed as the European Union (EU). Today, the EU develops treaties to solidify its "single market" economy, and to deal with a range of issues, including security and the environment. The EU even instituted its own currency, the euro, which was introduced during the late 1990s and early 2000s.

Some of the EU's initiatives involved the production of audiovisual media, including theatrical films and television. For instance, a support program called MEDIA was established to help independent studios—often small or medium-sized—with development, production, and distribution, providing financing as well as assisting with the coordination of creative partnerships. In 1987, another organization, CARTOON, was created with the specific aim of supporting animation production and individuals working in that field; it is an international non-profit association based in Brussels that organizes events and aids in educational efforts.[1] CARTOON has paid for training and technical upgrades; brought together studios that formerly operated in relative isolation, without the means to create large-scale television and feature-film projects; and helped balance a field dominated by American and Japanese production by keeping work within Europe.[2] To recognize the best films produced by European animators, CARTOON developed the Cartoon d'Or prize; its winners have included Nick Park, Sylvain Chomet, and Joanna Quinn, among numerous others.

CARTOON supports educational efforts through the European Training Network for Animation Schools (ETNA), which counts more than thirty members; this online platform enables the exchange of information, posting of news, screenings of student work, and the promotion of its institutions. Among its members are GOBELINS, the school of visual communication located in Paris; the Lucerne University of Applied Sciences and Arts (HSLU) in Switzerland; and the FAMU Film and TV School of the Academy of Performing Arts in Prague.

A Global Challenge: Creating a National Style

Innovative Animation on British Television

Animation has been developing across the world in a range of modes, often supported by government funding. This model has been in place in the UK throughout much of film history, since the 1930s, when the General Post Office Film Unit produced the work of Norman McLaren and Len Lye (see p. 86). In recent decades, especially the 1990s, some of the most innovative work in television worldwide has been supported with funding from the British Broadcasting Corporation (BBC) and Channel 4.[3] The BBC is known for distributing animated series, often aimed at younger viewers. It obtains works through various acquisition strategies, including purchasing the rights to existing programs, commissioning its own new work, and participating in international co-productions. From 1969 to 1974, the BBC aired the original episodes of the sketch comedy "Monty Python's Flying Circus," featuring the animation of Terry Gilliam. Aardman Animations got its start making models for a BBC program, "Vision On," during the 1970s,[4] and later films by the studio, such as the half-hour film of 1993 *Wallace & Gromit: The Wrong Trousers* (dir. Nick Park), also aired on the network. In 1990, the BBC opened an animation unit, headed by Colin Rose. While comedy remained of interest, experimental films of various kinds also appeared on the BBC network, including the pixilated film *The Secret Adventures of Tom Thumb* (dir. Dave Borthwick, 1993) **(23.1)** and the scratched direct film *The Albatross* (Paul Bush, 1998). The BBC also aired *La Vieille Dame et les Pigeons* (*The Old Lady and the Pigeons*, dir. Sylvain

23.1 Dave Borthwick, *The Secret Adventures of Tom Thumb*, 1993

Chomet, 1997), a surreal story of a man who dresses like a pigeon to get free meals and faces dire consequences; it is the Oscar-winning debut film of Sylvain Chomet, who moved into feature production a few years later.

When Channel 4 first went on the air in the early 1980s, it did not have an animation division, but animation was part of its programming from the start. During its first holiday season, it broadcast the now classic short *The Snowman* (dir. Dianne Jackson, 1982) **(23.2)**, and the commissioning editor Paul Madden sought out other innovative animation for the network through various routes.[5] For example, the dark, melancholy stop-motion film *Street of Crocodiles* (dir. Brothers Quay, 1986) was funded as "drama," and a comedy short about women's body image, *Fatty Issues* (dir. Candy Guard, 1988), was aired within a current-affairs documentary. In 1990, Clare Kitson (1947–) became Channel 4's first commissioning editor for animation, a post she held for nine years. Under her direction, Channel 4 became known internationally as the most innovative television network with respect

to animated programming. She created the program "Four-Mations" as a flexible time slot for screening both British and international animation; it would combine or "strand" different films based on similarity of concept, meaning that animated shorts of varied lengths could be accommodated. Channel 4 also supported

23.2 Dianne Jackson, *The Snowman*, 1982

23.3 (above and above right) Barry Purves, *Screenplay*, 1992

related to theatrical performance, directed by Barry Purves (the first of which was made at Aardman); David Anderson's *Door* (1990), a stop-motion film about the end of the world, written and narrated by Russell Hoban; a drawn animation by Joanna Quinn, *Wife of Bath (1998)* **(23.4)**, part of the "Canterbury Tales" series directed by Jonathan Myerson; and *The Man with the Beautiful Eyes* (2000), a visual adaptation of a Charles Bukowski poem directed by Jonathan Hodgson. Suzie Templeton's film of 2006, *Peter and the Wolf*, set to the music of Sergei Prokofiev, was made independently as an international co-production, with stop-motion mainly carried out at the Polish Se-ma-for Studio. The film debuted on Channel 4 on Christmas Eve of that

production through artist-in-residence programs. One of them, "Animate!," an initiative undertaken by the network in partnership with the Arts Council of England, encouraged the development of experimental animation for television.[6] In collaboration with the British Film Institute, under Kitson's direction Channel 4 also co-sponsored a residency at the Museum of the Moving Image in London. MOMI closed the same year that Kitson left Channel 4, in 1999.[7]

Examples of the work commissioned by Channel 4 include *Some Protection* (1987), by the Finnish director Marjut Rimminen, as part of the "Blind Justice" series, focusing on the treatment a young woman receives in correctional institutions; *Next* (1989) and *Screenplay* (1992) **(23.3)**, two stop-motion films

23.4 Joanna Quinn, *Wife of Bath*, from "The Canterbury Tales," 1998

23.5 Paul Reubens, "Pee-wee's Playhouse," 1986–91

year, after a theatrical debut at the Royal Albert Hall, accompanied by the London Philharmonic Orchestra.

Without a doubt, the support of television networks has aided the success of British animators on an international level. The best example is Nick Park (1958–) and the studio where he works, Aardman Animations. Interested in animation from a young age, Park pursued his career goal at the National Film and Television school, where he developed two characters he is famous for, an eccentric man named Wallace and his dog Gromit. In 1985, Park joined the Aardman staff in Bristol full-time, contributing animation to Peter Gabriel's *Sledgehammer* music video (dir. Stephen Johnson, 1986) and the American television series "Pee-wee's Playhouse" **(23.5)**. In 1989, Channel 4 commissioned from the studio a series of five five-minute films, "Lip Synch," built around real people and documentary-type audio; the resulting shorts included Peter Lord's *Going Equipped* (1990), based on an interview with a man about his life in crime, and Nick Park's *Creature Comforts* (1989), which is set in a zoo and employs a range of interview subjects. With this film and his half-hour *Wallace & Gromit: A Grand Day Out* (produced for the BBC), a story about the duo's trip to the moon made the same year, Nick Park helped put Aardman on the map. It was an exceptional

moment when these two films were both nominated for awards by the British Academy of Film and Television Arts and the Academy of Motion Picture Arts and Sciences in America: *A Grand Day Out* won the BAFTA against *Creature Comforts*, while *Creature Comforts* won the Oscar against *A Grand Day Out*.

In 1994, Park released his best-known short film, the half-hour *Wallace & Gromit: The Wrong Trousers*, on BBC1. This film, in which Wallace and Gromit fall into the clutches of a jewel thief, also won both BAFTA and Oscar awards, as did his 1996 half-hour production, *Wallace & Gromit: A Close Shave* (produced for the BBC), and a feature produced by DreamWorks, *Wallace & Gromit: The Curse of the Were-Rabbit* (co-directed with Steve Box, 2005). Aardman Animations had produced their first feature film in 2000: *Chicken Run* (dir. Nick Park and Peter Lord) **(23.6)**. It was distributed by DreamWorks, as was Aardman's later CGI film, *Flushed Away* (dir. David Bowers and Sam Fell, 2006). In 2003, the "Creature Comforts" concept was developed into a series of the same name for television. Directed by Richard Goleszowski, it was made for the British network ITV and was also aired on the Comedy Central (see p. 362) cable network.

23.6 Nick Park and Peter Lord, *Chicken Run*, 2000

Animation in Australia

The history of animation in Australia is long, dating back to the 1940s,[8] but much of its early studio production was initiated by outsiders, including the Hanna-Barbera studio (see p. 225) and Yoram Gross (see p. 267). In recent years, however, a number of organizations have been formed to represent Australian media creators, including animators, and to promote domestic production. For example, Screen Australia was founded in 2008 to nurture the development of a commercially sustainable motion-picture media industry in Australia. One of its many functions is to support the annual Melbourne International Animation Festival, which brings in films and audiences from Australia and across the world. The Australian Film Institute (AFI) has a much longer history, reaching back to the late 1950s; it, too, develops and sustains film culture in the country.

In 2006, the animated feature *Happy Feet* (dir. George Miller), from Kennedy Miller Productions, brought Australian production to an international audience (23.7). This film, which was the first CG animated feature made in the country, is a coming-of-age story about a young penguin who slacks the singing skills everyone else in his community has. He is a great dancer, but because dancing is frowned upon by his society, he must learn to assert his individuality. Co-founded in the late 1970s by George Miller (1945–) and Byron Kennedy (1949–1983), Kennedy Miller (later

Kennedy Miller Mitchell) Productions has been one of Australia's most successful live-action studios. Its work includes the film *Babe* (dir. Chris Noonan, 1995), which was revolutionary in combining live animals with animatronics (from the Jim Henson studio) and digital effects. The story, based on a book by Dick King-Smith, is about a pig with a great personality who is raised by dogs and learns their skills.

The Australian studio Animal Logic created effects for both *Babe* and *Happy Feet*. The company, which was founded in 1991, maintains offices at Fox Studios in Sydney and Warner Bros. Studios in Los Angeles, as well as in a Vancouver location set to open in 2016. It first worked in advertising and then moved into visual effects. In preparing for *Happy Feet*, a crew spent two weeks photographing landscapes in Antarctica; these were scanned into computers so that Animal Logic could create shots from any angle and with varied lighting. Another innovation used in the film was Horde, a system that allowed for the development of naturalistic crowd scenes, even with thousands of characters moving independently.[9] Animation created for *Happy Feet* relied in part on live-action references in the form of motion capture; fluid movements were developed around the steps of the renowned American tap dancer and choreographer Savion Glover and other performers.[10]

Although *Happy Feet* is an Australian production, the setting is Antarctica and its characters are animals. As a result, there are no specific references to Australia

23.7 George Miller, *Happy Feet*, 2006

23.8 Dennis Tupicoff, *Dance of Death*, 1983

in the production, except to the extent that it features voices from Australian performers, including Steve Irwin, Hugh Jackman, and Nicole Kidman. Funding for the film came largely from a US studio, Warner Bros., and one can hear American accents in it and see the influence of Latino and African American cultures, rather than Australian accents or cultural references.

As far as independent production is concerned, the Melbourne-based stop-motion animator Adam Elliot (1972–) (see p. 335) is probably the best-known animator in the country, based on the success of his trilogy of short films, *Uncle* (1996), *Cousin* (1998), and *Brother* (1999), his twenty-minute *Harvie Krumpet* (2003) and *Ernie Biscuit* (2015), and his feature film, *Mary and Max* (2009). There is a broad base of independent animation production in Australia, however. For instance, Dennis Tupicoff (1951–) has created award-winning festival films reflecting his interest in the aesthetics of rotoscoping and the documentary genre. His first international success, *Dance of Death*, was completed in 1983; it depicts a barrage of images of violence being shown to a girl and her family, including a game show called "Meet Your Maker" (23.8). A later film, *His Mother's Voice*, from 1997, is a visualization and study of the experience of a woman whose son has been killed, which explores how technique influences content. Using a process they call "glass flam-ation," Australian Jack McGrath (1984–) and New Zealand-born the Australian Mark Eliott (1957–) create stop-motion animation, manipulating hand-blown glass figures by heating and reshaping them, capturing their transformations incrementally. Their film *Dr. Mermaid and the Above Marine* (2009) was made at Sydney College of the Arts, Film and Digital Arts Studio and Glass Studio. Set in Bondi, Australia, the underwater fantasy tells the story of a

marine biologist who can talk to fish and tries to help them live a better life.

Changing Roles in South Korea

South Korean animation production started in the 1960s, and was initially dominated by public-service announcements and advertising. But in 1967, feature-length films began to appear. The first, *Hong Gil-dong*, was directed by Shin Dong-heon (1927–). It was based on the "Hong Gil-dong The Hero" comic strip created by Shin's younger brother, Shin Dong-won (1936–1995), which itself was an adaptation of a traditional novel (c. 1600) written by Heo Gyun. The country's first stop-motion animated feature, *Heungbu-wa Nolbu* (*Heungbu and Nolbu*, dir. Gang Tae-ung) was released in 1967 as well. It is also based on a traditional tale: the story of two brothers, one who is poor but kind, and the other who is wealthy but mean. Feature animation production continued at a fairly strong pace, with about eighty films being made between 1967 and 1986. Unfortunately, only a small number have survived.

In the mid-1980s, South Korea became a major center for subcontracted work, just as Taiwan had been since the late 1970s (see p. 234). The Korean animator Nelson Shin had moved to California in the 1970s and worked for various American companies before moving back to Korea in 1985 and opening his own studio, AKOM Production, to fulfill contracts for foreign producers. Other South Korean companies followed suit after seeing the profit potential. During the boom of TV production in the 1990s, South Korea profited from the increase in work, but as studios in other countries took some of its contracts, and the TV market stabilized, Korean animation companies began to consider developing their own productions. In 1995, the Ministry of Culture, Sports, and Tourism and the city of Seoul created the Seoul International Cartoon and Animation Festival (SICAF), featuring exhibitions and film competitions. Since 1999, the city of Bucheon has been the location of the Puchon International Student Animation Festival, which allows students to meet with professionals.

The animation industry soon started to produce original work, including the critically acclaimed feature *Mariiyagi* (*My Beautiful Girl Mari*, 2002), directed by Lee Sung-Gang (23.9, see p. 412). It tells the story of a lonely young boy who meets a girl in his dream world.

23.9 Lee Sung-Gang, *My Beautiful Girl Mari*, 2002

Other animated features of note include two quite different films released in 2011. *Dwae-ji-ui Wang* (*King of Pigs*, dir. Yeon Sang-ho) is a violent story about two middle-aged men who look back on their school days. In contrast, *Madangeul Naon Amtak* (*Leafie, a Hen into the Wild*, dir. Oh Sung-yoon) is a family film about a chicken that escapes from a farm and adopts a baby duck, based on a children's book of 2000 by Hwang Sun-mi. Today, many South Korean animation students are creating innovative short works, often incorporating Korean content. Among them is the award-winning stop-motion animator Kangmin Kim, who works at the Los Angeles-based Studio zazac. His film *38–39˚c* (2011) takes place in a Korean bathhouse, focusing on a man's relationship with his father.

Animation in Brazil

The practice of animation in Brazil dates back to a film from 1917, *O Kaiser*, by Alvaro Marins (1891–1949), who worked under the name Seth.[11] It is a satire on the political aspirations of the German Kaiser Wilhelm II, who dreams of ruling the world but is consumed by it instead. A handful of other animated shorts followed over the next two years, but the bulk of Brazil's animation production during the 1920s was devoted to advertising films, many of them created by Seth. Other animators and directors working during the 1930s and 1940s include João Stamato, who collaborated with both Seth and Luiz Seel (who also went by the name Louis Seel). Stamato and Seel's film *Macaco Feto, Macaco Bonito* (*Ugly Ape, Pretty Ape*, 1929) is about the antics of a mischievous monkey that escapes from its cage at the zoo, walking past other cages housing

Mickey Mouse (waving), Felix the Cat (missing and apparently dead), and Popeye (escaped). After beginning his career as an illustrator, in the late 1930s Luiz Sá (1907–1979) released two short films involving a character named Virgolino; he later moved into advertising and print comics. Brazil's first animated feature film appeared in 1953: *Sinfônia Amazônica* (*Amazon Symphony*), directed by Anélio Latini Filho (1926–1986) and composed of seven interconnected stories inspired by Amazonian legends.[12]

During the 1950s, the influence of the animator Norman McLaren from the National Film Board of Canada (see p. 177) spread to Brazil and led to experimentation. Roberto Miller created a direct film, *Rumba*, in 1957, after an extended stay in Canada, and went on to direct a series of abstract works. Two other abstract artists, Rubens Francisco Lucchetti and Bassano Vaccarini, worked together in the 1960s to create animation. Also influenced by McLaren, they, along with Miller, had founded a short-lived organization to support production, the Cêntro Experimental de Cinema de Ribeirão Preto, in 1960. In 1967, students from the School of Fine Arts in Rio de Janeiro founded another group, the Cêntro de Estudos do Cinêma de Animação (Center for Animation Film Studies, CECA). Both organizations were established during a difficult time in Brazil's history. For about twenty years, from 1964 to 1985, the country was ruled by an authoritarian military dictatorship. Brazil struggled financially and politically, as social and economic inequality escalated, and thousands of political prisoners were deported, sent to prison, or killed. It was a period of strict censorship, and many artists left the country. The cities were overrun by the poor, who were destined to live in hillside shanties known as *favelas*.

By the mid-1980s, Brazil had returned to civilian rule and begun its recovery. At that time, Marcos Magalhães (1958–) emerged as a leader in the development of Brazilian animation, organizing collaborations among artists of every age and ability. Early in his career, he gained recognition with a film he wrote and directed, *Meow* (1981) (**23.10**). It begins with a pan across the many favelas surrounding a city and then focuses on a cat, which makes loud demands that change according to political shifts; it was screened as part of the official selection of short films at the Cannes

23.10 Marcos Magalhães, *Meow*, 1981

film festival in 1982, where it received a special jury prize. In the mid-1980s, Magalhães helped bring about the first professional animation course in Brazil, with assistance from the National Film Board of Canada, and he coordinated the productions of twenty-eight filmmakers in a collaborative project, *O Planêta Terra* (*The Planet Earth*, 1986). In 1999, Magalhães worked as an artist-in-residence at the Division of Animation and Digital Arts of the University of Southern California (USC), where he made a film, *TwO*, which combines 3D computer animation and images scratched onto 35mm film stock. The following year, he produced the first Latin-American episode for the Nickelodeon series "Short Films by Short People," and in 2002 he received a fellowship from the John Simon Guggenheim Foundation to create animation workshops for non-professionals. Since 2002, he has been teaching at the Pontifical Catholic University in Rio de Janeiro.

In the early 1990s, Magalhães joined with three other Brazilian animators—Aida Queiroz, Cesar Coelho, and Lea Zagury—to propose the development of an international festival devoted to animation.[13] The four had met in 1985, in a course offered by the Brazilian Film Board, Embrafilme, and the National Film Board of Canada. Their dream was finally realized in 1993, when the first Anima Mundi festival **(23.11)** was held in Rio de Janeiro. At the event, there were retrospective screenings of films from Canada, England, Russia, and Holland, and the California Institute of the Arts (CalArts) presented works from its Experimental Animation Department, where Zagury had been a graduate student. In addition, a retrospective of Brazilian productions from the previous two decades allowed the public to view animation that had been

honored internationally. Industry screenings included the Brazilian companies Mauricio de Souza, Daniel Messias, and Briquet, and such American studios as MTV International, Pixar, Industrial Light & Magic, Pacific Data Images, Rhythm & Hues, and Xaos.

23.11 Anima Mundi festival poster, Rio de Janeiro, Brazil, 1999

Also at this inaugural event, the first Anima Mundi workshop was held: participants were co-led by Coelho (who, with Queiroz, runs the Campo 4 studio in Rio de Janeiro) and David Silverman from the US (famous for his work on "The Simpsons," see p. 354), creating a 16mm film screened at the end of the festival. The Open Studio, a permanent workshop open to the general public, allowed the creation of moving images in the form of either a zoetrope (see p. 17) or drawings made directly on a filmstrip. At the same time, the Funarte Gallery held an exhibition of original art and backgrounds from Brazilian and international animated films.

Today, the Anima Mundi festival includes such categories as short films for children, short commissioned works (including advertising), and other short films; student productions; feature-length animation; and animation made by children. A contest for web and cellular-phone animation, runs concurrently with the festival. From the start, public participation has been a major component of the festival. To reach a broader range of people, animation from the festival is screened in a touring package that is exhibited in different cities within Brazil. Since 2001, the festival's Anima Escola program has brought animation education to schools across the country, further extending the art form throughout the country, and planting the seeds for future generations of artists.

A Survey of Other Latin American Animation

In Latin America, there have been government initiatives and individual projects aimed both at developing an animation community and at examining culturally specific experiences. In Argentina, for instance, ANIMA—the International Animation Festival of Cordoba—is a combined academic conference and cultural event dedicated to the artistry and technology of animation. Established in 2001, it has run in odd-numbered years, organized by the Experimental Animation Center (NAEC), the National University of Cordoba, and the National University of Villa María, under the direction of Alejandro R. Gonzalez. ANIMA has brought in an international array of artists and scholars and has presented retrospective screenings.

Argentina's animation history dates back to Quirino Cristiani's lost film *El Apóstol* (*The Apostle*, see p. 49) from 1917, thought to be the first feature-length animation ever made; two of his other early features, *Sin Dejar Rastros* (*Without a Trace*, 1918) and *Peludópolis* (1931) are also lost. All three dealt with topical political matters. Other relatively early films from Argentina include the cel animations *Upa en Apuros* (*Upa in Trouble*, dir. Tulio Lovato, 1942) and *Domador* (*The Lion Tamer*, dir. Burone Bruché, 1948). Production continued periodically, with several other cel-animated films appearing in the 1970s.

For many years, Argentina has been home to a community of experimentally oriented animators. Luis Bras (1923–1995) began his animation career in advertising, but exposure to the work of Norman McLaren in the early 1960s caused him to begin trying new ideas. When he came to work at the National Film Board of Canada for two months, he created *Bongo Rock* (1969), a lively scratch film depicting stick figures dancing, drums, abstract forms, patterns, and more. His other direct films include *Toc, Toc, Toc . . .* (*Knock, Knock, Knock . . .*, 1965), *La Danza de los Cubos* (*The Dance of the Cubes*, 1976), and *Danubio Azul* (*Blue Danube*, 1977).[14]

Production in Argentina continued into the 1990s, with more diversity in techniques, including the use of computers. One example is Pablo Rodríguez Jáuregui's (1966–) *La Noche de los Feos* (*Night of the Ugly Ones*) from 1995, which is based on a short story of the same name (1968) by the Uruguayan writer Mario Benedetti. Rodríguez Jáuregui, who is one of the country's best-known animation directors, later made a documentary *¿Conoce Usted el Mundo Animado de Luis Bras?* (*Do You Know the Animated World of Luis Bras?*, 2000), about the pioneering animator.[15] Juan Pablo Zaramella (1972–) is known internationally through such festival films as the highly awarded *Luminaris* (2011), which employs **time-lapse** and pixilation. The short tells a story about a man who realizes his dream for a different kind of life by creating his own source of light. Zaramella also works in illustration and advertising.

It is not surprising that recent animated films from Latin America often deal with themes of violence and oppression. The Colombian animator Adriana Copete (1988–) is one of an emerging generation of Latin American animators whose work reflects on her country's political past and present. Copete's mixed-media work combines digital production with hand-drawn techniques and stop-motion, and incorporates the concepts of memory, oral history, and animated

documentary. Her film *Rebusque sobre Ruedas* (*Busking Tales*, 2014) **(23.12)** was funded by a grant from the Colombian organization IDARTES for animation development. The elaborate stop-motion film takes place in a busy urban setting where individuals live

their lives by ignoring the people and things that are around them, as a kind of survival mechanism. The Colombian animator Simón Wilches-Castro has also addressed his country's socio-political situation. His film *Semáforo* (*Stoplight*, 2012) is about rural people who are forced out of their homes by the ongoing war and must live as street performers and beggars in order to survive. It was created while he was a graduate student at the University of Southern California (USC), and it appeared in many international festivals.

23.12 (above) Adriana Copete, *Busking Tales*, 2014

Also at USC, Juan Camilo González (1984–) pursued work that is more abstract and yet still has its roots in Colombia's political past, filtered through the artist's own interpretation of it. His film *In Abyssus HumanÆ ConscientiÆ (ReconoceR)*, from 2011 **(23.13)**, is a meditation on the history of violence in Colombia, its name referring to the title of its score, by the Colombian composer Rodolfo Acosta. Carlos Santa (1957–), a leading figure in experimental animation in Colombia, has been creating animation since the late 1980s, but is probably best known for his feature, *Los Extraños Presagios de León Prozak* (*The Mysterious Presages of León Prozak*, 2010), which premiered at the Annecy International Animation Festival (see p. 297). The film combines work from various artists, using paint on glass, direct-film techniques, drawing, live-action, and rotoscoping, among other methods. The artists involved embrace different tones, including comic, erotic, mystical, and political, reflecting their personal concerns and sensibilities. One of them, Adriana Espinoza, creates portraits of the "disappeared"—missing people who have been taken away and are presumed to have been killed by the government or other forces.

In Chile, the animator Vivienne Barry (1947–) also worked on the theme of people who have disappeared, in her film *Como Alitas de Chincol* (*Like the Wings of Little Birds* [literally, "Like the Little Wings of the Chincol, or Rufous-collared Sparrow"], (2002) **(23.14**, see p. 416). Barry had gone

23.13 Juan Camilo Gonzáles, *In Abyssus HumanÆ ConscientiÆ (ReconoceR)*, 2013

23.14 Vivienne Barry, *Like the Wings of Little Birds*, 2002

into exile in Germany in 1973 after the Pinochet military coup in Chile, and studied animation there, working at the DEFA Studio Trickfilm of Dresden between 1978 and 1980.[16] Her film focuses on the people left behind in Chile's culture of violence, and the quilts they created to hold memories and express their grief and anger. As the film explains, it is "a tribute to the women who embroidered the story during the era of the dictatorship." The visuals feature *arpilleras,* a type of embroidered patchwork scene, layered to tell a story, made by women in the poorest neighborhoods of Santiago, Chile, during the dictatorship of Augusto Pinochet, between 1973 and 1990. The film begins with a fire that ignites a pile of fabric scraps. Fabric pieces then begin to sew themselves into the form of a house. Puppet figures are placed on an all-fabric background to depict the dropping of bombs on the city and the rounding up of people by armed soldiers, as well as bodies littering the street. The soundtrack is made up of real voices engaged in protest. Claudio Diaz's animated drawn short *Chile Imaginario* (*Imaginary Chile*, 2012) touches on the same themes, based on interviews with nine young people born after the coup.

Growth in India

The Indian film industry is huge, but outside the country it is best known for the Mumbai-based, Hindi-language live-action films of Bollywood, the largest producer of films in the country and one of the largest in the world. India's animation industry is also sizeable, but it mostly engages in work for other producers in the fields of film, television, electronic games, mobile animation, and visual effects. For example, in 1993, The Walt Disney Company entered a joint venture with Modi Enterprises, a big conglomerate based in New Delhi, to operate Walt Disney India. After the ten-year contract ended, Disney set up a new entity, The Walt Disney Company (India), an organization that has expanded into various types of production, including television and games.

Animation production in India had begun many years before. It grew out of a governmental organization, the Films Division of India, established in Mumbai in 1948, a year after the Indian Independence Act of 1947 split British India into two independent nations, India and Pakistan. At first, much of the animation it produced was intended for children and partly or completely illiterate adult audiences, as an educational resource; such films were initially screened in theaters and later were shown on television. In the mid-1950s, one-time Disney animator Clair Weeks, who was born in India, came to Mumbai as part of an American Technical Co-Operation Mission to help train the country's first animators, at Important Films of India. Among them was Ram Mohan (1931–), who subsequently became one of India's most important pioneers in the field. He co-directed (with the Japanese director Yugo Sako) *Ramayana: The Legend of Prince Rama* (1992), a feature based on the epic Indian tale. Mohan also founded Graphiti Multimedia in 1995, and established there an educational facility, the Graphiti School of Animation, in 2006. Since such a huge amount of animation is being done in India, there is a great need for workers, and animation education is a big concern. A number of animation schools have been set up in the country, primarily focusing on technical computer skills. In 2001, the Animation Society of India (TASI) was formed to educate the general public about animation by organizing presentations, workshops, screenings, and information exchange. Since 2005, it has also hosted the biggest animation festival in the subcontinent, Anifest India, held annually in Mumbai.

Images of Africa

Africa is the world's second largest and second most populous continent, making up 20 percent of the total land area of the Earth, and accounting for about 15 percent of the world's population. Despite its dominance in terms of size, the peoples of many African nations were subjugated and enslaved for centuries. By the late nineteenth century, European imperial powers occupied most of the continent, and when the film industry began to develop in the early twentieth century, it only added to the oppression of African cultures by commonly stereotyping and ridiculing black identity.

In recent decades, African contexts have provided the settings for some well-known American works, but these remain limited in scope. For example, *The Lion King* (1994, see p. 348), a blockbuster hit that includes music by the South African composer Lebohang "Lebo M" Morake in its soundtrack, is populated by animals, but no African people are included. In Disney's film *Tarzan* (1999), only a small number of humans appear, and they are of European origin. The DreamWorks film *Madagascar* (2005) takes place in part on that African island, but no human Africans live there either.

In contrast, the feature film *Kirikou and the Sorceress* (dir. Michel Ocelot, 1998) is based on a traditional West African story about a tiny boy who defends his village against a seemingly evil woman; it includes a diverse range of black African human characters **(23.15)**. It is an international co-production involving France, Canada, and Belgium, and was directed by the one-time president of ASIFA-International, the French animator Michel Ocelot (1943–), who lived in Guinea, West Africa, when he was a child.[17] In creating the visual design, Ocelot drew upon Egyptian art, which he felt would result in striking characters, and the paintings of Henri Rousseau for environments. Music was provided by the well-known Senegalese composer and musician Youssou N'Dour, and performed on traditional African instruments. The original dialogue, in French, was recorded in N'Dour's studio using an African cast.

On the African continent, animation industries can be traced relatively far back in history, but they have been slow to develop. In Egypt, the character Mish Mish Effendi debuted in a series by David and Shlomo Frenkel in 1936, continuing until the mid-1960s. The Egyptian animator Ali Muhib (1935–2010) started the Film Animation Department at the national television station in 1961 and then directed *The White Line* (1962), a live-action film that included motion graphics. In the late

23.15 Michel Ocelot, *Kirikou and the Sorceress*, 1998

1960s, he began to work in advertising, and then, beginning in 1979, directed the TV series "Mishgias Sawah," which apparently ran for thirty episodes.

Moustapha Alassane (1942–2015), from Niger, learned to animate at the Canadian National Film Board, where he met Norman McLaren. His subsequent productions earned him the title of the father of African animation, though he directed live-action narratives and documentaries as well. Alassane's animation includes the drawn animated shorts *La Mort du Gandji* (*The Death of Gandji*, 1963) and *Bon Voyage Sim* (*Have a Good Trip, Sim*, 1966), as well as the stop-motion films *Samba le Grand* (*Samba the Great*, 1977) and *Kokoa* (2001). His films generally contain social satire and dark humor, and he is known for recurring frog characters.

In the late 1980s, Jean Michel Kibushi (1957–), of the Democratic Republic of the Congo (DRC), founded the Malembe Maa Studio in Kinshasa to expose local audiences to African culture through animated films and crafts; it included mobile workshops that brought animation to schools and organizations in the city. Kibushi's work is closely connected to stories originating in the DRC. For example, his drawn-animation short *Kinshasa, Septembre Noir* (*Kinshasa, Black September*, 1992) was made as homage to the late *griot* (storyteller) musician Djamba Shongo Yodi, who was killed by the Congolese military in Kinshasa; the film uses artwork from children recalling the events of 1991. His feature-length stop-motion film *Project Ngando*, released in 2008, is adapted from the novel *Ngando* (*Crocodile*) by Congo's first novelist, Paul Lomami Tshibamba. Pre-production for the film took place in a series of three-week workshops at the Académie des Beaux-Arts in Kinshasa, covering narrative development, the design of characters as 2D drawings and **maquettes**, and movement studies performed by actors and dancers. Specialists from Bournemouth University in the UK came to the school to mentor the students and local artists.[18] The film is about a man and his apprentice dealing with the challenges of contemporary city life, until the young boy disappears.

It has been difficult for African studios to compete with animation produced abroad, where there are better facilities and greater numbers of trained artists. To address this issue, in 2004 UNESCO launched Africa Animated!, an initiative to provide the resources and technical knowledge necessary for African artists to create animation for children; collaborators included the South African Broadcasting Corporation (SABC), the Union of National Radio & Television Organisations of Africa (URTNA), the National Film and Television Institute of Ghana (NAFTI), and the Southern African Broadcasting Association (SABA). Individuals from various African countries were involved in regional workshops, creating animated shorts based on folk stories and designed using a blend of African arts.

23.16 Adamu Wasiri, "Bino and Fino," 2010–

The first five-week workshop, led by an international group of teachers, was held in Tanzania, at the Zanzibar International Film Festival. It involved fifteen African artists with little or no previous experience in animation, as well as students from the Mohamed Amin Foundation Media School, in Nairobi, Kenya, who were called on for post-production. Eventually, the animators involved in the initiative returned home, bringing their knowledge with them. One of them, Kwame Nyongo, participated in 2004, returned as a trainer in 2005, and then in 2009 created the Association of Animation Artists to represent Kenyan animators.

A number of Kenyan participants were later hired to work on the television series "Tinga Tinga Tales" (2010), animated at Homeboyz Entertainment in Nairobi. The series, which incorporates Tinga Tinga art from Tanzania, features images that were drawn and colored by hand. It was an international co-production, produced by the UK studio Tiger Aspect in partnership with CBeebies (the BBC's channel for children, see p. 363) and Playhouse Disney. Within developing industries, African culture has filtered into varied animated productions. Also in 2010, another popular children's television series appeared: "Bino and Fino," created by Nigerian animator Adamu Wasiri, focuses on a young brother and sister living in the city of Abuja and learning about their culture (23.16).

South African Animation

Apartheid was a system of racial segregation that was enforced in South Africa from 1948 to 1994, with laws formulated by the white minority Afrikaner society that had descended largely from Dutch settlers in the country. Under apartheid, the population was divided into racial groups, including white, black, colored, and Indian. Black South Africans were denied their citizenship and instead were grouped into a number of tribes. Opposition to apartheid within the country, which had been widespread since the 1950s, was met by suppression, imprisonment, and violence. Other countries applied pressure for change through sanctions, such as trade embargoes, and the country's leaders began a series of reforms in the 1980s. President F. W. de Klerk started the process of ending apartheid in 1990, and a democratic election involving all races was finally held in 1994. At that time, Nelson Mandela won the office of president, after being imprisoned for twenty-seven years, between 1964 and 1991, for his part in protesting apartheid as a member of the African National Congress (ANC), which fought for the rights of black South Africans.

William Kentridge (1955–) is one of South Africa's best-known artists, partly because of the emotional themes of his work, which revolve around the country's history of apartheid and the way that it has been both remembered and forgotten. These concerns were developed in his youth, from listening to his parents, who were in the field of law and active in the anti-apartheid movement. Kentridge has given voice to political themes through various media, including sculpture, printmaking, and theater. In 1989, he released an animated short, *Johannesburg, 2nd Greatest City after Paris*, launching a series of films—"Nine Drawings for Projection" (1989–2003)—in which he addresses his own implication in the system of oppression. He does so through two main characters that function as the artist's alter egos: Soho Eckstein, a wealthy mine owner and land developer representing the forces that have stripped the country bare, and Felix Teitlebaum, a romantic artist, who observes these forces at work and confronts Soho. The two are also in conflict over Soho's wife, who is more attracted to the sensual, natural character of Felix. These films are made using a technique of drawing on paper with charcoal, erasing, and redrawing on the same surface, a process closely related to Kentridge's exploration of memory, as traces of previous forms linger on the paper even as new images are drawn.

The organization Animation SA has attempted to centralize the art and industry of South African animation. The lack of skilled animation artists in the country is a problem, but efforts have been made to build a workforce. In 2010, the country's first public animation academy opened in Khayelitsha, a township on the outskirts of Cape Town; it was established through the efforts of a partnership between the Cape Film Commission (CFC), the Western Cape film industry, and the training organization Services Seta. David Sproxton, one of the co-founders of Aardman Animations, participated in its opening events, welcoming more than a hundred students to the first year-long program.

One of South Africa's oldest studios, Triggerfish, was founded in 1996, mainly to produce stop-motion animation, but later moving into 3D CGI. It is probably best known for its work on "Sesame Street," for both the American version and local programming in "Takalani Sesame," in collaboration with other South African

23.17 Anthony Silverston, *Khumba*, 2013

studios. Most of Triggerfish's work has been produced for clients outside the country, but in recent years it has launched its own feature films, including the 3D CGI film *Adventures in Zambezia* (dir. Wayne Thornley, 2012), an action-adventure story focusing on a community of birds; and *Khumba* (dir. Anthony Silverston, 2013), about a zebra in search of more stripes **(23.17)**. The studio has also established a division it calls Triggerfish Labs for the production of games, eBooks, and other digital content to extend its feature-film franchises.

International Feature Films

It is challenging to complete a short animated film when time, facilities, workforce, skills, funding, and other factors are limited. Those challenges are multiplied many times when one attempts to create a longer work, such as an animated feature or a television series. Yet, in countries across the world, studios are doing just that, finding ways to create animated productions to enter a global market, sometimes drawing on skills, advisors, and funding opportunities obtained from outside sources. The Pakistani animator Numair Abbas received a Fulbright scholarship to study animation at the UCLA Animation Workshop, and in 2010 set up his country's first studio dedicated to 2D-animated TV series. Located in Islamabad, within a complex called Numairicals Studios, it also produces live-action films and music and provides animation training and film-related events. Abbas's aim is to create animation for a Pakistani audience, despite a lack of infrastructure to support its production; over a period of years, he developed a series called "The Apartment Complex," which features a cast of neighbors. Abbas's mother, Nigar Nazar (1953–) is the first Pakistani female cartoonist, well known for her character Gogi, a modern, urban Pakistani woman who struggles with oppressive social structures. Nazar has conducted outreach programs for children, related to cartooning and animation.

Pakistan's first animated feature, *3 Bahadur* (*Three Braves*, 2014), produced by SOC Films, came from the director Sharmeen Obaid Chinoy, the first Pakistani to win an Oscar **(23.18)**. She won it for a live-action documentary, *Saving Face* (2012), about acid attacks on women in Pakistan, one of many films she has directed that relate to gender and culture. Chinoy's animated feature is aimed at kids, as a story about three eleven-year-old friends, a girl and two boys, who protect their community from evil-doers, and contains a strong undertone of female empowerment. This theme is also echoed in the Pakistani television series "Burka Avenger" (2013), about a teacher in an

23.18 Sharmeen Obaid Chinoy, *Three Braves*, 2014

"Sesame Street" puppet character of the same name; Hijazi served as writer and director on the series. Hijazi began her career in animation in 1997, as a writer and director of animated TV series and films, mainly focusing on children's education and development. Since 2012, she has been a board member of the International Center of Films for Children and Young People (CIFEJ), a Montreal-based organization founded in 1955 under the auspices of UNESCO and UNICEF to promote excellence in audio-visual media for children and young people. Hijazi shares a concern with many other animators emerging into the world marketplace: the development of a cultural identity, or in her case, an "Arab" style.[19] She relocated to Frankfurt, Germany, after witnessing the arrest and killing of some of her family and friends, as a result of increasing hostilities in Syria. But before she left, she was able to create a number of films, including the feature *The Jasmine Birds* (2009), which sensitively addresses children's concerns about sickness and death (**23.19**). In 2012, she registered Blue.Dar in Beirut, Lebanon and in 2015 she was in the process of establishing a new base for the studio in Germany.

Despite the difficulties involved in producing them, animated features have been increasing in number and

Islamabad girls' school who, when she covers her face with a *niqab*, becomes a martial-arts defender of gender and educational rights. This series, created and directed by the British-born popular-music star Haroon (Aaron Haroon Rashid), re-envisions the *burqa*, which covers the body, as the garb of a superhero rather than a tool of oppression.

In Syria, animation production is monitored by the National Film Organization, and thus most studios keep the focus on children and the family. Sulafa Hijazi (1977–) is one of the best-known figures in Syria's animation industry, as the director of Blue.Dar studio, which she founded in Damascus in 2010; it produces animation, live drama, puppet shows, documentaries, and print media. One of the TV series produced at the studio, "Malsoun" (2011–13), features the animated version of an Arabic

23.19 Sulafa Hijazi, *The Jasmine Birds*, 2009

23.20 Sylvain Chomet, *The Triplets of Belleville*, 2003

scope since the early 2000s. *The Triplets of Belleville*, a feature of 2003 written and directed by Sylvain Chomet (1963–), is an international co-production between studios in Belgium, Canada, and France **(23.20)**. It relates the story of an elderly woman's search for her grandson, accompanied by their faithful dog and a band of elderly singers. Undoubtedly, the film's success internationally was aided by an unusual trait: it contains virtually no dialogue aside from the lyrics of a song, "Belleville Rendezvous," which is heard several times. In terms of visuals and storytelling, the film owes a lot to the French director and physical comedian Jacques Tati, who starred in such films as *Jour de Fête* (*Holiday*, 1949) **(23.21)** and *L'École des Facteurs* (*School for Postmen*, 1947), which

23.21 Jacques Tati, *Holiday*, 1949

generally feature little dialog, focusing of *The Triplets of Belleville* seemed to fuel confidence that films produced outside the US and Japan could find a market. Chomet himself released another animated feature, *The Illusionist*, in 2010, based on a previously unproduced script written by Tati. It tells the story of an aging magician and a young woman who believes in him.

The development of animated features internationally resulted in more diverse subject matter, as one finds in the autobiographical documentaries *Persepolis* (dir. Marjane Satrapi and Vincent Paronnaud, 2007) and *Waltz with Bashir* (dir. Ari Folman, 2008). Produced in France, *Persepolis* **(23.22)** is an account of Marjane Satrapi's (1969–) experiences growing up in Iran during the Islamic Revolution, which occurred after the overthrow of the Shah in 1979 by the Shiite Muslim cleric Ayatollah Ruhollah Khomeini.[20] The country's secular government was replaced by a theocracy ruled by Islamic religious leaders, which was much more conservative; there were many people who resisted its restrictions, however, including Satrapi and her family. A graphic-novel version of *Persepolis* was published in 2000, and the film was released seven years later. Co-directed by Vincent Paronnaud, the film was drawn with pencil on paper and inked with marking pen (largely in black and white, replicating the visual design of the graphic novel). *Persepolis* was received enthusiastically across the world, but was given limited screenings in Tehran, where some scenes relating to sex were censored.

Waltz with Bashir examines events of the Lebanon War, when the film's director Ari Folman (1963–) was a nineteen-year-old infantry soldier in the Israel Defense Forces (IDF) **(23.23)**. During that time, he was present at a massacre of civilians that occurred in the Sabra and Shatila refugee camps in September 1982. The IDF was ostensibly guarding Beirut's Palestinian refugees when it allowed the Lebanese Phalange Christian militia to enter the camps and kill many people, including women and children. Israel's defense minister, Ariel Sharon, was later found to be responsible. Though Folman was a participant, as a soldier in the IDF,

23.22 Marjane Satrapi and Vincent Paronnaud, *Persepolis*, 2007

he did not have any memory of being there, and this realization inspired him to create the film. It follows Folman as he interviews various people who try to help him reconstruct his memories. He began production in the same way, by meeting with several people and writing a script based on their responses. Folman later revisited the same people, referring to the script and filming them as they spoke. In the film, interview scenes are intercut with the director's own visualizations of events. *Waltz with Bashir* was the first animated feature made in Israel since Yoram Gross (see p. 267) released *Joseph the Dreamer* in 1961.

23.23 Ari Folman, *Waltz with Bashir*, 2008

Conclusion

The styles and content of animation are diversifying as animators in varied contexts find ways of overcoming the hurdles that challenge production and exhibition. More than ever, animation is being embraced as a means of expressing a wide range of social and political perspectives, reflecting the lives, interests, and resources of people worldwide. Governmental and cultural organizations have aided this development by providing seed money and institutional support that allow relatively independent creators and small studios to create such works.

Increasing numbers of people are being attracted to this field: not only traditional animators, but also artists of every kind, as they blend a range of fine-art methods with animated forms. Today animation is found in the context of installations in galleries, live performances, digital projection mapping in site-specific works (see p. 436), and other venues. Once again it is clear that animation is not only the "seventh art" (see p. 70), but also a meeting point for all the arts, inspiring creators from many walks of life.

Distributing World Animation: GKIDS

Distribution can be a big challenge for international features, which might earn a profit but are unlikely to be blockbusters. One example is the Spanish feature *Arrugas* (*Wrinkles*, 2011), directed by Ignacio Ferreras, who had been an animator on one of Sylvain Chomet's feature films, *The Illusionist*. *Wrinkles*, based on a comic book of the same name (2007) by the Spanish cartoonist Paco Roca, focuses on two elderly residents of a retirement home, one of whom is in the early stages of Alzheimer's disease **(23.24)**. Unfortunately, dealing with the marginalized topics of the elderly and disability as it does, this film would probably not interest a major distributor. Nonetheless, it could find a home in the number of smaller businesses that have formed to handle distribution for niche markets. Sometimes these distribution deals are made after a film screens at a festival and is seen by individuals scouting for new work for the region of the world they represent.

In the US, *Wrinkles* is handled by just such a distributor: Guerrilla Kids International Distribution Syndicate, known as GKIDS, which caters to art-house and family audiences. Since 1997, the company has produced the New York International Children's Film Festival, which is North America's largest festival of film for children

23.24 Ignacio Ferreras, *Wrinkles*, 2011

and teens. In 2008, GKIDS moved into the theatrical distribution of feature animation by representing the international co-production *Azur et Asmar* (*Azur and Asmar*, 2006), an original fairy tale written and directed by Michel Ocelot in France. Among the other titles GKIDS represents theatrically are *The Secret of Kells* (2009), an international co-production by the Irish director Tomm Moore (1977–), and the French film *Le Chat du Rabbin* (*The Rabbi's Cat*, 2012), directed by Joann Sfar (1971–) and Antoine Delesvaux (1979–). In 2011, the company acquired North American theatrical rights to the Studio

23.25 Tomm Moore, *Song of the Sea*, 2014

23.26 Joann Sfar and Antoine Delesvaux, *The Rabbi's Cat*, 2012

Ghibli features (see p. 393), which were previously held by Walt Disney Studios Motion Pictures.

The Secret of Kells (2009) was animated at Cartoon Saloon, a Kilkenny, Ireland-based studio formed in 1999 by Paul Young and the film's director, Tomm Moore. Cartoon Saloon works with international clients, including Disney, Cartoon Network, and the BBC, to produce feature-length and short films, as well as television series, commercials, graphic novels, and children's books. Set in the eighth century, *The Secret of Kells* is a fictionalized account of a young boy who lives in a monastery. He is fascinated by the illuminated manuscript known as the Book of Kells, one of Ireland's greatest treasures, and plays a role in protecting it. Heavily influenced by Celtic mythology, the film invokes the spirit world and also incorporates many design elements found in the illustrations of the real Book of Kells. The Irish–French–Belgian co-production was nominated for an Oscar in the category of best animated feature. The studio's next feature, *Song of the Sea* (dir. Tomm Moore, 2014), also distributed by GKIDS, is about a Selkie, or seal-child, who journeys with her brother across mystical lands to return to the sea **(23.25)**.

The Rabbi's Cat is based on volumes one, two, and five in a series of *bandes dessinées* (the French-language term for comic books) of the same name by Joann Sfar, a French-born artist of Jewish heritage who has published more than a hundred graphic novels in various series. Set in Algeria during the 1920s, the film

23.27 Marguerite Abouet and Clément Oubrerie, *Aya of Yop City*, 2012

tells the story of a rabbi and his precocious cat, which is able to speak after it swallows a parrot **(23.26)**. The film was the first project undertaken by co-directors Sfar and Antoine Delesvaux after they formed their studio Autochenille Production with Clément Oubrerie in 2007. *The Rabbi's Cat* was made in collaboration with the French television channels TF1 and France 3. It is unique in its incorporation of various design styles, which reflect the original look of the images in comic-book form. Autochenille's second film, *Aya de Yopougon* (*Aya of Yop City*, 2012) **(23.27)**, was co-directed by the writer Marguerite Abouet and illustrator Clément Oubrerie, based on their graphic novel series of the same name, published between 2005 and 2010. These stories are semi-autobiographical, reflecting Abouet's experiences growing up on the Ivory Coast in Africa.

Notes

1 "CARTOON: The Driving Force of the European Animation," Cartoon Media. Online at http://cartoon-media.com/about-2/history.htm

2 Ibid.

3 Irene Kotlarz, "The History of Channel 4 and the Future of British Television," *Animation World Magazine* 4:6 (September 1999). Online at http://www.awn.com/mag/issue4.06/4.06pages/kotlarzch4/kotlarzch4.php3

4 Charles Leadbeater and Kate Oakley, *Surfing the Long Wave: Knowledge Entrepreneurship in Britain* (London: Demos, 2001).

5 "Channel 4: Commissioning and Purchasing Animation," *Animator Mag–Library*. Online at http://www.animatormag.com/archive/issue-26/issue-26-page-12/

6 See also Benjamin Cook and Gary Thomas, eds., *The Animate! Book: Rethinking Animation* (London: Lux, 2006).

7 Michael Brooke, "Channel 4 and Animation," *BFI Screen Online* (n.d.). Online at http://www.screenonline.org.uk/film/id/1282041/

8 Shevaun O'Neill and Kathryn Wells, "Animation in Australia" (June 15, 2012), *Australian Government*. Online at http://australia.gov.au/about-australia/australian-story/animation-in-australia

9 Bill Desowitz, "Getting Animated over Happy Feet," *Animation World Network* (November 17, 2006). Online at http://www.awn.com/articles/production/getting-animated-over-happy-feet

10 Paul Byrnes, "*Happy Feet*: Curator's Notes," *Australian Screen* (n.d.). Online at http://aso.gov.au/titles/features/happy-feet/notes/

11 Giannalberto Bendazzi, *Cartoons: One Hundred Years of Cinema Animation* (Bloomington, IL: Indiana University Press, 1994), 189. Subsequent information was drawn from this source in pp. 189–92.

12 It is sometimes reported that the famous Brazilian director Humberto Mauro (1871–1983) created Brazil's first puppet animation, the eighteen-minute *O Dragãozinho Manso* (*The Good Little Dragon*) in 1942. The film, made for the National Institute of Educational Cinema, is about a dragon that has difficulty making friends, until he becomes a hero. It uses puppets, but they are manipulated in real time, not through animation. Léo Ribeiro, "Humberto Mauro and His Experiences Animated," *BrasilAnima* (August 17, 2011). Online at http://brasilannima.blogspot.com/2011/08/humberto-mauro-e-animacao-brasileira.html

13 Information about Anima Mundi was taken largely from its website, http://www.animamundi.com.br/. See also a documentary, *Anima Mundi: 20 Years*. Online at https://www.youtube.com/watch?v=131Krcp8fFg&feature=share&list=UUauHXuU6ISl9tYkdFeuVgEQ

14 Javier Hildebrandt, "El Mundo Animado #14 – Especial Animación Argentina," *Sobre Historieta* (June 27, 2012), online at https://sobrehistorieta.wordpress.com/2012/06/27/el-mundo-animado-14-especial-animacion-argentina/

15 Histories of animation in Argentina sometimes mention the stop-motion film *La Gran Carrera* (*The Great Race*), about horse racing from 1945, the director of which is unknown. There are no identifying marks to indicate that is actually from Argentina. Alejandro R. González, email to the author (August 16, 2014).

16 Adriana Copete, "Latin American Animadoc: Frames as War Documents," unpublished paper (Fall 2013).

17 Puseletso Nkopane, "Animated Africa: Africa's Animation Industry," *Consultancy Africa Intelligence* (March 16, 2012). Online at http://www.consultancyafrica.com/index.php?option=com_content&view=article&tid=982:animated-africa-africas-animation-industry&catid=90:optimistic-africa&Itemid=295

18 Paula Callas, "Project Ngando Documenting JM Kibushi," *African Animation* (May 14, 2008). Online at http://paulacallus.blogspot.com/2008/05/project-ngando-documenting-jm-kibushi.html

19 Stephanie Van de Peer, "Animation in the Middle East," *SAS Blog* (May 5, 2014). Online at http://www.blog.animationstudies.org/?p=779

20 For information on the marketing of the film in North America by Sony Pictures Classics, which had previously distributed *The Triplets of Belleville*, see Sandy Mandelberger, "Industry Report: Marketing, Marketing Case-Studies – Persepolis," Cineuropa (April 14, 2008). Online at http://cineuropa.org/dd.aspx?t=dossier&l=en&tid=1366&did=83521

Key Terms

2D animation	maquette
3D CGI animation	motion capture
animatronics	motion graphic
direct film	post-production
distribution	pre-production
festival film	stop-motion
intercut	time lapse

CHAPTER 24

Animation in the Art World

Global Storylines

Since the 1990s, the worlds of fine art and animation have moved closer together: art museums now hold major animation exhibits, while artists increasingly incorporate animation into their practice

The presentation of animation overlaps with that of contemporary art, in installations, site-specific projections, and performance art, for example

Introduction

Fine art is generally prized for the uniqueness of its expressions, which are produced as singular items rather than in multiple copies. Popular culture is just the opposite. It is commodityoriented, usually created on a mass scale for some commercial purposes that is, the intention to sell many products. Animation fits easily into commodity culture, as it has been used to create advertising, television series promoting children's toys, and media franchises leading from one product to the next; but it has taken longer for it to find its place in the world of art.

Back in the 1910s, Winsor McCay (see p. 40) had lamented the direction in which his colleagues had taken animation, away from art and toward business (see p. 43), and for the most part, in the decades that followed, that is how the industry was developed and perceived, especially in the US. There was the odd exception, such as Disney's *Fantasia* (1940) (see p. 107), an industry film that aspired to the level of fine art. The uneasiness of this alliance was underscored in the 1970s, when Disney's high aspirations were lampooned by the Italian director Bruno Bozzetto in his feature *Allegro Non Troppo* (1976) (**24.1,** see p. 428). The film, a parody of *Fantasia*, includes six musical episodes aimed at an adult audience. In one of them, Bozzetto depicts the evolution of life growing out of a Coca-Cola bottle that drifts in space, in a mocking take on *Fantasia*'s "Rite of Spring" sequence.

One measure of an art form's perceived status is in the cultural institutions that promote it: for example, museums and galleries, which are maintained by curators who, by selecting items for display and purchase, act as cultural gatekeepers. In recent years, animation

24.1 Bruno Bozzetto, *Allegro Non Troppo*, 1976

of all kinds has attracted attention from such people and has consequently experienced a significant rise in status. This relationship has been two-sided, however: animation has benefited from appearing in museums, but museums have benefited from having animated artworks to show, as they pull in the public, including people who might not otherwise visit such venues.

In fact, American museums had begun to exhibit animation in the early 1930s. The first shows focused on Disney, as Walt Disney was a great promoter of his studio and sought varied venues for displays of its works. In 1932, the Philadelphia Art Alliance's show relating to the "Mickey Mouse" and "Silly Symphony" series also travelled to venues in other cities. Similarly themed exhibitions appeared at the Art Institute of Chicago in 1933 and at the Leicester Galleries in London in 1935; in New York City, shows in 1936 and 1938 at the Museum of Modern Art (MoMA) were just some of the exhibitions on display around that time. Today, there are a number of museums that are wholly dedicated to animation and its creators: for example, in Japan, the Osamu Tezuka Manga Museum in Takarazuka, where the famous comic book artist and animator (see p. 235) grew up.

Indeed, as the scope of animation practice has spread into many techniques, and production is taking place worldwide, there are more opportunities than ever to showcase animation as an art form. This development was evident in an exhibition curated in 2011 by Greg Hilty for the Barbican Centre in London, England, named "Watch Me Move: The Animation Show," after the famous phrase in Winsor McCay's landmark film *Little Nemo* (1911, see p. 41). The exhibition, which toured internationally, brought together about a hundred works representing the wide range of imagery produced throughout animation history. The show's mixture of international animation acknowledged the broad base of production, including artworks from both industry and independent sources.

In New York City, MoMA has continued to support animation exhibitions, for example with an extensive retrospective called "Pixar: 20 Years of Animation." It opened at the end of 2005 and ran into 2006, the same year that Disney acquired Pixar, after having distributed its films for some time (see p. 351). In addition to screenings, the show included paintings, concept art used to develop projects, sculptures, and digital installations related to a number of the studio's features and short films. The exhibition traveled globally, to locations that included London, Tokyo, Edinburgh, Melbourne, Helsinki, Singapore, Hong Kong, Hamburg, Amsterdam, and Paris. Given such major exhibitions, perhaps the

spirit of Winsor McCay can now rest easy, knowing that future generations have in fact seen animation as an art.

This chapter examines some of the ways that animation has overlapped with the fine-art world in terms of the varied media and techniques employed in its production, as well as different contexts used for exhibition, including installations, projections, and performance. Some of the artists discussed here have explored pop culture and built commentaries around it, while others have looked back through history, incorporating past art forms into their modern expressions. Still others have developed approaches that grow out of other occupations and fine-art practices, creating works that entertain, surprise, enlighten, comfort, and so much more. The horizons for animation in the international art world are vast.

Finding the Art in Animation

In the mid-1980s the makers of Absolut Vodka began a highly publicized and somewhat surprising advertising campaign, commissioning such famous visual artists as Andy Warhol and Keith Haring to design collectible bottles. In 1996, a producer at Troon interactive studio, Debra Callabresi, and the director Christine Panushka convinced the company that specially commissioned festival-film animations would be equally impressive— and the concept for an award-winning website, *Absolut Panushka*, was born. Panushka curated a selection of thirty-three ten-second films that feature the image of the bottle in the far-ranging styles of artists from across the world. Emphasis was placed on abstract animation, including films by Jules Engel (see p. 213) and others. The films were posted on a website, as the first streaming media on the World Wide Web; the site also included a history of experimental animation written by William Moritz, and a simple animation tool, allowing the public to view, learn, and create all on the same site. For many people, *Absolut Panushka* provided an introduction to the concept of animation as fine art, even though the relationship dates back to the early twentieth century.

In the late 1910s, painters in Europe had begun to experiment with animation, attracted by the possibility of incorporating time into their works. Since then, a relationship has existed between animation and the fine art world, a connection that has grown stronger in recent decades. One of the enduring affinities has occurred within the realm of Surrealism (see Box: Modern Movements in Painting, p. 72), since animated images lend themselves so well to the depiction of fantasies and dream states. The Belgian filmmaker Raoul Servais (1928–), for instance, was greatly inspired by the Belgian Surrealist painter René Magritte (1898–1967), whose work challenged preconceived ideas about reality—most famously in his painting *La Trahison des Images* (*The Treachery of Images*, 1929), which depicts a pipe and the phrase "Ceci n'est pas une pipe" ("This is not a pipe"). Servais's film *Harpya* (*Harpy*, 1979) shows a strongly Surrealist sensibility, incorporating erotic and analytical themes as it tells the story of a man who saves a harpy, an aggressive bird-like creature with a woman's face, which then becomes his downfall. The story is related using a combination of visual-effect techniques, compositing a live character into painted environments.

The French filmmaker Michel Gondry (1963–) is also known for his use of Surrealist elements, which are apparent in the animated effects, puppets, and environments found in music videos he made for the Icelandic singer Björk in the late 1990s; their collaboration began with a video for her song "Human Behaviour" in 1993, in which the singer is chased by a large bear and eventually swallowed up by it. This playful aesthetic is sustained in the feature films he has directed: for example, in the lively animated food found in the central character's fantastic apartment in *L'Écume des Jours* (*Mood Indigo*, 2013).

Naturally, creative methods affect the aesthetics of any given artwork; so the selection of materials and techniques is as important to an animator as it is to any other artist who draws, paints, or sculpts. Sara Petty's short *Furies* (1975), for instance, employs pastels, which are soft and powdery, well able to capture the pure energy of her film's central characters: two cats in motion. *Furies* was created in the mid-1970s, when Petty was a graduate student at the University of California, Los Angeles, and reflects the ways that college programs at that time were beginning to foster creator-driven works linking to the fine-art world.

Historically, links between animation and painting have been strong. Painters have incorporated their practices into animation by continuing to use paint but selecting different base media—working on paper, canvas, glass, or the surface of filmstrips, for example. The American Jeff Scher describes himself as "a painter

24.2 Jeff Scher, *White Out*, 2007

who makes experimental films and an experimental filmmaker who paints." His three-minute film *White Out* (2007), with music by Shay Lynch, is composed of about 2,500 watercolor paintings, which appear over a range of backgrounds that include pages of text, covers of drawing-paper pads, calendars, and more (24.2). He uses rotoscoping to create images that he believes are strongly evocative of dreams.

Allison Schulnik's (1978–) animated worlds generally begin in the form of large-scale oil paintings or sculptures, the media she uses to develop character studies that are an integral part of her animation process. Her studio space is divided into two halves to allow her to work back and forth between these objects and her animated films. Schulnik's animation, featuring enigmatic clay clowns that implode and rebuild, sinewy puppet dancers with long bands of copper-wire hair, and various natural elements, capture pensive, somewhat disconcerting moments. Over a series of four films, *Hobo Clown* (2008), *Forest* (2009),

Mound (2011), and *Eager* (2014) (24.3), Schulnik has developed the complexity of her staging, movement, and concepts, while employing figures that are somewhat similar from film to film, and suggestive of images from popular culture, but intensified. Her Hobo Clown is the saddest clown one can imagine, with copious fluids pouring from his eyes. When Schulnik exhibits her work, she typically includes her paintings and sculptures in the same space as her films. In this way, they function as installation pieces, allowing people to see components of her creative process as finished pieces that provide context for each other.

The Swiss animator Georges Schwizgebel (1944–) uses a paint-on-glass technique. He studied at the École des Beaux-Arts et des Arts Décoratifs in Geneva from 1960 to 1965, and then, influenced by films he saw at the Annecy International Animation Festival (see p. 297), he founded Studio GDS in 1971, with Daniel Suter and Claude Luyet. Schwizgebel's films generally take a playful approach to the continuity between time and space, creating a kind of dance for the viewer, as painted images metamorphose fluidly and continuously in harmony with their musical accompaniment. One example is his paint-on-glass film *78 Tours* (*78 R.P.M.*, 1985), the title of which refers to a "78 rotations per minute" record (recorded shellac disk) (24.4). The film begins with a close-up shot of people in what appears to be a field, but turns out to be the pattern on the dress of a woman who is lying in a field; the film continues to shift in time and space, accompanied by a waltz played on an accordion, with music by Alessandro Morelli.

The Polish animator Witold Giersz (1927–) also specializes in paint on glass, as one can see in his films *Koń* (*The Horse*, 1967) and *Pożar* (*Fire*, 1975). *Fire* opens

24.3 Allison Schulnik, *Eager*, 2014

24.4 Georges Schwizgebel, *78. R.P.M.*, 1985

Antonio Sistiaga (1932–) completed a seventy-minute direct film, titled with nonsense words: *ere erera baleibu izik subua aruaren* (24.5). He painted onto 35mm film, using a range of techniques, projecting the work without sound.

The Colombian animator Camilo Colmenares (1976–) works directly on film as well. His film *Quimtai* (2015) was made using laser engraving on black 35mm leader, based on abstract patterns of pre-Columbian art from the Tairona and Quimbaya cultures. These images were scanned into a computer before being output onto film, forty-five frames at a time; the characteristics of fabric texture were created by adjusting the speed, intensity, and resolution of the laser. The etched filmstrips were then scanned back into the computer and the resulting images were edited by the Israeli Tama Tobias-Macht,

in a meadow scene, created with the use of a multiplane rig, using thickly applied paint that metamorphoses to depict birds, butterflies, and flowers blowing in the wind; these images are tightly synchronized to a score, which also provides sound effects. Some movements are depicted with trace images left behind, such as when a buck runs through the forest, creating a path through the paint. As a result, the status of the work as a painting, as well as animation, remains clear in the viewers' minds.

Direct filmmakers work on a small surface, on top of and underneath a strip of film—painting, drawing, or etching. They consider the filmstrip to be just another surface for creative expression, one that allows projection onto a screen. Some of the earliest work in this area came from the Italians Bruno Corra and Arnaldo Ginna (see p. 77), who had begun this kind of experimentation by 1911, as part of their investigation into visual music. Today, direct filmmaking remains closely attached to the fine-art world in the work of many artists. One example is the Italian Leonardo Carrano (1958–), who began as a painter and moved into animation in 1992. His film *Dies Irae* (*Day of Wrath*, 2010), co-directed by Ada Impallara, was created by scratching, painting, and acid-corroding strips of film. This work is part of a larger project to visualize Wolfgang Amadeus Mozart's Requiem, with each of its fourteen movements being realized in collaboration with a different artist. In 1970, the Spaniard José

24.5 José Antonio Sistiaga, *Ere erera baleibu izik subua aruaren*, 1970

24.6 Chen Shaoxiong, *Ink History*, 2010

who uses a wide range of drawing surfaces, ranging from the human body to the walls of buildings, sometimes working on a very large scale. In 2006, Sun Xun founded an animation studio, π (Pi), in Beijing. Using mixed media, including woodcuts and traditional ink, his films investigate memory, politics, and corruption, embodied by a magician figure in such titles as *Lie* (2006), *Magician Party* (2008), and *Beyond-ism* (2010).

Re-Envisioning Pop Culture

Images from pop culture have been a ready source of inspiration for a number of artists employing collage techniques. Lewis Klahr (1956–), who began animating in the late 1980s, describes himself as a "re-animator," as he re-instills life into "dead images" of the past, found in advertisements, comic books, and other sources.[2] His collage films employ obscure narratives, showing a progression of events that is associative and intuitive rather than tightly structured, and more akin to poetry than a linear story.[3] Klahr's film *Altair* (1985) was created using figures from a postwar women's magazine, combined with such suggestions of domesticity as plates of food, clocks, and alcohol, made menacing through the choice of Igor Stravinsky's *The Firebird* as the soundtrack **(24.7)**. Playing cards that drift through the frame take on an undefined symbolic meaning. Watching Klahr's work, one becomes aware of the way in which conventional films manipulate a viewer's perceptions through repetition, framing, sound design, and other aesthetic choices.

who brought rhythm and structure to the work. *Quimtai* was made in Germany at the Academy of Media Arts Cologne, as Colmenares's thesis project.

When the South African William Kentridge (1955–) (see p. 419) appeared at the Shanghai Biennial in 2000, he inspired Chinese artists engaged in a range of practices. One example is Chen Shaoxiong (1962–), who works in photography, video, installation, and ink painting, conducting investigations into China's urban lifestyles and history. His limited-animation films *Ink City* (2005) and *Ink History* (2010) **(24.6)** are set in motion through camerawork, foregrounding their status as ink drawings.[1] Kentridge's influence is also found in the work of Sun Xun (1980–), an eclectic artist

Janie Geiser (1957–) is an interdisciplinary visual artist who began making films in 1990, first as an element of her performances and installations, and then as stand-alone projects reflecting her multidisciplinary background. Her collage works are atmospheric and only loosely narrative, providing a series of images and sounds that lead the audience toward certain sensations rather than a distinct story. She achieves these effects through the use of varied objects and materials, including images of human characters, which create the suggestion of a storyline for the viewer. For example, Geiser's *Immer Zu*, from 1997, incorporates found objects and both front-lit and silhouetted cutouts,

24.7 Lewis Klahr, *Altair*, 1985

often layered to semi-obscurity or highlighted through lighting effects (**24.8**). Close-up shots of the hands and faces of doll-like figures, accompanied by dramatic swells in music taken from 1940s **film noir**, create a mysterious ambience. Geiser often draws attention to the "puppet" quality of her characters, for instance by highlighting strings in *Immer Zu* and by breaking figures into parts in her later film, *Spiral Vessel* (2000).

Martha Colburn (1972–) began making films in the mid-1990s using found footage, but she soon embraced a range of animation techniques, including paint on glass, stop-motion, and collage of pop-culture imagery.

24.8 Janie Geiser, *Immer Zu*, 1997

24.9 Martha Colburn, *Cats Amore*, 2002

For example, *Cats Amore*, a film from 2002, was created by placing cat heads on the bodies of women in sexy poses **(24.9)**. In this film and others, Colburn is interested in breaking down political hierarchies, looking at familiar images in new ways.[4] She did two years of research before making her animated short *Dolls vs. Dictators* (2010). It is one of a number of her films that deal with themes of war; others include *Triumph of the Wild* (2009) and *Destiny Manifesto* (2010), which have titles reminiscent of the infamous Nazi film *Triumph of the Will* (dir. Leni Riefenstahl, 1935) from the World War II era and the concept of manifest destiny, the belief that the political domination of one culture over others is preordained. Colburn's works are made completely in-camera, with no editing after the footage is shot.

Installations

Animation installations are exhibits that shape the viewer's perception and experience within a given space. Unlike films, which are projected to a passive audience, seated in a fixed position, visitors of an installation can generally walk around the exhibition space and sometimes interact with the art.

The animation of the Dutch father and son Paul (1943–) and Menno de Nooijer (1967–) is inspired by the duo's interest in the medium of photography, both analog and digital. One of their early films, *At One View* (1989), features the two sitting next to each other, covering their faces with photos, which are moved back and forth through pixilation; meanwhile, a voice-over states, "There is no real difference between photography and film," and continues to narrate the filmmakers' theoretical views. Although the de Nooijers continued to make films in the early 2000s, at the same time they also branched out into performance and installation. One example is their installation *100 Jaar Schoonheid* (*100 Years of Beauty*, 2002), a ten-minute video investigation of 102 faces of people aged zero to one hundred, placed side by side in a grid. As each individual breathed in, his or her image became clear; as he or she breathed out, it began to fade. These visuals were accompanied by the sound of breathing.

Photography also underlies Eric Dyer's *Copenhagen Cycles* (2006/2014), a film created after the director took photos of the capital of Denmark and assembled them into complex zoetrope figures **(24.10)**. The zoetropes (see p. 17) could be viewed as an installation, but the images they generated were also captured by cameras to create animation. In 1980, Bill Brand used the principle of a zoetrope to install street art in New York City: *Masstransiscope*, constructed on the walls of the city's subway. It was composed as a series of thirty-inch-high images housed inside a long wood-and-steel structure with narrow slits, through which images could be seen as the train moved alongside it. Rather than the images passing by the viewer, the viewer passed by the images.

The zoetrope concept has also been adapted to animate three-dimensional objects and has been used in installations by Studio Ghibli and Pixar, among others. At Ghibli, the "Bouncing Totoro" zoetrope is made of 347 figures; its initial inspiration was the bus-stop scene in *My Neighbor Totoro* (dir. Hayao Miyazaki, 1988, see p. 396), in which Totoro and other characters bounce up and down. This installation, which is housed in the Ghibli Museum (see p. 403), inspired the Pixar Animation Studios to create its own, starring characters from its feature film *Toy Story* (see p. 376). This zoetrope was shown in the "Pixar: 20 Years of Animation" retrospective at MoMA, in New York City, and a copy was also shown in the Disney California Adventure Park in Anaheim, California, and at Hong Kong Disneyland.

Animation is often a supporting element of an installation, rather than its main focus. For example,

24.10 Eric Dyer, *Copenhagen Cycles*, 2006/2014

the American Erica Larsen-Dockray's autobiographical installation *My First Pregnancy* (2012) incorporated motion graphics and animation into an immersive audience-participation event: a kind of theme-park ride devoted to the topics of reproductive rights, pregnancy, and the female body, divided into eight areas—which Larson-Dockray called "episodes"—in a single room. Created as her graduation thesis from CalArts, the installation explained the impact of this unexpected event on her life and that of her partner. Animation was used to project female reproductive organs onto viewers, to visualize a conversation between Larsen-Dockray and a "nurse" at a low-fee clinic that turned out to be a shady pro-life organization, and in other ways to illustrate her "awakenings" about how the system worked for a young, uninsured woman, leading up to the birth of her child. A gurney was used to transport people around the installation.

The theme-park context also inspired the large-scale installation Dismaland Bemusement Park, produced in 2015 by the British graffiti artist and social activist known as Banksy. Clearly referencing

Disney properties, it contained games and art from about sixty artists. Included was a 2D animated film by the Argentine director and animator Santiago Grasso and animator Patricio Plaza, *El Empleo* (*Employment*, 2008); a stop-motion film from the American Kirsten Lepore, *Bottle* (2010) (see p. 329); and a puppet and mixed-animation film, *Don't Hug Me I'm Scared* (2011), by Becky Sloan and Joseph Pelling from the UK. The two-and-a-half acre site was constructed on a rundown property located in Weston-super-Mare, England.

Projections and Site-Specific Works

Every summer, the Pacific Northwest College of Art in Portland, Oregon offers a two-week program, Boundary Crossings, to support the development of installation art in interdisciplinary ways. The program's director, the Canadian animator Rose Bond, began animating in the smallest possible size, working directly on filmstrips,

24.11 Ben Ridgway, *Tribocycle*, 2013

Cosmic Flower Unfolding (2013), was inspired by imagery from his meditational practice and the illustrations of the nineteenth-century biologist Ernst Haeckel. His *Tribocycle* (2013) is a looping film for large-scale projections and installations **(24.11)**. Both animations are under two minutes in length and mandala-like in form. *Cosmic Flower Unfolding* was featured at, among other exhibitions, the international animation festival, Anima Mundi 2014, in Brazil, as part of its gallery selection. Later that year, *Tribocycle* played on the Digital Dome at the Institute of American Indian Arts in Santa Fe, New Mexico, as part of the Currents 2014 New Media Festival.

Projections are now used extensively in theater scenic design to add dynamism to a stage environment. The multimedia studio 59 Productions is known for designing these kinds of projected setting. It is probably most famous for its work on American theatrical performances of *War Horse*, which played in New York from 2011 to 2013 (and toured elsewhere), after a successful run in London theaters beginning in 2007. The story, about a man who enlists in World War I to search for his beloved horse after it is sold to the cavalry, is from the book of the same name (1982) by Michael Morpurgo, adapted for the theater by Nick Stafford. The production used large puppet horses, along with drawn backgrounds that were then animated, with 3D CGI figures and machinery added to the projected scenery. Their goal was to make the digital 3D imagery look hand-drawn—for example, in battlefield scenes depicting the charge of horsemen confronted with tanks. The large horse puppets were designed by the Handspring Puppet Company of South Africa.

but now she does the opposite: creating large-scale public art using buildings and their windows as a canvas. Her installation *Intra Muros* (2007), which visualized her own struggles with the creative process, was invited to debut at the 2007 Platform International Animation Festival in Portland and subsequently toured internationally. It featured multi-channel projection (several screens projecting simultaneously) onto the windows of the city's Maytag building. The eight-minute visuals, which were shown repeatedly in a loop, were accompanied by a lively soundtrack by the Canadian composer Judith Gruber-Stitzer.

Projections are often related to architecture, embodying various parts of a space, such as windows of a large building in the case of Bond's *Intra Muros* or the floors, ceilings, and walls of gallery spaces. Through the technique of "projection mapping," animated imagery can be displayed on the surface of any object or area. For many years, the American Ben Ridgway worked in the video-game industry (see p. 277), but since 1992 he has also been making abstract, experimental animations. His recent works can be shown in the context of a screening, but frequently they are presented as installations or projections. One of them,

Site-specific works are similar to installations and projections in that they are animated productions displayed in spaces other than a theater, television, or personal computer-type screen. As the name suggests, these works are created for—or mapped onto—a particular location, which may be outdoors and often involves large structures. Therefore, while an installation or projection can be moved from place to place, a site-specific projection-mapped animation appears in only one location.[5] In 2010, the British artist (residing in

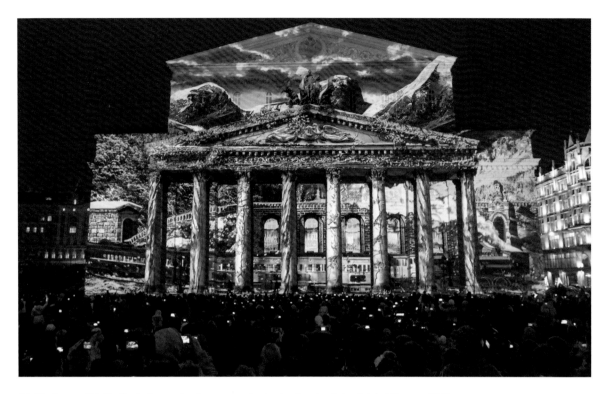

24.12 Cosmo AV, *Fire Evolution*, projection-mapped onto the facade of the Bolshoi Theater, 2013

Finland) Charles Sandison (1969–) created such a work, *FreePort [No. 001]*, for the Peabody Essex Museum in Salem, Massachusetts. Incorporating extracts from eighteenth-century ship captains' logs into the design, he created an immersive environment in the museum's interior, reflecting the trade routes, politics, and specific voices that led to the museum's establishment. For the 600th birthday of the Astronomical Clock Tower in Prague, also in 2010, a group of Czech artists known as the Macula created a ten-minute animated light-and-sound show that included celestial bodies, historical imagery, and a wide range of effects.

Projection-mapped animation is now a relatively common element of large-scale events. For the International Circle of Light Festival, held in Moscow in 2013, *Fire Evolution* was projection-mapped onto the Bolshoi Theater **(24.12)**, depicting fluid changes in the facade of the building and the nearby water displays, as well as such dramatic animated figures as a horse-drawn chariot rushing toward the viewers, and angels floating through the scenes. The production was created by a French studio, Cosmo AV, which was established in 2003 by Jose Cristiani and Pierre-Yves Toulot. Another example, which appeared in New York City, is *As Above, So Below—Manhattan Bridge*, produced by Harvest Light, a NYC studio established

in 2004. A team of artists, led by the Hungarian Farkas Fülöp and American Ryan Uzilevsky, designed the projection-mapped animation for the bridge area, which incorporated a wide range of techniques, written words, and live performers as part of the display. Music by Daft Punk accompanied the show.

Animation and Performance

Links between animation and performance extend back to the beginning of the twentieth century, in the showmanship of animated lightning-sketch routines by John Stuart Blackton and others (see p. 32). In more recent years, innovative animators have continued to engage with their own creations on stage, performing alongside them. Kathy Rose is among the early practitioners of this kind of performance animation. In the 1970s, she began with drawn animated films, such as *Pencil Booklings* (1978), which depicted the artist in conversation with her somewhat rebellious animated creations, using rotoscoping to capture images of herself. In the 1980s, she shifted toward performance work, combining dance with film. *The Cathedral of Emptiness*, which she first performed

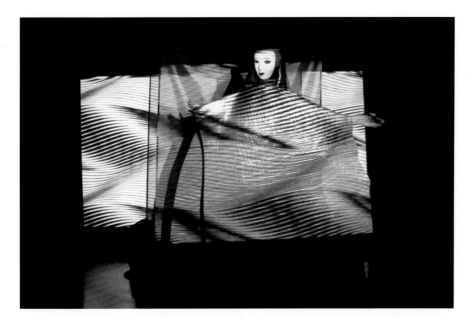

24.13 Kathy Rose, *Opera of the Interior*, performance in 2015

body transforms amidst projections that create dreamlike spaces. It was first performed at the Platform International Animation Festival in 2007.

Inspired by TED talks and mega-church media design, the American performance group Early Morning Opera created *ABACUS*, featuring kaleidoscopic data visualizations and dancing Steadicam operators who appear to record the event but also perform within it. For the show, the group's director, Lars Jan, developed an alter-ego, Paul Abacus, who passionately leads the audience through a barrage

in 2009, was strongly influenced by Japanese culture: by the filmmakers Yoji Kuri, Kihachiro Kawamoto, and Akira Kurasawa, for example, as well as *butoh* dance, and both noh and bunraku theater (see Box: Japanese Theatrical Traditions, p. 194). Rose also creates installations she calls "Living Tapestries" by combining fabrics with video projections (24.13).

The proliferation of digital technology has aided emerging animators in creating innovative performance-related works. Miwa Matreyek, Chi-wang Yang, and Anna Oxygen perform as part of a collective, Cloud Eye Control, which was formed in 2007. Their productions include fantastic scenarios that are front- and rear-screen projected onto screens and props, while performers in costume appear on stage or sometimes behind the screen in silhouette (24.14). One of their shows, *Subterranean Heart*, is described as a hyper-opera, combining experimental animation, music, and live performance. The story takes place in an underground mining facility, where scientists discover a powerful crystal in the body of a fallen worker. While she undergoes a kind of surgery, her physical

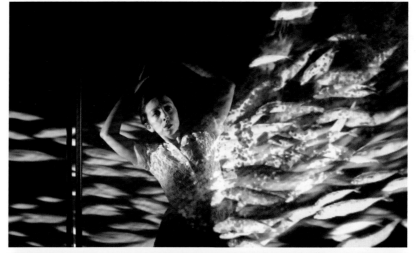

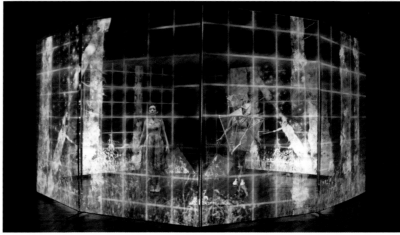

24.14 Cloud Eye Control, *Half Life*, performance in 2015

24.15 Bill T. Jones, Paul Kaiser, and Shelley Eshkar, *Ghostcatching*, 1999

of animated facts and figures projected behind him, in a commentary on methods of persuasion. Originally, the show was performed in 2010 using six screens in the Curtis R. Priem Experimental Media and Performing Arts Center concert hall in Troy, New York, but it has been adapted to a single-screen version for smaller venues.

Motion-capture technology has enabled new ways of blending performance and animation. Though it is widely used for big-budget effects and electronic games, artists have embraced its possibilities as well, especially as the tools have become more versatile and less expensive. As early as 1999, the American artistic director, dancer, and choreographer Bill T. Jones used motion capture to record his own dance movements, so they could be animated and later blended with his performance as

abstract images. The resulting short film, *Ghostcatching*, explores the concepts of capture and freedom, bringing together dance, drawing, and computer-generated imagery **(24.15)**. Paul Kaiser and Shelley Eshkar designed the visual and sound composition, while Jones created and performed the dance and vocal phrases heard in the piece.

Rachel Ho used motion capture and took advantage of real-time processing in creating her live performance *SLEIGHTING* in 2014 **(24.16)**. She describes the experience as combining VJ-ing (speaking over video images) and physical showmanship to create a movie experience that is unique every time. Working with Julian Petschek, Daniel Jackson, and John Brennan, she performed in a number of scenarios, from a boxing match to a woman dancing in her room. The projected figures of animated men and women, which were designed using the Autodesk character generator, were controlled by Ho's live performance. For the show, she donned a motion-capture suit illuminated by red balls, and paced the room, responding to the audience

24.16 Rachel Ho, *SLEIGHTING*, 2014

24.17 Pierre Hébert, *The Human Plant*, 1996

a mixture of original and new members, including Larry Janss, David Lebrun, Peter Mays, Jeffrey Perkins, Michael Scroggins, Amy Halpern, Shayne Hood, and Mike Pfau.

The Canadian animator Pierre Hébert (1944–) and the Hungarian Ferenc Cakó (1950–) both specialize in

with actions that could then be seen on the screen. The projected animated scenes were accompanied verbally, by Petschek as the VJ, interacting with the crowd.

Motion capture allows a performer to control animated movement, but the New York-based artist Daniel Rozin's interactive productions respond to the presence of their viewer, creating a visual representation of the individual's likeness that changes in real time. His installation *PomPom Mirror* of 2015 is a high-tech automaton (see p. 19) that incorporates 928 beige and black faux-fur pompoms, 464 motors, control electronics, an Xbox Kinect motion sensor, a Mac mini computer, custom software, and a wooden frame. Organized into a three-dimensional grid, the sculpture engages its motors to build silhouettes of viewers, using computer vision to shift the balls into matching silhouettes, as the viewer moves. The hum of the motors creates the impression that the device is alive.

Another performance practice involves the real-time development of animated visuals by an artist in front of an audience, often in the context of a concert performance. In other words, the act of animating is at the center of the show, as an equivalent to conducting live music. One example is Single Wing Turquoise Bird, which became a popular producer of light shows in the Los Angeles area during the late 1960s and early 1970s. The collective, formed of eight artists, uses film, slides, and liquid projections to blend music, painting, and moving images in its performances. Originally, the group created light shows for weekly rock concerts at the Shrine Exposition Hall in Los Angeles, for such bands as the Velvet Underground, Pink Floyd, and the Who. In 2009, Single Wing Turquoise Bird re-formed with

24.18 Ferenc Cakó, *From the Egg*, 1987

this kind of performance animation, but use different signature approaches. Since 1962, Hébert's practice has encompassed filmmaking, performance, visual art, and publications. Working at the National Film Board of Canada (see p. 177), he used early computer technology to create his abstract film *Around Perception* (1968), which employs visual and sound compositions meant to test the boundaries of human perception. Hébert is best known for using the direct filmmaking technique of engraving images onto 16mm or 35mm processed black film. He employed this process when he began to give live performances in the mid-1980s, scratching onto a film loop while it moved through a projector and building up images again and again as the film passed by him. Some of the improvised images Hébert developed at live shows inspired him to create a feature-length film, *La Plante Humaine* (*The Human Plant*, 1996), produced at the National Film Board of Canada, with music by Robert M. Lepage (24.17).

Between 1973 and 1991, Ferenc Cakó worked as an animator, designer, and director at the Pannonia Film Studio (see p. 311), in its puppet studio, which was founded and led by Foky Ottó. Cakó began to work with sand in the late 1980s, releasing *Ab Ovo* (*From the Egg*) in 1987 (24.18). This film reveals extraordinary mastery of the medium, with detailed images of humans and animals, both still and in motion, demonstrating the struggles inherent in life. In 1996, Cakó began to create live shows using sand, accompanied by music and projected on a large scale in the performance venue.

The Art of Video Games

Electronic games, too, have made inroads into the wider world of art. By the 1980s, museums were already curating exhibitions on the subject: for example, "ARTcade" at the Corcoran Gallery of Art (Washington, D.C.) in 1983 and "Hot Circuits: A Video Arcade" at the Museum of the Moving Image (New York City) in 1989. The Corcoran show included *Moondust* (24.19), an interactive, generative music game of 1983 that is considered to be among the first "art games"; it is relatively experimental in nature. In *Moondust*, a player aspires to protect a target in the center of the screen by covering it with "moon juice," which creates a graphical display that governs the sound accompaniment. The

game was created for the Commodore 64 (an early home computer) by Jaron Lanier, well known as a digital visionary who promoted virtual reality during the 1980s. Museum exhibitions continued through the years, including the Barbican Centre's (London) "Game On," which began touring internationally in 2002, and "The Art of Video Games" at the Smithsonian American Art Museum (Washington, D.C.) in 2012.

By the early 2000s, the practice of creating art games had grown and diversified, for example integrating live performance, moving games into public spaces, and engaging with current affairs and political topics. The American Ricardo Miranda Zúñiga (1971–) is among the artists who have embraced electronic games as a social practice, engaging a broad public in order to investigate such topics as immigration, discrimination, gentrification, and the effects of globalization. His game of 2002, *Vagamundo*, featuring audio by John Arroyo, was made in New York City—

24.19 Jaron Lanier, *Moondust*, 1983

at Harvestworks Media Center—and focuses on the plight of the city's undocumented immigrant laborers. *Vagamundo* appeared both online and as public art in the form of a mobile cart, similar to that of an ice-cream vendor, that was taken from street to street, allowing the public to play (24.20). In 2003, the Uruguayan game designer and researcher Gonzalo Frasca released *September 12th: A Toy World*. This "newsgame," so-called because it was based on recent events and is

housed on Newsgaming.com, comments on the futility of the war on terrorism that followed the attacks on the World Trade Center, New York City in 2001.

Genetic engineering was the topic explored by Natalie Bookchin in her virtual-pet game *MetaPet 1.0*. It challenges the user to manage a genetically engineered worker of the future, balancing a firm hand and a gentle coax while always remembering the "bottom line" of profits. It was launched at the Museum of

24.20 Ricardo Miranda Zúñiga, *Vagamundo*, 2002

Contemporary Art in Los Angeles in 2003 and later appeared online. Bookchin has worked on a range of online projects since 1997, including a collaboration with the political theorist Jackie Stevens on the website called agoraXchange. org. The site, which went online on in 2004, was commissioned by the Tate Gallery in the UK in an effort to imagine and build a massive multiplayer online game (see p. 290) that would be based on an entirely new world order, without violence or inequality.

A different kind of world order, or disorder, results as popular culture, fine art, and politics are combined in "The Long March: Restart" (2008), a large-scale installation game created by the Chinese artist Feng Mengbo that pits a Red Army soldier against a variety of enemies; a wireless controller allows the player to move the character through scenes illustrated with Communist propaganda and imagery from such classic video games as *Street Fighter II* and *Super Mario Bros.* (see p. 283). The game is based on Feng's series of paintings "Long March: Game Over," which resemble video-game screens. Feng's work is now part of the permanent collection at MoMA in New York City.

Conclusion

The world of animation is large and diverse, and as this book has shown, many factors have determined the forms of its production, the individuals enabled to produce it, and the content it includes. From optical toys of centuries past to the latest in virtual reality; from online Google Doodles and cycling short GIF animations to complex animation maps projected over enormous buildings; from television, to feature films, to games, on stage, and on the Web, animation surrounds us and is available in every form imaginable, international in scope. It has developed out of a complex history, and there are now many platforms supporting the growth of animation: as an industry, as entertainment, as a mode of communication, and, importantly, as an art form.

Notes

1 "Chen Shaoxiong," at Pékin Fine Arts. Online at http://www.pekinfinearts.com/artists/artists.php?id=10&menunum=1&subnum=8&item=1

2 Wexner Center for the Arts, Ohio, *Studio Visit with Filmmaker Lewis Klahr.* Online at https://vimeo.com/10551713

3 Lewis Klahr, *Message from the Director of* The Pettifogger: *Lewis Klahr.* Online at http://www.youtube.com/watch?v=S5wf3ZcGxDQ

4 Martha Colburn, "Martha Colburn Cuts the Boring Parts Out," New York Close Up | Art21. Online at https://vimeo.com/29484730

5 Dan Torre, "The Metamorphosis of Place: Projection-Mapped Animation," in Chris Pallant, ed., *Animated Landscapes: History, Form, and Function* (New York: Bloomsbury, 2015), 265–85.

Key Terms

collage
direct film
feature
found footage
franchise
installation
motion capture
motion graphic
zoetrope

Glossary

2D animation
Animation employing a series of drawn, painted, or digitally produced images that may incorporate the principles of perspective but that are essentially flat.

3D animation
Animated figures that have or depict volume. Once used to describe stop-motion puppet animation, the term now generally refers to computer-generated figures that give the illusion of depth.

absolute film
Term used to describe abstract animation, because it is a pure product of the film medium, with no parallel in nature.

Abstract Expressionism
A mid-twentieth-century movement in painting in the US, characterized by its use of gestural imagery and stream-of-consciousness styles of production.

aesthetic
Concerned with the appreciation of beauty, or the principles underlying the work of an artist or artistic movement.

animation
Practices by which the illusion of motion is created through the incremental movement of forms, displayed sequentially as a "motion picture."

animatronics
Constructed figures that are wired to move as they might in real life.

anime
A style of Japanese animation in popular culture.

anthropomorphism
The attribution of human characteristics to animals or other figures.

armature
The internal skeleton, generally made of metal, underlying a stop-motion figure to give it support and facilitate bending.

Art Deco
Fashionable art style of the 1920s and 1930s, characterized by streamlined geometric shapes and a sleek, high-quality aesthetic.

automaton (pl. automata)
Machine(s) designed to carry out an automated sequence of actions, generally in the form of humans or animals.

avant-garde
Individuals who explore new, experimental concepts, especially in the arts, to push culture forward.

avatar
The on-screen character in a video game that represents the player.

batik process
A design technique in which fabric is decorated, using wax to cover portions of the cloth, so that dye colors the exposed areas only.

benshi
Performers who provided voice acting for Japanese cinema from the late 1890s into the 1930s.

Big Five
The five most powerful studios in Hollywood during its golden age in the 1930s and 1940s: Loew's Incorporated/MGM, Paramount Pictures, Warner Bros., Fox Film Corporation, and RKO Radio Pictures.

block-booking
An American film distribution method that required exhibitors to purchase an entire year of productions rather than individual films; eventually ruled to be an unfair business practice.

branching narrative
A story within a video game that has a variety of alternative outcomes.

bumper
A short segment that marks the transition between a children's television program and a commercial break.

CAPS
Abbreviation of "Computer Animation Production System," developed by Disney and Pixar as a way to digitize the ink-and-paint process, among other capabilities.

caricature
A drawing of something in which its striking characteristics are exaggerated to comic or grotesque effect.

cartridge
A container for the software of an electronic game; it is inserted into a game console or home computer.

cel setup
Painted cels combined with their background, constituting a complete image for one frame of an animated production.

cel washer
A studio worker responsible for removing the ink and paint from cels so that they can be reused.

cel
Clear (or frosted) celluloid drawing sheet.

CGI (computer-generated imagery)
A general description of animation created using computers, most commonly applied to 3D productions.

choreutoscope
Magic-lantern device for holding six images that, when projected in rapid succession, simulate simple animated movement.

chromatrope
Two colorful, overlapping, circular glass plates lit with a magic-lantern projection lamp and spun in opposite directions to create visual effects.

CinemaScope
A widescreen production process popularized in the 1950s; it created images that were almost twice as wide as a standard film image.

cinematic
Qualities in film production, including creative lighting, framing, staging, and camera angles and movement, that reflect an aesthetic of cinema.

cinématographe
A camera, printer, and projector designed by the brothers Auguste and Louis Lumière and first demonstrated in Paris in 1895.

cinematography
The art and practice of motion-picture photography.

city symphony
A poetic film comprising the sights and sounds of an urban area; this genre first appeared in the 1920s.

Classical
Art that conforms to Greek and Roman models, or is based on rational construction and emotional equilibrium.

collage
An assemblage created by gluing materials, often paper but also mixed media, onto a surface. From the French coller, meaning "to glue."

collective unconscious
A theory of psychology developed by Carl Jung (1875–1961); it suggests there are shared elements of the human mind that connect all people to the earliest years of humanity.

comix
A name used by underground comic publishers to distinguish their products from mainstream comic books, beginning in the 1960s.

Constructivism
An art movement originating in the Soviet Union in the 1920s, concerned with making art of use to the working class.

contrapuntal
A theory of counterpoint, in which one element is contrasted with another to create complex meanings.

counterpoint
The combination of two melodies in a musical composition; related ideas have influenced theories of film editing and sound/image correlations.

Cubism
Modern art movement, beginning around 1907, that ushered in abstract imagery and broke with traditional forms of perspective.

cut scene
In a video game, a storyline that occurs between sections of game play; considered a reward for reaching a given point, but often seen as a distraction.

cutout
A 2D object, created from paper or another flat material, used as a stop-motion puppet.

cycle
Animated movement that occurs in a continuous loop.

Dada
An anarchic anti-art and anti-war movement of the mid-1910s that was characterized by absurdity.

depth of field
In film and photography, the amount of space in focus at any given time; a small depth of field results in some planes of action (foreground, middle ground, and background) being blurred, while the opposite—deep focus—results in everything being sharply defined.

Der Blaue Reiter
Expressionist painters working from 1911 to 1914, led by Wassily Kandinsky and Franz Marc, who aimed to express spirituality in their art.

direct filmmaking
The creation of images directly on filmstrips, without the use of a camera, by drawing, painting, or scratching.

direct sound
Images drawn or photographed in the optical-sound area of a filmstrip and then interpreted as sound by the projector.

direct-to-video film (DTV)
A movie that is released on video without first being shown in theaters.

dissonance
A clash resulting from the combination of two incompatible elements.

distributor
An organization that facilitates the rental or sale of a product.

docudrama
A dramatization based on real events.

double exposure
Repeated exposure of a film strip to different images, so that these images appear layered on top of each other.

drawn animation
Animation in which each image is created using pencils or similar dry media.

emergent game play
The sequence of events is determined by the player and his or her exploratory path, rather than being pre-set by the game designer.

exposure sheet
A sheet of instructions on paper that are given to a camera operator, so that he or she knows how to photograph the artwork for an animated film.

Expressionism
A German artistic style that peaked in the 1920s, portraying images with vivid distortions, intended to provoke an emotional response.

feature
A long-format film, generally running forty minutes or more.

feelies
Peripheral devices distributed with certain games to heighten the player's immersive experience.

festival film
A film (generally up to ten minutes in length) made to be exhibited at competitive screenings, in order to win prizes and create publicity for the director or studio that produced it.

film noir
A crime genre that emerged in the 1940s, employing highly stylized visual design elements to reflect on the complicated nature of morality.

film stock
Photographic material used to make motion pictures.

flexible film base
A key development in early motion picture technology that allowed strips of photographic film to move through camera mechanisms.

flipbook
A series of images assembled in book form, so that pages viewed in succession produce the illusion of motion.

floppy disk
A flexible and removable magnetic disk used with early computers to store data.

found footage
Film images that are repurposed for use in another context.

frame
One image of a sequence on a strip of motion picture film.

framing story
A narrative technique in which a series of events provides the context for a second series of events.

franchising
A merchandizing strategy in which a successful property is used to create related works that capitalize on the successful characters and concepts of the original.

full animation
An approach to drawn animated movement that incorporates constant motion and a high number of images per second.

Futurism
An early twentieth-century art movement, originating in Italy, concerned with depictions of modern life, including speed, energy, and violence.

game engine
The particular software used to create a specific game; sometimes used by fans to create videos employing the game's assets.

genre
A particular category of art, literature, or film, identified by the use of shared elements.

gestural
Elements that are expressive though a kind of natural language, suggesting forms in nature; for example, gestural painting translates emotion through an artist's application of paint in sweeping moves.

graphical
A visual display, as opposed to text-based information.

grayscale
A series of tones ranging from black to white through intermediate shades of gray.

hand of the artist
Animation introduced by an image of an animator's hand, which appears to bring a drawing to life, suggesting a magical transformation.

hand-coloring
Adding color to black and white film stock through the application of paints or dyes, using a brush or other small-scale process.

happening
An impromptu art performance, generally incorporating audience participation.

hierarchical programming
The method used to create naturalistic movement in digital animation, in which one action sets another in motion.

hold
A technique in which a character strikes a pose and does not move. In a moving hold (a form of cycle), the character stays in a pose but moves slightly on the spot.

iconography
Symbolic images that classify a given entity.

Impressionism
A late nineteenth-century painting style that emerged from Paris and influenced the development of modern art; it challenged the aesthetics of traditional painting through sketchy images that focused on the quality of light and depicted varied scenes, often of everyday life.

in-betweener
An artist in an animation studio who creates drawings that fill in the gaps between the key poses of a character.

incubator series
A television production concept that allows animators to develop short films in order to test ideas and audience reactions.

industrials
Training or promotional films produced for businesses and the government.

ink and paint
An animation studio department in which images are traced from paper onto the front of a clear acetate cel using ink, and colored on the back using paint.

installation
Art objects set up in a particular space, allowing viewers to walk around them.

intercut
In a film, a shift from one area of action to another.

interpolation
In-betweening done automatically by a computer to create animation between key frames.

interstitial
A short film shown between a television series segment and an advertisement.

intertextual
Within a narrative or other form of expression, a reference to an outside source that gives depth to the experience (if the audience understands the reference).

intertitles
Cards printed with words and inserted between motion-picture images to impart narrative details; typically used with silent-era films.

iris shot
A technique, often found in silent film, in which a scene begins or ends with a black circle opening or closing to reveal or obscure a scene or particular image within it.

kinescope
A film documentation of a television broadcast, created during the era of live television.

key frame
A drawing that defines the beginning or the end of a certain animated movement.

kinetic
Relating to movement.

laserdisc player
A late twentieth-century motion-picture distribution format that uses large disks; it was replaced by DVD technology.

lightning sketch
A type of performance, originating from variety theater, in which an artist at a drawing board quickly transforms images with a few strokes.

limited animation
A form of animation that employs relatively few in-between drawings, resulting in stylized movement. Emphasis is on camera movement, holds (still art), and voice-over narration.

linear
Progressing from one point in time to the next, in sequence, usually propelled by a cause-and-effect narrative.

Little Three
Three relatively powerful studios in Hollywood during its golden age in the 1930s and 1940s: Universal Pictures, Columbia Pictures, and United Artists. Small in scale compared to the Big Five.

live action
A type of motion-picture production that employs living actors who engage in real-time performance, as opposed to the frame-by-frame production of animated media.

machinima
The use of game engines to create new works.

magic lantern
An early form of slide projector; popular in the seventeenth century, it is used with painted or photographic glass slides.

mainframe computer
Large, costly computers used for bulk processing of data.

manga
Japanese print comics.

maquette
A sculpted object used by animators to visualize how a character looks as it rotates in space.

matte
Used during optical printing to combine areas of two different negatives into one projection print; it is typically a black plate that blocks off areas within the frame of a negative, so they will not be printed. Also the name given to a type of background painting.

medium (pl. media)
The material or form used in communication—for example, clay or pencils used to create images, or distribution formats, such as television or theatrical movies.

melodrama
Type of dramatic narrative characterized by a great range of exaggerated emotional highs and lows.

midcentury modern
A design style that emerged in the middle of the twentieth century, emphasizing clean lines, functional design, geometric forms, and bold, deep colors.

miniature
A small-scale version of an object used in stop-motion production.

minstrel show
A stage performance involving singing, dancing, and jokes, performed by white (and sometimes black) actors in blackface, which emerged in the nineteenth century.

model sheet
A sheet of paper containing reference drawings of a character in various poses.

Modernism
Modern artistic or literary philosophy and practice; a self-conscious break with the past and a search for new forms of expression that developed out of changes in late nineteenth century and early twentieth-century Western society.

montage
An editing technique in which a series of images is combined into a sequence, generally with the aim of creating meaning through juxtaposition.

morphing
Shifting from one form to another; a short way of saying "metamorphosis."

motion blur
A phenomenon of live-action film in which moving objects naturally blur when captured on film, because they are moving faster than the camera's shutter can capture; in animation, this effect is simulated through various methods that make the object appear to blur as it moves.

motion capture
A technique in which the actions of live performers are captured digitally and used as the basis for computer-animated figures.

motion graphic
An animated sequence of moving imagery, generally composed of text and geometric forms, as one might find in a company logo, for example.

motion study
Analysis of the movement of living beings carried out in sequential photographic studies, beginning in the mid-nineteenth century.

motion-control system
A photographic system for stop-motion, in which a camera is mounted on a rig and programmed to record a series of images automatically, moving through a set in the desired way.

multiplane
A frame that houses artwork on planes of glass, with a camera above it.

narrative
The connected events that form a story.

negative space
The space around an image that helps define it.

nickelodeon
Early twentieth-century makeshift theaters set up in storefronts to show films, usually charging five cents, or a nickel, for admission.

open world
A computer game genre in which characters are free to roam around from place to place.

optical printer
Equipment that allows the reproduction of film images onto another piece of film.

optics
The scientific study of sight and the characteristics of light.

original video animation (OVA)
An animated film created to be released on video rather than in theaters.

oscilloscope
An electronic laboratory device that measures electrical signals and creates waveform graphics.

package film
A long format film comprising multiple animated shorts.

paint on film
The process of applying paint directly onto a celluloid filmstrip, using a brush and an acetate-adhering paint.

paint on glass
A technique whereby slow-drying oil paint is manipulated on one or more sheets of glass.

parallax
When the right eye and the left eye are given two different sets of images to create an artificial impression of depth, as in stereoscopy.

parallel action
Two activities occurring in separate spaces at the same time.

parody
An exaggerated retelling of a well-known story for humorous effect.

patent
A government-issued license assuring ownership of a given process for a set period, excluding others from employing the process without permission of the rights holder.

peg-bar registration system (or "peg-and-perf")
An alignment system for paper and cels, in which they are punched to match pegs that hold them in place during drawing or photography.

pencil test
A process in which animation drawings are produced quickly in sketch form to test the fluidity of their movement.

peripheral device
In a computer game, any item that is external to the actual game, such as controllers used to relay a player's movements.

personality animation
The use of movement, voice, and character design to develop substantial, unique, thinking characters.

perspective
A way of representing three-dimensional objects on a two-dimensional surface that conveys an accurate sense of their height, width, depth, and position in relation to each other.

phantasmagoria
A popular form of magic-lantern performance involving frightening images.

phenakistoscope
A circular device with a series of images placed around its edges, separated by slits. The viewer stands in front of a mirror, looking through the slits at the reflected images; when the disk is spun, they appear to create a continuous loop of motion.

phonograph
A machine that reproduced recorded sound.

pinscreen
A frame housing a white board punctured by pins, which are pushed in and out to catch light at an angle, producing shadows that form images.

pixilation
A stop-motion technique in which animate objects, such as people, are photographed in a series of incremental movements.

pixilated
When a digital image is so enlarged that it becomes "blocky," revealing the individual pixels that structure it.

plasticine
A soft, clay-like medium that remains pliable for long periods.

platform game
A computer game in which a character achieves its goal by moving upward through a number of visual levels.

point-of-view shot
A framing angle that shows the viewer what a certain character can see

post-production
Following pre-production planning and the production stage of recording sound and image, this period involves editing and final adjustments before the release of a film.

praxinoscope
A series of images printed on a strip of paper and placed inside a spinning drum. The viewer sees a continuous loop of motion reflected by a mirror in the center of the drum.

pre-production
The planning stages in making a film, before

any action is recorded; may include writing, storyboarding, costume design, budgeting, and scheduling.

procedural animation
Animated movement that occurs in real time according to a set of programmed rules, rather than being limited by predetermined key frames.

progressive game play
A style of game play in which events proceed in a predefined, linear way from start to finish.

propaganda
Information intended to sway the opinion of the recipient.

psychedelia
Music or visual art based on the hallucinatory experiences produced by psychedelic drugs.

rear-screen projection
Live-action footage that is placed behind the subject in a film, creating a background.

Regionalism
An art movement of the 1920s to 1950s that favors Realism and familiar, local scenes of American people.

replacement
A stop-motion technique in which parts of a puppet or figure are changed for different versions (e.g. heads showing a variety of expressions).

reversed footage
Images that are projected in the order opposite to how they were captured, for example from end to start.

rotoscope process
Method of creating animation by drawing over live-action footage that is projected onto paper frame by frame, then filming those drawn images.

rubber-hose style
An animation style featuring loose, flexible body movements not based on anatomical reality but rather representing a kind of physical comedy.

satire
An exaggerated retelling of a well-known story or scenario with a political intention, generally to belittle the subject.

score
The music that accompanies a movie.

scratch film
The process of scratching images directly into a celluloid filmstrip.

set
The elements creating the backdrop of a stop-motion film; the area in which the action takes place.

setback
Also referred to as the stereoptical process. Patented by the Fleischer studio, it is a curved background of miniature objects placed behind an upright cel to give the impression of three-dimensional space.

shot
A film sequence recorded continuously by one camera, from start to stop.

silent era
The period from the birth of cinema in 1895 to about 1928, when sound-on-film technology began to spread internationally.

silhouette
A figure represented in outline, often in solid black on a light background, or lit from behind.

single-plate chronophotography
Photographic motion-study technique that captures a figure's entire sequence of movements in superimposed images on a single photographic plate.

slapstick
A type of physical comedy based on pratfalls and other actions with the body, often exaggerated and seemingly painful or dangerous; popular during the silent era of film.

slash-and-tear system
A system of animation in which a top layer of paper is torn away to reveal an image on the lower level; using this method, backgrounds do not have to be redrawn.

smear technique
Drawing blur lines onto the action of animated images, a convention for making animated images appear to move quickly.

Socialist Realism
The official Soviet art style mandated from the early 1930s through the mid-1980s, it glorified communism and the lives of the proletariat workers.

special effects
Illusions created either on set or after production has taken place, resulting in visual highlights or settings that do not exist in real life or would be difficult to capture in normal production.

splicing tape
Adhesive tape that holds pieces of film together in sequence, used in the editing process before the advent of digital technology.

sprites
The moving 2D characters and objects in a computer game.

squash and stretch
A type of animated movement in which exaggerated motion is created by elongating a figure outward and then upward in continuous repetition, for example a walk cycle.

state's rights distribution
An American method of distributing films, in which an agent sells them from territory to territory, across the country.

stereoptical process
See setback.

stereoscopy
A process that gives an impression of three-dimensionality by manipulating perspective in visual images. See parallax.

stereotype
A way of categorizing an individual or group based on a simplified view, generally derogatory.

still
A single image, or frame, taken from a motion picture.

stop-motion
Animation involving a puppet or object that is modified in form or position over time.

stopped-camera substitution
An effect that involves making an object appear, disappear, or move within a live-action context, created by stopping the camera and adjusting the object before continuing to film.

subtext
An implied or metaphorical meaning.

Surrealism
An artistic movement of the 1920s and later, the art of which is inspired by dreams and the subconscious.

synchronized sound/dialogue
A sound-on-film process, matching dialogue or sound effects to an image on screen.

syndicated programming
A package of episodes from a television series sold to a distributor as a whole.

synesthesia
A condition in certain individuals whereby the stimulation of one sense (e.g. sound) causes a sensation in another (e.g. sight, taste).

synthetic sound
Sound that has been drawn or photographed into a film. See also direct sound.

telerecording
A British term for film documentation of early television broadcasts that were presented live. See also kinescope.

thaumatrope
A disk with pictures on both sides, spun to create an effect of the two images merging into one.

theatrical short
Short films made to be released in theaters, rather than shown on television.

tie-down
A wire or bolt that secures a puppet or stop-motion figure to the base, or floor, on which it stands.

time-lapse
A sequence of frames shot at set intervals to record changes that have taken place slowly over time, played back at a sped-up rate.

under-cranking
A technique of the early silent cinema era, recording images at a slowed frame-per-second rate to add extra speed to the action when played back at a normal rate.

visual music
 The practice of creating a visual equivalent to music, often using abstract forms in painting or animation.

woodcut
 A print created using a carved block of wood.

z-axis
 A mathematical term used in graphing to describe movement forward and backward; the x-axis is left and right, and the y-axis is up and down.

zoetrope
 A series of images printed on a strip of paper and placed inside a spinning drum. Through slits in the edge of the drum, the viewer sees a continuous loop of motion.

zoom
 When recording images, a smooth shift from a distant to a close-up view, or vice versa.

zoopraxiscope
 A combination of magic lantern and phenakistoscope that enables the projection of images painted on a circular disk; invented by Eadweard Muybridge in the late nineteenth century to animate images from his motion studies.

Illustration Credits

p. 2 José Antonio Sistiaga, *Ere erera baleibu izik subua aruaren*, 1970. Courtesy José Antonio Sistiaga and Light Cone

p. 8 Anima Mundi festival poster, Rio de Janeiro, Brazil, 1999. © Anima Mundi Festival Archives

p. 10 (left) A kinetoscope arcade in San Francisco, CA, *c.* 1899

p. 10 (right) Otto Messmer, *Woos Whoopee*, 1928. Pat Sullivan Cartoons

p. 11 Walter Lantz, *Peter Pan Handled*, 1925. Ronald Grant Archive

1.1 Lascaux caves, southwest France, *c.* 15,000 BCE. Philippe Wojazer/Reuters

1.2 Engraving showing a magic-lantern show, 1889. Chronicle/Alamy

1.3 Victorian magic-lantern slide. C. & M. History Pictures/Alamy

1.4 Chromatrope, *c.* 1850. Science & Society Picture Library/Getty Images

1.5 Choreutoscope, replica of an original from 1866. Science & Society Picture Library/Getty Images

1.6 Étienne Gaspard Robertson, *Mémoires Récréatifs Scientifiques et Anecdotiques*, 1831

1.7 Thaumatropes with their original box, 1826. Science & Society Picture Library/Getty Images

1.8 Phenakistoscope, *c.* 1832. Mary Evans Picture Library/Alamy

1.9 Zoetrope, *c.* 1834. Bill Douglas Centre for the History of Film and Popular Culture, University of Exeter

1.10 Smoking monkey automaton, early twentieth century. Courtesy Lacy Scott & Knight

1.11 Richard Outcault, "The Yellow Kid Loses Some of His Yellow," *New York World*, 1897

1.12 Kate Carew, cartoon from *New York World*, 1903. Chronicling America: Historic American Newspapers. Library of Congress, Washington, D. C.

1.13 Étienne-Jules Marey, chronophotograph depicting a pole vault, 1887. Apic/Getty Images

1.14 Eadweard Muybridge, motion study of a horse running, 1878. Library of Congress, Washington, D. C., LC-DIG-ppmsca-06607

1.15 Thomas Eakins, *A May Morning in the Park* (*The Fairman Rogers Four-in-Hand*), 1879–80. Gift of William Alexander Dick, 1930, Philadelphia Museum of Art

1.16 Étienne-Jules Marey, chronophotograph depicting a flying pelican, 1882

1.17 Étienne-Jules Marey, "photographic gun," 1882

1.18 Louis Poyet, engraving from *La Nature*, July 23, 1892. Corbis

2.1 A kinetoscope arcade in San Francisco, CA, *c.* 1899

2.2 W. K. L. Dickson, *Sandow*, (*Eugen Sandow, the Modern Hercules*), 1894

2.3 Poster for the "Hurly-Burly Extravaganza and Refined Vaudeville" show, *c.* 1899. Library of Congress, Washington, D. C., LC-USZC2-1387

2.4 Electric Theater, *c.* 1905. Corbis

2.5 Cinématographe, *c.* 1895. Science & Society Picture Library/Getty Images

2.6 Thomas Edison's studio, the "Black Maria," 1892–1901. John Springer Collection/Corbis

2.7 Arthur Melbourne-Cooper, *Matches Appeal*, *c.* 1899–1915. Courtesy Tjitte de Vries and Ati Mul

2.8 Arthur Melbourne-Cooper, *A Dream of Toyland*, 1907. Courtesy Tjitte de Vries and Ati Mul

2.9 Edwin S. Porter, *Fun in a Bakery Shop*, 1902

2.10, 2.11 John Stuart Blackton, *Humorous Phases of Funny Faces*, 1906

2.12 Georges Méliès, *A Trip to the Moon*, 1902. The Kobal Collection

2.13 W. R. Booth, *Artistic Creation*, 1901

2.14 W. R. Booth, *The ? Motorist*, 1906

2.15 Segundo de Chomón, *The Electric Hotel*, 1908

3.1 Émile Cohl, *Fantasmagorie*, 1908

3.2 Winsor McCay, "Little Nemo in Slumberland," *New York Herald*, 6 May, 1906

3.3 Winsor McCay, *Little Nemo*, 1911

3.4 Winsor McCay, *How a Mosquito Operates*, 1912

3.5 Winsor McCay, *Gertie the Dinosaur*, 1914

3.6 *His New Profession*, 1914. Moviestore Collection Ltd/Alamy

3.7 Strand Theater, New York City, 1914

3.8 Pat Sullivan Cartoons, *Felix the Cat*, 1919. Ronald Grant Archive

3.9 John Randolph Bray, *Colonel Heeza Liar at the Bat*, 1915

3.10 Earl Hurd, *Bobby Bumps' Fourth*, 1917

3.11 Max Fleischer, patent diagrams for the rotoscope process, 1915. The United States Patent and Trademark Office

3.12 Max Fleischer, *Koko the Clown*, "Out of the Inkwell" series, 1910s. Fleischer Studio/Ronald Grant Archive

3.13 George Herriman, *Krazy Kat and Ignatz Mouse at the Circus*, 1916

3.14 Quirino Cristiani, *The Apostle*, 1917. Ronald Grant Archive

3.15 Willis O'Brien, *The Dinosaur and the Missing Link*, 1917

4.1 Felix the Cat wooden jointed doll by Schoenhut, *c.* 1922–24. Showtime Auction Services

4.2 Otto Messmer, *Feline Follies*, 1919. Pat Sullivan Cartoons

4.3 Felix the Cat toy, made in England, *c.* 1925. The Bowes Museum, Barnard Castle, County Durham

4.4 Otto Messmer, *Woos Whoopee*, 1928. Pat Sullivan Cartoons

4.5a "Aesop's Film Fables" poster, 1930s. Ronald Grant Archive

4.5b Paul Terry, *Dinner Time*, 1928. Aesop's Fables Studio. Courtesy the Stathes Collection/Cartoons On Film

4.6 Thomas Edison, *Dickson Experimental Sound Film*, *c.* 1894

4.7 Max Fleischer, *The Tantalizing Fly*, 1919

4.8 Walt Disney, *Alice's Wonderland*, 1923

4.9 Walt Disney, *Trolley Troubles*, 1927. © Disney

4.10 Publicity image for Walter Lantz, *Peter Pan Handled*, 1925. Ronald Grant Archive

4.11 Edwin G. Lutz, *Animated Cartoons: How They Are Made, Their Origin and Development*, 1920

4.12 Tony Sarg and Herbert M. Dawley, *The First Circus*, 1921

4.13 Willis O'Brien, *The Ghost of Slumber Mountain*, 1918

4.14 Kinex, *The Witch's Cat*, from the "Snap the Gingerbread Man" series, *c.* 1927–30. Courtesy Jerry Beck

p. 68 (left) Oskar Fischinger, *Composition in Blue*, 1935. © Center for Visual Music

p. 68 (right) Burt Gillett, *Three Little Pigs*, 1933. Photofest/© 1933 Disney

p. 69 Fleischer studio, *Gulliver's Travels*, 1939. Ronald Grant Archive/© Paramount Pictures. All Rights Reserved

5.1 Original promotional poster for Walther Ruttmann, *Berlin: Symphony of a Great City*, 1927. akg-images

5.2 Édouard Manet, *Luncheon on the Grass*, 1863. Musée d'Orsay, Paris

5.3 Marcel Duchamp, *Nude Descending a Staircase, No. 2*, 1912. Philadelphia Museum of Art. © Succession Marcel Duchamp/ADAGP, Paris and DACS, London 2017

5.4 Pablo Picasso, *The Young Ladies of Avignon* or *The Brothel of Avignon*, 1907. The Museum of Modern Art, New York/Scala, Florence. © Succession Picasso/DACS, London 2017

5.5 Lotte Reiniger, *The Adventures of Prince Achmed*, 1926. AF archive/Alamy. Courtesy BFI National Archive and Primrose Film Productions Ltd

5.6 Lotte Reiniger and Carl Koch at work on a multiplane rig, *c.* 1925. Courtesy Stadtmuseum Tübingen

5.7 Charles-Germain de Saint-Aubin, drawing depicting the ocular harpsichord exhibited by Castel in 1730, 1740–*c.* 1757. Imaging Services Bodleian Library © The National Trust, Waddesdon Manor

5.8 Léopold Survage, preparatory print for *Colored Rhythm*, *c.* 1912. Centre Pompidou, MNAM-CCI, Dist. RMN-Grand Palais/Droits réservés. © ADAGP, Paris and DACS, London 2017

5.9 Helena Petrovna Blavatsky, 1889

5.10 Hans Richter, *Rhythm 21*, 1921. Centre Pompidou, MNAM-CCI, Dist. RMN-Grand Palais/Droits réservés. © Estate Hans Richter

5.11 Walther Ruttmann, *Lightplay: Opus I*, 1921

5.12 Oskar Fischinger, *Circles*, 1933–34. © Center for Visual Music

5.13 Oskar Fischinger, *Composition in Blue*, 1935. © Center for Visual Music
5.14 Alexander Shiryaev, animated dancer, 1900–6
5.15 Władysław Starewicz, *The Cameraman's Revenge*, 1911. BFI National Archive
5.16 Berthold Bartosch and Frans Masereel, *The Idea*, 1932. The Kobal Collection
5.17 Anthony Gross and Hector Hoppin, *The Joy of Life*, 1934. Ronald Grant Archive/© Estate of Anthony Gross. All Rights Reserved, DACS 2017
5.18 Norman McLaren, *Love on the Wing*, 1937. BFI National Archive
5.19 Len Lye, *Trade Tattoo*, 1937. 35mm Technicolor, 5 minutes, sound. Courtesy the Len Lye Foundation and the British Postal Museum and Archive. From material preserved and made available by Nga Taonga Sound & Vision
5.20 Iris Barry at the MoMA film archive, New York City, *c.* 1935. © 2017. Digital image, The Museum of Modern Art, New York/Scala, Florence
5.21 Thomas Wilfred with his work *Lumia*, 1960. Thomas Wilfred Papers (MS 1375). Manuscripts and Archives, Yale University Library
6.1 Walt Disney Pictures, *Snow White and the Seven Dwarfs*, 1937. Ronald Grant Archive/© 1937 Disney
6.2 Disney, *Steamboat Willie*, from the "Mickey Mouse" series, 1928. Ronald Grant Archive/© 1928 Disney
6.3 Mel Blanc, *c.* 1940. Michael Ochs Archives/Getty Images
6.4 Disney's multiplane camera. Ronald Grant Archive/© Disney
6.5 Sergei Eisenstein visits The Walt Disney Studios, 1930. Ronald Grant Archive/© Disney
6.6 Mickey Mouse perfume bottle and lead figurine, 1930s. Christie's Images/Corbis. Mickey Mouse © Disney
6.7 A Disney animator working on cels of Mickey Mouse, 1938. Photo Alfred Eisenstaedt/The LIFE Picture Collection/Getty Images
6.8 Title card for *Three Little Pigs*, dir. Burt Gillett, 1933 Photofest/© Disney
6.9 Burt Gillett, *Three Little Pigs*, 1933. Photofest/© 1933 Disney
6.10 Burt Gillett, *Playful Pluto*, 1934. © 1934 Disney
6.11 Constantin Sergeyvich Stanislavsky, *c.* 1920s. Library of Congress, Washington, D. C., LC-DIG-ggbain-35320
6.12 Ben Sharpsteen, *The Cookie Carnival*, 1935. © 1935 Disney
6.13 Walt Disney Pictures, *Snow White and the Seven Dwarfs*, 1937 © 1937 Disney
6.14 Walt Disney Pictures, *Pinocchio*, 1940. Ronald Grant Archive/© 1940 Disney
6.15 Walt Disney Pictures, *Fantasia*, 1940. Ronald Grant Archive/© 1940 Disney
6.16 Walt Disney Pictures, *Dumbo*, 1941. Ronald Grant Archive/© 1941 Disney
6.17 Walt Disney Pictures, *Bambi*, 1942. Photofest/© 1942 Disney
7.1 George Pal, *Tulips Shall Grow*, 1942. © Paramount Pictures. All Rights Reserved
7.2 The Walter Lantz Studio at Universal Studios, 1930. Ronald Grant Archive
7.3 Merian C. Cooper and Ernest B. Schoedsack, *King Kong*, 1933. Licensed by Warner Bros. Entertainment Inc. All Rights Reserved
7.4 Ub Iwerks, *Fiddlesticks*, 1930. Metro-Goldwyn-Mayer Studios Inc.
7.5 Fleischer studio, *Tramp, Tramp, Tramp*, from the "Ko-Ko Song Car-Tunes" series, 1924
7.6 Norman Ferguson, *The Three Caballeros*, 1944. Photofest/© 1944 Disney
7.7 Mae Questel, *c.* 1930s. John Springer Collection/Corbis
7.8 *Betty Boop*, *c.* 1933–34. Ronald Grant Archive. © 2017 King Features Syndicate, Inc./Fleischer Studio Inc. ™Hearst Holdings Inc/Fleischer Studio Inc.
7.9 Cab Calloway, 1930s. Bettmann/Corbis
7.10 Fleischer studio, Stereoptical process patent, 1936. The United States Patent and Trademark Office
7.11 Dave Fleischer, *Popeye the Sailor Meets Sinbad the Sailor*, 1936. © 2016 King Features Syndicate, Inc. ™Hearst Holdings Inc.
7.12 Grant Wood, *Young Corn*, 1931. Cedar Rapids Museum of Art/Artepics/Alamy

7.13 Fleischer employees protest outside the New Criterion Theater, New York City, 1937. FPG/Hulton Archive/Getty Images
7.14 Fleischer studio, *Gulliver's Travels*, 1939. Ronald Grant Archive/© Paramount Pictures. All Rights Reserved
7.15 *Gulliver's Travels* in production at the Fleischer studio, 1939. Photofest
7.16 Fleischer studio, *The Mad Scientist*, from the "Superman" series, 1941. Fleischer Studio
8.1 Ben Sharpsteen, *Clock Cleaners*, 1937. © Disney
8.2 Clyde Geronimi, Wilfred Jackson, and Hamilton Luske, *Lady and the Tramp*, 1955. AF archive/Alamy/© 1955 Disney
8.3 Chuck Jones, *What's Opera, Doc?*, 1957. Licensed by Warner Bros. Entertainment Inc. All Rights Reserved
8.4 George Pal, *Jasper and the Haunted House*, 1942. © Paramount Pictures. All Rights Reserved
8.5 Crowds outside a theater showing *The Jazz Singer*, 1927. Ronald Grant Archive
8.6 Hugh Harman and Rudy Ising with Bosko, 1930s. Ronald Grant Archive
8.7 Bob Clampett, *Porky in Wackyland*, 1938. Licensed by Warner Bros. Entertainment Inc. All Rights Reserved
8.8 Bob Clampett, *The Great Piggy Bank Robbery*, 1946. Licensed by Warner Bros. Entertainment Inc. All Rights Reserved
8.9 Chuck Jones, *The Dover Boys*, 1942. Licensed by Warner Bros. Entertainment Inc. All Rights Reserved
8.10 Ub Iwerks, *Spooks*, 1932. Metro-Goldwyn-Mayer Studios Inc.
8.11 Rudy Ising, *Puss Gets the Boot*, 1940. Metro-Goldwyn-Mayer Studios Inc.
8.12 Bill Hanna and Joe Barbera, *The Two Mouseketeers*, 1952. Metro-Goldwyn-Mayer Studios Inc./Photofest
8.13 Promotional cel painting for *Red Hot Riding Hood* (dir. Tex Avery), 1943. Metro-Goldwyn-Mayer Studios Inc./Photofest
8.14 Tex Avery, *The House of Tomorrow*, 1949. Metro-Goldwyn-Mayer Studios Inc.
p. 142 (left) Walter Lantz, *Boogie Woogie Bugle Boy of Company "B,"* 1941. Courtesy Universal Studios Licensing LLC © 1941 Universal Studios
p. 142 (right) Jiří Trnka, *The Hand*, 1965. Ronald Grant Archive. Courtesy Kratky Film
p. 143 Robert "Bobe" Cannon, *Gerald McBoing-Boing*, 1951. Dreamworks LLC
9.1 Bradshaw Crandell, Women's Army Corps recruitment poster, 1943. Library of Congress, Washington, D. C., LC-USZC4-1653
9.2 Stuart Heisler, *The Negro Soldier*, 1944. Republic Pictures Home Video/Photofest. United States Department of War
9.3 (left) *The First Motion Picture Unit*, 1943. USAAF
9.3 (right) *Photographic Intelligence for Bombardment Aviation*, 1943. USAAF
9.4 L. Amalrik and O. Khodataeva, *Kino-Circus*, 1942. Courtesy Soyuzmultfilm
9.5 Lou Bunin, *Bury the Axis*, 1943. Courtesy Amy Bunin Kaiman
9.6 Egbert van Putten, *About Reynard the Fox*, 1941. Collection EYE Filmmuseum
9.7 Seymour Kneitel, *Japoteurs*, 1942. Licensed by Warner Bros. Entertainment Inc. All Rights Reserved
9.8 Walter Lantz, *Boogie Woogie Bugle Boy of Company "B,"* 1941. Courtesy Universal Studios Licensing LLC © 1941 Universal Studios
9.9 Bob Clampett, *Draftee Daffy*, 1945. Licensed by Warner Bros. Entertainment Inc. All Rights Reserved
9.10 Chuck Jones, *Spies*, from the "Private SNAFU" series, 1943. US Army Signal Corps
9.11 Joy Batchelor, working at her studio in London, *c.* 1954. Popperfoto/Getty Images
9.12 Tex Avery, *Swing Shift Cinderella*, 1945. Metro-Goldwyn-Mayer Studios Inc.
9.13 Norman McLaren, *V for Victory*, 1941. © 1941 National Film Board of Canada. All Rights Reserved
9.14 Hans Fischerkoesen, *Worthy Representation*, 1937. Courtesy Philips Company Archives
9.15 Hans Fischerkoesen, *Weather-Beaten Melody*, 1942. Deutsche Wochenschau

9.16 Paul Grimault, *The Passengers in the Big Dipper*, 1943. Les Gémeaux
9.17 Noburō Ōfuji, *The Black Cat*, 1931
9.18 Mitsuyo Seo, *Momotaro's Sea Eagle*, 1945. Geijutsu Eiga-sha
10.1 Anton Gino Domenighini, *The Rose of Baghdad*, 1949. Ima Film
10.2 Karel Dodal, *Bimbo's Unfortunate Adventure*, 1930. National Film Archive, Prague
10.3 Hermína Týrlová working on *Ferda the Ant*, 1944. National Film Archive, Prague
10.4 Josef Skupa shows his puppets to children in London, 1948. Hulton-Deutsch Collection/Corbis
10.5 Irena Dodalová and Karel Dodal, *The Secret of the Lucerna Palace*, 1936. National Film Archive, Prague
10.6 Jiří Trnka at Studio Loutkoveho Filmu, published in *Ciné Revue*, 1953
10.7 Albert Dubout, *Anatole Goes Camping*, 1947. © Dubout, www.dubout.fr
10.8 Taiji Yabushita and Kazuhiko Okabe, *The Tale of the White Serpent*, 1958. Toei Doga/The Kobal Collection
10.9 Wan Guchan and Wan Laiming, *Princess Iron Fan*, 1941. Cinema Epoch
10.10 Te Wei and Qian Jiajun, *Where's Mama?*, 1960. Shanghai Animation Film Studio
10.11 Wan Laiming, *Havoc in Heaven*, 1964. Shanghai Animation Film Studio
10.12 Soviet Union poster, 1944. akg-images
10.13 Yuri Norstein working on animation at Soyuzmultfilm studio, 1966. Sputnik/Alamy
10.14 Lev Atamanov, *The Snow Queen*, 1957. Photos 12/Alamy. Courtesy Soyuzmultfilm
10.15 Dušan Vukotić, *Ersatz*, 1961. Courtesy Ustanova Zagreb film
10.16 Halas & Batchelor, *Charley in New Town*, 1948. BFI National Archive
10.17 Norman McLaren, *c.* 1950. Norman McLaren Archive, University of Stirling
10.18 Norman McLaren, *Now Is the Time*, 1951. © 1951 National Film Board of Canada. All Rights Reserved
10.19 Norman McLaren, *Around Is Around*, 1951. © 1951 National Film Board of Canada. All Rights Reserved
10.20 Norman McLaren, *Neighbours*, 1952. © 1952 National Film Board of Canada. All Rights Reserved
10.21 Norman McLaren, *A Chairy Tale*, 1957. © 1957 National Film Board of Canada. All Rights Reserved
10.22 Evelyn Lambart, *The Town Mouse and the Country Mouse*, 1980. © 1980 National Film Board of Canada. All Rights Reserved
10.23 René Jodoin, *Dance Squared*, 1961. © 1961 National Film Board of Canada. All Rights Reserved
11.1 Lou Bunin, *Alice in Wonderland*, 1951. Lou Bunin Productions. Courtesy Amy Bunin Kaiman
11.2 Alexandre Alexeieff and Claire Parker, *Night on Bald Mountain*, 1933. Alexandre Alexeieff © Droits réservés. Claire Parker © Droits réservés. Photo Centre Pompidou, MNAM-CCI, Dist. RMN-Grand Palais/Hervé Véronèse
11.3 Gisèle and Ernest Ansorge, *The Chameleon Cat*, 1975. Collection Cinémathèque suisse. All Rights Reserved
11.4 George Pal, *Philips Broadcast of 1938*, 1938. Courtesy Philips Company Archives
11.5 Aleksandr Ptushko, *The New Gulliver*, 1935. Mosfilm
11.6 Jiří Trnka, *The Hand*, 1965. Ronald Grant Archive. Courtesy Kratky Film
11.7 Břetislav Pojar, *A Drop Too Much*, 1954. Courtesy Kratky Film
11.8 Karel Zeman, *Mr. Prokouk, Filmmaker*, 1948. National Film Archive, Prague
11.9 Dziga Vertov, *The Man with a Movie Camera*, 1929. Amkino Corporation/Photofest
11.10 Karel Zeman, *The Fabulous Baron Munchausen*, 1961. Courtesy Kratky Film
11.11 Kihachiro Kawamoto, *House of Flame*, 1979
11.12 Ray Harryhausen working on a model for *The Seventh Voyage of Sinbad*, 1958. The Kobal Collection
11.13 Don Chaffey, *Jason and the Argonauts*, 1963. Columbia/The Kobal Collection

11.14 George Pal and Henry Levin, *The Wonderful World of the Brothers Grimm*, 1962. Metro-Goldwyn-Mayer Studios Inc./The Kobal Collection
11.15 Mecki and his wife, stuffed toys from *c.* 1959. Interfoto/Alamy
11.16 Pokey and Gumby, created by Art Clokey for *The Gumby Show*, 1957. Premavision/Photofest
11.17 Art Clokey, *Gumbasia*, 1953. Premavision
12.1 Jackson Pollock at work at his studio in Long Island, NY. Martha Holmes/The LIFE Picture Collection/Getty Images
12.2 Lounge chair and ottoman designed by Charles and Ray Eames, 1956. G. Jackson/Arcaid/Corbis
12.3 Alfred Hitchcock, *Vertigo*, 1958. Photofest/© Paramount Pictures. All Rights Reserved
12.4 Izzy Sparber and Seymour Kneitel, *Boo Moon*, 1954. Dreamworks LLC
12.5 Chuck Jones, *Wackiki Wabbit*, 1943. Licensed by Warner Bros. Entertainment Inc. All Rights Reserved
12.6 Mary Blair, conceptual artwork for *Alice in Wonderland*, 1951. © Disney
12.7 Clyde Geronimi, Hamilton Luske, and Wilfred Jackson, *Alice in Wonderland*, 1951. Photofest/© 1951 Disney
12.8 Ward Kimball and C. August Nichols, *Toot, Whistle, Plunk and Boom*, 1953. © 1953 Disney
12.9 Clyde Geronimi, Hamilton Luske, and Wolfgang Reitherman, *One Hundred and One Dalmatians*, 1961. Ronald Grant Archive/© 1961 Disney
12.10 Stephen Bosustow with Mr. Magoo, a character from his UPA studio. Ronald Grant Archive
12.11 Robert "Bobe" Cannon, *The Brotherhood of Man*, 1946. UPA
12.12 John Hubley, *Flight Safety: Landing Accidents*, 1946. UPA
12.13 Robert "Bobe" Cannon, *Gerald McBoing-Boing*, 1951. Dreamworks LLC
12.14 John Hubley, *Rooty Toot Toot*, 1952. Dreamworks LLC
12.15 John Sutherland, *A is for Atom*, 1953. Sutherland Productions
13.1 A kinescope, recording programs directly from the monitor, 1948. *Popular Mechanic*, 1948
13.2 *Felix the Cat* in the first experimental TV broadcast, 1929. Photofest
13.3 "Mickey Mouse Club" television series, 1955–59. Photofest/ABC/© Disney
13.4 Burr Tillstrom, "Kukla, Fran, and Ollie," 1948. Gordon Coster/The LIFE Images Collection/Getty Images
13.5 NBC, "Howdy Doody" series. NBC/NBCU Photo Bank via Getty Images
13.6 Bob Clampett, "Time for Beany," 1950. Paramount Television Network
13.7 Total TeleVision productions, "Underdog," 1964–67. CBS/Photofest
13.8 Blake Edwards, *The Pink Panther*, 1963. Mirisch Corporation/United Artists/Ronald Grant Archive
13.9 Bill Melendez Productions, *A Charlie Brown Christmas*, 1964. CBS/Photofest
13.10 Promotional photograph for "Winky Dink and You," 1953–57. CBS/Photofest
13.11 Huckleberry Hound, from Hanna-Barbera's "The Huckleberry Hound Show," 1958–62. Licensed by Warner Bros. Entertainment Inc. All Rights Reserved
13.12 Characters from "The Flintstones" in a promotion for Winston cigarettes, 1960. Warner Bros.
13.13 The Comics Code Authority's "Seal of Good Practice," 1954
13.14 Children's Television Workshop, characters from "Sesame Street." Sesame Street/Scott J. Ferrell/Congressional Quarterly/Alamy
13.15 ABC, "Schoolhouse Rock!," *c.* 1979. ABC Photo Archives/ABC via Getty Images
13.16 "Transformers" toy by Hasbro, 1984. Chris Willson/Alamy
13.17 Filmation Associates, *The Secret of the Sword*, 1985. RCA/Columbia Pictures/Photofest
13.18 Halas & Batchelor, *Top Dogs*, 1960, from the "Snip and Snap" series. Photos 12/Alamy. Courtesy Halas & Batchelor
13.19 Hiroshi Sasagawa, "Speed Racer," 1967. Tatsunoko Production/Lion's Gate/Photofest
13.20 Osamu Tezuka, *Treasure Island*, 1947. © Tezuka Productions

13.21 Osamu Tezuka, "Astro Boy," 1963. NBC/Photofest © Tezuka Productions
p. 238 (left) John Whitney, *Arabesque*, 1975. © 1975 John Whitney, © renewed 2015 by Whitney Editions™, Los Angeles. All Rights Reserved
p. 238 (right) John Hubley and Martin Rosen, *Watership Down*, 1978. Nepenthe Productions/AVCO Embassy/The Kobal Collection
p. 239 George Dunning, *Yellow Submarine*, 1968. United Artists/Photofest © Subafilms Ltd
14.1 Nam June Paik in collaboration with John J. Godfrey, *Global Groove*, 1973. Single-channel videotape, 28 minutes 30 seconds, color, sound. Director Merrily Mossman. Narrator Russell Connor. Film footage Jud Yalkut and Robert Breer. Produced by the TV Lab at WNET/Thirteen, New York. Courtesy Electronic Arts Intermix (EAI), New York. © Nam June Paik Studios
14.2 San Francisco Museum of Art, "Art in Cinema" exhibition catalog, 1947
14.3 Harry Smith, Still from *Film # 12, Heaven and Earth Magic*, *c.* 1957–62. 16mm, 66 minutes, black and white, sound. Courtesy Harry Smith Archives
14.4 Larry Jordan, *Duo Concertantes*, 1964. Courtesy Lawrence Jordan
14.5 James Whitney, *Lapis*, 1966. Photo Courtesy Whitney Editions™, Los Angeles. All Rights Reserved
14.6 Norman McLaren, *Mosaic*, 1966. © 1965 National Film Board of Canada. All Rights Reserved
14.7 Norman McLaren, *Synchromy*, 1971. © 1971 National Film Board of Canada. All Rights Reserved
14.8 Portrait of Kubelka, from *Fragments of Kubelka* by Martina Kudláček
14.9 Len Lye, *Free Radicals*, 1958, revised 1979. 16mm, 4 minutes, black and white, sound. Courtesy the Len Lye Foundation. From material preserved and made available by Ng Taonga Sound & Vision.
14.10 Robert Breer, *Fist Fight*, 1964. Courtesy Robert Breer, Kate Flax, gb agency, Paris
14.11 Stan Brakhage, *Mothlight*, 1963. Courtesy the Estate of Stan Brakhage and Fred Camper (www.fredcamper.com)
14.12 Oscilloscope. Science & Society Picture Library/Getty Images
14.13 Hy Hirsh, *Eneri*, 1953. Courtesy The Creative Film Society, The iotaCenter, and Angeline Pike
14.14 Small-Scale Experimental Machine (SSEM, known as "Baby"), 1948. © The University of Manchester
14.15 John and James Whitney, "Five Abstract Film Exercises," 1940s. Courtesy Whitney Editions™, Los Angeles. All Rights Reserved
14.16 John and James Whitney working on "Five Abstract Film Exercises." Courtesy Whitney Editions™, Los Angeles. All Rights Reserved
14.17 John Whitney, *Arabesque*, 1975. © 1975 John Whitney, © renewed 2015 by Whitney Editions™, Los Angeles. All Rights Reserved
14.18 Larry Cuba, *Two Space*, 1979. Courtesy Larry Cuba
14.19 Ed Emshwiller, *Sunstone*, 1979. 3 minutes 55 seconds, color, sound. Courtesy Electronic Arts Intermix (EAI), New York and the Ed Emshwiller Family Estate
14.20 Peter Foldes, *Hunger*, 1974. © 1973 National Film Board of Canada. All Rights Reserved
15.1 Cover, *Zap Comix*, No. 1, 1967. © Robert Crumb, 1967
15.2 Peter Max sitting on his posters. Henry Groskinsky/The LIFE Picture Collection/Getty Images. © Peter Max
15.3 Harve Foster and Wilfred Jackson, *Song of the South*, 1946. Photofest/© Disney
15.4 Chuck Jones, *The Phantom Tollbooth*, 1970. Metro-Goldwyn-Mayer Studios Inc./Photofest
15.5 John and Faith Hubley, *Everybody Rides the Carousel*, 1975. Courtesy The Hubley Studio, Inc.
15.6 John Hubley and Martin Rosen, *Watership Down*, 1978. Nepenthe Productions/AVCO Embassy/The Kobal Collection
15.7 Isao Takahata, *Hols: Prince of the Sun*, 1968. Toei Company/Photofest

15.8 Yoram Gross, *Joseph the Dreamer*, 1961. Courtesy Yoram Gross Films
15.9 Yoram Gross, *Dot and the Kangaroo*, 1977. Courtesy Yoram Gross
15.10 Karel Zeman, *The Stolen Airship*, 1967. Carlo Ponti Cinematografica/Photos 12/Alamy
15.11 George Dunning, *Yellow Submarine*, 1968. United Artists/Photofest © Subafilms Ltd
15.12 Roland Topor and René Laloux, *Fantastic Planet*, 1973. Courtesy Kratky Film
15.13 Walerian "Boro" Borowczyk, *The Theater of Mr. and Mrs. Kabal*, 1967. Courtesy Friends of Walerian Borowczyk, walerianborowczyk.com and Arrow Films
15.14 *Archaeology Today*, from "Monty Python's Flying Circus," Photofest/Courtesy Python (Monty) Pictures Limited
15.15 Ralph Bakshi, *Fritz the Cat*, 1972. Cinemation Industries/Photofest
15.16 Ralph Bakshi, *The Lord of the Rings*, 1978. AF archive/Alamy
p. 274 (left) Nintendo Gamecube, *The Legend of Zelda: The Wind Waker*, 2002
p. 274 (right) Nick Park, *The Wrong Trousers*, 1993. AF archive/Alamy/© Aardman Animations
p. 275 Donaldson Collection/Michael Ochs Archives/Getty Images/Nickelodeon's "SpongeBob Squarepants" used with permission by Nickelodeon. © 2015 Viacom Media Networks. All Rights Reserved. Nickelodeon, all related titles, characters and logos are trademarks owned by Viacom Media Networks, a division of Viacom International Inc.
16.1 *Spacewar!* interactive display conceived in 1961 by Martin Graetz, Stephen Russell, and Wayne Wiitanen; realized on the PDP-1 in 1962 by Stephen Russell, Peter Samson, Daniel Edwards, and Martin Graetz, together with Alan Kotok, Steve Piner, and Robert A. Saunders. Courtesy MIT Museum
16.2 Atari, *Pong*, 1973
16.3 Namco, *Pac-Man*, 1980. ArcadeImages/Alamy
16.4 Poster for Don Bluth's *Dragon's Lair*, 1983. Silver Screen Collection/Getty Images
16.5 Ralph Baer's Magnavox Odyssey console, 1972. Evan-Amos
16.6 Nintendo Entertainment System (NES). GOIMAGES/Alamy
16.7 Sega Genesis. David Greedy/Getty Images
16.8 Nintendo, *Super Mario 64*, 1996. Jamaway/Alamy
16.9 Nintendo Entertainment System "Zapper," mid–1980s. Julia Buchner
16.10 Oculus VR Rift headset. Charlie Neuman/UT San Diego/San Diego Union-Tribune, LLC/ZUMA Wire/Alamy
16.11 *Tetris*, developed by Alexey Pajitnov at the Computing Center of the Soviet Academy of Sciences, 1984
16.12 Nintendo, *Super Mario Bros.*, 1985. vanillasky/Alamy
16.13 Nintendo, *Donkey Kong*, 1981. pumkinpie/Alamy
16.14 (left) *Dungeons & Dragons* players, 2007. Ray Stubblebine/Reuters
16.14 (right) *Dungeons & Dragons* dice and character sheet. Allan Munsie/Alamy
16.15 Nintendo Gamecube, *The Legend of Zelda: The Wind Waker*, 2002
16.16 Don Rawitsch, Carleton College, *The Oregon Trail*, 1971
16.17 Brøderbund Software, *Where in the World is Carmen Sandiego?*, 1999
16.18 Apogee Software, *Wolfenstein 3D*, 1992. Jamaway/Alamy
16.19 Sledgehammer Games, *Call of Duty: Advanced Warfare*, 2014. Jake Charles/Alamy
16.20 Warren Robinett for Atari, *Adventure*, 1979
16.21 Cory Arcangel, *Super Mario Clouds*, 2002–. Handmade hacked *Super Mario Bros.* cartridge and Nintendo NES video game system, variable dimensions. Courtesy Cory Arcangel. © Cory Arcangel
16.22 Burnie Burns at Rooster Tooth Productions, "Red vs. Blue," 2003. Courtesy Rooster Teeth Productions
16.23 Peggy Ahwesh, *She Puppet*, 2001. Courtesy Peggy Ahwesh
16.24 Core Design, *Tomb Raider*, 1996. Photofest

17.1 A Da, *Three Monks*, 1980. Shanghai Animation Film Studio
17.2 Zinaida and Vaentina Brumberg, *Great Troubles*, 1961. Courtesy Soyuzmultfilm
17.3 Fyodor Khitruk, *Man in the Frame*, 1966. Sputnik/Alamy. Courtesy Soyuzmultfilm
17.4 Fyodor Khitruk, *The Story of a Crime*, 1962. Sputnik/Topfoto
17.5 Yuri Norstein, *The Fox and the Hare*, 1973. Courtesy Soyuzmultfilm
17.6 Yuri Norstein, *The Hedgehog in the Fog*, 1975. Sputnik/Alamy. Courtesy Soyuzmultfilm
17.7 Yuri Norstein, *Tale of Tales*, 1979. Courtesy Soyuzmultfilm
17.8 Igor Kovalyov, *Hen, His Wife*, 1989. Courtesy Igor Kovalyov
17.9 Alexandr Petrov teaching in the Yekaterinburg History Museum, Russia, 2010. Sputnik/Topfoto
17.10 Alexandr Petrov, *The Old Man and the Sea*, 1999. Dentsu Tec/Photos 12/Alamy
17.11 Priit Pärn, *Breakfast on the Grass*, 1987. Courtesy Priit Pärn
17.12 Jiří Trnka. The Kobal Collection
17.13 Giuseppe Archimboldo, *Vertumnus*, c. 1590–91. Skokloster Castle, Sweden
17.14 Jan Švankmajer, *Dimensions of Dialogue*, 1982. Courtesy Kratky Film
17.15 Jan Švankmajer, *Alice*, 1988. Ronald Grant Archive/© Athanor Ltd, Film Production Company, Jaromir Kallista and Jan Švankmajer
17.16 Michaela Pavlátová, *Words, Words, Words*, 1991. Courtesy Michaela Pavlátová
17.17 Jiří Barta, *In the Attic: Who has a Birthday Today?*, 2009. Produced by Bio Illusion. Courtesy Ivan Vit
17.18 Jiří Barta, *The Pied Piper*, 1985. Produced by Kratky Film. Courtesy Ivan Vit
17.19 Magazine cover, courtesy *Homo Felix*
17.20 Vanda Raýmanová, *Who's There?* 2010. Courtesy Vanda Raýmanová, www.whoistherefilm.com
17.21 Katarina Kerekesová, *Stones*, 2010. Courtesy Katarína Kerekesová, www.foolmoonfilm.com
17.22 Ferenc Rofusz, *The Fly*, 1980. Courtesy Ferenc Rofusz
17.23 Marcell Jankovics, *Son of the White Mare*, 1981. Pannónia Filmstúdió
17.24 Csaba Varga, *Luncheon*, 1980
17.25 Zbigniew Rybczyński, *Tango*, 1982. Courtesy Zbig Rybczynski
18.1 Poster for the first International Animation Festival in Japan, HIROSHIMA '85. Illustration by Yoji Kuri, designed by Renzo Kinoshita
18.2 Poster for "Spike and Mike's Festival of Animation," 1988. Courtesy Spike and Mike's Festival of Animation, Mellow Manor Productions
18.3 The CalArts Character Animation class of 1976, with faculty member Elmer Plummer. Photofest
18.4 Richard Conde, *The Big Snit*, 1985. © 1985 National Film Board of Canada. All Rights Reserved
18.5 Wendy Tilby and Amanda Forbis, *When the Day Breaks*, 1999. © 1999 National Film Board of Canada. All Rights Reserved
18.6 Bill Plympton, *One of Those Days*, 1988. Courtesy Bill Plympton
18.7 Cyriak, *Welcome to Kitty City*, 2011. Courtesy Cyriak
18.8 Philip Hoffman with the "Film Farm" group of 2015. Photo Marcel Beltran
18.9 Helen Hill, *Recipes for Disaster: A Handcrafted Film Cookbooklet*, 2001. Courtesy Paul Gailiunas
18.10 Helen Hill and her pet pig. Courtesy Paul Gailiunas
18.11 Sheila Sofian, *Truth Has Fallen*, 2013. Courtesy Sheila M. Sofian
18.12 John and Faith Hubley, *Moonbird*, 1959. Courtesy The Hubley Studio, Inc.
18.13 Frank Mouris, *Frank Film*, 1973. Courtesy Frank Mouris
18.14 Joanna Priestley, *Voices*, 1985. Courtesy Joanna Priestley
18.15 Chris Landreth, *Ryan*, 2004. © 2004 Copper Heart Cut Inc. ne National Film Board of Canada. All Rights Reserved
18.16 Torril Kove, *My Grandmother Ironed the King's Shirts*, 1999. © 1999 National Film Board of Canada. All Rights Reserved

18.17 Faith Hubley, *W.O.W. (Women of the World)*, 1975. Courtesy The Hubley Studio, Inc.
18.18 Emily Hubley, *Delivery Man*, 1982. Courtesy Hubbub Inc.
18.19 Sally Cruikshank, *Quasi at the Quackadero*, 1975. Courtesy Sally Cruikshank
18.20 Caroline Leaf, *Two Sisters*, 1991. © 1991 National Film Board of Canada. All Rights Reserved
18.21 Joanna Quinn, *Girls' Night Out*, 1987. © Joanna Quinn/Beryl Productions Int. Ltd
18.22 Nazlı Eda Noyan, *A Cup of Turkish Coffee*, 2013. Courtesy Nazlı Eda Noyan
18.23 Nina Paley, *Sita Sings the Blues*, 2008. Courtesy Nina Paley, www.sitasingstheblues.com
18.24 Signe Baumane, *Rocks in My Pockets*, 2014. Courtesy Signe Baumane
18.25 Paul Driessen, *The End of the World in Four Seasons*, 1995. © 1995 National Film Board of Canada. All Rights Reserved
18.26 Adam Beckett, *Flesh Flows*, 1974. Courtesy The iotaCenter
18.27 Stacey Steers, *Phantom Canyon*, 2006. Courtesy Stacey Steers
18.28 Clive Walley, *Brushwork*, 1993. Courtesy Clive Walley
18.29 Frédéric Back, *The Man Who Planted Trees*, 1987. Courtesy Société Radio-Canada, Canadian Broadcasting Corporation
18.30 Tim Burton, *Vincent*, 1982. Photofest/© 1982 Disney
18.31 Barry Purves, *Rigoletto*, 1993. Courtesy Barry Purves. A Bare Boards Production for BBC/S4C 1993
18.32 Will Vinton and Bob Gardiner, *Closed Mondays*, 1974. Courtesy Vinton Entertainment, Inc.
18.33 Will Vinton, The California Raisin Band, c. 1989. Courtesy Vinton Entertainment, Inc.
18.34 Joan Gratz, *Mona Lisa Descending a Staircase*, 1992. Courtesy Joan Gratz
18.35 Nick Park, *The Wrong Trousers*, 1993. AF archive/Alamy/© Aardman Animations
18.36 Adam Elliot, *Cousin*, 1998. Adam Elliot Clayographies PTY Ltd
18.37 Adam Elliot, *Mary and Max*, 2009. Melodrama Pictures PTY Ltd
19.1 "Star Wars" collectible figures, 1977. Zangl/ullstein bild via Getty Images
19.2 Hong Kong Disneyland Resort, 2005. Alex Hofford/epa/Corbis
19.3 *Disney Magic* cruise ship, St. Thomas Island, Caribbean. Richard Cummins/Corbis
19.4 Don Bluth, *The Secret of NIMH*, 1982. United Archives GmbH/Alamy
19.5 Don Bluth, *Anastasia*, 1997. Photofest/Anastasia © 1997 Twentieth Century Fox. All Rights Reserved
19.6 Robert Zemeckis, *Who Framed Roger Rabbit*, 1988. © 1988 Touchstone Pictures & Amblin Entertainment, Inc.
19.7 Henry Selick, *Tim Burton's The Nightmare Before Christmas*, 1993. The Kobal Collection/© 1993 Touchstone Pictures
19.8 Michael Eisner and Frank Wells. Robert Nese/The LIFE Images Collection/Getty Images/© Disney
19.9 Jeffrey Katzenberg. Alan Levenson/The LIFE Images Collection/Getty Images/© Disney
19.10 Ron Clements and John Musker, *The Little Mermaid*, 1989. Photofest/© 1989 Disney
19.11 Gary Trousdale and Kirk Wise, *Beauty and the Beast*, 1991. Ronald Grant Archive/© 1991 Disney
19.12 Roger Allers and Rob Minkoff, *The Lion King*, 1994. Moviestore collection Ltd/Alamy/© 1994 Disney
19.13 *Beauty and the Beast* stage show, Milan, Italy, c. 2014. Bruno Marzi/Splash News/Corbis/© Disney
19.14 *The Lion King* stage show, Mexico City, Mexico, 2015. Sashenka Gutierrez/epa/Corbis/© Disney
19.15 Don Hahn, *Waking Sleeping Beauty*, 2009. Disney Enterprises/Photofest
19.16 Chris Sanders and Dean DeBlois, *Lilo & Stitch*, 2002. © 2002 Disney
20.1 Roy Lichtenstein, *Look Mickey*, 1961. © Board of Trustees, National Gallery of Art, Washington, D. C.
20.2 Matt Groening, "The Simpsons," 1989–. Photofest/The Simpsons © 1990 Twentieth Century Fox Television. All Rights Reserved

20.3 Eric Radomski and Bruce Timm, "Batman: The Animated Series," 1992–95. Licensed by Warner Bros. Entertainment Inc. All Rights Reserved
20.4 Mike Judge and Greg Daniels, "King of the Hill," 1997–2010. Photofest/King of the Hill © 1997 Twentieth Century Fox Television. All Rights Reserved
20.5 Eddie Murphy, Larry Wilmore and Steve Tompkins, "The PJs," 1999–2001. Courtesy Vinton Entertainment, Inc.
20.6 Colossal Pictures, MTV logo, 1984. MTV's "MTV ID" used with permission by MTV. © 2017 Viacom Media Networks. All Rights Reserved. MTV, all related titles, characters and logos are trademarks owned by Viacom Media Networks, a division of Viacom International Inc.
20.7 Steve Barron, scenes from the music video for A-ha, "Take On Me," 1985. Drawing by Michael Patterson. Animation direction by Michael Patterson and Candace Reckinger
20.8 Mike Judge and Yvette Kaplan, *Beavis and Butt-Head Do America*, 1996. The Kobal Collection/© 1996 MTV Networks. All Rights Reserved
20.9 Arlene Klasky, Gábor Csupó, and Paul Germain, "Rugrats," 1990–2006. Photofest/Nickelodeon's "Rugrats" used with permission by Nickelodeon. © 2015 Viacom Media Networks. All Rights Reserved. Nickelodeon, all related titles, characters and logos are trademarks owned by Viacom Media Networks, a division of Viacom International Inc.
20.10 Stephen Hillenburg, production cel from "Spongebob Squarepants," 1999–. Donaldson Collection/Michael Ochs Archives/Getty Images/Nickelodeon's "SpongeBob Squarepants" used with permission by Nickelodeon. © 2015 Viacom Media Networks. All Rights Reserved. Nickelodeon, all related titles, characters and logos are trademarks owned by Viacom Media Networks, a division of Viacom International Inc.
20.11 Pendleton Ward, "Adventure Time," 2010–. Cartoon Network/Photofest
20.12 Jonathan Katz and Tom Snyder, "Dr. Katz: Professional Therapist," 1995–2002. Photofest/Comedy Central's "Dr. Katz" used with permission by Comedy Central. © 2015 Viacom Media Networks. All Rights Reserved. Comedy Central, all related titles, characters and logos are trademarks owned by Viacom Media Networks, a division of Viacom International Inc.
20.13 Doodle Productions Ltd, *Moon Landing*, from the series "Messy Goes to OKIDO," 2015
21.1 Steve Wozniak and Steve Jobs, 1976. DB Apple/dpa/Corbis
21.2 Apple I. Breker/Splash News/Corbis
21.3 Apple II. Science & Society Picture Library/Getty Images
21.4 Steven Lisberger, *Tron*, 1982. Ronald Grant Archive/© 1982 Disney
21.5 James Cameron, *Terminator 2*, 1991. The Kobal Collection/© 1991 Studiocanal Films Ltd. All Rights Reserved
21.6 Rebecca Allen, *Swimmer*, 1981. Courtesy Rebecca Allen
21.7 Rebecca Allen, *Musique Non Stop: Kraftwerk Portrait*, 1986. Courtesy Rebecca Allen
21.8 Richard Linklater, *Waking Life*, 2001. Detour/Independent Film/Line Research/The Kobal Collection/Waking Life © 2001 Twentieth Century Fox. All Rights Reserved
21.9 Hironobu Sakaguchi and Moto Sakakibara, *Final Fantasy: The Spirits Within*, 2001. Square Pictures/The Kobal Collection
21.10 Graph based on the "Uncanny Valley" concept by Masahiro Mori and Karl MacDorman
21.11 James Cameron, *Avatar*, 2009. The Kobal Collection/Avatar © 2009 Twentieth Century Fox. All Rights Reserved
21.12 John Lasseter, *Luxo Jr.*, 1986. Photofest/© 1986 Pixar
21.13 John Lasseter, *Tin Toy*, 1988. © 1988 Pixar Animation Studios
21.14 John Lasseter, *Toy Story*, 1995. © 1995 Disney - Pixar
21.15 Tim Johnson and Eric Darnell, *Antz*, 1998. Dreamworks LLC/The Kobal Collection

21.16 Andrew Adamson and Vicky Jenson, *Shrek*, 2001. Dreamworks LLC/The Kobal Collection
21.17 Nineteenth-century stereoscope. Science & Society Picture Library/Getty Images
21.18 Eric Leighton and Ralph Zondag, *Dinosaur*, 2000. Ronald Grant Archive/© 2000 Disney
21.19 Brad Bird, *The Iron Giant*, 1999. Licensed by Warner Bros. Entertainment Inc. All Rights Reserved
21.20 QUBO, "Veggie Tales," 2006. QUBO/Photofest
p. 386 (left) Hayao Miyazaki, *Princess Mononoke*, 1997. Dentsu/NTV/Studio Ghibli/The Kobal Collection
p. 386 (right) Marjane Satrapi and Vincent Paronnaud, *Persepolis*, 2007. 2.4.7. Films/The Kobal Collection
p. 387 Cloud Eye Control, *Half Life*, 2015. Courtesy Cloud Eye Control
22.1 "Sailor Moon," c. 1992–97. Cartoon Network/Photofest
22.2 Katsuhiro Otomo, *Akira*, 1989. Akira Committee/Pioneer Ent./The Kobal Collection
22.3 Shinichiro-Watanabe, "Cowboy Bebop," 1998–99. Destination Films/Photofest
22.4 Attributed to Toba Sojô, *Scroll of the Animals*, twelfth century. The Art Archive/Alamy
22.5 Hayao Miyazaki, *Nausicaä of the Valley of the Wind*, 1984. Hakuhodo/Tokuma Shoten/The Kobal Collection
22.6 Hayao Miyazaki, *Princess Mononoke*, 1997. Dentsu/NTV/Studio Ghibli/The Kobal Collection
22.7 Hayao Miyazaki, *My Neighbor Totoro*, 1988. Studio Ghibli/Photofest
22.8 Hayao Miyazaki, *Spirited Away*, 2001. Studio Ghibli/The Kobal Collection
22.9 Isao Takahata, *Grave of the Fireflies*, 1988. Studio Ghibli/The Kobal Collection
22.10 Isao Takahata, *Pom Poko*, 1994. Studio Ghibli/The Kobal Collection
22.11 Utagawa Kuniyoshi, *Mitsukini Defying the Skeleton*, 1845. visipix.com
22.12 Satoshi Kon, *Paprika*, 2006. Photofest/Paprika © 2006 Madhouse, Inc. and Sony Pictures Entertainment (Japan) Inc. All Rights Reserved. Courtesy Sony Pictures Entertainment
22.13 Masaaki Yuasa, *MIND GAME*, 2004. Studio 4°C/Asmik Ace Ent./The Kobal Collection/© 2004 Mind Game Project
22.14 Mamoru Oshii, *Ghost in the Shell*, 1995. Bandai/Kodansha/Production IG/Ronald Grant Archive
22.15 Osamu Tezuka, *Broken Down Film*, 1985. © Tezuka Productions
22.16 Maya Yonesho, *One Door*, 2003. Courtesy Maya Yonesho
22.17 Studio Ghibli Museum, Mitaka, Tokyo. Yannick Luthy/Alamy
23.1 Dave Borthwick, *The Secret Adventures of Tom Thumb*, 1993. Courtesy bolexbrothers
23.2 Dianne Jackson, *The Snowman*, 1982. The Kobal Collection. © Snowman Enterprises Ltd, www.thesnowman.com
23.3 Barry Purves, *Screenplay*, 1992. A Bare Boards production for Channel 4 television, 1992
23.4 Joanna Quinn, *Wife of Bath*, from "The Canterbury Tales," 1998. © Joanna Quinn
23.5 Paul Reubens, "Pee-wee's Playhouse," 1986–91. CBS/Photofest
23.6 Nick Park and Peter Lord, *Chicken Run*, 2000. Dreamworks LLC/Pathé/Aardman Animations/The Kobal Collection
23.7 George Miller, *Happy Feet*, 2006. Licensed by Warner Bros. Entertainment Inc. All Rights Reserved
23.8 Dennis Tupicoff, *Dance of Death*, 1983. Courtesy Dennis Tupicoff
23.9 Lee Sung-Gang, *My Beautiful Girl Mari*, 2002. Courtesy Lee Sung-Gang
23.10 Marcos Magalhães, *Meow*, 1981. © Marcos Magalhães
23.11 Anima Mundi festival poster, Rio de Janeiro, Brazil, 1999. © Anima Mundi Festival Archives
23.12 Adriana Copete, *Busking Tales*, 2014. Courtesy Adriana Copete
23.13 Juan Camilo Gonzáles, *In Abyssus HumanÆ ConscientiÆ (ReconoceR)*, 2011. Courtesy Juan Camilo González
23.14 Vivienne Barry, *Like the Wings of Little Birds*, 2002. Courtesy Vivienne Barry

23.15 Michel Ocelot, *Kirikou and the Sorceress*, 1998. © 1998 Les Armateurs/Odec Kid Cartoons/France 3 Cinéma/Monipoly/Trans Europe Films/Exposure/RTBF/Studio O
23.16 Adamu Wasiri, "Bino and Fino," 2012–. Courtesy EVCL
23.17 Anthony Silverston, *Khumba*, 2013. Photofest/Courtesy Triggerfish
23.18 Sharmeen Obaid Chinoy, *Three Braves*, 2014. Courtesy Sharmeen Obaid Films
23.19 Sulafa Hijazi, *The Jasmine Birds*, 2009. Courtesy Sulafa Hijazi
23.20 Sylvain Chomet, *The Triplets of Belleville*, 2003. Sony Pictures Classics/Photofest
23.21 Jacques Tati, *Holiday*, 1949. AF archive/Alamy/Jour de fête de Jacques Tati (1958) © Les Films de Mon Oncle
23.22 Marjane Satrapi and Vincent Paronnaud, *Persepolis*, 2007. 2.4.7. Films/The Kobal Collection
23.23 Ari Folman, *Waltz with Bashir*, 2008. Bridgit Folman Film Gang/The Kobal Collection
23.24 Ignacio Ferreras, *Wrinkles*, 2011. Courtesy Dragoia Media
23.25 Tomm Moore, *Song of the Sea*, 2014. Big Farm/Cartoon Saloon/Digital Graphics/Irish Film Board/The Kobal Collection
23.26 Joann Sfar and Antoine Delesvaux, *The Rabbi's Cat*, 2012. Autochenille Production
23.27 Marguerite Abouet and Clément Oubrerie, *Aya of Yop City*, 2012. UGC Distribution/Photofest
24.1 Bruno Bozzetto, *Allegro Non Troppo*, 1976. © Bruno Bozzetto
24.2 Jeff Scher, *White Out*, 2008. Courtesy Jeff Scher
24.3 Allison Schulnik, *Eager*, 2012. Courtesy Allison Schulnik
24.4 Georges Schwizgebel, *78. R.P.M.*, 1985. © Schwizgebel
24.5 José Antonio Sistiaga, *Ere erera baleibu izik subua aruaren*, 1970. Courtesy José Antonio Sistiaga and Light Cone
24.6 Chen Shaoxiong, *Ink History*, 2008–10. Video, black and white animation, 3 minutes. © Chen Shaoxiong. Courtesy Pékin Fine Arts
24.7 Lewis Klahr, *Altair*, 1985. Courtesy Lewis Klahr
24.8 Janie Geiser, *Immer Zu*, 1997. Courtesy Janie Geiser
24.9 Martha Colburn, *Cats Amore*, 2002. Courtesy Martha Colburn
24.10 Eric Dyer, *Knippel Louises Bro*, from *Copenhagen Cycles*, 2006–14. Courtesy the artist and Ronald Feldman Fine Arts
24.11 Ben Ridgway, *Tribocycle*, 2013. Courtesy Ben Ridgway
24.12 Cosmo AV, *Fire Evolution*, projection-mapped onto the façade of the Bolshoi Theater, 2013. Ivan Novikov/AFP/Getty Images. Courtesy Cosmo AV
24.13 Kathy Rose, *Opera of the Interior*, 2015. Courtesy Kathy Rose
24.14 (above) Cloud Eye Control, *Half Life*, 2015. Courtesy Cloud Eye Control
24.14 (below) Cloud Eye Control, *Half Life*, 2015. Courtesy Cloud Eye Control. Photo Eugene Ahn
24.15 Bill T. Jones, Paul Kaiser, and Shelley Eshkar, *Ghostcatching*, 1999. Courtesy Bill T. Jones, Paul Kaiser, and Shelley Eshkar
24.16 Rachel Ho, *SLEIGHTING*, 2014. Courtesy Rachel Ho. Photo Scott Groller
24.17 Pierre Hébert, *The Human Plant*, 1996. © 1996 National Film Board of Canada. All Rights Reserved
24.18 Ferenc Cakó, *Ab Ovo*, 1987. Courtesy Ferenc Cakó
24.19 Jaron Lanier, *Moondust*, 1983. Courtesy Jaron Lanier
24.20 Ricardo Miranda Zúñiga, *Vagamundo*, 2002. Courtesy Ricardo Miranda Zúñiga

We have endeavored to credit rights owners where possible. The author and publisher apologize for any omissions or errors, which we will be happy to correct in future printings and editions of this book.

Index

Figures in *italic* refer to illustrations